W9-BNN-471

THE AUTHORITATIVE GUIDE TO FUNDING, PREPARING, SHOOTING, LIGHTING, EDITING, PRINTING, SCREENING, TITLING, PROCESSING, COPYWRITING, AND DISTRIBUTING YOUR FILM

Whether it's indoors or outdoors, big budgets or small, 35mm or hand-held video . . . whether you're behind the camera or in the lab . . . no matter how much time you have, how much money you want to spend . . . what style you want to use . . . whatever equipment, skills, and terminology you want to master . . .

You'll find the most current, cutting-edge information in clear, accessible language in . . .

The Filmmaker's Handbook

the definitive guide that gives every aspiring professional and beginning filmmaker the guidance and tools needed to master the fine art of making movies.

Steven Ascher's films include *Troublesome Creek: a Midwestern* (made with Jeanne Jordan) which won the Grand Jury Prize and the Audience Award at the Sundance Film Festival and was nominated for an Academy Award. Other films include *Del and Alex* and *Life and Other Anxieties* (made with Ed Pincus). He graduated from Harvard University and has taught filmmaking at the Massachusetts Institute of Technology. His awards include the Prix Italia, a George Foster Peabody Award, and he was nominated for a Directors Guild of America Award.

Edward Pincus's films include *Black Natchez, Panola,* and *Portrait of a McCarthy Supporter* (all made with David Neuman). His pioneering work in personal documentary led to *Diaries: 1971–76.* He founded the Film Section at the Massachusetts Institute of Technology and later taught filmmaking at Harvard. His awards include a Guggenheim Fellowship and he is author of the widely used *Guide to Filmmaking.* He is currently a commercial cut-flower grower in northern New England.

The Filmmaker's Handbook

A Comprehensive Guide
for the Digital Age

IIIIIIIIIIIII

Steven Ascher
and
Edward Pincus

IIIIIIIIIIIII

Drawings by Carol Keller and Robert Brun
Original Photographs by Ted Spagna
and Stephen McCarthy

COMPLETELY REVISED AND UPDATED BY STEVEN ASCHER

A PLUME BOOK

PLUME
Published by the Penguin Group
Penguin Putnam Inc., 375 Hudson Street, New York, New York 10014, U.S.A.
Penguin Books Ltd, 27 Wrights Lane, London W8 5TZ, England
Penguin Books Australia Ltd, Ringwood, Victoria, Australia
Penguin Books Canada Ltd, 10 Alcorn Avenue, Toronto, Ontario, Canada M4V 3B2
Penguin Books (N.Z.) Ltd, 182–190 Wairau Road, Auckland 10, New Zealand

Penguin Books Ltd, Registered Offices: Harmondsworth, Middlesex, England

Published by Plume, a member of Penguin Putnam Inc.

First Printing, June, 1984

First Printing (revised edition), March, 1999
10 9 8 7

 REGISTERED TRADEMARK — MARCA REGISTRADA

LIBRARY OF CONGRESS CATALOGING-IN-PUBLICATION DATA:

Ascher, Steven.
 The filmmaker's handbook : a comprehensive guide for the digital age / Steven Ascher
and Edward Pincus. —Completely revised and updated.
 p. cm.
 Pincus' name appears first on the previous edition.
 Includes bibliographical references and index.
 ISBN 0-452-27957-7
 1. Cinematography—Handbooks, manuals, etc. 2. Digital video—Handbooks,
manuals, etc. 3. Motion pictures—Production and direction—Handbooks, manuals, etc.
I. Pincus, Edward. II. Title.
TR850.P54 1999
778.5'3—dc21 98-41665
 CIP

Printed in the United States of America
Set in Janson Text
Designed by Jesse Cohen

*For
Jordan*

and

Jane

CONTENTS

PREFACE

When we wrote the first edition of *The Filmmaker's Handbook* in the early 1980s, it was possible to be a filmmaker and know almost nothing about video. That is no longer the case. The new generation of moviemakers needs to be versed in both video and film techniques. Some projects call for film and others are better suited to video. And on many productions the two technologies are intertwined.

This new edition is completely revised and updated, with the idea that readers may be interested in video, film or both. If you're already familiar with one type of technology, this book will help you see how others are similar or different. Ultimately, all types of equipment are simply tools used for the same goal—telling stories.

There have always been two worlds captured by the moviemakers: the fictional and the nonfictional. The theatrical feature film creates a world before the camera. A story is written and characters act out the events to make the film. In the documentary, filmmakers attempt to show the world as it is. The French contrast the films of Lumière, who filmed his baby eating breakfast and a train arriving at the station, with those of his contemporary Méliès, the magician, who created stories, costumes and special effects for his films. On the one hand, there is the difference between documentary and fiction; on the other, the difference between finding magic in the world and creating it for the camera.

In a sense, all moviemakers start out as independents. More often than not, the novice must become versed in all aspects of production—shooting, sound recording, editing, raising money and distribution—simply because there is no one else to perform these tasks. Learning these facets of filmmaking has its advantages no matter what your future career is in movies. The best cameraman or -woman is one familiar with the needs of the sound recordist and editor, and vice versa. In the book, when we use the industry's terms for craft division—editor, director of photography, camera operator, recordist and the like—it is for convenience and not to encourage the division of these roles.

The book presents technical information of practical value, introducing key terms and concepts while trying not to overwhelm the reader with technical jargon. We discuss equipment and techniques used by both beginning students and working professionals. Even if you can't yet afford some of the items discussed, it's useful to have a grasp of some of the things you'll need to know if you work in the industry.

You may want to read the book straight through or use it as a reference to

answer particular questions as they arise. Unfortunately, some of the topics in the book are by their nature complex. When possible, cross-references are supplied to help you find relevant material in other chapters to help clarify things. We suggest making liberal use of the Table of Contents and the Index.

For help with the first edition, we want to thank Mark Abbate, David Brown, Benjamin Bergery, Michael Callahan, Elvin Carini, Claude Chelli, Alfred Guzzetti, Ned Johnston, Rudolph Kingslake, Dennis Kitsz, Steve Kuettel, David Leitner, Mark Lipman, Ross McElwee, Robb Moss, Sami Pincus and Moe Shore.

For help with the second edition, thanks go to again to Alfred, David L. and Robb, and to Richard Bock, the Bueermanns, Frank Coakley, Sandra Forman, Victoria Garvin Davis, Len Gittleman, Peter Gloeggler, Sam Kauffmann, Julie Mallozzi, Eric Menninger, Michael Phillips, Adam Schatten and Tim Spitzer. Also to Rob Brun and Stephen McCarthy for wonderful illustrations and photographs.

Particular thanks to Bob Doyle and the NewMedia Lab for invaluable help with the video chapters.

We are very grateful to all the people, too numerous to mention, who graciously supplied information or photographs.

The new edition could not have been written without the support and contributions of Jeanne Jordan and Jordan Ascher, to whom thanks and love go beyond words.

Introduction to Film and Video Systems

This book is about making movies, whether they be dramatic features, documentaries, corporate videos, multimedia projects, TV commercials or home movies. We use the word *movie* very broadly to mean productions that may be shown and distributed in any number of ways, including in theaters, on television, to the public, within a company or movies made strictly for personal use.

At one time, people working in film seemed to live in a different world from people working in video, and there was yet another world of people using computers to make images. Today, the distinctions between these worlds have broken down. Now, most "film" projects are edited in "video" using computers. Many "videomakers" produce their movies digitally and then transfer the finished product to film for screenings in festivals or theaters.

To talk about different technologies in one book presents some challenges. People often use different words to describe the same thing. People shooting video may refer to the end product as a video, a tape or a show, while people doing the same thing with a film camera may say they're working on a film or a movie. But what should we call something that is shot on film, then transferred to video for editing and finally broadcast on TV? Throughout the book, we will generally use *film, video* and *television* to refer to those specific technologies, and use the words *movie* or *project* to denote motion pictures that may be made or shown with any type of equipment or combination of technologies. As this is *The Filmmaker's Handbook*, the terms *film-maker* or *moviemaker* will refer to the maker of the movie, regardless of the medium.

This first chapter is intended as an overview of the moviemaking process, an outline of techniques and equipment.

MAKING A MOVIE

Movie production ranges from multimillion-dollar, widescreen Hollywood epics to a parent capturing a child's birthday with a home video camera. Although movies vary widely in terms of budgets, number of personnel and intended uses, many of the processes required to create movies are similar for all productions.

Moviemaking tasks can be divided chronologically into *preproduction, production* and *postproduction periods.*

Preproduction is the time for planning and preparation. Fiction projects usually begin with a script, while unscripted documentaries may start as a written proposal outlining what is to be filmed. The filmmaker (or producer) draws up a budget of the movie's estimated cost and arranges for financing. For higher-budget projects, this usually involves soliciting investors, distributors, grants or a television contract. Lower-budget projects are often financed out-of-pocket, sometimes with the hope of recouping costs after the movie is finished. During the preproduction period, the *crew* is assembled and *locations* (the sites where the movie will be shot) are scouted. For some projects, *sets* may be built in a studio and *casting* is done to choose actors.

The production period essentially begins when the camera rolls. This is sometimes called the start of *principal photography.* Since movie equipment is generally expensive, it is often rented for the duration of production, or only on the days it is needed. With the advent of low-cost video gear, it is increasingly feasible to buy equipment outright.

The postproduction period (often just called *post,* as in, "We've just started post") begins once the principal shooting is completed. Editing is done to condense what are often hours of film or video footage into a watchable movie. It is usually in the editing room that the project can be seen in its entirety for the first time. Movies are often substantially rearranged and reworked during editing. A *rough cut* is honed to a *fine cut,* and, when a satisfactory version is complete (called *picture lock*), the various stages of *finishing* take place (including adding any music, *sound editing, sound mix,* making titles).

When a film is finished, *prints* are made, which are copies of the film that can be shown in screenings. The video equivalent is a *dub* (duplicate copy). Finally, the movie is *released* or *distributed*—sent out into the world to find its audience. There are many types of distribution, aimed at different markets. *Theatrical* release is the goal of most *feature films.* A theatrical run may take place in *first-run* movie houses or smaller, specialized *art houses. Television* distribution may include traditional broadcast television, cable TV or satellite. *Educational* or *A-V (audio-visual)* distribution usually implies selling or renting videos to schools and libraries. *Home video* release is selling or renting videos either directly to consumers or through video stores. *Multimedia* projects are generally computer-based, "interactive" programs that allow the user to control or respond to the program. Both multimedia and linear (noninteractive) movies may be distributed to consumers on disc (such as CD-ROM or DVD) or transmitted over the World Wide Web (Internet). A given project may be distributed through all of these channels or in various combinations.

Movies are increasingly distributed to a global marketplace and issues of multiple languages, technologies and venues must be dealt with. Many decisions made during the movie's production affect what kind of distribution is possible, and the filmmaker must try to anticipate distribution goals from the very start of the project.

FILM SYSTEMS

The Moving Image

The impression of continuous movement in a motion picture is an illusion. The film camera records a series of still photographs in rapid succession (usually 24 frames per second, written 24 fps). After the film is developed, these images, separated from each other by an instant of darkness, are projected on a screen. Since the eye retains images slightly longer than it is actually exposed to them, it tends to meld two successive images into one, creating a smooth transition between them. This phenomenon is called *persistence of vision* and is responsible for the illusion of motion in film, flip books and video.

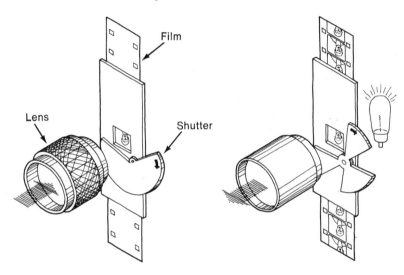

Fig. 1-1. The camera and the projector. The camera (left) draws in light to create an image of the world; the projector (right) throws the image back into the world. (Carol Keller)

The camera works by focusing light from the scene to be photographed onto a small rectangular area of the film. After each rectangle (*frame*) is exposed to light, the *shutter* blocks off the light. The *claw* then pulls more film into position and holds it in place. When the film is at rest, the shutter opens again, allowing light to strike the film. This stop-start process is called the *intermittent movement*.

The film projector operates on the same principle, but rather than focusing light from the surroundings onto the film, it projects the filmed image onto a screen using a bright light behind the film path. As long as the projector runs at the same speed as the camera, motion will appear normal. Sometimes cameras are run at a higher speed so that motion will appear slowed down (*slow motion*). See Chapter 2 for more on camera speeds.

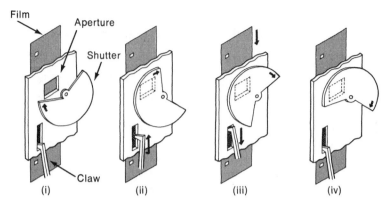

Fig. 1-2. The shutter and intermittent movement. (i) The claw holds the film in place during exposure. (ii, iii) The shutter rotates to block light from the film while the claw moves up to pull down the next frame. (iv) The claw freezes in position to hold the next frame steady for exposure. (Carol Keller)

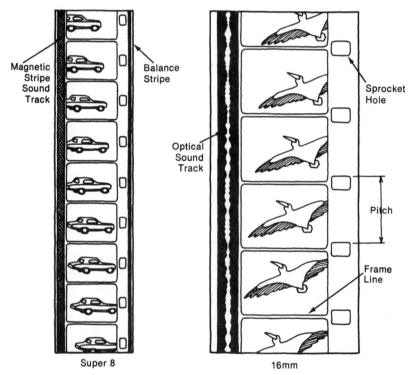

Fig. 1-3. The moving image is composed of a series of still images called *frames*. Successive frames are divided by the *frame line*. The claw advances the film by engaging a sprocket hole, or perforation. The 16mm film here has an optical sound track and the super 8 film a magnetic stripe sound track. Note the different sprocket hole positions in the various formats. (Carol Keller)

The Format

While all film cameras expose images in essentially the same way, the size and shape of the image produced vary with the camera type. The first movies, made in the 1890s by Thomas Edison, were shot on *cellulose nitrate* base film that was about 35 millimeters (mm) wide. Nitrate film is highly flammable and becomes explosive as it deteriorates with age (much of the first version of Robert Flaherty's *Nanook of the North* was destroyed by a fire from a cigarette ash). Nitrate has since been replaced by the more stable *cellulose acetate* base. The 35mm gauge remains the most commonly used in theatrical filmmaking.

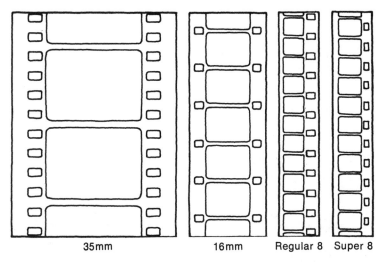

35mm 16mm Regular 8 Super 8

Fig. 1-4. Comparison of film formats. (Carol Keller)

In the 1920s, 16mm film was introduced as a cheaper alternative to 35mm. The area of the 16mm frame is only one quarter of that of the 35mm frame and, when projected side-by-side, the 16mm film looks grainier and less sharp. However, with the technological improvements made in lenses, cameras and film emulsions, 16mm is used extensively in professional filmmaking. In the 1970s, super 16 was developed. Super 16 is 16mm wide, but by extending the image into the side of the film normally occupied by a second set of perforations, super 16 allows a 40 percent larger image to be recorded on each frame (see Fig. 1-6).

In 1932, 8mm cameras were introduced that used 16mm film slit down the middle (double 8mm). In 1965 Kodak brought out super 8 film that was 8mm wide, but with smaller, repositioned sprocket holes it could record an image 50 percent larger than regular 8mm. Once the prime format for home movies, super 8 now has limited use.

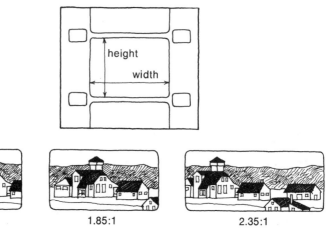

1.33:1 1.85:1 2.35:1

Fig. 1-5. The aspect ratio is the width of the frame divided by its height. Widescreen formats call for a different approach to image composition. (Carol Keller)

Aspect Ratio

A film's *format* refers to the width of the film material itself, as well as the size and shape of the image that is recorded on it. The 16mm and super 16 formats use film of the same width or gauge (16mm), but the size of their frames are different. The shape of the frame is described by the proportions of its rectangle: the width of the frame divided by the height is the *aspect ratio* (see Fig. 1-5). The standard for several formats (including regular 8mm, super 8, 16mm, as well as traditional video/TV) is an aspect ratio of four to three, or 1.33:1 (spoken *one three three to one*, or just *one three three*). In 35mm, the full frame for sound film has an aspect ratio of about 1.33:1 and is called *Academy aperture*, named for the Academy of Motion Picture Arts and Sciences that defined it. Though the Academy frame was once standard in theaters, and is the "traditional" standard for television, it is considered too narrow to satisfy contemporary theater audiences.

By using a higher aspect ratio, the filmmaker can compose wider images, which, when projected, will fill a wide theater screen. Most movies viewed in American theaters are made to be shown at 1.85:1, which is a *widescreen* aspect ratio. European theatrical films are made for projection at 1.66:1, which, for the same height, is not quite as wide as the 1.85:1 image. Most widescreen systems work by cropping out the top and bottom of the Academy frame, making the image proportionally wider. Sometimes very widescreen images are achieved by using *anamorphic lenses* to "squeeze" the width of the image being shot so that it will fit on the film frame (see Fig. 1-29). The image is then "unsqueezed" in projection, widening it to its original aspect ratio and restoring shapes to their natural proportion. The most common aspect ratios for anamorphic systems are as wide as 2.35:1. Anamorphic film systems are often called "scope" (from the trade name CinemaScope). Normal, nonanamorphic lenses are sometimes called *spherical*, and nonanamorphic prints are called *flat*.

For more on aspect ratio and the use of widescreen video formats, see p. 37.

COMPARING FILM FORMATS

As a rule of thumb, the larger the format, the better the quality of the image, the more expensive it is to shoot and the heavier the equipment. When a large area of film emulsion is used for each exposure, the grain and imperfections of the film detract less from the image. In the 35mm camera, about 12 square inches of film are exposed each second; in 16mm only about 2.5 square inches are used.[1] When a 16mm frame is projected on a modest 8′ × 10′ screen, it must be enlarged about 100,000 times. To fill a screen of the same size, a super 8 frame must be magnified more than 300,000 times. This is why theatrical features are usually shot on 35mm or 65mm film (although independent films often originate on smaller formats). For more on how format size affects picture quality, see Resolution, p. 33.

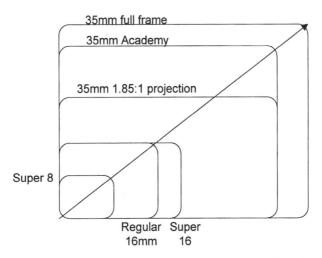

Fig. 1-6. Relative frame sizes of various film formats. The diagonal line shows that all but super 16 and 35mm 1.85 projection have virtually the same aspect ratio.

The film image is affected not only by the format but by the particular camera being used, the lenses and, especially, the film itself (called *film stock* or *raw stock*). A film camera will produce vastly different results depending on the film stock being used.

Most professional filmmaking is done with negative film stocks. After the film is developed, negative stocks render a scene with reversed tonalities, that is, what was light in reality is dark on the negative (see Fig. 4-2). When the *camera original* (the film that actually went through the camera) is negative, it must be printed on *positive*

[1]This is comparing 35mm Academy frame to regular 16mm. Standard 1.85 35mm exposes about 9″ each second.

film stock to be viewable. Sometimes films are shot with *reversal* film stocks, which are like slides in still photography—that is, they show a normal image as soon as they're developed. Usually, prints made from color reversal camera films show noticeably more grain and contrast than prints made from negative stocks. Back when TV news was shot on film, reversal was preferred because no print is needed to view the image. Editing reversal original saves time and money, but runs the high risk of scratching the film. Not all stocks are available in all formats.

Super 8

Super 8 cameras are inexpensive, portable and easy to use. Film is inserted in pocket-sized cartridges (see Fig. 2-21). Many super 8 cameras are equipped to record sound in camera, but *magnetic striped* film stock capable of sound recording is hard to find. Super 8 was once the format of choice for home movies, but small video cameras dealt Super 8 a nearly fatal blow, since amateurs much prefer the convenience of video. Super 8 has become nearly obsolete and most equipment is only available used. In the heyday of super 8, the range of available film stocks was limited, and manufacturers have since discontinued many stocks.

Fig. 1-7. Beaulieu super 8 sync sound camera. (Super8 Sound)

Super 8 has undergone something of a revival. It is sometimes used in music videos, commercials and even feature films (both ultra-low-budget films and high-budget movies including Oliver Stone's work with cinematographer Robert Richardson). Super 8 is being kept alive by companies like Super8 Sound in Los Angeles, which has created the Pro8 Negative line of stocks by using a film-cutting machine to load super 8 cartridges with a wide range of color and black-and-white 35mm negative camera stocks. Rather than edit or distribute films in super 8, most people transfer to video and/or *blow up* (enlarge) to 16mm or 35mm.

Aside from cost, why shoot super 8? When used with some film stocks, super 8 cameras can offer much of the flexibility of a small-format video camera but with a superior image. But super 8 can also offer "deficiencies" that filmmakers may be seeking. Sometimes a rough, grainy image is desired, perhaps as a stylistic touch or to simulate the look of old movies. Instead of trying to *degrade* a 16mm or 35mm image, filmmakers shoot one of the grainier, more contrasty Super 8 stocks.

16mm and Super 16

During its life span, 16mm has gone through enormous changes. Starting as an amateur format (once considered "spaghetti" by pros), the portability of 16mm cameras made them the tool of choice for news and documentaries. The grainy, handheld 16mm look is still associated with some sense of "realism." In the 1970s and 1980s, 16mm cameras and stocks improved greatly, and 16mm was used extensively for TV documentaries, low-budget feature films, animation and avant-garde films. At one time, 16mm projectors were found in virtually every school. By the mid-1990s, many productions that were formerly done in 16mm were being done in video, and 16mm as a *distribution* format had almost disappeared. Nevertheless, with newer, fine-grained film stocks, 16mm and super 16 are capable of a rich image quality that rivals 35mm and they are still used for higher-budget documentaries, some TV shows, commercials and many low-budget features.

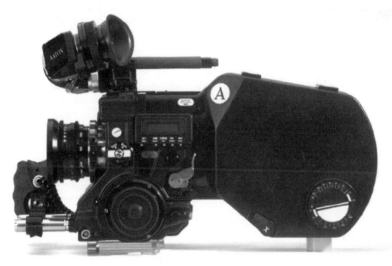

Fig. 1-8. Aaton XTRprod camera. Adapts for regular 16mm and super 16 filming. Versatile and exceptionally well balanced for handheld work. (AbelCineTech)

Films can be easily made in 16mm by a two- or three-person crew and even by an adroit lone filmmaker, but somewhat larger crews are the norm. Because so many projects are now done in video, used 16mm equipment can often be purchased at a great discount.

Institutions like universities and a few commercial theaters show films in 16mm, but more commonly, 16mm films are blown up to 35mm for theatrical distribution. When this is anticipated, there are advantages to shooting super 16 instead of regular 16mm. Because super 16 records a larger and wider frame, less magnification and cropping are necessary to create the 35mm widescreen image (see Fig. 1-9). Properly shot, super 16 films can look superb blown up to 35mm (such as *Leaving Las Vegas*). Super 16 is used increasingly as an origination medium for programs that will be distributed in widescreen and/or high-definition TV

formats (see p. 26). Some cameras (like most Aatons) can be switched between regular 16mm and super 16. Lenses designed for super 16 can be used for regular 16mm, but the reverse is often not the case.

The decision to shoot a feature in super 16 instead of 35mm may be made on the basis that production costs are lower, crews are smaller and film stock is less expensive in 16mm. This has to be weighed against the high cost of the eventual blowup to 35mm. Some underfunded producers figure they'll get the movie *in the can* (through production, but not necessarily all the way through postproduction) and try to raise blowup money later—perhaps after a successful festival showing or once a distributor is on board. The problem is that super 16 is not a release format. The image extends to the edge of the film that is normally reserved for the sound track on a 16mm print. To show a super 16 film, you either have to transfer it to video, blow it up to 35mm or make a special kind of 16mm print that recenters and crops the image—none of which is cheap. Nevertheless, many independent features are successfully done in super 16. For more on blowups from 16mm and super 16, see p. 494.

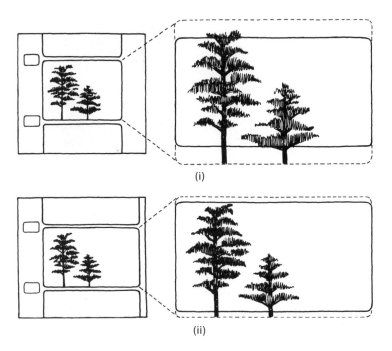

(i)

(ii)

Fig. 1-9. Blowing up 16mm film to 35mm. (i) When a regular 16mm frame is blown up to widescreen 35mm, the image must be significantly cropped. (ii) By using the area normally reserved for the optical sound track, the super 16 frame closely approximates the 1.85:1 widescreen aspect ratio. Very little of the super 16 image is lost when the blowup is made. (Carol Keller)

35mm

The standard format of feature films, as well as television commercials and TV movies not shot on video, is 35mm. Conventional 35mm cameras are heavy, cumbersome and expensive. These cameras are usually supported on tripods or dollies because of their bulk and the importance of having a steady image on a large theater screen. The newer generation of lighter, hand-holdable 35mm cameras and stabilization devices, such as the Steadicam (which enables the operator to carry the camera smoothly; see Fig. 8-18), provide greater mobility and allow 16mm filming techniques to be used in feature films (Steadicams are also used in 16mm and video production).

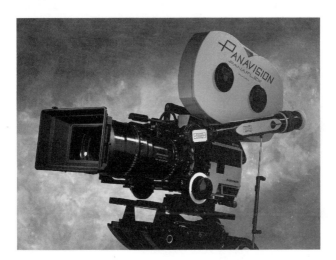

Fig. 1-10. Panaflex 35mm camera. (Panavision)

In general, the highest-quality equipment, techniques and lab services are available for 35mm production, for which film budgets usually run in the millions. Due to the sheer bulk of the equipment and the complexity of projects undertaken in 35mm, crews of about eight to more than a hundred persons are employed.

The standard 35mm frame is four perforations high. Some 35mm cameras are set up for the *three-perf 35mm* format, which uses a frame that is only three perforations high. This results in a 25 percent savings in film stock, since less film is needed for each frame. The aspect ratio of this narrow frame is roughly 1.85:1. Three-perf looks virtually the same as four-perf when transferred to video, and can be optically printed to the standard four-perf format for film distribution.

Large Formats

There are a number of widescreen formats used primarily for feature films. Some high-budget films are shot in 65mm, which is then shown in theaters on 70mm (the added width is used for sound tracks). Films like *Lawrence of Arabia* demonstrate the stunning detail and rich image of this format. The 65mm negative is reduced to 35mm for smaller theaters. Even larger are the IMAX and Om-

nimax formats, which run 65mm film *horizontally* through the camera, creating an image that spans 15 perforations per frame instead of 65mm's usual five. These are shown on huge, enveloping screens in specially constructed theaters. The image is spectacular.

SOUND RECORDING FOR FILM

Most films have sound tracks; even in the silent film era, films were intended to be shown with musical accompaniment. Through the years there have been various methods of *single system* recording, which means recording the sound in the camera right onto the film, either using a magnetic or optical stripe on the film. Today, virtually all filmmaking is done with *double system* recording, which means recording the sound using a separate audio recorder onto a separate piece of material (usually an audiotape).

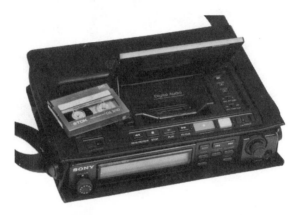

Fig. 1-11. DAT (digital audiotape) recorder. Sony TCD-D10 professional model. (Fletcher Chicago/Sony Electronics, Inc.)

Before portable recording equipment became available, most sound films were made in the studio under controlled conditions. The soundstage was acoustically isolated from distracting noises, and the bulky recording equipment was permanently mounted in place. When it was necessary to film on location, there was usually no attempt made to record a quality sound track. Instead, the film would be *looped* afterward in the sound studio. Looping, sometimes called *dubbing*, involves cutting scenes into short, endless loops that the actors watch while respeaking their lines. A similar technique is still used today to fix sound that was badly recorded or when the dialogue is to be redone in another language.

In the 1950s, advances in magnetic tape recorders made it practical to record sound on location. By the 1990s, lightweight audio recorders, like the classic reel-to-reel recorders made by Nagra, and DAT (digital audiotape) cassette recorders had become the most commonly used for professional film work.

The smallest, least expensive film cameras are noisy and are intended for shoot-

ing without sound (though sound can be added later). These cameras are sometimes called *MOS* (see p. 227) or *wild* cameras. Confusingly, the term *silent camera* is sometimes used to mean an MOS camera and sometimes means one that is quiet enough to be used for sound filmmaking. Audible camera noise on the sound track can be disastrous, especially in nondocumentary projects. Most good sound cameras are extremely quiet.

Synchronous or *sync* (pronounced *sink*) sound, also known as *lip sync*, matches the picture in the way you are used to hearing it: when the actor's lips move on the screen, you hear the words simultaneously. Nonsynchronous or *wild sound* is not *in sync*, or matched to the picture, in this way. Some films use wild sound exclusively, such as travelogue films that have only narration and a musical background. Wild sound can be recorded with any tape recorder and then transferred to the proper material for editing (see below).

Because sync sound requires precise alignment of sound and picture, only cameras and audio recorders equipped for sync sound work can be used. Most modern sound cameras are crystal-controlled (*crystal sync*) and operate at a precisely fixed speed (usually 24 fps). In both picture and sound, speed must be regulated exactly because even tiny fluctuations in speed (if uncorrected) result in the sound becoming *out of sync* with the picture. In that case, the picture of the actor's lips moving might appear before or after we hear the sound of his words.

A *microphone* or *mic* (pronounced "mike") is used to capture sounds and send them to the sound recorder. In double system recording, the camera and sound recorder are generally not attached to each other, so the microphone can be positioned close to the sound source for good recording, regardless of where the camera is. See Chapters 9 and 10 for more on sound recording.

FILM EDITING

In the 1990s, a sea change took place in the way films are edited. Instead of editing on film—using film editing equipment—many filmmakers now transfer their film footage to video and do their editing with computer-based, "nonlinear" video equipment (see p. 30). After video editing, a project may be finished in video, or you can return to the film negative and make film prints (see Chapter 13).

Even though fewer projects are edited the traditional way, it's important for filmmakers to understand conventional film editing, since the concepts as well as some of equipment and methods continue to be used.

During the production of the movie, as film footage is shot, it is sent to the laboratory for processing. When the footage comes back, it is called *dailies* or *rushes* (because on large productions it is rushed back and viewed every day; small films may not get such good service). In traditional film production, rushes are *workprint*—that is, a protection copy of the *camera original* film (the film which actually went through the camera). This prevents damage to the original and facilitates editing.

Similarly, sound is rerecorded or *transferred* from the original reel-to-reel or cassette tape to *magnetic film* (often called *mag stock*, *mag* or, in some cases, *fullcoat*). Mag has the same dimensions and sprocket holes as 16mm or 35mm picture film,

but it is has a magnetic oxide like that used in sound recording tape. Editing is then done with two strands of material (picture and sound) that are both sprocketed and can be placed in frame-for-frame correspondence. Before editing, the workprint and mag must be put in sync with each other (called *synchronizing the rushes* or *syncing up*). This is usually done by cutting and placing the mag alongside

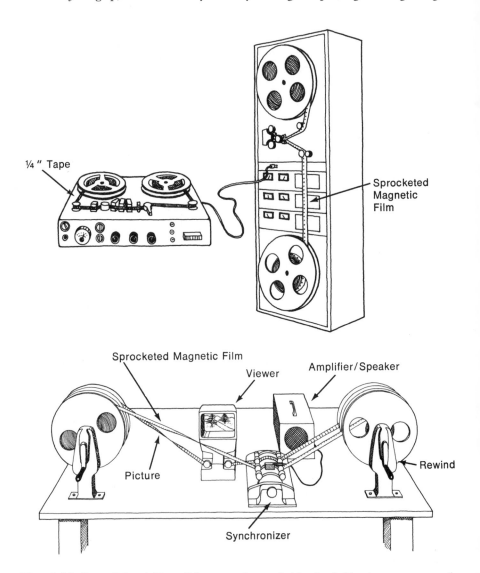

¼ " Tape

Sprocketed Magnetic Film

Sprocketed Magnetic Film

Viewer

Amplifier/Speaker

Rewind

Picture

Synchronizer

Fig. 1-12. In traditional film editing, sound recorded in the field using a tape recorder (top) (a ¼" recorder is shown here) is then transferred to sprocketed magnetic film (bottom) for editing. The mag film can then be edited with the picture in frame-for-frame correspondence. (Carol Keller)

its corresponding picture. Once the rushes are in sync, the two strands are then *edge coded*, by mechanically printing the same ink numbers on the edge of each strand. Edge code allows pieces of sound and picture to be readily identified and put back in sync.

During editing, sound and picture can be freely cut and combined. The editor can add, rearrange or remove images or sounds anywhere in the movie. Since film is edited in *double system* (sound and picture are on separate strands of material), changes can be made to either sound or image without necessarily changing the other. Often, several sound tracks are built. The use of multiple tracks allows music, narration and sound effects to be added to the sync sound. Multitrack editing machines can play two or more tracks in sync with the picture (see Fig. 13-7); this permits the editor to use multiple strands of sound as an integral element in the cutting of the film.

In order to project a double system film on a bigger screen during the editing process, you can either use a *double system projector* (see Fig. 12-2) or arrange for an *interlock screening* in a mix studio or theater that can interlock the projector with one or more *dubbers* that play the mag.

After editing is complete and the picture is locked, a sound mix is done to rerecord all the various sound tracks onto one final track. The pristine camera original is cut to match the edited workprint (called *negative matching* or *conforming*). Prints can then be made directly from the original or from an *intermediate*, which is itself a protection copy of the original.

The movie may call for various kinds of image transitions or manipulations. Simple transitions are done while making the print—like *dissolves* (where two images meld into each other) or *fades* (where the image appears from or disappears into darkness). More complex effects, called *opticals*, must be done in a separate step using an *optical printer*. Opticals include effects like *freeze frames* (where motion stops like a still photo) or *wipes* (where one image seems to push another off screen). Lettering for titles and credits is traditionally shot with a special camera onto a separate piece of film. The title rolls are then printed with the original negative. Color correction is done by a *color timer*, who views each scene in the film and estimates the correct printer setting.

All the steps of making a film print are time-consuming and involve a certain amount of trial and error. Typically, lab personnel do the titles, opticals and color corrections and then the director and/or director of photography view them in the *first answer print*. Any adjustments are then made and additional "corrected prints" are struck. The feedback process between the lab and filmmakers may take days, weeks or months to produce a finished print acceptable to the filmmakers.

After all the adjustments are done, a *release print* is made. The sound track is now combined with the picture; prints with sound tracks are called *composite* or *married* prints. Film editing methods are discussed in Chapters 12 through 17.

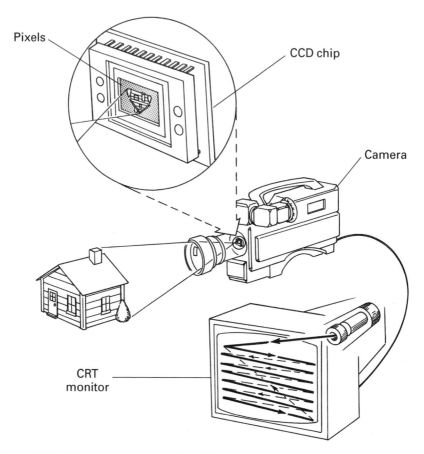

Pixels

CCD chip

Camera

CRT monitor

Fig. 1-13. Video camera and monitor. The camera's lens focuses an image of the world onto the CCD chip, which converts it to a video signal. The monitor "paints" the image on the screen following a pattern of lines called the *raster*. (Robert Brun)

VIDEO SYSTEMS

The Camera and Monitor

Like film cameras, video cameras use a lens to bring an image of the world into the camera. But instead of focusing that image on a strip of film, most modern video cameras focus the picture on a light-sensitive computer chip called a *CCD* (for *charge-coupled device*). The picture is focused onto the flat surface of the CCD, which is divided into a very fine grid of spots or sites called *pixels* (for *picture-elements*). Each pixel is in some ways like a tiny light meter that reads the brightness of light at that spot. When a pixel is struck by light, it creates and stores an electric charge. The more light that strikes it, the more charge builds up. A given CCD chip may have thousands or even millions of pixels in a chip that is less than

an inch across. The CCD measures the voltage of every pixel in the grid many times a second. It processes that information and sends it along as an electrical signal in one or more wires.

The video signal can then be recorded using a video recorder and/or displayed on a *monitor* (TV screen). Many monitors use a *cathode ray tube* (*CRT*) to convert the electrical video signal back into a visible image. Inside the monitor, a cathode ray gun fires a stream of electrons at the back of the video screen (the opposite side from which you watch). The inside of the screen is coated with a phosphor surface that glows when it is excited by the ray of electrons. The ray "paints" the image on the screen, line by line. The higher the current of the ray, the brighter the screen glows.

Taking the video system as a whole, we can see that a bright area in the original camera image creates a high charge at a given CCD pixel, which eventually results in a high current in the cathode ray, which produces a brighter glow on the monitor screen. The brightness of the video signal is called its *luminance*.

The Raster

The video system processes the image by dividing the picture into a series of horizontal *scan lines*. This pattern of lines is called the *raster*. The camera scans the image starting at the top, from left to right. It reads the brightness levels all the way across a scan line, then returns to the left side and moves down slightly as it scans across again. This is very much like the way your eye takes in a paragraph of written text. When it reaches the bottom of the screen, it returns to the top and starts over. The monitor's CRT makes the same scanning pattern, "painting" the image on as it goes. A *sync signal* makes sure the camera and monitor scan at the same rate.

| Field 1 | Field 2 | Complete frame |

Fig. 1-14. Interlace. Each field contains half the horizontal video lines. When the two fields are shown in rapid succession, the eye integrates them into one complete frame with all the lines. (Robert Brun)

In some computer and digital video systems, all the horizontal lines are scanned in order from top to bottom—this is called *progressive scanning*. Most analog and traditional video systems use *interlaced scanning* (see Fig. 1-14). Here the camera scans every *other* line (starting with the odd lines, 1,3,5 . . .), proceeding to the bottom of the picture. It then returns to the top and scans all the even lines 2,4,6 . . .). Each set of scans (even or odd) is called a *field*. When the two fields are shown in rapid succession, they make up one *frame*, which represents *all* the horizontal scan lines.

In North America, traditional broadcast video systems use a standard developed by the *NTSC* (*National Television Standards Committee*). NTSC video uses 525 horizontal lines, scanned in an interlaced pattern. A new field is scanned 60 times a second. Since two fields make up one complete frame, this results in video that runs at about 30 frames per second (fps).

In the U.K., Western Europe, China and Australia, the video standard used is called *PAL* (*Phase Alternating Line*). In France, Eastern Europe and Russia, the *SECAM* (*Système Electronique pour Couleur avec Mémoire*) standard is used. Both PAL and SECAM run at 25 fps and divide the picture into 625 horizontal scan lines. By using more lines than NTSC, these systems are capable of a sharper image than NTSC.

For more on the raster, see The Raster Revisited, p. 193.

Color

By combining different amounts of red, green and blue light, we can create virtually any color light. Color video cameras render color by breaking down the light coming through the camera lens into its red, green and blue components. In *single-chip* color cameras, one method is to use tiny filters over the pixels that allow the CCD to measure the relative amounts of red, green and blue light in a given area. In the generally superior *three-chip* color cameras, a prism or mirror in the camera splits the light coming through the lens into separate red, green and blue paths and then sends each path to a separate CCD. The intensity of color in a video signal is called its *chrominance*. For more on color, see Chapter 5.

The Video Recorder

In the early days of television, the live image from black-and-white television cameras could be broadcast over the air and received on home TV sets. But there was no way to electronically record the image for later broadcast or viewing. The only way to preserve a TV show was to make a *kinescope* by shooting the TV set with a film camera. The first *videotape recorder* (*VTR*) was produced in 1956, and used reel-to-reel tape.

Today, there are many types of video recorders. For field recording, cameras may be used with small VTRs (sometimes called *tape decks* or just *decks*). Often, the camera and recorder are combined in one unit, called a *camcorder*. Most VTRs today use tape in cassettes instead of open reels. Many people use the term *videocassette recorder* (*VCR*) to mean machines used in the home. Video images can be recorded on tape and viewed immediately without processing. Videotapes can be rerecorded many times, but image defects appear when tapes are reused. For editing, it is increasingly common to record digital video using computer drives or disks. Eventually, some video production may be done entirely without tape. However, tape is a terrifically inexpensive form of data storage.

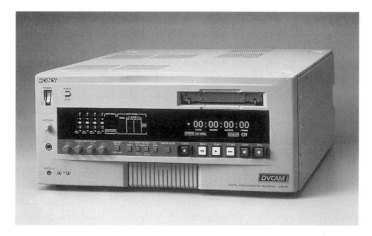

Fig. 1-15. Videotape recorder, or VTR. Sony DSR-80 digital deck accepts Mini-DV and DVCAM cassettes. (Sony Electronics, Inc.)

THE VIDEO FORMAT

There are many types of video cameras and recorders in use around the world. They differ not only in quality, features and size, but in the very nature of the video signal they are capable of producing and recording.

Component Versus Composite Video

We have seen that video cameras generate separate red, green and blue color signals. In *component* video systems, the red, green and blue signals are kept separate from one another or, in another version, the luminance is kept separate from two "color-difference" signals (see Fig. 7-4). The important concept here is that the color components are *separated* from each other, and are sent in *separate paths* from one piece of equipment to another. Component video offers the sharpest image and cleanest colors. Component systems are preferred for many professional applications and are becoming increasingly popular for consumer use as well.

In *composite* video systems, the color signals are merged (*encoded*) with the luminance into *one* signal that can travel on a single path. Composite is sometimes thought of as "video soup," since all the color and brightness information is mixed in together into a single electronic signal. Composite video makes recording and broadcasting easier, but results in a marked loss of image quality. Composite comes from the time when color television was first invented and engineers had to find a way to cram the additional color information into the existing black-and-white television signal. The result is a compromised system that degrades the picture.

As of this writing, composite video is still the prevailing system for television broadcast and nonprofessional video uses worldwide. It may someday be phased out as digital video systems become more common. See p. 194 for more on composite and component systems.

Analog Versus Digital

Until the 1980s, virtually all video and audio production was done using *analog* tape recorders. In analog systems, video or audio signals are represented by constantly changing electrical waves that correspond to picture (or sound) information. There are many high-quality analog tape recorders for both video and audio, but analog recording has a few key drawbacks. The electronics of any recording system and the tape stock onto which you record are never perfect, and they introduce a certain amount of background noise. On a sound recording, this may be noticeable as a low hiss during quiet passages. In video, it may show up as grain or snow in the image. When you make a copy of an analog tape (called a *dub*), noise builds up and other distortions are introduced into the signal. After several *generations* (making copies of copies) this can be a real problem.

In digital recording, the video or audio signal is represented by a set of numbers, which are recorded as simple on-off pulses. Digital information is very "robust"—it is not susceptible to tape noise and you can make many generations of copies without any loss in quality (digital copies are called *clones*). Because digital data is what computers use, once a video or audio signal is in digital form, a whole world of possibilities is opened up for storing, editing and manipulating sounds or images.

Digital recording is becoming increasingly affordable and more sophisticated. But it's important to remember that even though the digital process is *capable* of extremely high quality, it is perfectly possible to make a low-resolution, low-quality digital recording. Just because something is digital doesn't *necessarily* mean it sounds or looks better. Even at high resolutions, analog systems can sometimes

Fig. 1-16. In a camcorder, the camera and VTR are together in one unit. Most camcorders can be used with an on-camera microphone or external mics. Sony Digital Betacam shown here. (Sony Electronics, Inc.)

have advantages. For example, many musicians and audio pros think that good analog equipment produces a smoother, sweeter sound than digital machines.

Eventually, digital equipment will be used for the entire video chain from shooting, to recording, to editing, to broadcast and finally to display. Until then, it will be used for various parts of the process. It is possible to convert sounds and images back and forth between analog and digital forms as needed, though there is some quality loss each time you do.

See Chapters 7 and 9 for more on digital video and audio systems.

Sound Recording for Video

Most video sound recording is done single system, with the sound recorded right on the videotape. Different tape formats have different configurations of sound tracks. Most formats allow for *stereo recording* (two channels: left and right). Some formats allow you to record four separate tracks. Having multiple tracks gives you flexibility in production, since you can assign different microphones to different channels. In postproduction, multiple channels may be used for building layered sound tracks. In distribution, having four tracks allows you to send out a movie for international use in two different versions (for example, a version with narration and one without). One of the virtues of video is that it is generally easy to transfer the movie from one video format to another. Even if you shot the film with a two-channel Hi8 camera, you could *bump up* the tape during editing to a four-channel format and then release in six-channel DVD (see p. 28).

Most camcorders have microphones built into the camera. These are simple and convenient, but may result in inferior sound, since the microphone is often too far from the sound source for optimal recording. Professionals generally use separate mics, which can be placed nearer the subject. These may be fed to the

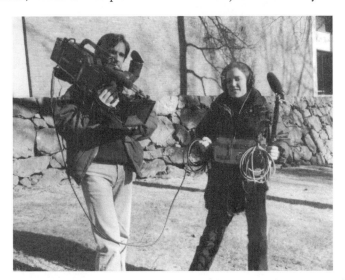

Fig. 1-17. Two-person video crew. The sound recordist carries a boom microphone and a mic mixer, shown here connected to the camera by a cable. (Stephen McCarthy)

camcorder or VTR through a cable or by using a wireless transmitter. When there is a sound recordist on the crew, often the mics are fed first to a *mixer*, which allows easy monitoring of sound levels and blending of multiple mics. Sometimes professionals shoot video double system, using a separate sound recorder. This may be done to achieve higher quality (say, for a concert shoot) or sometimes as a backup (when wireless transmitters are used, for example).

See p. 259 for more on audio for video camcorders.

Timecode

Video production was revolutionized by the introduction of *timecode*. Timecode is simply a means of electronically assigning a unique number or address to every frame of video (and in some cases, audio). In the United States, the standard professional system is *SMPTE* code (*Society of Motion Picture and Television Engineers*). SMPTE (pronounced "simpty") timecode uses an advancing digital clock to keep track of every frame of video. Since timecode is a clock, it also allows you to track the *running time* of any section of material. Timecode gives you the ability to quickly locate any image and gives a crucial degree of control in video editing and image manipulation. The numbers are normally invisible on screen, but are readable by the VTR, and can be displayed in various ways. Timecode can also be *burned in*—incorporated into the picture in a little window (see Fig. 1-18).

Fig. 1-18. Timecode. Shown here burned-in on screen.

Some video formats, like standard VHS, do not accommodate timecode in shooting, but can be *post-striped* with timecode for editing. Some consumer cameras use a proprietary timecode that may be incompatible with other manufacturers' equipment. Tapes without timecode can still be edited, but certain operations become much more difficult. For more on timecode, see p. 196.

COMPARING VIDEO FORMATS

Unlike the comparatively steadfast film formats, video formats are continually being invented, changed and dropped as better formats arrive on the scene. Like

buying a computer that may be outdated a few months after you get it out of the box, investing in a video format (either buying particular equipment or simply using it to shoot a project) is fraught with the knowledge that a new, better format is just around the corner. The good part is that systems tend to get smaller, cheaper and more powerful. The downside is that equipment becomes obsolete. The movie you shoot today will need to be transferred to another format in several years when you can no longer find playback equipment in the old format.

Whereas with film formats there is a rough correlation between the size of the format and the quality it is capable of, you cannot make that assumption with videotape formats. A VTR running ½″-wide tape may be much better quality than one running 1″ tape.

Manufacturers generally identify the intended market for various pieces of equipment. The categories are not exact, but in descending order of quality there is: broadcast, industrial, prosumer, home/consumer. While we might all agree that a $40,000 camera is for professionals only, a "home video" Hi8 image might look surprisingly professional with good lighting and exposure. Broadcasters are traditionally exacting about the signal and image quality they will allow on their air; industrial or nonbroadcast uses allow much more flexibility. Even so, small video cameras are making increasing inroads in broadcast television, particularly in *electronic news gathering* (*ENG*) and documentary. In the listings that follow, distinctions between consumer and professional are not meant to discourage experimentation. Also, bear in mind that by the time you finish this paragraph, several new formats will have been introduced.

VHS and Super VHS

VHS (*Video Home System*) rose to prominence in the home video cassette market. For many, the idea of a home video VCR is synonymous with VHS. The VHS format is inexpensive and convenient and there are millions of VHS machines in the world.

VHS is a composite, analog format using ½″-wide tape. In terms of image quality, today VHS is perhaps the worst format, with such problems as color bleeding, particularly with the color red. The VHS image degrades significantly when recording at slow speeds—LP (long play) or SLP (super long play)—or when making dubs. Some VHS decks have *hi-fi* (*high fidelity*) tracks that provide excellent sound quality. These must be recorded at the same time as the picture. Most prerecorded videos that you buy or rent have hi-fi tracks.

Super VHS (S-VHS) systems have significantly improved image quality. S-VHS is an *S-video* system (see Color Video Systems, p. 194) which is higher quality than composite, but not up to component quality. The resolution of S-VHS is 400 lines as opposed to 250 for standard VHS (see p. 193 for more on this measure of resolution). Some S-VHS systems have timecode and all have hi-fi sound. VHS camcorders have the advantage that cassettes can be popped out and played on any VCR. However, because VHS cassettes are larger than Hi8 or DV, VHS camcorders tend to be larger than other small-format camcorders. VHS-C cameras use a cassette that is smaller than other VHS models.

8mm and Hi8

The 8mm video format offers improvements over VHS. The tape cassettes and camcorders tend to be smaller and the image quality is better. Hi8 (High-Band 8mm) is an improved version of 8mm; Hi8 camcorders and tape are more expensive. Like S-VHS, Hi8 can output S-video, and Hi8's resolution is about 400 lines. To get the most out of S-video, you need a monitor equipped with S-video inputs. Hi8 is popular for home video use and has been used for news gathering where larger cameras would be awkward, though DV (see below) can better fill that niche. Some Hi8 systems have non-SMPTE timecode. There are Hi8 editing systems, but often 8mm, Hi8 and VHS are bumped up to larger formats for editing.

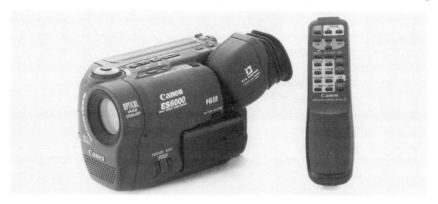

Fig. 1-19. Canon 8mm video camcorder and remote control. (Canon U.S.A., Inc.)

1″, 2″ and ¾″

Introduced in the 1950s, videotape recorders running 2″-wide tape on open reels were the first machines used for broadcast-quality video. This system, also called *quad*, was replaced by the improved 1″ machines that were the standard throughout the 1980s and into the 1990s. As an analog, composite format, 1″ was done in by better quality component and digital systems.

Machines using ¾″-wide tape in cassettes (called U-Matic by Sony) were brought out in the late 1960s. Though inferior to 1″, ¾″ systems were widely used for field recording, industrial and broadcast applications. The ¾″ decks are easy to use and the tape is rugged. At one time, ¾″ was the chief offline editing format, though the image quality deteriorates with dubbing. Timecode can be recorded with the picture or added later to audio tracks. Like Betacam, ¾″ has an improved SP version (see below).

Betacam

Introduced in 1982, the Sony Betacam started a revolution in field video production. The Betacam format uses ½″ cassette tape to record an excellent analog, component video image (professional Betacam, which is often referred to just as Beta, should not be confused with the little-used consumer Betamax format that

also runs ½" tape but at a slower speed and lower image quality). Betacam SP provides a further improvement by using metal tape and allowing four audio tracks: two standard *longitudinal* tracks and two high-quality FM tracks that are recorded with the video signal.

By the 1990s, analog Betacam camcorders had become the standard tool for a wide variety of broadcast and industrial production. They can be balanced on the shoulder and provide good operator access to controls. Beta editing suites ushered in the era of affordable component editing.

The Digital Betacam format (also called D-Beta or Digi-Beta) provides a very high quality component digital signal and is used for both production and postproduction. The cost and size of the D-Beta camcorder make it a tool for professionals only; even so, the camera is easily hand-holdable and is the same size as the widely used analog version (see Fig. 1-16). In terms of quality and versatility, Digital Betacam sets a very high standard.

D1, D2, D3, D5 and Other Digital Formats

There are several professional digital cassette formats used primarily for postproduction. Many of them offer four audio channels and a dedicated timecode track.

D1, D5 and DCT (Digital Component Tape) are all very high quality, component digital formats that use 19mm (about ¾") tape, but the cassettes are not interchangeable. All of these digital tape formats can be copied (cloned) with virtually no image deterioration. These have been used for creating complex, layered graphics or as a mastering format for film-to-tape transfers and online video editing. D1 is very expensive and may not survive competition with newer formats.

D2 and D3 are composite formats, and therefore don't provide the pristine video signal of component. As composite formats they offer certain conveniences, but may not be as versatile for mastering purposes.

JVC has the Digital S format, which uses a VHS tape and is intended for field production. This offers the benefits of digital recording in a relatively low-cost package. Digital S tapes are incompatible with analog VHS.

See p. 206 for more on comparing digital formats.

DV, DVCAM and DVCPRO

DV (Digital Video) records an excellent digital component image on a very small tape cassette. Aimed at the prosumer market, mini-DV cameras bring digital recording to an affordable level (see Fig. 1-20). Within a few years of their introduction in the 1990s, mini-DV revolutionized independent and multimedia production the way Betacam once changed the broadcast world. For a few thousand dollars, a filmmaker can record video that rivals or surpasses that of an analog camcorder costing tens of thousands. DV has a resolution of about 500 lines.

For industrial and broadcast use, Sony has DVCAM and Panasonic makes DVCPRO. Both are fully professional systems that record the same signal as mini-DV, but the tape cassette formats are somewhat different.[2] The professional

[2]DVCPRO machines can play mini-DV and DVCAM tapes with a cassette adapter. DVCAM machines cannot play DVCPRO cassettes.

Fig. 1-20. Panasonic DV camcorder. (Panasonic Broadcast)

Fig. 1-21. Sony DVCAM family of camcorders and decks. (Sony Electronics, Inc.)

systems are more costly and offer more features and better quality camcorders than the mini-DV units. For simplicity's sake, throughout the book we will use *DV* to mean all of these formats.

One of the innovations of DV is the use of FireWire (IEEE1394, also called iLINK) technology. A FireWire cable allows a direct digital two-way connection between DV devices (for example, between a camera and an editing system or VTR). A single FireWire cable takes the place or numerous video, audio and deck control cables normally used for input and output (see Fig. 1-22).

HDTV

For years, *HDTV* (*High-Definition Television*, also called *HD* and *Hi-Def*) represented the holy grail of video quality, and has, at times, seemed just as elusive. HDTV represents a quantum leap in resolution over traditional, analog sys-

tems and results in an image that rivals 35mm film in clarity. HD was introduced with many different competing formats and great uncertainty about how this data-intensive, costly system would be received in the marketplace. Production companies, broadcasters and consumers already have an enormous investment in traditional equipment, and upgrading to Hi-Def is a major undertaking.

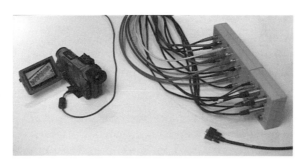

Fig. 1-22. The single FireWire connection to the camera at left replaces all the cables pictured at right for video, audio and deck control. (Bob Doyle)

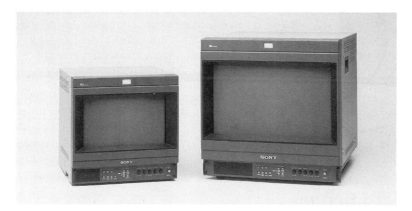

Fig. 1-23. HDTV widescreen monitors. (Sony Electronics, Inc.)

Sometimes the term *digital television* (*DTV*) or *advanced television* (*ATV*) is used to refer to the new digital broadcast formats. Of these, there are several high-definition formats (HDTV) and standard-definition formats (SDTV). One HD system uses 1080 scan lines (more than twice NTSC's 525-line raster) with an aspect ratio of 16:9 (1.78:1).[3] The result is an extremely sharp, widescreen digital picture that is only slightly less wide than U.S. standard 1.85 widescreen theatrical films. Some HD formats are interlaced, like traditional video, and some are progressive, like computer formats (see The Raster, p. 17). As of now, broadcasters haven't agreed which formats will prevail.

[3]A pixel grid of 1920 (horizontal) × 1080 (vertical).

There are various ways of producing a Hi-Def image. High definition studio equipment is capable of full resolution HDTV recording, but the VTRs are not small. Sony makes a high-definition, hand-holdable camcorder that looks just like a Betacam and records a somewhat reduced data stream (see Fig. 6-1); other types of cameras are available as well. Since film is already capable of high-resolution images, 35mm and super 16 film cameras can be used as "capture" media for transfer to HD. Existing films can be transferred to HDTV and the results look dramatically better than traditional video transfers. There are also *upconverters* made by companies such as Faroudja and Snell & Wilcox that allow standard definition video programming to be "fudged" into the HDTV format, providing a signal that may look good enough to allow some programs and TV stations to get away with it.

DVD and Other Disc Systems

There are several disc formats used primarily for playback of material originally recorded with other systems. Laserdiscs, introduced in the 1970s, provide high-quality composite video playback in a 12" disc that can record about 60 minutes per side. *DVD* (*Digital Video Disc* or *Digital Versatile Disc*), introduced in the 1990s, is a component format with much improved video and audio abilities, capable of over 500 lines of resolution. One 4¾" DVD disc can handle over two hours of compressed video with room for more than 5 high-quality digital sound tracks, allowing for surround sound and/or soundtracks in multiple languages as well as subtitles. DVD's can be used for music, video and multimedia applications. See Mix Choices, p. 468 for more on DVD audio capabilities.

Compact Discs (*CDs*) can be used for audio, video, still image and multimedia applications. *Magneto-Optical* (*MO*) discs are finding increasing use in audio postproduction; these can be used as "digital dubbers" for sound editing and mixing and can also be used for video.

While video- and audiotapes tend to deteriorate with repeated playing, optical discs are far more resistant to wear and tear.

VIDEO EDITING

Along with film editing, video editing has been radically transformed in recent years. Digital editing systems that use computer drives to store video images are replacing "traditional" editing systems that use videotape. As computer-based digital editing becomes increasingly affordable, video*tape* editing will be done less and less. Nevertheless, the techniques of editing videotape still play a role in the acquisition, processing and distribution of video images.

Editing on Tape

Though nonprofessional projects (and some professional ones) are edited using the *camera original* videotape (the one that went through the camera), most professional editing jobs are done with a protection copy of the original, called a *workdub* or *worktape* (copying a tape is *dubbing*). The workdub is made in whatever format the editing equipment uses. Unlike film, video requires no syncing up—the sound

and picture are recorded in sync right on the videotape. If the original tapes were shot with timecode, that code is transferred to the workdub.[4]

Editing the workdubs is called *offline editing*. The goal of offline editing is not to produce a finished movie that can be distributed. Rather, the offline is a kind of "pre-edit," done to arrive at the basic editing structure of the movie with all the shots in order and cut to their proper length. Like film editing, a rough cut is refined to a fine cut. Unlike film editing, videotape editing doesn't involve cutting and splicing pieces of material. Instead, you search through the workdubs to find the shot you want and then rerecord (copy) that shot onto another tape (sometimes called *the editing master* tape; see Fig. 14-1). You then find the next shot you want and record it following the first one on the master. You thus build up the movie in order, shot by shot.

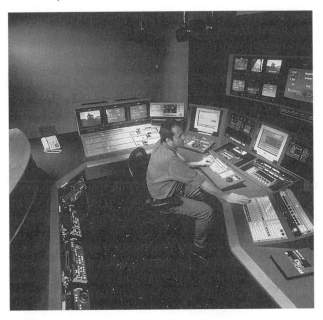

Fig. 1-24. Online Editing Suite. (Sony Electronics, Inc.)

The chief drawback of tape editing is that it is difficult to later change the order of shots. You can't simply remove or add a shot from the middle of the master without leaving a hole or covering up other shots you may want. The solution is either to start over from the beginning or to copy part of the master onto a new tape (a new master), make changes, then copy the rest. This is not only slow, but with analog videotape, the image degrades every time you make a copy of a copy (adding generations). After several generations the movie may be unwatchable. With digital tape systems, there is little generational loss, and some systems can automate part of the process, but it still takes time.

[4]This can be difficult with some prosumer formats.

Offline tape editing is usually done with comparatively inexpensive equipment so you can afford to spend more time trying out ideas and solving editing problems. In offlining, little attempt is made to color correct the images, balance the sound or do complex video effects—these things will be done later. The end product of offline editing is a list of every shot in the movie with the exact timecode address of the beginning and end of each shot. This is called an *edit decision list* or *EDL*.

Once the EDL is in hand, *online editing* can be done. The traditional online session takes place in a high-priced video postproduction facility with high-end equipment. The online editor needs to know a lot of engineering to operate the sophisticated electronics. As time goes on, online editing equipment is becoming less expensive and more user-friendly; it is increasingly possible for moviemakers to do onlines in their own workplaces.

To begin the online, the EDL is loaded into the editing system. Most systems can automatically *execute* the EDL (find and place each shot already selected during the offline session). Each shot is rerecorded from the clean camera original tapes to a final master tape. When you make a print from a film negative, it can take weeks to do all the color balancing, titles and visual effects. In a video online, on the other hand, these things can be done on the spot. You have a chance to experiment with different effects, color balance or lettering styles and see the results immediately (of course, at the high hourly rates you don't want to do *too much* experimenting). You can walk into the online with the raw tapes and an EDL and walk out with a completed show. On some projects, sound is mixed during the online. For more complex sound work, separate sessions are booked for *audio sweetening* (creating and placing sounds) and then blending them in a *mix-to-pix* session.

Digital Nonlinear Editing

Videotape editing, as just described, is a *linear* process. You start at the beginning and lay down shots one after the other in their proper length until you reach the end of the sequence. Film editing is *nonlinear*. You can start wherever you want, move shots around, change their length, even start at the end and work backward if you want. In order to bring that kind of flexibility to video editing, some clever people realized that if video and audio were converted to digital form, they could be loaded onto a computer drive and manipulated much like a word processor handles text. Images and sound could be joined, deleted, cut from one location and pasted in another. Actually, nonlinear video editing systems went through several stages of evolution before computer drives were used, including using banks of videotape or laserdisc players to accomplish a similar goal.

Editors trained in videotape editing find nonlinear editing incredibly liberating. They can experiment with changes anywhere in the movie at any time, instantly search through the footage for a particular shot or save multiple versions of the project for later reference. Many of the onerous mechanical tasks of editing are automated so the editor can concentrate on the movie itself. In tape editing, repositioning sounds is particularly unwieldy. Often, editors working with tape don't even *attempt* some kinds of sound manipulations because they're so hard to do. Nonlinear systems make it easy to do complex sound work.

Fig. 1-25. Media 100 nonlinear editing system. (Media 100, Inc.)

There may be some drawbacks to nonlinear editing. Because nonlinear editing has the reputation of being "fast" and because editing systems may rent for high daily or weekly rates, editing schedules are sometimes made very short. Editors can find themselves cheated out of the "thinking time" they need to structure and refine the movie. Also, because changes can be easily made up until the last minute, indecisive moviemakers can get trapped in a morass of endless possibilities.

To begin editing on a nonlinear system, the camera original tapes or workdubs are loaded into the system or *digitized*. Often the total amount of footage exceeds the storage capacity of the system's computer drives. In this case, material can be worked on in smaller chunks. Material can also be digitized at a lower resolution, which sacrifices image quality but increases the system's recording capacity.

Some systems are capable of digitizing video footage at essentially full broadcast quality (high resolution). With these systems, it may not be necessary to do a later online session. Most systems have capabilities to do video effects, create titles and do some degree of sound balancing or mixing. A finished movie can be output from the system onto tape ("print to tape") or exported as a computer file.

Less sophisticated and costly systems work at lower resolution, which results in a noticeable loss of image quality. Working at low resolution can be thought of as "offline" editing. When you are done with the "low-res" offline, the machine creates an EDL with which you can then do an online edit on the system at a higher resolution or on tape at a traditional post facility. Some systems are capable of working at medium-level resolutions that are not up to broadcast standards but will suffice for various nonbroadcast uses.

Digital nonlinear editing has advanced rapidly from its introduction in the late 1980s. It will continue to become more accessible as the cost of computers and

storage devices drops. It seems a reasonable assumption that nonlinear editing will one day become the *only* way movies are edited.

CHOOSING A FORMAT
FOR YOUR MOVIE

At one time, making a movie was pretty straightforward in terms of the film or video format you worked in. For example, to make a 16mm film, you shot with a 16mm camera, edited 16mm film and made 16mm release prints. Today, filmmakers are either blessed or cursed with a profusion of video and film formats to choose from. Though you may still prefer or be forced to work in one format exclusively, it is increasingly common to shoot in one format, edit in another and release the movie in several others.

Adding to the flexibility and/or confusion of our time, the traditional definitions of video, audio and film have fallen apart. Digital "video" camcorders can be used for still photography. Computer-generated graphics can be combined seamlessly with video and then transferred to film. Sounds can be digitally sampled and transformed beyond recognition. The term *digital media assets* is sometimes used to refer to digitized material that may be have been acquired—and may be used—in any number of ways.

Before you begin any project, you have to make some fundamental choices about what equipment and methods you will use. It may help to consider the three stages of the filmmaking process separately, while also keeping in mind the whole:

1. *Capture.* By what means will you initially record images and sound? Will you shoot film or video? Which format?
2. *Postproduction.* How will you edit? What kinds of picture or sound manipulations will you need to do? What technologies will you use?
3. *Distribution.* Where do you want to show the movie? What kind of steps do you need to take *in advance* to be sure the movie is suitable for these outlets?

The choices you make affect how the movie gets made, how much it costs and where you can show it when you're done.

What follows are some ways to think about your choices. They are presented in no particular order, and each filmmaker (and each project) will have different priorities. Formats mentioned here are described in more detail earlier in the chapter. Bear in mind that technology is continually evolving, so the picture may have changed by the time you read this.

The "Look" of the Movie

How a movie looks has an enormous impact on what the movie means to the audience. Marshall McLuhan said, "the medium is the message," and there is no doubt that the medium itself plays a large part in how we understand a movie's content and experience its emotional impact. Hollywood feature films are traditionally shot in 35mm film, which is capable of an extremely sharp image with

subtle color variations and the ability to handle a wide range of contrast from dark to light. Images originating from typical (standard-definition) video cameras are generally much less sharp, have cruder color rendering and have a much more limited range from dark to light. Sometimes when video crews shoot news or documentary coverage on feature film sets, you have an opportunity to see the same dramatic scene through the lens of the video camera and as filmed by the 35mm film camera. There is a noticeable difference in terms of the emotional "feel" and texture of the scene, which is especially important for dramatic films (the sense of texture is also influenced by many other aspects of filmmaking, including lighting, sets and costumes, editing, sound, music and performances).

Some of the differences between film and video images have to do with measurable physical qualities, like sharpness. But our response to those qualities is complex. In terms of being able to render fine detail, 35mm film is technically sharper than standard video. Video cameras and monitors sometimes try to compensate for that by adding an artificially hard edge around people and objects. This "enhanced" video image makes things pop off the screen, but the image can seem *too* crisp. The film image makes a more gradual transition from areas of the picture that are sharp to areas that are out of focus. As a result, film can actually look in certain ways *softer* than video.

Some of our responses to image quality have to do with past associations. Today, news is shot exclusively on video; news footage tends to be brightly and flatly lit and shot with the crisp video look. This look makes news and sports feel "real." The same crisp video look can make TV dramas seem "fake"—that is, instead of allowing the audience to enter into the dramatic world the show is trying to create, the video image makes us aware of the "reality" of a bunch of actors walking around on sets. Many high-budget TV dramas and sitcoms are shot on film in order to capture a richer, softer look that allows viewers to "suspend disbelief" and enter into the movie.

For documentaries, too much softening of the image can have the effect of distancing the viewer. When a TV interview looks like it was shot through heavy gauze, we may feel the filmmakers are trying to manipulate us or hide something (the interviewer's wrinkles, perhaps).

Traditionally, footage shot with film and video cameras has looked very different. The gap is narrowing. Video processing software can approximate the "film look," complete with scratches and dirt, if you so desire. Even for theatrical films, video and computer processing for some or all of the picture is increasingly common.

Controlling image quality is an art, and there are no simple rules about what looks best for a given movie or scene within that movie. Different film and video systems have quite different looks. The palette of colors, overall contrast, grain or image defects may vary widely from one film stock to another, one video camera to another, one lens filter to another. Images can be tweaked during shooting or postproduction. Filmmakers learn with experience what works for them.

Resolution

Resolution is a complex topic. Resolution refers to a system's ability to capture fine detail; in this sense, resolution plays a part in how sharp the image can look.

The term *resolution* also applies to the related concept of how much *information* is stored in each film or video image or each second of an audio recording. There are various ways to measure how much information or data is used to capture and reproduce an image or sound. With digital video recordings, we can count exactly how many digital bits of data are used for each frame. As a crude rule of thumb, the higher the resolution, the finer the detail in the image and the more information (or storage space) is needed to record it. For example, 35mm film is a higher-resolution format than 16mm; if you take a ruler and compare the surface area of 35mm and 16mm frames, the 35mm image is over four times bigger (see Fig. 1-6).

Fig. 1-26. A Steadicam being used to shoot from an awkward spot. (Cinema Products Corp.)

In general, high-resolution images look better than low-resolution. But the very highest resolution doesn't *always* look the best. Sometimes filmmakers use filters or other methods to deliberately soften a very high resolution image, "throwing away" fine detail to make a more subtle look.

At the same time, there is all sorts of "information" in an image that the eye can't perceive, so you can throw it away (lowering the resolution) without any noticeable difference. For example, your eye is much less sensitive to color than to brightness, so most video systems discard a lot of color information and no one is the wiser. There are engineers who, from the time they wake up in the morning, do nothing but think up ways to strip information out of images so you won't notice it. Take a look at the image played from a DVD. The pictures are fabulously sharp, the colors vivid, yet DVDs are highly "compressed" (see p. 204) and require relatively little data storage for each frame. This reduced amount of data makes

DVDs a great format for distributing movies (because you can fit a long movie on a small disc) but makes them less useful for production or editing.

RANKING THE FORMATS. Filmmakers and consumers often want to know which is the "best" format. Preferably, they'd like a simple numbered scale or ranking to compare format A to format B. Though there are various numbers used to measure different types of resolution (and you will find them discussed elsewhere in this book), the numbers are sometimes more misleading than helpful. What your eye perceives can't necessarily be boiled down to a meaningful single number. Then you have to factor in the entire process of bringing the image to the screen. For example, by some measures, 35mm film is much higher resolution than HDTV. Yet, after the film has been printed and projected on a jittery projector with a bad lens, the film image you see in a typical theater may be no better than high-definition video.[5]

Yet, we need some way to compare the formats.

To give an *extremely rough* ranking of formats in terms of resolution, think of 35mm and HDTV as being two very high resolution formats. Below them is 16mm film, then a group that includes D1 and Digital Betacam. Below that is DV and super 8 film. Next comes analog Betacam. Below that are Hi8 and S-VHS. Next comes ¾″ U-matic, and at the bottom of the pile is VHS.

But this "order" is only part of the story. Here are some things to bear in mind about resolution.

RESOLUTION COSTS MONEY. As a rule of thumb, film and video formats that are capable of high resolutions cost more than systems that work at lower resolution. For example, an HDTV camera costs a lot more than a DV camera. On the other hand, if you need a high-definition image, you may be able to capture it acceptably using super 16 film, which might cost less than producing in HDTV. Also, as technology evolves, high resolution becomes more affordable.

In video cameras, often it is not the camera itself but the recording format (VTR) that makes the most difference in resolution. If you look at the live output of a good-quality DV camera and a much more expensive Digital Betacam, the images may look surprisingly similar. It is after the signals have been *recorded on tape* that the differences show up.

On the other hand, inexpensive cameras often have cheap lenses and small CCDs, which may reduce resolution. In that case, it may be the particular gear rather than the format that limits you most.

START WITH THE HIGHEST RESOLUTION YOU CAN AFFORD. If you initially capture picture or sound in a high-quality, high-resolution recording, you will have the most flexibility to process, edit and manipulate your material later on. As images and sound go through the steps from recording to editing to distribution, many factors conspire to lower the quality and clarity. If you start with a low-quality

[5]Not to mention the fact that there are several HDTV formats, so which one shall we use for the comparison?

recording, *you can't add resolution later*. If your work demands many layers of images or effects, or needs to be copied through many generations (see p. 495), it is particularly important to begin with as much information as you can.

CONSIDER THE END PRODUCT. The larger an image is projected, the more critical it is that it be sharp. Any defects in the image are magnified when material is shown on a big screen. If you anticipate big-screen film or video exhibition (for example, in theaters) then high resolution is a key concern.

Fig. 1-27. Toshiba widescreen (16 × 9) projection television. (Toshiba)

The opposite is true as well. When images are shown on a small screen, the eye cannot perceive fine detail. Look at Fig. 7-6. These images are very low resolution, but when viewed from far enough away, they begin to look sharp. In a normal living room, it is estimated that on anything smaller than a 40-inch-screen, high-definition TV (very expensive) looks no sharper than standard-definition TV (much less expensive). If you know your movie will *only* be shown on a small monitor, perhaps for a museum installation or computer-based multimedia project, then you can probably work in a lower resolution.

One of the most common forms of distributing movies is also one of the lowest resolution: VHS tape. Surprisingly, even typical analog NTSC television broadcasts are lower resolution than most of the videotape formats used in production and postproduction. All video and television distribution is further degraded by the badly adjusted TVs found in many homes and businesses.

It is sometimes argued that because audiences often view movies on low-resolution systems, there is no point in producing in any higher resolution than the end product. This argument falls apart for several reasons. First, if you shoot with a VHS camera, the image will look far worse than first-generation VHS quality by the time you get through postproduction. But even so, material that be-

gins at a higher resolution still looks better in the end. Compare your typical video rental feature film (shot on 35mm) as viewed on VHS tape with material shot on Hi8 that has been transferred to VHS.

With the wide range of distribution methods today, you have to assume that your movie *may* be shown on a high-quality system; and you want to make the most of it if you can.

Nevertheless, one must strike a balance between the end product and the originating format. For example, if you're producing multimedia for the Web, a DV camera might be the best combination of price and quality for what you need.

CONSIDER THE CONTENT. As mentioned earlier, resolution is not a fixed thing that affects all images the same way. For example, a close-up of a face may look fine on a low-resolution system, while a wide shot of a landscape with many small areas of color and fine detail might look terrible. If your movie is mostly "talking heads" (interviews), then resolution may be less critical.

Lighting is very important. Skillful lighting can elevate a low-quality format, and bad lighting can make even a high-res format look bad. Lighting contrast (see Chapter 11) is also a consideration. In general, when there is a large contrast between sun and shadow, film looks much better than video (though video is improving in this area). When a scene has a great range from dark areas to light, the film image will usually capture more detail and look better, even if the film is later transferred to video. For some TV shows, the interiors are shot on video, the exteriors on film. If your movie has a lot of important landscape or outdoor scenes, think first of shooting in film.

Aspect Ratio
See the discussion of aspect ratio on p. 6 before reading this section.

Widescreen film formats were developed in the 1950s as a way to give theaters a competitive edge over TV. Forty years later, video answered back with widescreen formats of its own. As noted on p. 6, film aspect ratios are usually indicated with a colon, such as 1.33:1. In the video world, the same thing is usually talked

Fig. 1-28. CCD imagers. The CCD chip at left is conventional 4 × 3 format. CCD at right is 16 × 9 widescreen format. The photo has been enhanced to show the chips' light-sensitive area. (Sony Electronics, Inc.)

about as 4 × 3 ("four by three") or, for widescreen TV, 16 × 9 (which is the equivalent of 1.78:1).

Movies intended for theatrical exhibition should ideally be released in a widescreen aspect ratio: 1.66:1 for Europe; preferably at least 1.85:1 for U.S. theaters, though art houses and some other theaters can often accommodate 1.66.1 or less.

Movies intended for television broadcast are increasingly being shot in widescreen formats, so they will be compatible with both high-def and standard-def widescreen broadcasts. This can be done using either a film camera (the super 16 frame is very close to 16 × 9) or by using a widescreen video camera. Video cameras achieve widescreen images in various ways. Some cameras use only a portion of a 4 × 3 CCD, others have CCDs in a 16 × 9 format (see Fig. 1-28). Like film, video images can be anamorphically "squeezed" to fit a widescreen image in a narrower frame (see Fig. 1-29). Unlike film, no special lenses are used; the horizontal dimension is compressed electronically. A standard VTR can be used to record the signal, but a widescreen monitor (see Fig. 1-27) is needed to display it.

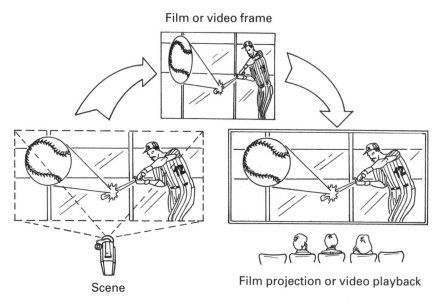

Film or video frame

Scene

Film projection or video playback

Fig. 1-29. A widescreen image can be *squeezed* (compressed horizontally) to record it on a non-widescreen film or video format. It is then *unsqueezed* for widescreen viewing. In film, the squeezing process is done with anamorphic lenses on the camera and projector. In video, standard lenses are used and the image is compressed electronically. (Robert Brun)

Since many people still have non-widescreen TVs and many moviemakers use non-widescreen film and video cameras, compromises are called for. You may need to create programming that can be shown in more than one aspect ratio.

When widescreen movies are shown in non-widescreen video/TV (4 × 3 or 1.33:1) you have three choices. You can allow the sides of the image to be consistently cut off to fit the narrower frame (called *center crop*). You can do a *pan and scan*

to reposition the image if needed on a shot-by-shot basis so you don't lose crucial details near the edges of the frame (for example, the face of the person talking). This introduces artificial "camera" movements that the director never intended. Another option is to show the movie in *letterbox format*. In letterbox, the image is made smaller on screen, which preserves the sides, but introduces a black border over and under the image. Some viewers prefer the letterbox, others are bothered by the smaller image that doesn't seem to "fill" the TV screen.[6]

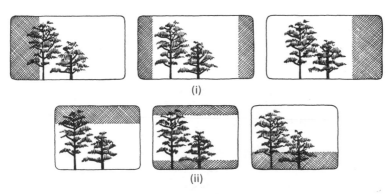

(i)

(ii)

Fig. 1-30. Scanning. When you change aspect ratios, the image must be cropped. (i) To reduce the aspect ratio you can use horizontal scanning to crop from either edge or from some combination of both edges. This might be used to convert a widescreen film to the conventional 4 × 3 television frame. (ii) To increase the aspect ratio you can use vertical scanning to crop from the top and/or bottom of the frame. This could be used to convert a conventional 4 × 3 image to widescreen film or video. (Carol Keller)

If a movie has been shot in conventional 4 × 3 aspect ratio, it will need to be "converted" if widescreen film or video distribution is called for. This is done by cropping the top and/or bottom of the frame. Cropping changes the composition and needs to be checked carefully to ensure that essential details are not cut off. If they are, individual shots may need to be repositioned. For more on composing images for multiple aspect ratios see Widescreen Formats, p. 221.

Some Production Issues

Often, the cost of production goes down as the size of the camera goes down. While 35mm cameras require a crew to lug them around, a DV camera can be tossed in a shoulder bag. Of course, if you shoot a feature film in DV, you probably can't do it alone. For a documentary, the ability to work alone or with a very small crew can be a major asset (see p. 210). Feature films are less expensive to *shoot* in 16mm or digital video, but then the cost of blowing up the 16mm—or transferring the video—to 35mm has to be factored in. Sometimes the postproduction costs

[6]Some TVs can be set to enlarge the picture in the vertical dimension, which gets rid of the black borders but distorts the image. Some widescreen TVs can do the same to the horizontal dimension, to artificially create a "widescreen" effect from standard images.

outweigh the production savings, and the quality is not as good as if you had started in 35mm.

The size of a camera affects how people respond to the production. A small camera can help relax documentary subjects. A small camera on a feature film may make some people think it isn't a "real" (that is, Hollywood) film. At times this can be a help or a drawback.

From the cameraperson's standpoint, small cameras have advantages and disadvantages. Small, prosumer or consumer cameras may not have the features or accept the accessories that professionals rely on to do their job. You may find your creativity hampered by the lack of manual controls or the inability to choose lenses or other devices. Many small video cameras are designed to be held in front of the face, with *all the weight* on your right arm. This can make steadiness difficult and may be very tiring after a few hours of shooting. A slightly heavier camera that balances on the shoulder can sometimes be easier to work with. But beware of a camera that has a shoulder rest or brace but doesn't really balance on the shoulder—your arm *still* has to hold it up.

FILM CAMERAS VERSUS VIDEO CAMERAS. For the most part, video is a lot *easier* to shoot than film. Because tape is cheap and comes in long, easy-to-load cassettes, shooting video can be much more relaxed than film. You can take more risks with things that might or might not work out. If you're interviewing someone for a documentary, and he takes a long time to loosen up, you can keep shooting until he does without fretting about the cost. Even so, shooting a lot of footage isn't always better than shooting less (see The Shooting Ratio, p. 229).

The video image can be instantly viewed on a monitor—a great convenience for the director or client—and the tape can be checked right away after the shot.

Fig. 1-31. Canon DV camcorder (model XL1). Accepts interchangeable lenses. (Canon U.S.A., Inc.)

Unlike film, video needs no processing to be viewed. Film shooting can be done with a *video assist* (also called a *video tap*), which sends out a video image of what the camera is shooting. A video tap allows you to check the action but it's not the same as seeing what the film stock is actually capturing (see Video Assist, p. 68). Shooting video outdoors can sometimes require more lighting gear than film (to balance out high-contrast sunlit locations).

Film shooting involves using a separate audio recorder. This allows the sound recordist a lot of freedom to get close to the sound source or to even go off and record at another location, completely independently of the camera. However, an audio recorder may be awkward to operate if you're shooting alone.

When shooting video, audio is usually recorded in the camera. This can be more convenient, especially for solo work. However, if there is a sound recordist on the crew, he or she will usually be connected to the camera by a cable or by often-finicky wireless transmitters. Of course, it is possible to shoot "double system" with a separate audio recorder, as is done with film.

Some Postproduction Issues

As noted earlier, nonlinear editing is rapidly replacing traditional film and videotape editing. For a well-funded film or TV project, nonlinear is usually by far the best way to go. For film projects, one disadvantage of nonlinear editing is that if no film workprint is made, the filmmakers may have a harder time evaluating the lighting, exposure, sets, performances and editing. On big budget feature films, even if nonlinear editing is done, often a film workprint is *also* made to provide feedback during production and for test screenings during editing.

For an independent filmmaker working with little money or on a less complex project, there can be certain benefits to working the old-fashioned way (using linear tape or traditional film editing equipment). One benefit is cost. Though nonlinear systems are rapidly dropping in place, they can still be a sizable investment when all the software, computer and storage needs are figured in (see Chapter 14). A used flatbed film editing machine can be purchased for the cost of a few weeks' rental of a fully equipped digital editing system. Tape-based video editing systems have also become much more affordable.

In many cases—particularly for independent films—a project is begun without all the money or time needed to complete it. You might work on something for a while, then put it aside to raise money, get client feedback or do other work. If you're editing in film or videotape, the editing equipment can be used by other people or for other purposes while the project is on hold. You can start work again right away when you're ready, at another time or in another editing room. With nonlinear editing, once you've digitized your footage into the system's hard drives, if another project needs the drives, your material will be deleted. You won't lose your editing choices (the EDL is easy to save), but possibly hours of raw footage will need to be reloaded before you can start work again. You may also have to do this if you want to edit in another location. This should become less of a problem as removable storage media (like portable computer drives and discs) become less expensive. When working in DV, sometimes it is possible to store edited material on tape without any quality loss (see Chapter 14).

Some Distribution Issues

In general, technical standards for the video signal are more stringent for movies intended for broadcast than for movies not intended for TV distribution (see Broadcast Standards, p. 192). Multimedia software for the Web may be even less demanding. This means that if you're making a corporate video, you usually have more leeway in terms of the level of cameras and editing equipment you use than if you're doing a program for broadcast.

MOVIES FOR TELEVISION AND NONBROADCAST VIDEO. Many kinds of TV programming are shot on video, including news, sports, magazine shows, variety and talk shows, soap operas and some sitcoms. In the nonbroadcast realm, videos are made for many uses, including corporate, educational and promotional purposes. Video offers many benefits for production: it can be broadcast live; sent via satellite, cable or Internet; and it accommodates instant switching between multiple cameras. Video quality and flexibility are increasing all the time.

Yet many TV and video programs are shot on film, including TV movies, commercials, and high-end weekly dramas, sitcoms and documentaries. Film is used primarily because of image quality: film often has a richer look than video, both in terms of the image itself and the suggestion of how much money went into the production. Another reason producers may choose film for projects bound for TV has to do with the numerous and changing video formats in use around the world. A program shot in film can be transferred to NTSC, PAL or other video standards with no quality loss. Though video standards converters are rapidly improving, video still degrades somewhat when transferred from one broadcast standard to another.

As digital television grows in importance, it is unclear how well material shot in earlier, lower-resolution video standards will make the transition to the sharper formats (see HDTV, p. 26). One argument for shooting film is that it adapts well to both HDTV and standard-definition widescreen broadcasts. Also, film formats don't become obsolete as fast as video, so shooting film now is thought to "future-proof" the show.

THEATRICAL AND FESTIVAL DISTRIBUTION. Most movies intended for theatrical distribution are shot on 35mm film, and most commercial theaters, as of this writing, use 35mm film projectors for showing film prints. (Some smaller theaters also have 16mm projection). The 35mm prints look and sound far superior to 16mm on a big screen. Many film festivals require or prefer that movies be shown on film; 16mm is usually acceptable. If your goal is theatrical distribution, it's generally an advantage to shoot on 35mm film. However, if you don't shoot 35mm, you have a few options:

Independent filmmakers often shoot 16mm or super 16 for fiction or documentary features because it is cheaper to shoot than 35mm and the small cameras provide a lot more mobility. Either of these formats can be blown up to 35mm, but super 16 is preferred. 16mm films can be distributed in 16mm, but super 16 must be specially printed and cropped to do so (see p. 9).

Increasingly, filmmakers are using digital video formats to originate low-

Fig. 1-32. Camera crane. (Fletcher Chicago/Egripment USA)

budget movies intended for festival or theatrical exhibition on 16mm or 35mm film prints. The quality of film prints made from a video original has improved enormously because of improvements in cameras and advances in transfer technology. Once transferred to film, the video scan lines may be virtually invisible and the general image quality is good, though a first-rate transfer is very expensive. This process has been used successfully for films such as *Hoop Dreams*, which was shot in analog video and transferred to 35mm. See Chapter 17 for more on video-to-film transfer.

Though film projection is the traditional way movies have been shown in theaters, as digital cameras and large-screen video projectors improve, it is not unlikely that video will at some point replace it.

On the Other Hand

Technology has a way of becoming an end in itself. As new equipment and methods are introduced, filmmakers scramble to learn about them, obtain them, pay for them. The rush to find new ways to do things can obscure what you're really trying to do.

PICTURE QUALITY ISN'T EVERYTHING. At times, moviemakers can become obsessed with achieving the best possible picture and sound quality, spending a lot of time and money to maintain high standards. The effort can pay off in sharp images and rich, clear sound tracks. Quality is important. Many movies have been dragged down by inattention to the technical aspects of filmmaking.

However, it's worth keeping in mind that while image quality is important, it's much less important than a film's story or performances. At the Sundance Film Festival recently, the movies that got the most attention (and awards) were not the slickest, most perfect films, but the most interesting, compelling ones. Audiences

can be quite forgiving of an imperfect image if they're emotionally or intellectually involved in the movie. A few years ago, a presentation was made of several films that had been blown up from 16mm to 35mm for theatrical release. One of the movies, because of the film stocks used and the way it was shot, was noticeably grainier than the rest. When the audience of critical filmmakers pointed this out, the presenter responded that he had been at a theater when this film (which made millions at the box office) was shown to the public, and not a single person there had mentioned the grain.

OLD CAN BE GOOD TOO. As new equipment arrives on the scene, older items become cheaper. As mentioned earlier, you can often get very good deals on used equipment.

Compared to video, one advantage of film equipment—both cameras and editing equipment—is that formats haven't changed much over time, so the gear can be used for many years. Video equipment becomes obsolete much faster.

Depending on your needs, newer may not necessarily be better. Many film and video projects have been happily and successfully completed using technology that was once—but is no longer—"state of the art."

THE COST OF INDEPENDENCE. As digital tools become more affordable, it becomes technically possible for one person to shoot and edit a movie, do the color correction and sound mix, create the titles, effects and everything else. Working this way can be a boon: it saves time, money and hassle and gives the filmmaker unprecedented creative control. But it entails some loss too. When you are no longer interacting with the professionals who would have otherwise done the sound mix, color correction, graphic layout and such, you lose the benefit of their expertise. Technology can be democratizing, but it can be isolating too.

The Film Camera | CHAPTER 2

An Overview of the Camera

The motion picture camera has the following components:

Fig. 2-1. Arriflex 16mm BL. The film chamber door and magazine lid are open to reveal the film path. The feed roll is 400′ of core-loaded film. The pressure plate is open to show the film gate. The camera has a mirror shutter for reflex viewing. (Arriflex Corporation)

1. *The lens:* focuses light from the world onto the film.
2. *The lens mount:* receptacle where the lens is attached to the camera (see Chapter 3 for the lens and lens mount).
3. *The viewfinder:* allows the camera operator to see what image is being recorded on the film.
4. *The film chamber:* a light-tight compartment that holds the film before and after it is exposed to light. Many cameras use a detachable *magazine* to hold the film.
5. *The motor:* supplies the power to run the film past the lens for exposure.
6. *The film gate and claw:* The claw pulls down each frame of film for exposure and holds it steady in the film gate during exposure.
7. *The shutter:* blocks light from the film when it is moving between successive exposures.

The unexposed film (*raw stock*) is loaded into the camera from the *supply* or *feed reel.* The film passes through the film gate for exposure and is spooled on the *take-up reel.*

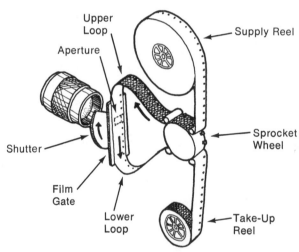

Fig. 2-2. Simplified camera. (Carol Keller)

THE FILM GATE AND SHUTTER

The Film Gate

In the film gate, the raw stock is exposed to light that comes through the lens. The gate is composed of two plates that sandwich the film. The plate between the lens and the film is the *aperture plate.* The aperture itself is a rectangle cut out of the aperture plate, through which light from the lens shines. The aperture's edges define the border of the image on the film. The base of the film rests on the other

half of the gate, the *pressure plate*, which holds the film flat during exposure. Super 8 cartridges and some quick-change magazines (see Camera Film Capacity, p. 62) have a built-in pressure plate that is not part of the camera's body.

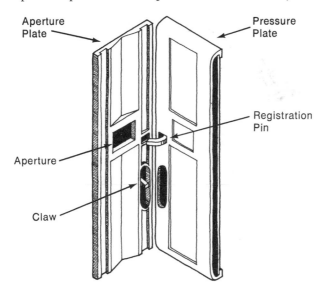

Aperture Plate

Pressure Plate

Registration Pin

Aperture

Claw

Fig. 2-3. Film gate with open pressure plate. Not all cameras use registration pins. (Carol Keller)

THE CLAW. Most cameras and projectors have a claw or shuttle that advances the film, frame by frame, in the gate. The claw engages a perforation in the film and pulls the film forward one frame (the *pulldown*). After exposure, the claw engages the next frame and pulls it down (see Fig. 1-2).

It is critical that the film be held absolutely steady in the gate or else the image will not be steady when projected on screen. Some cameras have a registration pin to help ensure steadiness during exposure. The pin enters a perforation while the film is stopped in the gate and holds it motionless.

THE INTERMITTENT. The claw is on an *intermittent* (that is, a noncontinuous, stop-start) movement that allows the film alternately to stop in front of the aperture and then to move on. Since the film roll is moving continuously through the camera, there must be some slack between the intermittent claw and the constantly moving feed and take-up reels to prevent the film from tearing. On most cameras and projectors, *loops* are formed between the film gate and the sprocket wheel, which drives the film, to supply the needed slack.

Loops must be accurately formed. If they are too small, the film may tear or chatter. When a camera jams, it usually "loses its loop." If the loops are too large, they may rub against the camera housing and scratch the film. See your camera's manual for proper loop size.

The Shutter

After each frame of film is exposed to light coming through the lens, the shutter must close to block the light while the next frame moves into position in the gate. The film must be completely at rest before the shutter opens again for the next exposure. If the shutter does not block the light when the film is moving, the image will be blurred. The simplest kind of shutter is a rotating disc with a section removed.

A circle may be represented by 360°. The shutter opening is the number of degrees open in the disc. The 180° shutter, a half-moon in shape, is used in many cameras, particularly in 16mm.

SHUTTER SPEED AND EXPOSURE. Exposure is determined by the intensity of light that passes through the lens and the time each frame is exposed to the light. The *reciprocity law* simply says: Exposure = Intensity × Time. Doubling exposure time is equivalent to doubling intensity. The halving and doubling of light intensity are measured in stops (see Chapter 3). If you close down the lens by one stop, you must double the time of exposure to keep exposure constant.

Standard film speed is 24 frames per second (fps). A camera with a 180° shutter admits light to the film half the time (the disc is half open) so the exposure time (the *shutter speed*) is ½₄ × ½ = ½₈ second (which we usually round off to ⅟₅₀ second). As a rule of thumb, most film cameras have a shutter speed of about ⅟₅₀ second when operated at 24 fps, but check your camera to determine the angle of its shutter opening. The general formula for any shutter opening and camera speed is:

$$\text{Exposure time (shutter speed)} = \left(\frac{1}{\text{speed in fps}}\right) \times \left(\frac{\text{angle of shutter opening}}{360}\right)$$

For shutter openings less than 180°, the shutter speed is faster than ⅟₅₀ second. For example, a 135° shutter at 24 fps yields a shutter speed of ½₄ × ¹³⁵/₃₆₀ = ⅟₆₄ (approximately ⅟₆₅ second).

In general, the longer the time of exposure, the better. Short exposures increase the possibility of strobing (see Strobing, below). The longer the time of exposure, the less light needed for proper exposure.

THE VARIABLE SHUTTER. On cameras equipped with a variable shutter, the shutter angle can be narrowed to change the shutter speed. Narrowing the angle reduces exposure time. A 90° shutter, for example, gives a shutter speed of about ⅟₁₀₀ at 24 fps (using the formula just given for shutter speed). Closing the shutter reduces the exposure, allowing high-speed film to be used outdoors or allowing the lens to be opened to decrease depth of field or to shoot at a selected *f*-stop (see Chapter 3).

A variable shutter that can be closed down while the camera is running allows exposure changes in the middle of a shot. For example, when the camera moves from a sunlit to a shaded area within a shot, it is often necessary to change exposure. The iris diaphragm of the lens can be changed, but this would change the depth of field and may be more noticeable than shutting down the variable shutter. If the variable shutter can be shut down continuously to 0° with the

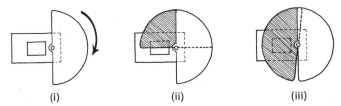

(i) (ii) (iii)

Fig. 2-4. Variable shutter. (i) A 180-degree shutter shown fully open. The small rectangle represents the aperture. (ii) To close the shutter, an adjustable disc (shaded) swings out; shown here, it forms a 90-degree opening. (iii) The shutter is almost completely closed. (Carol Keller)

camera running, in-camera fades and dissolves can be created (see p. 71). If variable shutters are used for exposure control, you risk strobing in the image if there is a great deal of camera or subject movement (see below). On cameras with a variable shutter, always check that the shutter is properly set before every day's shooting. If someone else has used the camera, the shutter opening may have been narrowed.

SPECIAL SHUTTER SETTINGS. There are certain situations in which specific shutter angles are used. One example is when filming with some fluorescent, HMI or other types of discharge lights that use pulsed rather than continuous light; the wrong shutter speed can result in footage with uneven light levels (flicker); see p. 313. A 144° shutter is sometimes used for filming video monitors (see Chapter 17).

STROBING OR SKIPPING. In normal film and video footage, whenever the camera or subject moves, there will be a certain amount of blur. You can see this if you examine an individual frame. This is to be expected and results in natural-looking motion on screen. Decreasing the exposure time (by reducing a film camera's shutter angle or by using a high-speed electronic shutter with a video camera) reduces the amount of blur. The increased sharpness of each frame is helpful if you want to do freeze frames, make still enlargements of individual frames or do slow-motion playback to analyze the footage. However, for footage projected at normal speed, shooting with a short exposure time often results in *strobing* or *skipping* when there is any camera or subject movement. If the movement is too fast, the eye cannot integrate successive frames and the image seems to skip rather than move continuously, causing the viewer eye strain. Skipping most often appears in pans (horizontal camera movements), especially fast moves across strong vertical lines (see Chapter 8). The higher the image contrast or greater the sharpness, the more likely that strobing will occur.

A phenomenon related to strobing, and frequently referred to by the same term, is often noticed when the wheels of a moving vehicle on the screen seem to be stopped or to be traveling in reverse. This occurs when the intermittent exposures happen to catch spokes at the same position in consecutive frames (thus, the wheels seem stopped) or catch them in a position slightly behind so the wheels appear to be spinning in reverse.

CAMERA SPEED AND MOTORS

CAMERA SPEED OR FRAME RATE

The first cameras were cranked by hand. The camera operator would hum a popular song of an appropriate tempo to approximate the filming speed. On modern cameras, either a spring-wound or electric motor drives the film through the camera and controls the rate at which the film moves.

Standard Speed

Standard worldwide theatrical film projection speed is 24 fps (frames per second). As a rule of thumb, unless special effects are desired, it is assumed that the standard running speed of a film camera is 24 fps (also known as *sound speed*). However, as the filmmaking world has become more complex, there are certain situations in which 24 fps is *not* used as the basic speed.

1. In Europe and other places where PAL or SECAM television standards are used, film footage intended primarily for transfer to video is shot at 25 fps to match the video frame rate (see Chapter 17). Increasingly, even theatrical films may be filmed at 25 fps to simplify postproduction.

Fig. 2-5. Speed control on Beaulieu cine 8 camera. (Super8 Sound)

2. In North America and places where NTSC video is standard, film is sometimes shot at 29.97 fps. This may be done when filming TV monitors to avoid flicker (see Chapter 17). Another use is for filming music videos to maintain sync with prerecorded music (see Music Videos, p. 297). Filming at 29.97 or 30 fps is occasionally done for footage intended for video transfer as a way to increase the clarity of the image, especially if the video will be run in slow motion or freeze-framed. If you shoot at 29.97 or 30 fps and show the film on a film projector (as opposed to transferring it to video), motion will be slowed down.
3. Film is sometimes shot at 23.976 fps when the film footage needs to keep sync with a video camera or sometimes when a VTR is used for audio

recording (see Editing Video Assist Dailies, p. 391). This speed is sometimes also used for filming monitors (see Chapter 17).
4. Certain camera speeds can cause problems with some HMI, fluorescent and other discharge type lighting (see p. 313).

When the camera speed (or frame rate) matches the projection speed, movement on the screen looks natural. When the camera speed increases, more frames are filmed each second. When film shot at high speed (say 40 fps) is projected at the normal speed (24 fps), action is slowed down (slow motion). Conversely, if you film at a slower speed, say 8 fps, and then project at normal speed, movement is sped up—in this case, three times as fast.

When you change camera speed, you need to make an exposure compensation, since the exposure time is different. Consult a frame-rate/exposure chart or use the formula for shutter speed (see p. 48). In general, if you double the frame rate, you lose a stop of exposure, so compensate by opening the lens one stop. If you cut the frame rate in half, *close* the lens by a stop.

Slow Motion

Slow motion is often used to analyze motion or even to call attention to motion itself. In Leni Riefenstahl's *Olympiad*, a film of the 1936 Olympics in Berlin, the movements of the athletes are broken down and extended in time with slow motion, letting the viewer's eye see things unobservable in real time. Televised sports events often show replays in slow motion ("slow-mo") to analyze the action. Slow motion extends real time, sometimes giving an event more psychological weight. A character's death may occur in an instant, yet be the most important moment in a film. In countless films the protagonist's death is shown in slow motion, extending the time of death to give it greater emotional emphasis.

Speeds faster than 24 fps can be used to minimize the effect of unwanted camera jiggle and vibration. When the camera is handheld or on a moving vehicle, faster camera speeds lengthen the distance between jerky or uneven movements and make the image seem steadier. Of course, any subject movement will also be in slow motion. Some standard film cameras can run three times sound speed (that is, 72 fps), and, when equipped with a special high-speed motor, can run at 128 fps or faster. The higher the frame rate, the more film you use every minute.

Slow motion effects can be achieved in two ways: (1) run the camera at higher than regular speed; (2) shoot at normal speed and then slow the footage down later during postproduction. There is a noticeable difference between the two methods. When the camera runs fast, you are capturing many continuous frames in a given period of time (say, 80 frames in a second). This makes the slowed action seem smooth and continuous on projection or playback. When normal film or video footage is slowed in post, motion can appear discontinuous and jerky because you have available only 24 or 30 frames in that second. The slow motion effect is achieved in post by holding each frame for longer than normal, then moving to the next frame. There will be a slight jump between the two frames. Also, the natural blurring that takes place with any camera and/or subject movement—which is invisible at normal projection speeds—will be more pronounced when

Fig. 2-6. Arriflex 16SR Highspeed. A similar SR is available for standard-speed operation. This camera is reflex, with quick-change magazines and on-board battery (not shown). (Arriflex Corporation)

normal footage is slowed down. This effect may be desired, or at times it may just look inferior to true slow motion shot with a camera running at a higher frame rate. If you're shooting at normal speed with the intention of doing slow motion in post, you may want to minimize blur by adjusting a variable shutter to a faster shutter speed. Film camera shutter speeds are discussed on p. 48; see Chapter 6 for video camera shutters.

HIGH-SPEED CAMERAS. Sometimes very high frame rates are needed for an effect or to capture or analyze fleeting events. If you want to see individual water droplets slowly crashing on the ground or a bullet shattering glass, use a high-speed camera (and sometimes strobe lighting). High-speed cameras with intermittent-type movements can run up to around 500 fps. Speeds higher than 250 fps are rarely needed in nonscientific filming. A camera speed of 250 fps stretches 1 second of real time into more than 10 seconds of film time. Cameras that run up to 10,000 fps do not use an intermittent movement. Instead, the film runs continuously and a rotating prism forms the individual frames. At 10,000 fps, one second of real time is stretched into 6½ minutes.

High-speed filming implies very short exposure times, which usually requires a fast film stock and a lot of light. Some cameras can be operated at normal speed and then ramp up to high speed when the key action begins. Some can automatically adjust the exposure. Some high-speed cameras require specially ordered film: those with double pulldown claws require double-perf stock; some need perfs with high-speed pitch (see Chapter 4).

Fig. 2-7. Locam II high-speed reflex camera. Allows speeds up to 500 fps. Shown with a shoulder brace for handholding. (Redlake Corp.)

Fast Motion

UNDERCRANKING. When film is shot at slower than normal speed, each frame is exposed for a greater length of time. For example, filming at 12 fps gives one stop more exposure than filming at 24 fps. This can be used to advantage in scenes where the light level is too low for exposure at normal speed and there is no movement in the scene; you can undercrank the camera (run it at a slower speed) to get proper exposure. This technique may be used when filming exteriors at night. Any motion, like car headlights, will seem speeded up. If filming a dark church interior at 12 fps, you might have actors walk at half speed, or move the camera half as fast as usual so the movement will appear normal in projection. If you take under-cranked footage and slow it down in postproduction, you can get an interesting ghostlike effect.

Chase sequences can be undercranked to make motion appear faster and more dangerous. The sped-up motion of silent film comedy was, supposedly, the result of an unintentionally undercranked camera on a Mack Sennett set. You can get this effect by filming at about 16 to 20 fps and then projecting at 24 fps.

TIME-LAPSE. With significantly slower speeds, time is proportionally sped up. In time-lapse, the sun can set, a flower can grow and blossom or a building can be demolished and another constructed in a few seconds (sometimes called *pixilation*). For very condensed time, you need a camera that can make single-frame exposures. Some film and video cameras have this option. Some cameras can do time-lapse with an *intervalometer* (an animation motor may also be needed for some film cameras). Intervalometers vary from relatively simple devices that allow you to set

the frame rate for a given time period, to highly sophisticated devices that can vary camera speed at set times, change the exposure, switch on lights, signal a malfunction and turn on the coffee.

Finding the right frame rate for a time-lapse sequence takes some experimentation. Start by estimating how long you want the finished sequence to run on screen. From this you can figure the total number of frames to expose. Say you wanted to film a sunset that takes two hours and have the shot run 10 seconds in the movie. 10 seconds \times 24 fps = 240 frames. This means you need to expose an average of 2 frames a minute during the sunset. It's a good idea to start shooting sometime before and continue after the main action to provide flexibility in editing.

Exposures may be programmed for one or more frames at a given time interval or at varying intervals. The fewer exposures at a time and the farther apart, the more jumpy or staccato the motion will look. Single-frame exposures are often slower than the normal camera shutter speed. Very slow shutter speeds for each exposure will increase motion blur. You can use this effect to turn car lights at night into colored streaks. Some time-lapse sequences look best without changing the lens iris or exposure time over the sequence. In this case, base the setting on the light reading at the most important part of the sequence. You could also "ride" the exposure, changing it manually or by using automatic features in the camera or intervalometer. In some situations an auto-iris can extend the usable length of the sequence if the light is changing. In others, it might fight with the effect you're looking for: a sunset might look too silhouetted, for example. Often, a wide-angle lens produces the best time-lapse effect. A wide shot of traffic at a certain frame rate might show a fast-moving river of cars; any single car might be seen moving from one side of the frame to the other. However, using a telephoto lens to get a long shot of the same scene at the same rate might result in individual cars popping into one frame and disappearing in the next. An interesting effect can be had by walking or dollying the camera, taking a frame or two every step.

Various video software applications can create time-lapse sequences from footage shot at normal speed. See chapter 14.

ANIMATION. Animation can be seen as a variant of time-lapse photography. A series of paper drawings or paintings on acetate (*cel animation*) are done with slight changes between the images. A few frames of one drawing are exposed, then the next one is filmed. On projection, the art seems to "move." This technique can also be used for "claymation" and other pixilated shots of real objects that seem to move by themselves.

Today, animation is increasingly generated with computers, but traditional film animation can be done with an *animation stand* and camera capable of single exposures. *Motion-control* animation stands like the Oxberry allow you to program moves across an animated or still image. Motion control film and video setups are often used to do moves on photographs, for rock-steady, precise zooms and pans. Larger photos, titles and artwork can sometimes be filmed simply with a camera and tripod (see Preparing Film Titles, p. 488), but it is difficult to achieve the necessary smoothness of movement.

(i)

Fig. 2-8. (i) Bolex H16 Reflex 16mm camera. Beam-splitter reflex with nondivergent lens turret. Shown here with zoom lens and automatic exposure system. Spring-wound motor with 16½' run; capable of single-frame operation. This camera accepts 100' internal loads or an external magazine. It has a 135-degree variable shutter. (ii) Bolex H16 EBM 16mm camera. An electric motor runs the camera. Pictured here with accessory pistol grip and 400' detachable magazine, it also will take 100' internal loads. 170-degree fixed shutter. (Bolex)

(ii)

CAMERA MOTORS

Most cameras today have electric motors powered primarily by rechargeable batteries (see Batteries and Power Supplies, p. 182).

In order to be used for sync sound filming (see p. 12), the speed of the camera must be very precisely controlled. Most modern cameras used for sound work are equipped with *crystal-controlled motors*, which use a very stable crystal oscillator to ensure accuracy. These cameras drift in speed less than one frame in several hours, longer than any roll of film. Some cameras have precise crystal control over a wide range of speeds. Others are crystal at 24 or 25 fps and are less precise at other speeds. Some older cameras have *governor-controlled motors*, which are not as accurate; these can sometimes be used with a cable between camera and sound recorder, or can sometimes be retrofitted with a crystal. *AC synchronous motors* rely on the AC wall current (mains) for speed control and require AC input into the audio recorder for sync work.

Some cameras are not intended for sync sound work. Sometimes called *MOS* or *wild cameras*, nonsync cameras may have *variable-speed* motors or governor motors.

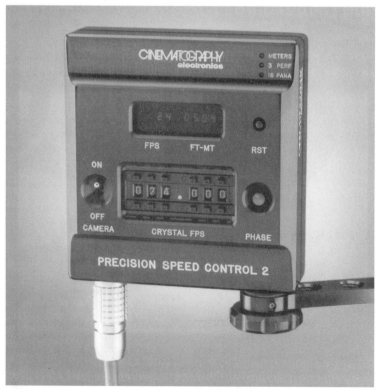

Fig. 2-9. Precision speed control. Allows frame rates from 1 to 159.999 frames per second in .001 fps increments. Has phase button for shooting video monitors. (Cinematography Electronics Inc.)

These cameras are often small, light and noisy. Some wild and sync cameras can be run in reverse for reverse motion shots, for example, when spilled water appears to be sucked back into its container. This effect can also be achieved by shooting double-perf film with the camera upside down. In the latter case, to reverse the motion, project the film tails out (that is, the last frame first).

Some nonsync cameras use *spring-wound motors*, which are wound by hand prior to the shot. Their chief disadvantage is that they run out of power after about a 30-second shot. These are very light and low cost. They need no batteries and are safer in explosive environments since they are less likely to produce a spark.

Speed Controls and Indicators

Many cameras can be fitted with an external speed control to allow precise speed selection over a wide range of speeds (see Fig. 2-9). These can be very useful for filming TV and computer monitors (see Chapter 17). Most crystal cameras have a warning system when the camera is not holding crystal speed. You can also get an external speed-checking device like the Cine Check. Some wild cameras have tachometers to indicate approximate speed. To determine its accuracy, use a speed checker, or run a premeasured length of film through the camera and time it with a stopwatch.

VIEWING SYSTEMS

The viewfinder allows you to see what is being recorded on film. Most modern cameras use a *reflex viewfinder*, which allows you to see through the lens (the *taking* lens). Some older or lower-cost cameras employ a *nonreflex viewfinder* that is separate from the taking lens. These generally give a less accurate representation of what is being filmed. Some cameras have no viewfinder at all and rely on finders attached to the lens or require a prism inserted in the film gate. The oldest-style reflex system was found in 35mm where the camera operator, his head covered by a dark cloth, viewed a dim image through the back of the film.

THE REFLEX VIEWFINDER

Modern reflex cameras divert light coming through the lens to a viewfinder where the image is projected on a *viewing screen*. Many newer cameras have *fiber-optic* viewing screens, which use a bundle of glass fibers to bring the image to the viewfinder. Fiber-optic screens are bright and allow you to see if the image is properly focused across the whole image.

Some cameras use a *ground-glass* viewing screen. Ground-glass screens are generally darker than fiber-optic screens, especially when the lens is stopped down (see Chapter 3). *Aerial image* systems often have a clear viewing screen with a circle in the center of the image for focusing. The central disc may be a ground-glass or a *range finder*. Range finders are usually *split image* or *microprism:* in the former, you focus by aligning the two parts of the image; in the latter, you focus by making the texture of the microprism disappear. Center-focusing viewfinders have

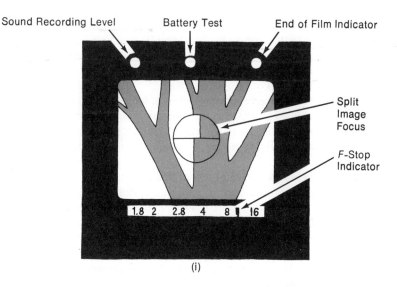

Sound Recording Level Battery Test End of Film Indicator

Split Image Focus

F-Stop Indicator

1.8 2 2.8 4 8 16

(i)

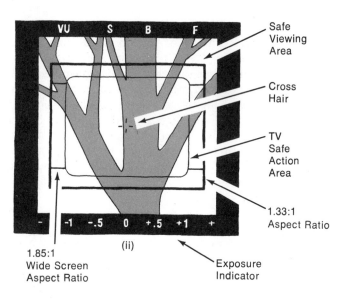

VU S B F

Safe Viewing Area

Cross Hair

TV Safe Action Area

1.33:1 Aspect Ratio

− −1 −.5 0 +.5 +1 +

(ii)

1.85:1 Wide Screen Aspect Ratio

Exposure Indicator

Fig. 2-10. Viewfinder screens. (i) An aerial image typical of super 8 reflex cameras. The split-image range finder here shows that the image is out of focus. (ii) A ground glass typical of 16mm cameras. Note the safe viewing area, which provides warning of things just outside the frame. Horizontal marks near the edge of the frame indicate approximate top and bottom cropping when shooting for 1.85:1 widescreen aspect ratio. Viewfinders sometimes have indicators for lens aperture, out-of-sync warning and end-of-film warning. On some 35mm cameras, the viewfinder includes a magnification system to enlarge the frame for critical focusing, and a lens to unsqueeze an anamorphic image. (Carol Keller)

disadvantages compared to viewing screens that show focus across the whole image. First, the viewfinder gives no impression of depth of field. Also, you may need to focus on a point that is not in the center of the frame, so changing focus in the middle of a shot can be difficult.

Composition in the Viewfinder

Most viewfinders are marked for the standard *projector aperture*, which is a slightly smaller frame than the *camera aperture* (which is the entire frame that is actually recorded on film). The difference between the two is significant only in very detailed work. Some viewfinders display an area that is even larger than the camera aperture and give you advance warning when objects, such as the microphone boom, are about to enter the frame. Since video monitors usually cut off the edges of the original image, many viewfinders are etched with a *TV safe action* area (see Fig. 2-10). See p. 220 for more on TV cutoff and working with widescreen formats.

The Mirror Shutter

In some cameras, light is diverted from the lens to the viewfinder screen by a *mirror shutter*. The mirror, either part of the shutter itself or rotating in synchronization with it, alternately allows all the light to hit the film, and then, when the shutter is closed, all the light to go to the viewfinder (see Fig. 2-11). One advantage of a mirror shutter system is that when each frame of film is exposed, no light is lost to the viewfinder, so in critical low-light situations you have as much exposure as possible. One disadvantage of mirror shutters is that when the camera is running, the viewfinder image flickers, since light only goes to the viewfinder about half the time. On better-designed systems, the finder is brighter and the flicker less annoying.

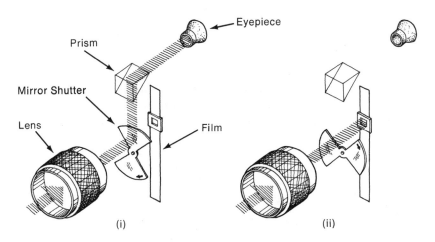

Fig. 2-11. Mirror shutter. (i) With the shutter closed, all the light is diverted to the viewfinder. (ii) With the shutter open, all the light strikes the film and exposes it. Compare with Fig. 2-12. (Carol Keller)

One paradox of the mirror shutter is that you see an image in the viewfinder when the shutter is *closed*, but the viewfinder image goes dark when each frame of film is actually exposed. In some situations this can be misleading. For example, if you film a gunshot and see the flash of the gun in the viewfinder, it may not actually appear on film. Systems are available to synchronize gun triggers to the camera shutter. If you film under strobe lights—at a dance, for example—the flashes you see in the viewfinder are exactly the ones that will *not* be photographed. Some strobing rates read well on film (for example, those around 10 to 15 flashes per second). If the rate is too slow, there may not be enough frames exposed; if the rate is too fast, too many frames will be exposed and the strobing effect may be lost.

Beam-Splitter Reflex

In an alternate design for reflex viewing, a partially reflecting mirror (*pellicule*) or a prism with a partially reflecting mirror (*beam-splitter*) in the light path diverts some of the light to the viewfinder, letting the balance hit the film (see Fig. 2-12). This system is used in most super 8 cameras. Anywhere from one third of a stop to a full stop of light (depending on the camera) goes to the finder and does not contribute to exposing the film. This avoids flicker, but the exposure loss can be serious for low-light filming. If the prism is in the camera body, an exposure compensation for the light loss is usually made by altering the shutter speed used for exposure calculation. For example, some 16mm Bolex cameras have 135° shutters (⅟₆₅ second at 24 fps), but the Bolex manual suggests that an exposure compensation be made by using an "effective" shutter speed of ⅟₈₀ second with your light meter. In super 8 cameras with built-in light meters, the exposure compensation is made automatically (see Chapter 4).

This same kind of split beam with an integral viewfinder is sometimes incorpo-

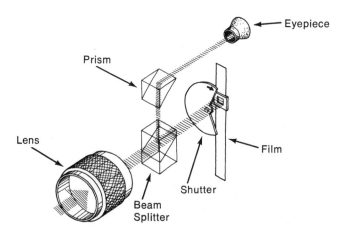

Fig. 2-12. Beam-splitter reflex. Some light is always diverted to the viewfinder, making it unavailable for exposing the film. The beam-splitter prism may be internal to a zoom lens or may be part of the camera. (Carol Keller)

rated into older zoom lenses to convert a nonreflex camera to one that has many of the focusing and framing capabilities of a reflex. In such lenses, the exposure compensation for light lost to the viewfinder is made by T-stop calibrations engraved on the iris diaphragm ring of the lens (see Chapter 3).

The viewfinder on beam-splitter systems tends to be darker than that on mirror reflex systems, making the use of a full ground-glass difficult. Consequently, most beam-splitter systems use an aerial image with center focusing, as discussed earlier.

The advantage of the brighter focusing image of a mirror reflex system so outweighs that system's disadvantages that, for the most part, the beam-splitter reflex is rarely found in new 16mm and 35mm equipment. The price of used beam-splitter reflex zoom lenses and nonreflex cameras has subsequently dropped very low and good buys are available.

The Diopter Adjustment

The viewfinder eyepiece on reflex cameras can correct for the cameraperson's near- or farsightedness. Make sure the *diopter adjustment* on the eyepiece is adjusted every time someone new uses the camera. The diopter does not affect the actual focus of the image on film, but it does affect your ability to *see* if the image is in focus.

If your system has a ground-glass, partial ground-glass or fiber-optics screen (most 16mm and 35mm cameras do), adjust the diopter as follows: Remove the lens or open the iris diaphragm on the lens. Point the camera at a bright area, like the sky or a bright wall. (If viewing through a lens, throw the image out of focus as much as possible.) Rotate the eyepiece diopter adjustment ring (on some finders it is a push-pull) until the grains of the ground-glass (on fiber-optics screens use the etched frame line) are as sharp as possible. If there is a locking device, lock the setting in place. The eyepiece is now adjusted.

On reflex cameras that have an aerial image in place of a ground-glass (many Super 8 cameras), the diopter adjustment is more critical, since you are calibrating the focusing system. To adjust this system: Zoom the lens out to the longest focal length, open the lens aperture wide and focus the lens at infinity. Find a distant object that you can focus on (like a building far away) and focus the eyepiece until the object is as sharp as possible. Lock the adjustment and the eyepiece is adjusted.

If you wear eyeglasses while shooting, adjust the diopter with your glasses on. Wearing eyeglasses during shooting makes it difficult, if not impossible, to see the whole viewfinder image. If possible, adjust the diopter for your eyes without glasses or wear contact lenses. If the camera's diopter adjustment is not strong enough to correct your eyesight, a correction lens can be mounted in the eyepiece.

The Eyepiece

To prevent stray light from entering the eyepiece and traveling through the reflex system in reverse and fogging the film, viewfinders have light traps that shut light off from the finder. During filming, your eye usually seals off stray light. When you are filming without looking through the viewfinder, close the light trap or place something against the eyepiece. This problem is most serious on beam-splitter systems, especially if there is a light source behind the camera. On some

cameras, the light trap can be set so that it opens when you press your eye up against the eyepiece and closes when there is no pressure on the eyepiece.

Some cameras have illuminated viewfinders that highlight the frame line, which can be a boon for shooting dark scenes. Condensation from your breath on a cold day can be a real problem. Some cameras offer heated viewfinders. Some people apply a little anti-condensation coating to the viewfinder (never use this on the taking lens). Some cameras allow you to insert a frame of a film print in the finder to help match a previously filmed shot.

The eyepiece is usually fitted with a rubber eyecup that cushions the eye (or eyeglasses) and helps seal out stray light. A foam or chamois cover will make it more comfortable. Covers get lost and dirty, so carry spares.

Reflex Viewfinder Placement

Most camera designs favor right-eyed viewing, but some finders can extend out for left-eyed viewing. Test yourself to see if you favor one eye over the other. With both eyes open, point at an object. Then alternately close your left and right eye. The favored eye's vision will correspond best to that of both eyes. Although most people are right-eyed, this group does not seem to comprise as large a majority as right-handed people do. Some left-eyed people have no difficulty viewing with their right eye. Try to cultivate viewing with your right eye, since many viewfinding systems will only accommodate right-eyed viewing. Also, right-eyed viewing on most cameras permits a less restricted view of the surroundings. Documentary filmmakers often develop the ability to look through the viewfinder with the right eye, keeping the left eye open to see what is happening outside the frame.

For tripod- or dolly-mounted cameras, you should use a viewfinder that extends to the back of the camera (see Fig. 3-11). For shoulder-mounted camera rigs, the ideal position of the viewfinder is close to the film plane (*zero finder*), since this generally allows the camera to be optimally balanced. Cameras used in both tripod and handheld work should ideally have interchangeable finders.

Some viewfinders swivel for viewing in awkward positions—for example, if you are kneeling on one knee with the camera on the other or if the camera is pointed backward over your shoulder. *Orientable* finders (also called *dovetail* or *erect image* finders) maintain an upright image even when the finder is rotated (see Fig. 5-9).

CAMERA FILM CAPACITY

Magazines

Some small cameras are designed to be used with film loaded on spools that mount inside the camera body. But most cameras use *magazines* (*mags*), which are detachable film chambers (see Figs. 2-1 and 2-14). The standard 16mm magazine is 400', which runs 11 minutes at 24 fps (36 feet per minute). Some 16mm cameras accommodate 200' or 1200' mags. Aaton now makes an 800' mag that accommodates new 800' film rolls. In 35mm, a 1000' mag holds about 10 minutes of film (35mm runs at 96 feet per minute). Some 35mm cameras have 200', 400', 500' or other size magazines. Large-capacity mags weigh more but allow more shooting between reloads.

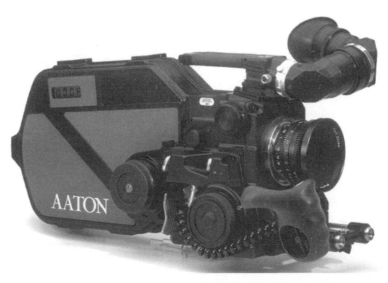

Fig. 2-13. Aaton 35-III. Handheld 35mm camera with quick-change magazines. (Abel-CineTech)

Fig. 2-14. Magazine for Aaton 35-III camera is open, showing feed and take-up in same compartment. (AbelCineTech)

Some magazines, like Mitchell mags, mount on top of the camera and are made up of a feed compartment in front of a take-up compartment. A variant of this is called a *displacement magazine*, like the 400′ mag for the Arriflex 16 BL (see Fig. 2-1).

Here the feed and take-up are together in one smaller chamber. *Coaxial magazines* often mount behind the camera body and have the feed and take-up chambers side by side (see Fig. 5-9). Coaxial mags have the advantage of being lower profile for shooting in tight spaces and they don't change the camera's balance as the load moves through the camera, which may be an advantage for Steadicam work. Generally, if the magazine has separate compartments for feed and take-up, this facilitates threading, unloading partial rolls and dealing with problems.

In *quick-change magazines*, such as all Aaton mags and Arri 16SR mags, much of the camera mechanism and the pressure plate are part of the magazine itself. This makes each mag more expensive and heavier, but has the tremendous advantage that once magazines are loaded with film, they can be clipped on the camera with no additional threading. This can make all the difference in documentary shooting when the action won't wait for you to reload. Even in dramatic shooting, minimizing the time for mag changes can be important. Most quick-change mags are of a coaxial design.

Loading Magazines

Magazines may be loaded with film prior to the day's shoot and then reloaded as necessary. Feature filmmakers may have a photographic darkroom available either in a studio or a truck. More typically, mags are changed using a *changing bag*, which is a lightproof, double-layered, double-zippered fabric bag (see Fig. 2-15). Look for a clean, dry place to work with subdued light. Some people like to work on a table or flat surface. You can work on the floor, but this may introduce dirt. Some changing bags are of a kind of tent design that give you room to work with big mags. Some people prefer to load 16mm mags on their lap; your legs help keep things from sliding around. Also, a lap is good for many locations (like outdoors) where no good, clean surface may be available.

Fig. 2-15. A changing bag functions as a portable darkroom. (Ted Spagna)

Cleanliness is essential, because any dirt on the film may lodge in the gate (see Checking the Gate, p. 72). Some people like to blow mags clean with a can of compressed air (like Dust Off), a tank of nitrogen or even a rubber bulb syringe. Be careful with any compressed gas: avoid blowing dirt into cavities in the mag or camera; also, the cold, expanding gas can damage mirror shutters. Some people prefer to clean mags with a paintbrush reserved for this purpose. You can also grab bits of dirt with a piece of tape, sticky side out, wrapped around a finger.

Before loading, the changing bag should be examined for rips or tears. If you find one, do a temporary repair with gaffer's tape or discard the bag. Turn the bag inside out and brush it clean with your hand. When not in use, zipper the bag closed and, if possible, keep it in a cover. When you're in the bag, bring the sleeves above the elbows to avoid light leaks and don't work in direct sunlight: use the shade of a tree or go inside.

Develop a standard operating procedure for loading mags so you won't get confused under pressure. Remove the moisture-proof tape from around the film can before putting it in the changing bag. You can hang the tape on the wall near you and reuse it to seal up cans (though black camera tape is often used for this purpose as a signal that the roll is exposed). Hold the can closed and put it in the bag; you can put the can *under* the mag to make sure it doesn't accidentally open while you're closing up the bag.

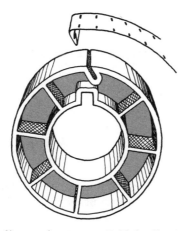

Fig. 2-16. Attaching the film to take-up core. Fold the film over itself and insert it in the slot. Position the slot as illustrated—angled against the direction of the take-up to keep the film from slipping out. Rotate the core to wind up several turns of film. Some magazines take up emulsion face-in and others face-out. (Carol Keller)

Once you've zipped up the changing bag with the film and clean mag inside, and gotten your hands in, you can open the film can. The end of the film will usually be taped down. Do not lose track of this tape! It might end up jamming the camera. If you stick it on the inside of the can you'll know where it is. You can reuse it to tape up the film after it is exposed.

On some magazines, you just have to slip the film into the feed side in the dark and then can do most of the threading outside the bag with the lights on. Be sure the feed roll pulls out smoothly. If the roll fights you or makes noise when pulled, it's probably not seated properly. Never pull hard on any film roll or you might cause cinch marks.

Nearly all raw stocks are supplied emulsion-in (see Fig. 4-11). Some magazines take up emulsion-in and others, emulsion-out.

Many mags have a post to accept a standard 2″ plastic core. When film is taken up on a core, attach it as shown in Fig. 2-16. Wind the film around the core several times in the direction it takes up, and make sure there is no bump where the film fits into the slot on the core (you may have to refold it). Generally, the camera gate should be brushed or blown clean before attaching the fresh mag. Make sure all loops are the right size (you can count the frames) and be sure they are centered properly so they don't bind or rub. Generally, you should check the gate every time you change mags or more often (see p. 72).

Some mags use a "core adaptor," which is a mechanical core that clamps shut on the film when you slide a lever. These have two disadvantages: (1) it's easy to accidentally leave them in the film when unloading; (2) many labs prefer that film be delivered with a core in it.

Run a few feet of film through the camera to make sure everything is running smoothly. If you hear a fast ticking sound, your loops may be off. If you hear a low, slow rubbing sound, the film roll may have *dished* in the feed side, and need to be gently pressed flat. Sometimes a firm slap with the palm of your hand on the side of the mag (take it off the camera first) will stop a roll from rubbing. With mags that have separate feed and take-up compartments, you can run the camera with the take-up side open to see if everything is okay, and check that the film is not being scratched (see p. 73 for scratch test).

Labeling and Managing Magazines

After the mag is loaded, a piece of tape should be put across the latches to prevent accidental opening. The edges of the magazine covers are sometimes sources of light leaks that may fog film, especially with old equipment. Taping the magazine with camera tape along the length of the lid ensures against leaks (see p. 74 for a light leak test).

The magazine should be labeled with a piece of tape or a sticker to identify its contents:

1. The type of film (eg., 7248)
2. The emulsion and roll number from the film can's label (see Fig. 4-10); this is useful if there are problems later
3. The length of the roll (eg., 400′)
4. The camera roll number (eg., CR 55); this should be marked only after the mag is on the camera
5. The mag's number or serial number (useful if scratches are found later)
6. The date

In documentary shooting you may not have time to get everything down. Items 1, 3 and 4 are essential. Some people use color-coded tape for different types of film stock.

Have on hand spare cores, cans and black bags for *short ends* (the unshot portion of a partially filmed roll). When unloading exposed film, tape up the end of the roll and be sure the black bag is neatly folded before closing and retaping the can. Be sure to mark the can clearly as EXPOSED. See Chapter 16 for labeling the can after the film is exposed and Chapter 4 for handling, storing and shipping film stock.

When magazines are reloaded during a shoot, some people prefer to unload the exposed film, remove it from the changing bag and then go back in with the fresh stock. This avoids any confusion. With mags that have separate feed and take-up compartments, it's faster to clean the empty feed side, put the mag and fresh stock in the changing bag, load the feed side and—while still in the bag—unload the exposed film into the can you just emptied.

Magazines are generally emptied at the end of the day's shooting and should be emptied before air travel. When unexposed film is put back in a can (*recanned*), it should be labeled as noted above, except without the camera roll and mag numbers. Mark UNEXPOSED/RECAN and put the name of the person unloading in case there are questions later.

SPARE MAGAZINES. Have at least one extra magazine. This lets you change mags if problems develop and allows you to load the next roll before it's needed, saving time at what might be a crucial moment. When you use two different raw stocks (for example, a slow-speed film for interiors and a high-speed for exteriors), the extra magazine makes both immediately available. On a feature film it is common to have five or more mags. Some documentary crews load up a lot of film at the beginning of a day's shoot so they can do without a magazine changer and keep the crew size to a minimum. In two-person documentary crews, a few spare magazines can be carried by the sound recordist—usually two quick-change mags or three or four regular mags.

Daylight Spools

Film in 16mm and 35mm is supplied on cores (*darkroom load*) or daylight spools (see Fig. 2-17). Spool-loaded film for 35 mm is generally only available in 100', while 16mm film is supplied on 100', 200' and 400' spools. You don't need a changing bag for daylight spools, but load them in subdued light since bright light could fog the edges of the film. Integral head and tail leaders protect the unprocessed film from stray light: the way the unexposed film is wound on the spool helps prevent stray light from penetrating to the inner layers. After shooting, the film is not as protected. If the camera runs out of film during a shot (*run-out-shot*), unload the film in a changing bag to protect the tail of the shot.

Most 16mm magazines have both core and spool adaptors (sometimes you remove the core adaptor to mount a spool). Though most magazines will accept daylight spools of up to 400', spools are heavier than darkroom loads and may scrape against the side of the magazine, creating an annoying noise. Sometimes darkroom loads are spooled down onto daylight spools for use with small, spool

load cameras. This will result in reversed key numbers (see Chapter 4) if the film is not rewound once before spooling. Some labs will do this for you.

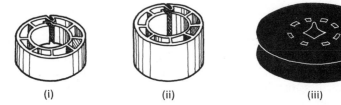

(i) (ii) (iii)

Fig. 2-17. Cores and daylight spool. (i) A 16mm core. (ii) A 35mm core. (iii) A 16mm, 100' daylight spool. (Carol Keller)

Super 8 Cartridges

Super 8 Cartridges are lightproof, but you should still avoid exposing them to direct sunlight. Do not break the cartridge's moistureproof foil until you load the camera. A notch in the plastic cartridge automatically sets the ASA number on many super 8 cameras with automatic exposure. When using Pro8 negative stocks, it may be necessary to manually carve out the notch for proper ASA and filter settings on certain cameras. On many cameras, the footage counter resets to zero when the film compartment door is opened. Be sure to write down the footage if you open the door to check the gate or change film in the middle of a cartridge.

OTHER CAMERA FEATURES

Video Assist

A *video assist* (also called a *video tap*) diverts some light from the film camera to an attached small video camera that allows you to watch the image on a video monitor and/or record it on tape. Video taps can be valuable for allowing the director or others to see the shot, for reviewing takes, for logging or even editing footage prior to processing. A video assist can be crucial for Steadicam, crane or car shots in which the operator cannot look through the camera. However, there can be some drawbacks to video taps. The image is a low-quality approximation of what is being recorded on film, and often misrepresents what the image will eventually look like. Since you're not actually seeing the film, you can't know about a host of film problems, including scratches or even a run-out. When a director is immersed in the monitor instead of watching the action directly, actors can feel isolated. Many people kibitzing over the video monitor can lead to a "too many cooks" problem. And video taps consume a lot of battery power and can reduce the mobility of the camera.

The video cameras used for the assist vary in sensitivity and quality. Some people prefer black-and-white because color can be misleading. Most video taps get their light by shunting off light from the camera's viewfinder (making the viewfinder image darker). Some taps actually replace the finder. Many video taps produce a

flickering image because, like the camera viewfinder, the tap only gets light half the time—when the mirror shutter is closed. There are newer, "flicker-free" designs that electronically store the frame when the shutter is closed and reproduce it when the shutter is open, filling in the time that would otherwise be dark. Another system uses a pellicle (like a beam-splitter reflex viewfinder; see p. 60) to divert light before it reaches the shutter. The video image is better, but the film loses some light.

See p. 391 for editing the image recorded from a video assist.

Fig. 2-18. Video assist. A small video camera mounted on the film camera (shown here just above the gray 12-volt battery). (AbelCineTech)

Sound Dampening

Camera noise on the sound track can be annoying in a documentary or disastrous in a fiction film. Even when filming without sound, a noisy camera can be disruptive. Noise calls attention to the camera and can distract subjects or alter animal behavior when doing nature filming.

High-end 16mm and 35mm cameras designed for sync-sound work are usually very quiet. Camera manufacturers often rate cameras intended for sync-sound shooting according to a noise level expressed in decibels (dB; see Chapter 9). Cameras in the low 30 dB range are usually considered adequate in 16mm for sync-sound. Shooting outdoors or in noisier locations allows the use of a noisier camera. Since much of 35mm cinematography is done on a soundstage where there is virtually no background noise, standards for a quiet camera are more stringent; some are as quiet as 19 dB. But noise ratings have to be taken with a grain of salt. Cameras have to be in good repair to be really quiet. On some cameras, most of the noise comes from the magazine. A magazine barney (see below) may make a difference. Slightly shrunken film chatters in some cameras more than in others. High-frequency sounds may be more bothersome than low, rumbly sounds.

Camera noise can be dampened with a *barney*, which is a soft cover, sometimes made of lead foam (see Fig. 2-19). Barneys are often custom-fitted for the camera, allowing access to controls. Barneys may cover the whole camera or just the magazine. In a pinch, a heavy coat or a sound blanket (see Chapter 10) can serve as a makeshift barney. White barneys are sometimes used to reflect sunlight and keep the film cooler in hot weather. The heater barney is a battery-operated camera cover that keeps the camera warm when filming in very cold weather.

Another sound-dampening device is the *blimp*, which is a hard, soundproof camera housing. The Mitchell BNC ("B" for blimp), one of Hollywood's standard cameras, is a blimped version of the Mitchell NC. Although blimps are quite heavy, they are so effective that cameras can be used on a soundstage very close to the microphone without camera noise. Underwater housings are available for cameras in all gauges for filming underwater or in very wet locations.

Fig. 2-19. Camera with white barney, rubber lens shade and French flag (small card on articulated arm for preventing lens flare).

In-Camera Timecode

Timecode can be very useful in production and postproduction (see Chapters 1 and 6). Some newer film cameras can expose timecode along the edge of the film, which can be read after the film is developed (see Fig. 2-20). The Aaton/ Panavision system uses both Arabic numerals ("man-readable") and a matrix of dots (machine readable). The Arriflex system uses a bar code instead. Older cameras not equipped for internal timecode can still work with timecode using time-code slates. See Chapter 10 for use of timecode during shooting and Chapter 17 for timecode in film-to-tape transfers.

Fig. 2-20. In-camera timecode. The camera exposes the timecode along the edge of the film. The AatonCode system uses both human-readable numbers and a machine-readable matrix of dots. (AbelCineTech)

Multiple-Format Cameras

Some cameras are capable of shooting more than one format. For example, suitably equipped Aaton and Arriflex 16mm cameras can shoot either 16mm or super 16. The camera must have a super 16 gate, the proper viewing screen and the lens must be shifted over (recentered on the frame) when changing between formats. Many 35mm cameras have a number of interchangeable gates and viewing screens for different aspect ratios and formats. Bear in mind that a lens designed for one format won't necessarily cover the full frame of a wider screen format. For example, super 16 lenses will cover the 16mm frame, but the reverse is not necessarily true (see Chapters 1 and 16 for more on 16mm and super 16).

Fig. 2-21. EWA super 8 backwinder allows rewinding the cartridge up to 270 frames for making dissolves and multiple exposures. (EWA)

In-Camera Effects

Some cameras can make in-camera effects, such as fades and dissolves. In 16mm and 35mm, effects are generally created in the laboratory during the printing stage, so few cameras have this feature (some Bolexes are an exception). Some

super 8 cameras have back-winding capabilities for dissolves and multiple images but are limited to certain lengths. Back-winders for super 8 cartridges may rewind the cartridge to greater lengths.

You create multiple images by exposing the same section of film two (*double exposure*) or more times. Make sure you compensate to avoid overexposure. The rule of thumb is to underexpose each image one stop. However, if a light scene is to be double-exposed, it may have to be further underexposed (since it will bleach out a darker scene), whereas a dark scene may need to be exposed normally without any underexposure.

Do in-camera fades by closing down a variable shutter to 0°. Merely stopping the lens iris down will generally not produce a totally black image, and the changing depth of field may be noticeable. Make dissolves by overlapping a fade-out with a fade-in. A frame counter in addition to a footage counter is needed for dissolves, or for making any precise in-camera effect. Some super 8 cameras will do fades and dissolves automatically at the touch of a button. The matte box is also used for some in-camera effects (see Chapter 3).

CAMERA TESTS AND MAINTENANCE

Of the following tests, checking the gate is done regularly while shooting. The other tests are often done before a shoot when checking out a camera from a rental house or other equipment supplier.

CHECKING THE GATE. Dirt or bits of emulsion often lodge in the camera aperture and are exposed as a shadow on the edge of the picture ("hairs in the gate"). A good way to check the gate is to remove the lens and, from in front of the camera, examine the edges of the aperture with a lighted magnifier. You need to manually inch the motor forward so that the mirror shutter is open, giving you a clear view of the aperture and the film behind it. Some people prefer to check the gate *through* the lens. This takes practice and only works well with long lenses. Open the iris all the way, focus to infinity and set a zoom to telephoto. Use a small flashlight to look around the edge of the frame. The advantage of this system is you're less likely to introduce dirt while checking the gate (in a dusty location, for example). The disadvantage is that all the lens settings have to be reset and you still have to take the lens off if there's dirt.

To clean the gate, carefully insert an orangewood stick (sold as cuticle sticks for nail care in drugstores) and lift the dirt out of the frame. Never insert anything metal and don't touch the mirror shutter or any of the optics. Compressed air may damage the mirror. Don't forget to inch the motor forward after cleaning to close the shutter and return the mirror to viewing position. You can inch the film forward a few frames or run it a bit and check again to be sure the dirt is *really* gone.

How often should you check the gate? The answer depends on the camera, cinematographer and the project. On a feature, the gate should be checked whenever a new film roll is begun and at least before the camera is moved from one

setup to another. Some people check the gate after every take, or every *good* take (printed takes). Once you find a hair, you have the unpleasant task of trying to guess how long it's been there, so the more often you check, the safer you are. On a documentary, you may only have time to check once a roll. Hairs are more critical in 16mm—where the edge of the gate forms the edge of the image—than in some 35mm formats where the full Academy gate may give you some extra clearance from the part of the frame you're actually using. The gates on some cameras seem to naturally stay fairly hair-free, such as many Aaton and Panavision cameras. Dirty locations and soft film emulsions require more attention to the gate. Do everything you can when loading and cleaning magazines to avoid or remove dirt that might otherwise end up in the gate.

SCRATCH TEST. Run a few feet of film through the camera, and remove the film from the take-up reel. Examine the footage for surface scratches by holding the film obliquely toward a light source. To locate the cause of a scratch, mark the frame in the aperture; unload the film; mark where the scratch begins; thread the film with the first marked frame in the aperture, and note the location where the scratch begins. Then clean the gate, rollers or other scratching surfaces. Test for scratches whenever checking out a camera or magazine for the first time, and check occasionally during use. Keep some short ends around for scratch testing, but use only film that hasn't run through a camera gate before.

REGISTRATION TEST. *Registration* refers to the steadiness of the image—the camera's ability to expose each frame in the same place relative to the sprocket holes. Bad registration causes image jiggle and viewer eye strain. To check registration, mount the camera on a steady tripod and tape a lens's zoom ring so it does not move, and then don't touch the camera. With negative film, photograph a black cross or grid on a white wall; with reversal, shoot a white cross on a black field. Underexpose by about a stop to compensate for double exposure. Wind the film back to the beginning, move the camera slightly and photograph the cross again. (In 35mm you must mark the frame in the gate when you start so you can place it in the gate to start the second pass.) Having moved the camera, there is now a small amount of space between the two images of the cross. On projection, the less the movement of the crosses with respect to each other, the better the registration.

Another test of registration, particularly in 16mm, is done by shifting the frame line adjustment during projection so the frame line can be seen. If the frame line seems to get thicker and thinner (to breathe), registration is poor. Any jiggle between the frame line and the edge of the screen is probably a measure of the poor registration of the *projector*.

FRAME LINE TEST. The frame line in 16mm should bisect the perforations (see Fig. 1-3). To test a camera, fold a strip of exposed and developed film over itself, place pins through the perfs and check that the frame lines are perfectly in line with each other. The projector frame line adjustment can correct for a *consistently* misplaced frame line. Problems arise, however, when you use two different cameras (or purchase stock footage) with a dissimilar frame line.

TESTING VIEWFINDER ACCURACY. To check the accuracy of the viewfinder, mount the camera on a tripod. Get a test chart or make one with numbered rectangles with the proper aspect ratio (1.33:1 for standard 16mm; 1.85 for standard widescreen 35mm) nested within one another. Carefully align the viewfinder with one of the rectangles, photograph and check for accuracy. The only discrepancy on a reflex finder should be between camera aperture and projector aperture (see p. 57).

TESTING RETICULE POSITION. Viewfinders like those on zoom lenses with auxiliary finders have a mask or reticule that defines the outlines of the frame. To check for proper orientation, place the camera on a flat surface (like a solid table) and align the frame edge with the table edge. The two should be parallel. If they are not, adjust the reticule. On some zooms, it is a simple adjustment.

LIGHT LEAK TEST. Light leaks show up on developed camera original as uneven fogging extending outside the picture area. If you detect light leak in your footage, it may come from poor handling when loading or unloading the magazines. To check a camera for light leaks, load it with unexposed raw stock and mark or expose the frame in the aperture. Move a bright light source (held a few inches from the camera) around from every angle, develop the film and check for edge fogging. If edge fog is found, reload the footage, placing the marked frame in the aperture. Edge fog at any point locates the source of the light leak. In the field, you can tape the edges of a magazine to reduce the chance of light leak.

OTHER TESTS. See Chapter 3 for lens focusing tests that may discover faults in the camera viewfinder or the adjustment of the lens mounting. Always check rushes for any defects (see Chapter 16) and immediately troubleshoot (search for the fault). An image with total vertical blurring is a sign of a lost loop in the camera. Partial vertical blurring is a sign of a shutter timing error; the frame has been exposed while moving. The whole image moving in and out of focus (breathing in the gate) usually calls for pressure plate adjustment. These last three problems can also be caused by a malfunctioning projector, which should also be checked. Investigate any image flicker or unevenness in exposure.

Camera Quality

Accurate registration in a camera is a sign of good mechanical design, but it does not measure its sturdiness, nor how well it will keep to its original specifications. The quality of workmanship often determines whether a camera will become noisier with age or break down often, but reliability is also a question of design. Seek advice on specific cameras from filmmakers who have field-tested the equipment and from camera rental houses. Some cameras are easier to repair than others. Modular designs (with replaceable units) permit easy field repair.

Camera Care

Keep the camera clean. Do not blow compressed air into the aperture or places where dirt can become lodged. Never use metal to scrape emulsion from the gate.

You can use alcohol on a cotton swab to remove emulsion deposits, but take care not to leave any cotton fibers. Acetone damages some plastics. Use magazine covers, lens socket caps and body caps to keep dust out of camera openings.

Do not run a camera without film at speeds higher than 24 fps.

Hand-carry a camera on a plane rather than checking it as baggage. When shipping, use rugged shipping cases, and detach the lens before shipping. Place all delicate equipment in foam-lined and -fitted cases. Secure the camera on a car seat rather than leave it loose on the car floor or in the trunk where it will be subject to more vibration.

When you use a battery belt connected to the camera by a cable, be careful not to rest the camera on a surface and walk away, pulling the camera along behind you. Use a coiled cable to minimize the risk. When you rest the camera on a table, do not let the lens extend over the edge where it may be hit by an unwary passerby.

Obtain the manufacturer's operation and maintenance manual for special information on oiling and overhaul instructions for your camera. Check whether any special lubrication is required for cold weather filming. Try to assemble a group of tools and spare parts for field repairs.

Shooter's Ditty Bag
Typical items in a cinematographers's (or assistant's) bag:

Changing bag	Camera tape; white and black
Camel's hair brush	Tweezers
Compressed air in a can	Depth of field calculator
Clean paintbrush	Electrical multimeter
Spare cores, cans, black bags	Soldering iron, wire
Lens tissue	Needlenose pliers
Lens cleaning fluid	Adjustable wrench
Orangewood sticks	Screwdrivers
Crocus cloth for removing burrs	Grease pencil
Jeweler's screwdrivers	Chalk
Camera oil or grease	Magnifying lens with light
Set of Allen wrenches	Small flashlight
Slate	Marking pens (Sharpies)
Swiss Army Knife	50' measuring tape
(w/scissors for cutting gels)	Contrast viewing glass

The Lens | CHAPTER 3

This chapter is about lenses for both film and video cameras. The lens is the eye of the camera system. To create the kinds of images you want, it's important to understand the basic characteristics of lenses and how they gather light.

Photographic lenses are generally made of several pieces of glass, called *elements*. Some of these elements are cemented together (*compound elements*) and then mounted in the lens *barrel* (housing). The lens gathers light rays from the subject and bends them to form an image in the camera.

FOCAL LENGTH AND PERSPECTIVE

Focal Length

If we take a light source at infinity—a star will work fine, but anything at a great distance may serve as "infinity"—the lens will focus the rays at a point behind the lens. This point falls on the *focal plane*, and the lens is said to bring the star into *focus* in the focal plane (see Fig. 3-1). In a film camera the film normally rests in the focal plane when it is exposed; in a video camera the CCD will be in the focal plane. (Since most lens concepts are identical for film and video, we will use *the film* or *the CCD* interchangeably to mean the surface where the image is formed.)

The *focal length* measures the power of a lens to bend light rays coming from the subject. The shorter the focal length, the greater the bending power and the closer the focal plane is to the rear of the lens. The focal length of a lens is defined as the distance from the lens (actually, the *nodal point* of the lens) to the focal plane when the lens is focused on an object at infinity. Lenses are identified by their focal length. *Prime lenses* (also called *fixed focal length lenses*) have only one focal length. *Zoom lenses* have a range of focal lengths, allowing you to change focal length during a shot. Focal length is usually expressed in millimeters (mm) or, more rarely, in inches (1″ is approximately 25mm).

For each shot, the cinematographer decides how large the subject should be in the frame. For example, should the shot include the whole body or should the face

Fig. 3-1. Focal length. (i) The rays from a point light source at infinity are parallel when they strike the lens. The distance from the lens to the focal plane (where the rays are brought back to a point) is the *focal length*. (ii, iii) The closer an object is to the lens, the farther from the lens the rays converge and the larger the object appears on the film. The photographic lens forms an upside-down image flipped from left to right. (Carol Keller)

fill the frame? There are two ways to increase the size of the subject in the frame: you can either move the camera closer to the subject or use a longer focal length lens (see Fig. 3-2). If we view a scene with two lenses, the lens with the longer focal length will reveal less of the scene and will make any object in its field of view appear larger. This lens "sees" the scene through a narrower angle—the longer the focal length, the narrower this angle.

Focal length is directly proportional to the size any object will appear on film. If we double the focal length (keeping the distance to the subject constant), the subject will appear twice as large on film. The size of the object is inversely proportional to its distance from the camera—that is, if we double the distance, we halve the size of the subject on film (see Fig. 3-3). At 10′, a 50mm lens yields the same size subject as a 25mm lens does at 5′.

Perspective

As just discussed, there are two ways to control the size of an object in the frame: change the distance between camera and subject or change the focal length. Does it make a difference if you move the camera closer to the subject rather than use a lens of a longer focal length? Figure 3-3 illustrates that it does. When you change focal length to enlarge part of a scene, it's like enlarging a detail from the image. Both foreground and background objects become larger to the same relative

Fig. 3-2. Angle of view and focal length. (left) Keeping the angle of view constant, moving closer to the man (dollying in), makes him appear larger. (right) Keeping the camera in the same position while using increasingly longer focal lengths also makes the man larger but decreases the angle of view. (See the results in Fig. 3-3.) (Carol Keller)

degree. In other words, if the focal length is doubled, all the objects in the frame double in size on film.

On the other hand, as the camera is moved closer, the relative size of foreground and background objects increase at different rates. Objects closer to the camera become larger faster than objects farther from the camera. In the first set of photographs in Figure 3-3, the camera is moved closer to the subject. The building in the background does not increase in size nearly as much as the man in the foreground. If you move twice as close to an object, the object doubles in size on film, but objects in the background increase by less than that.

Perspective may be thought of as the rate at which objects become smaller the farther they are from the camera. In Figure 3-3, as the camera moves in toward the subject, the man increases in size at a rate faster than that of the building, increasing the feeling of depth and making the man appear relatively far from the building. However, in the other set of pictures we can see that, if we only change the focal length and don't move the camera, the perspective doe not change. Although the image is magnified, the relationship between the man and the building remains the same. By cropping out closer objects, the space appears flatter and the foreground and background seem compressed.

Fig. 3-3. Zooming compared to dollying. When you start at the same position (top), you can move the camera closer (the two photos at left) or zoom in (the two photos at right). In the zoom, everything gets proportionally larger—the man and the building double in size. In the dolly shot, at left, the man doubles in size but the building stays about the same size. (Compare how many windows are visible in the bottom pair of photographs.) (Ted Spagna)

Fig. 3-4. Compression and exaggeration of depth. The long focal length lens makes the foreground and background appear close together (top). The cars look flat, packed together and close to the distant sign. In this still from *Citizen Kane*, a feeling of deep space is created, in part, by using a short focal length lens (bottom). (Ted Spagna, RKO General)

By altering both focal length and camera-to-subject distance, the cinematographer can control perspective. Coming in closer and using a wide-angle lens exaggerate distances, while moving back and using a lens with a long focal length compress distances. An image is said to have *natural perspective* when the perspective appears similar to what one would see if standing at the camera position. Lenses of "normal" or medium focal length generally yield images of natural perspective. A 25mm lens is considered normal for 16mm cameras (for other formats, see Focal Length and Format, below).

Lenses of appreciably shorter focal length than normal are called *wide-angle* or *short focal length lenses*. A rough rule-of-thumb estimate is that wide-angle lenses are about half the focal length of normal lenses (50 percent), while lenses below about 35 percent of normal are *extreme wide angle*. Lenses with a focal length appreciably longer than normal are called *long focal length* or *telephoto lenses*. Lenses longer than about 150 percent of normal focal length are considered telephoto.

Perspective Effects

As discussed above, the farther the camera is from the subject, the flatter or more compressed the perspective; that is, objects of different distances from the camera do not appear greatly different in size on film. With a long focal length lens, distant objects do not appear as small as you might expect (see Fig. 3-4). This effect is easily observed when a race is filmed head-on with a long focal length lens. The runners seem to be closer to one another than they in fact are, and although they seem to be running hard, they do not appear to be making much progress. This illusion occurs because of the great distance to the subject and the use of a long focal length lens. A very long lens can make the world seem almost flat or two-dimensional.

Wide-angle lenses are apt to exaggerate depth; the distance between foreground and background seems greater than you would expect, objects far from the camera seeming too small in relation to the objects close up. This phenomenon is sometimes called *wide-angle lens distortion* or *perspective distortion*. Although you may not find exaggerated perspective pleasing, it is, in fact, not "distorted," and, when the image on screen is viewed from up close, the perspective seems natural. As you get even closer to the screen, the perspective flattens. If you usually sit close to the movie or TV screen (and do not suffer from nearsightedness), you probably prefer compressed perspective; if you sit far from the screen, it may be because you prefer more depth in the image.

You can use a wide-angle lens to make a room seem larger. However, if someone is near the camera and moves toward it, he will appear to move unnaturally fast. In general, use a wide-angle lens to exaggerate the speed of any movement toward or away from the camera. A wide-angle lens on a moving vehicle pointed in the direction of the movement strongly suggests speed, especially if objects sweep past near the lens. Use a wide-angle lens to emphasize heights; for example, shoot down from the top of a building or shoot a person from below. Perspective effects are accentuated when there are objects both in the close foreground and distant background. A distant landscape or seascape with nothing in the foreground will show perspective less.

Fig. 3-5. Close-ups with different focal length lenses. If a head-and-shoulder close-up is made with a wide-angle lens, facial features are distorted—the nose appears too large and too far from the ears (top). A medium-length lens gives a feeling of depth without looking unflattering (middle). A long focal length lens compresses the features, flattening the face (bottom). Although this lens sometimes creates a feeling of distance or remoteness, it is not unflattering. (Ted Spagna)

PERSPECTIVE IN THE CLOSE-UP. When you shoot a head-and-shoulder close-up with a wide-angle lens, the camera must be fairly close, which exaggerates depth. The nose will seem too large, and the ears too small and too far from the front of the face. Such close-ups are usually used for comic or eerie effect (see Fig. 3-5). If the subject moves toward the camera, the nose grows in size. A hand movement in the direction of the camera seems too fast, the hand itself too large. Faces in profile and motion perpendicular to the lens's axis show this exaggeration of perspective less.

If you film at the most common filming distances—about 5' or more from the subject—you do not have to worry about exaggerating facial features. For close-ups of faces, it is better to err on the side of flatter perspective (a longer focal length lens at a greater distance). However, when perspective is *too* flat, intimacy is lost and the viewer may feel distant from the subject (see Fig. 3-5).

Focal Length and Format

With experience, cinematographers learn which focal lengths will achieve the effect they're looking for. For example, when shooting a typical interview with a 16mm film camera, a range of focal lengths from about 10mm to 50mm will allow everything from a medium shot of the subject to a close-up of the face. Or, a 150mm lens will provide really compressed perspective for a long shot of a crowd coming down the sidewalk. Once you get comfortable shooting in any format, you will begin to have an instinctive feel for roughly what length lens you need in various situations, and what angle of view each focal length provides.

When you shoot with a different film or video format, keep in mind that the angle of view afforded by any focal length lens changes according to the format. With film cameras, the image produced by a 25mm lens with a 16mm camera is about the same as a 50mm lens with a 35mm movie camera (note an approximate doubling between the formats). The same angle of view in super 8 would require about a 14mm lens.

With video, it's not the tape format but the size of the camera's CCD that matters. The $\frac{2}{3}''$ imager (CCD) found on many larger professional video cameras is just *slightly* narrower than the 16mm film frame. To get the same angle of view of the lenses just mentioned, a video camera with a $\frac{2}{3}''$ CCD would need a 22mm lens. A camera with a $\frac{1}{2}''$ CCD would need about a 16mm lens. The wider the actual image recording area on the piece of film (or the wider the CCD chip), the longer focal length lens you need to produce the same angle of view. Cameras that have a 16 × 9 format CCD will have a different angle of view when switched to 4 × 3 mode.

Once you learn how various focal lengths look in one format, you can translate those numbers when working in another format. Appendix D gives you the relationship of focal length to angle of view in various formats. Consumer and prosumer video lenses often don't even *indicate* the focal length, because the manufacturers assume you won't know how to interpret it.

THE LIGHT-GATHERING POWER OF THE LENS

F-Stops

The lens gathers light from the subject and projects its image on the film or on the video camera's CCD. The light-gathering power of the lens is called the *speed of the lens*. It is expressed as an *f*-number (f-*stop*, or *relative aperture*), which is the ratio between the focal length of the lens and its diameter (the *aperture*):

$$f\text{-number} = \frac{\text{focal length}}{\text{lens diameter}}$$

The *f*-number essentially tells us the light-passing power of a lens. As the lens diameter increases, so does the amount of light that passes through the lens. As the focal length increases, the light is dispersed over a greater area and the amount of light available to the film or CCD for exposure decreases. The *faster* a lens, the more light it lets through; the *slower* a lens, the less light. Lenses of about *f*/2 (that is, the diameter of the lens is one half the focal length) are considered fast.

Inside the lens is the *iris diaphragm*, which can close down to control the amount of light that the lens lets through. The iris is a mechanical device, usually made of overlapping blades (see Fig. 3-6), which can be set to form a large or small hole or aperture (*lens aperture*). It functions similarly to the iris in the eye. In dim light, the eye's iris opens to admit more light, and in bright light it closes down to let less light pass through.

f/11 f/4 f/2.8

Fig. 3-6. Iris diaphragm. As the blades of the iris open, more light passes through the lens. (Carol Keller)

A similar formula to the speed of the lens is used to express the light-gathering power of the lens at any iris diaphragm opening. The *f*-number, or *f*-stop, is the focal length of the lens divided by the diameter of the aperture. The standard series of *f*-stops, or *f*-numbers, is:

1, 1.4, 2, 2.8, 4, 5.6, 8, 11, 16, 22, 32

The distance between consecutive numbers is called a *stop*. On most lenses, the *f*-stops are engraved on a ring on the lens barrel. Each stop represents the halving (or doubling) of the amount of light that the lens passes. At high *f*-numbers, the

iris is more closed and less light passes through. As the ring is turned toward the lower numbers (*opening up*), the iris opens; conversely, as the ring is turned to the higher numbers (*stopping down* or *closing down*), the iris closes. For a lens set at *f*/4, for instance, opening up a stop would mean setting the lens at *f*/2.8 (which doubles the amount of light for exposure), and closing down two stops from *f*/4 would mean setting the lens at *f*/8. Remember, opening the lens three stops lets *eight*, not six times more light in (each stop doubles the previous amount). See Fig. 4-19 for intermediate *f*-stops.

Lens manufacturers generally engrave the focal length, serial number and speed of the lens (widest relative aperture) near the front element. The speed is sometimes written as a ratio; 1:1.4 would be an *f*/1.4 lens.

The standard technique for setting the *f*-stop is to open the lens to its widest opening and then stop down to the selected opening without passing it. This avoids any play in the iris that, in some lenses, can cause a full stop error at the smaller apertures.

T-Stops

When you are calculating exposure, you need to know how much light passes through the lens to the film. The *f*-stop is a geometric relationship between focal length and aperture and does *not* take into account how much light is lost within a lens. Each air-to-glass surface within the lens reflects some light. A zoom lens may have more than 15 elements and can lose a significant amount of light to internal reflections. A *T-stop* accounts for this loss (T is for "true" stop or "transmission.") The T-stop is defined as the equivalent to an *f*-stop of a *perfect lens* (a perfect lens transmits *all* the light it gathers with no internal losses). Thus, on a perfect lens, the *f*-stop and T-stop are identical. On a zoom lens that loses a full stop internally (that is, a 50 percent loss), setting the lens to *f*/8 would result in the same exposure as T11. Note that the T-stop is always a higher number than the *f*-stop.

Some *cine* (movie) lenses are calibrated in both *f*-stops and T-stops (sometimes the *f*-stop in white on one side of the iris diaphragm ring and the T-stop in red on the other side). Many lenses are marked only in T-stops; others only in *f*-stops. Be sure to check the lens you're using. With prime lenses, the difference between *f*-stops and T-stops is usually less than ¼ stop—not enough to upset exposure calculations. With zoom lenses, the difference is usually greater. One zoom might have the widest aperture marked as *f*/2, but the T-stop could be T2.5, which means this lens loses ⅔ stop in transmission.

If the lens is marked with T-stops, use them to calculate film exposures even though the light meter is marked in *f*-numbers (see Chapter 4). For depth of field calculations (see below), use *f*-stops.

With video lenses, the difference between *f*-stops and T-stops is complicated by the additional light lost in the camera's internal optics. However, T-stops are not usually a concern in video, since most people set the exposure according to video levels, not with a light meter. See Chapter 11 for a technique of using a light meter for video.

FOCUSING THE IMAGE

Depth of Field

Nearly all lenses have provisions for focusing the image. On most lenses, you turn the lens barrel which has distance markings on it. When shooting a portrait of a man ten feet from the camera, you can set the barrel to 10′ and the man will be brought into sharp focus.

Fig. 3-7. Depth of field. The lens is focused on the man in both photographs. The depth of field is not adequate to make the foreground and background appear sharp (left). The lens has been stopped down, and the entire picture now appears sharp (right). (Ted Spagna)

In an ideal (theoretical) lens, there is only one subject plane in focus—everything in front of or behind this plane is out of focus. In the case of the portrait, if the man's eyes were exactly 10′ from the camera, his nose and ears would be out of focus. Fortunately, with real lenses the area that looks in focus is more generous. A zone (called the *depth of field*) extends from in front of the subject to behind the subject, delineating the area of acceptable sharpness (see Fig. 3-7). In other words, the depth of field is the zone, measured in terms of near distance and far distance from the camera, where the image appears acceptably sharp.

Depth of field is not an absolute. There is no clear demarcation between parts of the image that are sharp and those that are blurry and out of focus. Instead, there is a gradual transition between the two. Even the idea of "acceptable sharpness" is relative. It depends on many factors, including the film or video format, the type of film, lens filters and lighting. Something that looks sharp on a small TV screen may look out of focus when the image is projected on a large theater screen. In general, the more you magnify an image, the *softer* (less sharp) it looks (see Fig. 7-6). The concept of depth of field is important, but complicated. A simple theoretical discussion follows, with complications discussed later.

CIRCLE OF CONFUSION. A *point* in the subject is considered in focus when it is registered as a *point* on film or video (see Fig. 3-8). This point in the subject is said to be in *critical focus*. All of the points in the subject that are in critical focus make up the *plane of critical focus*. Any point that is nearer or farther from the camera than the plane of critical focus registers as a circle on film instead of a point (see Fig. 3-8). This is called the *circle of confusion*. When a circle is sufficiently small or far enough away, the eye reads it as a point. Consequently, there is a region on either side of the plane of critical focus where points in the subject photograph are circles so small that they appear as points to the eye and thus appear to be in sharp focus. This region where objects in the scene appear acceptably sharp on the screen is the depth of field. For example, when the lens is focused at 15′, we might find the depth of field extends from 12′ (near distance) to 20′ (far distance). The total depth of field is the near distance subtracted from the far distance. Thus, the total depth of field in this case would be 8′ (20′ − 12′).

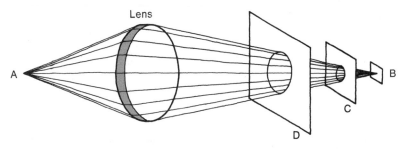

Fig. 3-8. Depth of field. The rays of light from a point in the subject (A) converge to a point behind the lens (B). The rays of light form a cone. If the film were positioned at plane C or D, it would intersect the cone to form a circle (the circles of confusion at C and D). The film positioned at C is closer to the plane where the rays converge, and thus produces a smaller circle of confusion. If the circle is sufficiently small, it appears as a point to the viewer and the image (A) seems in focus. The same principle applies for a video camera; substitute the CCD chip for the film in the description above. (Carol Keller)

We use depth of field to define what parts of the subject are acceptably sharp, but as we have noted, "acceptable sharpness" depends on many things. To provide a reference point for sharpness, a permissible maximum circle of confusion is chosen (sometimes called the *circle of least confusion*). Charts or formulas can be used to calculate the subject zone where points will be rendered as discs of light smaller than this circle. For example, in 16mm a permissible circle of confusion of ¹⁄₁₀₀₀″ or less is often chosen (see below for further discussion).

Controlling Depth of Field

There are two ways to control depth of field: change the size an object appears in the image (*image reproduction ratio*) or change the *f*-stop. The larger an object is reproduced, the less the depth of field. You can make an object appear larger by moving the camera closer and/or by using a longer focal length lens (if you're

using a zoom lens, zoom in). You might want to decrease depth of field for a portrait in order to throw the background out of focus. You might want to increase depth of field for a large group portrait, in which case move the camera farther away from the subject and/or use a wider-angle lens.

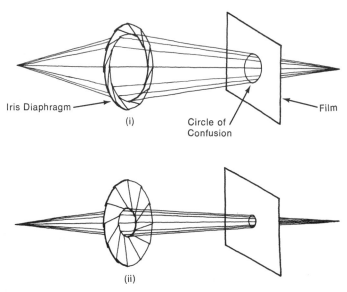

Fig. 3-9. Stopping down the lens increases depth of field. (i) Circle of confusion at wide aperture. (ii) As the iris diaphragm closes, the diameter of the cone of light gets smaller and consequently the circle of confusion is smaller. (Carol Keller)

Stopping down the *f*-stop (using a smaller aperture) increases depth of field (see Fig. 3-9). The iris can be stopped down if you add light to the subject, use a faster film (see Chapter 4) or increase video gain (see Chapter 6). You can open the iris when there is less light on the subject, when you use a slower film, when you use a neutral density filter (see Chapter 5) or when you increase shutter speed (see Chapters 2 and 6).

In summary, to minimize depth of field, open the iris, move closer or use a longer focal length lens. To increase depth of field, stop down, move farther away or use a wide-angle lens (also see Split Field Diopters, p. 102). Long focal length lenses at close focusing distances and with wide apertures (for example, at *f*/2) yield the least depth of field, whereas wide-angle lenses at far distances and stopped down (for example, at *f*/16) give maximum depth of field. A 25mm lens set at *f*/2 (with a $\frac{1}{1000}$" circle of confusion) when focused at 4' has a total depth of field of 7" (about a ½'). At *f*/11, total depth is 6'. If the same lens were set at *f*/2 but focused at 10', total depth of field would be over 5'. In other words, moving farther back, stopping down or doing both increases depth of field dramatically.

It is commonly thought that wide-angle lenses have more depth of field than longer focal length lenses. They do, but not as much as cinematographers tend to think. In a typical shooting situation, you find you don't have enough depth of

field to keep your subject in proper focus, so you consider going to a wider angle lens and getting closer to the subject, with the goal of keeping the subject the same size in the frame. For example, you change from a 50mm lens at 10' to a 25mm at 5'. Will the wider angle lens give you more depth of field? For close distances like this, the difference is negligible, and you will not improve the situation. However, for the zone *outside* the depth of field, for example when the background extends out to infinity, the wider angle lens will make the background less blurry than the longer focal length lens. For this reason, when cinematographers want to throw a background out of focus, they reach for their long focal length lenses.

Although depth of field increases as the iris is closed down, the sharpest images are not obtained with small iris openings. Most lenses are sharpest when stopped down two to three stops from their widest aperture. (see Lens Sharpness, p. 104).

Setting the Focus

For feature films and other controlled filming situations with large crews, setting the lens focus is often done by measuring the camera-to-subject distance with a tape and then adjusting the lens using the distance markings on the lens barrel. For documentary or other uncontrolled shooting, focus setting is generally done by eye, looking through the viewfinder to determine proper focus. Some film and video cameras have provisions for automatic focus control (see Setting the Focus, p. 175).

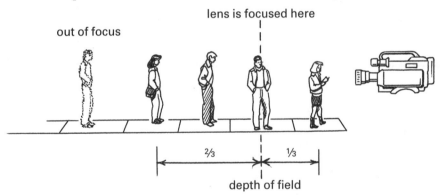

Fig. 3-10. Split focus. Depth of field extends about twice as far behind the plane at which the lens is focused as in front. (Robert Brun)

WHERE TO FOCUS. Focus is one of the creative aspects of image making. You can use focus to draw the viewer's attention where you want. However, if something important is out of focus, the viewer may feel annoyed or uncomfortable. Generally, when a subject is speaking, he or she should be in focus, unless another subject's reaction is more important. For close shots, a rule of thumb is to focus on the subject's eyes.

A properly constructed lens focuses on a plane perpendicular to the direction of the lens. For example, suppose you want to focus on a group of people for a portrait and want them as sharp as possible at 10' from the camera. Should they be lined up along the arc of a circle, so that they are all 10' from the lens? No, only

the person directly on line with the lens should be 10' away. All the others should be in the same plane, perpendicular to the axis of the lens.

If you are focused on a subject, you will have roughly *twice as much depth of field behind the subject as in front of it.* Thus, if two objects are at different distances from the camera, focusing at a point halfway between them will not render the two objects equally sharp. You should instead focus on a point one third the distance from the closer to the farther object (see Fig. 3-10). If one object is at 10' and the other at 40', the *split focus distance* is 20' (that is, 10' in front and 20' behind).[1] Only use this rule if there is sufficient depth of field to render both objects sharply.

For a shot in which camera and/or actors' movements are planned (*blocked out*), you should rehearse focus changes (*follow focus*). A camera assistant or focus puller often changes (*pulls*) focus during the shot. Follow-focus devices (sometimes remotely controlled) are available for studio rigs (see Fig. 3-11) to make focus pulling easier. Place tape or make chalk marks on the floor to cue the actors or the focus puller. Put tape on the lens distance scale and mark settings for a homemade follow-focus device.

TAPE FOCUS. On some productions, and for some shots, an assistant measures distances with a 50' tape. The distance is measured from the film plane (marked on many cameras by an engraved φ on the camera housing) to the chosen plane of critical focus. Measurements can also be made to the near and far points that must be in focus; then, if there is adequate depth of field, calculate the split focus distance and set the focus accordingly. For wide-angle lenses, tape focusing is often more accurate than eye focus. The lens must be properly collimated for the focusing scale to be accurate (see Depth of Focus, p. 107).

FOCUS IN THE VIEWFINDER. In many shooting situations, focusing by eye through the viewfinder is preferable to tape focus. With small crews or when the action is uncontrolled, it may be impossible to use a tape. Eye focus is often faster and is usually more accurate with long focal length lenses or in other situations where depth of field is shallow. Many video camcorder lenses lack the distance markings that are needed for tape focus.

Be sure the viewfinder's diopter is adjusted properly to your vision before focusing either a film camera (see Chapter 2) or a video camera (see Chapter 6). To focus the camera lens, rotate the focus ring or other focus control until the subject is brought into sharpest focus. If the camera is not running, "go through" focus once or twice: that is, rotate the focus ring past the point where the image is sharpest, stop and then rotate back to the point of sharpest focus. With film cameras, focus with the lens iris at the widest aperture to keep the viewfinder bright, to minimize depth of field and to see the image pop in and out of focus better. With video cameras, opening the iris beyond normal exposure will not help.

[1] A more accurate (although complicated) formula for split focus is:

Split focus distance = (2 × nearest distance × farthest distance) / (nearest distance + farthest distance). This formula gives 16' for the above example.

Fig. 3-11. Arriflex 16SR 3 equipped with follow focus knob, matte box, extended view-finder for tripod or dolly work, and video assist. (Arriflex Corporation)

When focusing a zoom lens, remember that depth of field will be minimized at the longest focal length (zoomed in). To focus the lens, zoom in all the way, set focus, then zoom out to whatever focal length you like. If you focus instead at a wider focal length (where depth of field is greater), the subject will usually go out of focus when you zoom in. If, while shooting, the image is sharp at wide angle but goes out of focus when zoomed in, it probably means you did not focus at long focal length as you should have. If the image becomes seriously out of focus when zooming out from long focal length to wide angle, it probably means the lens is not properly seated (see The Lens Mount, p. 105).

When pulling focus during a shot, you obviously shouldn't open the iris or do too much "going through" focus as described above. If an unrehearsed focus pull must be done while the camera is rolling, documentary filmmakers often zoom in quickly, refocus and zoom back to the selected focal length. This "focusing zoom" is generally edited out. Whenever you're shooting, always have a general idea of how much depth of field you're working with. For example, if you're using a wide-angle lens stopped down to a high f-number, you know you have *a lot* of depth of field, so focusing is less critical. Using the hyperfocal distance (see below) can help you estimate when refocusing is necessary.

When shooting with video cameras, focus and depth of field can be judged in the viewfinder or monitor (see Chapter 6). When using film cameras, some viewfinders provide a better sense of focus and depth of field than others (see Chapter 2). Ground-glass or fiber-optics reflex viewfinders give a rough idea of the depth of field; aerial image finders give almost none. In general, any small film or video viewfinder image tends to exaggerate depth of field. If something looks

out of focus in the viewfinder, it will be out of focus when recorded on film or video. But a sharp viewfinder image is not a guarantee that the picture will look sharp on screen.

Depth of Field Charts

Depth of field charts (see Appendix B) and calculators give an estimate of the depth of field. For a given focal length lens, you cross-reference the distance the lens is focused at, the lens aperture (*f*-stop) and the circle of confusion to find the near and far extent of depth of field.

Charts and calculators are designed for a "generic" reading of depth of field, but the particulars of your lens, the film or video format, or individual shots can result in actual depth of field that is as much as 15 to 20 percent different. With a sharp lens and a high-resolution film or video format, depth of field is reduced, since the eye has a sharp reference point that makes areas that are out of focus more obviously soft. By the same token, if you soften the overall image, say with a diffusion filter (see Chapter 5), the apparent depth of field increases, since *everything* is somewhat blurry. Depth of field calculations are properly made from the front nodal point of the lens, which varies with lens design. Typical charts and calculators don't take into account individual lens variations, possibly throwing off readings at close focusing distances (the lens manufacturer's charts, however, should compensate for this). Some lenses have rough depth of field guides engraved opposite the *f*-stop ring. Use only *f*-stops, and not T-stops, in depth of field calculations.

To use any depth of field chart, you need to choose what circle of confusion you want to work with; see Appendix B.

The Hyperfocal Distance

For any lens at a particular focal length and *f*-stop, the closest distance setting such that the far limit of depth of field extends to infinity is called the *hyperfocal distance* (see Appendix C). When the lens is set at the hyperfocal distance, depth of field extends from half that distance to infinity (infinity may be written ∞ on lenses and charts). For example, a 25mm lens at *f*/8 has a hyperfocal distance of 10′ (based on a $\frac{1}{1000}$″ circle of confusion). When the lens is focused 10′, the depth of field extends from 5′ to infinity. The hyperfocal distance is also the near limit of depth of field when the lens is focused at infinity.

The hyperfocal distance setting is quite handy when focusing is difficult. If you set the lens at the hyperfocal distance, you don't need to worry about focus unless the subject comes closer than one half the hyperfocal distance. Of course, the remarks about depth of field not being an absolute apply here as well, and to use the hyperfocal distance chart you must choose an appropriate circle of confusion for your work.

Some very wide angle lenses (and some inexpensive lenses) have no provisions for focusing. These lenses are usually prefocused at the hyperfocal distance of the widest aperture. Consult the manufacturer's data sheet to find the closest focusing distances at the various *f*-stops.

THE ZOOM LENS

The zoom lens offers various focal lengths in one lens. Focal length may be changed during a shot (zooming) or between shots. Zoom lenses are larger, heavier, more delicate and more prone to flare and distortion than fixed focal length (*prime*) lenses (see Fig. 3-13). Zoom designs have improved to the point that high-quality zoom lenses are as sharp as most primes.

CHOOSING A ZOOM LENS

The zoom is sometimes the only lens used on a production, thus placing great demands on its capabilities. When selecting a lens (or camera/lens combination) there are various criteria to take into account:

Zoom Range

Zoom lenses vary in their range of focal lengths. Zooms are designated by their zoom range (for example 10–100mm) or the widest focal length times a magnification factor (for example, 10 × 9.5 is the same as 9.5–95mm). Because the angle of view afforded by any particular focal length lens depends on the film or video format you're shooting, you need to know what gauge film or what size video CCD chip your camera has to evaluate focal length ranges (see Focal Length and Format, p. 83). Sometimes consumer video lenses only indicate a magnification factor (10X) and you can't easily tell exactly what the range is.

Having a good wide-angle lens can make a big difference in many shooting situations, particularly in documentary work or whenever you're shooting in close quarters or want to capture wide vistas or deep focus shots. To take the example of a 16mm film camera, having a lens that goes to 9.5mm or even 8mm opens up a whole range of possible shots (and ways that the camera can interact with the film subjects) that cannot be done if your lens only reaches to 10mm or 12mm. Shooting people in cars or around a dinner table usually requires a good wide-angle lens. A difference of a couple of millimeters at long focal lengths is trivial, but at short focal lengths is very noticeable (a 9.5mm lens is about 25 percent wider than a 12mm).

Long focal lengths allow you to capture small details in the landscape or create shots with highly compressed perspective. Shooting at long focal lengths requires that the camera be very steady on a tripod (see Telephoto Lenses, p. 99). Having both long and short focal lengths in one lens gives you tremendous flexibility and allows for extreme zoom shots that range from a tight close-up to a distant, wide view in one shot. Some video cameras have an "electronic zoom" feature that magnifies the image beyond the range of what the lens does optically. This is like enlarging the pixels using a digital video effect. It lowers the resolution and may be objectionable.

CHANGING THE ZOOM RANGE. Some zoom lenses can be fitted with a wide-angle attachment to convert to a zoom range of shorter focal lengths. A .8X wide-angle converter could be used with a 12–120mm lens to make it 9.6–96mm. As a

Fig. 3-12. *Vivre sa Vie* (*My Life to Live*), Godard's 1962 film. Anna Karina is backlit with window light. Note how the extensive flare obscures the border between her hair and the window. (Corinth)

Fig. 3-13. Optex-Canon J20 zoom lens. Super 16, 10.5–210mm. The generous zoom range makes this a versatile lens. (ZGC, Inc.)

Fig. 3-14. .6X wide-angle adaptor. Century Precision Optics Double Aspheric adaptor mounts on the front of lens. With this adaptor, you cannot zoom during shots, but Century Precision makes a larger adaptor that permits full zooming. (Fletcher Chicago/Century Precision Optics)

rule, these attachments do not affect aperture or focus settings and may not significantly impair the image (converters that require you to refocus when you zoom are lighter and more compact but are much less useful). A wide-angle attachment can be a crucial addition to a consumer camcorder with a limited zoom range.

Rear-mounted lens attachments, such as range extenders, change the relative aperture and reduce the lens's speed. For example, a 2X range extender converts a 12–120mm zoom range to a 24–240mm and changes an *f*/2.2 aperture to an *f*/4.4. Aberrations are also magnified and may make the image unacceptable. Stopping down does minimize most of the aberrations, but stopping down to *f*/8 is the equivalent of *f*/16 when using a 2X extender. Many video cameras have a built-in 1.5X or 2X range extender that can be set by switching a lever. Doing so provides longer focal lengths, but sacrifices some image quality and lens speed. Front-mounted range extenders do not change relative aperture, but sometimes they vignette at the shorter focal lengths. Range extenders are also used with prime lenses.

Lens Speed

The widest aperture *f*-stop and T-stop are an important part of zoom lens designations. Faster lenses allow you to shoot in lower light (though using very wide apertures limits depth of field and lens sharpness; see Depth of Field p. 86 and Lens Sharpness p. 104). The Angenieux *f*/1.1, 16–44mm T1.3 designation tells us this lens is *f*/1.1 at its widest aperture. Its equivalent T-stop is T1.3 (it loses about one third of a stop), thus, it is a very fast lens with a limited zoom range of 16–44mm (2.8 × 16 tells us its magnification factor is only 2.8).

Zoom lenses, for the most part, do not shift *f*-stop over the zoom range. There are exceptions. In order to achieve high speeds, some designs maintain their widest aperture only at wide angle. For example, the Angenieux 9.5–57mm is a very fast *f*/1.6 (T1.9) from 9.5mm to about 12mm. But at 45–57mm it is *f*/2.2 (T2.5). This means that if you were to shoot wide open at *f*/1.6 at 9.5mm and then zoom to

Fig. 3-15. Extreme wide angle shot taken with Century Precision Optics .55X Super Fisheye adaptor. Note barrel distortion causing trees to appear curved (Fletcher Chicago/Century Precision Optics)

57mm, there would be a noticeable loss of exposure at the long focal length. It is undesirable to zoom across a range that loses more than one third of a stop. When this lens is stopped down to $f/2.2$, the f-stop is constant across the zoom range and there are no problems. Some lenses have detents that prevent zooming at focal lengths that will change the f-stop. When shooting film, calculate exposure with T-stops, since some zooms lose almost a full stop in transmission.

Minimum Focus Distance

Being able to focus on a subject that is close to the camera can have a big impact on your shooting style, particularly in documentary work where the relative position of camera and subject is often not under your control. Some zooms focus down to 2', some even down to their front element. Others focus only to 7' or more and need close-up diopters or must be switched into macro mode for close focusing (see p. 100 for more on these items). To give you flexibility in shooting, ideally a zoom should focus to four or five feet (or less) with no additional attachments or adjustments.

Front Element

The diameter of the front element affects what size filters, lens shade or matte box you can use (see Chapter 5). Particularly when you're using more than one lens, it helps if both lenses accept the same size attachments (you may need adaptor rings).

On some zooms, the front part of the lens barrel rotates for focusing. On others, the outermost part of the lens remains stationary, which is important when mounting polarizing or graduated filters that should not be rotated once they are positioned. If you are using a matte box, this is not an issue (see Chapter 5).

ZOOM TECHNIQUES

Zooming

Zooming changes the image significantly and, unless it is handled well, can be quite disruptive. Graceful zooming starts up slowly, reaches the desired speed and gradually slows to a stop. Almost all video cameras are equipped with motorized zooms. Some have a choice of zoom speeds. External zoom drives weighing a few ounces are available for 16mm and 35mm. For a slow, smooth zoom, use a motorized zoom.

Manual (nonmotorized) zooming puts you in direct contact with the "feel" of the zoom, which some filmmakers prefer. Manual zooming allows you to respond quicker to fast-changing action. It can also be used for a deliberately "rougher" shooting style. Some lenses can accommodate a zoom lever that extends perpendicularly from the zoom ring; the longer the lever, the smoother the zoom can be. Long levers can produce smooth, relatively slow zooms on a tripod but are awkward when used with a handheld camera. Detachable drag mechanisms are available that adjust the resistance of the zoom. Jerkiness in the zoom shows up more in the projected image than it does in the viewfinder. Novices tend to zoom too often ("zoom-happy") which can be quite annoying. Zooms are most effective when they are motivated and deliberate, not random.

ZOOM VERSUS DOLLY. Some people object to the zoom effect because the viewer is brought closer to (or farther from) the filmed subject without changing perspective. In zooming, the entire image is magnified equally (see Fig. 3-3), similar to when you approach a still photograph. In a dolly shot, the camera moves in toward the subject and the perspective changes; objects also pass by the side of the frame, suggesting to the viewer that he or she is physically moving into the space. The moving camera creates a feeling of depth in the space. The zoom tends to flatten space and can call attention to the act of filming itself. Some filmmakers like this feature and will use the zoom to pick out a significant detail in the subject.

ZOOM TECHNIQUES. Zooming in the opposite direction of subject or camera movement results in a treadmill effect. If an actor runs toward the camera but the lens zooms back, the viewer feels as though the actor has made no progress. Similarly, if you shoot out of a car's front window and zoom wider, the viewer will feel as though the forward movement is disrupted. In *Vertigo*, Alfred Hitchcock combined zooming in one direction and moving in reverse to simulate the feeling of vertigo. The camera is lowered down a staircase and the lens simultaneously zoomed back to keep the size of the field constant. Although the viewer sees the same subject matter, the perspective is exaggerated (since the camera moves closer), evoking the sensation of dizziness due to height. Steven Spielberg used a similar effect in *Jaws*.

Zooming to change focal lengths in a shot is often hidden by combining the zoom with a camera movement—for example, a pan. "Burying" a zoom in a pan can make the zoom almost invisible.

Before you use a zoom lens, zoom back and forth several times to distribute the lubrication in the mechanism. Some lenses have "zoom creep"—the lens zooms by itself. In this case, bring the lens to a technician for repair, but a temporary solution is to fit a wide rubber band, not too loose or too tight, around the zoom ring and barrel to create a little friction.

Sometimes, a subject in the center of the frame at wide angle may not be at the center when zoomed in, which may be due to a flaw in the lens design called *sidedrift*. You can compensate for this while zooming by using the crosshair in the viewfinder (see Fig. 2-10) as a centering aid. A similar effect also can occur due to the geometry of the zoom effect. In this case, a point looks centered at wide angle but is actually slightly off-center. Zooming in magnifies the difference, and the object becomes very off-center by the end of the zoom. To solve this problem, rehearse the zoom and center the object at long focal length. Side-drift is not often noticeable in handheld work, since the camera operator unconsciously adjusts for it. Some zoom lenses change their focal length slightly when focus is changed. If so, check framing when you change focus.

Check zoom lenses for vignetting with the lens wide open, at the shortest focal length and the distance scale at infinity (see Chapter 5). The lens shade or matte box should also be checked with the lens set at the closest focusing distance. Zoom lenses often have less depth of field than primes of equivalent focal length. This is only important at close focusing distances; use the manufacturer's depth of field charts in such instances.

PRIME LENSES FOR SPECIAL USES

Fast Lenses

For low-light filming, prime lenses are available that are faster than most zooms. Though lenses are generally less sharp when used with the iris wide open, some primes are optimized for shooting this way. For example, for 16mm cameras there are the Zeiss-Distagon Super-Speed lenses, which are T1.3 (less than one fourth of a stop faster than f/1.4) and come in focal lengths of 9.5, 12, 16 and 25mm. They use aspherical elements, which are expensive but make these lenses sharp even when shooting wide open.

Depth of field can be very shallow when the lens is wide open at common camera-to-subject distances. Focusing can become extremely difficult. The new generation of high-speed, wide-angle lenses makes night shooting far easier because of the great depth of field of wide-angle lenses at common filming distances.

Telephoto Lenses

Telephoto lenses (also called *tele-lenses*) are, loosely speaking, about 50 percent longer than normal lenses for the format; for example, a lens greater than 35mm for a 16mm camera or greater than 70mm for a 35mm camera would be considered telephoto. True telephotos are of a sophisticated design that allows them to be physically shorter than their focal length would imply.

Telephoto lenses render the subject large even at great distances, providing extreme compression of perspective. The camera crew can be unobtrusive and can work a safe distance from dangerous events. Since they have little depth of field, telephotos are useful for throwing a distracting background out of focus. When you want a dramatic focus pull, use a long focal length lens.

You can simulate a moving camera shot by using a telephoto to track a subject moving laterally to the lens (that is, pan with the subject from far away). The tracking pan keeps the subject's size constant in the frame and makes it appear that the camera is dollying. Akira Kurosawa often used these tracking pans in his samurai movies to simulate the free movement through space usually achieved with a dolly shot—the longer the focal length, the more sustained the effect.

Telephotos longer than 150mm tend to be fairly slow, although Canon has an f/2.8, 300mm and 400mm lens. *Catadioptric* lenses use reflecting mirrors and achieve long focal lengths in a very compact design. They are usually in the f/8 range and employ neutral density filters in the place of an iris diaphragm for exposure control.

Telephotos are extremely vulnerable to camera vibration. A camera may function perfectly well with shorter focal lengths but reveal vibrations with a 300mm lens. You should use a lens support or cradle with long telephotos to minimize vibration and to avoid straining the lens mount; use a very steady tripod and do not handhold the camera (but see Image Stabilization Devices, p. 239). Heat waves often show up in landscape telephoto shots, which can be avoided by shooting in the morning before the ground has heated up. Distant scenes may be overexposed

due to atmospheric haze. In such instances, use a haze filter and stop the lens down one half to one full stop. Tele-extenders may be used to increase focal length, but keep in mind the limitations discussed in Changing the Zoom Range, p. 93. Inexpensive telephotos are like tele-extenders, often using optics that are not much more sophisticated than a magnifying glass. Spherical and chromatic aberrations are serious on these lenses, but stopping down minimizes their effects.

CLOSE FOCUSING

Zoom lenses often focus no closer than three feet from the subject. Prime lenses often focus closer. The closer the subject is to the lens, the farther the lens must be from the film plane to focus. Specialized *macro* lenses allow you to bring very close objects into focus. Often macro lenses can yield an image reproduction ratio of 1:1, that is, the image size is the same as the subject size—a thumbtack would fill the standard video frame. Many video lenses have a built-in macro mechanism, which allows for close focusing but may cause the focus to shift while zooming.

Many lenses can be extended farther from the film plane by the use of *extension bellows* or *extension tubes*. Bellows permit a wider range of focusing distances and greater magnification and are faster to adjust than tubes. Extension tubes and bellows work best with normal or slightly long focal length lenses. If they are used with a zoom lens, the zoom will not remain in focus across its range, and the results are often not sharp.

When the lens is far from the focal plane, less light strikes the film and an exposure compensation must be made (the engraved *f*-stops assume the lens is about its focal length distance from the film plane). Generally, no exposure compensation need be made until the subject is closer than ten times the focal length of the lens—for example, closer than 250mm (10″) with a 25mm (1″) lens. Video cameras will make the exposure compensation automatically, as will film cameras with behind-the-lens meters (like most super 8 cameras).

Close-Up Diopters

Close-up diopters or *plus diopters* are supplementary lenses mounted in front of the lens like a filter. Also called *Proxars* (actually a brand name) these permit closer focusing with all lenses, including zooms, and require no exposure compensation. Plus diopters come in varying strengths ($+\frac{1}{2}$, $+1$, $+2$, etc). The higher the number of a plus diopter, the closer you can focus. As power increases, however, the quality of the image deteriorates. It is better to use a longer focal length lens with a less powerful diopter than a shorter focal length with a more powerful diopter. For best results, close down the lens a few stops. With a close-up diopter mounted, the focus scale on the lens is no longer accurate, so focus by eye through the viewfinder. Also, you can no longer focus at infinity.

The convex side of the diopter should face the subject. If an arrow is marked on the diopter mount, face it toward the subject. Diopters may be combined to increase power. Place the higher-power diopter closer to the lens, and make sure the

Fig. 3-16. Extreme depth of field is possible in carefully set-up shots with a split-field diopter mounted on the lens. The nondescript field between the two billiard balls obscures the border between the two halves of the diopter. (Tiffen)

glass surfaces of the diopters don't touch A +2 diopter combined with a +3 diopter has the same power as a +5 diopter.

Split-Field Diopters

Split-field diopters are usually half clear glass and half close-up diopter. These diopters allow half the frame to be focused on far distances and half to be focused at close distances. Frame the distant objects through the clear glass, the close ones through the plus diopter. The area between the two parts of the diopter will be out of focus and, for the shot to be successful, should be an indeterminate field (see Fig. 3-16). Carefully compose the shot on a tripod and use a reflex finder. If the diopter is used in a matte box, it may be positioned so that an area greater or less than half the frame is covered by the plus diopter.

Fig. 3-17. Tilt-focus lens. Tilting the lens allows you to position the plane of focus at an angle to the camera instead of perpendicular to it. Can be used to bring an angled subject into even focus or to create out-of-focus effects. Similar to using a split field diopter but without a hard dividing line. (Century Precision Optics)

LENS QUALITY AND CONDITION

At the start of a feature film, lens tests are generally done to ensure that the lenses being used are sharp, working properly and well matched to each other. On smaller productions there may not be time or resources to do tests or to choose

among several lenses. On all productions, it is very important to be vigilant about scrutinizing the image for defects that may come from lens problems. When shooting film, this means projecting the rushes on a good screen and watching carefully. When shooting video, it means viewing tapes on a high-quality monitor. Unfortunately, on many productions, footage is viewed on bad video monitors, low-resolution tape formats or editing systems that may mask lens problems.

Even expensive lenses vary in quality, which becomes apparent in use and can be checked by a lens technician. When you purchase a lens, if possible, take a few of the same model lens to a technician, since significant differences may exist from sample to sample. Small bubbles, which are often visible in a lens element, usually do not affect quality. Small surface scratches on used lenses do not affect performance, unless they are fairly numerous, in which case they lower image contrast. A chip in a lens element severely impairs the image by scattering light. All the controls on a lens should move smoothly, and nothing should rattle when you shake the lens. There should be no play in the iris diaphragm. A lens that has been hit hard should be tested by a technician.

LENS ABERRATIONS. Centuries before the invention of lenses, painters used a *camera obscura* (literally, "dark room"), which is a dark room with a small hole in one wall that looks out onto an exterior landscape. The landscape is projected on the opposite wall. Reduced in size, this concept is the pinhole (lensless) camera. Using a lens in a camera increases brightness and sharpness, but introduces aberrations in the image. *Lens aberrations* are distortions in the formation of the two-dimensional image by the lens. Common aberrations include: *curvature of field* (if the lens is perpendicular to a wall, either the edges *or* the center of the frame will be sharp but not *both*); *chromatic aberration* (light rays of different colors bend at different angles, decreasing image sharpness and creating a rainbowlike fringe on some objects); and *astigmatism* (vertical lines focus in a different plane than horizontal lines). *Geometric distortions* are most apparent when a grid is photographed. *Barrel distortion* causes the grid lines to bow away from the center; *pincushion distortion* will make them appear bowed in.

Nearly all aberrations, except distortion, are most apparent when the lens iris is wide open or nearly so and they limit lens sharpness (see below). As the iris is stopped down, the effect of the aberrations becomes less pronounced.

VIGNETTING. *Vignetting* is an optical phenomenon in which less light reaches the edge of the image than the center. Conventionally designed wide-angle lenses often show vignetting. *Retrofocus* wide-angle lenses increase the back focus distance to avoid considerable darkening of the edge of the image.

Vignetting, in the loose sense, refers to any loss of light toward the edges of the frame. This often occurs when lenses from a smaller format are used in a larger format (for example, 16mm lenses often do not completely *cover* the film area for super 16 or 35mm cameras). Vignetting is most apparent when the lens is wide open and the distance scale is set at infinity (and, in the case of zoom lenses, at the widest angle). If a lens shade or matte box cuts off picture area, it too is said "to vignette."

LENS SHARPNESS. Defining lens sharpness has the same problems as defining film sharpness, which is discussed fully in Chapter 4. Resolution, contrast, acutance and modulation transfer function (MTF) are all used in lens evaluation. Resolution charts do have a special use in lens testing; although they have all the limitations discussed in Chapter 4, they are useful for judging if a particular lens has been badly constructed or damaged. For example, improperly centered lenses show more resolution on one side of the image than they do on the other.

Diffraction, an optical phenomenon, occurs when light passing through a small hole scatters and renders the image unsharp. Iris openings of *f*/16 or smaller may cause noticeable loss of sharpness. Diffraction is a function of the absolute size of the aperture (the *f*-stop is a relative aperture—the ratio between aperture and focal length); thus wide-angle lenses especially become less sharp when stopped down. While long focal length lenses often stop down to *f*/32 without problems, some wide-angle lenses only close down to *f*/11 to prevent loss of sharpness at the smallest openings.

A lens is said to be *diffraction limited* when its sharpness is limited (at particular *f*-stops) only by diffraction, thus showing no aberrations at those *f*-stops. Most lenses are sharpest when stopped down two to three stops from the widest aperture. For example, an *f*/2 lens would be sharpest around *f*/4 to *f*/5.6.

Since lens sharpness is limited at the wide apertures by aberrations and at the very smallest apertures by diffraction, you should try to shoot at middle apertures when possible. To avoid shooting at the smallest apertures, use a neutral density filter (or a slower film stock) so you can open the iris a few stops. Some people think there is a contradiction in the idea that sharpness decreases at small *f*-stops while depth of field increases. *Sharpness,* however, refers to how clear the image can be, whereas *depth of field* tells us the relative sharpness of objects at different distances from the camera.

To get the most out of a sharp lens, you need to use a sharp film stock or high-resolution video format. However, particularly in video, a sharp lens can often vastly improve the look of a format that is lower resolution than the lens (cheap lenses make any format look bad). As you can imagine, much of lens evaluation is subjective. The cinematographer may just like the look of a particular lens or favor a lens and format combination. In super 8 and 16mm, the tendency is to maximize image sharpness, but in 35mm, which can achieve great sharpness, many cinematographers prefer a softer, more diffuse image.

FLARE. Lenses are made of multiple pieces of glass—elements—and the more elements, the more reflections take place within the lens, which add an overall exposure to the image, thus lowering contrast. Zoom lenses are particularly vulnerable. This *flare* is particularly noticeable when a light source is photographed; for example, when someone is standing in front of a bright window. Flare diffuses the image, lightens the blacks, increases the appearance of grain, decreases sharpness and often softens the edges of backlit figures.

Nearly all modern lenses have anti-reflective coatings on their elements to minimize flare. One rule of thumb for checking coatings is that the more colors you can see reflected in the front elements of the lens, the more efficient the coating will be.

The front element of the lens often picks up stray light from bright objects or other light sources even when the light source is not in the frame. This may cause flare and internal reflections of the iris diaphragm to appear on the film as bright spots in the shape of the iris opening. If the front element of the lens is viewed from in front of the camera and you can see reflections from light sources, there will be some flare in the image. The solution is to use a deeper lens shade or matte box (see p. 165) or to flag the light source (see Chapter 11). Since flare adds exposure to the film, it sometimes affects the exposure calculation (see Chapter 4).

Flare is generally considered a phenomenon that deteriorates the quality of the image, a form of system noise. On the other hand, you may like the effects of flare. It was considered an artistic breakthrough when Jean-Luc Godard's cameraman, Raoul Coutard, in the early 1960s, pointed the camera lens into large café windows in interior shots and "degraded the image with flare" (see Fig. 3-12).

THE LENS MOUNT

Many consumer video camcorders and super 8 cameras have permanently mounted zoom lenses. Although this prohibits the use of other lenses, it allows for an accurate and sturdy mount. Most other cameras accept interchangeable lenses. The *lens mount* is the system that allows the lens to be attached to the camera. The camera is equipped with a certain mount and accepts lenses of the same mount. With some mounts, adaptors can be used to join otherwise incompatible lenses and cameras. Some cameras have interchangeable mounts, allowing the use of different lenses without adaptors. Whenever changing lenses or using lens adaptors, be sure the lens is properly seated and collimated before shooting (see p. 107).

Film Cameras

The C mount was at one time the most common 16mm lens mount. It is a simple screw mount that is not particularly strong, nor designed for very close tolerances, and it is not desirable for zoom lenses, heavy lenses or very wide angle lenses. Adaptors allow lenses with a variety of mounts to be fitted onto a camera that accepts C mounts, but you cannot adapt a C mount lens to a camera that takes, for example, an Arriflex or Aaton mount.

The Bolex Rx mount is a variant of the C mount that is specially designed to accommodate the change in back focus on the Bolex camera equipped with a behind-the-lens viewfinder prism. Prime lenses of less than 50mm and zoom lenses in Rx mount should only be used on these Bolexes and not on other cameras.

Arriflex lens mounts have evolved over time. The Standard mount was replaced by the Bayonet ("Arri bayo") mount. Newer cameras are equipped with the PL (positive lock) mount. The earlier mounts can be used on PL-equipped cameras (with adaptors), but PL lenses will not fit on cameras equipped with the other mounts.

Many other manufacturers have their own mounts, including Aaton, Mitchell, Cinema Products (CP) and Eclair. Panavision lenses can be used on Panavision cameras and on Arriflex and other cameras modified for the Panavision mount.

Lenses may be manufactured with *neutral mounts*, allowing you to install the proper mount for your camera. Adaptors are available to accept a variety of 35mm still photography lenses with motion picture cameras.

THE LENS TURRET. Before the advent of high-quality zoom lenses, 16mm cameras often had turrets that would accept two or three lenses. Take care that a wide-angle lens does not include in its field of view a long focal length lens mounted on the same turret. A divergent turret, like the one on the Arriflex S (see Fig. 3-18), permits you to mount a slightly greater range of lenses. When you rotate the turret, grasp the turret grips and never the lens. Although turrets are never as stable as single-lens mounts, the Arriflex S and Eclair NPR have very stable turrets.

Fig. 3-18. Arriflex 16S with three prime lenses on a divergent turret. The camera has reflex viewing with a mirror shutter, a registration pin and high-quality optics, but it is very noisy. This camera accepts 100′ internal loads (pictured) or an external magazine. (Arriflex Corporation)

Video Cameras

Many video lenses are designed for a particular CCD and beam-splitter prism assembly in the camera. For example, with a lens designated J14×8.5B4, the "J" indicates that it is made for a ⅔″ CCD and the "B4" indicates the type of prism it is compensated for. Because of this, video lenses should only be used with the appropriate camera.

Some video cameras, such as certain Canon models, accept 35mm still photography lenses, opening up a wide range of lens options.

Lens Seating and Collimation

Depth of Focus

Depth of focus is the tolerance in the accuracy of the mounting or seating of the lens on the camera. Never confuse depth of focus with depth of field. Depth of focus is an area *behind* the lens (inside the camera). It refers to the very small distance on either side of the focal plane where the film or CCD can be situated and still record an acceptably sharp image. The greater the depth of focus, the more leeway you have for a lens that is mounted slightly too close or too far from the film or CCD. A lens that is mounted improperly is said to be "out of collimation."

Depth of focus increases as the iris is stopped down. However, unlike depth of field, it is *least* in wide-angle lenses. This means that a fast, wide-angle lens needs to be very accurately mounted. On some lenses, even tiny pieces of dirt on the mount can throw off focus.

If a prime lens is not properly seated, its focus scale will not be accurate and a tape-measured focus setting will be inaccurate. Although focusing through the viewfinder will correct this error, an improperly seated lens might not be able to focus to infinity.

If a zoom lens is not properly seated, it will go out of focus as it is zoomed out to wide angle. The lens may focus well at long focal lengths where depth of focus is considerable (although there is little depth of field), but, as the lens is zoomed to wide angle, tolerances become more critical and the picture may go out of focus. If the image goes out of focus when zooming in from wide to telephoto, it means you probably didn't focus properly. If it goes out of focus when zooming out from telephoto to wide angle, it probably means the lens is out of collimation.

In an emergency, an improperly seated zoom can still be used as a variable focal length lens (that is, for changing focal lengths *between* shots), especially at the longer focal lengths.

Flange Focal Distance and Back Focus

The distance from the focal plane to the lens mount flange is called the *flange focal distance* or *depth*. This is essentially a measure of whether the camera's part of the lens mount (the lens seat that receives the lens) is set to the standard distance. On a film camera, depth can be measured with a depth gauge inserted into the lens port to measure the distance between the lens seat and the film plane. The tolerance in the depth is measured in ten thousandths of an inch and is usually adjusted by a technician. On some cameras, the depth can be adjusted in the field.[2]

Different camera systems have a different specified depth, but if the depth is set correctly, you should be able to use many different lenses (assuming they are set up to specs) without problems.

The distance between the rear element of a lens and the film plane (or CCD) is the *back focus*. Every lens has a specified back focus. We can think of the lens mount

[2] With some 35mm cameras, the depth is checked during the shoot on a regular basis and adjusted if necessary. In 16mm, this adjustment is not commonly made in the field.

as having two parts: the female part (lens seat) that is attached to the camera and the male part that is attached to the lens. For the back focus to be correct, the female part of the mount must be set correctly (the depth) and the male part must be attached to the lens correctly relative to the rest of the lens barrel and the glass lens elements.

Back focus is measured with an optical device called a *collimator*. For a film camera, a test image is projected through the front of the lens and bounced off the film and viewed through the collimator. When the lens focus ring is set at infinity, the test target should be in sharp focus, indicating the lens is properly collimated. With film cameras, collimation is generally tested and adjusted by a lens technician. However, there is a simple check you can do yourself, which should be done at the beginning of a shoot, or when using a new lens or camera, or in the field if you suspect the lens may be damaged or out of whack (see below).

With some video cameras, back focus can be adjusted in the field by the camera operator (see below).

Fig. 3-19. Focus chart. Get a full-size chart or use this one in a pinch. (Century Precision Optics)

Checking Collimation—Film Cameras

There is a simple test to check the accuracy of a reflex focusing system and the seating of a zoom lens. Put a starburst lens focus chart on the wall (see Fig. 3-19). Point the tripod-mounted camera at the chart. Zoom in all the way, filling the frame with the test pattern. Focus the lens carefully. Use only enough light so the iris can be set wide open. Beginning at the longest focal length, hold for a few seconds, and then zoom to wide angle, stopping for a few seconds at different focal lengths. Project the developed film on a good-sized screen to check that the chart stays in focus throughout the zoom. If not, the camera's focusing system must be checked; the lens may need to be reseated or repaired or this may be due to a behind-the-lens filter (see p. 166). If you don't have a focus chart, you can tape a piece of newspaper to the wall, draw a black line down the middle of it, and shoot it from a 45° angle. Focus on the line and zoom out as described above. On projection, the line and the region on either side should be in focus.

Checking Collimation—Video Cameras

The collimation on some video lenses must be set by a technician. However, some lenses have a back focus adjustment that the camera operator can check or reset when necessary. Put the camera on a tripod and view the image with the sharpest, biggest monitor you can find. Put up a starburst focusing chart or a newspaper as described above. Use only enough light (or use filters) so you can set the iris wide open. Zoom in on the chart and focus the lens, then zoom out to the widest angle. Loosen and adjust the back focus lever until the image is as sharp as possible. Touching *only* the zoom control, zoom in. If the image is not sharp, refocus the lens using the front focus ring, *not* the back focus adjustment. Zoom out and reset the back focus again if necessary. Repeat this process until one lens focus setting produces a sharp image at both telephoto and wide angle, then tighten down the back focus adjustment. This should be close to the dot or other marking for standard position on the back focus adjustment.

CARE OF THE LENS

Remove lenses from the camera when shipping, and pack them in fitted, foam-lined cases. In temperatures above 100°F, the mounting cement loosens and vibrations are particularly dangerous. Shocks, prolonged vibration and extreme heat can loosen a lens element. Keep the lens mount clean. Both camera and lens mating parts must be free of dirt and dust to ensure proper seating of the lens, especially zoom and wide-angle lenses. If necessary, clean the mount with a soft cloth.

When a lens is not in use, cover the front element with a lens cap to protect it from dust and fingerprints. Use a rear element cap when the lens is not on the camera. Some people like to keep a clear, daylight filter in place at all times to protect the front element (see Chapter 5).

Dust on the Lens

Dust on the lens lowers contrast. It may be blown off with a rubber syringe (available at any pharmacy) or with small containers of compressed air (like Dust-Off or Omit). Avoid compressed air that may have oil droplets in the spray. Tip the lens down when blowing dust off. Some cinematographers use their breath to remove dust, but take care not to blow saliva on the element, since it is harder to remove than dust.

If air doesn't remove all the dust, use a clean camel-hair brush, reserved for the *sole* purpose of lens cleaning. Avoid touching the bristles, since oil from the hand will stay on the hairs. An alternate method is to fold photographic lens tissue over itself several times, tear off an edge and lightly brush the element with the torn edge. Do not rub a dry element with the lens tissue, for you may damage the lens coating.

Fingerprints on the Lens

Oil and fingerprints are more difficult to remove and, if left on the lens, can etch themselves into the coating; remove them as soon as possible. First, remove dust from the lens as described above. Use photographic tissue—not eyeglass or silicone-coated tissue, which may damage the coating. Never rub tissue on a dry lens. Breathe on the lens to cause condensation. Rub the tissue as gently as possible, using a circular motion combined with a rolling motion to lift any dirt off the element. To avoid grinding grit into the coating, continually use a clean portion of the tissue. Whenever the condensation evaporates, breathe on the lens again.

For particularly stubborn fingerprints, apply a drop of lens cleaning solution to the tissue (*not* directly to the lens). Take care the solution does not come into contact with the area where the element meets the barrel, since it may loosen the element. After moistening the element, use a dry tissue as described above (only rubbing a moistened lens).

The Film Image | CHAPTER 4

Unexposed film is called *raw stock*. After you choose the film gauge—super 8, 16mm or 35mm—the raw stock determines much of the look of the film. Consult with filmmakers or the laboratory for advice on obtaining the look you want.

PROPERTIES OF THE FILM STOCK

Developing the Image

The top layer of the raw stock, the *emulsion*, consists of the light-sensitive material *silver halide crystals* suspended in gelatin. The crystals vary in size, the larger ones being more sensitive to light. Exposure to light forms a *latent image* in the emulsion. The latent image becomes visible when the film goes through the *developer*, a solution that reacts chemically with those silver halide crystals that have been exposed and reduces them to *metallic silver*, which is opaque to light. At a later stage in the development process, crystals that have not been exposed to light are removed from the emulsion by another solution, the *hypo* or *fixer*.

The areas of the emulsion most exposed to light end up with the greatest con-

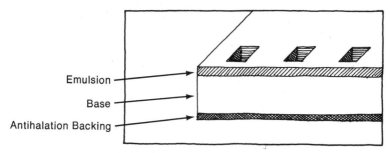

Fig. 4-1. A cross section of film. The antihalation backing, which on some stocks is between the emulsion and base, is removed during processing. (Carol Keller)

centration of metallic silver. These are the densest, most opaque areas; they appear dark when you project light through them. Conversely, areas that receive little light end up with less metallic silver and are relatively transparent. This is a *negative film* (see Fig. 4-2). On the negative, all the brightness values in the original scene are reversed: what was dark in the scene becomes light (transparent), and what was light becomes dark (dense).

The emulsion rests on a binder that allows it to adhere to a firm, flexible support material, the *base*. All currently manufactured stocks have a *safety base*, usually of cellulose triacetate (*acetate*), that is not flammable. Some stocks are also available on a synthetic polyester base, such as Kodak's ESTAR, which is thinner and stronger than acetate. Standard cement splices do not work on polyester; splicing is done with either tape or a special fusion splicer. Polyester base film is sometimes used for high-speed cinematography. Release prints and intermediates (see Chapter 16) made on polyester can withstand rougher handling and take up less storage space.

Bright light can pass through the emulsion, scatter in the base, reflect off the back of the film and reexpose the emulsion; this is known as *halation*. Most camera stocks incorporate an *antihalation backing* in the emulsion to absorb these unwanted light rays. Even so, a bright light source in the subject will often show a halo in the image due to halation.

The Negative-Positive Process

In the process discussed above, the exposed raw stock became a negative image of the photographed scene after development. If you make a print of the negative, using essentially the same process to reverse the tonalities again, you end up with a *positive* of the original scene. In the positive, bright areas of the scene end up light (transparent) and dark areas end up dense. Thus you reverse the tonalities of the

Fig. 4-2. The negative. Fig. 11-24 shows the positive image. (Stephen McCarthy)

original scene twice to produce an image that looks normal. The negative-positive process is, at this time, the standard for film development in 16mm and 35mm filmmaking.

The Reversal Process

Reversal film uses a different development process from negative and yields a positive image that can be directly projected without the need of a print (like a slide in still photography). A reversal print can be made of the reversal original to yield a print in one step.

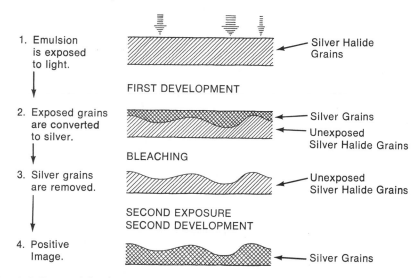

Fig. 4-3. Reversal development. A cross section of the emulsion shows the various steps in processing. The arrows at top represent varying degrees of exposure. (Carol Keller)

The key to the reversal process lies in the development of the image. The film is exposed to light in the camera to form a latent image. As in the negative process, the developer reduces the silver halide of the latent image into metallic silver. Whereas in the negative process the remaining (unexposed) silver halide crystals are washed away in the hypo, in reversal development the *metallic* silver is removed by immersing the film in a bleach, leaving the unexposed silver halide crystals, which are still light-sensitive, in the emulsion. The film is then uniformly exposed to light (or immersed in a chemical fogging agent), exposing the remaining silver halide. It is then redeveloped in a second developer, and fixed again in the hypo. Thus, light areas in the subject build up heavier densities that get bleached away, leaving relatively little silver halide behind. These are then exposed to light and developed, leaving a transparent region on the film. Light areas of the subject end up transparent on the film, and, similarly, dark subject areas build up greater densities on the film and are more opaque (see Fig. 4-3). Thus, the reversal process maintains the relative brightness values of the original scene.

Reversal film was once the standard process in super 8 and 16mm. Though reversal is still used, negative film is now used much more often.

The Characteristic Curve

A basic knowledge of characteristic curves will help in understanding the practical aspects of exposure, which are discussed in detail later. The *characteristic curve* for an emulsion is a graph that shows the relation between the amount of light that exposes the film and the corresponding density built up in the film. To plot the curve, the film is exposed to progressively greater quantities of light in constant increments. The film is then developed, and the densities are measured. For negative stocks, the greater the exposure, the greater the density, whereas for reversal, the greater the exposure, the *less* the density. Exposure is plotted along the horizontal axis and density along the vertical axis (see Fig. 4-4).

Even when the film receives no exposure, some density is built up. The base itself has some density (it absorbs some of the projected light), and the development

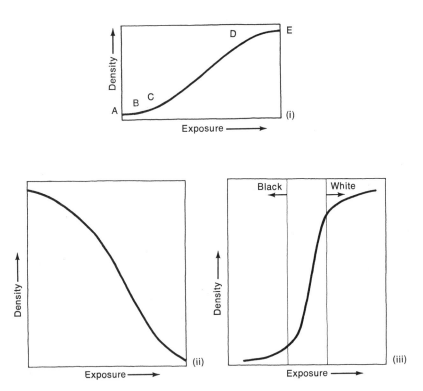

Fig. 4-4. Characteristic curves. (i) A simplified black-and-white negative characteristic curve: Point A is the base-plus-fog density; B to C is the toe; C to D is the straight line portion; D to E is the shoulder. (ii) A reversal characteristic curve. The greater steepness of the curve shows the higher contrast of reversal stock. (iii) A very high contrast black-and-white negative stock used for titles. (Carol Keller)

process adds an overall light *fog* to the film (some unexposed silver halide gets converted to metallic silver). This is the minimum density of the film. For black-and-white film, it is called *base-plus-fog* and for color film *D-min* (for minimum density).

In the negative process, increases in exposure do not increase the density above base-plus-fog until the *threshold* of the emulsion, the point where the curve starts to rise, is reached (point B in Fig. 4-4). Even though a dark area in the subject emits some light, if it falls below the threshold of the film, it will not produce any change in the density. That area produces minimum density, will show no detail and will appear in a positive print as undifferentiated black.[1]

The *straight line section* of the curve (C to D in Fig. 4-4) is the portion where a given change in exposure produces a constant change in the density. The *toe* of the curve (B to C) is the area of lowest densities—usually the darkest shadows that show some detail—where constant increases in the exposure do not lead to proportional increases in density. The densities here increase more gradually than they do in the straight line section; the slope in the toe is thus less steep (slower rising) than in the straight line section. The *shoulder* (D to E), like the toe, is a flatter curve than the straight line section. Again, constant increases in exposure do not lead to constant increases in density. At point E, increases in exposure do not cause any increase in density. This is the maximum density (*D-max*) possible in this film.[2]

If an area of the subject gets exposed high on the shoulder, differences in brightness will not be recorded as significant differences in density. For example, a white wall may be three times as bright as a face, but if both expose high on the shoulder, the difference in their densities will be insignificant. In a positive print (or the reverse original), this area will appear as an undifferentiated white (*blocking of the highlights*).

Shadows will show no detail if they fall near the film's threshold, and highlights will show no detail if they fall too high on the shoulder. Generally, for correct exposure, the important parts of the subject that should show good tonal separation must fall on the straight line section. Shadow and highlight values may fall on the toe and shoulder, respectively, but, if you want some detail, they should not be too close to the outer limits. When you are filming, there are many ways to control exposure in order to control where on the characteristic curve parts of the subject will fall (see Exposure and Film Stocks, p. 148).

Characteristic Curves for Color Film

Modern color film stocks are composed of three emulsion layers; each layer is similar to a black-and-white film emulsion. The top layer is only sensitive to blue light (and records the blue *record*, or blue part, of the scene). The second layer records the green record; the bottom, the red record. All the colors rendered by the film are created from a combination of the record of these three *primaries* (see Chapter 5 for further discussion on primaries).

[1] In video, the equivalent concept is that dark areas that fall below the black clip will not be visible (*crushing the blacks*).

[2] The video equivalent is the white clip level.

Incorporated into each of the three emulsion layers of a color stock is a distinct group of *dye couplers* that release dyes of the appropriate color during development (see Fig. 4-5). The more exposure a particular emulsion layer receives, the greater the density of the metallic silver in that layer and the more color dye that remains after development. Most of the metallic silver, along with the unused dye, is bleached away during developing. The three color layers will be recorded with the dye color of each layer's complementary color (see Chapter 5). The blue, green and red record will be recorded with dyes colored yellow, magenta and cyan, respectively.

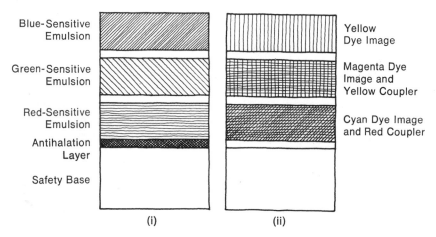

Blue-Sensitive Emulsion — Yellow Dye Image

Green-Sensitive Emulsion — Magenta Dye Image and Yellow Coupler

Red-Sensitive Emulsion — Cyan Dye Image and Red Coupler

Antihalation Layer

Safety Base

(i) (ii)

Fig. 4-5. Color negative before (i) and after processing (ii). Yellow and red couplers are found in the green- and red-sensitive emulsions to compensate for deficiencies in color absorption of the magenta and cyan dyes. (Carol Keller)

Blue
Green
Red

Density
Exposure

Fig. 4-6. Characteristic curve for color negative. The three curves represent the three layers of a color emulsion. (Carol Keller)

Because of imperfections in the absorption of color dyes, additional colored dye couplers are incorporated into the emulsion of color negative films. They form a *color masking* to compensate for unwanted dye absorption. The masking gives color negative its characteristic overall orange appearance. Reversal films

have dyes that absorb their complementaries more accurately and thus have no need for color masking.

A color emulsion is represented by three curves, one for each emulsion layer (see Fig. 4-6). The curve closest to the horizontal axis (the red curve in Fig. 4-6) represents the color most susceptible to underexposure, and the highest curve (the blue), the color the most susceptible to overexposure. Underexposure or overexposure of only one of the layers can cause a color cast in underexposed shadow or overexposed highlight areas.

Film Speed and ASA

The *speed* of a stock is a measure of its sensitivity to light. The "faster" a film stock, the less light it needs to produce an acceptable exposure. The *exposure index* (*EI*) expresses the speed as a number that can be used with light meters to help determine proper exposure. The film manufacturer recommends an exposure index for each stock that may be given in the form of an ASA number (American Standards Association, now American Standards Institute or ANSI). The metric equivalent is a DIN number marked with a degree sign. An *ISO number* (International Standards Organization) gives the ASA number first, then the DIN number. On the label for Eastman Kodak stocks you will find the exposure index indicated in this format (see Fig. 4-10). EI500/28° means ASA 500, DIN 28.

A medium-speed emulsion will be rated around ASA 100. ASA speeds below 50 are usually considered slow. Fast or high-speed emulsions are rated ASA 200 or higher. Doubling the ASA number means that the film will be twice as sensitive to light. A film rated at ASA 100 needs only half the exposure (that is, one stop less) than a film rated ASA 50. The faster film can be used in conditions with less light or to allow a smaller iris opening on the lens.

Black-and-white emulsions are sometimes rated by two exposure indexes, one for tungsten illumination and the other for daylight. The tungsten rating is generally about one third of a stop slower than the daylight rating, representing the emulsion's lower sensitivity to the red end of the spectrum.

Color film stocks are also rated with one EI for tungsten light and one for daylight. Here the implication is that you will use a filter for one type of light, and some light will be absorbed by the filter. For example, a tungsten-balanced stock rated ASA 500 will be rated ASA 320 for use in daylight with an 85 filter (see Chapter 5 for more on color and filters).

The manufacturer's recommended exposure index is intended as a starting point. It is not unusual for cinematographers to rate the film at a slightly different ASA (see The Light Meter and Exposure Control, p. 132, for more on varying the EI).

Contrast of the Image

Contrast measures the separation of tones (lights and darks) in an image. The higher the contrast, the greater the separation between tones (see Fig. 4-7). The steepness of the characteristic curve (mathematically, the *slope*) indicates the amount of contrast at any point on the curve. The steeper the curve, the higher the contrast, and thus the greater the separation of tones. The straight line section is

steeper than either the toe or the shoulder portions, so areas of the subject that are exposed on the straight line section will show more tonal separation (contrast) than areas that fall on the toe or shoulder.[3]

Low-contrast images—images without good tonal separation—are called *flat* or *soft* (*soft* is also used to mean "not sharp"). High-contrast images are called *contrasty* or *hard*. An image with good contrast range is sometimes called *snappy*.

Fig. 4-7. Varying degrees of contrast. Low-contrast image looks flat and dull (left). Note muddy blacks and lack of bright whites. Normal contrast (center). High-contrast image has bright whites and deep blacks but lacks midtones (right). Note loss of detail on bright side of face and dark sweater. (Stephen McCarthy)

GAMMA AND FORCE PROCESSING. *Gamma* (γ, defined as the slope) is a measure of the steepness of the straight line section of the characteristic curve. Increasing gamma entails increasing the separation of tonalities that fall on the straight line section of the curve—that is, increasing contrast. Gamma depends on both the nature of the emulsion and the manner of development. Laboratories often talk about developing to a particular gamma. A higher gamma results from increasing the time or temperature of development. Increasing gamma also increases the sensitivity of the film to light (raises the ASA number; see p. 117), and, when done for this purpose, is called *force processing* or *pushing*.

Force processing may be used when there is insufficient light to shoot. For example, a film rated ASA 100 is exposed as though it were rated ASA 200 to effectively double its sensitivity. The lab is then instructed to "push one stop" to compensate for the underexposure by increasing development time. Some stocks can be pushed one to three stops, but force development increases graininess, sometimes to a degree that makes the image unacceptable. Consult the lab on particular stocks.

When you are force processing, change ASA speed on the light meter for expo-

[3]The tonalities in the straight line section are "stretched" and those in the toe and the shoulder are "compressed."

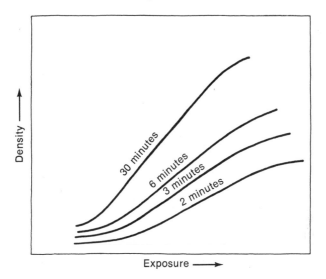

Exposure ⟶

Fig. 4-8. Force processing. As the development time increases, the characteristic curve becomes steeper (contrast increases)—because the brighter parts of the scene (right side of graph) respond more to increased development than the darker parts. Fog level also increases with development time. (Carol Keller)

sure calculations. When pushing one stop, double the ASA number; when pushing two stops, multiply it by four.

Pushing increases contrast because areas in the scene that fall on the straight line section and the shoulder increase in density more than those on the toe (see Fig. 4-8). Shadow values that fall on the toe will not significantly increase their densities, so pushing will not result in much more detail in the shadows. Middle tones and highlights, on the other hand, will show significant increases in density.

When reversal stocks are pushed, the blacks often become muddy and look grayish (a lower D-max). Pushing does not generally raise the threshold of the film; that is, if shadow values fall below the threshold, pushing will not render any more detail. When we are concerned with "seeing into the shadows," stocks with long flat curves do best; pushing helps little. One way to change the film stock's response to shadow value is through flashing (see Reducing Contrast in the Film Stock, p. 120).

TWO ASPECTS OF CONTRAST. To get a general idea of the effect of altering contrast, try playing with the adjustments on a television set (see Appendix A for how the controls affect contrast). An example of very high gamma can be found in a photocopy (xerox copy) of a photograph. A characteristic curve of a photocopy would have a very steep straight line section—almost vertical (the reversal equivalent of Fig. 4-4 iii). Dark areas in the original are rendered black, and slightly lighter areas are rendered white; nothing prints gray (no midtones). However, although the photocopy has a high gamma, if it does not have a rich black and a bright white, the overall contrast will probably seem low to the viewer. To demon-

strate this, try copying the same photograph onto white and then blue paper. Thus, it is not only gamma but also the range from black to white, sometimes called the *contrast range* of the image, that determines its overall contrast.[4]

OTHER FACTORS. A low-contrast lens or flare in the lens (see Chapter 3), either in the camera or projector, can make the image look flat. During projection, any stray light in the room will also cause loss of overall contrast. For example, suppose the darkest part of the screen reflects 1 unit of light and the lightest 100 units, making the overall ratio 100:1. If someone opens a door and lets 2 units of light cover the screen, the darkest area now reflects 3 units (2 + 1) and the lightest 103 (100 + 3), a ratio of about 34:1, which is a significant drop in overall contrast.

Reducing Contrast in the Film Stock

Gamma can be increased via force processing, which affects the rendering of bright areas in the scene more than it does the dark areas. Gamma can be lowered by underdeveloping (*pulling*) the film in the lab. Pulling reduces film speed, grain and contrast. If this is planned, the film is overexposed during shooting, then underdeveloped to the same degree. For example, you might rate the film at half its normal ASA (use ASA 50 for a film normally rated at ASA 100), then instruct the lab to pull by one stop. With some stocks, pulling can result in a rich image with subtle shading. Be sure to check with the lab first; not all stocks can be successfully pulled and the lab may not perform this service (and will usually charge extra if they do). Pulling is sometimes done for footage that is accidentally overexposed in shooting.

Another way to reduce contrast is by *flashing*, a process in which the film is uniformly exposed to a dim light either before (*preflashing*) or after (*postflashing*) the scene is photographed. This exposure raises base-plus-fog density (or, in reversal, it lowers D-max) and increases the exposure of shadow areas, but it has little effect on the bright areas. It thus lowers the contrast between shadow and highlight values.

The effect of flashing is similar to the screening room example given above. On negative film, two units of exposure from the flashing may double a shadow density while having almost no effect on higher densities. The contrast range of the image is thus reduced.

The Arriflex VariCon unit is a device that mounts in front of the camera lens like a matte box and reflects a low-level white or colored light into the camera. Unlike postflashing, using the Varicon lets you see and adjust the amount of flashing while filming. Any color used affects the shadow areas but generally not the faces (midtones). The Panaflasher is a Panavision unit that flashes the film in the camera magazine, but you can't see the effect in the viewfinder.

When two stocks of different contrast are used on the same film (especially when they are used for the same scene), the contrastier stock is sometimes flashed to better match the lower-contrast film. Flashing also provides detail in some

[4]In video, there are separate controls for the level of the brightest white (gain), the level of the darkest black (pedestal) and the rendering of the midtones (gamma). See Chapter 7 for more on contrast in video.

shadow areas that would otherwise be rendered as black, since it may give them enough exposure to be boosted over the threshold. Flashing can thus be used like pushing to increase the sensitivity of film to light. Unlike pushing, however, it does not increase contrast and it affects the darker, rather than the lighter, areas of the scene. Do not expect much increase in film speed—depending on the stock, at most a half stop or so. Print stocks may also be flashed.

You may not like the way flashing increases graininess, desaturates colors and imparts a milkiness to the image, especially in the shadow areas. Be sure to consult your lab and make tests before flashing footage.

SHARPNESS

Definition, or *sharpness*, expresses the degree of clarity in an image. There are several physical measurements that more or less correspond to the viewer's evaluation of sharpness.

Resolution

Resolution, or *resolving power*, is the ability to record fine detail in the image. Resolution in film is measured by photographing a test chart with sets of parallel lines in which the space between the lines is equal to the thickness of the lines, the thickness progressively diminishing. The image is then examined under a microscope to determine the greatest number of lines per millimeter that can be distinguished. Don't confuse resolving power with measurements of resolution used in video (see Chapter 7).

Resolving power is of limited use for predicting the viewer's evaluations of sharpness, since those evaluations are highly dependent on the contrast in the image—the higher the contrast, the sharper the image appears. An image may have a very high resolution, say, 100 lines/mm, but will not appear to be sharp if the contrast is excessively low. Bear in mind that resolution measures small details that may not be as important to the eye as larger areas in the image.

Acutance

Acutance was introduced to remedy the limitations of resolving power as a measure of sharpness. It measures the ability to reproduce clean boundaries in the image. To measure acutance, a portion of the film is shielded from exposure by a straight edge. In an ideal situation, the line between exposure and no exposure would be reproduced as a knife edge with a sharp change in density. Actual stocks, however, change density gradually. The more rapid the change, the higher the acutance and the sharper the emulsion. To the eye, the sharp boundaries between the larger areas of the image (measured by acutance) are usually more important than the very fine detail (measured by resolution).[5]

[5]In video, "enhancement" is sometimes done to increase the contrast of sharp boundaries by adding a white line around edges (to compensate for poor resolution.) See Chapter 7 and Appendix A.

Modulation Transfer Function (MTF)

Acutance has largely been replaced by MTF as a measure of sharpness. MTF measures the "noise" in the photographic system. If you were to examine a small area of the image, you would see that some of the variations in light and dark are caused by differences in brightness in the scene. However, some of the variations are due to lens or film imperfections that result in light spilling from a lighter to a darker area. MTF measures the loss of image quality due to graininess, light scatter in the film emulsion, and aberrations in the camera or projector lens. MTF encompasses the aspects of both resolution and acutance that contribute to evaluations of sharpness.

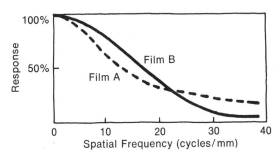

Fig. 4-9. The MTF of two stocks. Although film A (resolving power—100 lines/mm) resolves better than film B (46 lines/mm), film B may appear sharper, since it renders the larger details better. (Carol Keller)

To measure the MTF, a test pattern of alternating light and dark strips, with distance between the strips decreasing, is photographed on film. As the light and dark areas become closer, the emulsion tends to average out the light and dark, and the contrast range of the original pattern is decreased. MTF compares the *spatial frequency* (the distance between light and dark areas, measured in cycles per millimeter) with the accuracy of the response of the emulsion (expressed as a percentage, 100 percent being perfect accuracy). The response at the lower spatial frequencies, around 10 to 20 cycles/mm, closely corresponds to measurements of acutance, while the response at higher spatial frequencies closely corresponds to resolving power (see Fig. 4-9). The data sheet for a raw stock generally includes an MTF curve.

Resolution, acutance and MTF can be used to evaluate any part of a film system (for example, film, lens or projection), but MTF alone can predict the sharpness of a combination (say, lens and emulsion) from the MTF of each component. MTF can also be used to evaluate video systems, or film/video combinations. A lens that showed a high response at one spatial frequency would lose its advantage when combined with a stock (or video format) that showed low response at the same frequency. Some lens manufacturers claim their lens's MTF complements Eastman Kodak's color negative stock, maximizing the potential of each.

Graininess and Granularity

The photographic image is composed of small grains of metallic silver, or, in the case of color films, masses of dye that occupy the areas where metallic silver formed during the development process. When a single frame is enlarged, it will show the roughness caused by these grains or dyes. The viewer's perception of this roughness is called *graininess*, and the objective measurement that attempts to quantify it is known as *granularity*.

A uniformly exposed and developed sample is scanned at great magnification to record density variations. A count of these variations gives a numerical value expressed as *RMS granularity*. A difference of 6 percent is barely noticeable. Figures range from under 5 for some color negative stocks to 18 for some black-and-white stocks. Film manufacturers publish the RMS granularity figure on their data sheets.

Graininess is usually considered to be an undesirable component of a film system, but different grain structures create a look that in some stocks, even those with high granularity, may be considered pleasing. You may like a sharp, clear grain in black-and-white. Some grain structures on color film look beautiful, while others merely impair the image.

Every emulsion has a built-in graininess for any particular development process. In general, faster films are made up of larger silver halide crystals and thus appear grainier. Fine grain emulsions are usually found in slower film stocks. Kodak has reduced graininess in fast stocks with "T-grain" technology. T-grains are flatter, so sensitivity is increased because more of the grain is exposed to light; but since grain mass is not increased, the appearance of grain does not increase. Black-and-white reversal films often exhibit less grain than negative films, because the larger, more light-sensitive grains are exposed first and then washed away during the bleaching stage, leaving the finer grains behind.

Graininess in black-and-white is fundamentally different from graininess in color. Black-and-white grains are made of metallic silver, which is opaque to light. In color film, the grain pattern results from uneven distribution of silver grains that are replaced by dyes during development. The dye itself is transparent to light. Generally, slightly overexposing color negative film results in less graininess, whereas in black-and-white overexposure causes an increase in graininess. Color negative films are significantly less grainy than comparable-speed color reversal emulsions.

Storage conditions of the raw stock or exposed undeveloped film can affect graininess. High temperatures or long storage periods increase fog and grain. Force processing also make the image grainier.

Graininess, but not granularity, varies with subject matter. It is most readily seen in large areas of uniform density. A blue sky that is not overexposed and bleached out will show more graininess than a landscape. Color negative usually shows the most grain in uniform shadow areas that do not print as deep black. Sharp images divert the eye from the grain: graininess is most apparent in blurry images. Since grain position changes from frame to frame, grain seems to move or "boil" during projection, making it more noticeable. Granularity does not measure this dynamic aspect of graininess.

CHOOSING A RAW STOCK

As you prepare to shoot a movie, you must select which stock or stocks to use for the project. There are many options, and new stocks are constantly being introduced. Seek advice, do tests and find out what stocks were used for movies that have a look that you like. For the latest listing of available film stocks, check out the manufacturers' Web sites (see Bibliography).

Black-and-White Versus Color

Today, most motion pictures, distributed in film or video, are in color. Audiences expect color. Black-and-white may have associations of being old-fashioned or historical. Because black-and-white is now relatively unusual, it can also command attention. Black-and-white films made in the "color era" have a unique place; for example, Martin Scorsese's *Raging Bull*.

The ascendancy of color in the film industry makes it difficult to find laboratories that do high-quality black-and-white work. Black-and-white, when properly handled, can be exhilaratingly beautiful, but good contrast is the key to this beauty. When the blacks turn muddy or there are no clear whites, the image looks dull. On the other hand, a print with too much contrast has a short tonal range and looks harsh.

Part of the aesthetic challenge of black-and-white is to render the world through the range of gray tones from black to white. Some people think black-and-white gives a realistic look, while others feel that it presents an abstract image of the world. Lighting tends to be more difficult because there is no color contrast to give snap to the image. For example, in black-and-white, a green leaf and red apple may photograph as the same gray tone, whereas in color they would be strongly differentiated. The Hollywood lighting style for black-and-white includes a rim light to separate the subject from the background (see Chapter 11).

Films that mix black-and-white and color generally must be printed on color film stock; color balancing color print stock to achieve a pleasing black-and-white look can be difficult. Movies intended for distribution only in video can be shot in color and then made monochrome during the transfer to video.

Black-and-white films have longer storage lives (color dyes fade) and using black-and-white film may lower production costs. However, some TV broadcasters will not air a contemporary black-and-white movie. Distribution for black-and-white movies is generally more difficult.

Negative Versus Reversal

Most films are made with negative stocks. There is a greater range of available stocks in negative than in reversal. Negative can handle a greater range of lighting conditions and is more forgiving of exposure errors. It is much easier to make a good-quality print with good sound in negative than in reversal. Labs offer more options and services for negative; some don't handle reversal at all. In short, if you are thinking of starting a project in 16mm or 35mm, think first of negative.

Nevertheless, there are certain advantages to reversal. If you want to minimize costs, you can shoot reversal and project or edit it without making a print. The traditional super 8 home movie is reversal original. Most 16mm news photography was done with reversal. However, projecting or editing the original puts it at great risk of scratching and should not be done for important projects. If you plan to edit and distribute in video, you might just as well start with negative. There are now negative stocks available even in super 8 (see p. 8).

Manufacturers include "chrome" in the name of the stock to indicate color reversal—Ektachrome, Fujichrome, etc. Most reversal stocks are made for direct projection of the original with a 5400°K light source and may appear slightly red on a projector with a tungsten bulb (see Chapter 16). A reversal original often looks wonderful, but when a print is made the contrast increases and the image looks hard and grainy. This is particularly a problem in black-and-white. There are low-contrast companion printing stocks for color reversal, but they usually do not produce a good optical sound track. Printing from an internegative can help. Maintaining a low lighting contrast ratio during shooting (see Chapter 11) will result in better contrast in the prints.

Reversal film is easier to handle than negative film. Its emulsion is usually more resistant to scratches. Dust prints as black on reversal, which is much less noticeable than the white sparkle that results from dust in the negative-positive system. Reversal also allows for selective workprinting, since it is easy to examine the original and cull out unwanted footage. Reversal allows white superimposed titles to be burned in a print in one step, whereas titles for negative may be more expensive, often involving an additional printing generation (see Chapter 16).

Film Speed

Film speed is often the key element in selecting the raw stock. In general, the faster the speed, the more flexibility you have. Not only is it easier to shoot in available light, but supplementary lighting need not be as bright, cutting lighting costs and creating a better environment for the actors. High-speed film stock allows the lens to be stopped down to increase depth of field. On the other hand, high-speed films may produce a poorer-quality image, with more grain and less sharpness (but there *are* exceptions). As a rule of thumb, select the slowest film that allows you either to shoot at a preferred *f*-stop (this is the usual practice in studio production) or to get an adequate exposure in available light situations (often very important in documentaries). At this time, the range of standard color negative films extends from ASA 50 to 640. Documentary cinematographers who shoot in unpredictable available light situations often look for the fastest film of acceptable quality. On many productions, two or more stocks are used: a slow speed for exteriors and higher speeds for interiors or night work. Do tests to ensure that the stocks you want to use intercut well. Often, two different stocks can be used for the same movie, but look too different to be intercut in the same *scene*.

PUSHING. Film sensitivity can increased with forced processing (pushing, see Gamma and Force Processing, p. 118). Different stocks respond to pushing with radically different results; some show unacceptable graininess when pushed even

one stop. A stock that responds well to force processing gives you flexibility when encountering unexpected low-light conditions.

Daylight Balance Versus Tungsten

For complete discussion of color balance and film stocks, see Chapter 5.

Film stocks are generally made to be used without a filter with *either* tungsten illumination (professional lighting at 3200°K) *or* daylight. Eastman Kodak uses the letter T or D after the ASA number to indicate the type (100T film is ASA 100, tungsten). Films balanced for tungsten light can be used in daylight with a filter (usually an 85 filter). Similarly, films balanced for daylight can be used in tungsten light with a different filter (80A).

If you plan to shoot *exclusively* in daylight (either outdoors or in a window-lit interior), then it makes sense to use daylight-balanced film. However, since the 80A filter cuts out two stops of light, this can cause problems when you shoot indoors with tungsten illumination. Two stops are a lot to lose when you're lighting a scene—you need four times as much light to compensate. (Of course, you could use a daylight-balanced lighting units such as HMIs; see Chapter 11).

For most filming situations, it is generally a better idea to order tungsten-balanced film. This allows you to shoot indoors with a minimum amount of artificial illumination (since no light is lost to the filter). When you shoot outside, the ⅔ stop lost by 85 filter is usually not a problem. In fact, often you need additional ND filters to cut the light level down even more. In some situations you can shoot tungsten-balanced film outdoors with no filter (see Chapter 5).

Some stocks are balanced for 3400°K, which is the color temperature of many photofloods. Some reversal stocks are designated "Type A" to indicate 3400°K balance. These require an 85 filter for use in daylight.

Contrast and Film Stocks

Compared to high-contrast film stocks, low-contrast stocks have a longer, more gently sloped characteristic curve and can handle a greater range of brightness in the scene (they have greater exposure range or latitude; see p. 148). Generally, the slower a stock is, the greater its latitude will be—but not always. Negative stocks have greater latitude than reversal. When you film an interior scene that includes bright windows, a film with a small exposure range will usually not be able to show detail in both the dark interior and the bright window (see Fig. 4-23). Some film stocks are designed to be especially sensitive to the darker areas, "reaching into the shadows" to provide good detail and crisp, rich blacks.

It's important to think about contrast in terms of the several linked steps that bring the image from the camera to the viewer. Most negative camera stocks are designed with reduced contrast (gamma), which, when printed on contrastier release print stock, will produce an image of pleasing contrast. As discussed above, most reversal stocks are made for direct projection without making a print first. The high overall gamma looks correct on the original, but prints often look too contrasty.

Some stocks are designed especially for direct transfer to video. These feature low contrast (great exposure range) and color rendering that is well matched to the telecine. See Chapter 17 for more on contrast and video transfer.

Color Reproduction

Every film stock has a particular *palette*, or range of colors or tones it creates on screen (analogous to the palette from which a painter selects paint). The colors you see on screen are due partly to what's in front of the camera (sets, costumes, lighting, filters) and partly to what's *in* the camera (the stock). Different manufacturers design their films for different looks. Often, different laboratories will make the same stock appear quite different in terms of color, grain and sharpness. Often, higher-contrast stocks tend toward deeper, more saturated color.

PACKAGING, HANDLING AND PURCHASING

Most cameras use *core-mounted* film. The film roll is wound around a plastic hub (the core) and must be handled only in darkness (see Fig. 2-16). Some cameras accept *daylight spools*, which are solid metal reels that allow the film to be

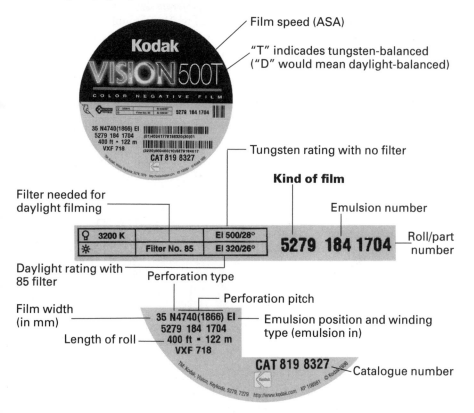

Fig. 4-10. Film label and enlarged details. This label is for Kodak 5279 color negative film, also called Vision 500T. (Eastman Kodak Company)

loaded in light. See Camera Film Capacity, p. 62, for a detailed discussion of roll lengths and camera loading procedures.

Film stocks have a multidigit identification number (see Fig. 4-10). The Kodak film in the illustration has the number 5279-184-1704. The film type is 5279; the "52" tells us this is a 35mm stock. If it were 16mm, it would start with "72" instead (7279). Experienced filmmakers often refer to stocks only with the second two digits, as in, "give me two rolls of 79." The second part of the number (184 in the example) is the emulsion batch number. For consistency, many filmmakers prefer to buy only film from a single batch, though with improved quality control that may not be necessary. When each batch of film is manufactured, it is first created in wide rolls, which are cut down into many smaller rolls for sale. The last part of the number (1704) is the roll number and part of the roll from which this piece of film was cut. It's a good idea to note the entire number as a check against potential problems (see p. 66)

Perforations

Super 8 film is perforated on one side (*single-perforated*, or *single-perf*), while 35mm film is perforated on both sides (*double-perforated*, or *double-perf*). Film in 16mm may be single- or double-perforated (see Fig. 1-3). Double-perf film can be used in any camera and has a slight advantage over single-perf when cement splicing the original. When shooting super 16 you must use single-perf.

The *pitch* of the perforations is the measured distance from the bottom of one perforation to the bottom of the next perforation. 16mm camera original for high-speed cameras sometimes has a slightly longer pitch and may be marked "high speed" on the label.

Different camera formats use a different number of perfs for each frame. For example, the standard 35mm frame spans four perfs, but there is also a three-perf format (see Chapter 1). However, both formats use identical 35mm film stock.

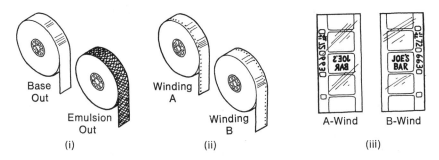

Fig. 4-11. Emulsion position and winds. (i) Film can be wound base-out or emulsion-out. (ii) Single-perforated film, wound base-out, can be winding A or winding B, depending on the position of the perforations as shown. (iii) With the base facing you, B-wind film reads properly through the base, while A-wind film will be reversed or flipped. Note that the key numbers usually read the same as the image. Compare with Fig. 16-1. (Carol Keller)

Windings

Raw stock perforated on one edge and wound with the emulsion side in has two possible windings, designated *winding A* and *winding B* (see Fig. 4-11). Camera original is almost invariably in winding B. Stock in winding A is generally only used by laboratories for printing.

Another laboratory use of these terms exists that often leads to confusion; *A-wind* and *B-wind* are used to distinguish whether the picture "reads correctly" (that is, not flipped left to right) when viewed facing the emulsion side (A-wind) or when viewed facing the base (B-wind). An easy way to remember this is that B-wind film reads correctly through the *base*. B-wind is also called *camera original position*.

Key Numbers and Edge Identification

Along the edge of 16mm and 35mm film, the manufacturer exposes a latent image with information such as the name of the manufacturer, the film identification number and a running footage count. This information is readable after the film is processed, and can be printed from the negative to another piece of film (when making a workprint, for example). The numbers that track the footage are called *key numbers* or *latent edge numbers*. Key numbers allow each frame of film to be identified by number and are indispensable for conforming the original (see Chapter 16).

Today, most film stocks also have a machine-readable bar code version of the key number. This is generically called *keycode* (Eastman calls its system KeyKode). When editing film on video, keycode is a tremendous boon because it allows the telecine and other machines to automatically identify and find each frame of film (See Chapter 17).

Fig. 4-12. 16mm key numbers and KeyKode. (Eastman Kodak Company)

In 16mm, key numbers are printed every half foot (20 frames). When counting frames in 16mm there is a dot at the beginning of the number, which is the *zero frame reference mark*. In Fig. 4-12, you can see the dot to the left of the letter "M" in the key number M69 1234 7880. This is the frame that should be considered exactly 7880. The next frame going toward the tail (in the direction of 7881) would be 7880 + 1. The frame on the other side of the mark going toward the head (in the direction of 7879) would be 7879 + 19.

Fig. 4-13. 35mm key numbers and KeyKode. (Eastman Kodak Company)

In 35mm, key numbers are printed every foot (16 frames for standard four-perf cameras). There is also a midfoot key number to help identify short pieces of film; this is located 32 perforations from the main number. When counting frames in 35mm, the zero-frame reference dot immediately follows the last four digits of the key number. Thus, for the key number KJ 23 1234 5677, the frame where the dot falls is 5677. The next frame going toward the tail (in the direction of 5678) would be 5677 + 1. The frame on the other side of dot (going toward the head) would be 5676 + 15.

Unfortunately, there are now so many types of coding and numbering schemes in filmmaking that the names (and concepts) can easily be confused. Here are some things that key numbers and keycode are *not:*

1. Ink edge numbers (sometimes also called "edge code," "Acmade numbers" or just "edge numbers"). Generated by a machine that stamps an ink number on film workprint and mag sound to aid in synchronizing (see p. 380). Some labs also use ink numbers on the negative.
2. In-camera timecode. Generated by some cameras and exposed on the edge of the film during shooting (see Fig. 2-20).
3. Video (telecine) timecode. Generated during the film-to-tape transfer for use in video editing; *not* printed on the film (see p. 521).

For more on key numbers and timecode, see Timecode and Audio in the Telecine, p. 520.

Handling Film Stock

Unprocessed film undergoes change over time. There is a gradual lowering of speed and contrast and an increase in the fog level. Color films are particularly vulnerable, since the changes may occur at different rates in the three emulsion layers, causing a color shift that may not be correctable in printing. Poor storage conditions not only cause changes in the emulsion's photographic properties, they can also change the film's physical condition (for example, brittleness and shrinking).

High relative humidity (over 70 percent) can damage labels and cartons and

produce rust on metal cans. As long as the original moistureproof tape seals the raw stock can, humidity is less of a problem.

Eastman Kodak recommends using raw stock within 6 months of purchase. Avoid heat when storing film. The lower the temperature, the slower the aging process. At high temperatures, change occurs rapidly. An automobile left in the sun can heat up above 140°F (60°C), and film in the car can undergo significant changes in a matter of hours. Similarly, stock left on a radiator will show significant deterioration in a short time.

If storing film for up to three months before use, keep it below 55° F (13°C) at relative humidity of 60 percent or lower. Put it in a refrigerator if the storage area is too warm. Whenever storing film for more than three months, put it in a freezer, ideally at 0° to −10°F (−18° to −23°C). Since relative humidity in a refrigerator or freezer is very high, pack film in plastic freezer bags to control humidity. After you remove the stock from cold storage, allow it to come to room temperature before breaking the moistureproof seal. This prevents condensation and spotting on the stock. Minimum warm-up times are 1 to 1½ hours for super 8 and 16mm stocks and 3 to 5 hours for 35mm. If the day is particularly warm and humid, increase the warm-up period.

Once the seal is broken, expose the film as soon as possible, and then, after exposure, have it processed as soon as possible. If processing must be delayed, avoid high temperature and humidity, since the latent image is even more vulnerable than the unexposed stock to deterioration. If the cans are resealed with the moistureproof tape, a household refrigerator may be used to store the film, although a freezer at 0°F is preferred. Though not recommended, we have found some exposed stocks maintained an excellent image when frozen for over a year prior to processing.

Kodak recommends storing processed film in a cool, dry place 70°F (21°C) or lower. Though often impractical, long-term storage for color film is ideally at 36°F (2°C) or lower. For the ultimate protection against color dye fading, make black-and-white separation positives.

When traveling through airports, beware of X-ray machines. Unprocessed film can tolerate some X-ray exposure, but excessive amounts will increase the fog level and grain. Exposure is cumulative, so repeated X-ray inspections are most problematic, especially for high-speed films. Sometimes you do best by hand-carrying the film and demanding a hand inspection at the gate. However, some inspectors will demand to look inside the film cans! Bring a changing bag in case it's needed. In the past, another solution was to pack the film in a cooler lined with lead foil and send it as baggage. However, newer baggage X-ray machines may be far more powerful (and damaging to the film) than the ones used to inspect hand-carried items.[6] Kodak recommends never shipping unprocessed film as checked baggage on commercial airlines and suggests contacting the airport manager in advance to get a manual inspection. Check the X-ray policies of commercial couriers and mail carriers. Consider using an export company or customs broker to ship the film and

[6]With some newer X-ray machines, the lead foil automatically triggers a more intense and damaging ray on the film.

do all the paperwork. Another possibility is to process the film in the area or country where you're shooting. Be sure to label film (PHOTOGRAPHIC MATERIALS—NO X RAY). Normal X-ray inspection shouldn't damage audio- or videotapes, but avoid metal detectors.

Static electricity discharges can expose raw stock and cause lightninglike streaks or blotches on the processed film. Low temperature and low humidity increase the possibility of static discharge. Black-and-white stocks are more susceptible than color. Improvements in stocks have made the problem less common now; in the past, cameras had to be grounded at times, to avoid the problem. You can help avoid static discharge by giving raw stock removed from cold storage adequate warm-up time and by rewinding raw stock at slow speeds.

Purchasing Raw Stock

Order raw stock from the manufacturer's catalogue by catalogue number and stock name. For example, ordering Kodak Vision 500T film allows numerous further possibilities, but the catalogue number 819 8327 identifies the stock as 5279, 35mm, 400' on core, emulsion in, standard perforations.

Use fresh raw stock. Order it to arrive a week or so before it is needed, rather than months in advance. As discussed above, many people prefer to order stock with the same emulsion number to guarantee uniformity. If you encounter a raw stock of an unknown age, the manufacturer can tell from the emulsion number when it was manufactured. Of course, this tells you nothing about its past storage conditions.

Some manufacturers and supply houses can deliver stock overnight if you run out during a shoot.

It is often possible to purchase raw stock that was ordered by another customer and never used. There are businesses that buy and sell unexposed stock. Generally, they will allow you to return defective stock. Test a roll by sending about 15 to 20 feet of unexposed stock to the lab to be developed and checked for increased fog, which, if present, is a sign of poor storage or possible exposure to airport X-ray machines. Buy previously owned stock of the same emulsion number to avoid having to test each batch. Raw stock less than 3 months old sells for about 15 to 25 percent off list price, and less if the stock consists of short-ends (parts of complete rolls). Stock older than 3 months is cheaper, but you may be pennywise and pound foolish. The stock is only one of many costs.

THE LIGHT METER AND EXPOSURE CONTROL

Many of the ideas in this section build on concepts introduced in Properties of the Film Stock, p. 111.

Exposure

When you are filming a scene, there is no single "correct" exposure. We might say that a scene is properly exposed when the image on film looks pleasing to the eye and important elements in the scene are shown with sufficient detail. If a

close-up of a person's face is significantly overexposed (that is, too much light is allowed to strike the film), the face on screen will look too bright and facial details will be washed out. If the shot was seriously underexposed, the projected image would look very dark and muddy. In both cases, facial details are lost—either because they are washed out or because they are indistinguishable from parts of the emulsion that have received no exposure at all.

When shooting negative film, the negative is exposed in the camera and then a positive print (or video transfer) is made to view the image. Compare the negative image in Fig. 4-2 with the positive in Fig. 11-24. You can see that the dark parts of the positive image (the man's sweater and the doorway on the left side) are quite thin and transparent on the negative. The light parts of the scene (the bright side of his face and the splash of sun on the back wall) show up in the negative as dark and relatively dense (thick or opaque). For an area in the scene to be rendered with good detail on a positive print, that area in the negative needs to be sufficiently dense and detailed. Areas where the negative is too thin and transparent will have relatively little detail in the positive print. In this image, the sweater or the doorway might be considered "underexposed" in the sense that they show up on the positive print as very dark and lacking much detail. However, in the context of the whole picture, this lack of detail seems natural. The most important part of this scene is the man's face, and as long as his skin tone appears naturally bright and rendered with good detail, other parts of the scene can be allowed to go brighter or darker. Thus "correct" exposure means identifying what's important in the scene and exposing that properly.

If important details are visible on the film after processing, shots that are slightly too bright or too dark can often be corrected when the film is printed or transferred to video. In general, reversal stocks are less forgiving of exposure errors than negative stocks. When shooting with color negative stocks, we want to avoid significant *under*exposure because the resulting negative will be thin and without detail. When shooting reversal stocks, significant *over*exposure will result in the film being thin and lacking in detail (think of an overexposed slide). With both negative and reversal, the goal is to expose in the *middle* of the range, to capture detail in both the bright areas (the *highlights*) and the dark ones (*shadows*), so the overall exposure seems natural and pleasing.

Exposure and Incident Light

The exposure of an object on film is related to the amount of light *falling on* the object—that is, the *incident light*. Incident light can be measured with an *incident light meter* that has a translucent plastic hemisphere (or *hemispherical diffuser*), which simulates the light-gathering ability of a typical three-dimensional subject—specifically, the human head. The incident meter is held at the position of the subject (or in the same light) and is *pointed in the direction of the camera*. The meter averages together the light coming from the front, the sides and, to a lesser extent, the back of the subject.

Many cinematographers use incident meters almost exclusively. Incident light readings are quick and easy to do, and they usually result in proper exposure of facial skin tones. Faces, especially in close-ups and medium shots, are often the most important element in the frame.

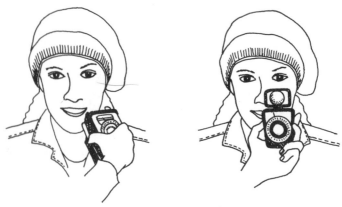

Fig. 4-14. The reflected meter is pointed at the subject from the direction of the camera (left). The incident meter is held in the same light as the subject and pointed toward the camera (right). (Carol Keller)

Fig. 4-15. A scene with a lot of contrast. If you take a light meter reading in the sunlit area and expose accordingly, the shadow area is underexposed (left). If you take your reading in the shadows, the sunlit areas is overexposed (right). A compromise exposure, slightly underexposing the figures in the shadows (center). Film stocks vary in their ability to handle high-contrast scenes.

Some scenes contain a great range of incident light. Consider the example of filming people by a building on a sunny day. If you take an incident reading near the people in the shadows, and then set the exposure accordingly, the people in the sun are likely to be drastically overexposed. Conversely, if the incident reading is taken in the sun, the people in the shadows will be underexposed. This happens to varying degrees with all film stocks. This happens when the range of brightness in

the scene (the *lighting contrast;* see p. 309) exceeds the film's sensitivity range (*latitude* or *exposure range;* see p. 148).

In Fig. 4-15, the figures in the foreground are lit by direct sun and the figures above them in the background are in shadow. Had you witnessed this scene with your naked eye (and a dramatic scene it was), you would have had no problem seeing detail in *both* the shadow and sunlit areas. This is because the eye's retina has a great range of sensitivity and your iris constantly adjusts the amount of light that strikes it. Film stocks, however, have a much narrower range of sensitivity. The image on the left is exposed for the sun. The image on the right is exposed for the shadows. The image in the center is a compromise exposure that attempts to split the difference.

Other approaches to this contrast problem include adding light to the shadow areas to reduce contrast or using a lower-contrast film stock that has greater latitude.

Exposure and Reflected Light

An object's exposure on film is more fully described as resulting from the *total amount of light reflected by the object* in the direction of the camera's lens. This is determined not only by incident light but also by what percentage of the incident light is reflected by the object (that is, its *reflectance*). Subject reflectance is determined by color and surface texture; a dark-colored, textured object reflects less light than a light-colored, smooth one does. For example, a dark wool sweater in the sun (low reflectance, high incident light) might produce the same amount of exposure as a bright white car in the shade (high reflectance, low incident light). That is to say, their *brightness* (*luminance* or *intensity*) is the same.

To see how reflectance relates to incident light, look at the middle image in Fig. 4-15. Of the figures in the background, the tiger and the figure in the middle received equal amounts of incident light, but the white, reflectant tiger produces more exposure than the dark clothes of the man next to him.

The amount of light reflected by the subject can be measured with a *reflected light meter*. This meter requires more care to use properly, but it can give more precise readings than the incident meter, especially for subjects whose reflectance is not near that of facial skin tones. It can also be used in certain situations, like filming through a window, where the incident meter would be useless. The reflected meter is *pointed at the subject* from the camera position (or closer). The reflected reading must always be interpreted and never taken at face value.

When film is exposed, developed and then projected on a screen, it can produce a range of tonalities from dark black (where the film holds back the projector light) to bright white (where most of the light shines through). The tone in the middle of this range is called *middle gray*. Reflected light meters are designed so that if you take a reading of any uniform object and then expose the film accordingly, the object will appear as middle gray on film. Thus, a reflected reading of a black cat will produce the cat in middle gray when the film is projected—the cat appearing unnaturally light and other objects in the scene probably being very overexposed. So, if you want dark objects to appear dark, you must give them *less* exposure than the reflected meter reading of the object would indicate. Similarly, for light objects to appear light, they must be given *more* exposure than the meter suggests.

A *gray card*, or neutral test card, is a piece of dull gray cardboard that reflects 18 percent of the light that strikes it. This card is intended to represent an indoors object of "average" reflectance. If you take a reading of the gray card and expose the film accordingly, the tonality of objects in the scene will usually look natural on film—neither too light nor too dark.

Gray cards are available at photographic or film supply stores. It's a good idea to carry one. Keep it protected in an envelope. As an experiment, set up a gray card facing the camera from several feet away. Use an incident meter to take a light reading at the card (remembering to point the meter *toward the camera*). Now take a reading of the card with a reflected meter (pointing it *toward the card* from a few feet away). The two readings should be the same.

Since Caucasian skin is about twice as reflectant as the gray card—having approximately 35 percent reflectance—you could just as well base an exposure on a reading of skin tone, as long as you remember to give the film *twice* as much exposure as the meter indicates. This is normally done by opening the iris diaphragm one stop (see p. 143 for other types of skin).

Fig. 4-16. Direct reading Spectra incident light meter. The upper scale reads footcandles, the lower reads *f*-stops. Requires slides; the tab of the ASA 32 slide is visible at top. (Simon Associates)

LIGHT METERS

Meter Types

Light meters, or *exposure meters*, may be either handheld or built into the camera; in super 8, built-in meters are often coupled to the iris diaphragm to allow automatic adjustment (see p. 174). Some meters can take *both* incident and reflected readings. Some of these work quite well; others are primarily designed for one type of reading and are inferior for the other. Some reflected meters have a sliding or detachable translucent plastic bulb (hemispherical diffuser) for incident readings, but the diffuser is much smaller than the ones found on true incident meters

and does not respond as well to side and back light. Similarly, some incident meters have detachable parts to convert them for reflected readings; these may have too-large angles of acceptance (see p. 139) compared to true reflected meters. If possible, get a meter of each type (which also gives you a backup if one breaks).

The most useful meters give you a direct reading of *f*-stops when you push a button (see Fig. 4-17). Less useful are meters that require you to find the *f*-stop using a calculator dial on the meter (time is precious when shooting). Some direct reading meters (like the older-style Spectra) use a set of slides that must be inserted to key the meter to the film and shutter speed settings. Slides are easy to lose and may not be available for the particular film stock and processing combination you are using.

Fig. 4-17. Minolta Auto Meter IV F. Digital LCD readout. Shutter speed and ASA are keyed into the meter and then *f*-stops can be read directly. A few readings can be stored and then averaged. (Minolta Corp.)

Most light meters operate with a photoelectric cell that generates electricity when light strikes it. Some meters use this electricity to deflect an indicator needle. These meters may be less expensive and require no batteries. Most modern meters have a digital readout and use batteries (either more expensive button-type photo batteries or inexpensive AA cells). Digital meters are often more rugged than meters with needle mechanisms and some are more accurate. All meters are generally most accurate in the middle of their operating range. Readings at the lower end of the scale tend to be the least precise. Light meters may have a zeroing adjustment and/or a battery check. It's a good idea to have a technician check your meter periodically.

Reading the Meter

In controlling exposure, you are regulating the amount of light that strikes each frame of film. The amount of light is determined by how long the shutter is open (the shutter speed, determined by the shutter angle and the camera speed) and how much light passes through the lens during this time (affected by the iris diaphragm setting, the filters being used, light loss in the lens and light loss in the viewfinder optics). Usually, the meter is set to compensate for all the other factors, then the light reading is used to determine the proper iris setting (that is, the *f*-number) for a particular shot.[7]

For typical film cameras, the shutter angle is about 180° and, when run at sound speed (24 fps), the shutter speed is about 1/50 second. The shutter speed for any camera can be found in its instruction manual or can be easily calculated if you know the shutter angle (see Chapter 2). If you change the camera speed (for example, to produce slow-motion effects), you will alter the shutter speed.

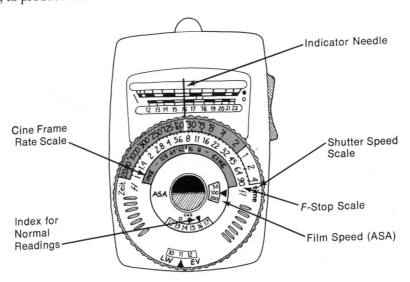

Fig. 4-18. Calculator dial found on Gossen Luna Pro reflected/incident meter. The film speed window indicates that the meter is set for ASA 100 film. The light reading (16) is set opposite the triangle in the window just below the ASA setting. A camera with a 180-degree shutter run at 24 fps has a shutter speed of 1/50 second (50 can be found on the time scale between '60 and '30). The *f*-stop is read opposite this point. Alternately, the *f*-stop could be read opposite the 24-fps mark on the cine scale (found between 32 and 16). The meter indicates a reading between *f*/5.6 and *f*/8. (Carol Keller)

The meter must be set to the proper film speed (ASA) for the film stock you are using. Remember to compensate for filters you may be using (for example, when shooting in daylight with tungsten-balanced color film, see Chapter 5). Cameras

[7]See Chapters 2 and 3 if the terms in this paragraph are unfamiliar.

with built-in meters usually compensate for filters automatically, and, in super 8, the ASA and shutter speed may be set automatically as well (see Chapter 2). With direct reading meters, the shutter speed is also set on the meter so that *f*-stops can be read directly when the trigger is depressed (see Figs. 4-16 and 4-17).

On meters with calculator dials, the indicator needle is read against a numbered scale. Set this number on the calculator dial. You will find the shutter speed on the *shutter speed scale* (sometimes labeled *time* or *zeit*), which is marked in fractions of a second ('60, '30, etc.). You can then read the *f*-stop opposite the proper shutter speed. With cameras equipped with 175° or 180° shutters, you may find it easier to read from the *cine scale*. This is marked in frames per second (64 fps, 32, 16, etc.) and usually has a bold mark at 24 fps, corresponding to ¹⁄₅₀-second shutter speed. After you have thus determined the *f*-number, you can set the lens's iris accordingly.

Fig. 4-19. Intermediate values on the *f*-stop scale. Above the scale are one-third stop increments; below the scale are half-stop increments. (Carol Keller)

In most circumstances, it does not pay to be more precise than about one third of a stop when calculating exposures; few meters are accurate enough and few films stocks (especially negative stocks) will show the difference.

VIEWFINDER OPTICS. With cameras that have internal beam-splitter viewfinders (for example, most super 8 cameras and the 16mm Bolex), some light is diverted from the film to the viewfinder (see Fig. 2-12). When you use a *handheld light meter* rather than a built-in one, do not set it to the *actual* shutter speed (based on shutter angle and frame rate); instead, use an *effective* shutter speed that compensates for light lost in the viewfinder. The effective speed is always faster. On some Bolexes at 24 fps, actual speed is ¹⁄₆₅ second, effective is ¹⁄₈₀. Your camera's manual should indicate the proper setting.

F-STOPS AND T-STOPS. *F*-stops do not take into account light lost internally in a lens, whereas T-stops do (see p. 85). When you use a professional zoom lens marked in T-stops (sometimes a red scale on the opposite side of the iris adjustment from the *f*-stops), use the T-stops instead of the *f*-stops for all exposure calculations. Ignore the fact that light meters are marked in *f*-stops. T-stops should also be used whenever you are filming with more than one lens.

The Angle of Acceptance

All meters built into still and movie cameras are of the reflected type. Built-in, through-the-lens meters may average together the light from the entire frame (called *averaging meters*), they may read only the light from objects in the center of

the frame (*spot meters;* see Fig. 4-20) or they may read the whole frame, giving more emphasis to the center (*center-weighted meters*). Consult your camera manual to find out what part of the frame the meter reads.

Fig. 4-20. Metered area in a camera with through-the-lens spot metering. The relative size of the metered area varies from camera to camera. (Carol Keller)

Fig. 4-21. A typical reflected light meter has a wide angle of acceptance (about 40° here) and averages areas of differing brightness (top). A spot reflected meter (pictured here with a 5° angle of acceptance) can read a small area in the subject (bottom). (Carol Keller)

A few cameras, like the Canon Scoopic, have built-in meters that do not read through the lens. This meter is comparable to having a handheld meter attached to the camera.

Handheld reflected meters have a window over the photocell that allows light to enter from an *angle of acceptance* (usually between 15° and 60°). Some meters are designed to simulate the angle of view of a "normal" lens, but the meter may read a wider or narrower area than the lens you are using. All the light reflected by objects within the angle of acceptance is averaged together, so if you are trying to read the light from an individual object, it is necessary to get close to it (but be careful not to cast a shadow with the meter or your body). Handheld *spot meters* are simply reflected meters that have a very narrow angle of acceptance, often 1° or less. They can be used to read the light from small areas at a greater distance. Cameras with zoom lenses and built-in, through-the-lens meters can be zoomed in for variable-angle spot metering.

Fig. 4-22. Minolta Spot Meter F. This meter has a 1° angle of acceptance, approximately the angle of view of a 550mm lens on a 16mm camera. (Minolta Corp.)

TAKING READINGS

The Incident Reading

Because the incident light meter is easy to use and renders skin tones consistently, it is preferred by cinematographers in most filming situations. As previously discussed, the incident light meter measures the amount of illumination falling on the subject rather than the light reflected by it. For many scenes, taking an incident reading is faster than using a reflected meter. Incident meters are preferred when studio lighting is used because they conveniently indicate how much light is contributed by each light source. In this case, the hemispherical diffuser is often replaced with a *flat disc diffuser* that can more easily be aimed at one light at a time. Incident meters are often advantageous in those situations in which it is difficult to approach the subject to take a reading. If the subject is fairly far away outdoors, you

can take an incident reading from the camera position (assuming it is in the same light), and, unlike a reflected reading, it will not be thrown off by large expanses of sky or other extraneous elements. Unlike the reflected meter, the incident meter is useless when you film something that *emits* light (like a television screen), when you film through something that *filters* light (for example, a tinted car windshield) or whenever the meter cannot be placed in the same light as the subject.

Often, the part of the scene that is most important to expose correctly and consistently is skin tone. Incident meters are not affected by extraneous elements in a scene, and are therefore very good for exposing skin tones consistently. Even if, in printing, variations in exposure are evened out, the skin tones may still show differences in color, grain and contrast. Exposing some important area (here skin tone) the same in every shot is sometimes called *pegging the key tones;* a reflected meter and gray card can also be used for this purpose (see below).

Nevertheless, there are instances where the incident reading must be interpreted and not used directly. Often it is necessary to "bias" or "weight" an exposure reading to compensate for important parts of the frame that are especially light or dark. Say you are filming someone in the snow. The normal incident reading would expose the person's face fine, but the snow, because it is so reflective, would probably overexpose. As a general rule, if important subject matter is especially reflective (a white car, for example), close the iris a half to one stop from the incident reading; if it is especially dark and absorptive (dark clothing), open the iris by the same amount.

The Reflected Reading

The reflected light meter can give the filmmaker a more complete idea of the exposure of various elements in a scene. Many people are familiar with the idea of reflected readings from doing still photography with cameras equipped with built-in meters. Still cameras often have averaging meters or center-weighted meters. You take a reading of the whole scene, set the exposure and shoot. This kind of reflected reading can work fine for "average" subjects, particularly if they are front lit (the light coming from behind the camera). But a single reflected reading of the whole scene can cause the subject to be poorly exposed if the subject or the background is particularly light or dark, or if the light is coming from behind the subject. For movies, there is the added consideration that the framing of the picture may change significantly *during* the shot.

Whenever you use a reflected meter, always ask yourself if the area of the scene that you're pointing the meter at is important. Base the exposure on the most important areas, and use readings of other areas to give you a sense of the overall range of brightness in the scene. If the range of brightness (the contrast) of the scene is very great, you may need to take steps to lessen it.

Also ask yourself how you want the area you're reading to look on film. As discussed above, the reflected reading of an object will cause that object to appear on film in the *middle* of the tonal range. If you're reading an object that's near to average reflectance (like the 18 percent gray card), then the meter reading will result in that object looking natural on film. But if the object you're reading should look relatively dark on film, you need to give it less exposure than the meter indicates

(usually by closing down the iris—that is, using a higher f-stop than the one indicated on the meter).

CLOSE-UPS AND MEDIUM SHOTS. In medium shots and close-ups (see Fig. 8-2), it's important that facial skin tones be exposed correctly and consistently. To take readings directly from the subject's face, put the meter close enough so that other areas are excluded from the meter's field of view. Be careful not to block the light or cast shadows with your body or the meter. If your skin tone is similar to your subject's, you can read the back of your hand instead, as long as it is in the same light. Since Caucasian skin is about twice as reflective as the gray card, you must give it about twice as much exposure as the meter indicates to render it appropriately light on film. Thus if the meter reads $f/8$, open up the iris to $f/5.6$. Black skin is usually less reflective than the gray card. You might stop down the iris a half stop for medium black skin, a full stop for darker black skin (a meter reading of $f/8$ would then be exposed at $f/11$). Some people have black skin that is extremely dark and absorptive and may require more exposure compensation.

You can easily find out exactly how much to compensate for your skin tone or the skin of your subject by comparing a reflected reading of the skin with an incident reading (or a reflected reading of a gray card) taken in the same light. If the reading of your hand reads, say, $f/5.6$, and the incident reading is halfway between $f/4$ and $f/5.6$, you know to open the iris a half stop from a reading of your hand. You have thus "calibrated" your hand as a portable gray card.

Faces are normally lit so that part of the face is bright and part is in shadow. In general, if compensations are made as above, the exposure should be based on a reading of the brighter side. However, if the light comes from the side, more than half the face may be in shadow, in which case it may be important to see more detail in the shadows. In this case, you might increase the exposure a half to one stop from the exposure used for the bright side. (For exposing faces that are fully back-lit see Backlight, below.)

One way to get consistent skin tones is to use the reflected meter with an 18 percent gray card. Angle the gray card halfway between the subject and main source of light and take a reading from about six inches away with the reflected meter. This is essentially a measure of the incident light (since the gray card has the same reflectancy in every situation), and it should produce about the same reading as an incident light meter.

WIDE SHOTS. In wide shots, landscapes and scenes where people do not figure prominently, instead of basing the exposure on skin tone, it is often better to take a reading of the *average amount of reflected light in the scene.* To do this, point the meter (or the camera, if you are using a built-in meter) at the scene from the camera position. If you are shooting outside, a bright sky will tend to throw off the reading; angle the meter downward somewhat to avoid reading too much of the sky. In general, you should avoid pointing the meter at any light sources. An averaging meter with a wide angle of acceptance may take in the whole scene and give you an average just by pressing the button. A spot meter, on the other hand, will fluctuate wildly as you scan it across highlight and shadow areas, so you will need to calculate the

average. Take a few readings of important areas that are particularly bright or dark. Some meters will store readings in memory, helping you to find the average.

When calculating the average between readings of bright and dark areas, you are not looking for the mathematical average, but one that is expressed in *f*-stops. Thus, the average of two readings (say, *f*/2 and *f*/16) is the stop halfway between the two (*f*/5.6), *not* the mathematical average (2 + 16) / 2 = 9. Meters like the Gossen Luna Pro indicate light readings on a numbered scale, which can be averaged in the familiar way and then converted to *f*-stops.

REFLECTED AND INCIDENT READINGS TOGETHER. Spot readings of specific areas can be useful for fine-tuning an exposure based on an incident reading or on an average reading of the whole scene. For example, you might take an incident reading near the subject, then scan around the scene with a reflected meter to get a precise reading of particularly bright or dark areas of the subject or background. (You could also do this with an incident meter.) If important areas are reading much brighter or darker than the subject, you can then bias or weight your exposure to compensate, as described above. One rule of thumb says that to see detail in the shadows, they should not read more than 2 stops or so darker than the exposure you're using. Thus if the lens is set for the main subject at *f*/5.6, the shadows should fall around *f*/2.8. Different film stocks vary in their ability to register shadow detail (see Exposure and Film Stocks, p. 148).

Backlight

Light that comes from behind the subject in the direction of the camera is called *backlight*. Backlighting is often encountered outdoors when shooting in the direction of the sun or when shooting people in cars, or indoors when the subject is positioned in front of a window or a bright wall. Usually when you expose a backlit subject, it is desirable for the shaded side of the subject to appear *slightly* dark, which it is, but not so dark that the person appears in silhouette with no facial detail (see Fig. 4-23).

If you base the exposure on a typical reflected light meter reading from the camera position, the meter's angle of acceptance will include a great deal of the background. The meter then assumes that the subject is very light; it indicates that you should stop down quite far, throwing the person into silhouette. A rule of thumb to prevent silhouetting in this case is to open the iris 1½ stops above what the meter indicates (for example, open from *f*/8 to halfway between *f*/4 and *f*/5.6). Many super 8 cameras have a backlight button that does just that. (And many video cameras have a similar backlight feature.)

A more precise exposure calculation can be done by taking an incident reading or by getting very close to the subject to take a reflected reading of the shaded part of the face. Be careful to block any backlight from striking the meter directly. Since you do want the face to appear slightly dark, close the iris about one stop from the exposure you would normally use for the skin tone. For example, when exposing Caucasians with a reflected meter, the same effect can be gained by exposing at the *f*-number that the meter indicates (*without* the usual compensation of opening the iris one stop).

Fig. 4-23. A backlighting problem when shooting toward a window. Exposed for the interior, the outside is overexposed (top). Exposed for outside, the woman is silhouetted (bottom). A compromise exposure, slightly underexposing the woman (middle). (Stephen McCarthy)

Special Exposure Conditions

Setting exposures may involve a series of compromises, especially when areas in the scene vary greatly in their brightness. If you are interested in seeing detail in bright areas, keep the iris slightly further stopped down; if detail in shaded areas is important, open up a little more. In backlit settings, it is common to have one exposure for wide shots that include a lot of the bright background and another for closer shots where shadow detail may be important. The latter might be opened up a half stop or so more than the former.

FLARE. If you are filming in the direction of a strong light source that is shining directly into the lens (for example, against a very bright window or into the sun), you may pick up lens flare from light that reflects within the lens (see Fig. 3-12). Zoom lenses are prone to severe flare. Flare tends to fog the film, desaturating colors and increasing overall exposure. If there is no way to block this light with your hand or a lens shade, keep in mind that flare can increase exposure a half stop or more. When flare is severe in the backlit situations, you may want to close the iris a half stop *in addition* to the correction you made for backlighting.

SNOW OR SAND. When you film people on a sunny beach or in a snowscape, a typical reflected reading from the camera position will be thrown off by the bright background. For close-ups and medium shots, use an incident meter or take a close reflected reading of skin tone in the normal way. If good reproduction of the snow or sand is important, decrease this reading by a half to one stop (especially for wide shots).

NIGHT SCENES. As long as some bright highlights, such as street signs, storefronts or narrow areas of street light, are visible, large areas of the frame can be rendered dark in night scenes. Similarly, if there are bright facial highlights recorded on the film, then the general exposure of the face can be lower than normal. (See Special Lighting Effects, p. 342)

DISTANT LANDSCAPES. Haze, which may not be apparent to the eye, increases the exposure of distant objects on film. In hazy conditions, use a skylight or haze filter on the camera. Use a spot meter to average distant highlight and shadow areas, or, with an incident meter, *decrease* the exposure a half stop for front-lit scenes, or about a stop for side-lit scenes.

PARTIALLY OVERCAST SKIES. Thick clouds passing in front of the sun can decrease exposure by three stops and change the color temperature of the light. Do not forget to open the iris to compensate for the former. In controlled filming situations, sometimes a frame is mounted above the subjects (an "overhead") to hold thin diffusion material, which helps minimize the difference between sun and clouds (see Chapter 11).

SUNRISE AND SUNSET. For sunrise or sunset shots in which the foreground scene is mostly silhouetted, take a reflected reading of the sky but not the sun di-

rectly. Closing down the iris from this reading may deepen the color of the sun, but it will also make the landscape darker. When possible, bracket exposures by using the reading you think is correct, then shoot with a half to one stop more, then the same amount less. If scenes are front-lit by a red rising or setting sun, no 85 filter need be used with tungsten-balanced color film. Backlit scenes may look blue without it.

FLAT COPYWORK. For discussion on flat copywork see Preparing Film Titles, p. 488.

Built-in Meters and Automatic Exposure Control

Reflected light meters are built into most super 8 cameras and some 16mm cameras. Usually they read through the camera's taking lens. Built-in meters can be convenient, particularly if the light changes while you're shooting, but they have a number of drawbacks. If you only have a built-in meter, you lack the ability to take incident readings and you must carry the camera around to take readings, which can be awkward.

In most super 8 cameras, the ASA and shutter speed settings on the light meter are keyed automatically by the film cartridge and the camera speed selector (see Chapter 2). If the meter indicates that there is insufficient light for filming, you may decide to push-process the film to increase its speed (ASA). However, if you push one stop, the meter's reading (if any) will be one stop too low for the film.

If you use a handheld meter to set your exposure, and then start shooting, it can sometimes be unnerving to see how different the through-the-lens reflected reading is. Say you're shooting someone against a dark background, zooming in from wide shot to close-up. The exposure should remain unchanged, but the through-the-lens reading will be very different at the end of the shot than it was at the beginning.

AUTOMATIC FEATURES. Cameras with built-in meters may allow the filmmaker to choose between manual and automatic control of the aperture. Automatic exposure control is available in most super 8 cameras and some 16mm cameras. See Automatic Exposure Control, p. 174, for a discussion of this feature.

Measuring Foot-candles and Lux

Filmmakers often need to measure the intensity of light in absolute terms (a reading of f-stops is relative to the shutter and film speed being used). One *foot-candle* is the intensity of light emitted by a "standard candle" at a distance of 1'. (Light bulbs are sometimes rated in candle power.) *Lux* are the metric version of foot-candles. Cinematographers often instruct a crew to light a set to a certain number of foot-candles; a total film "system," including camera, lens and film stock, is sometimes evaluated in terms of how many foot-candles or lux it needs to operate.

Foot-candles can be measured with an incident meter. Some meters will read directly in foot-candles, others have a conversion chart on the back to calculate

them. Shooting ASA 100 film at standard shutter speed with the lens set to f/5.6 requires about 260 foot-candles of light.

EXPOSURE AND FILM STOCKS

Beginners usually think about exposure on the basic level of "did the picture come out?" In some ways, that question never goes away, but experienced cinematographers understand that exposure is fundamental to their art, and that it offers opportunities to create a wide range of effects on film. Exposure choices depend on the particular scene and the film stock you're using.

Exposure Range

Perhaps the biggest challenge when exposing either film or video is accommodating the fact that the range of brightness in many scenes exceeds the camera's ability to faithfully record it. A common example is shooting an interior scene with bright windows visible in the background. Your eye can easily adjust to both the dim interior and the bright exterior—in one glance you can see detail in a picture on the wall and a sunlit view through the window. However, film and video systems cannot handle this much contrast in one exposure. You might have to choose between exposing for either the interior or the exterior, but can't count on both being rendered with detail (see Fig. 4-23).

As discussed above (see Contrast of the Image, p. 117, and Contrast and Film Stocks, p. 126), some stocks can accommodate a great range in scene brightness, rendering both bright highlights and deep shadow with good detail. Such stocks are said to have great *latitude* or *exposure range* (see below for more on latitude). A stock's latitude is determined by the length of the straight line portion of the film's characteristic curve (see The Characteristic Curve, p. 114). You can determine the exposure range of a stock by shooting tests, asking the lab or checking the manufacturer's data sheet. Color negative has about a nine- or ten-stop range; most reversal films have closer to five or six stops. Generally, video cameras have a more limited exposure range than negative film stocks (see p. 188 for a discussion of exposure range and video).

With a reflected light meter, you can check the difference in f-stops between important light and dark areas in the frame. If the brightness range of the scene is too great for the film stock, it may be necessary to recompose the shot, add light, flash the film, change an actor's costume or makeup or redecorate the set (see Setting Lighting Contrast, p. 337).

Exposure Error

Filmmakers always want to know, "How much can I be off in my exposure and still get an acceptable image?" The answer depends in part on the latitude or exposure range of the stock (see above). The larger the stock's exposure range, the more error that can be tolerated. But the amount of acceptable error also depends on what you're shooting: the higher the lighting contrast in the scene, the less leeway you have.

As an example, imagine shooting an outdoor scene with areas of bright sun and

deep shadow. With proper exposure, you might just be able to capture detail in the brightest areas and the shadows. But if the exposure were increased even slightly, the highlights might be pushed into the shoulder of the characteristic curve and lose detail. Similarly, if the exposure were decreased, the dark areas would now fall on the toe of the curve and no longer show detail.

Now imagine shooting the same scene on a cloudy day. The contrast range between highlights and shadow is now much smaller, so all the areas of the image fall on the straight line portion of the curve, far from the toe or shoulder. You might be able to increase or decrease exposure a few stops without losing detail.

With an average subject, color negative stocks might allow one to one and a half stops of underexposure or two or more stops of overexposure. A color reversal film might have only a stop or less leeway at either end. Since some degree of exposure error can be corrected during printing, when reversal stocks are shown in the original, latitude is especially limited.

Confusingly, the word *latitude* is used to mean both the total exposure range and the degree of acceptable error (in the latter case, it is sometimes called *exposure latitude*). If someone says, "This stock has a latitude of ten stops," they mean the total exposure range the stock is capable of. If they say, "You have two stops of latitude on the overexposure side," they're talking about exposure error. As we have discussed, latitude as a measure of acceptable exposure *error* depends not only on the exposure range of the stock, but on the contrast of the particular scene.

Exposure and Tonality

As noted above, color negative stocks generally look better when slightly overexposed and reversal stocks do better if slightly underexposed. An underexposed negative is thin and transparent. When it is printed, the printer light has to be set very low (see Chapter 16), which results in increased grain and the blacks becoming milky. To get a rich black in the print, you need to be able to punch a sufficient amount of light through during printing. If faces are properly exposed (and thus dense enough on the negative), then a bright printer light can be used that will produce a rich black in the shadows and help suppress grain. This is why it's important in night scenes, for example, to have *some* bright highlights in the frame. If the highlights are properly exposed, then you can use a bright enough printer light to make the dark parts of the frame look dark and clean. But if *everything* is dark and underexposed in shooting, the printed image will be murky and grainy, and color will be muted.

Some cinematographers routinely overexpose color negative *slightly* (about a half stop or so) in order to get richer, more saturated colors and less grain. Black-and-white negative, on the other hand, becomes grainier with overexposure. Color reversal produces richer, more saturated colors when it is slightly *under*exposed.

When shooting color negative specifically for video transfer, bear in mind that while overexposure decreases grain, it requires a higher video *gain* in the telecine, which increases noise (and noise looks a lot like grain!). When shooting 35mm negative for transfer, overexposure is generally not recommended. However, 16mm can still be overexposed up to a stop.

Gross over- or underexposure should be avoided. When negative or reversal

film is greatly overexposed, highlights bleach out, faces look pasty, and deep blacks are lost. "Printing down" when the lab makes a print from overexposed negative *may* yield a bright white and a rich black, but will usually not restore much detail in the highlights. Printing overexposed reversal usually requires sacrificing a bright white. In general, correct exposure uses the full range of densities and results in an image of good contrast.

Exposure Control

In brief, the filmmaker has the following means of controlling exposure at his disposal.

1. *Film speed.* Aside from the choice of raw stocks, film speed can be altered via force development (pushing) and sometimes via underdevelopment (pulling). A film that is properly exposed in the highlights but contains areas of underexposed shadow can sometimes be helped with flashing.
2. *The lens.* The iris diaphragm is the primary means of exposure control. Neutral density filters can be used to avoid overexposure or for opening the iris to a selected *f*-stop (to control depth of field or maximize lens sharpness). Polarizing filters, and, in black-and-white, contrast filters can be used to alter the exposure of various elements in the scene (see Chapter 5).
3. *Shutter speed.* Cameras equipped with variable shutters can be set to increase and decrease exposure time, but this may affect the smoothness of motion. Changing the camera speed affects exposure time, but also affects the speed of motion (see Chapter 2).
4. *Ambient light.* Light on the scene, or on selected parts, can be increased with artificial lighting fixtures or with reflectors that reflect sunlight. Neutral density and colored filters can be placed over lights and windows, and lightweight cloth nets can be used to cut down the amount of light falling on a subject (see Chapter 11).

EXPOSURE AND VIDEO CAMERAS. As a point of comparison, it's useful to note which of these tools of exposure control are available when shooting video. In the above list, Item 1 is obviously not applicable to video. However, in its place there is the gain setting, which can increase or decrease the camera's sensitivity. For Item 3, many video cameras have an adjustable shutter, but few allow you to change the camera speed (frame rate). Everything else in the list applies equally to film and video.

Color and Filters | CHAPTER 5

The first part of this chapter is about the basic principles of color for both film and video systems. The second part is about color- and image-control filters that can be used with film or video cameras.

COLOR

Primary Colors and Complementaries

If a red light, a blue light and a green light all shine on the same spot, the spot will appear white. You can think of white light as made up of these three colors, called the *additive primaries*, and expressed as:

$$red + blue + green = white[1]$$

Red and blue light together yield a purple-red color called magenta. Blue and green light produce a green-blue color called cyan, and red and green together produce yellow.

$$red + blue = magenta$$
$$blue + green = cyan$$
$$red + green = yellow$$

Cyan, magenta and yellow are the *subtractive primaries;* that is, they are made by subtracting one of the additive primaries from white light. For example, if the red component is taken away from white light, cyan (blue + green) is left:

[1]People familiar with painting may think of the primary colors as red, blue and yellow. This is a different color system. Mixing all colors in paint produces black. Mixing lights of all colors produces white.

$$\text{cyan} = \text{blue} + \text{green} = \text{white} - \text{red}$$

Similarly,

$$\text{magenta} = \text{blue} + \text{red} = \text{white} - \text{green}$$
$$\text{yellow} = \text{red} + \text{green} = \text{white} - \text{blue}$$

Each additive primary has a *complementary color*, a color that when added to it produces white. From the above three equations, you can see that cyan is the complement of red, magenta the complement of green and yellow the complement of blue. A filter works by passing the components of its own color and absorbing its

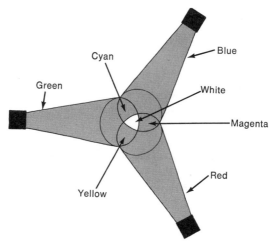

Fig. 5-1. Additive color. Spotlights of the additive primaries—red, green and blue—form white light where all three overlap. Where any two overlap, the subtractive primaries are formed. (Carol Keller)

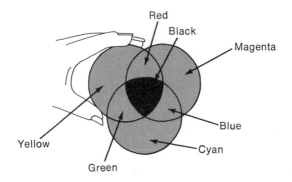

Fig. 5-2. Subtractive color. If you view white light through yellow, cyan and magenta filters, you get the additive primaries where any two overlap and black where all three overlap. (Carol Keller)

complement. A yellow filter thus passes its components (red and green) and absorbs its complement (blue).

The eye is more sensitive to the green portion of the light spectrum than to the red or blue parts. To create light that appears white, the three colors are not mixed in equal proportion. In video, a signal that is a mixture of 30 percent red + 59 percent green + 11 percent blue will appear white on screen. Because more visual information is conveyed in the green component, the green CCD in a three-chip video camera, or the green light in a film printing report, are of special importance.

Color in Film and Video Systems

We use various terms to describe colors. The *hue* is the base color (such as red, green, etc.). *Saturation* describes how pure the color is. Saturation can be thought of as the absence of white; the more saturated a color is, the less white it has in it. Very saturated colors are intense and, particularly in video, may seem to spread or bloom. Desaturated colors are pale; very desaturated colors are almost monochrome (black-and-white). Experiment with a color TV to get a sense of changing color values. A TV's hue or tint control changes the base color, and the "color" control varies the saturation (see Appendix A).

Many factors influence our perception of color. For example, the same color will seem more saturated when surrounded by a black border than a white border.

Standardizing Color Reproduction

There are many opportunities for color values to change (intentionally or not) between the time you shoot a scene and the time that scene appears in a finished film or video. Whenever film or video material is printed or dubbed or transferred from one format to another, the color may change, either because a technician adjusted it or because of the inherent nature of the system. *NTSC* (*Never Twice the Same Color*) video is particularly notorious for shifting color values.

There are various ways to measure color and to try to keep it consistent.

In video, standardized *color bars* can be recorded on a tape and used to adjust color reproduction when the tape is played back (see Bars and Tone, p. 404). To measure the standard color values in the bars, a *vectorscope* is used (see Fig. 5-3). A color's hue is indicated by the position of the signal around the circular face of the vectorscope. The saturation (chrominance level) is indicated by the distance from the center (closer to the edge means higher chrominance). When setting up a tape to bars, the phase (hue) and chroma level (saturation) are adjusted until the six dots are centered in the six little boxes around the circle.[2]

When shooting film, color scales (chip charts) are sometimes filmed along with the slate to aid in timing (color balancing) film or video dailies. Perhaps more useful is to shoot an 18 percent gray card (see The Reflected Reading, p. 142) A patch of bright white next to the gray can help too. Lab personnel will adjust printing or transfer machines to make sure the gray card is reproduced without any color cast, which should make all the other colors fall into place in terms of hue. Aaton's Greyfinder system automates this process for the telecine transfer (see Figs. 5-4 and 17-5).

[2]This is for NTSC video.

Fig. 5-3. Vectorscope. (Tektronix, Inc.)

Fig. 5-4. Shooting a gray card for color balance. Shown here being used with the Aaton Greyfinder system. See also Fig. 17-5. (AbelCineTech)

Sometimes you shoot with nonstandard lighting to create a certain effect. You might use colored gels for a firelight effect or a nightclub scene. If you shoot the gray card under *standard* (uncolored) tungsten light, and *then* turn on the gelled lights, you have a better chance of getting the color you're looking for in the workprint or video dailies.

COLOR TEMPERATURE

The human eye adjusts to most lighting situations so that the color of the light source appears to be white. However, a light source will appear colored if it is strongly deficient in one or more of the primaries. If a light appears red it means it is deficient in its complement, cyan (blue + green). Daylight appears bluer than tungsten light when the two are seen together. For example, if you stand outside on an overcast day and look through a window into a room lit by typical household incandescent (tungsten) bulbs, the interior light will seem relatively yellow compared to the bluer daylight. However, if you now go in the room, your eye will adjust so that the tungsten light appears white.

Although the eye accepts a broad range of light sources as white, different light sources are, in fact, composed of unequal amounts of the primaries. The reddish cast of sunset and the blue of an overcast winter day occur when one of the components of white light clearly predominates. Unlike the human eye, color film stocks and video camera CCDs are designed for light of a *particular* color balance. If the light source differs in its color balance (the proportions of the primaries), the video camera or film stock will not provide natural rendition of color—unless compensations are made electronically or by using filters. In order to judge how much compensation is needed, we need a way of measuring the color components of the light source.

If a piece of metal is heated, it first becomes red in color ("red hot"). Heated to a higher temperature, the metal starts to become blue and then white ("white hot"). You can correlate the temperature of an ideal substance, called a *black body*, with the color of the light it radiates when it is heated to different temperatures. This color temperature is measured in degrees *Kelvin*, which is a temperature scale equal to Celsius (centigrade) minus 273° (absolute zero).

Standard tungsten studio lamps have a color temperature of 3200°K (read "degrees Kelvin" or just "Kelvin"; color temperatures are often written without the degree sign, but we use it in the book for clarity). A lower color temperature light source has a larger red component, while a higher color temperature source has a larger blue component. Light sources and images are thought of as being warm or warmer as they move toward red (think of red in fire), and cold or colder as they move toward blue (think of the icy blue light of an overcast winter day). Some people get confused by the fact that *colder* blue light reads higher (*hotter*) on the Kelvin temperature scale.

Approximate Color Temperatures of Common Light Sources

Light Source	Degrees Kelvin
Match flame	1700
Candle flame	1850–2000
Sunrise or sunset	2000
40- to 60-watt household bulbs	2800
100- to 200-watt household bulbs	2900

Light Source	Degrees Kelvin
500-watt household bulbs	3000
Studio tungsten lights	3200
Photofloods and reflector floods	3200–3400
Fluorescent warm white tubes*	3500
Sunlight one hour after sunrise or one hour before sunset	3500
Early morning or late afternoon sunlight	4300
Fluorescent daylight tubes*	4300
Blue (daylight) photofloods	4800
White flame carbon arc	5000
Summer sunlight, noon, Washington, D.C.	5400
Xenon arc projector	5400
Nominal photographic "daylight"	5500
Average daylight (sunlight and blue sky)	5500–6500
HMI lamps	5600
Overcast sky	6000–7500
Summer shade	8000
Summer skylight with no sun	9500–30,000

*Fluorescents have a discontinuous spectrum and thus do not have a true color temperature. The temperature indicated is a rough equivalent.

Video and Color Temperature

With video cameras, adjusting the camera for light of different color temperatures is called *white balancing*. This is discussed in Setting the White Balance, p. 171.

Color Film and Color Temperature

When a color film emulsion is manufactured, it is balanced for a light of a particular color temperature. The color temperature of the light source must match the film in order to reproduce natural color. Unlike the human eye, which accepts a wide range of color temperatures as white (or colorless), color film will have a color cast unless the color temperature of the source of the illumination matches the color temperature for which the film was balanced.

TUNGSTEN BALANCE. Film stocks balanced for 3200°K are called tungsten-balanced, or Type B. Some film stocks considered to be for amateur use are balanced for 3400°K, the color temperature of some photofloods (see Chapter 11). These stocks are called Type A tungsten.

When tungsten-balanced films are shot with daylight illumination, the excess blue in daylight can overexpose the blue layer in the emulsion, giving a bleached-out, bluish look to the film. To prevent this, a conversion filter is normally used (see Color Conversion Filters, p. 159). However, some color negative stocks have sufficient latitude to allow filming in daylight without an 85 filter (which is useful in low light or when there isn't time to put on a filter). Shooting without the 85 decreases

the film's latitude. Color reversal always needs the conversion filter, since the lab cannot adequately compensate in the print. Consult the lab for advice.

DAYLIGHT BALANCE. Film stocks balanced for color temperatures around 5500°K are considered *daylight-balanced*. Daylight is made up of both direct sunlight and skylight, which is bluer. Shady areas with no direct sun can often have very bluish light, since they are illuminated mostly by skylight. Daytime color temperature varies from 2000° to well over 10,000°K (see chart, pp. 155–6). During sunrise and sunset, as the light of the sun becomes redder, the color temperature drops until it is far below tungsten. When daylight-balanced films are shot with tungsten illumination, a conversion filter is usually used (see below).

See p. 126 for further discussion of tungsten- versus daylight-balanced films.

Off-Balance Color Temperature

If the color temperature of the light source does not match the film's color balance, you can do one or all of the following: filter the lens to restore the proper balance (see below); filter or change the light source (see Chapter 11); make corrections in printing (see Chapter 16) or accept an overall color cast in the image. Some scenes seem to demand a color cast—candlelight, firelight, sunset and night scenes, for example.

Some scenes contain a great range of color temperatures. For example, when shooting indoors with illumination coming from both tungsten lights and windows (see Mixed Color Temperature Lighting, p. 341).

Differences in color temperature are more significant at the lower color temperatures. The difference between 3000°K and 3200°K is marked, while the difference between 5400°K and 5600°K is not very significant.

Measuring Color Temperature

The color temperature of a source of illumination can be read with a *color temperature meter*. A *two-color meter* measures the relative blue and red components of the light, whereas a three-color meter also measures the green component. A two-color meter is adequate for measuring light sources of continual spectral emission like tungsten, firelight and daylight. For light sources like fluorescents and mercury arc lamps, measure the green component with a three-color meter.

Most lighting situations do not require a color temperature meter, since it is enough to know the approximate color temperature of a light source. Large differences can be corrected by a filter (see below) and smaller differences can be corrected in printing (see Chapter 16). Color negative, in particular, allows for a very wide range of printing corrections.

Color meters prove most handy when balancing the color temperature of different light sources (see Chapter 11). For example, the meter can measure if adequate compensation has been made by putting gels on windows to match the color temperature of tungsten light fixtures. Use a two-color meter to measure the decrease in color temperature of tungsten light when there is a voltage drop or to measure the change in color temperature in early morning or late afternoon. If a sequence is shot over several days or weeks, but is supposed to appear

as the same time period in the finished film, the meter can be used to match the light balance day to day.

Fig. 5-5. Minolta Color Meter III color temperature meter. (Minolta Corp.)

The color temperature meter is sometimes used with a set of filters for color temperature compensation (see below). Filter the light source or lens to change color temperature. Some meters read in degrees Kelvin, while others read in mired values (see Color Compensating Filters, p. 164). Point the meter at the light source as you would do with an incident meter (see Chapter 4).

FILTERS

Filter Factors

All filters absorb some light, and compensation must be made for the loss of light to avoid underexposing the film or video image. The *filter factor* is the number of times exposure must be increased to compensate for the light loss. Each time the filter factor doubles, increase the exposure by one stop. Manufacturers supply filter factors for each of their filters.

If you know that a filter decreases exposure by one stop (a filter factor of 2), compensate by opening the lens one stop. When two or more filters are used simultaneously, the filter factor of the combination is the product of each of their factors. If one filter has a factor of 4 and the other a factor of 2, the combination will have a filter factor of 8 (4 × 2). To compensate, open the iris 3 stops.

When shooting video, any light loss from a filter will become apparent as you look through the viewfinder. Be sure to set the exposure with the filter in place on the lens.

When shooting film, you can divide the filter factor into the ASA number to calculate exposure directly from the exposure meter. If you were using a filter with

a filter factor of 4 with a film rated ASA 100, the meter could be set at ASA 25 (100 divided by 4) and exposure calculated directly. In this case, *don't open the iris beyond what the meter indicates*. Film stock data sheets list filter requirements and factors for various light sources.

FILTERS FOR FILM CAMERAS

Color Conversion Filters

When you expose daylight-balanced film under tungsten illumination or tungsten-balanced film in daylight, you should use a *conversion filter*.

Since tungsten film in daylight appears blue, you will want to warm up the daylight to match tungsten illumination. Filters that warm up a scene are red or yellow. Most cinematographers identify these filters by their Kodak Wratten filter numbers. The 85 filters have a characteristic salmon color. A #85B (or simply, 85B) is designed to convert daylight for use with standard 3200°K tungsten-balanced color negative films and Type B reversal films. An 85 filter (sometimes called a *straight 85*) can be used for shooting Type A reversal films (balanced for 3400°K) in daylight. Most people use a straight 85 for typical 3200°K color negative, since Kodak recommends it and the difference is insignificant. The 85 has a filter factor of 1.6 (⅔ stop loss).

Daylight-balanced film used under tungsten illumination will appear red-brown, so add blue. The 80A conversion filter is blue. An 80A converts most daylight films (balanced for about 5500°K) for use under 3200°K illumination. The 80A has a filter factor of 4 (a loss of two stops).

Color conversion filters are used so frequently that cinematographers tend to think of film speeds in terms of the ASA that compensates for the filter factor. Manufacturers will list a color negative balanced for tungsten as ASA 100 for tungsten light and ASA 64 for daylight with an 85 filter (100 divided by filter factor 1.6 is approximately 64). Conversion filters are often used in combination with neutral density filters (see Neutral Density Filters, below).

Filters for Black-and-White

There is a set of filters primarily made for black-and-white film. These filters are mostly used to darken a sky or to change the relative exposure of two differently colored objects that would otherwise be recorded as similar tonalities.

Equally bright red and green objects may photograph in black-and-white as the same gray tone. Since filters absorb their complementary color and transmit their own color, photographing the red and green objects with a red filter makes the green object darker than the red (since the red filter absorbs much of the green light).

The sky can be darkened using graduated neutral density filters and polarizers (see below). Black-and-white film allows the use of several differently colored filters to darken a blue sky but not a white, overcast sky. Since red and yellow filters absorb blue, they will darken a blue sky. Unlike the effect with a polarizer, the darkening doesn't change as you move the camera, so the camera may be panned without worry.

Some of the most commonly used black-and-white contrast filters are: Wratten #8 (K2; yellow or light orange) for haze penetration, moderate darkening of blue sky and lightening of faces and Wratten #15 (G; deep yellow) for heavy haze penetration, greater sky darkening and, especially, aerial work and telephoto landscapes. The red filters (for example, the #23A, #25, #29) have increasing haze penetration and increasing power to darken skies. The #29 can make a blue sky appear black with prominent white clouds. The green filters also darken the sky, but make foliage lighter. Blue filters lighten blue skies and blue objects and increase haze and ultraviolet effects.

Presumably, these filters could be used for shooting black-and-white (monochrome) video, but this is not usually done.

FILTERS FOR BOTH FILM AND VIDEO CAMERAS

Haze Control

Unlike the human eye, film and video are sensitive to ultraviolet light. Atmospheric haze scatters large amounts of ultraviolet light, making the haze appear heavier when shooting distant landscapes. To minimize this effect, use a *UV* or *1A* (*skylight*) *filter* with both black-and-white and color work. The UV is clear to slightly yellow in color, while the 1A is slightly pink. The filter factor is negligible, and no exposure compensation need be made. Haze filters have no effect on fog and mist because these atmospheric effects are composed of water droplets and are not due to the scattering of ultraviolet rays.

The 1A filter is useful to warm up the blue cast due to ultraviolet light present in outdoor shade, which is especially noticeable when snow scenes are filmed. Since the 1A and haze filters do not significantly affect exposure and, in general, have no unwanted photographic effects, they are useful in protecting the front element of the lens in difficult environmental conditions—for example, in salt spray or sand. Some filmmakers leave this filter in place at all times.

Neutral Density Filters

Neutral density (*ND*) *filters* are gray in color and affect all colors equally. They are used to reduce the amount of light passing through the lens without affecting color. They allow you to open the lens to a wider aperture to reduce depth of field, to shoot at an aperture that yields a sharper image or to shoot at all if the light level exceeds the film stock or video camera's ability to handle it.

Neutral density filters are generally marked in increments of .1ND, which is equivalent to one third of a stop; .3ND is one stop, .6ND two stops and 1.2ND four stops. When you combine ND filters, these numbers should be added, and not multiplied as is done with the filter factor. Sometimes ND filters are marked 2X or 4X, in which case you are given the filter factors (one and two stops, respectively).

ND filters are often combined with color conversion filters for daylight filming when you want to reduce the amount of light. For example, an 85N3 combines an 85 filter with one stop of neutral density (the decimal point is dropped when ND filters are used in combination with other filters or sometimes for gels used in lighting).

When shooting film, an ASA 100 tungsten-balanced film would have a daylight exposure index of ASA 32 with the 85N3. Similarly, an 85N6 (two stops of neutral density) would give the film a daylight ASA of 16.

Many video cameras have a built-in ND filter and/or combination ND and 85 filter. See Camera Sensitivity, p. 185.

Graduated Filters

Graduated filters (also called *grads* or *wedges*) have one section neutral density and one section clear. The transition from dense to clear can be abrupt or gradual (filters with a smooth transition from dense to clear are sometimes called *attenuator filters*). Grads are primarily used to darken a sky that would otherwise bleach out and show no detail. Grads can be used to make day-for-night scenes more realistic by darkening the sky. Some grads have a color, such as orange to heighten a sunset effect.

Grads should be used with a matte box (see p. 165). The larger the filter you use, the more freedom you will have to position it correctly. Position the neutral density portion to cover the sky, and align the graduated region with the horizon line or higher. If you are working with great depth of field (say with a wide-angle lens at small apertures), the grad itself may be too sharply in focus to achieve the effect you want. Keep it as close to the lens as possible and use a soft-edged grad if stopped down.

Fig. 5-6. Graduated filter. Shown here off the camera, a grad can be used to selectively darken or color the sky. Grads vary in the sharpness of their transition from dark to light. (Stephen McCarthy)

Polarizing Filters

Aside from graduated filters and special effects, the *polarizer* is the only way to darken a sky in color photography. A polarizer is somewhat like a neutral density filter in that it affects all colors equally. The difference is that it selectively cuts down light oriented in a single plane—that is, *polarized* light. On a clear day, some of the light from the sky is polarized, as is light reflected from glass and water, but not metal. Polarized light can be progressively eliminated by rotating the polarizer. Reflections from glass and water can sometimes be totally eliminated, but be careful not to overdo the effect; otherwise, a car may look as though it has no windshield or a pond as though it is dry.

As you move the camera, the orientation of the polarizer to the light source may change, altering the amount of light that is filtered out. The exposure of an object may thus change during the shot. When the polarizer is used to darken the sky, this change is particularly noticeable when the camera pans. Maximum darkening of the sky occurs with the filter oriented at right angles to the sun. When it is pointed toward the sun or 180° away (the sun directly behind), the polarizer has no effect. Similarly, polarized shots taken at different angles to the sun may not edit together well, since the sky will appear different from one shot to the next. Clear blue skies can most easily be darkened with the polarizer. The hazier the sky, the less noticeable the effect will be. An overcast sky, whether in color or in black-and-white, can only be darkened by a graduated filter.

The polarizer has a filter factor varying from 2 to 4 (one to two stops), depending on its orientation and the nature of the light in the scene. Side lighting and top lighting, when the sun is at right angles to the polarizer, may require a compensation of two or more stops.

When shooting film, calculate exposure compensation by taking a reflected light reading through the polarizer, with the polarizer oriented as it will be on the lens.

When shooting video, set the exposure with the polarizer in place and oriented as it will be for the shot.

Fig. 5-7. Without polarizer (left). Polarizer filter (right). With filter, reflections from the windshield are minimized. (Schneider Optics)

Diffusion Filters

Diffusion filters soften hard lines and are often used to minimize facial lines and blemishes. They are sometimes used to indicate a dream sequence or a historical

sequence. As diffusion increases, flare from bright areas creeps into adjacent areas. A diffusion effect can be achieved by stretching silk stocking material in front of the lens or over the rear element (see below for discussion of mounting filters behind the lens). Sometimes diffusion or nets are used with video cameras to soften the image slightly and give it more of a "film" look.

Tiffen's Softnet filters have netting material laminated within a glass filter. Black net or dot pattern diffusion filters do not affect contrast; white net filters do soften contrast. Diffusion filters generally require no exposure compensation, though net material may cut out some light. Wherever a net is mounted, keep it as close to the lens as possible and check that the net pattern is blurred and not in focus on the image. Use a good lens shade or matte box to keep stray light from striking a diffusion filter directly.

In 35mm film, a softened image is often desirable. In 16mm and video, the image is softer to begin with, and diffusion should be used sparingly unless an exaggerated effect is desired.

Fig. 5-8. Diffusion filter (right). Without diffusion (left). Diffusion filter softens fine detail and causes light sources in the frame to spread. (Stephen McCarthy)

Fog Filters

Fog filters are available in various grades to simulate everything from light to heavy fog. In general, the more contrasty the scene, the stronger the fog filter needed. With too strong a filter, objects may lose so much contrast that they become invisible. Fog filters are sometimes used for heightened mystery or sometimes for romanticized flashbacks.

In natural foggy conditions, objects tend to become less visible the farther away they are. Most fog filters do not simulate this effect, so try not to photograph objects too close to the camera or let a subject move toward or away from the camera during a shot. Double fog filters lower image definition less than standard fog

filters do. There is no exposure compensation for fog filters, though slight over-exposure can increase the fog effect.

LOW-CONTRAST FILTERS. *Low-contrast (low-con) filters,* available in various grades, reduce contrast without softening lines or reducing definition as much as diffusion filters. Low-cons affect the shadow areas but not the highlights. Colors are less saturated and the overall look is softer. There are several variants of low-contrast filters, including the *pro mist* and *ultra-contrast filters.* No exposure compensation is required when using low-con filters.

Special Effects Filters

There are filters (sometimes called *vari-burst*) that will take light sources in the image and break them up into spectral colors. *Star filters* break bright high-lights into stars of four, six or eight points, depending on the type of filter you select. The filters may be rotated to position the directions of the points. Other filters are available that break the image into multiple repeating images of vari-ous patterns.

Split field diopters are discussed in Chapter 3.

Color Compensating Filters

According to current industry practice, major color corrections are made dur-ing shooting, and fine-tuning of the color is left for postproduction. There are times, however, when specific color adjustments may be made via filtration on the lens. For example, when shooting with certain discharge-type light sources such as fluorescent, mercury vapor or sodium vapor lights (see Chapter 11). Or to com-pensate for off-balance color temperatures when shooting reversal film for direct projection. Or when you want to create a specific color effect, such as a sepia look for scenes intended to look old.

Precise color adjustments can be made with a set of *color-compensating (CC)* or *light-balancing* filters. The most advantageous system in common use assigns a *mired value* to every color temperature. To convert from one color temperature to another, subtract their mired values. If the result is a positive number, use yellow filtration to warm the scene, since yellow increases mired value and decreases the color temperature. A negative number calls for blue filtration to decrease mired value and raise the color temperature. Unlike in degrees Kelvin, where a differ-ence of 100°K is more significant at 3200°K than at 5500°K, mired values indicate a constant shift across the scale.

Mired values are used to measure any red-blue color shift. When you put gels on windows to lower the color temperature from 5500°K (mired value 182) to 3200°K (mired value 312), a gel with a +130 mired value is needed (an 85 gel is close enough, with its mired value of +131). If you want the daylight to appear cooler than the tungsten interior light, use a gel that does not lower the color temperature as much. A gel called a half 85 (mired value +81) lowers the color temperature to 3800°K, so that the window light will appear bluer than the 3200°K interior lights. (Consult the *American Cinematographer Manual* for mired values of typical light sources and filters and for the Kodak Color Compensating filter system.)

MATTE BOXES, LENS SHADES AND MOUNTING FILTERS

The Matte Box and Lens Shade

Use a lens shade (see Fig. 2-19) or matte box (see Figs. 3-11 and 5-9) to prevent stray light from hitting the front element and causing flare. If you look at the front of the lens and see the reflection of any light source, there is the potential for flare. A deeper matte box or shade gives better protection. Matte boxes are often adjustable and should be adjusted as deep as possible without vignetting the image. Similarly, use a lens shade as deep and narrow as possible. Long focal lengths allow for a narrow shade. The shades for extreme wide angle are often so wide that they offer little protection from stray light. A French flag (see Fig. 2-19) can be set to cut light sources that the lens shade or matte box miss. When light sources are *in* the scene you're filming, sometimes you can shade the source itself to minimize flare (see Chapter 11).

CHECKING FOR VIGNETTING. To check for vignetting, make sure you can see into each corner of the frame. Place a pointed object—a pencil or finger—parallel to the front surface of the lens, and move it toward each corner of the image. If you cannot see the end of the object through the viewfinder because the corners are dark, there is vignetting. Try this test at close focusing distances and, with a zoom lens, at its widest angle. This test can also be made at the focusing distance and focal length for each particular shot.

MATTE BOXES. Matte boxes have slots that accommodate one or more filters. Often one of the slots rotates for filters like polarizers, split field diopters and special effect filters. Glass filters are expensive; with a matte box, one set of filters can be used for different lenses. Gelatin filters can be mounted in frames that fit into the slots.

Fig. 5-9. Matte box mounted on front rods. Shown with Aaton XTRprod camera. (AbelCineTech)

Use mattes in the matte box for special effects; for example, a keyhole matte simulates looking through a keyhole. A mask that blocks half the frame in one shot and the other half when the film is exposed again lets an actor play two roles in one shot. Matte boxes often mount on *front rods*, which extend from the camera to support the lens, the matte box and/or other accessories. Some matte boxes are fairly large and may be too intimidating in documentary settings. If the front element of the lens does not rotate during focusing, a lightweight matte box can sometimes be attached to the lens itself. A thick *optical flat* (clear glass) in the matte box can help suppress camera noise. A *lens doughnut* is sometimes needed as a seal between the lens and the *back* of the matte box, to keep light from entering from behind.

LENS SHADES. A glass filter can usually be mounted between the lens and the lens shade. On some shades a filter can be dropped in place. Some shades have provisions for rotating a filter. Lens shades are available in metal, hard plastic and soft rubber. Rubber shades are collapsible and cause less shock if inadvertently hit. Lens shades often act like a megaphone, increasing camera noise in the direction of the subject. Rubber shades minimize this effect. Rectangular lens shades work more efficiently for their size but can only be used on lenses with nonrotating focusing mounts.

Mounting Filters

Most special effect filters are used in front of the lens. Colored and neutral density filters may be placed either in front of or behind the lens. If the orientation of the filter matters, a matte box or a lens with a nonrotating front element will make things simpler.

Filters are manufactured in glass or in gelatin (*gels*), or as gelatin sandwiched between glass. Colored filters fade over time. Gels are the least expensive filters and fade the fastest and should be fairly fresh. Store them in a cool place to increase shelf life. Some cameras have a behind-the-lens slot for gels, and there are adaptors for mounting gels on the rear of the lens. When you mount a gel in a matte box, it should lie reasonably flat. Gels are extremely vulnerable to scratching and crimping. Dust can sometimes be blown off but cannot be wiped off. Cut the gel carefully to size, so that it fills the gel holder completely and won't shift while filming. Handle gels in paper or only by their edges, preferably with tweezers.

Behind-the-Lens Filters

When a gel is mounted behind the lens, it refracts light and moves the focal plane back about one third the thickness of the gel. If the lens is wide angle (about 12mm or wider in the 16mm format) and the aperture wide, depth of focus is so narrow that the image may be thrown out of focus. If you plan to use behind-the-lens filters, have the flange focal distance adjusted by a technician to compensate for the change. You must then *always* use a clear gel (UV 1A or 2A) when not using another filter.

There can be serious problems when you use gels behind the lens. The closer the gel is to the film, the more likely it is that physical imperfections and dust will

show up on the film. The longer the focal length of the lens or the more a lens is stopped down, the greater the chance of gel defects showing up on the image. On some cameras the gel is placed behind the reflex mirror shutter, which keeps the viewfinder bright but doesn't show whether the gel has shifted out of place or not. Check cameras with behind-the-lens slots often to make sure that no one has inserted an unwanted gel, or that a gel has not shifted or become damaged.

As discussed above, sometimes nets or silk stockings are mounted behind the lens for a diffusion effect. These do not affect the collimation the way gels do, but must be used with care to be sure they don't come off or damage the lens or camera. Rubber bands or special *transfer tape* (also called *snot tape*) that has a rubber-cement-like adhesive can be used to attach the net to the lens.

GLASS FILTERS. Glass filters are the most expensive, but they are also the most durable and can be cleaned of fingerprints, dust and the like. Glass filters, unless of the highest quality, may impair the image. It is not sensible or economic to use an expensive lens and a poor-quality filter. Gels sandwiched between glass are generally of lower quality. Dyed glass filters should have an antireflective coating (*coated filters*). You can check the quality of the filter with a collimator; if there is a noticeable loss of resolution, use a higher-quality filter. To avoid an unwanted optical phenomenon known as *Newton's rings*, do not mount two or more glass filters so that their surfaces touch.

Some cinematographers like to keep a glass filter over the front element of the lens to protect it from scratches or from poor environmental conditions, such as sand or salt spray. Use a high-quality coated filter. Clear, IA or haze filters will not alter image color or tonal rendition to any serious extent.

Glass filters come in a variety of sizes, sometimes designated in millimeters and sometimes by *series size* in Roman or Arabic numerals. Different lenses may take different-sized filters.

ADAPTOR RINGS. Most lenses accept an *adaptor ring* that screws into the area around the front element or slips over the barrel for mounting glass filters in front of the lens. The filter of appropriate size is then secured with the lens shade or another adaptor ring. A *retainer ring* lets you mount two filters. Use step-up rings to mount a large filter on a smaller lens.

To remove tightly screwed retainer rings, extension rings and the like, use light pressure. Too much pressure distorts thin rings from the round, making removal more difficult. A solvent such as carbon tetrachloride may have to be used for a particularly stubborn ring. In general, whenever you screw threaded rings, be careful to screw them properly (cross-threading damages the threads). If you need to force a threaded ring, this is probably a sign of misthreading.

The Video Camcorder

This chapter is about the basic operation of video cameras and recorders used in production. An overview of video recording can be found in Chapter 1, the use of lenses is discussed in Chapter 3 and a more detailed discussion of the video recording process is in Chapter 7. See Chapters 9 and 10 for microphones and audio recording for video.

Overview of the Camcorder

The video camcorder combines a video camera and VTR (videotape recorder) into one convenient unit. The smallest, lightest camcorders have a single body and are called *one-piece* units. Some camcorders are *dockable*, which means the camera and recorder can be separated if necessary (very handy if one part breaks down). In studio settings, instead of camcorders, several independent cameras can be used with one or more separate VTRs. Regardless of the physical package the camera and recording mechanism are in, all camera/recorders share certain elements:

1. *The lens.* Brings the image (light) into the camera. The lens has controls for the focus of the image, the brightness of the image (using the *iris diaphragm*) and for the magnification of the image (using the zoom to change focal length).
2. *The CCD.* Light-sensitive electronic chip that converts the light coming through the lens into an electrical signal.
3. *Camera electronics.* Processes the signal from the CCD before sending it on. Adjusts the color of the image. May have capability for adjusting the length of exposure (using the *shutter*) and changing the sensitivity of the CCD (using the *gain* adjustment).
4. *The viewfinder.* A small monitor (TV screen) that allows you to see the video signal.
5. *The videotape recorder (VTR).* Stores the video signal on tape. Includes a *tape transport*, which moves the tape past the *heads*, which impart the signal

to the tape. The signal may be recorded in analog or digital form depending on the VTR.

6. *Audio recording.* Most camcorders have built-in or attached microphones. All have provisions to plug in external mics. The recording level (volume) of the sound must be adjusted before shooting (see Chapters 9 and 10).

7. *The power supply.* Camera can be run on rechargeable batteries or by plugging into an AC power supply.

8. *Timecode.* Critical for many aspects of postproduction (see p. 196). Not all cameras have timecode capability.

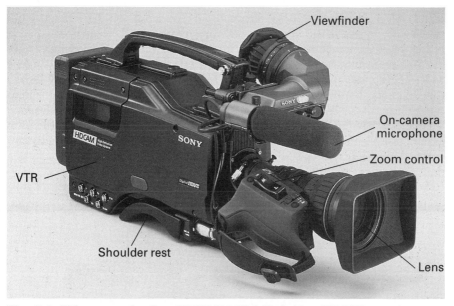

Fig. 6-1. Video camcorder. Sony HDW-700 High Definition (HDTV) one-piece camcorder. (Sony Electronics, Inc.)

Many camcorders, especially consumer units, are highly automated, allowing the user to basically "point and shoot." Some of these cameras do not even *allow* you to make various adjustments. Since control of focus, exposure and color is part of the creative process of shooting, it's not necessarily an advantage to have these things automated. Professional camcorders are generally not so automatic or at least provide manual overrides for most features. If you hope to record high-quality images and sound, it's important to know which automatic settings can be trusted, and when you need to make manual adjustments.

PICTURE CONTROLS

Viewfinders and Monitors

To look at the video image, we use a *monitor*.[1] The viewfinder is a small monitor mounted on the camera that allows you to see the image you're shooting. Professionals often shoot with a much larger, separate monitor as well, which allows others to watch the image too. When you're shooting, viewfinders and monitors show you the video signal as it comes out of the camera, but they don't tell you what is actually being recorded on tape. For example, if you had problems with the tape heads, you would only find out when you stopped recording and watched the tape in playback. See p. 220 for discussion of TV cutoff and the difference between what you see in the viewfinder and what may be seen by audiences.

For years, camcorders were made with black-and-white CRT viewfinders (see p. 16). Increasingly, camcorders have color *LCD* (*liquid crystal display*) viewfinders, and some units employ fold-out "viewscreens" or "mini-monitors." LCDs are thin and light, but some LCD screens are not as sharp as CRT monitors. Color can be a big help, but the color you see in the viewfinder may be misleading. Viewscreens have advantages and disadvantages. They allow you to hold the camera in positions that would be difficult with a standard viewfinder and they make viewing tapes easier, especially when a few people want to watch. But they drain the battery faster and are hard to see in bright light.

Studio video cameras use large, rear-mounted monitors instead of the tubelike eyepiece found on most camcorders.

Fig. 6-2. Consumer DV camcorder showing SwivelScreen color LCD monitor. (Sony Electronics, Inc.)

[1]The key difference between a monitor and a typical TV set is that a monitor has a *video input* where you can plug in a video signal from a camera or VTR. The TV set has an *antenna input* to pickup broadcast television signals (and a channel selector so you can tune into, say, the news on Channel 7). If you want to view the output of a camera or VTR on a TV that lacks a video input, you need an *RF adaptor* (either built into the VTR or detachable). The RF adaptor will *modulate* the video signal, allowing you to watch it usually on Channel 3 or 4 of the TV. If you're traveling, this is handy for viewing tapes in a hotel or home.

The ultimate picture reference is a high-quality studio monitor in a fairly dark room. Moviemakers who place too much reliance on field monitors and camera viewfinders are often surprised (sometimes pleasantly, sometimes not) by what they see later on a better monitor.

Adjusting the Viewfinder

With the exception of the viewfinders on some consumer cameras, virtually all viewfinders and monitors have adjustments for brightness, contrast and color (when applicable). These adjustments only affect the image as you see it on the monitor; they have no affect on the video signal that is actually being recorded or played on tape. However, if the monitor is not "set up" properly, you will not be able to evaluate the image correctly and that will affect decisions you make about *other* adjustments that *can* change the actual recorded signal. It is *very important* to adjust the monitor before beginning work. See Appendix A for instructions.

Some viewfinders have a *detail* or *peaking* adjustment that puts a white line around shapes, which can help you easily distinguish when things are in or out of focus. If the viewfinder has a zebra indicator for exposure, be sure to find out at what level it is set (see Measuring Video Levels, p. 190). Video viewfinders often display a wide range of information on tape usage, battery level, exposure and other data. Consult your camera's manual for details.

Viewfinder Focus. If your camera is equipped with a typical eyepiece (tubelike viewfinder), you must focus the viewfinder for your eye before shooting. This is done with the focus or *diopter* adjustment on the viewfinder. This does not focus the image as it comes through the camera lens; rather, it allows you to make the tiny monitor screen in the viewfinder as sharp as possible for your eye. With the camera on, turn or slide the viewfinder focus adjustment until the video scan lines or printed characters on the screen are sharp. If your camera generates *bars* (a test signal), they provide a sharp image to look at while focusing the eyepiece. Everyone's eyes are different and you should reset the viewfinder focus anytime someone else has been using the camera.

Unlike film cameras, with video cameras you can take your eye away from the viewfinder eyecup anytime you want while shooting. On some cameras you can flip the magnifying lens out of the way for more comfortable distance viewing. Some people who wear glasses prefer to shoot this way. If the camera's diopter won't compensate for your vision, you can switch to contact lenses for shooting, get a prescription diopter lens to put in the eyepiece or use a camera with a viewscreen.

Setting the White Balance

Video cameras need to adjust to the different overall color balance of light indoors and out. When shooting film, questions about the color of light and its suitability for a given film stock are usually talked about in terms of *color temperature* or *color balance*. In video, the same principles are generally talked about with the term *white balance*. Before reading this section, please see the discussion of color temperature on p. 155.

The CCDs in many video cameras are designed so that light of about 3200°K will look natural as "normally" processed by the camera. 3200°K is the color temperature of professional tungsten movie lights. Many cameras have a *white balance* switch with a "preset" position for 3200°K (on some cameras this is labeled "indoors").

Because the color of light in a scene often varies from 3200°K, video cameras need to be able to adjust the white balance. Say you were shooting indoors, using tungsten illumination. Then you decide to take a shot of the street outside. The tungsten light has a lower color temperature (it is more yellow/red) compared to the daylight, which is bluer by comparison. Some cameras can automatically adjust to the difference (see below). On other cameras the white balance is adjusted manually.

Professionals typically reset the white balance manually for every new lighting condition; for example, scenes lit by household bulbs, tungsten movie lights, fluorescents, daylight and shade (no direct sun, just skylight) can all have a different color balance. Whenever the lighting changes they "do a white balance" by holding a white card or piece of paper *in the same light as the subject*, zooming in so the card more or less fills the frame, then pushing the camera's white balance button. The camera's circuits will balance the relative strength of the red, green and blue signals coming from the CCD until the white card looks white on video. (If white objects look white, then the other colors will look natural too.) It does no good if the white card is not reflecting back the same light that is falling on the subject. Be aware of window or artificial lighting that may be coming from different directions.

When you are shooting predominantly in daylight (around 5600°K), most cameras can adjust electronically to the bluer light. On some cameras, the difference between 3200°K and 5600°K is too large for the circuits to handle by themselves. These cameras have a built-in *filter wheel*. The "5600K" position on the wheel inserts an orange filter, which warms up the light coming through the lens before it reaches the CCD. (This filter is similar to the 85 filter used for tungsten-balanced films. It cuts down the light intensity by about ⅔ of a stop; see p. 159). You usually should still do a manual white balance with the filter in place to fine-tune the color.

Sometimes, even after white balancing, the overall color balance you see in the monitor seems too cool or too warm. This may be a problem with the way the monitor is adjusted or just the way the camera's electronics work. Color correction can always be done later during postproduction, but many camerapeople prefer to get the color as close as possible while shooting. One trick is to "fool" the camera by doing a white balance on a nonwhite object. If you balance on a piece of pale blue paper, the camera will try to make the blue appear white, which will warm the entire image (alternately, you could do the white balance with a blue filter over the lens). If you're using lighting, you can do a normal balance using white light, then put colored gels on the lights (see Chapter 11). In general, skin tone looks better if slightly too warm rather than too blue.

For shooting a scene that has light sources of different color temperature, see Mixed Color Temperature Lighting, p. 341.

AUTOMATIC WHITE BALANCE. Many consumer camcorders and some professional ones are designed to set white balance continuously and automatically with

no user input. Experiment with your camera to see how well it works. In some situations, having quick, automated white balance is very convenient. In other situations, such as when you're carefully lighting a scene, auto white balance may prevent you from controlling color the way you like.[2]

Usually the automatic white balance circuit needs a few seconds after a lighting change to make its adjustment. Some systems get confused by very bright light or by light sources such as fluorescent or mercury vapor. Some consumer cameras have no provision for manual tuning of white balance as described above but allow you to choose between "auto white balance" and preset positions for "indoor" and "outdoor." Some cameras have a "hold" function that can be used for manual override of white balance. You can zoom in on a white card, let the camera balance itself, then press "hold."

BLACK BALANCE. Some professional cameras have a *black balance* feature, which ensures that black is truly black with no color cast. A black balance should be done if the camera has not been used for a while or if the temperature has changed significantly. Cap the lens (or close the iris if it closes all the way to "C") and press the black balance control. Then do a new white balance.

Fig. 6-3. Toshiba remote head camera system accepts tiny ½" "Lipstick" and ¼" Micro CCD camera heads (at right) and ½" C-mount (at left). Can be used for hard-to-reach camera angles and point-of-view shots. (Toshiba ISD)

Setting the Exposure

Setting the exposure on a video camera usually begins with adjusting the iris diaphragm (see p. 84) to control how much light comes through the lens. On some cameras this is done by turning the iris ring on the lens (turn toward the lower *f*-numbers to increase exposure); on others cameras there may be a knob or button on the camera body to control exposure.

[2]On some cameras, there is an "auto white balance" button that performs a white balance while you push it. In some sense, this is really a "manual" white balance, and shouldn't be confused with cameras that continuously and automatically alter the balance.

How should you set the exposure? The simplistic answer is so the picture looks good. With too much exposure, the scene on video will look very bright and washed out. The brightest parts of the scene will have no detail at all—just undifferentiated white. With too little exposure, the scene on video will be murky and dark. Now, the darkest parts of the scene will have no detail—just undifferentiated black (see Fig. 4-15).

First make sure the viewfinder or monitor is properly adjusted (see Appendix A). Then set the exposure so the balance between light and dark is as pleasing as possible. The most important parts of the scene—often people's faces—should have sufficient detail and be neither washed out nor murky. Overexposure can be a particular problem with video. Washed-out areas of the frame often look objectionable and may "bloom" or spread into other parts of the frame. Sometimes, however, you have to let a bright sky "burn out" if you hope to see detail in the darker landscape.

In some situations, there simply may be not enough light to shoot, or there may be too great a range between the bright and dark parts of the scene to get a pleasing image. There are several solutions, including using lights or repositioning or adjusting the camera. This discussion of exposure is deliberately simplified. For more precise and specific ways to adjust exposure, see Forming the Video Image, p. 188.

AUTOMATIC EXPOSURE CONTROL. Many video cameras (and some film cameras) have the ability to set the exposure automatically. The automatic control, sometimes called *auto-iris*, is simple to use and performs adequately in some situations, but tends to produce inconsistent results.

The auto-iris mechanism gauges the brightness of the scene and sets the exposure, but it doesn't know which part of the scene you're interested in. Dark or light backgrounds can be a particular problem. If you shoot someone against a bright background or with backlighting, the camera reads the brightness and closes down the iris, often throwing your subject into silhouette. Some cameras have a backlight feature that compensates by opening the iris a stop or more. (See Fig. 4-23 for more on backlight.)

Auto-iris often makes iris adjustments when none is needed. Say you're shooting a close shot of someone taking off a dark sweater, revealing a white shirt underneath. Normally, you would want the exposure to remain constant—you don't want the skin tones and background to change. Auto-iris, however, would close the iris as the white shirt became visible. Similarly, if you pan the camera (turn it horizontally) across a group of dark and light objects, the brightness of the background will change unnaturally as the camera passes the various objects.

Automatic exposure control works best in scenes that are front-lit (where the light comes from behind the camera position), that have relatively uniform backgrounds and where the subject and background are neither excessively bright nor dark. Auto-iris can be a big help in "run-and-gun" documentary situations where your subject changes locations rapidly. Because the automatic features will generally prevent you from overexposing the image, many camerapeople let the auto-iris initially set the iris, then lock the setting in place by switching to manual control. You might let the auto-iris get a reading of a wide shot of the scene, or

you might choose to zoom in on the most important part of the frame. In either case, let the iris adjust, lock it in place, then set the zoom where you want.[3]

Many beginners prefer the supposed security of auto-iris, despite the sometimes odd exposures it produces. Some cameras offer more sophisticated "programmable" automatic control of iris or shutter speed (see The Shutter, p. 185). These may perform better than conventional auto-iris in some situations.

Setting the Focus

Before you can shoot, you need to focus the camera's lens on what you're shooting (see Focusing the Image, p. 86). Most professional cameras allow you to focus manually by turning the focus ring on the lens.

Many consumer camcorders have autofocus capability. These cameras may be difficult or impossible to focus manually. Some autofocus mechanisms judge focus by sending out an infrared signal (like the one your TV remote uses) that measures the distance between camera and subject. Other cameras do a sophisticated analysis of the image at the CCD to maximize sharpness. Like automatic exposure control, autofocus can be very handy and may work fine in some situations. It can be useful when you can't look through the viewfinder or when focusing it difficult. However, autofocus has several drawbacks.

Like automatic exposure control, autofocus has no way of knowing which part of the frame you're interested in. Say you're shooting a man in the foreground who is looking at a mountain in the distance. Normally, the filmmaker should be able to control whether the man or the mountain is in better focus. Using autofocus, however, the camera will usually choose whichever part of the scene is centered in the frame. If you're shooting two people talking to each other across a table, autofocus may not allow you to focus on the people instead of the wall behind them. Some systems will allow you to center on the subject, then "lock" the focus, but this is a real handicap while shooting. Canon has a feature that allows you to select while shooting which part of the frame to use for autofocus and exposure settings.

Situations that can throw off autofocus include low light, shooting through glass or other material (like a scrim or a fence), bright backlight and horizontal stripes. Autofocus systems always do a certain amount of "hunting" to find proper focus. Some are faster than others. Since focus is one of the key creative controls in shooting, autofocus should only be used if absolutely necessary.

THE VIDEOTAPE RECORDER

Video cameras convert light into a constantly changing electrical signal (see The Camera and Monitor, p. 16). It is the job of the videotape recorder (VTR) to

[3]An 18 percent gray card (see The Reflected Reading, p. 142) can be used to as an "average" subject for the purposes of setting exposure. Set the card in the same light as the subject you want to shoot, zoom in on the card and lock the auto-iris at that setting. The video camera can thus be used just like a reflected light meter for film (see Chapter 4).

record that signal on tape. The basic principles of recording video on tape are similar to how audio is recorded on tape (see Magnetic Recording, p. 248).

To record the signal, the VTR sweeps its *record heads* across the tape as the tape moves past them. The heads are magnets that magnetize tiny particles on the tape. To play back the tape, it is rewound and again sent past the VTR's heads. The heads now respond to the magnetized tape particles and convert the changing magnetic field back to an electrical signal, allowing you to see the image again.

Some video recorders record digitally on computer disks instead of tape, but this tends to be more for postproduction, not field recording. For specifics of digital video recording on tape or disk, see Digital Recording, p. 199.

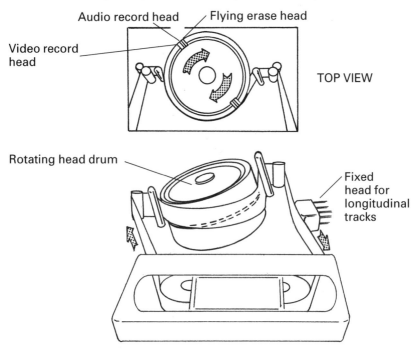

Fig. 6-4. Simplified view of the tape path and heads. Video formats vary widely in the configuration of the heads and the tape path. (Robert Brun)

THE TAPE PATH

When you insert a tape cassette into the VTR, a mechanism inside the machine opens the front of the cassette, pulls the tape out, and wraps it around the *head drum*, which is a fast-spinning cylinder containing various heads (see Fig. 6-4). Other fixed (stationary) heads may be positioned inside the VTR along the tape path. A capstan and pinch wheel are used in both video- and audiotape recorders (see Fig. 9-3) to actually pull the tape along. The VTRs for different video formats can differ quite widely in the way the heads are arranged and in many other aspects of the machines.

Erasure

The erase head clears the tape of any signal prior to recording. This head is essentially an electromagnet that randomizes the magnetic pattern of the tape particles. Older or cheaper VTRs only have a fixed, full-track erase head that erases all the video and audio tracks. If the machine only has a fixed erase head and you try to add a new shot to material that has already been recorded (as is typically done in editing), there will be a moment of image breakup at the beginning and/or end of the new shot. Most newer camcorders and other VTRs are equipped with *flying erase heads*, allowing you to edit or rerecord material without breakup (*glitches*). Flying erase heads are mounted on the rotating head drum and can begin or end erasure cleanly at a selected point. In some machines, they allow you to erase video without affecting linear audio tracks.

The Head Drum

The tape wraps diagonally around the cylindrical head drum. The drum has a slot cut in it, out of which the heads protrude slightly. VTRs have two and sometimes many more heads in the drum which rotate along with it. During recording, each head sweeps a path across the tape, magnetizing a diagonal swath (called a *helical scan*). Just as one head finishes its swath, another head rotates into position to begin its swath. Sometimes at the bottom of a TV screen you can see the *head switch*, where the signal switches from one head to another.[4]

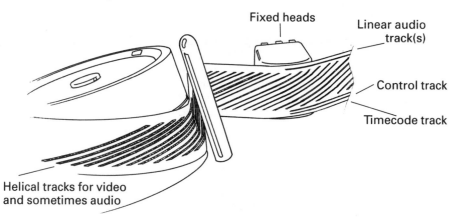

Fixed heads

Linear audio track(s)

Control track

Timecode track

Helical tracks for video and sometimes audio

Fig. 6-5. The rotating heads record helical tracks while fixed (stationary) heads record the linear (longitudinal) tracks sometimes used for audio and/or control track signals. Track and head layouts vary by format. (Robert Brun)

The faster the heads move across the tape (*write speed*), the better the quality of signal that can be recorded. This is partly a function of how fast the tape moves through the machine. A VHS tape recorded in *SP* (*Standard Play*) mode will look better than if you use the slower *LP* (*Long Play*) or *EP* (*Extended Play*) modes. The

[4]Some VTRs are available in two-head and four-head versions. With four heads the VTR can get cleaner reproduction of still (freeze) frames.

only reason to use slower speeds is that you can record more time on the same-length of tape (but the fastest speed should be used whenever possible). Write speed is also a function of how fast the heads rotate. Some VTR formats use very fast rotating heads on slow-moving tape to allow high quality *and* long record times. DV heads rotate at an amazing 9000 rpm.

Other Tracks

Along with the picture information, some VTRs record a *control track* on the tape. Control track pulses can be thought of loosely as electronic sprocket holes, which guide the video playback. In some video formats (like S-VHS), the control track is a separate physical track on the tape; in others (like Hi8 and DV), the necessary control information is embedded in the video signal.

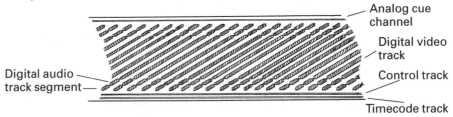

Analog cue channel

Digital video track

Digital audio track segment

Control track

Timecode track

Fig. 6-6. Digital videotape track layout. Individual formats vary in the number, type and position of tracks. (Robert Brun)

All videotape formats record the video signal in diagonal tracks (helical scans) across the surface of the tape using the rotating heads. Some video formats record audio information the same way. Most formats also employ fixed heads to record *longitudinal* (also called *linear*) tracks along the edge of the tape (see Fig. 6-5). Depending on the format, longitudinal tracks may be used for recording audio, timecode and/or control track information. (for more on audio tracks, see Audio for the Video Camcorder, p. 259).

OPERATING THE CAMCORDER

Before you shoot, be sure to charge and/or check the batteries (see Batteries and Power Supplies, p. 182). Set the timecode, if any (see Timecode, p. 196). After inserting a fresh tape cassette into the VTR, run at least 30 seconds into the tape before starting critical recording. Professionals usually record 30 seconds of *bars and tone*, using the camera's color bar generator and an audio test tone from the camera or the sound mixer (see Recorded Information, p. 279, and Bars and Tone, p. 404). If you anticipate needing to change tapes quickly, you can record bars and tone on several tapes at the start of the day, advancing the timecode for each (make sure the camera's code is the same as the tape when you put each tape back in to actually shoot with it).

See Audio for the Video Camcorder, p. 259, as well as the rest of Chapters 9 and 10 for information on audio recording. We'll assume here that audio is ready to go.

When you're ready to start shooting, make sure the viewfinder is focused for

your eye, and that you've checked or set the white balance, exposure and camera focus (see pp. 171–175).

All cameras have a *trigger* to start and stop the VTR (push once to go into "Record" mode, push again to stop). Many camcorders have a two- or three-position power switch (or there may be more than one switch) to allow you to put the camera in different states of readiness. In one state, power is supplied to the camera so you can see through it, but the tape is not threaded in the VTR and the head drum is not spinning. This is sometimes called "Save" mode. In another state, the tape is threaded, the heads are spinning, and the tape will start recording immediately when you push the trigger (sometimes called "Standby" or "Operate" mode). The names vary from machine to machine, and not all camcorders have a true "Save" mode.

"Standby" mode should be used when recording is imminent. It allows you to roll tape instantly and generally ensures a clean transition from one shot to the next. However, when you are paused between shots, the "Standby" position drains the battery faster and can wear down the tape or heads if you park in the same spot on the tape too long. Going to "Save" mode disengages the tape and stops the heads from spinning. This conserves power and cuts down wear and tear, but when you are ready to shoot, the camera takes a few seconds to come up to speed. If there is fast-breaking action, it's probably best to leave the camera in "Standby." If you know it will be several minutes between shots, switch to "Save" or power down the camera completely (some cameras switch to "Save" automatically after a little while).

Newer camcorders are generally designed to provide seamless transitions between shots. If you stop the camera or even take the tape out and put it back in, the camera will ensure that the new shot begins without a glitch.[5] On older cameras, every time you stop the tape and then start again, the image breaks up briefly at the transition. If there is breakup between shots, it's very important to let the image stabilize for six to ten seconds before any action begins on the new shot. This *preroll* is crucial in editing for the machines to lock to the control track or timecode.

When you've finished recording a tape, remove it from the VTR and slide the *record lock* on the cassette to prevent accidental erasure (on some cassettes this is a removable plastic button). Label all tapes before shooting or immediately after. Indicate the name of the project, the production company, the date, the cassette number, the timecode (if any) and be sure to write CAMERA ORIGINAL or apply the manufacturer's premade sticker. It often helps to write some notes about the tape's content as well. See Chapters 8, 10 and 12 for more on logging and notekeeping.

The *tally light* in the viewfinder indicates when you're recording, or, for a switched, multicamera shoot, when the camera is being selected ("taken"). There is usually a tally light on the outside of the camera so everyone knows when you're recording. For documentary work, many filmmakers put a piece of tape over it.

[5]If you play back or take out the tape, it's a good idea to rewind briefly from the end of the recorded material, play forward and pause at the last bit of good video to ensure that the camera can lock on to the image. On some cameras, a continuous image will be maintained if the power switch stays in "Standby" position between shots, but not if you switch to "Save" mode.

Recording Problems

If the heads become clogged with tape particles or dirt, they won't make good contact with the tape. The resulting image may be noisy (*video snow*) or contain many *dropouts* (momentary loss of recording that often appears as horizontal white or black lines). To clean the video heads, get a *head-cleaning cassette* and run it like a tape through the machine for about 10 seconds. Never rewind or reuse the head cleaner. Some people clean the heads on a regular basis; others only when the heads are obviously dirty (as indicated by bad recordings).

For persistent clogs, get head-cleaning fluid and a cleaning swab (*not* a Q-Tip; see p. 276). With no tape in the deck, clean the rollers and the tape path. Swab *very gently* over the heads *horizontally* along the tape path. Do not rub up and down (perpendicular to the tape path.) It is very easy to damage the heads, so avoid manual cleaning if possible.

Humidity can also cause recording problems. Avoid steamy locations when possible. In winter, when bringing a cold camera into a warm house, allow it to warm up in a sealed plastic bag to avoid condensation. When shooting in cold weather, try to keep the camera warm. Frozen tapes should be warmed before use. A hair dryer on *low* heat or air setting is sometimes used to warm or dehumidify equipment.

Tape Stock

Like audiotape, videotape is composed of a *base* or backing material (usually mylar) that provides the dimensional strength and stability, and a thinner magnetic layer that actually records the video signal. The magnetic layer was once made up primarily of ferric (iron) oxide. Now manufacturers make a variety of formulations for the magnetic layer, ranging from various oxides to higher-quality "metal" tapes that have no oxide. The word *oxide* is sometimes used to mean standard-grade tape; other times people use it just to refer to the magnetic layer in general.

A higher-quality tape will have fewer defects and may allow you to record with less noise, clearer color and better detail. But picking a tape stock is not like picking a film stock. Film stocks vary in terms of basic color palette, contrast, and sensitivity to light. In video, the camera itself determines most of these things. The same video stock serves equally well for recording color or black-and-white, in daylight or indoor illumination.

Since tape stocks continually evolve, ask a professional for advice on picking a stock. If you are renting a camera, the rental house will often have a preference. Low-quality tapes may shed their oxide, clogging the heads and causing dropouts. In the Betacam and ¾" U-Matic formats, there is a standard oxide, and a more expensive metal tape for *SP* (*Superior Performance*) operation. The metal tapes are not only higher quality, but SP machines often require metal tape. Some analog Betacam SP VTRs can record four audio channels with SP tape, but only two with standard oxide. Some Beta SP VTRs are actually damaged if you try to record with nonmetal tape (but can play back standard oxide). Hi8 cameras cannot record in Hi8 mode with standard 8mm cassettes (which are a lower grade).

As video formats become smaller and attempt to record more information on

narrower and shorter tapes, the quality of the tape stock becomes more important. *Metal particle tape* (*MP*) offers improvements over standard oxide, and *metal evaporated tape* (*ME*) is better yet. While ME is a good camera stock (though it may clog heads in some machines), it may be too fragile for typical editing use, where constant shuttling can wear the tape down. Manufacturers' claims on the virtues of new tape formulations should be checked by shooting tests or asking advice. Advertised specifications on "high-frequency response" correspond to the tape stock's ability to render detail and edge sharpness; "coercivity" is the stock's ability to retain the magnetic signal.

Cassettes come loaded with different-length tapes. Often, longer tapes are less expensive per minute of running time, and allow you to make fewer tape changes while shooting. On the other hand, in some formats long-playing tapes may use tape stock with a thinner base. These stocks may be more vulnerable to stretching and breaking and should be used with care.

Though tape stock is in theory reusable, each pass through the VTR adds to the likelihood of dropouts or other defects. Professionals generally only use fresh, virgin tapes for critical camera recordings, using the best-quality tape stock they can afford. Digital tape formats may have more leeway for reusing tapes. For editing purposes, used stock is fine for work tapes. Tape suppliers may be able to give you a good price on *one-pass* stock that has been run through a machine only once.

UHF

S-video

BNC

RF or f connector

Fig. 6-7. Common video connectors. See Fig. 9-20 for other connectors used for video and audio. (Robert Brun)

STORING TAPE STOCK. Improperly stored videotape can deteriorate in various ways, including becoming brittle, stretching or losing its magnetic charge. To maximize usable life, keep tapes away from any magnetic fields (including electric motors). Store them in spaces that would be comfortable for humans—Sony recommends medium humidity (neither very dry nor very moist) at temperatures from 59° to 77°F. Tapes should be fully wound or rewound and stored upright. No one knows exactly how long newer tape formulations will hold up. Since all tape formats eventually become obsolete, it's a good idea to transfer important archive masters to a new format every several years. CD/DVD and other optical disc formats may make better archive media than DAT and other tape formats.

BATTERIES AND
POWER SUPPLIES

Cameras, VTRs, audio recorders and most film cameras need electric power to run. For a shoot to go smoothly, you must have power when you need it.

AC Power Supplies

For interior work, you can use an *AC power supply*, which is plugged into the wall (wall current is called the *mains* in the U.K.) With AC power, you never run out of juice, but your mobility is limited by the cable. When shooting in a foreign country, keep in mind that different countries have different types of power (see Electric Power, p. 344). The AC power may be supplied at 120 or 240 volts at a line frequency of 50 or 60 Hz. In some places what comes out of the wall isn't AC (alternating current) at all. Many power supplies and battery chargers can accommodate different types of power (either automatically or with a switch). In some cases, you have to convert the power to a different standard before plugging in (see p. 344). Check the manual that came with your equipment.

Battery Power

For shooting in the field, and when portability is important, rechargeable batteries are used to power the camera. Most camcorders and 16mm film cameras use "on-board" camera-mounted batteries that range from several ounces to a few pounds. Battery belts and packs can also be used, especially for larger cameras. Batteries have to be managed carefully so you don't run out of power when you need it.

There are several types of rechargeable batteries. *Nickel-cadmium* (*NiCad*) batteries have been the most widely used camera battery. Other battery formulations gaining popularity include *nickel-metal-hydride* (*NiMH*) and *lithium-ion* (*Li Ion*), which are more expensive and supply more power than a NiCad in a smaller, lighter package. *Lead acid* batteries (what cars use) are heavy for the amount of power they supply. These may be used for powering lights directly or sometimes for a camera using a car's cigarette lighter adaptor.

Estimating your battery needs with a film camera is relatively straightforward. Talk to others or check the manual to determine how much film your camera will

shoot per battery. If you know how much film you plan to shoot, you know how many charged batteries you need for the day.

Since video cameras (and audio recorders) use power whether they're rolling tape or merely standing by with the circuits on, it's harder to estimate battery needs. You could spend hours rehearsing actors on camera, then run out of power before shooting a minute of tape. You can determine how much continuous recording time a battery will supply, then figure you'll need power for at least two to three times longer—for the time when you're looking through the camera but not actually recording. It's better to be safe than sorry, so bring as many batteries as you can afford or lift (professional NiCads can be *heavy*). You can nurse batteries along by powering down the camera or by going into "Save" mode when not recording (but it's probably not worth powering down for less than a few minutes' break). Avoid rewinding tapes when you're trying to save battery power.

Check batteries often during use to determine how much capacity is left. Bear in mind that most rechargeable batteries will put out their full rated voltage until just before they're depleted (at which point the voltage drops sharply), so battery checks may not give much prior warning of low charge. Batteries should be checked under load (with the camera running) if possible. Sony offers a camcorder system that displays how many more minutes of use the battery has in it.

Batteries put out much less power when they're cold. For cold-weather shooting, keep the battery warm until you're ready for it or get an extension power cable so you can keep the battery inside your coat while shooting. Camera-mounted lights (and video taps on film cameras) consume a lot of power. It's always safer to give them their own battery (separate from the camera's) to be sure you can keep the camera running even if the other systems run out of juice. A battery belt or battery pack makes a good auxiliary supply. On an expedition where normal battery charging is difficult, consider a solar-powered charger or a lithium, high-capacity, nonrechargeable expedition battery.

For many types of smaller equipment that consume less power (including audiotape recorders, microphones and wireless transmitters) nonrechargeable batteries are often preferred because they allow longer continuous service without changing the batteries. Alkaline batteries provide more power than standard cells. Lithium and other expensive types are better yet. When replacing any battery, be sure the polarity is correct (that is, the plus-minus orientation of each cell). If the equipment uses several batteries together, never replace less than a full set. Reversed or dead cells will drain the others.

Battery Charging and Maintenance

There are many types of batteries and chargers, so be sure to read the manual that comes with your equipment. Generally, the more power a battery puts out, the more time it needs to charge. Some chargers are designed to switch off when the battery is fully charged. With others, you must unplug the battery when done. Overcharging a battery can destroy it. If the charger isn't one that automatically shuts off, unplug a battery if it feels hot.

Slow chargers are the least expensive, and can take up to 16 hours depending on the system. This can make it hard to keep batteries fully charged if you're on the

road or shooting every day. *Fast chargers* may work in as little as an hour, and can make all the difference for recharging during a shoot. Sometimes not all the cells in a battery get full on a fast charge. Some electronic chargers are designed to do a quick charge and then go into *equalize* mode, topping off all the cells. Most rechargeable batteries will slowly lose their charge just sitting on the shelf. Be sure to recharge just before a shoot. Even better, get a charger that will maintain a full battery for months by delivering a continuous *trickle charge*.

Charge a depleted NiCad as soon as possible after use and charge batteries every few months if unused. Batteries retain their charge best in a cool place. 0° to 10°C is ideal. However, never try to charge a cold or frozen battery. Warm it up to room temperature first. As noted above, cold batteries put out less power when you use them. Don't charge batteries if the temperature is above 110°F.

There is a lot of debate about the concept of battery *memory*. Some people claim that if a NiCad battery is repeatedly discharged only partway and recharged, it will eventually lose its ability to store a full charge. Anton Wilson (of Anton/Bauer, makers of widely used batteries) points out that this memory effect only happens if the battery is discharged to *precisely* the same amount each time, and that even then the problem can be corrected by a few full discharge/slow-charge cycles. To avoid any memory problems, be sure to discharge a battery fully each time you use it (until the low battery warning comes on in the camera) and rotate through your batteries by starting with a different one each day. Overdischarging can harm a battery as much as overcharging. Most video cameras will shut off before overdischarging a NiCad, but a lighting fixture will drain it past the safety point. NiMH and Li Ion batteries have no memory effect at all.

Fig. 6-8. Mighty Wonder Pod shoulder brace can be used to steady a camera that doesn't balance on the shoulder. Shown with Sony DCR-VX1000 DV camera. (Videosmith, Inc.)

Nicads and other rechargeable batteries have a limited life both in terms of age and the number of discharge/charge cycles. You should expect to get around 400–600 cycles before a NiCad will not take a full charge. You can often replace just the cells in a professional NiCad, saving the cost of buying a whole new battery.

ADVANCED CAMERA FEATURES

Camera Sensitivity

Camera CCDs have improved a great deal in their sensitivity to light. Even a consumer Hi8 camera may be usable in candlelight, though the image-rendering may not be ideal. Some cameras have a *gain* or *sensitivity switch* that boosts the camera's sensitivity. Increasing gain also increases noise in the image, which looks a bit like graininess in film. Video gain is measured in dB (decibels). A typical gain switch might include settings for 0, +9 and +18 db. Boosting gain 6 dB doubles sensitivity, equivalent to opening up one stop. (In film terms, like doubling the ASA or pushing one stop). Switching to +18 db is like opening up three stops. Usually, small increases in gain can improve the image in low-light situations without introducing too many image defects, but higher increases may show noticeable noise and should only be used if necessary. Experiment with your camera.

In sunlit scenes, there is often too much light for the CCD. Even with the lens iris closed down to minimum aperture, the image may look overexposed. Professional cameras equipped with an internal filter wheel may offer a choice between settings at 5600K, 5600 +¼ND and 5600 + ¹⁄₁₆ND. The first position inserts an orange filter that warms the light and cuts down the intensity by not quite half (⅔ stop; see Color Conversion Filters, p. 159). The second position adds a neutral density filter (see Neutral Density Filters, p. 160) which cuts the light to ¼ its previous level (this is a .06ND which cuts out 2 stops). The last position cuts the light to ¹⁄₁₆ (a .12ND or 4 stops). Some newer cameras have a position on the gain switch that *decreases* sensitivity for overly bright situations.

The Shutter

In the United States, Canada and other countries where the NTSC standard is used, video is generally shot at 30 frames per second (see The Raster, p. 17). Since each frame is made up of two fields, this means that the CCD scans the image 60 times a second. Each field then is effectively exposed to light for ¹⁄₆₀ second (this is the normal "shutter speed" of the camera).[6]

Many video cameras are equipped with an adjustable *high-speed shutter*, which can shorten the length of exposure for each frame. Some high-speed shutters are capable of shutter speeds up to ¹⁄₁₀,₀₀₀ second or more (the faster the shutter speed, the shorter the exposure). Unlike a film camera, this shutter is not a moving mechanical part. The video shutter works by reducing the amount of time the CCD collects light for each field. Bear in mind that using a higher shutter speed does not mean the

[6]The PAL/SECAM standard is 25 fps; ¹⁄₅₀ second shutter speed.

camera records more frames each second. An NTSC standard camera still records 30 frames a second, but each frame is exposed to light for less time.

Why use a higher shutter speed? In a normal film or video image, any movement in the frame (whether caused by the camera or the subject moving) will have a certain amount of blur. This blur looks natural at normal playback speed, but if you plan to slow the footage down or display still frames, you can make each frame crisper by using a higher shutter speed. This is typically done for analyzing sporting events. Using high shutter speeds can cause certain image problems (see Strobing or Skipping, p. 49; for more on slow motion, see p. 51).

Since high shutter speeds cut down the exposure time, you will need more light if you increase the shutter speed. Very high speeds usually are only feasible in bright sun. Conversely, in a situation where you want to keep the iris open to achieve short depth of field, you can use the variable shutter to reduce exposure if the scene is too bright (see p. 48).

Some cameras have a shutter speed setting that is *slower* than normal (for example, ⅟30 second for standard NTSC cameras). This results in strobing if there is any camera or subject motion, since one exposure effectively stretches across more than one frame. This can be used for shooting stationary scenes in very low light or for special effects.

Some cameras have special shutter settings to allow you to shoot different kinds of computer and video monitors without flicker. Sony's system is called Clear-Scan. See Chapter 17 for more on shooting monitors.

In-Camera Effects

Many video cameras have a range of capabilities for in-camera visual effects. These may include generating titles, doing fades and dissolves, in-camera editing, colorizing or distorting the image. See your camera's manual for details. In general, it is far better to do these effects in postproduction than in the camera.

Some cameras are capable of shooting individual frames, allowing you to do time-lapse or animation work (see pp. 53 and 54).

Many DV cameras have a setting that allows you to easily capture a still image and record it on a few seconds of tape with audio to identify it. Some of these record progressive scan images (all the scan lines in one frame), giving you a high-resolution still image. Still images derived from conventional video cameras are half-resolution, since each field only contains half the scan lines (see Fig 1-14).

Camera Chips and Pickup Tubes

Before CCDs (see Figs. 1-13 and 1-28) were used in cameras to transform light into a video signal, *pickup tubes* were used. These work a bit like CRTs, but in reverse (see Chapter 1). Tube cameras are finicky to work with. The three color signals can go out of registration and the tube can become permanently burned if aimed at a bright light. Tube images sometimes suffer from *lag*, where a bright object leaves a trail behind it.

CCDs are much more stable than tubes, but suffer from other image defects, such as *smear* in which a bright object causes a streak that extends vertically up and down from the object. There are many types of chips (IT, FIT, Hyper HAD,

etc.) offering improvements to increase sensitivity and decrease image defects. Three-chip cameras (one each for red, green and blue) are generally preferable to single-chip cameras.

Many professional camcorders use ⅔″ chips, but chips are getting smaller and some camcorders have CCDs as small as ⅓″ or ¼″. The smaller the chip, the smaller you can make the camera. However, using a very small imager (CCD) may result in lower picture quality, especially if the image will be shown on a large screen. The more pixels across the chip, the sharper the image. But more pixels on a smaller chip means less light strikes each pixel, which compromises sensitivity. Many camcorders are rated in terms of how many *lux* they need to operate. Like foot-candles, lux are a measure of light level (see Chapter 4). Bear in mind that image quality is usually impaired when operating at minimum light levels.

The size of the CCD affects the angle of view afforded by a lens of a given focal length (see Focal Length and Format, p. 83).

Digital Signal Processing

The new generation of digital cameras have a growing assortment of sophisticated image controls and features. Some of these features require a fully digital camcorder, others only require that the camera head be digital even if the VTR is analog.

A *setup card* is an insertable memory chip that can be programmed to adjust various aspects of the picture, including contrast and color balance. A setup card can be used to try to make a video camera mimic various film stocks. The card can be set to a cameraperson's preference, then brought from shoot to shoot or used to ensure consistency on a multicamera shoot.

Some cameras can capture a previously recorded image and superimpose it in the viewfinder, allowing you to re-create a setup taped earlier. Another system records camera settings for each shot on the cassette, aiding in reviewing or re-creating shots.

Sony's Cliplink system allows the cameraperson to identify important shots while shooting, and have information about those shots downloaded to the editing system, which is especially helpful in fast-paced newsgathering and editing.

Some digital cameras can target individual tonal areas in the frame and process them individually. One system can detect skin tones and soften skin texture for a more flattering look while leaving the rest of the image sharp.

The Video Image | CHAPTER 7

This chapter provides more technical information about video recording in production and postproduction. See Chapters 1, 6 and 14 for the fundamentals of video recording, cameras and editing.

FORMING THE VIDEO IMAGE

The Video Camera's Response to Light

In Chapter 6 we outlined a simplified way of adjusting the exposure of the video image when shooting. It's useful to learn a more exact basis for setting exposure and video levels in production and postproduction.

The camera's CCD can be thought of as a device for converting light into an electrical signal (see Video Systems, p. 16). Generally speaking, the more light that strikes the CCD, the higher the voltage of the signal. But to look more closely at the relationship between light and the resulting video signal, we can draw a graph like the one in Fig. 7-1. The amount of light striking the CCD increases as we move from left to right.[1] Look at the curve marked "A." Note that below a certain amount of light (the far left side of the graph), the system doesn't respond—this is the *black clip* level. Then, as the exposure increases, there is a corresponding increase in the signal. Above a certain amount of exposure, the system stops responding. This is the *white clip* level. You can keep adding light, but the signal won't get any stronger.

This is much like a characteristic curve for film (see p. 114). When the exposure for any part of the scene falls below the black clip level, that area in the image will be undifferentiated black. Anything above the white clip will be bright and featureless white. For objects to be rendered with some detail, they need to be exposed between the two.

[1]By the "amount of light" we mean *exposure*, which is determined by the amount of light in the scene, the setting of the lens iris, filters being used and the setting of the electronic shutter.

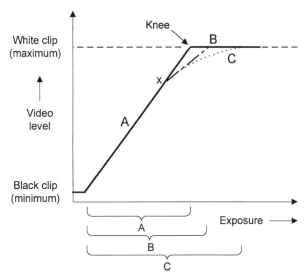

Fig. 7-1. Video cameras' response to light. The horizontal axis represents increasing exposure (light) from the scene; the vertical axis is the strength of the resulting video signal. With conventional video cameras (A) the signal strength increases in a straight line as exposure increases and is then clipped off abruptly at the white clip level. With a knee-compression circuit (B) the knee point is moved down (to "x"), allowing the camera to capture brighter highlights, extending the exposure range of the camera. Some digital cameras can approximate the "soft shoulder" of film (C), allowing a more gradual transition into overexposure, and increasing the "highlight handling" ability of the camera by two stops or more compared to A.

The response curve helps explain why the world looks very different to the naked eye than it does through a video camera. Your eye is more sensitive to low light levels than most video cameras are—with a little time to adjust, you can see detail outdoors at night or in other situations that may be too dark for the camera. Also, your eye can accommodate an enormous *range* of brightness. For example, you can stand inside a house and, in a single glance, see detail in the relatively dark interior and the relatively bright exterior. Video and film systems are much more limited in the range from bright to dark that they can capture with any detail. When shooting, you may have to choose between showing good detail in the dark areas *or* showing detail in the bright areas, but not *both* at the same time (see Fig. 4-15). Kodak estimates that many of their color negative film stocks can accommodate about a ten-stop range of brightness (a *contrast ratio* of about 1000:1 between the brightest and darkest value). Video cameras can generally handle a more limited range, some as low as about five stops (40:1).

The image in Fig. 4-23 was shot with film; the middle shot shows a "compromise" exposure that balances the bright exterior and dark interior. With video it is often harder to find a compromise that can capture both; instead you may need to expose for one *or* the other (see Controlling Contrast, p. 191).

Measuring Video Levels

A *waveform monitor* gives us a way to actually measure the level of the video signal. The waveform monitor measures each line of video as it is scanned and displays the video level (voltage) for each point in the frame (see Figs. 7-2 and 7-3). It can be valuable for shooting and indispensable for setting levels in postproduction.

The waveform monitor can be set to read in *IRE* (Institute of Radio Engineers) units. Zero IRE units represents absolute black. Actually, in NTSC video, blacks are clipped below 7.5 units, so the darkest part of a scene will read no lower than 7.5 units (between 0 and 7.5 is sometimes called "blacker than black").

At the other end of the scale, 100 IRE units represents *peak white* level, which is the maximum voltage the system can effectively handle (sometimes called *100 percent picture white*).

Because of broadcasting requirements, the video level should generally not go above 100 units. As noted above, there is a white clip circuit that prevents the signal from going much higher. The white clip is why overexposed parts of the frame show no detail. Say you were taking a shot of the landscape, and the sky was being

Fig. 7-2. Waveform monitor. (Tektronix)

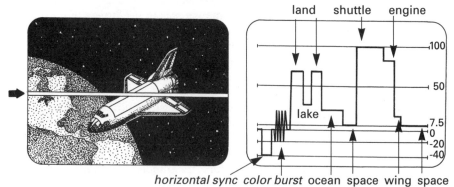

Fig. 7-3. The waveform monitor display of a single horizontal line (at left) shows video levels across the picture. (Robert Brun)

exposed at 100 units. If there was a particularly bright cloud that would naturally read at 130 units, the white clip would cut off (clip) the brightness level of the cloud near 100. The sky and the cloud might then be indistinguishable. When there is a lot of clipping in a bright area, it will seem to "bloom" and have no detail.

Some cameras display video levels in the viewfinder using a *zebra* indicator. This superimposes a striped pattern on the image wherever it exceeds a preset level. In some cameras the zebra level is set at about 80–95 IRE units. This gives the cameraperson warning of areas that are approaching the clipping level. Some people prefer to have the zebras set to kick in right at 100 units. This is very close to the clipping level. With zebras set at 100, you might open the lens iris until the zebra stripes appear in the brightest areas and then close slightly until the stripes just disappear. In this way, you are basing the exposure on the highlights, and letting the exposure of other parts of the frame fall where it may. However, sometimes, to get proper exposure on an important part of the frame (say, a person's face) you must allow highlights to be clipped. The zebra stripes give you warning about where you're losing detail.

Since it is usually an advantage to expose flesh tones consistently from shot to shot, some people base the exposure on the face. Exposure may be set so Caucasian skin reads between 60 and 80 units. Some cameras are set up so the zebra indicator kicks in at about 70 units as a way to position white flesh tones. Black skin will read darker. Bear in mind that many scenes call for flesh tones to read higher or lower than this "standard."

Controlling Contrast

As noted above, the world is naturally a very contrasty place—often too contrasty to be captured pleasingly on video. Contrast is important because it affects not only where you can see detail in the scene, but also the "feel" of the image. When the lighting contrast of a scene exceeds the camera's ability to capture it, there are a number of things you can do (see Setting Lighting Contrast, p. 337).

The video system's response can also be adjusted to achieve different "looks" in terms of image contrast.

HIGHLIGHTS AND OVEREXPOSURE. In film, there tends to be a fairly gradual transition from normal exposure to overexposure; the shoulder of the curve is relatively "soft" (see Fig. 4-4). In video, the camera's response to light cuts off abruptly at the white clip level—one object can be normally exposed and an object just slightly brighter will appear as completely overexposed and lacking detail. To compensate for that, some cameras use a *soft clip* or *knee-compression* circuit. The soft clip compresses the highlights, bringing down the level of bright areas (see Fig. 7-1). Parts of the scene that would otherwise be overexposed can be captured with some detail, allowing you to see detail in, say, a sunny background while you're shooting in the shade (helping you find the kind of "compromise" exposure discussed above). If too much compression is used, the image may lack contrast or "snap." Some cameras have a *dynamic contrast* circuit that can automatically increase compression for contrasty scenes that have extreme highlights, and decrease it when not needed. Experiment with this feature to see its effects.

GAMMA AND CONTRAST. In film usage, *gamma* refers to the slope of the straight line portion of the characteristic curve (see Chapter 4). In video usage, gamma refers to the slope specifically in the midtone region of the response curve. Cameras, telecines and other equipment allow gamma to be set at various levels. Setting the gamma low will flatten contrast. It has the effect of "stretching the blacks" (allowing us to see more gradations and detail in the shadows) while compressing the whites. Low gamma tends to soften or desaturate colors. Increasing the gamma increases contrast. This has the effect of "crushing the blacks" (losing detail in the shadows) and stretching the whites. Colors look more saturated or garish when the gamma is high. Some digital cameras allow the use of "setup cards" with preprogrammed gamma settings, allowing you to produce different effects in different scenes.

PEDESTAL AND BLACKS. The *pedestal* is the level of darkest black in the video signal (it is the level a camera puts out with the lens cap on). Pedestal, also called *setup level*, is normally set at 7.5 units in NTSC. Any blacks falling below 7.5 units will be clipped by the video system, much the way signals above 100 units are clipped. If shadows are too dark, blacks will be "crushed" and show no detail. Sometimes people raise the pedestal above 7.5, causing the darkest tones to become grayish instead of rich black. This can be used to create a softer look. Raising pedestal causes midtones to become brighter too—but not as much. Highlights will not be affected at all. Turning the brightness control up on a TV gives you a sense of this effect; see Appendix A.

Broadcast Standards

Setting video levels is partly a means to getting a pleasing picture and partly dictated by the engineering requirements of the video system. Levels that are slightly too high or too low in shooting can be adjusted in postproduction. However, detail that is lost to gross over- or underexposure cannot be reclaimed later.

You have more flexibility in setting levels if the final tape is not going to be broadcast. When you submit a tape for broadcast, or even for finishing in a postproduction house, a technician will scrutinize it for proper levels. For example, PBS guidelines call for video levels not to exceed 105 percent without clipping (peaks should not be flattened by trying to exceed the clipping level). Technicians typically try to adjust the image so that the brightest white reads near 100 units and the darkest black reads at 7.5 units. However, scenes are sometimes deliberately shot with nonstandard levels. For example, you might use smoke or a low-contrast filter to soften contrast by bringing up the dark tones to gray. In this case the darkest black level may read above 7.5 units. Similarly, you might shoot a night scene that lacks any bright areas that can be set as high as 100 units.

Broadcasters have numerous requirements pertaining to the technical aspects of the video signal. The term *broadcast quality* comes from requirements for the video *signal*, not the way the picture *looks*. Something that looks fine to you may not pass muster for technical reasons. When preparing a tape for broadcast, consult a technician and discuss any potentially problematic equipment or scenes in advance.

The Raster Revisited

Earlier, we outlined the basic structure of the video raster—the pattern of lines used to reproduce the image (see Video Systems, p. 16). It's helpful to understand a little more about the way the system works.

Only part of the video signal is actually visible on screen. As the CRT sweeps across the screen, it completes one horizontal scan line, then the beam shuts off as it returns (*retraces*) to start the next line (see Fig. 1-13). The period that the beam is off is called *blanking*. Horizontal blanking occurs at the end of every line, and *vertical blanking* or the *vertical interval* occurs after every field while the beam returns to the top of the screen.

In the NTSC system, there are a total of 525 horizontal scan lines, but 40 of them are used for vertical blanking. The remaining 480 are considered *active picture area*. Actually, just as a picture frame covers up the edges of a painting, a video monitor frames out some of the active lines. What you see on screen is usually somewhat less (as low as 450). If you switch a monitor into "overscan" mode, you can see lines that are normally obscured.

In digital systems, it is common to refer to the raster in terms of the grid of pixels. The digital version of a typical NTSC signal has about 480 pixels in the vertical dimension (corresponding to the scan lines of the active picture area) and 720 in the horizontal dimension. One of the HDTV formats has a pixel grid of 1920 horizontal × 1080 vertical.

RESOLUTION AND SHARPNESS. The *resolution* of a video image refers to its ability to reproduce fine detail. When fine detail is rendered clearly, an image will usually look sharp to the eye. But sharpness is a complicated topic. There are many factors that come into play in determining overall sharpness. These include the measurable fine detail of the image (resolution), the contrast of the picture and the distance from which we view it (the farther and smaller an image is, the sharper it looks).

In the vertical dimension of the frame, resolution is limited by the raster of the video system being used. NTSC has 525 scan lines, PAL and SECAM have 625 lines. By using more lines, PAL and SECAM are capable of a sharper image. When you are comparing two VTR formats (say, Betacam and VHS), as long as they both belong to the same system (NTSC or PAL/SECAM) their resolution in the *vertical* dimension has the same limits.

However, different camera and tape formats *do* differ in terms of their resolution in the *horizontal* dimension. Some formats cram more pixels into each horizontal line. As a way to compare different formats, we need a measure of resolution along the horizontal dimension.

To do this, a measurement can be made of finely spaced vertical lines. The higher the resolution of the format, the smaller and more tightly packed the lines can be and still allow us to distinguish them. As Joe Kane puts it, "How small can a picket fence be in size and still have the individual slats show up?" The measurement is called *TV lines per picture height*. "Per picture height" means that instead of counting lines all the way across the frame, we only measure the same distance as the height of the picture. This allows comparisons between widescreen and non-widescreen images.

Don't confuse TV lines with the horizontal scan lines described above, or with

the line-pairs-per-millimeter measurement used to evaluate film stocks. If someone says, "DV has a resolution of 500 lines," that person is referring to TV lines per picture height. TV lines are a fairly inexact, simplified way to discuss resolution.

Bear in mind that even if a *format* is theoretically capable of a certain resolution, a low-resolution camera CCD, soft lens or unsharp monitor may reduce the actual performance. The term *resolution* is also used to describe how much data is stored for each frame. See Resolution, p. 33.

VIDEO FORMATS AND FEATURES

Color Video Systems

For the basics of video color, see Chapter 5. For an introduction to composite and component systems, see p. 19.

The camera's CCD generates three distinct color (chrominance) signals—red, green and blue (R, G and B). From the R, G and B signals, the camera produces a luminance signal (represented with the letter Y) that corresponds to the brightness of the picture. How these four signals (R, G, B and Y) are processed and routed through the video system has a big impact on the quality of the image and on what types of equipment you can use together. The way a system handles color is sometimes called its *color space*. These are the four major methods currently in use:

1. **Composite video.** R, G, B and Y are merged (encoded) into one signal that can be sent in a single wire. Simplifies recording and broadcast but results in a lower quality image.
2. **Component video.** Effectively separates each of the three colors and luminance. Uses three wires: Y and two "color difference signals" (R minus Y; B minus Y). You will find component written variously as "Y, R − Y, B − Y" or "YUV" or "YC_rC_b"—all mean the same thing. Used in Betacam, D1, DV and other formats. High-quality image with excellent color reproduction.
3. **Y/C,** also called **S-video (Separate video).** Combines the colors into one chrominance signal (C) but keeps them separate from the luminance. Image is not as good as component, but better than composite. Used in S-VHS and Hi8. An S-video cable has wires for Y and C.
4. **RGB.** Keeps the three colors separate using different paths for R, G and B. Since the colors are isolated from each other, this is a form of component video. Used in computers and some video systems. Can offer a wider palette of colors than standard component.

To get the most out of any noncomposite system (component, Y/C or RGB), you need a VTR and a monitor that have outputs and inputs in that system. A Hi8 camera, for example, will only show its best picture quality if connected to a monitor using an S-video cable (Fig. 6-7). If the signal is routed through any composite equipment or connector, many of the benefits of these other systems are lost.

However, sometimes you need to connect noncomposite equipment to composite

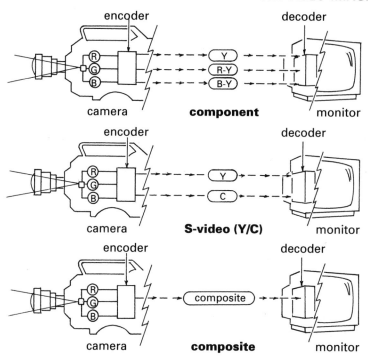

Fig. 7-4. Component, S-video and composite video systems vary in the paths they use to convey the video signal from one piece of equipment to another. For systems that use multiple paths, the signal is sometimes sent on multiple cables and sometimes the various paths are part of one cable. See text for explanation. (Robert Brun)

systems. Most component or Y/C gear also has standard NTSC or PAL composite connectors (usually labeled "video in" and "video out"). These can be handy, but the quality of the image is lower.

Composite Systems

Until the advent of digital broadcasting, all television was broadcast in composite form. The vast majority of TV sets and other video equipment are designed for composite video. However, component and the other systems described above are increasingly common. Eventually, composite video may become obsolete. Different parts of the world use different, incompatible composite standards, which requires different sets of cameras and editing equipment. Video can be converted from one standard to another, but with some loss in quality (see p. 527).

1. *NTSC.* (Pronounced "en-tee-ess-see.") Used in the United States, Canada, Japan, Central America and other places where electrical power is supplied at 60 Hz. NTSC uses 525 horizontal scan lines to record a complete frame (see p. 18). The original black-and-white television standard was exactly 30 frames per second. When color was introduced, this was dropped slightly to 29.97 fps. This difference is imperceptible to the eye, but complicates things like

timecode, camera shutter speeds when filming a monitor (see Chapter 17), and synchronizing sound recorders and other equipment (see below). NTSC has a number of drawbacks. Since it uses fewer horizontal scan lines than PAL, the picture is not as sharp (and high-definition digital formats are much sharper than either of them). NTSC is prone to certain image defects, including *ringing* (edges of objects repeat or echo) and *dot crawl* (lines seem to vibrate or move a bit like a barber pole). Because film is generally shot at 24 fps, the 30 fps NTSC frame rate creates certain problems in transfers (see Chapter 17).

2. *PAL.* (Pronounced "pal.") Used in most of Western Europe, Great Britain, Australia, New Zealand and China. In PAL, the image is scanned with 625 lines at 25 fps. PAL provides a higher-quality video image than NTSC. Because the frame rate is exactly 25 fps, and the electrical current in PAL countries is at 50 Hz, many aspects of working with PAL are simplified.

3. *SECAM.* (Pronounced "see-cam" or "say-cam.") Used in France, parts of Eastern Europe, the former Soviet Union, Iran and Iraq. Like PAL, uses 625 scan lines at 25 fps, but the color encoding is different.

Component Systems

Component systems maintain separation between the color components in the video signal (see p. 19). In video production, the term *component* usually refers to the Y, R − Y, B − Y system described above. However, bear in mind that the RGB method is also a component system.

When people use the terms *NTSC video* or *PAL video*, they are usually referring to *composite* video. For example, someone might ask if a camera has an NTSC output, meaning encoded, composite video. Yet, among component standards there is an NTSC version as well as a PAL version. Since the NTSC component standard is 525 lines at 60 fields a second, it is sometimes referred to as "525/60 component." The PAL version is 625/50. The same terminology applies to various digital formats.

TIMECODE

To make full use of the tools available for film and video production, timecode is essential. The idea of timecode is simple: to assign a number to every frame of picture or sound so we can easily find those frames and work with them. Timecode is a running "clock" that counts hours, minutes, seconds and frames (see Fig. 1-18). Timecode comes in a few different flavors, which can be confusing.

Types of Timecode

In the United States and other parts of the world where NTSC video is standard, video is generally recorded at about 30 frames per second. Video timecode is a 24-hour clock that goes as high as 23:59:59:29 (twenty-three hours, fifty-nine minutes, fifty-nine seconds and twenty-nine frames). One frame later it returns to 00:00:00:00. Note that since there are thirty frames per second, the frame counter only goes to up to :29. This timecode system is called *SMPTE nondrop timecode.* Many people just refer to it as "SMPTE" (pronounced "simpty") or "nondrop" (often written "ND"). This is standard, basic timecode.

One of the quirks about NTSC color video is that it actually doesn't run *exactly* at 30 fps. It runs just slightly slower, at 29.97 fps. You can't see the difference, but this .1 percent reduction in speed affects the way timecode keeps time. If you watch a tape until the nondrop timecode indicates one hour of video, and then quickly look at your watch, you will see that actually one hour and 3.6 seconds have gone by. This discrepancy is no big deal if the movie is not intended for broadcast. Nondrop timecode is often used for production.

Since broadcasters need to know program length very exactly, *drop frame (DF)* timecode was developed. This system drops two timecode numbers every minute so that the timecode reflects real time[2] A program that finishes at one hour drop frame timecode is indeed exactly one hour long. With drop frame timecode, *no actual frames* of video are dropped and *the frame rate doesn't change*. The only thing that's affected is the way the frames are counted (numbered). This is a point that confuses many people. Switching a camera from ND to DF has no affect on the picture or on the number of frames that are recorded every second. The only thing that changes is the way the digits in the timecode counter advance over time.

Many television-bound programs are done with DF code. Many editing systems can work with either drop or nondrop, and shooting with nondrop doesn't prevent you from finishing with drop. Mixing drop and nondrop code in the same project can sometimes cause problems. DF timecode is sometimes indicated with semicolons instead of colons between the numbers (00;14;25;15).

In Europe and other parts of the world where PAL video is standard, video runs at exactly 25 fps. EBU timecode uses a similar 24-hour clock, except the frame counter runs up to :24 instead of :29. EBU code keeps real time, so there is no need to drop frames.

Consumer or prosumer equipment sometimes uses nonprofessional timecode systems such as *RC timecode*. These systems may limit your ability to interface with professional equipment. On some such systems, the timecode cannot be set.

Recording Timecode

There are a few ways to record timecode on tape. Some tape formats have a *longitudinal* track just for timecode (LTC). Some formats allow you to use one of the audio tracks for code. Longitudinal and audio timecode can be added or changed even after the video has been recorded.

Another type of timecode recording is *vertical interval timecode (VITC*, pronounced "vit-see"). VITC is recorded as part of the video signal (during vertical blanking; see The Raster Revisited, p. 193). One advantage of VITC is that it can be read by the VTR even when the tape is not moving (very useful for editing). VITC does not use up any audio tracks. VITC must be recorded at the same time as the video and cannot be added later (except during dubbing to another tape).

There are other ways of recording timecode. The *address track* on a ¾″ U-matic VTR is reserved for code but must be recorded with the video.

[2] The :00 and :01 frames are dropped every minute, unless the minute is a multiple of 10 (no frames are dropped at 10 min., 20 min., etc). Thus, the number following 00:04:59:29 is 00:05:00:02. But the number following 00:09:59:29 is 00:10:00:00.

On analog tape formats, timecode degrades when copied from tape to tape. Use a timecode generator to regenerate the code while dubbing and be sure it is sync-locked to the video.

ADDING CODE TO A NONCODED TAPE. If you plan to do an online edit, it is virtually impossible without timecode. If the original footage was shot without code, you may be able to poststripe it with code after shooting (this works best with tape formats that use longitudinal or audio timecode tracks).

If this is not possible, one solution is to create a new set of master tapes by bumping up the original footage to a timecode tape format. For example, footage shot in Hi8 might be transferred to Betacam with timecode added during the transfer. The Beta tapes would then become the masters, used to generate worktapes and to do the online edit. This can also be done if your editing facility can't handle small-format tapes.

Using Timecode in Production

Many camcorders are equipped to generate timecode and record it on the tape. Professional cameras have several different timecode modes. In *record run* mode, the timecode advances whenever the tape is running, providing a continuous, running count of tape as you shoot it. Most professional cameras allow you to select each tape's starting code number. If you are using tapes less than an hour long, you might start the first tape at one hour (1:00:00:00), then start the second tape at two hours (2:00:00:00) and so on. That way, the timecode on each tape is different. If any two tapes have the same code, there will be confusion during editing. Many cameras allow you to select *user bits* (*U-bits*), which are recorded with the timecode and can be used to identify camera roll numbers, the date or other information. Be sure to use U-bits if the timecode on any two tapes is the same.

Some people prefer to shoot with a time-of-day (TOD) clock recorded as timecode (this is sometimes called *free run* mode). TOD code is usually discontinuous on the tape, since every time you stop the camera there is a jump in the code. TOD code is useful if you need to identify when things were filmed, or if more than one camera is shooting at the same time. This may cause problems, however, if you shoot the same tape on successive days. Say you finish the first day at four in the afternoon (16:00:00:00 code). You start the next day at eleven in the morning (11:00:00:00 code). When you edit this tape, the edit controller will find the lower code number *after* the high number, causing problems. Using TOD code will likely result in several tapes having the same code numbers unless the date or other information is included in the U-bits. Some camcorders have a *real time* mode that puts the time of day in the user bits, and allows you to select record-run code for the regular timecode.

Sometimes when you are using more than one video camera, you want to have them running the exact same timecode to facilitate editing. Some professional cameras allow you to *jam sync* one camera with the code from another camera or separate timecode source. Keep in mind that some cameras may drift slightly over time, so you may need to rejam the cameras every few hours to keep their timecode identical. For perfect sync, the two cameras should be *genlocked* together.

This may be done with a master sync signal fed to both cameras. If you plan to do live switching between multiple cameras to record on one tape, genlocking will ensure the cameras are in phase to permit switching.

See Timecode Slates and In-Camera Timecode, p. 283, for using timecode with audio recorders and film cameras.

DIGITAL RECORDING

Basic Theory

Before digital recording existed, there was analog. In analog recording, changes in light or sound are represented by a changing electrical signal. If you record someone with a microphone and tape recorder, and the person starts speaking louder, the voltage of the signal sent from the mic to the recorder increases. The level of the electrical audio signal is *analogous* to the loudness of the sound. Analog recording systems can be very high quality, and continue to be used, but problems arise particularly when we try to make copies of analog recordings.

The idea of digital recording is to measure the level of the electrical signal from moment to moment, and record those measurements as discrete *numbers*. Later, we can re-create the original signal by referring back to that list of numbers.

As an example, imagine you wanted to track the path of a turtle as he crawls across a piece of paper. You could attach a pencil to his shell and let him make a tracing as he walks (a kind of analog recording). Or you could take a ruler and make a series of measurements—after one minute he's 6″ to the left and 8″ above where he started; at a minute two he's 12″ to the left and 10″ above the starting point. This is a kind of digital recording. Later, you could take your ruler and your list of measurements and re-create the path he took on another piece of paper.

Let's say that for some strange and perverse reason, other people want to know exactly where this turtle went. If you had his tracing on paper, you could make copies of the paper to give to people. But copies often come out a different size than the original, and copies of copies can get fuzzy. But if you had taken measurements with the ruler, you could just hand people the list of numbers and they could make their own map. The list of numbers can be copied over and over, and the tenth copy should be just as accurate as the first.

Digital recording works by *sampling* the audio or video signal at regular intervals; each sample is a measurement of the voltage at that moment in time. That voltage measurement is then converted to a number that can be recorded on tape or on disk. In digital systems, the numbers are in binary code, which uses a series of ones and zeros. (The number 5 would be 101 in binary.) Each digit in a binary number is a *bit* (101 is thus a three-bit number). Eight bits together make a *byte*.

Converting the original voltage into a number is called *quantizing*. In some video systems, every sample is converted into an eight-bit number. In higher-quality systems, the samples may be quantized into a ten-bit number. The more bits you use per sample, the finer the gradations you can represent in color or brightness. One way to visualize this is to imagine using a ruler to measure the strength (voltage) of the video signal. One end of the ruler is zero voltage, the

other end is the maximum voltage the system can record. With a low number of bits, the ruler might only have markings in, say, one-inch increments. With many bits, we have markings in tiny fractions of an inch, so we can make more precise measurements.

The entire process of converting a video or audio signal to digital form is called *digitizing* and is done by an *analog-to-digital (A/D) converter*. The converter may be part of the camera, or it may be part of the audio or video recorder. To view or hear the signal, it can be reconstructed in its analog form using a *digital-to-analog (D/A) converter*.

Sampling Rate

How often we sample or measure the video or audio signal affects how accurately we can re-create it. To go back to the turtle example, since he is moving fairly slowly we could measure his position, say, once a minute and get a fairly accurate idea of where he went. Now imagine tracking an ant. In one minute he might go up, down and around. We have to measure his position much more than once a minute to get a good record of where he went. In digital terms, we need to use a higher *sampling rate* for the faster-moving ant.

In audio and video recording, the speed with which the signal changes is related to its *frequency*—the higher the frequency, the faster it is changing. Frequency is measured in *hertz* (*Hz*; see Frequency, p. 246). To make high-quality recordings, we need to be able to capture high frequencies. If a sound recording lacks high frequencies, it may sound muddy or dull. If a video recording lacks high frequencies, fine detail in the image may be lost, making it appear unsharp. A Swede named Henry Nyquist proved that the sampling rate has to be at least *twice* the maximum frequency we hope to capture. Since humans can hear sounds up to about 20,000 Hz (20 kHz), a digital audio recorder needs to sample at least 40,000 times a second to capture the full range of sound. Many digital audio recorders use a sampling rate of 44.1 kHz or 48 kHz in order to do just that. For more on audio sampling rates and the specifics of digital audio recording, see Chapter 9.

Pixels 'n' Bits

When an image is digitized, it is divided into a grid of *pixels* (picture elements). Each pixel is essentially a sample of the brightness and/or color of the image at that spot. The smaller the pixels (and the closer together the lines of the grid), the sharper the image will look. Take a look at Fig. 7-6. The top image is divided into a lattice of fairly large pixels. The middle image has much smaller pixels (and thus has more pixels for the same area). The middle image is capable of capturing finer detail—its *resolution* is higher. Note that the idea of using more pixels to increase resolution is similar to the idea just discussed of using a high sampling rate. In this case the samples are in space, not time.

If the number of samples is too low, not only will the image look unsharp, but other artifacts may be introduced. One such defect is *aliasing*, which may produce a moiré pattern or cause diagonal lines in the frame to look like jagged stair steps (notice the man's hairline in Fig. 7-6). Other types of aliasing can occur with audio.

If the number of pixels is high enough, the eye can't even discern that the image

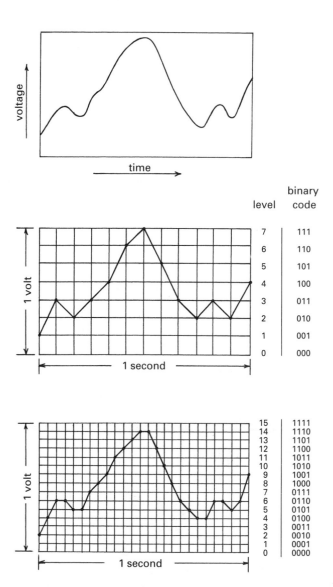

Fig. 7-5. Digital recording. (top) The original analog signal. Note that the voltage level changes continuously over time. (middle) To record the signal digitally, we take *samples* (measurements) at regular time intervals (the vertical lines). The level of the signal at each sample is measured according to a level scale (the horizontal lines). The number of units in the scale is determined by the *number of bits* in the system; a three-bit system is pictured here. Samples can only be measured in *one-unit increments*. A measurement that falls between, say, level two and level three must be rounded down to two or up to three. (bottom) By taking more samples in the same period of time (higher *sampling rate*) and using more bits per sample, we can make a higher-resolution recording. Pictured here is a four-bit system with twice the sampling rate as the middle graph. Now the scale has finer gradations, allowing us to measure the signal more precisely. Note that this curve better approximates the shape of the original analog signal. (Robert Brun)

Fig. 7-6. A relatively low number of pixels forms a coarse, low-resolution image (top). Using more pixels in a finer grid produces a higher-resolution image (middle). This image has the same number of pixels as the middle image but only three bits per pixel instead of eight (bottom). Note the discontinuous tonalities. Try viewing these images from a distance to see how they appear sharper. Compare with Fig. 11-24.

is divided into pixels at all. Compare Fig. 11-24, which is the same image with yet more (and smaller) pixels. Interestingly, our ability to judge resolution in an image is related to how large the image appears. Try viewing Fig. 7-6 from several feet away and notice how the images appear sharper from that distance.

We can increase resolution by increasing the number of pixels and by increasing how precisely we measure the brightness of each pixel. Eight-bit systems can distinguish between 256 different brightness values for each pixel. With sixteen-bit systems, there are 65,536 gradations. The more gradations, the finer the detail you can render. In Fig. 7-6, the middle image uses eight bits, while the bottom image (which has the same number of pixels) has only three bits per pixel. Notice how the shading on the wall and on the man's face is relatively continuous in the middle picture and is blocky and discontinuous in the lower picture (this is sometimes called *banding*).

If the number of bits is too low, the recording may distort the image so that it no longer accurately resembles the original. To go back to the ruler analogy mentioned above, if the ruler only has markings every inch, and we try to measure something an inch and a half long, we have to round the measurement *up* to two inches or *down* to one inch; in the digital world, no in-between measurements can be taken.

To use an extreme example, in a three-bit system, the image has no more than eight levels of brightness from black to white. In the bottom image of Fig. 7-6 you can count each level on the wall. Clearly, this is very unlike the way the scene appeared in reality. Unsurprisingly, you won't find many three-bit camcorders on the market.

Color Sampling

The eye is very sensitive to fine image detail in terms of overall brightness. But it is much less sensitive to fine detail in color. Because of this, smart engineers realized that a video system can sample the color of the signal (chrominance) less often than the brightness (luminance). Many high-quality component digital formats including D1 and Digital Betacam are designated as 4:2:2 ("four-two-two") to indicate that in a given amount of time, the luminance is sampled four times, while the two color signals are only sampled twice (see Color Video Systems, p. 194). This reduction in color information is virtually undetectable to the eye.

Some formats reduce the color sampling even further. DV is 4:1:1.[3] Here the chrominance is sampled one quarter as often as the luminance. This is similar to analog Betacam. The color rendering of 4:1:1 systems is technically inferior to 4:2:2 and the difference may be detectable in side-by-side comparison, particularly for multilayered graphics, or special effects. However, many factors play a part in overall quality and 4:1:1 may be more than adequate for your uses.

As we saw above, using more bits per pixel gives us finer gradations in brightness; this also allows us to capture subtler color rendition. Some systems use eight bits per sample, others use more. The number of bits is sometimes called *bit depth* or *color depth*. Color depth may also be expressed in terms of how many thousands or millions of colors a system is capable of. In a twenty-four-bit system you have

[3] Though Panasonic has a 4:2:2 DV format (DVCPRO 50).

eight bits (256 levels) for each color (R, G & B). Multiply 256 levels times three colors and you get 16.4 million color possibilities.

Digital Compression

Major advances in digital technology are taking place in two seemingly opposite directions. One could imagine it as two separate camps. One camp is developing digital camera chips and audio recorders capable of ever-increasing resolution—machines that capture images and sound with greater and greater clarity and fidelity.

The other camp is busily working on ways to throw away the vast mountains of data these systems create. In order to make cost-effective and efficient use of digital recordings, we have to find ways to minimize the amount of storage, processing and transmission equipment needed to deal with them. The goal of *digital compression* is to remove data from digital signals while maintaining the best possible picture and sound quality.[4] Video and audio are compressed for storage and transmission and then *decompressed* in order to view and hear the signals. Compression schemes are sometimes called *codecs* (for compression/decompression).

After images and sound have been compressed, they take up less storage space on tape or on computer disks. This allows us to use smaller, cheaper camcorders (production), load more footage into an editing system (postproduction) or fit a longer movie onto a disc for playback at home (distribution).

Compression is also useful because systems are often limited in how much data they can process per second. After the video signal has been compressed, it can be sent through a narrower "pipeline." For example, video images sent on the Internet may be compressed so they can be sent through telephone lines. Many homes still use "old-style" copper phone wires. These wires pass much less data per second than a typical video cable (which is to say, their *bandwidth* is less). Some houses are wired for cable television. The wire used for cable TV is "fat" enough (has high enough bandwidth) to pass many channels of full-resolution, uncompressed video.

Digital video is data-"hungry." It takes a lot of information to record a full-resolution video image. Digital audio, on the other hand, requires far less information. For this reason, audio often does not need to be digitally compressed for production work.

Digital compression is rapidly evolving, and techniques in use today may be modified tomorrow. As a filmmaker, understanding compression helps you to choose the type of camcorder or VTR format you want to use. Compression is also important in digital editing and in distribution choices.

Types of Compression

Compression can be done in many different ways. Since technologies are changing, we will concentrate more on general concepts than specific systems.

Compression involves compacting the digitized video information (a computer

[4]The word *compression* can have several meanings in film, video and audio. Digital compression should not be confused with compressing audio levels (see Compressors, p. 451) or video levels (see Highlights and Overexposure, p. 191).

file) into a smaller space. For viewing, we must then expand the data (decompress it). *Lossless* compression means that after we decompress the file, nothing is lost and it can be restored to its original condition. *Lossy* compression, on the other hand, throws away information that can never be restored.

One approach to video compression is to delete information from individual frames; this is called *intraframe* coding. With intraframe coding, only one frame is compressed at a time, with no reference to other frames. This is used in several digital camera systems. Different video formats compress to a different degree. Digital Betacam compresses slightly, reducing the data by half (a 2:1 ratio). The DV format compresses at 5:1. Compressing in the camcorder has two important benefits. First, by reducing the amount of information recorded per second, it allows longer record times on a small tape. Also, compressing in the camera produces a very clean, low-noise signal (compressing in the editing system can sometimes result in much more noise from badly shielded computers). With enough compression in the camera, it may not be necessary to compress further for editing.

With intraframe coding, *every* frame of the original signal is stored on tape or disk, so we can easily isolate frames when needed to edit the material. Many nonlinear editing systems make use of *Motion-JPEG* (*Joint Photographics Experts Group*) compression. Starting with M-JPEG, manufacturers create their own custom algorithms, so footage digitized on one editing system usually cannot be edited on another (to change systems, you have to redigitize your original tapes). This incompatibility problem is one reason why MPEG compression (see below) is beginning to be used for editing.

When digitizing video or audio material into the editing system, you can usually select how much compression you want to do. The more you compress, the more footage you can store on the disks, and the lower the image quality. Some systems indicate resolution levels by comparing the image to various VTR formats. For example, a little compression may be called "Betacam quality"; a lot of compression may be "VHS quality." Avid uses several "AVR" (Avid video resolution) levels to indicate different degrees of compression. Some *single-field* systems are designed to store only one field from each frame, instantly cutting the amount of data by half.

Another approach to compression combines intraframe coding with *interframe coding*. Here, the system processes a *group* of frames *together*. Some frames are stored individually, but the frames *between* these frames are not stored, but *predicted* (calculated). To use a simplified example, imagine trying to store the alphabet. You could write down all the letters individually ("A, B, C, D," etc.) or you could save space by just writing "A to Z." In the latter case, it's not difficult to reconstruct the sequence starting from A and going all the way to Z.

MPEG (*Moving Picture Experts Group*) *compression*, which is used in many video systems, employs such a method. Certain frames are stored; these are called *I frames*—they are Independent, intraframe coded frames. To cut down on storage, the system *does not record* several of the frames between each pair of I frames. Instead, during playback, it looks from one I frame to the next and "guesses" at what belongs in between. The guessing isn't random, it's based on carefully checking exactly what changed in the picture from one I frame to the next. The computer then fills in a series of *P* (Predicted) frames and *B* (Between) frames in the gap

from one I frame to the next. The number of frames between the two I frames varies depending on the compression being used. Some systems designed for editing use *only* I frames to make it easy to do frame-accurate edits.

There are currently two versions of MPEG compression. MPEG-1 was designed for "VHS-quality" pictures and is used in some CD-ROMs and multimedia applications. MPEG-2 was designed for full-screen, higher-quality images.[5] MPEG-2 is used in DVDs and some digital broadcasting systems and is finding increasing use in both cameras and editing systems. MPEG-2 should create a more standardized environment than M-JPEG, allowing you to transfer material from one editing system to another.

Variable bit rate methods, which are used in DVDs and DSS satellite broadcasts, reduce the amount of data by constantly varying how much compression is done, pushing it to the maximum whenever possible. Thus, more data is stored for footage that has a lot of movement or complexity and less data is needed for static footage where there is lot of redundancy to be eliminated. The system is always looking for how much changes from one I frame to the next; if nothing changes between frames, you can really cut down the data flow and save space. As a simplified example, imagine that you had to store the word *Mississippi* a hundred times in a row. You could either write it out in full a hundred times, or you might save space by writing "Mississippi × 100." Variable bit rate compression is very useful for the distribution of movies because it allows you to pack a lot of material on a disc or transmit a lot of data on a low-bandwidth TV channel.

Keep in mind that compressing an image and decompressing it just for viewing it is one thing, but trying to work with that uncompressed image is another. For example, the highly compressed image on a DVD may look great on TV, but feeding the signal into a VTR for further editing may result in unacceptable degradation. Similarly, when you digitize and compress video into a nonlinear editing system, print to tape, then digitize that tape back into the system, the image may degrade more than you like.[6] Charles Poynton uses the example of orange juice. You can take fresh orange juice, remove the water and make condensed, frozen juice. When you add water again, you get drinkable juice for your breakfast table. But you wouldn't necessarily want to take *that* juice and condense it again. At each stage, something is lost.

Comparing Digital Video Formats

Trying to understand the differences between the various camcorder and editing formats today is a daunting task. Even experts disagree on their relative merits. Then, of course, there are the salespeople who want you to understand that only *their* system is the best. People will throw a lot of numbers at you; some love to get particularly obscure if they sense that you're the least bit technophobic (of course, if you're a *real* technophobe, you're probably not even reading this).

See Resolution, p. 33, for an overview of resolution and the production process. Ultimately, perhaps the key differences in formats come down to resolution and

[5]However, at certain data rates, MPEG-1 looks better than MPEG-2.
[6]This is only if you're compressing. *Native DV* can be imported and exported without loss.

cost. As discussed in Chapter 1, resolution is a somewhat elusive concept. One system may appear better "by the numbers" yet another system might have a more sophisticated design that produces images that look better in a side-by-side comparison. But when it comes down to it, how often *do* we examine images side by side? Even an "inferior" system may be absolutely fine for what you're doing.

Currently, the highest-resolution video images are obtained with high-definition (HDTV) systems. By the time you read this, HDTV systems may be commonplace, but right now they are fairly new to the marketplace and just beginning to be used by independent producers.

At a lower tier down, a kind of "benchmark" standard against which video systems are sometimes measured is called *ITU-R 601* (also called *601 video*). The 601 standard sets guidelines for the video signal: it is a component, digital signal that produces a data rate of about 700 kilobytes per frame.[7] Some people refer to this as "D1 quality," because this signal can be recorded on a D1 VTR without being compressed. But other types of machines can also record uncompressed "D1-level" video.

As a way to compare formats, think of the chips on a video camera as being able to generate 601 video (actually some can produce even better signals). You could record this on a D1 VTR without changing it at all.

Digital Betacam compresses the signal at a 2:1 ratio, which reduces the cost of the VTR and tapes significantly, and the "loss" in picture quality is virtually undetectable compared to D1. Actually, since D-Beta is a ten-bit system, some people think it looks *better* than D1.

DV compresses 5:1 (about 136kB per frame). This allows even further reductions in cost, and results in an excellent picture. However, if you need to do chroma keys or other multiple-layered work, the increased compression may be a detriment.

For both cameras and editing systems, people sometimes look to the number of kilobytes per frame as a measure of picture quality. Within a given editing system, 300kB per frame generally looks much better than 150kB. However, when comparing different formats or systems, many other factors come into play. The data rate doesn't tell the whole story in terms of picture quality.

Also, even within a system, you can't assume that higher data rates *always* look better. As discussed above, when compression is done right, you can reduce the data rate without making the picture suffer. Avid's AVR levels represent a *maximum* data rate per frame, but the rate may go lower if the system can "get away with it." Many digital systems are designed to balance the desire for good picture quality with the need to minimize storage. In fact, a new profession has been created to address this issue. A *compressionist* may work on a movie prior to release on a digital format, determining, on a shot-by-shot basis, how much compression can be used to maintain quality while minimizing the data (in MPEG-2, compression can even be adjusted differently for the edges or center of a given frame). For more on compression in editing, see Digital Nonlinear Editing, p. 415.

[7]For the NTSC version that's 720 × 480 pixels at eight bits per pixel times 3 colors in a 4:2:2 format, eight bits for Y, four for each color component.

Shooting | CHAPTER 8

The first part of this chapter is about putting together the crew and equipment for a shoot. The second part is about camerawork and directing, for both narrative (fiction) and documentary. Since shooting a movie draws on all the skills and techniques of filmmaking, in some sense *all* the other chapters in the book are relevant to this one. More specifically regarding the choices made by the director or camera operator, it's important to have an understanding of lenses (Chapter 3) and editing (Chapter 12).

PREPARING FOR THE SHOOT

THE CREW AND LOCATION

Production Tasks

The following is a brief description of the roles of key members of a large Hollywood-type film production unit, which gives an idea of the range of tasks involved in a movie shooting. The use of terms like *cameraman* is not meant to imply that the job is performed by a male.

The *producer* raises the money for a production and often creates the "package" which may include the script ("literary property"), the director and the actors. The producer is ultimately responsible for the budget and the overall production and can usually hire and fire personnel. The *director* is responsible for the production unit, translating the script into visual terms and directing the actors. In television production, the producer is often more like the film director.

The *director of photography* (or simply DP), also called the *cinematographer, first cameraman* or *lighting cameraman*, composes the shots, plans camera movements and decides how to light scenes, usually in consultation with the director. On small units, the DP may operate the camera, but on large units, the *camera operator* or *second cameraman* sets the controls and operates the camera during a take. The *first assistant cameraman* (1st AC) operates the follow focus, checks the gate for dirt

and manages the camera equipment. The *second assistant* or *clapper loader* operates the slate, loads film and keeps the camera report sheet.

Fig. 8-1. The large production unit on location. A production still from *Lady Tubbs* (Universal, 1935) shows a tripod-mounted, blimped camera (at left center) on a platform that serves as a dolly and can be pushed along the tracks by the grips. Note the microphone boom and the reflectors used to fill in the harsh shadows created by the sun. (Universal Pictures)

The *gaffer* and a staff of *electricians* place the lights as directed by the DP. The *best boy* or *second electric* assists the gaffer in setting up lights and cables. The *grips* move things around, place props, build scaffolds and other rigging for cameras or lights. The *dolly grip* pushes the dolly. The sound department is run by the *sound recordist* or *mixer*, who records the sound and directs the *boom operator*, who maneuvers the microphone, sometimes assisted by a *cableman*.

The *script supervisor* is responsible for continuity and making sure shots match in everything from weather to hairdo and that everything has been shot from the angles called for in the script. The *assistant director* (or *AD*) maintains order on the set, makes sure the needed actors and crew are present and controls extras in crowd scenes.

The *second unit* is usually responsible for stunts, crowd scenes, battle scenes and special effects—essentially those scenes that are shot without sound. These scenes have their own director and camera crew.

The *unit production manager* does a breakdown of the shots in the film so that they can be filmed as economically as possible. When the production is *on location*—that is, away from the studio—the unit manager arranges for food and

lodging and supervises the relation between the production and outside labor and suppliers. He or she deals with emergencies and tries to keep the production on schedule. A *line producer* performs similar tasks.

Art direction, set design and construction, prop selection, makeup, hairdressing, costume design, wardrobe on the set and countless other jobs are considered specialized tasks that each require one or more people to perform them. *Production assistants* (*PAs*) are low-paid "gofers" (go for this, go for that) who do all sorts of tasks. Don't confuse PAs with *APs* (*associate producers*).

Production stills (photographs of the actors or crew on the set) are shot by a *still photographer*. On any size production, do not neglect to have production stills made; they are invaluable in promoting the film and are difficult to create after the production is finished (see Chapter 18).

Job responsibilities vary by country and by type of production. On union productions, union rules determine much of standard industry practice. The crew is divided into departments (camera department, sound department, art department, etc.), with an established chain of command in terms of who reports to whom and what duties fall within or outside a given job's jurisdiction. For example, the camera crew often cannot touch a lighting fixture. On nonunion or smaller productions, there may be significant overlap in responsibilities, and one person may be called on to perform a variety of tasks.

Crew Size

Some filmmakers make their movies alone, which is especially feasible when using a small-format video camera. A typical small crew for a documentary may consist of a cameraman and a sound recordist, with either or both functioning as director. A third person may be needed to manage equipment, drive the car, help set up lights and run errands. In documentaries, the smaller the crew, the better the access to the subjects being filmed and the less disruption to their lives. Advances in technology—faster lenses, smaller cameras and wireless microphones—allow the crew to remain relatively unobtrusive.

In all types of productions there are advantages to small crews. Aside from keeping the budget lower, small crews can move quickly and gain access to all sorts of locations, such as city streets, small houses or mountaintops, that would be difficult for larger crews. Finding the right crew size is a balancing act. If the crew is too small for the complexity of the production, then crew members become overburdened and the work becomes inefficient and slow. However, as crew size grows, there is a kind of instant multiplying effect: more people require more support (cars, meals, accommodations), which requires more people. Mobility is so difficult for large production units that it is often cheaper to build elaborate sets in a studio than to shoot on location (see below). See p. 538 for discussion of hiring crew and actors.

The Crew and the Subjects

Both in fiction and documentary work, maintaining a comfortable, professional atmosphere is extremely important. Avoid shouting and arguments in front of the actors or documentary subjects and do not involve them unnecessarily in your

technical business and problems. Actors and subjects should be treated with a great deal of respect and deference; they are often extremely vulnerable to disruptions of mood. *Only* the director should give instructions to actors; anyone else wishing to communicate should ask the director. Particularly in intimate or difficult scenes, some actors prefer that crew members not even make eye contact with them while the camera is rolling.

On documentaries, the more your subjects trust you, generally the more comfortable they will be in front of the camera. Some filmmakers like to spend time with their subjects prior to filming (with no equipment) to provide a chance for everyone to get to know each other. Discuss with them in advance what kind of scenes may be filmed; arguing when they ask you to stop is usually a mistake. To keep the shooting relaxed and low-key, keep the crew small and use as few lights as possible. For film shoots, clapper sticks are often disruptive (see Chapter 10).

Location Planning

Whenever possible, locations should be scouted in advance; the British call it *doing a recce* (from *reconnaissance*). For a documentary, the director and cinematographer might just do a quick check to see what they'll need to work at the location. For a drama or other more controlled shoot, the production manager, designer and/or art director might also come along to evaluate what must be built or changed. Bring a still camera and/or video camera to record the layout of the space. A video camera or *director's finder* (a small handheld finder for viewing a scene at different focal lengths) is useful to block out shots. The location should be checked for a variety of needs:

1. *Direction.* Is the space adequate for shooting? Are the rooms cramped or is there enough space to get the camera back away from the action? If a dolly will be used, is there room for the tracks? Are the walls, furniture or artwork usable for your movie or will they need to be changed? Any problems with views out windows? For an exterior location, will there be a problem with crowd control?
2. *Lighting.* What is the natural light and how is it expected to change over the time of the shoot, from morning to night? How much artificial light will you need? Are the ceilings high enough to hide lights out of frame? How much electric power is there; will generators or other sources be necessary (see Chapter 11)?
3. *Sound.* Is the location quiet enough to shoot? Is it in a airport flight path or near a highway? Do the floors squeak when you walk on them? Is the space too reverberant (see Chapter 10)?
4. *Support.* Is there adequate parking or can permits be obtained to reserve more? Are there enough bathrooms? Are there areas where equipment, wardrobe and makeup can be set up separately from the shooting area? Will you need fans or air conditioners to keep the space from getting too hot? Is the location difficult to find?

Finding a good location that suits all your needs is difficult. Often, filmmakers will shoot exteriors in one place, and the interior that is meant to represent the

inside of that building in an entirely different place. If the production budget will support it, shooting in a studio can solve many of the typical problems of locations. Even on a low-budget production, a quiet space, a few *flats* (movable walls) and some props can take you a long way if you have good lighting and clever art direction.

Wherever you're shooting, plan for everything you can and leave room for the inevitable surprises. While on location, never count on the weather. Crews have been stranded for weeks waiting for snow, sun or whatever else. Be ready to shoot interiors when the weather is not right, and have a backup schedule for when an actor gets sick or some special equipment does not operate. Duplicate wardrobes and props allow the production to continue even when a prop has been misplaced or a shirt has gotten dirty. Backup locations allow you to continue if plans fall through.

You may need a location release, a permit or an insurance bond to shoot at some locations (see Chapter 18). Many states have film bureaus that will help you obtain permits and scout locations.

ORGANIZING EQUIPMENT

Equipment Prep

Equipment for a shoot may belong to you, people you hire, a rental house, a school or other institution (see Renting Versus Buying Equipment, p. 539). Prior to the shoot, the *equipment package* needs to be assembled and tested to be sure everything's working. For camera tests, see Chapters 2, 3 and 16. For audio equipment, see Chapter 10. The night before the shoot, be sure that replaceable batteries are fresh and rechargeable batteries are charged (see Chapter 6).

If you will be traveling to the location, use solid shipping cases to protect the gear in vehicles or planes. Many people prefer to hand-carry the camera itself and delicate lenses or audio gear on airplanes (see p. 75). Bring batteries when hand-carrying, since inspectors may demand that you operate the equipment to show it's legit. Particularly for documentary work, it's a good idea to bring along soft shoulder bags to carry gear once you arrive. See p. 131 for shipping film.

A Field Package

The following is a basic list of equipment for a professional field shoot in video or film. Depending on your camera and production style, you may need more or less stuff. All items are discussed elsewhere in the book.

Video Camera	*Audio for Video*
Camera with zoom lens	Shotgun (hyper-cardioid) mic
Soft camera case	Lavalier mic; assorted clips
Tripod with fluid head and spreader	Wireless transmitter and
3–4 batteries with charger	receiver
AC power supply	Fishpole mic boom with
Wide-angle adaptor	shock mount

Field monitor
Cables for camera-to-monitor
 connection plus spares (often
 BNC-to-BNC cables)
Playback adaptor (if applicable)

Zeppelin windscreen plus felt
 or fuzzy cover
Field mixer
Headphones
Cables for mic-to-mixer and
 camera-to-mixer connections
 (often XLR-to-XLR)

Film Camera	*Audio for Film*

Camera body and zoom lens
2–3 magazines
3 batteries and charger
Tripod with fluid head, spreader
Wide angle adaptor or prime lenses
Lens shade or matte box with support
85 and ND filters; close-up diopters;
 polarizer
Barney; French flag
Zoom lever or motor
Light meters, changing bag
Camera tape and other accessories (see p. 75).

Audio recorder (DAT, ¼"
 or other)
Mics, boom and windscreen
 as for video (see above)
Slate
Headphones
Field mixer, if needed
Mic cables and spares

Lighting and Grip	*Other Lighting and Grip*

Lighting units, spare bulbs
AC power cables; cube taps or
 power strips
Gels, CTB and CTO (small sheets
 for lights, large rolls for windows)
Spun and/or other diffusion
Collapsible reflector
Assorted clamps, clips, hangers
Clothes pins, sash cord, etc.
Gaffer's tape, black wrap

C-stands with arms
Sand or water bags
Flags, silks, nets (various sizes)
Foam-core or white show cards
Dolly; curved and straight
 track and wedges (if applicable)
Apple boxes
Sound blankets
Overhead with silk, net and solid
Photofloods; fuses
Tie-in cables

COMPOSITION AND SHOT SELECTION

Scenes and Takes

A script is divided into a series of *scenes*—a scene is an event that takes place in one setting in a continuous time period. However, when someone walks from one room to another and the camera is moved to a new location, it is often considered two separate scenes in the script. A *sequence* is generally a scene or a series of scenes that make up a unit. For example, you might refer to the "baptism sequence" in

The Godfather, which includes a scene in a church intercut with a scene of a man being killed in a car.

A scene may be made up of a single *shot* (such as a wide shot of the entire action) or it may be divided into several shots or *camera angles* (or just "angles") that will eventually be edited together (such as matching close-ups of two actors talking). Various *takes* are filmed, each trying to render a particular shot. For example, "Scene 8, Take 14" is the fourteenth attempt to capture Scene 8 in the script. Often, letters are used to indicate a particular angle called for in the script. "Scene 8B, Take 4" is the fourth attempt to get the second camera angle (B) of Scene 8.

During production, every time the camera is moved to a new spot to get a different scene or camera angle, this is considered a new *setup*. The daily production report on a feature tracks how many setups were filmed that day. Changing setups often implies not only changing camera position, but lighting and other aspects as well.

Take (or *camera take*) refers to each section of footage from the time the camera begins shooting until it is turned off. *Shot* is sometimes used to mean camera take and sometimes to mean the edited take—that is, the portion of the take used in an edited version of the movie. To confuse matters further, *scene* sometimes means shot (as in, "scene-to-scene color correction"). Usually the context distinguishes the meaning.

Types of Shots

Shots are divided into three basic categories—the *long shot* (*LS*), *medium shot* (*MS*) and *close-up* (*CU*). The long shot includes the whole body of the person in relation to the environment, usually taken from fairly far away from the person. A wide view of a landscape is sometimes called a long shot or a *wide shot*. The *establishing shot* is a long shot that defines the basic space or locale where the subsequent events will take place. The medium shot is not too detailed, includes part of the subject and usually includes people from head to knee or from waist up. The close-up shows a detail of the scene; in the case of a person, it is a head and shoulder shot. A "two-button close-up" shows everything from the face down to the second button on a person's shirt. In a *big close-up*, just a face fills the screen, or in an *extreme close-up* (*ECU*) part of a face or a small object fills the screen—for example, a watch or a fly.

Two shots taken from opposite angles are called *reverse-angle* shots. A conversation between two people is often shot with each person alone in the frame in three-quarter profile. When the scene is edited, we see one person looking left, then the other looking right. This shooting-editing style is called *angle-reverse-angle*. These shots are often close-ups, but sometimes the back of the other person is visible. Generally, the speakers are matched in size and are in the same relative position on the screen (see Leading the Action and The 180° Rule, below). Angle-reverse-angle cutting is often contrasted with the *two shot*, which is a single shot of two actors from the front showing them from the knees up (*knee shot*) or waist up. The *point of view* (*POV*) shot is taken from someone's or something's vantage point. It can be taken from behind an actor or as though from over his shoulder or at the position of his eyes. POV shots also include shots from extreme vantage points, such as from directly overhead (*bird's-eye view*).

Fig. 8-2. Shot division. The categories are not exact. (i) The *extreme close-up* fills the screen with a small detail. (ii) The *big close-up* fills the frame with a face. (iii) The *close-up* includes the head and shoulders. (iv) The *medium shot* includes most of the body. When two people are shown in medium shot, it is a *two shot*. (v) The *long shot* includes the whole body and the surroundings. (Carol Keller)

The shooting and editing of *static shots* (that is, shots taken with no camera movement) can be contrasted to that of *moving camera shots*. A camera mounted on a moving support (see p. 234) can move from a long shot to a medium shot in a single take (called a *dolly* or *tracking shot*).

Whether you use static or moving camera shots, the parsing or dividing of the action into various shots (instead of shooting an entire scene from one camera position in a single shot) helps both in shooting the scene and editing it (having multiple camera angles available in the editing room allows you to change the pace of the scene and to edit around mistakes (see below and Chapter 12).

One logical and traditional breakdown of a scene is the movement from the long shot to the medium shot to the close-up. This order suggests forward movement into the scene, as though the camera is delving deeper into the action. When a scene goes from a medium shot to a long shot, we expect action on a larger scale (for example, a new arrival in the scene) or a leave-taking from the action (as might happen at the end of a movie).

Composition

Each shot is composed or *framed* in the camera viewfinder. When you film from a script, each shot is *blocked out*, or planned, before the take. In unscripted work, framing and movement are improvised based on both what is seen through the viewfinder and what is seen and heard outside the frame.

The notion of composition comes primarily from easel painting and secondarily from still photography, and refers to the arrangement of objects within the frame—their balance and tensions. Composition in motion pictures is quite

different, since objects move within the frame (*subject movement*) and the frame it-self can move (*camera movement*). Furthermore, one shot is edited next to another, creating a whole new set of tensions and balances through time. Thus, although the placement of objects in the frame shares some of the importance that it has in painting and still photography, movies acquire an additional definition of composition when it includes subject movement, camera movement and editing.

Since a shot often reveals its meaning through motion, it is possible to have strong film composition without well-composed still frames. When a *storyboard* is made for a scene, each shot is drawn as one or more still images, noting camera and actor movements (blocking). There is a tendency to compose for the frame, the result—if filmed directly from the storyboard—often being static. Composition that is dynamic usually resolves tension by the use of subject or camera movement or through editing.

Although there are no set rules for composition, there are expectations that compositions create, and that may be used to surprise the audience or to confirm or deny their expectations. For instance, camera angles from below are used to suggest the importance, stature and height of the subject. In horror films, compositional imbalance in the frame often suggests something scary lurking outside the frame.

Objects should be placed naturally in the static frame. Don't compose so the edge of the frame and important objects are so close that they seem to "fight." Keep objects comfortably *within* the frame or use the edge to cut them off *decisively* and to direct attention to important areas of the frame. Avoid large dead spaces, and don't lose the subject in a mass of irrelevant details. The *rule of thirds* is a rough compositional guide to help you avoid placing important areas of interest *dead in the center* of the frame, which may produce a dull image. Instead, position important areas one third of the screen width from either side or one third the screen height from the bottom or top. Thus, in close-up or medium close-up shots, place the subject's eyes one third of the screen height from the top (the nose will then be roughly centered in the frame). In medium shots, place heads about a third of the way down from the top of the frame. Keeping in mind the above, it must be pointed out that exceptions are legion.

Leading the Action

Whenever a subject has a definite movement toward the edge of the frame, place the subject closer to the edge from which he is moving (see Fig. 8-3). For example, if you track a runner running from left to right, frame him closer to the left side of the frame as if to leave room for running on the right. If the shot continues for some time, the runner can advance in the frame (still leaving room at the right) to suggest forward movement. Similarly, someone in profile looking off screen to the right should be framed closer to the left side of the frame, leaving space on the right.

The 180° Rule

Screen direction refers to the right or left direction on screen as seen by the audience. If a subject facing the camera moves to his left, it is screen right. *The 180° rule* (also called the *director's line* or *the line*) tells how to maintain screen direction

when different shots from the same scene are edited together. If a subject is moving or looking in one direction, in general it is best not to let screen direction change when cutting to the next shot. For example, when watching football on television, the blue team is seen moving from screen left to screen right. If the camera were now to shift to the opposite side of the field, the blue team would appear to be moving in the opposite direction (that is, their screen direction has changed from right to left). It is likely that the audience would be confused. To avoid this confusion, TV crews often keep all their cameras on one side of the field, and, when they want to use a camera position from the opposite side of the field, a subtitle is flashed on the screen that says "reverse angle."

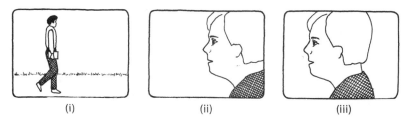

(i)	(ii)	(iii)

Fig. 8-3. Leading the action. (i, ii) Leave more room on the side of the frame toward which the action points. (iii) The void at the right throws the frame off balance, and you expect something to happen (for example, the man may be attacked from behind). (Carol Keller)

Fig. 8-4. The 180-degree rule. If all the camera positions are kept on one side of the sight line, screen direction will be preserved in editing. (Carol Keller)

To help plan your shots, imagine a line drawn through the main line of action—be it a moving car, a football field or the eye line of a conversation. If all camera setups are on one side of the line, screen direction will be preserved from shot to shot. Shots *on* the line (for example, someone looking directly into the camera or a shot from the end zone in the football example) are considered neutral and can go with shots on either side of the line.

During a take, the camera can move across the line with minimal disorientation. But if later in the editing room you don't use the shot where the camera crosses the line, you may have to violate the 180° rule. Rule violations disorient the audience, but rarely are they disastrous. Sometimes inserting a neutral shot minimizes disorientation. The problem is most serious when screen direction itself has been used to construct the space of the scene. For example, in an angle-reverse-angle scene of two people talking, they must be looking in opposite screen directions when there is a cut from one to the other, otherwise they will not appear to be talking to one another. Similarly, chase sequences depend on screen direction to establish whether one car is chasing another or if the two are headed toward each other.

Sometimes there are two different lines of action and there is no way to avoid breaking the rule. For example, a couple is talking in the front seat of a moving car in a scene that is shot angle-reverse-angle. When the driver is shot, the background is moving left; but when the passenger is shot, the background is moving right. Since the relation of the couple is most likely the key element of the scene, draw the line of action along their eye line to preserve their screen direction in the editing.

Continuity

Usually several takes of the same scripted action are shot, in part because actors blunder and crew members make technical errors, and in part because shooting multiple camera angles minimizes the chance of discontinuities in the edited sequence. Even if you plan to shoot the action in one take, allow for an *overlap of action* from one shot to the next in the scene to guarantee that there are no discontinuities in time in the editing. For example, when a medium shot of someone slamming a car door cuts to a close-up, shoot the first shot all the way through the slamming of the door. When you begin the second shot, shoot the actor from a point in the action *before* the first take ended, including the slamming of the door. This allows the two shots to be cut together at several points without discontinuity. (Note: the two shots should usually be taken at different angles to make a smoother cut and to minimize any slight discontinuities.)

The same problem arises in documentary, but an overlap of action is usually only possible in scenes where people repeat the same process several times (for example, when cooking or chopping wood).

A *cutaway* is a shot away from the main action that can be used to cover discontinuities or to condense the action. For example, when shooting someone speaking to a group, a shot of a member of the audience could be considered a cutaway or a *reaction shot*. In editing, cutaways can be used to smoothly join one part of the speech with another. You cut from the speaker (in sync sound), to the cutaway and back to the speaker at a later part of his speech. Without the cutaway, the condensed speech would be more obviously discontinuous (see Chapter 12).

When a character walks off camera, the viewer generally accepts a time jump when the next shot begins with him a bit later. For instance, if someone walks off frame toward the street, a cut to the same person opening a car door or walking down the street does not seem discontinuous. When panning or tracking with a

moving subject, it's usually a good idea to let him walk out of frame at the end of the shot to provide more options in editing.

There are many ways to cover or show discontinuities in time. Say you're shooting a character painting a picture and you want to show her starting with a blank canvas and then in the next shot show her putting the last touch on the finished work. To simply cut from one wide shot to another would probably seem too severe. The routine solution is to dissolve from one shot to the other. Another possibility is to do a *reveal*. The first shot ends as a wide shot. The second shot might begin with a close-up of her face and *pull back* (either by zoom or moving camera) to reveal the finished painting.

In both documentary and fiction shooting, you should always have in mind what shot you can cut the present one with. In a two-way conversation, a close-up of one person will almost invariably cut next to a close-up of the same size of the other person (assuming the 180° rule is observed), but two close-ups of the same person can rarely cut smoothly together. Whenever you feel there will have to be a cut made to another shot, change camera angles and focal lengths to make continuity editing easier.

When shooting, always ask yourself how the shot you're taking might work with the other shots you've gotten or need to get. Do you have enough *coverage*— that is, have you provided enough options for editing? Have you got cutaways? Do you have an establishing shot? Have you got interesting close-ups? See Style and Structure, p. 222, for more on coverage and shooting styles.

Errors discovered while viewing rushes or during editing often necessitate *pickup shooting*, which entails going back to get additional shots to fill in a sequence. A documentary crew might return to get a cutaway from a car window, or, in a fiction film, there might be the need for a reaction shot of an actor. Make Polaroids of sets, lighting setups, makeup and costumes to help match shots that may need to be redone. Many directors of photography keep detailed notes about lenses, camera angles and lighting to facilitate reshoots.

Other Elements in the Dynamic Frame

The focus may be "pulled" from the background to the foreground to shift audience attention. Some filmmakers consider this technique mannered unless it is used to follow a movement. Selective focus is used to accentuate a portion of the subject. In a close-up, it is advisable to focus on the eyes. A tilt-focus lens (see Fig. 3-17) allows you to tilt the plane of focus. Lighting may be changed within a shot; for example, car headlights might suddenly illuminate a person.

Shots tilted sideways (tilted horizon line) are called *Dutch angle* or *canted* and are sometimes used, often in medium close-up, to add tension to a static frame. Sometimes one tripod head (see The Tripod, p. 229) is mounted perpendicularly on another to allow the camera to be smoothly tilted side to side while tilting forward and back.

Cinematographers often shoot at an angle that reveals as many sides of the object as possible in order to enhance the feeling of depth. For example, a building filmed head-on reveals one side; shot from an angle it reveals two sides; and shot down and at an angle it reveals three sides. Use familiar references to establish scale. An enormous boulder will seem larger if there is a person in the frame.

Fig. 8-5. Dutch angle from *Citizen Kane*. Note the strong diagonal lines in the frame. (RKO General)

Hollywood directors frequently use camera angle, camera movement and lighting to create a feeling of deep space in the image. This allows them to clearly distinguish foreground from background and exclude large areas of unmodulated black or white. European directors in the 1960s and 1970s often emphasized the flatness of the screen through their use of lighting and camera angle, sometimes shooting perpendicularly to a wall or allowing large areas of the frame to be overexposed or underexposed.

Composition in the Monitor or Viewfinder

TV CUTOFF. When you shoot with standard (non-widescreen) video cameras, or film cameras in the Academy format (regular 16mm or 35mm; see Chapter 1), the viewfinder shows you the *entire* image that is being recorded on tape or film. Most TV monitors, however, cut off the edges of the frame. This is done so that viewers never see beyond the edge of the picture area. Consumer TV sets are the worst in terms of cutoff. It's important to remember while shooting that nothing crucial in the scene be positioned too close to the edges of the viewfinder frame (top, bottom or sides). However, if something undesired (like a microphone) is in the frame

but right at the edge, you can't always *count* on it being cut off. Items near the edge may show up on some TVs but not on others. Some cameras display a *TV safe action* frame as a guide to remind you. The *TV safe title area* is even closer to the center (see Fig. 8-6). Some monitors are switchable between *underscan*, which shows you the entire image, and *overscan*, which shows you typical cutoff.

Camera Aperture
TV Safe Action
TV Safe Title

Fig. 8-6. TV safe action and safe title areas for a conventional 1.33:1 (4 × 3) film or video frame. Many camera viewfinders crop the outer edges of the full frame (here the outermost box). This illustration can be measured for proper proportions when laying out titles. (Carol Keller)

WIDESCREEN FORMATS. If you are shooting in a widescreen film or video format, use a viewfinder marked with widescreen proportions (see Aspect Ratio, p. 37). Some film cameras have interchangeable viewing screens or ground glasses in different aspect ratios, such as 1.66, 1.85 and 2.35. Some viewfinder screens show different formats nested within each other, so shots can be composed from the center out, thus guaranteeing that important parts of the scene are visible in each format. This also allows you to "protect" every aspect ratio from undesired things like microphone booms. However, protecting for different-shaped frames can lead to poor compositions.

Keep in mind that what you see in a camera's viewfinder—and in particular, the relationship between the widescreen and non-widescreen frames—depends on the format. For example, if you are shooting with a regular 16mm camera or conventional non-widescreen (4 × 3 or 1.33) video camera, the *full width* of the frame in the viewfinder will be used by both the standard and widescreen frames (see Fig. 2-10).

If the material will later be converted to a widescreen format (either by 35mm blowup or conversion to a 16 × 9 video format) the top and/or bottom of the frame may be cropped (see Fig 1-30ii). When composing the image, if you are trying to protect for both formats, feel free to place subjects on either *side* of the frame, but be careful not to place important things too close to the *top and bottom*. The standard and widescreen frames thus can be thought of as having "common sides."

On the other hand, when using some widescreen video cameras or some super 16 cameras, the full width of the frame displayed in the viewfinder applies only to the widescreen frame. If the image will later be converted to a non-widescreen format, one or both sides will be cropped later (see Fig. 1-30i). Often, the 4:3 TV cutoff box is displayed in the center of the frame, so you can see how much will be lost. In this case, if you were trying to protect for both formats, you are free to place important parts of the subject near the top or bottom, but if they are too close to the left or right sides, they may be cut off. However, while you are "safe" in avoiding the sides, center-weighted compositions that leave the sides of the frame empty can be quite dull. In this case, you might instead choose to compose for the widescreen image and plan to do a pan and scan later if necessary (see Fig. 1-30).

For more on 16mm and super 16, see pp. 9 and 494.

High-definition formats, like HDTV and 35mm, may allow you to frame things slightly wider and still see small details. With lower-resolution formats, you may have to move in or zoom in tighter to see products, facial expressions, lettering or other fine details.

STYLE AND STRUCTURE

Style in movies, like all art forms, is continually evolving. At any given time, different types of movies make use of various conventions in shooting and editing. The conventions shift over time for a variety of reasons: a stylistically new film will spawn imitators; changes in technology make new techniques possible; ideas are borrowed from one type of moviemaking and applied to others.

What follows is a deliberately sketchy history of some styles used in moviemaking as a stimulus to thinking about the relationship of style and shooting possibilities.

Documentary Styles

In documentary filmmaking, some of the key stylistic questions relate to how much the filmmaker attempts to control or interact with the subjects, and to the way information is conveyed in the movie.

Some of the first motion pictures were made by Thomas Edison in the 1890s. These were "documentaries" in the sense that a camera was set up to record real events, such as the death of an elephant. Or the Lumière brothers' *Train Coming into a Station* (1896), which is a single, continuous shot of a train arriving (and which reportedly caused pandemonium because audiences thought the train was coming into the *theater*).

The style adopted by British documentarians of the 1930s and 1940s is a kind of hybrid that involves staged events and real people (nonactors). Because the

cameras and the disc sound recording equipment were heavy and hard to move around, action was often produced and orchestrated for the camera. Scenes may be scripted and shot much like a narrative film. Many of these films use a "voice of god" narration—the authoritative male voice that provides factual information and often spells out the message the viewer is intended to take from the film.

In the 1960s, lightweight 16mm cameras were introduced that could record sync sound with portable tape recorders. With the advent of handheld cameras, new access to locations and people's lives was obtained. Jean Renoir spoke of the heavy studio camera as an altar to which actors had to be brought. The handheld camera could now go out into the world instead of bringing the world to the camera. *Cinema vérité* (also called just *vérité* or *direct cinema*) films attempt to spontaneously react to events and capture life as it is lived. With a small crew and enough time for subjects to get comfortable, the filmmaker can become very unobtrusive. Unself-conscious subjects will reveal to the camera how they really live and self-conscious subjects will reveal themselves in how they choose to perform. Many of these films use no narration or interviews and attempt to minimize the sense that the material has been influenced or interpreted by the filmmaker.

In the 1970s, a "personal documentary" movement emerged. In these movies, filmmakers explore their own lives, or shoot others with the explicit acknowledgment of the camera's presence and the filmmaker's role in interpreting events for the audience. Rather than seeking the illusion of objectivity, these films embrace a subjective and personal view, and are often narrated by the filmmakers themselves.

In the 1980s and 1990s, nonfiction programming grew in popularity on network television. Magazine-style shows like *60 Minutes* are structured around short segments in which a correspondent is the guide and narrator of a particular story. These productions, once shot on film but now shot on video, have their roots in journalism. The correspondent is seen interviewing subjects and doing *stand-ups*—telling the story directly to the camera. These shows usually contain some amount of "vérité-style" footage in which people are seen living their lives or doing their jobs. This footage is often referred to with the antiseptic term *B-roll*. B-roll is noninterview material that is generally allowed to play for only a few seconds in sync sound. Then the location audio is dipped down and the picture becomes a bed over which to lay narration.

Today, nonfiction films are made using all of these styles, or combinations of styles. When you embark on a documentary project, you need to determine the stylistic framework for the movie. In what ways will the audience learn about the subject? By watching events unfold in a vérité-style approach? By seeing interviews with the subjects? By seeing interviews with "experts" commenting on the subjects? Will there be a narration (also called *voice-over*)? If so, is the narrator a disembodied voice or someone also seen on screen (either a subject, the filmmaker or a correspondent)?

Often the film's topic will dictate style. Documentaries about past events generally use a combination of interviews (*talking heads*) and *archival* material (*stock footage*). Often this is combined with present-day footage of locations where events took place. Sometimes *reenactments* of past events are shot using actors. This footage is sometimes shot in a stylized way to avoid being too literal; for

example, actors might be filmed without any dialogue or perhaps not showing their faces.

One of the reasons television tends to favor correspondent- and interview-based material is that it is easier to produce on a short shooting schedule. Interviews can be scheduled and stand-ups can be scripted fairly quickly. In contrast, when you're filming real people living their lives—without attempting to "direct" them—you're never sure what's going to happen or when. Many a filmmaker has completed weeks, months or years of shooting someone with no idea if enough of a story has emerged to even make a film. On the other hand, there is a unique power in stories that develop over a long period of time, in which characters change, grow, are born or die.

Documentary Shooting

As discussed above, some documentary shooting is relatively controlled and even scripted. In some cases there is time to preplan shots as you might a fiction film (see below).

When shooting interviews, try to place subjects in a setting that tells the audience something about the person. Another approach is to use a neutral backdrop to provide consistency from one subject to the next. A textured cloth or black (*limbo*) backdrop can be brought from location to location, but if there are many talking heads, a uniform backdrop may become dull.

Usually the interviewer sits close to the camera so the eye line of the interview subject is *toward*, but not directly *into*, the lens, which may make the audience feel uncomfortable. When positioning the subject, be attentive to screen direction—try to alternate setups with subjects facing screen left with those facing screen right, especially for people with opposing opinions. When the interviewer is to be shown on camera, or if there is more than one camera, sometimes one camera angle is from the side, to get more of a profile shot. Filmmaker Errol Morris uses what he calls the "interrotron," a device that projects his face on a screen in front of the lens (essentially a teleprompter; see Fig. 8-22), so the interviewee can look *directly into* the lens while talking to him. *On-camera* hosts or correspondents generally look directly *to camera*.

Some filmmakers shoot interviews with no camera movements *during* shots, but zoom in or out to vary the focal length *between* shots. This allows cutting in or out of the material at any point and avoids ever having to cut *during* a zoom, which some people find objectionable. However, a well-timed zoom can enhance an interview by bringing the viewer closer for important or emotional material, or pulling back to capture, say, interesting hand gestures. If the zoom is gradual and properly timed to the phrases of speech, cutting opportunities should not be too limited. If lower-third subtitles will be used to identify subjects (see p. 360), be sure to leave room at the bottom of the frame.

Shooting uncontrolled, noninterview documentary scenes takes a special combination of sensitivity, luck and quick thinking. Perhaps more than any other kind of shooting, cinema vérité filming requires that the camera operator think like a director and an editor, all while spontaneously reacting to changing events. The tendency while shooting is to concentrate on the central action or person talking;

remind yourself that the audience may also need to see the context (wide shot) and reactions from other people in the scene. Think about the sequence as a whole. Ask yourself if you've gotten enough coverage. Though you don't yet know how the sequence will be edited, try to provide multiple options for editing and shots you think might make interesting beginnings or endings.

It is especially important to think of individual shots and camera movements as having a shape, with a beginning and end. Novices, especially when shooting video, tend to move the camera *constantly*, which makes the footage very hard to cut. When doing a camera movement (whether it be a zoom, pan, dolly or walking shot), it is often a good idea to begin with a static frame that is held for a few seconds, then transition into the movement, and glide to a stop on another frame and hold that a few seconds. The editor may cut out the static beginning and end, but at least she has them if needed.

One of the challenges of shooting uncontrolled action is finding ways to condense time. Almost invariably, a scene as edited on screen must play much faster than the actual event took in real time. This means judiciously shooting parts of the action in a way that will allow the editor to cut out the uninteresting parts in between. Take the example of shooting two people talking over dinner. The meal might take two hours in real time and run two minutes in the edited movie (see The Shooting Ratio, p. 229). If the camera remained locked in a two-shot the entire time, the sequence would be almost impossible to cut. Instead, get a variety of angles, some two-shots, some close-ups. Be sure to shoot ample footage of the person listening as well as the person talking. An over-the-shoulder shot taken from behind the person talking shows the relationship of the two subjects without showing moving lips. This can be very useful in the editing room. Similarly, when shooting someone on the telephone, try to get some angles from behind or where the phone's mouthpiece blocks the camera's view of the person's lips. When shooting someone playing an instrument, be sure to get neutral shots in which no fingering or hand position is visible.

Narrative Styles

In fiction and other scripted filming, one of the director's prime concerns is where to place the camera. On a broader stylistic level, the director must plan how individual shots relate to the action of the scene and to the juxtaposition of other shots through editing.

In the *deep focus shot* (see Fig. 8-7), the whole frame is in focus. The meaning of the scene thus develops in the deep space of the frame. The camera movement, subject movement, dialogue, lighting, costumes and so forth all contribute to the forward movement of the film. The *long take*—that is, a shot of long duration—allows the action to unfold in real space and underlines the fact that the shot's meaning comes from filming, not from editing.

The staging of the shot, or *mise-en-scène*, is contrasted with *montage*, in which meaning and forward movement are conveyed through *editing*, through the juxtaposition of various shots that by themselves may contain less information or content. When the action of a scene is captured in many shorter shots, the filmmaker has an opportunity to control pacing and to direct the audience's attention in ways

that may not be possible with longer takes. Montage also opens up the possibility of constructing entirely new meanings by suggesting connections between shots that otherwise might seem unrelated (for more on montage, see Chapter 12).

Fig. 8-7. Deep focus shot from *Citizen Kane*. A wide-angle shot with both foreground and background in focus allows the action to develop within the frame. (RKO General)

Andre Bazin, the French film critic often credited as the decisive influence on the French New Wave, thought it characteristic of advanced film directors of sound pictures to be concerned with mise-en-scène, with the integrity of the photographed space. If you think of dangerous stunts, it is easy to grasp the visceral effect of seeing the events photographed rather than constructed. Out of all the silent filmmakers, Buster Keaton seemed to understand best the power of unmanipulated space. His stunts, often performed in long shot, were clearly incredible feats. Much of the attraction of unmanipulated documentary is its ability to convince the viewer that what is seen on the screen actually occurred.

On the other hand, when audiences "suspend disbelief" and enter into the world of the movie, a carefully constructed edited sequence can deliver enormous emotional impact or bring out otherwise buried meaning. Staging and editing should not be thought of as opposites but as two stylistic tools at the filmmaker's disposal.

The first dramatic filmmakers approached motion pictures as an extension of theater. A story would be acted out in front of a fixed camera. Though the early

silent films of the 1900s were not shot literally on a proscenium stage, the camera's relationship to the action was much like a theatergoer's view of a stage play. D. W. Griffith is credited with first exploiting the power of the close-up. The camera comes in close to reveal nuances of an actor's expression, creating a new relationship between audience and actor and necessitating a new, more subtle style of acting. The Silent Cinema defined the basic vocabulary of the film image. Today, shots taken without sound are referred to as *MOS*. The story goes that when the German directors came to Hollywood in the early 1930s, they referred to silent footage as *"mit-out-sprache"* ("without speech"), hence MOS.

Hollywood films of the 1930s and 1940s generally were shot in studios using a conservative shooting/editing style. Scenes are first filmed all the way through in *master shots* (relatively wide angle, continuous takes). Then close-ups are filmed, if needed. The edited scene begins with the wide establishing shot to ensure that the audience is well oriented and comfortable in the setting before cutting to the closer shots. From this evolved a "traditional" style of covering a two-person scene using a master shot, a two-shot, a close-up and a reverse. A radical exception to this style is found in *Lady in the Lake*, which was filmed with a subjective, point-of-view camera that is meant to reveal what the audience would see if they were inside the protagonist's head.

In the 1960s and 1970s, as the general culture loosened up, so did narrative style in many films. The old dictates of master shot/close-up coverage gave way to freer-form shooting that assumes that audiences have the visual sophistication to understand a scene that might be, say, *only* an extreme close-up. John Cassavetes experimented with a style that seems to merge documentary and narrative sensibilities. To the audience, both the acting and the camera work may appear spontaneous and improvised. The usual notions of "coverage" give way to scenes that flow organically from one moment to the next.

The 1980s brought the *music video*. Made by and for a generation that was raised watching TV, music videos introduced a new lexicon of quick cutting and the juxtaposition of wildly differing types of imagery. Stylistic touches exploited in music videos and TV commercials have found their way into many other types of movies; these techniques including deliberately shaky camera work, distorted images, fast cutting and intentional jump cuts (see Chapter 12).

Today, narrative films combine elements of all these styles. Many mainstream Hollywood or TV dramas are very straightforward stylistically, seeking a style that will not "intrude" on the storytelling. Independent dramas tend to take more risks, but often what sets them apart is the kinds of stories they tell, not the fundamental visual language in terms of shot selection and editing.

Narrative Shooting

When a movie is made from a script, the filmmaker has the possibility of preplanning the shots. Some directors simply do a rough breakdown of scenes in terms of camera coverage: a wide shot here, matching close-ups there. Some prefer to *storyboard* sequences by drawing a picture of each shot. Storyboards can be drawn by hand or by using software like Storyboard Quick. Some directors like to shoot rehearsals with a small-format video camera to get ideas for the final production. Sometimes

blocking out the movements of the camera and the actors can't be done until you see the set or location and the actors can rehearse in place. It's important to rehearse *before* setting lights, props, and dolly tracks that will limit everyone's flexibility.

Blocking the camera and actors is a kind of choreography. Keep the image as dynamic as possible. Be attentive to the depth of the space you're shooting in, either to show it or let actors move through it. Use blocking to *reveal* things rather than merely showing everything up front. Some shots are most interesting for what they *don't* show.

When shooting a two-way conversation using matching close-ups, be attentive to balancing the composition of the two angles. When shooting one actor's close-up, it's a good idea to set a microphone for the off-camera actor as well—the performances from these takes can sometimes be better than the on-camera takes. Higher-budget films often shoot with two cameras simultaneously in this situation.

Fig. 8-8. Sony Video Walkman Hi8 recorder and monitor can be used as a portable "director's monitor" for mobile shooting and allows you to record and review takes separately from the camera. Very handy when using a film camera with a video assist. A wireless link is available for sending the signal and controlling the recorder from the camera. (Fletcher Chicago/Sony Electronics, Inc.)

Make sure to cover for mistakes. While the beginning and end of a take may be good, the middle may have an error or just be too slow on the screen. Shoot a reaction shot or a cutaway as editing insurance even if you don't intend to use it. You may want one continuous take, but, too often, surprise errors show up during editing and it is essential to be able to cut around them. Getting a take exactly right is expensive and, for long takes, very difficult. One saying has it that the best takes are the first and the tenth (the advantages of spontaneity versus practice), but the production's budget may not permit ten takes. Even if a long take is good, you may need to cut the sequence or film shorter and your beautiful three-minute shot now becomes a burden.

Both the order of scenes and the overall length of the movie are often changed substantially in the editing room relative to the original script. Keep this thought in the back of your mind as you plan out your scenes.

Perhaps the best way to think about the shooting and editing style for your movie is to watch other movies and note which scenes work particularly well or particularly badly.

The Shooting Ratio

The total amount of material shot on a production is invariably greater than the length of the final edited movie. The ratio of total footage shot to final footage (the *shooting ratio*) varies widely by type of movie, budget and director's style. An unscripted documentary might be shot at 40:1 or higher, while a carefully planned fiction film might be on the order of 10:1 or 15:1. Some animators use almost all the footage they shoot (1:1 ratio). When shooting film on a low-cost production, laboratory expenses are often the most significant budget item and the shooting ratio is a key concern.

No matter how predictable you assume the action, the unexpected always seems to happen: there are weather changes, flubbed lines and technical difficulties with picture or sound. Additional takes are invariably needed in acted work, and documentary is always unpredictable. With experience, you will find the ratio you are comfortable working at.

Since videotape is relatively inexpensive on a per-minute basis, people tend to shoot video at a much higher ratio than film. A day of video documentary shooting can easily result in four or five hours of tapes; the same day shooting film might produce only an hour of film footage. While it can be liberating to shoot video so freely, this can create real problems in the editing room. Managing a project that has hours and hours of material can be a headache and may require many days just to view and log the footage. When cutting individual scenes, video camera work can often be *too relaxed* and rambling. When you shoot film, you have to edit in your head and make every foot of film count. With a video camera, it's almost harder to turn off than to just keep shooting. Shots may have no particular beginning or end, and may be impossible to cut. We have found that students who first learn to shoot film tend to shoot more carefully than those who started with video.

SUPPORTING AND MOVING THE CAMERA

The Tripod

The tripod is a three-legged camera support. The camera mounts on the *tripod head*, which sits on the tripod's *legs*. Heads designed for motion picture work are able to *pan* (short for panorama), which is to rotate the camera horizontally, or to *tilt*, which is a vertical rotation. *Friction heads* for tripods are the least expensive, but they are hard to pan smoothly. *Fluid heads* have a built-in hydraulic dampening device to make panning much easier. Their light weight and ease of operation make them the most advantageous for small crew work. Large cameras are often

used with *geared heads* that use two gear wheels to control movement (see Fig. 8-10). These are heavy and expensive and take experience to use, but can produce very smooth, repeatable movements.

Fig. 8-9. Fluid head. Sachtler Video 18 Sensor has seven-step pan and tilt drag controls. Touch and Go quick-release plate. Top surface slides forward and back for proper balance, which is indicated by the LED display. (Fletcher Chicago/Sachtler Corp. of America)

Tripod heads have locks that prevent them from moving inadvertently. The lock on the tilt movement is very important, since the camera and tripod can fall over if there is an unintended tilt. Friction and fluid heads often have devices to control the amount of friction or dampening for different panning speeds. Most heads have a balancing mechanism of some kind, either a spring affair or a forward/back adjustment. When the camera is properly positioned and balanced, it should not move when the head is unlocked.

Wooden tripod legs are generally heavier but are less expensive than light-weight aluminum or carbon fiber legs. *Standard legs* will telescope out to around 6', and *baby legs* raise to around 3'. The *high hat*, used for low-angle shots, does not telescope and is often attached to a board. Tripod legs and heads are rated by the weight they will support; do not use a camera heavier than the rating.

Level a tripod so that the horizon line is parallel to the top or bottom of the frame. Unleveled tripods result in canted shots and tilted pans. To level a tripod, extend one of the legs (loosen the leg lock and tighten at the proper length); extend the other two legs but don't tighten them yet; hold the tripod in a vertical position and press down on it until the legs are even, and then tighten all of them. Point one of the legs in the direction that you will shoot the camera, and place the other two legs to approximate an equilateral triangle. With a *ball-in-socket head*,

Fig. 8-10. Geared head. Arrihead 2 shown with Arriflex 535B 35mm camera. (Arriflex Corporation)

loosen the ball and move the head until the bubble on the attached spirit level is centered. If the tripod has no level, use architectural horizontal or vertical lines to level the camera. If the camera is not pointed up or down, align a true vertical with the vertical edge of the frame; or align a true horizontal, viewed head-on, with the top or bottom of the frame.

Quick-release mechanisms save a lot of time mounting and releasing the camera from the tripod head without having to screw and unscrew the connection each time. Safety locks prevent the camera from slipping off during a tilt.

Tripod legs often have a point or spike at each toe that can be secured in dirt or sand. A *spreader* (also called a *spider* or *triangle*) is a three-armed device that spreads from a central point and clamps to each tripod leg; this prevents the legs from sliding out from under the tripod head. A spider that remains attached to the tripod even when stored for travel will save a lot of setup time.

When shipping or transporting a tripod, loosen all locks and drag mechanisms on the fluid head so the head is free to move in its case.

A *rolling spider* or *tripod dolly* (a spreader with wheels) facilitates moving the camera between shots. Do not use it for dolly shots except on the smoothest of surfaces. When no spreader is available, a piece of rug, 4' × 4', can be used. You can tie rope or gaffer's tape around the perimeter of the legs for an improvised spreader.

Some tripods (usually made for still photography) have devices for elevating the center of the tripod. This extension usually contributes to the unsteadiness of the image; it is more desirable to extend the legs. If additional height is needed, mount the tripod on a platform. On larger productions *apple boxes*—strong, shallow boxes of a standard size—are nailed together to make low platforms. Apple boxes are available in full, half and quarter size.

Fig. 8-11. Sachtler tripod legs. A range of lightweight legs that accept fluid heads. The spreader fastens to the standard legs even when folded for travel. This saves a great deal of time when moving and storing the tripod. (Sachtler Corp. of America)

Fig. 8-12. Super Grip II uses a suction mount with vacuum pump and can be attached to cars, windows and nonporous surfaces. Car mounts should be set up by experienced persons using safety lines when possible. (Fletcher Chicago/Alan Gordon Enterprises)

Heavy-duty suction cups and clamps allow you to attach cameras to vehicles and other surfaces. The surface must be fairly flat, smooth, clean and dry to use suction cups. If the camera is mounted on a moving vehicle, tie it down with safety lines.

If you will be shooting for extended periods on a tripod or dolly (see The Moving Camera, p. 234) it is very helpful to have a viewfinder extension (with leveler; see Fig. 1-10) or, for a video camera, a rear-mounted monitor. Remote controls for the lens and camera are available for both video and film cameras. Some mount on the tripod handle, some extend from the lens or camera directly or on cables. On a tripod or dolly, it can often be difficult to reach the lens or camera switch without them.

Pans and Tilts. Whenever possible, plan and rehearse pans and tilts. Adjust the tripod so the front leg points in the direction of the lens to maximize the amount of room behind the camera. On very wide-ranging pans, you may have to cross over a tripod leg, which is not easy to do without practice.

Pans work best when motivated by a subject moving through space. Panning with a moving subject makes the rate and movement of panning natural. Panning to follow a subject is sometimes called *tracking*, but this should not be confused with the tracking shot where the camera itself moves through space (see below). However, panning with a long focal length lens can be used to simulate a moving camera shot (see Telephoto Lenses, p. 99).

The most difficult pans are across landscapes or still objects, since any unevenness in the movement is evident. These pans must be fairly slow to avoid strobing (see p. 49). A safe panning speed for landscapes under average lighting and subject conditions pans an object five seconds or more from one edge of the frame to the other. Following a moving subject minimizes the strobing problem, since the

viewer's eye follows the subject, making strobing in the background less important. The *swish pan*, a fast pan that blurs everything between the beginning and end of the movement, also avoids the strobing problem.

Panning is sometimes thought to be the shot most akin to moving your eye across a scene. If you look from one part of the room to another, however, you will see that, quite unlike the pan, equal weight is not given to all the intermediate points in the visual field. Viewers tend to read images from left to right, and scene compositions should take this into account. Therefore, pans generally cross still landscapes from left to right, as though the world unfolds in this way.

Cinematographers sometimes say that shots with camera movements like pans, tilts, zooms and dolly shots are supposed to start from a static position, gradually gain speed, maintain speed and then slow down to a full stop. This rule is often honored in the breach, and shots often appear in films with constant speed movement.

Keep in mind that the larger the movie is projected, the more exaggerated any camera movement will be. A quick pan or shaky camera may be far more disorienting or objectionable on a large screen than on a small one.

The Moving Camera

When the camera moves through space, the viewer experiences the most distinctly cinematic of the motion picture shots. The moving camera is perhaps the most difficult and often the most expensive shot in the cinematographer's vocabulary. These shots are called *dolly*, *track* or *truck shots:* when the camera moves in, it is called *dolly in* or *track in;* when the dolly moves out, *dolly out* or *track out.* If the camera moves laterally, it is called *crabbing* or *trucking* (for example, *crab left* or *truck right*).

A wheeled vehicle with a camera support is called a *dolly*. The *doorway dolly* is basically a board on rubber wheels with a simple steering mechanism; this is a lightweight, portable and inexpensive dolly. The *western dolly* is a larger version. Though these dollies are steerable, they cannot move laterally like a *crab dolly*.

A dolly with an integral *boom* provides up-and-down (vertical) movement, which adds enormously to the lexicon of possible shots. A *jib arm* can be used with a tripod and/or a dolly for up-and-down or side-to-side movement. Jib arms are harder to control than built-in booms, but they can provide extended reach for high angle shots. If the support can reach great heights, it is called a *camera crane*. Industrial "cherry pickers" (like a telephone repair truck) may be used to raise the camera up high for a static shot, but they do not have the proper dampening for a moving shot that ends with the camera motionless.

Most dollies can be run on plywood sheets or smooth floors. Use air-filled tires when running on pavement. Large tires, especially when underinflated, give smoother motion on rougher surfaces. For the smoothest, most repeatable movements, use a dolly that runs on *tracks*. Track comes in straight and curved sections of various lengths that can be combined as needed. Track can be used indoors or out, but needs to be carefully leveled and positioned to produce bump-free, quiet movements. Some dollies can be switched from flat wheels to *bogey wheels* for track.

Fig. 8-13. Dolly with boom permits vertical as well as horizontal movements. (J. L. Fisher, Inc.)

Fig. 8-14. Doorway dolly. Lightweight, affordable, basic dolly. (Matthews Studio Equipment, Inc.)

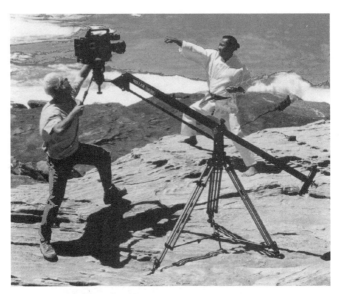

Fig. 8-15. Miller Projib. Compact jib arm for studio and location work. Jib arms are often mounted on a dolly. (Miller Fluid Heads)

There are substitutes for professional dollies—wheelchairs, shopping carts, children's wagons, a pushed automobile. Do not secure the camera rigidly to most of these improvised dollies. Handholding often insulates the camera from vibrations.

The person pushing the dolly (the *dolly grip*) becomes an extension of the camera operator and needs just as much practice and finesse to get the shot right. Keep this in mind when choosing a dolly grip.

Shooting from a Moving Vehicle

When you need a tracking shot faster than what you can get from a dolly, use a motorized vehicle. An automobile, especially if it is equipped with a shooting platform, is extremely versatile. In general, the larger the car, the smoother the ride. Automatic transmissions are preferable, since manual shifting may create a jerky movement. Keep tire pressure low to smooth out the ride. The camera should be handheld to absorb automobile vibrations. It is easiest to achieve smooth camera movement if the car's speed remains constant, and most difficult if the vehicle goes from a stop into motion.

Shooting in the same direction as the moving vehicle results in the motion appearing normal on the screen. Shooting at right angles to the direction of the vehicle makes the car appear to be going roughly twice as fast as it is. At intermediate angles, the speed is between these extremes. Wide-angle lenses increase apparent speed and long focal length lenses can decrease apparent speed (see Perspective Effects, p. 81). To determine how fast the vehicle will appear to move on the screen, take into account the lens focal length, the angle of shooting and the speed of the vehicle. With a film camera, you can shoot at higher camera speeds to smooth out unevenness in the ride.

Fig. 8-16. Briefcase dolly. Can be used with straight or curved track. The dolly platform folds, becoming a thin carrying case for travel. (Fletcher Chicago/Egripment USA).

The Handheld Camera

The handheld camera was first experimented with during the era of Silent Cinema, especially in the films of Dreyer, Clair, Vigo and Vertov and in various MOS sequences during the studio era of sound film such as James Wong Howe shooting a boxing sequence on roller skates. However, not until the early 1960s with the New Wave in France and cinema vérité films in the United States was the potential of the handheld camera realized. Not only could the camera now capture new subject matter in new locations, but handheld shooting, at its best, imparted electricity to the image. Handheld shooting is often best in unscripted situations—whether a documentary or with improvised acting. The extreme mobility of this camera permits following the action, achieving a feeling of intimacy impossible in a tripod- or dolly-mounted camera.

TIPS FOR HANDHELD SHOOTING. You should avoid handheld shooting of landscapes or scenes with strong architectural elements, since any jiggles become obvious due to the stillness of the subject.

Shoulder-mounted cameras are the steadiest, because the operator's body braces the camera and dampens vibrations. Cameras that are held in front of the eye, like many small-format video cameras, are more difficult to hold steady and can start to feel heavy after hours of shooting. Cameras that don't balance on the shoulder can be used with a *body brace*. Braces are available for small video cameras that increase stability but still require you to support the front of the camera (see Fig. 6-8). Heavy, unbalanced cameras like the Arriflex BL need a brace, but the brace takes all the weight (see Fig 8-17). A brace does encumber you and prohibits you from responding as quickly to unpredictable events. Some cinematographers feel the brace imparts a mechanical feel to the shooting, but for those situations where the mobility of the handheld camera is needed and the action is predictable, a brace may work out well.

Fig. 8-17. The shoulder pod or body brace. (Cine 60)

You should memorize which way to turn the lens controls for focus, aperture and zoom. Make up your own memory aid such as "pull to bring infinity close and bright," which means (assuming the lens is operated with the left hand) pull counterclockwise for farther distances (infinity), to open up the aperture (bright) and to zoom in closer. Not all lenses turn the same way, so you may need to make up another memory aid for your rig.

To shoot a handheld camera over extended periods of time, it helps if you're in good physical shape. Find a comfortable position for shooting by practicing before you begin. Some people shoot with one foot in front of the other, others with their feet in-line, shoulder-width apart. Don't lock your knees; if you like, keep them slightly bent. Stand so you can smoothly pan in either direction and move forward or backward. For filming while walking, walk Groucho Marx style, with your knees bent and shuffling so that the camera does not bob up and down.

When you film without a script, avoid excessive zooming and panning, which could produce results that are unwatchable and uncutable. As a test, we often tell students to count slowly to six without making any camera movements. If they feel their fingers itching to zoom or pan, they are not yet calm enough to shoot (see The Zoom Lens, p. 93).

When you shoot while walking backward, have someone (like the sound recordist on a small crew) put his hand on your shoulder and direct you. Some camera eyepieces swivel so that you can walk forward with the camera pointing backward over your shoulder. Try cradling the camera in your arms while walking and shooting: use a fairly wide angle lens, positioned close to the subject and keep in stride. To steady a static shot, lean against a person or a support, such as a car or building. Put the camera on your knee when shooting the driver in the front seat of a cramped car.

Documentary filmmaking creates some of the most difficult follow-focus situa-

tions, since the camera-to-subject distance constantly changes in unpredictable ways. When careful focusing is not possible, zoom to a wider angle to increase depth of field and move the distance ring to the approximate position. As your skill increases, it will become easier to pull something directly into focus by looking at the viewfinder. As previously said, remember that the wider the angle of the lens, the less annoying any camera jiggle will be in the image (see Chapter 3).

Image Stabilization Devices

Image stabilization devices can be used to lessen unwanted camera vibrations and jiggles. These range from devices built into a camera or mounted on the lens, to handheld or body mounted devices, to helicopter and other vehicle mounts, such as the Tyler mount and Wescam system.

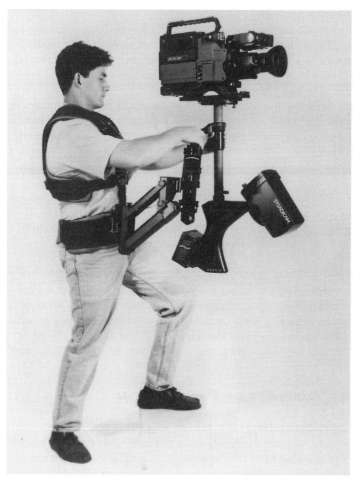

Fig. 8-18. ProVid Steadicam. The camera operator watches a small monitor mounted on the Steadicam. (Cinema Products Corp.)

THE STEADICAM. The *Steadicam* and other similar devices allow the camera to be mounted on a harness worn by the camera operator that absorbs most shocks, enabling smooth movements. The camera movements possible are similar to those from a dolly, but a Steadicam permits much faster setups, shooting in tighter quarters and significantly increased mobility. Any vehicle—automobile, boat, helicopter or even skates—can achieve dolly-smooth movements. Pans, tilts, running shots and shots going up stairs can be made with the subtlety of the moves of the human body without any handheld jiggles. With a Steadicam, you do not look through the camera's viewfinder but, rather, at a small video monitor that displays a through-the-lens reflex image. Although you can respond to unplanned subject movement (unlike a dolly, for which each shot must be blocked), response is slower than that of the shoulder-mounted camera. Also, Steadicam shots have a floating smoothness that some people find more mechanical and less exciting than well-done handheld shots.

The Steadicam must be set up specifically for each camera and requires that film cameras be equipped with a video tap. Film cameras with vertically mounted magazines or coaxial magazines (see p. 62) work best, since the camera's center of balance remains more stable during a take. The Steadicam operator needs special training and plenty of practice.

The implications of the Steadicam for theatrical feature film productions are monumental. Not only does it add to the repertory of dollylike shots, but, more importantly, it creates new relationships between filmmaker and location and between filmmaker and actors. Quick, inexpensive setups relieve the pressure on actors and crew. The use of a Steadicam in a documentary is often limited, since the equipment may be overwhelming to many people in documentaries.

There are various prosumer devices designed to smooth out camera movement for small-format video camcorders, including Steadicam Junior and Handyman 1000. With practice, these can provide smooth moves in some shooting situations, but some people find them awkward for documentary work.

OTHER IMAGE STABILIZERS. Some video camcorders have built-in image stabilization devices. *Electronic image stabilization* (*EIS*) digitally processes the video image to reduce image shake. *Optical image stabilizers*, which are used with some film and video cameras, use a device on or in the lens to dampen vibration and shake. Experiment to see if you like the effect of the stabilizer. Some devices add a slight lag to intentional camera movements, giving an unwanted floating effect.

OTHER ASPECTS OF PRODUCTION

Recordkeeping

Keeping good records during shooting has enormous benefits. It enables you to keep track of what has been shot and what needs to be shot and it allows you to locate video, film or audio footage for later processing or editing. There are several different kind of logs or reports used in production.

For a video shoot, you can make a simple log form with columns to indicate the

tape number, timecode start and stop, scene number or content and any notes about whether the take was good or bad. Devices such as the Scriptboy can provide a wireless remote readout of the camera's timecode to aid the person logging. The Shot Logger is a handheld computer that allows information to be entered and later uploaded to a nonlinear editing system (see Fig. 8-19). There are various systems for uploading log information from the shoot to a telecine log file during film-to-video transfers (see Telecine Logs, p. 523).

When shooting film, the camera assistant fills out a *camera report* that indicates every take on a given roll of film, including length of the shot and any remarks (see Fig. 8-20). Good takes are normally circled. This tells the lab which takes to print or transfer to video.[1] The sound recordist may fill out a similar *sound report*, which indicates what material is recorded on the roll. Some sound recordists use *sound take numbers*, which advance sequentially every time audio is rolled from the beginning of the production to the end. These can aid in finding material later. When timecode is being used it's a good idea to note the approximate timecode for each take or at least when changing rolls.

For feature and other scripted work, the script is generally marked to show what camera angles were used to cover each page of the script. This *continuity script* serves as a reminder of what coverage needs to be gotten, and tells the editor what shots have to be taken (see Fig. 8-21).

Fig. 8-19. Shot Logger permits quick logging of takes, including timecode start and stop and comments. Receives timecode from camera via wireless link. Log can be printed or uploaded directly into a nonlinear editing system. (Fletcher Chicago/Production Magic)

[1]In 35mm, typically only selected takes are printed. In 16mm, some labs will only print complete rolls.

CAMERA REPORT

Roll # **15** Sheet # **1**

Production **ON A ROLL**	Director **H. TESSMAN**
Camera Person **J. BRACK**	Assistant **A. JULIA**
Recordist	Loader

Date **6/7/99**
Job #
Camera # **610** Mag # **236**

Scene#	TK#	SD.	Dial	Ftg	Remarks	Scene#	TK#	SD.	Dial	Ftg	Remarks
22	1		100		INT. KITCHEN -WS						
	2		210								
	③		310	100	BEST						
	④		400	90							
	5		450								
22A	1		550		CU - ROB						
	②		670	120							
	③		880	110	tail slate						
22B	①		900	90	CU - IVAN						
			⟨920 OFF⟩								

OUT AT **920** NEG. TYPE **5279**
PRINT **510**
NO PRINT **410** EMUL. NOS. **184-1704**
(WASTE)END **80** EXP INDEX **NORMAL**

FILM-TO-TAPE TRANSFER SPEED ☑24 F.P.S. INSTRUCTIONS TO LAB TIMER
☐ 30 F.P.S. **Print warm for early morning**
☐ _____

SUBJECT TO CONDITIONS ON REVERSE SIDE PRINT CIRCLED TAKES ONLY

Fig. 8-20. The camera report accounts for every take on each camera roll. The best takes are circled. In 35mm, usually only circled takes are printed. (Form by DuArt Film and Video)

22 INT. DRISCOLL FARM HOUSE - KITCHEN - MORNING

22 22A CU-ROB 22B MS-IVAN 22C CU-JANE
WS-MASTER

Ivan and Rob are standing at the counter, going over documents. Jane is at the table, dressed in sweats, the paper and drinking coffee.

 ROB
 Now, here's the power-of-attorney
 I drew up. It just authorizes
 whoever you choose to sign
 checks...and make some decisions
 if you can't.

 IVAN
 That makes sense. Did you put
 your name in there?

 ROB
 That's for you to do.
 (he glances over at
 Jane)
 You can authorize whoever you want.

Jane looks up, waiting to see what her father will s

 IVAN
 Come in and show this to Margaret,
 I want her to see what we're doing
 here..

Fig. 8-21. Lined script. Each vertical line indicates a different camera angle or shot that was filmed. Zigzag portions indicate off-camera dialogue or action. The script is normally marked by the script supervisor during the shoot.

In unscripted documentary work there is often not time for detailed recordkeeping. It is important to put down notes whenever you can, at least at the end of every day, indicating what has been shot and which roll or film or tape covers what.

Wardrobe, Makeup and Set

An actor's wardrobe, makeup and hair can have a huge impact on the look of the movie and on the character's presence on screen. Don't overlook the importance of good makeup and wardrobe as well as set decoration. In some documentary settings it is not appropriate to deal with these issues, but in others—such as shooting interviews—you can choose the setting, make suggestions for wardrobe and apply some minimal makeup.

Guidelines for clothing also apply to wall treatments, furniture and other items on the set. In general, it's a good idea to avoid very bright or very dark material, especially when shooting video. White shirts often burn out (overexpose) when the camera is set for proper skin tones. Video reacts badly to various colors or patterns; this is especially a problem with NTSC video. Avoid fine patterns like checks and stripes. Bright reds tends to smear (*chroma bleeding*) by the time the movie is shown on VHS tape.

Avoid shiny surfaces or jewelry. Washable *dulling spray* or even a little dry soap can be applied to bright items, or lights can be flagged (see Chapter 11) to minimize reflections. When shooting people with glasses, light them from high above or to the side to avoid *kicks* in the glasses.

Applying makeup is an art and needs to be tailored to individual faces. Facial shine, caused by sweating under hot lights, is a common problem that is easily remedied with a little *translucent face powder*, which can be brushed on actors or interview subjects and will be totally invisible. Apply the powder first to the brush, not directly to the skin, and touch up faces whenever you see shine. Many cinematographers carry powder in their ditty bag.

Prompters and Cue Cards

Actors may forget their lines. Correspondents or on-camera narrators may be asked to speak long passages directly to the camera. Lines can be written on cue cards. When a host or correspondent reads to camera, her eye line must be directed as close to the lens as possible so she won't appear to be reading. A low-budget technique is to cut a hole in the center of the cue card for the lens. A better solution is to use a *teleprompter*, which mounts in front of the lens and displays written copy from a computer or a roll of paper. Teleprompters may limit camera mobility and require a solid camera support. Some actors are adept at using an *ear prompter*, which is a pocket-size tape recorder that transmits a signal to a miniature receiver that fits in the actor's ear. The actor reads his lines into the prompter prior to the take; then during the take he hears the words played back while he speaks to the camera. It takes practice.

Fig. 8-22. Teleprompter. A monitor displaying the script faces up, into a partially reflecting mirror surface where it can be read by the person being filmed. The camera shoots from behind the mirror. (Intelliprompt)

Sound Recording Systems | CHAPTER 9

This chapter is about audio recording equipment used for both film and video. Many of the principles that apply to one type of system are relevant to the others. See Chapter 10 for discussion of the sound recordist's role and recording techniques.

SOUND

What you hear as sound is a series of pressure waves produced by vibration. A violin, for example, works by vibrating air rapidly back and forth. When you pluck the string, it makes the body of the violin vibrate—when it moves one way, it compresses the air (pushes it) in that direction; when it moves the other way, that pressure is temporarily reduced. Sound waves travel through the air and cause your eardrum to *oscillate* (move back and forth) in response to the sound. Like ocean waves breaking on a beach, sound waves alternately press forward and recede back.

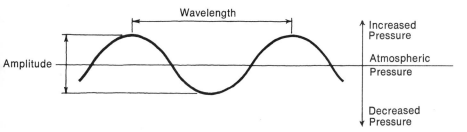

Fig. 9-1. Graph of a simple sound wave at an instant in time. The height of the wave (or *amplitude*) corresponds to loudness. The distance from one peak to the next (the *wavelength*) corresponds to the sound's frequency. (Carol Keller)

Loudness

The *loudness* or *volume* of a sound results from the amount of pressure produced by the sound wave. Loudness is measured in *decibels* (*dB*), which are used to compare the relative loudness of two sounds. If a sound is increased in volume by 10 dB, it will sound about *twice* as loud as it did originally.

The softest audible sounds occur at the *threshold of hearing*. When we talk about the absolute loudness of sounds, the threshold is used as a reference point. For example, the volume of normal conversation is about 65 dB above threshold, thus its sound level is said to be 65 dB. The *threshold of pain* is at about 130 dB. A sound level of 130 dB is equivalent to the noise of a jet passing within 100 feet.

Dynamic Range

For any passage of sound—be it music, speech or noise—the difference in volume between the quietest point and the loudest is called the *dynamic range*. The dynamic range of a symphony orchestra is about 80 dB, which represents the difference in volume between the full group playing fortissimo and a single violin playing very softly. Actually, the dynamic range of the orchestra is somewhat lessened by the shuffling and coughing of the audience, which may be louder than the quiet solo violin.

Dynamic range is a term used in evaluating audio systems. The human ear has a dynamic range of 130 dB between the thresholds of pain and hearing. High-quality analog tape recorders have a dynamic range of 70 dB, or higher, between the loudest sounds that can be recorded without audible distortion and the low-volume sound of the tape noise. Tape noise, or *hiss*, is always present in analog recordings and, like the shuffling sounds of the symphony audience, it determines the lower limit of the dynamic range (the *noise floor*). The dynamic range of a tape recorder is sometimes called the *signal-to-noise* (*s/n*) *ratio*. The "signal" is the sound we want to record; the "noise" may be tape hiss or *system noise* from the amplifiers and circuits in the recorder and the microphone. With digital recorders, tape noise is virtually eliminated (see Digital Audio Recording, p. 249).

Frequency

Musical notes are *pitches;* the modern piano can produce pitches from a low A to a high C. The lower notes are the *bass*, the higher ones the *treble*. What is perceived as pitch is determined by the *frequency* of the sound wave. Frequency is a measure of how frequently the waves of sound pressure strike the ear—that is, how many cycles of pressure increase/decrease occur in a given length of time. The higher the frequency, the higher the pitch. Frequency was formerly measured in *cycles per second;* now the same unit is called a *hertz* (*Hz*). Musical notes are standardized according to their frequency. Orchestras usually tune up to concert A, which is 440 Hz. Doubling this or any frequency produces a tone one *octave* higher.

The male speaking voice occupies a range of frequencies from about 100 to 8000 Hz (8 kHz). The female speaking voice is slightly higher, ranging from about 180 to 10,000 Hz. The ear can sense low frequencies down to about 20 Hz, but these sounds are very rumbly and are felt throughout the body. At the other extreme, sounds above 20,000 Hz are audible to dogs and bats, but seldom humans.

When sound volume is low, the ear is much more sensitive to midrange frequencies (2000 to 4000 Hz) than to low or high frequencies. Thus, a low-frequency sound *seems* quieter than a middle-frequency sound if they have the same sound pressure (that is, the same reading in decibels). Home stereos often have a "loudness" control that increases the low bass when the volume is down to compensate for this deficiency. When sound volume is high, the ear responds much more evenly to all frequencies of sound; low, middle and fairly high frequencies of the same sound pressure all seem equally loud.

Tone Quality and Harmonics

All naturally occurring sounds are made up of a *mixture* of waves at various frequencies. A violin string vibrates at a basic frequency (called the *fundamental*), as well as at various multiples of this frequency. These other frequencies are called *harmonics* or *overtones*, and they are usually quieter than the fundamental. With tones that sound "musical," the frequencies of the harmonics are simple multiples of the fundamental. Most other sounds, such as a speaking voice or a door slam, have no discernible pitch; their harmonics are more complexly distributed. The relative strengths of the harmonics determine *tone quality* or *timbre*. When a man and a woman both sing the same note, their voices are distinguishable because the man's voice usually emphasizes lower harmonics than the woman's. Pinching your nose while talking changes, among other things, the balance of harmonics and produces a "nasal" tone quality.

Frequency Response

Frequency response is used to describe how an audio system responds to various frequencies of sound. As noted above, at low volume the ear favors middle-frequency sounds, and at high volume its frequency response is more even or *flat*. A good audio recorder is capable of providing a fairly flat frequency response throughout the frequency range of human hearing.

Because all sounds incorporate a *spread* of frequencies, if you change the frequency response of your equipment by increasing or decreasing the response to low, middle or high frequencies, you can change the character of the sounds. The bass and treble controls on a stereo do this to some extent; most people like to turn the bass up in dance music to make the rhythm, carried by low-frequency instruments like the bass guitar and bass drum, seem more powerful. *Equalizers* (see Fig. 15-3) are often used to alter the frequencies of sounds during recording or after. With an equalizer, you could boost low frequencies to make, say, a truck engine sound deep, rumbly or menacing, or you could boost the high frequencies of a piano to make its sound "brighter." If we diminish high frequencies without changing the bass, the effect is like putting cotton in your ears: the sound is muddy and dull.

Telephones have a fairly limited frequency response, which is centered on the middle frequencies needed to understand speech. In movies, the sound of someone talking through a phone can be simulated with an equalizer by cutting the low and high frequencies and boosting the *midrange*.

AUDIO RECORDERS

Today, film and videomakers have a wide range of options for recording audio. When shooting video, sound is usually recorded right on the videotape in the camcorder. Different video formats have different audio capabilities. On some video shoots, sound is recorded on a separate audio recorder. For film shoots, until the mid-1990s, most professional sound recordists used analog tape recorders with ¼" wide tape; the Nagra recorder was the industry standard. These recorders continue to be used, but many newer digital formats have come into use, including DAT (digital audio tape) and devices that record to computer disks or chips.

We will first look at how the recording process works, then examine the different types of recorders.

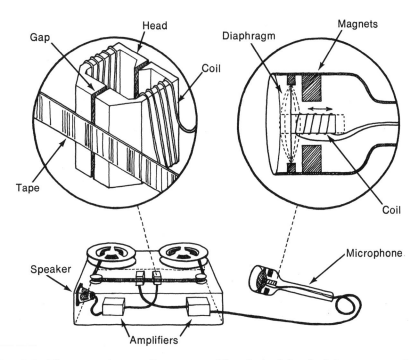

Fig. 9-2. The magnetic recording process. The playback head of the tape recorder is shown in a cutaway view (the width of the gap is exaggerated for clarity). The microphone cutaway shows the components of a dynamic microphone. (Carol Keller)

Magnetic Recording

In simplest terms, the idea of magnetic recording is to convert sound energy in the air to magnetic energy, which can be stored on tape. When the tape is played back, the process is reversed to reproduce sound.

The *microphone* responds to sound waves by producing electrical waves that have essentially the same character in terms of frequency and amplitude. Most modern microphones employ an extremely light diaphragm that can move sympathetically with the slightest variations in sound pressure. Mics vary in the way the moving diaphragm generates electricity. The common *dynamic microphone* that comes with many home audio recorders is also called a *moving-coil microphone* because it has a very light coil of wire attached to the diaphragm. When the diaphragm moves back and forth, the coil moves past a magnet and induces an alternating electric current that flows through the wires in the coil. Thus, sound pressure is translated into electric pressure, or *voltage*.

This voltage travels from the microphone to an *amplifier*, which increases its strength, and then on to the *magnetic recording head*. A recording head is an electromagnet, not unlike the ones used in metal scrap yards or that kids sometimes play with. When electricity passes through the head it generates a magnetic field. The head is a C-shaped piece of metal with wire coiled around it. On its front is an extremely narrow opening called the *gap*. The head completes a flow of energy: advancing and receding sound waves become electrical waves, which finally result in a magnetic field that is oriented first in one direction and then in the opposite.

Magnetic tape is made up of a thick support material or *base* and a thin emulsion that stores the information. Tape emulsion is called oxide and contains small particles of iron. Each piece of iron is a miniature bar magnet with distinct north and south poles. When a particle of iron passes the gap in the recording head, the magnetic polarity of the particle aligns itself with the magnetic field at the head. When the tape moves on, it maintains that orientation. Since the magnetic field is always alternating back and forth, any given stretch of tape contains groups of particles that alternate in their alignment. The alignment of the particles corresponds to the original sound in this simplified way: the louder the sound, the more particles will be forced to line up the same way; the higher the frequency, the closer together the alternating groups will be.

When you play back the tape, it is passed over the same head, or a similar playback head. Now the magnetic field stored in the iron particles induces an electric current in the wires coiled around the head. This signal is amplified and sent to a loudspeaker, which acts like a moving-coil microphone in reverse. Instead of the microphone's diaphragm, the speaker employs a large paper cone that is connected to the coil. When current passes through the coil, it moves the cone, which in turn pushes the air to produce sound pressure waves. If you stand in front of a large bass speaker, you can both hear and *feel* the sound waves generated by the paper moving back and forth.

Digital Audio Recording

The process described above is how sound is recorded with a typical analog audiotape recorder. The way digital audio recorders and digital video camcorders record sound is similar in many respects. First of all, microphones and speakers are analog, so sound is captured and reproduced using the same equipment regardless of the recorder format (the same microphone could feed an analog *or* digital recorder). The difference is in the way digital recorders process and store the sound.

See Digital Recording, p. 199, for the theory behind digital audio and video recording. Basically, the sound signal coming from the microphone goes to an analog-to-digital (A/D) converter, where the voltage of the signal is sampled (measured) and that measurement is expressed as a number.

The *sampling rate* refers to how often we measure the level of the sound signal. The more frequently we measure it, the more accurate the recording can be. Music CDs use a sampling rate of 44.1 kHz (which means 44,100 samples per second). Many professional audio recorders used for film and video are operated at the higher rate of 48 kHz. Some high-quality systems and DVDs can run at 96 kHz.

The *number of bits* used per sample determines how precisely each sample can be measured. The more precise, the better the recording. Digital audio systems are generally 16-, 20- or 24-bit. The more bits used, the finer distinctions we can make between sounds that have similar waveforms. Having more bits also increases dynamic range (see p. 246).

Thus, the A/D converter transforms the original sound signal into a series of numbers that represent the way the signal's level fluctuates over time. As a simplified example, the quietest sound on an 8-bit system might be given the number 1, and the loudest given the number 255. Actually, since the numbering system used in computers and digital audio equipment is binary (base 2), a number like 250 would be 11111010. This system makes it easy to move numbers around, because you only need ones and zeros to represent any value. A number can be transmitted from one place to another by sending a series of electrical pulses: send an *on* pulse for the ones, send an *off* pulse for the zeros.

To record the on/off pulses on tape, let's go back to the magnetic recording process described in the previous section. Instead of the fixed (stationary) heads used in analog tape recorders, digital tape recorders use rotating heads like you find in a video camcorder (see Fig. 6-4). Like a fixed head, the rotating head has a gap, and causes the magnetic particles in the tape to line up as they pass the head. The key difference with digital is that the signal has *only two possible levels:* completely *on* or completely *off* (representing ones or zeroes). This is why digital recording is so "robust." To record an analog signal, you have to capture and store in the tape *tiny* variations in magnetic levels. With digital systems, on the other hand, once the signal variations have been converted to numbers, then the tape has a much simpler and cruder job: record either "full on" or "full off."

To play back the tape, the on/off pulses are read by the heads and then sent to a digital-to-analog (D/A) converter, which transforms the binary numbers back to an analog signal, which can be heard through speakers or headphones.

Tape noise is a problem with analog recordings because very quiet sounds may be lost in the noise of the tape (see p. 288). Digital systems generally don't have a problem with tape noise because even quiet sounds are recorded with pulses that are either full on or full off, so there's no confusion about what is signal and what is noise.

There are other types of digital "noise" that can result if the sampling rate or number of bits are low. Together, the sampling rate and number of bits contribute to the resolution of a digital audio recording. Low-resolution recordings may sound "gritty" or overly crisp ("cold"). When the recording can't capture the

subtleties of the original sound, artifacts result, which may be disturbing to the ear. High-resolution recordings sound more faithful to the original sound source in terms of frequency response, dynamic range and lack of noise. In the 1950s, vinyl LP records were considered "hi-fi" (high fidelity). Today, our standards for fidelity are a whole lot higher.

For more on the idea of resolution in picture and sound throughout the production process, see Resolution, p. 33.

Fig. 9-3. Nagra 4.2 This ¼″ tape recorder has served as a standard for the industry. (Nagra USA)

THE ANALOG TAPE RECORDER

The Tape Path

Most audiotape recorders used for film or video have the following components: a *feed*, or *supply*, reel of tape; an *erase head* that cleans the tape of any distinct magnetic pattern; a *record head* to record the audio signal; a *pilot head* or a *timecode system* for speed-control information; a *playback head* to reproduce the audio; a *capstan* and *pinch wheel* to move the tape forward, and a *takeup* reel to store the tape. On some machines, a single head is used for recording, playback and sometimes pilot as well. On reel-to-reel (also called *open reel*) recorders, the feed and take-up reels are separate. On cassette decks, they are enclosed in a cassette.

Erasure

The first head in the tape path is the erase head, which clears any magnetic signal present on the tape. Erase heads work by exposing the tape to an inaudible, very high frequency tone. On most recorders, the erase head turns on when the

machine is switched to "Record" mode. Care must be taken not to erase a tape accidentally.

Although most erase heads work very well, some recordists prefer to use a *bulk eraser* to clean (demagnetize) recorded tapes before reuse. Using a bulk eraser may lower tape noise slightly, and it certainly removes any confusion between new and old sound. Bulk erasers, like most other kinds of *demagnetizers* (also called *degaussers*), involve exposing the tape or other object to a powerful, alternating magnetic field. To use any kind of demagnetizer, turn it on while the tape or magnetized object is several feet away. Move the tape onto the eraser slowly while rotating the tape. Rotate the tape around a few times keeping it flat and remove the tape slowly, still rotating. Larger format material, like 16mm mag stock, should then be turned over and erased again. As you remove the tape from the demagnetizer, it is imperative that you pull it away *very slowly* (1 or 2 inches/second), especially when the two are within a couple of feet of each other. Only after the tape or object is at arm's length from the demagnetizer should you turn off the machine. Turning it on or off when the tape is close will leave the tape more magnetized than it was at the start.

Bear in mind that the permanent magnetic field of an unshielded loudspeaker can partially erase a tape, so never store tapes on a speaker.

Recording

For a discussion of setting the recording level on analog recorders, see p. 288.

TRACK POSITION. Some audio recorders used for film and video record monaural, or mono, sound (that is, one channel only) on a track that spans the full width of the tape. Some recorders use at least two audio tracks and are capable of recording in stereo. This may open up possibilities for stereo recording (see p. 301) or using multiple microphones (see p. 299). Some stereo recorders also have a *center track* between the two audio tracks that may be used for cuing information. Some timecode-capable recorders use the center track for timecode; others use one of the audio tracks or another dedicated track. On many professional recorders, tapes cannot be "turned over" to get twice the recording time, the way some cassettes are.

See pp. 196 and 283 for more on audio timecode.

BIAS. Like film stocks, magnetic tape stocks have a threshold below which weak, low-energy signals will not be recorded. In order to boost all of the audio signal above this threshold, the recorder mixes in a *bias current*. Bias current itself is not audible, but if its level is badly adjusted the effects are. Properly setting the bias reduces noise, distortion and the occurrence of *dropout* (momentary loss of recording).

Different types of tape require different amounts of bias. Some recorders have a switch to set the bias for two or three tape stocks; others have to be adjusted by a technician. If you are getting poor-quality recordings or if you switch to a new type of tape with a different oxide (see The Tape, p. 255), the bias should be checked. Afterward, use the tape stock for which the machine is adjusted.

EQUALIZATION. *Equalization* refers to balancing various parts of the audible spectrum—boosting or diminishing certain frequencies relative to others. One type of equalization, called *pre-equalization*, or *pre-emphasis*, is used in the tape recorder to improve its ability to record high-frequency sounds. Different tape speeds and stocks require different amounts of pre-emphasis. Most high-quality recorders have an equalization switch (sometimes labeled "EQ") that has settings for various tape speeds or stocks; on some recorders, one switch changes both speed and equalization. On many recorders, the user has no direct control over equalization.

Other types of equalization are discussed below and in Chapters 10 and 15.

Playback

Some recorders have one head that doubles as both a record and playback head. However, having separate heads for recording and playing back offers a number of advantages. A major benefit of having a separate playback head (sometimes called a *confidence head*) is that it allows you to monitor the actual recording as you make it. Without a separate playback head, when you listen through headphones while recording you hear the sound *before* it gets to the tape. With a separate playback head, you can monitor what is *actually recorded on the tape* as a check in case there is dirt on the record head, too much signal going to the tape or the tape has run out.

Recorders with separate heads have a switch that connects the headphones either to the sound directly from the microphone ("Direct" or "Source" position) or to the sound at the playback head ("Tape" position). By switching back and forth, you can do an A/B test to hear if there is significant loss in quality from direct to tape. A *slight* change in volume is normal and is usually no cause for concern; a large change may mean dirty heads or other problems.

Head Care

Magnetic heads must be kept clean and free from magnetic charge. They must not be too worn and must make good contact with the tape as it passes. The first sign of a dirty, worn, magnetized or improperly adjusted head is the loss of high-frequency sounds—recorded material sounds muddy or dull.

Heads should be cleaned with commercially prepared head cleaner, which dries instantly, or with isopropyl (rubbing) alcohol. Buy some head-cleaning swabs or use a Q-Tip that has been twirled in your fingers to ensure that no hairs come off and lodge in the tape path. Heads should be cleaned at least every couple of tapes to remove accumulated oxide.

Heads can become magnetized over time. Some recordists demagnetize the heads regularly, others wait until poor sound quality indicates they are probably magnetized. Have an experienced person show you how to demagnetize heads; beginners often increase the magnetic charge by doing it incorrectly. Always turn off the recorder before demagnetizing. Use a hand degausser, not the tiny pencil type used for erasing sections of tape or a large bulk eraser, which may affect parts of the recorder (like the meter) that are supposed to be magnetized. Slowly move the degausser to within ¼″ to ⅛″ of the head; slowly wave the tip of the degausser along and then across the head slightly; then retract it slowly (see precautions

on erasure, p. 251). The R. B. Annis Company (1101 N. Delaware Street, Indianapolis, IN 46202) makes an excellent hand degausser as well as a magnetometer, which helps you determine if the head is actually magnetized.

When a magnetic head becomes worn, the gap gets wider and its response to high frequencies is impaired. If the face of the head is not perfectly parallel to the tape path or if the face is parallel but the head is tilted to the side, the effect is the same. The terms used for various types of head alignment include *height*, *zenith*, *rack* and *azimuth*. If the heads are excessively or unevenly worn, have a technician check them for possible replacement or realignment.

Speed Control for Synchronous Recording

For an audio recorder to be used for sync sound film or video work, the speed of the tape must be very precisely controlled. Even a high-quality analog tape recorder, if not specially adapted for sync work, will not be accurate enough.[1] There are different speed control systems in use. All are based on the idea of recording a clocklike or pulsed signal on the tape while the audio recording is being made. On playback, the machine is controlled so the pulses are played at exactly the same speed they were recorded (called *resolving*).

The classic speed control system in Nagra's *neopilot* (or just *pilot*) *tone*. On a Nagra 4.2, the pilot is recorded right in the audio track without interfering with the audio. Some analog cassette recorders are modified for sync work by devoting one of the audio tracks to pilot. The pilot signal is a series of regular pulses; these are sometimes thought of as "electronic sprocket holes." Pilot is generated in the recorder by a very accurate *crystal*. This is the audio part of *crystal sync* (see p. 13). In an older system, the pilot pulses are generated by the camera and carried to the recorder on a cable (*cable sync*).

In the United States and other countries with 60Hz wall current, a 60Hz pilot is recorded. In Europe a 50Hz pilot tone is used. When the tape is played back, a *resolver* compares the pilot tone to a *reference* (usually the AC wall current) to make sure that 60 (or 50) pilot pulses are played back every second. Timecode-capable analog recorders use the timecode instead of pilot tone for speed control. Sometimes a slower reference is used to slow down (pulldown) playback for film-to-video transfers (see Resolving Audio, p. 523).

Tape Transport

On most recorders, the tape is pulled along by a *capstan*, which is a smooth, vertical cylinder that is rotated by a motor. Next to it is a rubber *pinch wheel* that holds the tape snugly against the capstan as it rotates. If the capstan has dirt on it, or if the motor is malfunctioning, *wow* or *flutter* may result. Wow is any irregularity or variation in the speed that repeats less than ten times per second, and flutter is any variation that repeats faster than that. Recording and playing back slow piano music while listening critically for wobbling in the sound is a good way to deter-

[1]This is for sync sound recording (see p. 12). Wild recording (without picture) does not require such precise speed control. Many digital recorders are accurate enough for sync *without* being specially adapted for film or video work.

Fig. 9-4. Walkman Professional analog cassette recorder. (Sony Electronics, Inc.)

mine if your recorder is running irregularly. For field recording, the machine must maintain a constant speed even if it is jostled around.

Rollers and capstans should be kept clean. Don't let the pinch wheel remain pressed against the capstan for more than a few hours if the tape is not rolling or a flat spot may result. This happens on some recorders when the machine is left in "Pause" mode.

When batteries weaken, the tape may slow down during recording. When this tape is played back with fresh cells, the sound will be speeded up (voices take on the familiar "chipmunk" sound). Sometimes such recordings can be salvaged by playing them back slowly on a variable-speed playback deck while rerecording on another recorder running at normal speed. A digital audio workstation could also be used to correct the speed.

TAPE SPEED. Most ¼″ tape recorders offer a choice of two or three tape speeds: 3¾, 7½ and sometimes 15 inches per second (ips). Generally the faster the speed, the smoother the tape runs (that is, less wow and flutter). Faster speeds increase dynamic range, reduce audible noise and improve the recorder's response to high-frequency sounds. The standard for most movie work is 7½ ips; 15 ips is used for critical music recordings.

The Tape

Magnetic tape is made up of a thick *base* and a relatively thinner *emulsion* or *oxide* that actually stores the magnetic information. Tape is available in a variety of base and oxide types.

Most tape oxides are made of iron, called also ferrous oxides; if the package does not say otherwise, your tape is probably of this type. Various other more expensive emulsions, including chromium dioxide, or CrO_2, and "metal" formulations, are available, some of these offering lower noise and better frequency response. Special tape formulations are more often used for cassette recorders in

which tape noise is a serious problem. With ¼″ recording, the quality is usually good enough to use the more economical iron oxide tape.

The base material of tape is either acetate of polyester (sometimes called Mylar). Acetate breaks easier, stretches and shrinks more with temperature and humidity and becomes brittle with age. Tape is usually made of acetate base unless labeled otherwise. Polyester base is stronger and more stable but may be more expensive in the ¼″ format.

Tape comes in a variety of base thicknesses, which are measured in mils; 1.5 mil and 1.0 mil are the standards. 1.0-mil tape is thinner and may break or stretch more easily, but allows loading more tape on a reel. In critical applications, tapes less than 1.0 mil (sometimes labeled "extended play") should be avoided. Most portable ¼″ recorders accept 5″ reels that carry enough tape to run at 7½ ips for 16 minutes with 1.5 mil tape, or 24 minutes with 1.0 mil.

The main problem with thin-base tapes is that sounds *print through* more often. Print-through occurs when the sound on one layer of tape becomes imprinted on the next layer out on the reel, causing a slight echo that can be heard during quiet moments before or after loud sounds. Print-through is mostly noticeable on material recorded at quiet locations where there is no background sound to mask the echo. It can be minimized by storing the tape tail-out on the reel (so the echo occurs *after* loud sounds where it will be partially masked), by keeping the tape in cool locations (less than 70°) and by rewinding it every now and then.

Ask a recordist or a sound house for recommendations of good tape stocks. Relative to other film costs, tape is cheap. Don't be penny-wise, pound-foolish.

Noise Reduction

Many analog tape recorders and video camcorders are equipped with *noise reduction* units such as one of the Dolby systems. There are several different versions of Dolby noise reduction, including A, B, C and SR (*Spectral Recording*). Dolby C works by boosting the level of mid- and high-frequency sounds as they are recorded and then diminishing their level in playback, leaving the sound signal normally balanced. Tape hiss is also a high-frequency sound; however, since it is inherent in the tape, it is not affected by the Dolby during the recording. It is diminished, though, when the Dolby reduces the high frequencies in playback.

If a recorder has a noise reduction unit, you should generally use it. Tapes recorded with noise reduction must be played back with it, on a machine that employs the *same system*. Always indicate on the tape box whether a recording was made with noise reduction and which system. Tapes made without noise reduction *should not* be played back with it or the sound quality will be degraded (for example, with Dolby C, high frequencies may be lost).

Don't confuse Dolby noise reduction with the various Dolby multichannel audio formats (see Chapter 15).

DIGITAL AUDIO RECORDERS

Digital recorders offer high quality in a small, light package and have had a huge impact on audio and video production. There are many types of digital

recorders used for field production. These include cassette tape formats, like DAT; open-reel tape recorders like the Nagra D; disk recorders like the Dēva (see Fig. 9-6), which record on hard drives or computer tape data drives; chip-based systems like the Nagra Ares C, which record on computer memory cards with no moving parts, and magneto-optical disc systems like Sony's MiniDisk.

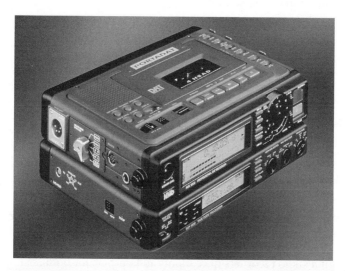

Fig. 9-5. HHB PORTADAT. This professional DAT recorder is widely used for high-end field production. Optional timecode unit is shown attached under the recorder. (HHB Communications, Inc.)

Compared to analog tape recorders, digital tape machines provide longer continuous recording on a smaller tape. The DAT cassette is small enough to fit in a shirt pocket. Most DAT and other digital formats have very accurate speed control and can be used for film or video work with no additional modifications (unlike typical analog recorders; see Speed Control for Synchronous Recording, p. 254).[2] Many lower-budget productions are done with basic nontimecode, consumer DAT machines. With a separate microphone preamp you may be able to use a professional mic with a consumer recorder. Higher-budget productions generally use professional-level recorders with built in preamps and timecode capability. The quality of the mics and preamps is very important to the quality of the recording. An older analog recorder with good preamps sometimes sounds better than a newer digital machine.

See Digital Audio Recording, p. 249, for the principles of how digital tape recorders work. Digital audio systems generally have settings to allow you to select the sampling rate and sometimes the number of bits. The higher the sampling

[2]Some consumer DAT and other digital recorders may have slight sync drift between camera and recorder over long takes.

rate or the more bits, the better the recording quality and the more space you need to store the recording on tape, disk or chip. As of this writing, 48kHz is a standard sampling rate for DAT recordings used for film and video. Some digital recorders offer a 32kHz sample rate to save tape or permit more audio tracks. For film and video work, a sample rate lower than 41kHz may result in less than professional quality sound. Talk to the recordists, mix facilities or other professionals for recommendations on recorder settings.

Fig. 9-6. Dēva portable digital recorder. Records on removable computer drives instead of audiotape. Has mixing and editing capabilities. (Zaxcom, Inc.)

Many digital audio recorders are timecode-capable. See Chapter 7 for an overview of timecode, and Chapter 10 for timecode and speed control issues for double system film or video recording.

Most digital audio recorders have inputs and outputs for both analog and digital signals. Analog inputs are needed for analog sources like microphones. When connecting two digital recorders, it is possible to use either analog or digital connections, however some degradation occurs when a signal is converted from digital to analog and back to digital again. Whenever possible, use direct digital-to-digital connections when sending data from one digital system to another. There are different formats or protocols for transmitting digital audio data, including *AES/EBU* and *S/P DIF*. Be sure the receiving equipment can handle the format being sent. Some formats allow you to send compressed digital recordings over ISDN phone lines.

The particulars of operating a digital audio recorder vary widely with the type of recorder. Many have controls quite similar to typical video decks or analog tape recorders. For discussion of setting the recording level on digital recorders, see Setting the Recording Level, p. 288. Like analog machines, some digital recorders have a second set of heads (*confidence heads* or *read after write*) that allow you to check how the recording sounds as it goes down on tape or disk (see Playback, p. 253). Rotating heads wear out over time. Don't run the machine unnecessarily or leave the machine in pause for long periods with the heads spinning.

Most digital systems have indexing capability, to allow you to mark and quickly locate the beginnings of takes. Disk- and chip-based systems can instantly access any point in the recording. Some digital recording systems offer such features as nondestructive level and equalization settings, which allow you to make adjustments that can be changed later if desired (see Chapter 15).

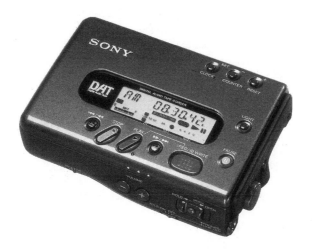

Fig. 9-7. Sony TCD D8 consumer DAT recorder. Very good quality, affordable digital recorder. (Sony Electronics, Inc.)

Like video camcorders, digital audiotape recorders need to have the heads cleaned periodically. For a DAT machine, get a head-cleaning cassette (see Recording Problems, p. 180) and follow the manufacturer's recommendations.

DAT tapes may suffer some degradation of signal over time and are not, as of now, considered a good archive medium. Nagra D–type tapes and discs such as DVDs or CDs should have better longevity. All archive formats suffer from the problem that, as time passes and technology advances, it gets harder to find older-style playback equipment.

AUDIO FOR THE VIDEO CAMCORDER

All video camcorders and VTRs have provisions for recording audio. Some record digital audio, some analog, and some combine both technologies. See The Videotape Recorder, p. 175, for the basics of how VTRs record a signal on tape.

Audio Tracks

Some videotape formats record sound using *linear audio tracks*. Linear (also called *longitudinal*) tracks get their name because they run in a line along the length of the tape, usually near the edge (see Fig. 6-6). Depending on the VTR, linear tracks can often be erased or rerecorded separately from the picture to allow you to make changes or add sounds in editing. (In some formats, rerecording audio only is called *audio dub* mode.)

Some videotape formats use rotating heads to record sound. This method generally provides much higher quality. The stereo hi-fi tracks in VHS and Hi8 machines, and the FM tracks in Betacam, are essentially mixed in with the video

signal. With these systems, you can only record the audio *at the same time* as the video. If you record something on the hi-fi or FM tracks, you can't change it later unless you transfer the material to a different tape. Some systems can record *both* linear and hi-fi or FM audio tracks. Some analog VTRs can record a digital *PCM* audio track using the rotating heads.

Most purely digital tape formats use rotating heads for audio, but the audio signal is independent of the picture and can be rerecorded at any time. D1 and D2 and some DV machines, for example, offer four audio tracks and allow complete flexibility in recording or rerecording any of them.

Some DV camcorders give you a choice of one or two high-quality tracks or four lower-quality tracks (using a lower sample rate or number of bits). For example, you might have a choice between two tracks of 16-bit audio sampled at 48kHz or four tracks of 12-bit audio at 32kHz. The quality of the 32kHz option may be too low for professional use (see Digital Audio Recorders, p. 256).

Camera Mics and External Mics

Most camcorders have a microphone mounted either in the camera or on the top. These can be handy for informal shooting or when working alone. But camera-mounted mics have a key disadvantage: in many shooting situations the camera is positioned too far from the sound source for optimal sound recording (see Chapter 10). Professionals generally use separate ("external") mics that may be connected to the camera in a number of ways. TV reporters often use a handheld mic that is connected to the camcorder by cable or by using a wireless transmitter (see p. 269). The camera operator monitors sound using an earphone and/or the level meters in the camera.

A typical small video field production crew consists of a camera operator and a

Fig. 9-8. Wireless receiver mounted on a camcorder. (Sony Electronics, Inc.)

sound recordist; the recordist may have a boom mic and a portable mic mixer (see Fig. 1-17). The recordist can position the mic close to the subject and set the recording levels using the mixer. The microphone and the mixer may be connected by cable or by wireless transmitter. Similarly, the mixer and the camcorder may be connected by cable or by wireless. See Microphone Mixers, p. 271, for more on mic mixers.

Level Control

Most professional camcorders give you a choice between manual control of audio recording levels and automatic control (see Setting the Recording Level, p. 288). Many consumer camcorders *only* have automatic control, which is convenient but may result in inferior recordings. Whenever possible, choose a camcorder that offers the option of manual level control.

Recording Audio Outside the Camcorder

In some situations, the primary audio recording may be done with a machine *other* than the camcorder. For example, for a concert shoot, one VTR or audio deck may record the master tracks, while several cameras separately record picture. When a wireless connection is used between the mic mixer and the camera, recordists sometimes run a separate recorder (such as DAT) as a backup in case the wireless transmission fails. Care needs to be taken to ensure that the audio recorder and camcorder are running precisely the same timecode (see p. 283).

Fig. 9-9. Electro-Voice 635A omnidirectional dynamic microphone. (Electro-Voice)

THE MICROPHONE

Microphone Types

There are three basic types of microphones used for film and video production. *Dynamic* or *moving-coil* microphones are the standard equipment used by musical performers, amateur recordists and many professionals. They are usually quite rugged and resistant to hand noise (see Windscreens and Microphone Mounts, p. 266) and they require no batteries or special power supply. Many inexpensive microphones that come with home recorders are dynamic mics.

Condenser microphones are used extensively for motion picture sound recording. They are often more sensitive, expensive and fragile than dynamic mics. Condenser mics use a capacitor circuit to generate electricity from sound, and they need power supplied to them to work. Power may come from batteries in the microphone case, on the mic cable or in the recorder itself. *Electret condenser microphones* employ a permanently charged electret capacitor. They can be made very cheaply and may require no power supply. Some ECM mics are the size of a peanut or smaller.

Directionality

Every mic has a particular pickup pattern—that is, the configuration of directions in space in which it is sensitive to sound. *Omnidirectional* or *omni microphones* respond equally to sounds coming from any direction. *Cardioid mics* are most sensitive to sounds coming from the front, less sensitive to sounds coming from the side and least sensitive to those coming from behind. The name derives from the pickup pattern, which is heart-shaped when viewed from above. *Hyper-cardioid microphones* (sometimes called *in-line, short-tube shotgun* or *mini shotgun*) are even less sensitive to sounds coming from the side and behind. *Super-cardioid microphones* (or *super in-line, long-tube shotgun* or *shotgun*) are extremely insensitive to any sounds not coming from directly ahead. However, some hyper- and super-cardioid mics have a certain amount of sensitivity to sound emanating from *directly* behind as well. *Bidirectional mics* have a figure-eight pickup pattern with equal sensitivity on either side; these mics may be used in a studio placed between two people talking

Omnidirectional Cardioid Super-cardioid

Fig. 9-10. Representations of the directional sensitivity of omni, cardioid and super-cardioid microphones (not drawn to the same scale). These suggest the mics' response to sound coming from different directions. Imagine the omni mic at the center of a spherical area of sensitivity; the diaphragm of the cardioid mike is at about the position of the stem in a pattern that is roughly tomato-shaped. Though the lobes of sensitivity are pictured with a definite border, in fact sensitivity diminishes gradually with distance. (Carol Keller)

to each other. Since the names for these microphone types are not entirely standardized among manufacturers (one company's "hyper-cardioid" is another's "super-cardioid"), be careful when you select a microphone.

Manufacturers print *polar diagrams*—graphs that indicate exactly where a microphone is sensitive and in which directions it favors certain frequencies. It is important to know the pickup pattern of the mic you are using. For example, many people are unaware of the rear lobe of sensitivity in some hyper- and super-cardioid mics, which results in unnecessarily noisy recordings (see Fig. 9-12).

Hyper- and super-cardioid microphones achieve their directionality by means of an *interference tube*. The tube works by making sound waves coming from the sides or back of the mic strike the front and back of the diaphragm simultaneously so that they cancel themselves out. In general, the longer the tube is, the more directional the mic will be. For proper operation, don't cover the holes in the tube with your hand or tape. Usually, the more directional a microphone is, the more sensitive it will be to wind noise (see Windscreens and Microphone Mounts, p. 266).

Contrary to popular belief, most hyper- and super-cardioid mics are *not* more sensitive than cardioid mics to sounds coming from directly ahead; they are not like zoom lenses; they don't "magnify" sound.[3] However, directional mics *do*

Fig. 9-11. Sennheiser K3-U modular condenser microphone system. This system has been replaced by the K6 series of modular mics, but many of the older mics are still in use. (Sennheiser Electronic Corp.)

[3] *Parabolic mics*, which look like small satellite dishes (sometimes used at sporting events), actually do have a magnifying (amplifying) effect.

exclude more of the competing background sound, so that they can produce a good recording at a greater distance from the sound source—as recordists say, the "working distance" is greater. The disadvantage of highly directional mics is that you may encounter situations in which it's hard to capture important sounds within the narrow lobe of sensitivity. A classic case is trying to record a two-person conversation with a super-cardioid mic: when the mic is pointed at one person, who is then *on-axis*, the other person will be *off-axis*, his voice sounding muffled and distant. Panning a long microphone back and forth is an imperfect solution if the conversation is unpredictable. In such cases, it may be better to move far enough away so that both speakers are approximately on-axis. Unfortunately, the best recordings are made when the microphone is close to the sound source.

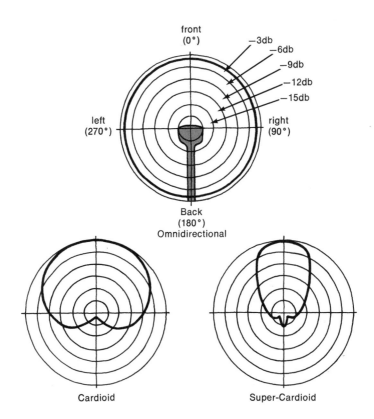

Fig. 9-12. Polar diagrams indicating the sensitivity of omnidirectional, cardioid and super-cardioid microphones. Imagine each diagram as a cross section of the mike's sensitivity, with the microphone lying along the vertical axis (as the omni mic is here). The microphone's diaphragm would be positioned at the center of the graph. (Carol Keller)

Microphone Sound Quality

Microphones vary in their frequency response. Some mics emphasize the bass or low frequencies, others the treble or high frequencies.

The frequency response of a microphone or recorder is shown on a *frequency response graph* that indicates which frequencies are favored by the equipment. Favored frequencies are those that are reproduced louder than others. An "ideal" frequency response curve for a recorder is flat, indicating that all frequencies are treated equally. Many mics emphasize high-frequency sounds more than mid-range or bass frequencies. Recordists may choose mics that favor mid to high frequencies to add clarity and *presence* (the sensation of being close to the sound source) to speech. Some mics have a "speech" switch that increases the midrange ("speech bump"). In some situations, a mic that emphasizes lower frequencies may be preferred. A male vocalist or narrator, for example, might like the sound coloration of a bassy mic to bring out a fuller sound. A large-diaphragm mic, like the Neumann U-89, can be used for a "warm" sound.

Sometimes recordists deliberately *roll-off* (suppress) low frequencies, especially in windy situations (see Chapter 10).

When you purchase a mic, check the frequency response graph published by the manufacturer. An extremely uneven or limited response (high frequencies should not drop off significantly before about 10,000 Hz or more) is some cause for concern.

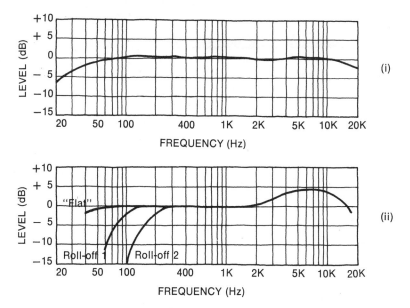

Fig. 9-13. (i) The relatively flat frequency response of a good-quality tape recorder. Where the graph drops below the 0dB line indicates diminished response. (ii) A microphone frequency response curve. This mike is more sensitive to high frequencies. The three parts of the curve at left represent increasing amounts of bass roll-off controlled by a built-in, three-position switch (see Bass Filters, Chapter 10). (Carol Keller)

The microphones that come with recorders and cameras are very often low quality and may need to be replaced. Set up an A/B test where you can switch from one mic to another and record on tape. You may find that you prefer the sound of the less expensive of two mics. An A/B test is especially important if you need two matched microphones for multiple microphone recording (see Chapter 10.)

Windscreens and Microphone Mounts

The sound of the wind blowing across a microphone does not in the least resemble the rustle of wind through trees or the moan of wind blowing by a house. What you would hear instead are pops, rumble and crackle. When recording, don't let wind strike a microphone (particularly highly directional mics) without a *windscreen*. A windscreen blocks air from moving across the mic.

A minimal windscreen is a hollowed-out ball or tube of *acoustifoam*—a foam-rubber-like material that does not muffle sound (see Fig. 10-13). This kind of windscreen is the least obtrusive and is used indoors and sometimes in very light winds outside. Its main use is to block the wind produced when the mic is in motion and to minimize the popping sound caused by someone's breathing into the mic when speaking.

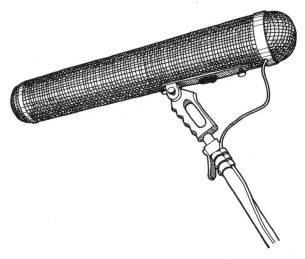

Fig. 9-14. A zeppelin windscreen for a shotgun mic shown with a pistol grip and mounted on a microphone boom. (Carol Keller)

For breezier conditions, a more substantial windscreen called a *zeppelin* is used.[4] Like its namesake, this windscreen is large and tubular; the mic is completely encased in it. In strong winds, an additional socklike, furry covering should be fitted around the zeppelin. Rycote makes a "Softie" windscreen that combines a soft windscreen with a simple shock mount. A good windscreen should have *no* noticeable effect on the sound quality in still air.

[4]In the U.K., windscreens are called "wind shields" and zeppelins may be called "blimps."

When you are caught outside without an adequate windscreen, you can often use your body, the flap of your coat or a building to shelter the mic from the wind. Hide a lavalier under clothing or put the tip of a wool glove over it (see below). Often, a bass roll-off filter helps minimize the rumble of wind noise (see Chapter 10).

Besides wind noise, microphones are extremely sensitive to the sound of any moving object, such as hands or clothing, that touches or vibrates the microphone case. *Hand noise*, or *case noise*, becomes highly amplified and can easily ruin a recording with its rumbly sound. The recordist should grip the microphone firmly and motionlessly, grasping the looped microphone cable in the same hand to prevent any movement of the cable where it plugs into the mic. Even better, use a pistol grip that has a *shock mount* (usually some form of elastic or flexible mounting) to isolate the mic from hand noise.

In many recording situations, a *fishpole* (collapsible) *boom* should be used to enable the recordist to stand away from the action (see Chapter 10). A shock mount will isolate the mic from hand or cable noise on the boom.

Lavalier Microphones

Lavalier microphones (*lavs*) are very small mics generally intended to be clipped on the subject's clothing.[5] Also called *lapel mics*, these are often used with a wireless transmitter (see below) or may be connected by cable to the recorder. Most TV news anchorpersons wear one or two lavs clipped on a tie or a blouse. Lavaliers are quite unobtrusive. They're useful for recording in noisy environments because they're usually positioned so close to the person speaking that they tend to exclude background sound. This also results in a "close" sound, which sometimes sounds unnatural. The Tram TR-50 and Sennheiser MKE-2 may pick up more sound from the distance. In some situations, recordists like to mix the sound from a lavalier

Fig. 9-15. Lavalier mic. The Countryman Isomax omnidirectional lavalier is available in a choice of three frequency responses in either matte black or white. (Fletcher Chicago/ Countryman).

[5]*Lavalier* used to refer a larger type of mic designed to be hung on a cord around the subject's neck. These are rarely used today.

with a boom mic, to get both good voice *and* some background sound; this is best done when you have two recording tracks available.

Most lavaliers are omnidirectional, although hyper-cardioid lavs are available. Many have a flat frequency response. However, when you clip a mic on someone's shirt you may get too much bass (from being right over the chest cavity) and not enough treble (since the mic is out of line with the speaker's mouth.) Some lavs have a midrange speech bump (see Microphone Sound Quality, p. 265) to compensate. A good position for a lavalier is in the middle of the chest at the sternum (breastbone). For subjects wearing a T-shirt or a sweater, sometimes the mic is clipped on at the collar. The problem with collar placement is it may be too close to the subject's voice box and may cause sound variations if the subject turns his head away from the mic. If the subject is looking generally in one direction (perhaps for an interview), put the mic on that side of his collar.

Often it is preferable to hide the mic; for fiction shooting, it's essential. Clip or tape the mic under clothing, but listen carefully for case noise caused by the cloth rubbing on the mic. Silk and synthetic fabric are the worst for noise; cotton and wool are often fine. Small frames or cages are available to provide separation between the cloth and the mic. You can improvise with some rolled-up tape to prevent rubbing (see Fig. 9-16). Leave enough slack in the cable so that the body movements don't pull on the mic; make a small loop in the cable for *strain relief* and tape or clip it

Fig. 9-16 Hiding a lavalier. To prevent cloth from rubbing on the mic, one technique is to use rolled-up gaffer's tape. Some recordists like to hide the mic under a tie's knot. Most recordists prefer not to place mics under clothing whenever possible. (Robert Brun)

in place. If you can't hide the mic in clothing, sometimes you can put it in the subject's hair or a hat. Carry some moleskin or surgical tape for taping mics to skin. For more on using lavaliers, see Chapter 10.

Wireless (Radio) Microphones

To allow the camera and subject greater freedom of movement, a *wireless*, or *radio, microphone* can be used. With this system, a lavalier mic is clipped on the subject, along with a concealed radio transmitter that is about the size of a pack of cigarettes. A receiver mounted on the recorder or camera picks up the signal with a short antenna. Wireless sound quality is usually not as high as that of *hard-wired* mics (mics connected by cables), but some of the systems are very good.

Using a wireless opens up many possibilities for both fiction and documentary shooting. You never need to compromise camera angles for good mic placement, since the mic is always close to the subject but out of view. In unscripted documentaries, there are great advantages to letting the subject move independently, without being constantly followed by a recordist wielding a long microphone. Some people feel uncomfortable wearing a wireless, knowing that whatever they say, even in another room, can be heard. As a courtesy, show the person wearing the mic where the off switch is. Some recordists object to the way radio mics affect sound perspective: unlike typical sound recording, when the subject turns or walks away from the camera wearing a wireless, the sound does not change.

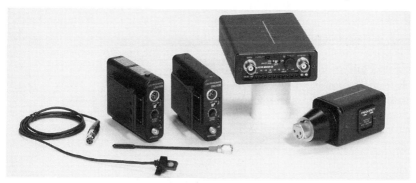

Fig. 9-17. Wireless system. Lectrosonics 200D shown with lavalier mic, antenna, two belt-pack (clip-on) transmitters and a "plug-on" transmitter for handheld mics and other gear. The receiver (horizontal box) offers a choice of frequencies. (Lectrosonics, Inc.)

As discussed above, wireless transmitters can also be used to connect a standard boom mic or mic mixer to the camera or recorder, or to transmit timecode or headphone feeds on the set.

Wireless transmission is not completely reliable. Depending on the physical obstructions and competing radio transmissions in the area, wireless signals may carry up to several hundred feet or they may be blocked altogether. Many wireless systems operate in the VHF bands; UHF systems may have less interference. Some systems use multiple frequencies or allow you to switch if the signal breaks up. "Diversity" radio mics use multiple antennas to help avoid breakup. Inexpensive consumer

wireless systems can get interference from many household sources. Avoid electric motors, computer monitors and other electronic interference.

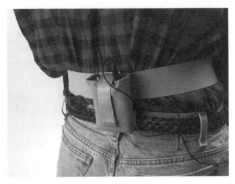

Fig. 9-18. A belt/body pack wireless transmitter can be carried in a waist pouch. As shown here, this arrangement could be used to conceal the transmitter under a sweater or coat. (Fletcher Chicago/Lectrosonics)

Always position the receiving antenna *as close to the transmitter as possible*. If the signal breaks up, experiment with different antenna positions. Make sure the transmitter antenna is straight. It can be run around the belt line or up the subject's back (clip it on clothing near the shoulder and hide it under a coat or sweater; use a rubber band between the clip and the antenna for strain relief). Antennas sometimes work best if dangled away from the body. Check and/or replace transmitter and receiver batteries every few hours.

Most professional wireless transmitters use a limiter (see Automatic Level Control, p. 293) to prevent excess volume levels. Most models have a level adjustment and some have a light to indicate excess level. With the subject speaking normally, turn the level up until the light flashes often, then turn it down a bit (for more on level adjustments, see Chapter 10).

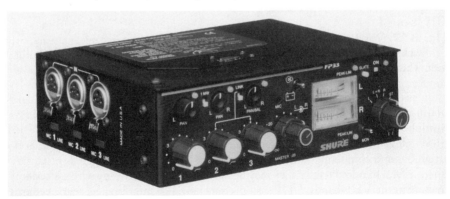

Fig. 9-19. Portable microphone mixer. Sure FP33 stereo mixer is often mounted in a carrying case. See Fig. 1-17. (Shure Brothers, Inc.)

Microphone Mixers

A *microphone mixer* (see Fig. 9-19) allows you to take inputs from various audio sources, combine and control them and then output the signal to a camera or recorder. A mic mixer could be used to balance multiple microphones or to control a single boom mic (see Fig. 1-17). Sometimes when recording a person giving a speech in a lecture hall, instead of using your own mics you get a *house feed* from the facility's public address system. A mic mixer can be used to control that signal before recording it.

Most mixers have two or more *input channels* to control the level of different inputs and one or more *master faders* to control the level of the combined output. Many mixers have a tone generator for recording a reference tone (see p. 280). For more on mixer controls, see p. 452.

Audio Connections

Not all microphones, mixers and recorders are compatible; many need various adaptors or devices between them.

IMPEDANCE. *Impedance* is a measure of the resistance of any audio device to the flow of electric current. Impedance, sometimes represented by Z, is measured in *ohms*. The impedance of a microphone may be low or high; the same is true for the microphone input on the mixer or recorder. In general, low impedance is 600 ohms (often written 600 Ω) or less, and high-impedance devices measure in the thousands of ohms. It is extremely important to use a low-impedance mic with a low-impedance mic input, or a high with a high. Exact matching is not necessary. Usually, professional microphones with XLR connectors (see below) have low impedance. The manuals for the recorder and microphone should list their impedances.

Low-impedance equipment is preferable because it allows you to use up to several hundred feet of microphone cable without picking up hum and interference from AC wall current and radio stations. With high-Z (high impedance) equipment, lengths over 6'–10' may result in various types of noise. If your mic and recorder impedances are mismatched, use a *matching transformer* on the mic cable. Try to put it closest to the piece of equipment with the higher impedance.

BALANCED CABLES. Interference and hum from nearby power lines, automobile engines, fluorescent lights and radio stations can be a problem even with low-impedance equipment. The best solution is to use a microphone and recorder that are connected by a *balanced cable*. In a balanced mic cable, the two wires of a standard cable are enclosed in a sheathlike third wire that insulates them from electric interference (see Fig. 9-20). Balanced cables can usually be recognized by the three contacts, instead of two, in the connectors at either end. Most professional audio gear uses either XLR or three-contact ¼″ plugs for balanced cables. If a piece of equipment has only RCA or mini connectors, these are not balanced inputs. If you connect a balanced mic cable to an unbalanced cable or input using an adaptor, the signal will not be balanced.

Whenever you get electrical interference, try moving the recorder or the cable

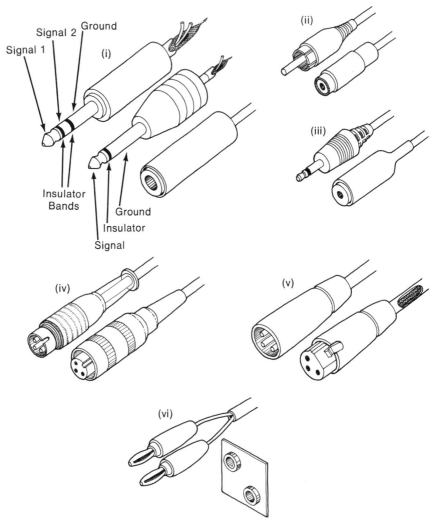

Fig. 9-20. Audio connectors. (i) ¼" males and female. A three-contact stereo plug is at left, a two-contact mono plug is in the center. The three-contact version can also he used for balanced cables. (ii) *RCA* or *phono* male and female. (iii) *Mini-phone* or simply *mini* male and female. This is a miniaturized version of the ¼" connector (diameter is ⅛" instead of ¼"). There is a stereo version of this plug, recognizable by the two black insulator bands (see i). (iv) Three-pin *Tuchel* male and female. The sleeve on the female engages the threads on the male. This Tuchel is a variant of a *DIN* connector. (v) Three-pin *XLR* or *Cannon* connectors. The male and female snap together. Both XLR and Tuchel connectors may have more than three pins. The female XLR is pictured with the insulation cut away to show the balanced or stereo cable with the two signal wires encased in the sheathlike ground. (vi) *Banana* plugs and jacks. See Fig. 6-7 for video connectors. (Carol Keller)

to another position. Sometimes wrapping the microphone cable, especially the connectors, or even the recorder, in aluminum foil helps.

MICROPHONE POWER. The electric power needed to run a condenser microphone may come from a battery in the mic or on the cable. Power may also come from the batteries in the camera, recorder or mixer; the most common version of this method is 48-volt *phantom power*. Some recorders and power supplies deliver 12-volt phantom power or 12-volt *T power* (also called *A/B*). Always check that your mic is compatible with the power supply *before* plugging it in or you could damage the mic. Phantom power frees you from carrying an extra set of usually expensive batteries for the mic. The disadvantage is that, on some recorders, if the microphone input is set up for phantom powering, it will not accept dynamic mics or condensers that have their own power. Some recorders have a switch that permits input from any type of microphone. Phantom powering often involves rewiring microphone cables to reverse or "flip" the phase, making them not interchangeable with normally wired cables.

MIC AND LINE INPUTS. Most mixers and recorders have *mic inputs* for taking signals directly from microphones and *line inputs* for connecting to all other types of audio equipment. The line level is thousands of times stronger than mic level (and higher impedance); it is much less susceptible to interference. Use line inputs and outputs to connect mixers, recorders and wireless receivers whenever possible. Never plug a line level signal into a mic level input or damage could result.

Sometimes when you connect two pieces of equipment, a low (60 Hz) humming sound results if either piece is plugged into the AC wall current. If this happens, connect a *ground wire* between the case of one machine and the case of the other.

It's worth learning the names of connectors used for audio cables. All connectors have male and female forms; the male is sometimes called the *plug*, the female, the *jack* (see Fig. 9-20).

Sound Recording Techniques | CHAPTER 10

This chapter is about methods of audio recording for film and video. See Chapter 9 for discussion of audio recording equipment.

PREPARING FOR A SHOOT

GATHERING GEAR

Lists of useful audio equipment for a film or video shoot appear on pp. 212 and 213. Here are some considerations in choosing audio equipment.

Recorders

When shooting video, the choice of camcorder or VTR format is usually driven by picture needs, but it clearly has an impact on sound as well. In selecting a system, consider: How many audio tracks do you need? Does the camcorder allow manual adjustment of audio levels? Can you use external mics? Are there professional mic connectors (such as XLR) or will you need adaptors? If you're working with a sound recordist, will you need a mic mixer so he or she can control levels?

For film or double-system video shoots, the recordist may have more freedom in choosing a recorder. This decision should be made on the basis of budget, what features you need, and how postproduction will be done. You must choose between digital and analog, with timecode or without. Many of the questions mentioned above apply here as well. How many tracks do you need? Can you easily input professional-type mics? Some newer digital formats are very light and high quality. A DAT recorder saves a lot of back strain. But don't rule out older analog machines. The classic Nagra 4.2 or newer IV-S recorders are very high quality, rugged and versatile. Sometimes when a recorder is *too* small, or has badly arranged controls, it may be hard to use in pressure-filled situations.

Spare batteries, fuses and an AC power connection for the recorder should be kept on hand. To conserve batteries, avoid excessive rewinding or fast-forwarding

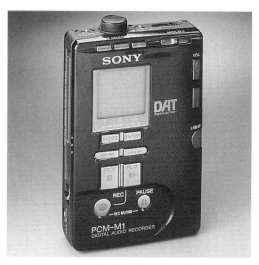

Fig. 10-1 Sony professional DAT recorder, model PCM-MI. (Sony Electronics, Inc.)

of tapes. Digital machines with rotating heads should not be left in pause for a long time, to save both power and head wear.

Microphones

Unless you can carry several mics, your choice of a primary microphone is very important. Some recordists prefer a super-cardioid (long shotgun) mic like the Sennheiser MKH-70. This mic allows you to stand farther back from the subject and is good for isolating voices in noisy environments, such as a train station or a parade. Some long shotgun mics are very big and offensive-looking, and, for documentary work, may be intimidating when pointed at people. Also, a long shotgun is often too directional for recording in tight quarters (see Directionality, p. 262). For these reasons, some recordists prefer a slightly less directional microphone (a hyper-cardioid, like the Sennheiser 416 or MKH-60), which forces them to get closer to the sound source but is excellent for general uses. This type of mic is good for unpredictable documentary or dramatic scenes.

Modular microphone systems allow you to use one power supply with several heads of varying directionality (omni, cardioid and hyper-cardioid; see Fig. 9-11). This provides a great deal of flexibility. There are modular systems at both ends of the price range.

Always try to have at least one backup microphone and cable as insurance. If the second microphone is less or more directional than your primary mic, you will have more flexibility. Lavalier mics are very small, pack easily and can be used for general recording in some situations. If the backup mic uses the same cables and preamplifiers as your main mic, you will not need as much spare equipment.

In many shooting situations, a *microphone boom* is essential to allow the mic to be positioned close to the sound source while keeping the person holding the mic out of the shot. Typically, recordists carry extendible booms that can be adjusted

for each shot. Studio mic booms are mounted on a pedestal to relieve the boom person of the considerable fatigue from holding a boom all day. For smaller, mobile crews, borrow a stand from a lighting kit and get a bracket so you can mount the boom on it; this is particularly useful for situations such as sit-down interviews or static scenes in a drama.

In some documentary situations, the boom may be too big or intrusive. The mic can be handheld for more intimate situations. A short *table stand* for the mic can be handy at times.

Headphones

The choice of headphones is quite important. For controlled shooting situations, it makes sense to get headphones that have good fidelity and *high cut-off* ear pads—ones that block any sounds coming directly to the recordist without having gone through the microphone first. With these headphones, you can be sure of the recording without being misled by other sounds around you. The problem with high cut-off headphones for unstaged documentary filming, especially when a directional microphone is used, is that the recordist can only hear sounds he or she *expects* to hear; if someone speaks outside the mic's range of sensitivity, the recordist will not hear or react to it. Some documentary recordists work with no headphones at all so they can better relate to people and react to events. *Low cut-off headphones*, such as the kind that come with personal "Walkman-style" recorders, are lightweight but may fail to reproduce defects that can be heard on a better sound system. Sound leaking out of these headphones may be picked up by the mic, possibly causing an echo on the track.

Some camcorders have a small speaker at the operator's ear or may be used with an earpiece. These should only be used as a rough reference.

Stereo headphones should be used with a mono plug (or can easily be rewired) when you are recording monaural sound so that you can hear the signal with both ears.

Other Equipment

A typical professional video package includes a mic mixer (see p. 271). Get a *breakaway cable* with a headphone return line in it. This allows the recordist to monitor the sound *coming from* the camcorder, and makes it easy for the camera and sound recordist to separate quickly. One or more wireless microphone systems (see p. 269) will greatly increase your mobility and flexibility for both film and video shoots.

Recordist's Tools and Supplies

Having a few tools can mean the difference between easily finishing a shoot and canceling it. Many repairs are very simple. After phoning a technician, inexperienced persons can often make adjustments or isolate what needs to be repaired or replaced.

For any system:

Permanent felt-tip marker (e.g., Sharpies)
Small roll of gaffer's tape (similar to duct tape)
Spare batteries for recorder and mic
Sound report sheets or log
For video recorder or DAT:
 Head-cleaning cassette
For open-reel or analog recorders:
 Head-cleaning fluid or isopropyl (rubbing) alcohol
 Cotton swabs or head-cleaning sticks
 Spare take-up reel and reel retainer nut (if so equipped)
 Single-edge razor blades (for breaking polyester tape)
For repairs:
 Swiss army knife with scissors
 Screwdriver handle and detachable blades: two sets, medium and
 jeweler's size
 Small needle-nose pliers w/wire cutting edge
 Small volt/ohm meter ("multitester"—costs about $25)
 Battery-operated soldering iron, rosin-core solder
 Short length of light wire
 Fuses for the recorder or camera
 Head demagnetizer (for analog tape heads)

Preparing the Recorder

Equipment should be checked thoroughly before using. This is especially important if it has been transported, used by someone else or come from the rental house. School equipment is more likely to be malfunctioning than working properly. Many recordists check their equipment whenever they arrive at a new location for shooting.

1. *Clean the heads.* See p. 253 for analog recorders; p. 259 for digital audio recorders; p. 180 for video recorders.
2. *Check the batteries.* If possible this should be done with the machine in "Record" position, with tape rolling to see how the batteries read under load. Many rechargeable batteries will read fairly high on the meter until they are ready to give out, then the voltage drops sharply, so be prepared if the reading seems at all low. See Batteries and Power Supplies, p. 182, for more on managing batteries.
3. *Timecode and/or pilot.* For a timecode-capable deck, check that the timecode can be properly recorded and played back. On analog sync recorders, check that the pilot signal is actually being recorded on tape. Some recorders have a meter setting for this purpose, while others allow you to hear the

pilot through the headphones. Otherwise, play back the tape with a resolver to make sure the pilot is there.

4. *Test the audio.* Do a test recording, which you can erase when you begin recording for real. Check the meter. Make sure you can move the level control without causing static. If not, moving the control rapidly back and forth a few times often helps. Set the headphone level adjustment, if there is one. Gently shake the recorder, cable and microphone while listening through headphones to be sure there are no loose connections. This should not produce noise or static. Some people put tape over the microphone cable connectors to keep them from rattling. Play back the tape and listen carefully for any defects. If the sound is muddy, try recleaning the heads. If the sound does not improve, this *may* indicate that the heads need demagnetizing (see Chapter 9).

If you cannot get the recorder to work properly, systematically isolate various components. Try a different mic or mic cable; plug the mic into a different input; make sure the recorder is not in "Pause"; check the AC/battery power switch (if there is one); try running the recorder on AC power; try cleaning the battery contacts with an eraser or grit-free abrasive, and so on.

Before going out to shoot, coil up excess cabling and fasten with Velcro *cable ties.* Make the recorder and/or mixer package as neat and compact as possible. It is much easier to concentrate on recording if you can move without getting tangled up. When carrying an audio recorder, wear it on the side of you that allows easiest access to the controls and the meter, and put some padding under the strap to spread the load. Wear soft-soled shoes and clothing that does not rustle.

Fig. 10-2 Cable tie. This Velcro fastener can be used to keep coiled cables under control. (Fletcher Chicago/The Rip Tie Company)

THE SOUND RECORDIST'S ROLE

The sound recordist is responsible for placing the microphones (although someone else may hold them), operating the recorder or mixer and making sure that the quality of the recording is good. For staged (controlled) work, the recordist, who is sometimes called the *mixer,* can usually experiment with various mic positions and monitor the level of a rehearsal take before shooting begins.

On video shoots, the sound person usually does not control the VTR, but he or she must ensure that the sound *actually recorded on tape* is acceptable. When possible, this means monitoring from the VTR with headphones and/or doing periodic tape playback to check tape.

For unstaged documentary shooting, the recordist should be alert and attentive to the action and not be glued to the meters. With time, your judgment will make you less dependent on both the meter and the headphones. For intimate documentary scenes or for times when the sound person is called on to interview subjects, you can wear the headphones around your neck, for reference from time to time. Be careful not to point the mic at the phones or you will get a loud whistling *feedback* or sometimes a slight echo on the track.

Communication

On all productions, crew members must communicate with each other. The camera operator must be able to signal to the recordist (or boom person) that he is in the frame, and the recordist must be able to indicate his need to change position. Often in documentary work, only the recordist can hear whether a scene is worthy of being filmed. For all of these reasons, the filmmakers should have a set of signals with which to communicate silently. If these are hand signals, they should be sent with minimal commotion, so as not to disturb actors or documentary subjects. This requires that crew members watch each other as much as the action. The recordist, or whoever is operating the microphone, should not position himself on the camera operator's blind side (which is usually the right), and the camera operator should frequently open her other eye so that she can see the recordist while shooting. This is most important when filming improvised or unstaged action. After a crew works together for a while they begin to predict each other's needs, and eye contact precludes the need for hand signals.

If circumstances are such that a good-quality recording can't be made, the recordist should say so. If an airplane makes a take unusable, tell the director when the take is over (some directors want you to signal the problem *during* the take; smart directors will be looking at you as soon as they hear the plane). The director must decide whether to try to salvage a take with postdubbing or other postproduction cures (hence the phrase used for every conceivable production problem: "We'll fix it in the mix!")

The sound department is treated as a second-class citizen on some sets. The recordist may be forced to find mic positions only after all the lighting and blocking is done, making his job harder. He may also be blamed for the dog barking next door.

Recorded Information

Videotapes should be clearly labeled with the name of the production, the production company, tape number, date, timecode type (drop or ND), timecode start, any noise reduction used, stereo/mono, and any special track assignments (such as LAVALIER CH. 1., BOOM MIC CH. 2.).

For film shoots or whenever a separate audio recorder is used, in addition to the above information, also label audiotapes with the camera roll or videotape num-

ber, name of recordist and, when applicable, sample rate, timecode frame rate, tape speed, type of sync signal (for example, 60 Hz pilot). This information may be also spoken into the microphone and recorded on tape at the head of the roll. When a camera roll is changed partway through the sound roll, an announcement should always be made on the tape.

In professional video work, bars and tone (see p. 404) are recorded for at least thirty seconds at the head of each tape. The audio reference tone is used to calibrate playback equipment to the proper level. The reference tone is usually generated by the mic mixer, a separate tone generator or the camera. On analog camcorders or any deck equipped with a VU meter (see Setting the Recording Level, p. 288), the recording level is normally adjusted so the meter reads 0 VU. For digital camcorders, the tone is usually set to read −20 (or sometimes −18) on the peak-reading meter (see Analog Recording Level, p. 288). It's not a bad idea to write on the tape or speak into the mic what reference level is being used.

If you are using an audio recorder for a film or video shoot, record a reference tone at the head of each audiotape. The same guidelines apply. Some recorders have a built-in tone generator that works at a preset level. The tone on the Nagra 4.2 or IV-S is usually preset to read −8 dB on the modulometer. After the tone is recorded, run off a few feet of tape so print-through will not spoil anything important. If your equipment doesn't generate a reference tone, don't worry about it.

When shooting scripted material, scene and take numbers are usually recorded on tape at the beginning of each take. For a video shoot, someone may be assigned to keep logs of each take (see Recordkeeping, p. 240). On a film shoot, the sound recordist often keeps a *sound report*, which is a written log of each take, noting the length, any problems and whether the director considers the take good or bad (see Fig. 8-20). If timecode is being recorded, the takes can be identified by timecode start and stop. On some productions, a *sound take number* is given each time you roll tape (and is included on the slate). This identifies each piece of sync and wild sound. Since sound take numbers advance chronologically throughout the production (unlike scene numbers), in conjunction with the log, they aid in locating pieces of sound and picture.

In unstaged documentary film work, shots are not usually given numbers and there is no time for meticulous log keeping. Instead, the sound person should record a quick message after every shot or two, describing what was filmed, if there were problems with the slate and so on; this can save a great deal of time in the editing room. An announcement should be made on tape before sections of wild sound (sound recorded without picture), and a verbal note should be recorded when MOS shots (shots without sound) are filmed. It is a good idea to keep an informal log on the tape box, listing the contents of each sound roll.

AUDIO FOR FILM SHOOTS

Today, virtually all filming is done double-system, with a film camera and a separate audio recorder. Certain procedures are followed to coordinate sound and picture. Many of these also apply when shooting video double-system (with a separate audio recorder) or with multiple video cameras.

Recorder Operation

For staged work, there is a traditional regimen for beginning each take. The director (or assistant director) calls for quiet and then says, "Sound." The recorder is then started, and the recordist says, "Speed," when the tape is running smoothly. The director then says, "Camera," and the camera operator calls, "Speed" or "Rolling," when the camera has come up to speed. If slates are being used, they are done at this point (see Slating, below). The director then calls for "Action." Normally, the camera and recorder are not turned off until the director says, "Cut."

Some audio transfer systems and film-to-video transfer systems require five to seven seconds of "preroll" before the slate or first usable audio. Consult the transfer house before you shoot to find out how much preroll, if any, they need. Make sure you let the recorder run the allotted time before the slate is done or the camera starts.

In unstaged documentary filming, it is important that the recordist be ready to roll tape at a moment's notice. If shooting appears imminent, the recorder should be put in the "Standby" position (on some recorders this is done by pressing the "Record" button, but not the "Forward" button) and the recording level should be set. If the scene looks interesting, the recordist should not hesitate to roll tape. Tape is cheap. If the scene does not pan out, simply say, "No shot," into the mic and stop recording. If the scene is good, the camera should roll. The first part of the scene that has no picture can usually be covered with another shot or a cutaway. There is no advantage to rolling vast amounts of tape, but often if you wait too long to start the recorder, the take will be useless.[1]

If your recorder is equipped with a separate playback head, it's a good idea to monitor the "Tape" position and not the microphone directly (see Playback, p. 253). This allows you to check the recording quality and whether you have run out of tape. Running out of tape is unnecessary and embarrassing. Some recordists routinely change tapes at the end of every camera roll (or two) even if some tape is remaining, thus ensuring adequate supply and minimizing time wasted for tape changes. For open reel recorders, it's often faster to replace *both* feed and take-up reels if you're in a rush, saving the time it would take to wind up the end of the old tape.

If the footage will be transferred to video for editing, it's generally a good idea to record all wild sound (sound without picture) on separate tapes so that they don't have to wade through it during the telecine session or when syncing up.

If you don't have enough tape to complete a shoot, in emergencies you *may* be able to switch to a slower tape speed or lower sampling rate, but don't forget to log this and to inform the person transferring the sound.

Develop a system to keep track of which tapes have been recorded and which are fresh (if you reuse tape, it is especially easy to get confused). Tape cassettes have little *record inhibit* tabs that should be pushed in after recording to prevent accidental rerecording. Analog audio cassettes have small tabs on the edge opposite the one where

[1]The Dēva disk recorder (see Fig. 9-6) can store 10 seconds of sound from *before* you press "Record," allowing you to capture sound that you would otherwise have missed. Almost like having a time machine.

you see the tape that can be punched to prevent accidental recording. These tabs can be plugged up or taped over later if you want to rerecord the tape.

Fig. 10-3. Traditional clapper board. (Victor Duncan, Inc.)

Slating

When shooting video, sound and picture are recorded on the same tape—they're always in sync. In double-system filming, picture and sound are recorded separately, and the sound must be correctly lined up with the image during post-production—that is, sound and picture must be put in sync (see p. 378). Syncing is much easier to do if there is some distinct event that can be seen clearly in the picture and heard on the sound track. For example, the closing of a car door might suffice. A *slate* is an event in sound and picture that can be used to facilitate syncing.

The traditional slating device—called variously a *slate, clapper board, clap sticks* or, simply, *sticks*—is literally a piece of slate on which information can be chalked, with a hinged piece of wood on top that makes a sharp noise when it makes contact with the board (see Fig 10-3). Information written on the slate includes the production company, name of film, director, director of photography, scene and take numbers, sound take number (if any), camera and sound roll numbers and date. A small gray card (see Fig. 5-4) may be included to assist in color correcting the workprint or video transfer. Some people also use a color control scale.

The clapper board is usually handled by an assistant who writes and reads aloud the scene and take numbers and/or the sound take number before snapping down the hinged part of the slate at the beginning of each take. The numbers are often written on pieces of tape that can be stored on the back of the slate and quickly stuck on the front as needed.

Another slating device is the *slate light*, which is connected to the recorder. When its trigger is pushed, it flashes a small light (some flash consecutive numbers

to identify takes) and it produces an audible beep. The slate light can be very handy for documentary filming, although the light is sometimes hard to see in daylight. Slating can also be done by *gently* tapping the microphone once or twice or even by snapping your fingers within range of the recorder.

When you make any slate; it's imperative not to turn off the camera or recorder between the slate and the shot itself, as novices sometimes do. Make sure that the slate is really visible and clear to the camera to avoid spending unnecessary time syncing up. It's a good idea to say, "Slate" or "Marker," into the mic just before any slate to help the editor find the sound later.

When possible, do *head slates*, which are done at the beginning of the shot. Head slates speed the process of putting the sound and picture in sync in the telecine suite or editing room. *Tail slates*, done at the end of the shot, are often preferable for unstaged documentary filming or emotional acted scenes, since they are less disruptive and do not loudly announce to everyone that filming is about to begin. Traditional clapper boards are usually held upside down to indicate a tail slate; the person slating should call out, "Tail slate" or "End sticks," when doing so. If the film runs out before the last tail slate on a roll and the camera operator says, "Run out," you can use this as an approximate slate. If camera or sound miss a slate and you do it a second time, announce, "Second sticks," to alert the editor. In any situation, a gentle, quiet slate helps put actors or film subjects at ease. Generally, actors should not be rushed to begin the action immediately after the slate.

It is more difficult, but certainly not impossible, to put shots in sync without a slate (see Chapter 13).

The term *slate* also refers to the recording of information on film or tape. MOS takes are slated, not for synchronization, but to identify the scene number on film at the head of the take (MOS should be written on the clapper board and the hinged bar should not be raised). Each roll of film is normally slated at the head by shooting a card or clapper board with production name and company, camera roll number, date, and so on for a few seconds. Similarly, sound tapes are slated at the head with information on the roll number or the content.

Timecode Slates and In-Camera Timecode

Timecode offers a lot of benefits for film production, especially when editing is done with nonlinear or other video equipment. Using timecode can automate the syncing process, as well as help identify and locate audio material by timecode number. For the basics of timecode, see Timecode, p. 196.

One use of timecode in film production is for *timecode slates*. With this system, a timecode generator feeds code to the audio recorder (the generator may be built-in). The same generator or a different one feeds identical code to a timecode slate (sometimes called a *digi-slate*). This slate may look like a standard clapper board with a timecode display on its face (see Fig. 10-4). Slates are done in the usual way, usually at the head of the shot. When the clap sticks are lowered on the slate, the timecode at that instant is held for a few frames on the display. Any sync sound camera can be used. After the film is processed, the sound is synced either during the film-to-video transfer or after. The frame with the slate is stopped on the screen. The timecode is

read visually and then entered into the computer. The system then locates the same timecode number in the audio and, presto, the shot is in sync.

Fig. 10-4. Timecode slate. Dcode TS-2(sb) slate reads and displays SMPTE/EBU timecode. Incorporates a timecode generator (see Fig. 10-5) for independent "smart slate" operation. (Denecke, Inc.)

This method does *not* require a timecode-capable camera. There are different types of timecode slates. A *smart slate* has its own timecode generator; a *dumb slate* receives its timecode from another machine (usually the audio recorder, either via cable or wireless connection).

A more sophisticated method uses a camera that can expose a running timecode display along the edge of the film (*in-camera timecode*). The AatonCode system (also used in Panavision cameras) exposes on the film a combination of human-readable numbers and a machine-readable matrix of dots (see Fig. 2-20). The Arriflex system uses a bar code. With a timecode-capable camera, both the camera and the audio deck are recording essentially identical timecode on their respective media. In postproduction, properly equipped telecines can read the film timecode and automatically sync it to the audio code. Sometimes, autosyncing is done later on the editing system (see Timecode and Audio in the Telecine, p. 520).

The beauty of this system is that slates are no longer necessary. There are no distracting slate claps to disturb actors or subjects, nor is footage wasted doing slates. The camera can shoot at will, and as long as the recorder is running, you know you'll be able to quickly sync up the material. This can be very useful for interviews in which you want to start and stop the camera while always rolling sound. This also makes it possible to quickly sync up footage from multiple cameras. For a concert shoot, you could have several roaming cameras and never need an audio or visual slate to find sync.

Filmmakers are increasingly using timecode as a way to coordinate information from the set, log it and send it all the way through postproduction via computer

disk. Such items as scene, take, camera and sound roll numbers, director's comments, color balance and the like can be referenced to timecode numbers and loaded into the telecine database (see Fig. 17-5).

Setting Timecode in Camera and Recorder

When using timecode with film equipment, you have several options in terms of frame rates and timecode settings for camera and audio recorder. Before shooting, be sure to contact the lab or post facility that will be doing the video transfer to find out their preferences. Shoot a test before beginning a production to make sure all systems are working.

When shooting in North America or other places where NTSC video is used, film cameras are generally run at 24 fps and, if the film is going to be edited on video, timecode for the audio recorder and timecode slate is often set to *30 fps*, nondrop. The 30 fps timecode setting on an audio recorder is a *special* timecode generally used only for audio. It is a *true 30 fps* system—*not* the typical system used in NTSC video cameras (for which the timecode counter counts 30 fps but the video actually runs at 29.97 fps.)[2] There is a difference between the two!

The reason the audio is recorded using 30 fps timecode is based on the fact that when the film is transferred to video, it will be slowed down (pulled down) in speed by .1 percent (see The Scanning Process, p. 512). The audio will also be pulled down by .1 percent to keep sync with the picture. When you slow down the 30 fps audio, you get 29.97 fps, which will stay in sync with the video used by the rest of the video recorders and editing equipment.

When shooting in Europe and other PAL or SECAM countries, things are blessedly much simpler. There is no .1 percent slowdown during video transfer. If film is shot for PAL video transfer at 25 fps, then audio and in-camera timecode (if any) can use EBU 25 fps timecode. For films shot at 24 fps and then transferred to PAL or SECAM, see Film-to-Video Standards Conversion, p. 528.

Regardless of what system you are using, always consult with the camera rental house, the film-to-tape transfer facility, the editor and any other participants in the process *before* the shoot.

Some Wrinkles in Timecode

TIMECODE DRIFT. Timecode generators tend to drift slightly over time. This can lead to sync errors if the timecode in a slate or camera differs from the timecode in the audio recorder. When using more than one timecode device, pick one of them to serve as the master clock and use it to *jam sync* the other machines regularly (when you jam sync, one timecode generator sets the other to its timecode). Do so whenever convenient, in any case no more than every few hours.

[2]Even though the SMPTE timecode used with standard NTSC video counts 30 frames for every digit in the "seconds" column of the timecode, the video images are actually recorded at a rate of 29.97 frames per second. The difference between the two is why we have drop frame and nondrop timecode (see Timecode, p. 196).

Fig. 10-5 Timecode Generator. Dcode SYNCBOX generates all common timecode formats and can be "jam" set from an external timecode source. Often used with a timecode slate. (Denecke, Inc.)

TIMECODE SLATE PROBLEMS. When using timecode slates, some people prefer smart slates because they require no connection between the slate and the audio recorder. On the other hand, this provides one more opportunity for timecode to go out of whack. A wireless transmitter can be used to send code from the recorder to a dumb slate, which simplifies things somewhat, but requires a good wireless link.

As a safety precaution, when using a timecode slate be sure to record the sound from the clap sticks (the old-fashioned slate system) in case there's a problem with the code. Also frame the slate in the camera viewfinder clearly so the timecode numbers are big and easy to read.

TIMECODE AND SAMPLE RATE. Unlike video camcorders, digital audio recorders don't really record "frames." With video, we can look at the picture and see clearly where one frame ends and another begins. Digital audio, on the other hand, is recorded in a *constant stream* of numbers (when using a 48 kHz sample rate, there are 48,000 numbers—samples—recorded every second). DAT and other digital audio recorders generally use the *sample rate* to govern the speed of the recording and playback. Thus, 48,000 samples are recorded every second; then, in playback, the machine makes sure 48,000 samples are played back every second. The timecode may be derived or calculated from the sample rate. This leads to the interesting and sometimes disconcerting fact that some systems allow you to play back the audio at a constant speed (say, 48,000 samples per second) while dialing up different timecode frame rates (24 fps, 29.97, 30, etc.). In other words, the audio doesn't change speed, but the timecode counter does. It can make your head swim.

RECORDING TECHNIQUE

Basic Strategy

The general objective in sound recording is to place the microphone close enough to the sound source to produce a loud and clear sound track. A good track should be easily intelligible, should lack strongly competing background sounds, unpleasant echo or distortion and should be reasonably faithful to the tone quality of the original sound. Once a good recording is in hand, you have a great deal of freedom to alter the character of the sound later as you choose.

The ideal placement for many mics is between 1 and 3 feet in front of the person speaking, slightly above or below the level of the mouth. If the microphone is directly in line with the mouth, it may pick up popping sounds from the person breathing into it. A windscreen helps (see p. 266). If a directional mic is too close, it will bring out an unnatural bass tone quality. This is the *proximity effect*, which results from the particular way low frequencies interact with directional microphones. If a microphone is too far from the subject, background sound (*ambient sound*) often drowns out the speaker's voice. Also, the undesirable acoustic qualities of the recording space, like echo and boominess, become more noticeable (see Acoustics of the Recording Space, p. 295).

The microphone's position is almost always compromised by the camera's needs. It is important, however, that the sound source be solidly within the pickup pattern of the microphone. Generally a boom mic will be brought in from *just above* the camera's frame, as close as possible without getting in the shot.

Keep in mind that sound, like light, diminishes in intensity with the *square* of the distance (see Fig. 11-5). Thus, moving *twice* as far from the sound source diminishes the sound to *one quarter* of its previous level. If the recording level of the sound seems low, especially with respect to louder background sounds, you must get closer to the sound source and not try to correct the problem by turning the level way up.

Many beginners think the recordist should try to capture all sounds in a general fashion, standing back from, say, a party, a conversation or a street scene to record all the sounds together. The result of such recordings is usually an indistinct blur. The recordist should instead select individual sounds and get close enough to record them clearly. If an overall mélange of sounds is desired, it may be necessary to mix together several distinct tracks later. For documentary filming in noisy conditions, you may need to get closer to the subject than you feel comfortable doing. A few experiences with scenes ruined by bad sound will help overcome shyness.

Putting the mic very close to the sound source minimizes both ambient sound and the natural echo or reverberation of sound reflections in the recording space. In some situations, a close mic sounds artificial. For example, if the camera is filming a distant long shot and the mic is very close, the recording will lack the proper *sound perspective*. Although distorted sound perspective is found regularly in movies, some people object to it. To correct this, the recordist could move farther back, but at the risk of sacrificing clarity. Alternately, after the sound has been recorded, a *reverb unit* (see p. 451) can easily be used to give a sense of distance to

the sound. Similarly, any missing ambient sounds can be added later by mixing in additional tracks. These kinds of effects are usually better handled under the controlled conditions of sound editing than they are while making a live recording. You can always add background sounds, distance effects and equalization during sound editing and mixing, but nothing can make a noisy, echoing or weak recording sound pleasing and clear.

SETTING THE RECORDING LEVEL

One of the recordist's key jobs is controlling the volume of the recording. We'll first look the basics with analog recorders, then discuss the variations when using digital recorders.

Analog Recording Level

All magnetic tape has inherent noise. Even a *virgin* tape straight out of the package will play back a hissing noise. When sound is recorded on tape it must be louder than the tape noise to be audible. Ideally it should be significantly louder so that the tape noise can be heard only as a quiet background during pauses in the sound signal.

If the sound is recorded too loudly, called *overmodulation*, it will be "clipped" and distorted. Overmodulation in analog tape recorders occurs when *all* the particles in the tape oxide become magnetized, which is called *tape saturation*. Once the tape is saturated, any additional level will cause the recording to sound crackly and harsh—the loud sounds seem to break up. Very loud sounds like laughter and applause often overmodulate on an otherwise properly modulated tape.

The loudness of sound as it passes through a tape recorder, or other audio device, is called its *level* or *gain;* this is adjusted with a *volume* or *level control* or *pot* (short for potentiometer).

In general, the level should be set to record sounds *as loudly as possible without overmodulating.* Although there are exceptions to this principle, the idea is to minimize noise and provide the most flexibility for later stages of sound processing. In film and video production, nearly all sound is rerecorded at least once from the original tape or disk to another tape or disk during editing and finishing. Loudly recorded sound that should ultimately be softer can be reduced in volume during rerecording.

Most recorders are equipped with a meter to guide you in setting the recording level. The classic meter for analog equipment is the *volume unit (VU) meter*, which is found on both inexpensive and costly recorders (see Fig. 10-7). If a meter is not identified otherwise, it is probably a VU meter. Many recordists feel that VU meters provide the best indication of the subjective loudness of sounds.

VU meters are calibrated in decibels; the scale usually goes from about −20 to +3 dB, with a bold change in the color or thickness of the markings at the 0 dB point. For typical voice recording, the level should be set to produce a healthy deflection of the needle, so that the highest swings rise to between about −7 and −1 dB. If the needle jumps above the 0 dB point, the level should be reduced somewhat.

RECORDING PLAYBACK

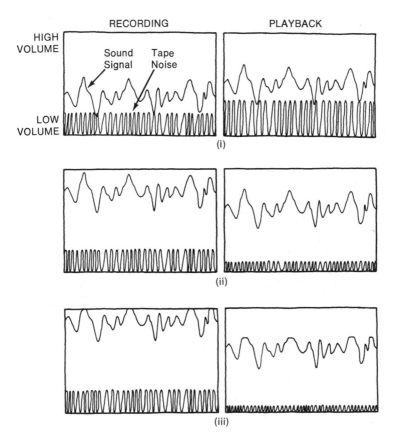

Fig. 10-6. Setting the recording level. (i) If the sound signal is recorded at a low level—near the level of the tape noise—when the volume is increased to a medium level in playback, the noise gets louder too. (ii) If the signal is recorded as loudly as possible without overmodulating, you can lower the volume in playback and the noise level will diminish as well. (iii) If the level is set so high in recording that the signal is distorted, it will still be distorted in playback even if the level is reduced (note the clipped peaks). (Carol Keller)

The VU meter employs a relatively "heavy" needle that is slow to respond to quick peaks in volume and provides a reading of the *average* sound level. It was designed for the human voice. The VU meter gives up to 8–10 dB *headroom* (safety margin) above 0 dB before the tape actually saturates. This reflects the fact that the loudest volume peaks in human speech are about 8 dB above the average sound level. Given the slow response time of VU meters, short, percussive sounds (called *transients*) like those of a hammer, scissors, chirping bird or jangling keys will not deflect a VU meter very much even if they are being recorded loudly; you should not turn the level control way up to try to get them to do so.

Digital recorders and many newer analog machines generally have *peak-reading* meters instead of VU meters. The meter may be arranged as a line of lights, or as

bars on a LCD screen (see Fig. 10–8). There are also dial-type peak reading meters, such as Nagra's *modulometer* (see Fig. 10-7). Unlike the VU meter, the peak-reading meter responds *instantaneously* to quick surges in volume and provides a reading of the *maximum* sound level. VU meters give too low a reading for fleeting sounds, like the hammer or the keys, because the volume peaks have passed by the time the needle is finished responding. The peak-reading meter, on the other hand, responds quickly enough to give an accurate reading of sounds of short duration. Modulometers and many digital peak meters have a *peak hold* function, which displays the maximum peak for some time after the peak has passed, giving you a chance to see it.

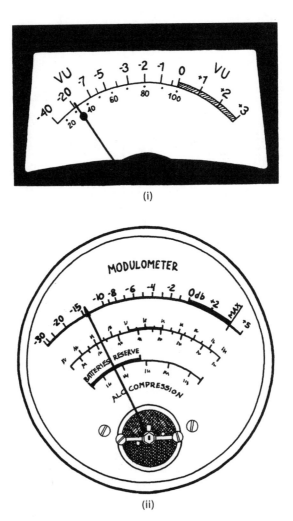

(i)

(ii)

Fig. 10-7. (i) VU meter. (ii) Modulometer on Nagra 4.2. Sound level is read on the top scale. (Carol Keller)

Volume peaks are of concern because these are the first to saturate the tape and become distorted. With a peak-reading meter you can be fairly certain that peaks are not overmodulating, but with a VU meter you can only make an educated guess.

For normal voice recording, the level should be set so that the highest deflections of the peak reading meter rise to between about −8 and −2 dB. (On a modulometer this is easy to remember because the needle will be roughly in a vertical position.) Though most recordists are careful to avoid letting the needle pass the 0 dB mark, it is usually the case with analog recordings that occasional, loud peaks can read higher without causing problems. However, if the needle goes above 0, reduce the level somewhat.

Whether you use a VU meter or a peak-reading meter, the actual point of overmodulation and distortion is really determined by the type of sound, the recorder's amplifier and the tape being used. Some sounds may read a few decibels above the zero point without serious distortion, some will distort and some will not be badly harmed by the crackle and breakup produced (a gunshot, for example).

The meters on most recorders only inform you of the strength of the signal as it goes to the record head, not what is *actually taking place on the tape*. Tape stocks vary in noise and saturation levels. Whether or not you are under- or overrecording can really only be determined by listening to the tape playback with good headphones or a good speaker.

If your recorder has an adjustment for headphone volume, set it at a comfortable level and leave it there. In those situations in which it is difficult to watch the meter, this will help you to estimate proper recording level by the way it sounds in the headphones.

Digital Recording Level

With digital recording, the same rule applies as for analog: you want to record sounds as loudly as possible without overmodulating. However, the rule is interpreted slightly differently.

First of all, tape noise is not a problem with digital recordings. This means that very quiet sounds can be recorded without fear of losing them in the "noise floor." Even so, if you record with the level too far down, you won't make use of all the digital bits available, and the quality of the recording may suffer (the sound may be harsh or "gritty").

At the other end of the scale, overmodulation is a fundamentally different thing in digital than analog. As just discussed, when a sound is recorded too loudly on an analog machine, the tape oversaturates and the resulting breakup may sound crackly. On a digital recorder, the tape saturation is the same regardless of whether the sound is quiet or loud; you're just recording a different set of ones and zeros (see Digital Audio Recording, p. 249). When a sound is too loud on a digital system, you run out of ones and zeros to assign to it. The result is a distorted, unacceptable recording.

Thus, with a digital recording, you should worry a little *less* about recording too quietly and worry *more* about recording too loudly. Digital recorders use peak reading meters (see above) so you can be sure no peaks are too loud. On digital peak

meters, 0 dB represents the level at which the digital signal will be clipped, so *make sure all peaks are safely below 0 dB*. If the highest peaks rise no higher than −4 to −2, you will leave that much headroom so unusually loud peaks won't reach up to 0. If sound levels fluctuate a lot, turn the level down a little to leave more headroom. Some digital recorders employ a limiter (see below) to prevent overrecording.

Fig. 10-8. LCD display on a Sony camcorder. Note the stereo, peak-reading audio level meters on the right side of the display. (Sony Electronics, Inc.)

Recording Problems

In general, recordings sound better if the level is not changed a great deal during recording. This usually means setting the level at a compromise position between, say, the loud and soft voices of two people talking. (Another solution might be to move the microphone closer to the softly spoken person.) Try to anticipate surges in volume, choosing perhaps to underrecord slightly an orator whose every sentence is greeted with loud cheers from the audience. Or, you might allow the applause to overmodulate and plan to replace it with a better-recorded piece during sound editing. (This is a situation where a good limiter could be very helpful; see below.) Usually, a certain amount of level adjustment (called "riding the gain" or "riding the pot") is unavoidable. Level changes that are made gently and not suddenly will be less disturbing.

When using a recording format that has more than one track, some recordists use two tracks as insurance against overmodulation. One track records the signal

from the microphone or mixer at full level. The signal is also split over to the second track, which is recorded with the level *turned down* 3–5 dB or more. This track is only used if the first one overmodulates. Be sure to label tapes that have been done this way and record the reference tone on the second track at full level *before* turning the level down.

When quiet sounds seem underrecorded, do not turn the level control beyond three fourths of its full range, since this will usually add system noise to the recording. Instead, get closer to the sound source. If extremely loud sounds (like live rock music) require that the level control be set at less than one fourth of its travel, this too will degrade the sound signal. If this is the case, get an *attenuator*, or *line pad*, to place on the cable between the microphone and the recorder (some mics have built-in attenuators). The attenuator cuts down the strength of the signal.

Automatic Level Control

Many audio and video recorders are equipped with some form of automatic control of recording level. The names for the various types of automatic adjustment are not entirely standardized. Some types work better than others, but often the effectiveness depends more on the sophistication of their design than on the particular type used.

Automatic level control (*ALC*), or *automatic gain control* (*AGC*), works by automatically choosing a predetermined recording level. If the sound signal coming into the recorder is too quiet it will be boosted, and if it is too loud it will be cut down in volume. ALC requires no attention on the part of the operator, and it can be quite effective for straightforward recording in which the sound level does not vary too much. However, most ALC devices do not handle sudden volume changes well. Say you're recording someone in a kitchen. While he speaks, the level is set fine, but when he stops, the ALC responds to the quiet by boosting the level, thereby bringing the sound of the refrigerator to full prominence. ALCs may have a slow recovery time and, if a sudden, loud sound occurs while someone is speaking, the recording level will drop, reducing the level of the speech, and return to normal some moments later.

On the average, most ALC systems can't outperform a competent recordist who sets the level manually, but some ALCs work quite well. Test your own system and judge for yourself.

Some systems are designed so that *you* set the basic recording level, and the level control only kicks in to prevent you from overmodulating. *Limiters* cut in sharply when the sound is close to overmodulating, protecting against sudden volume peaks. Some limiters work so well that they are virtually unnoticeable; others cut in very sharply and produce an unnatural, flattened effect in the sound. Some wireless microphones and other systems have limiters and *compression indicators* instead of a meter. The level should be increased until the indicator lights up, showing that the limiter is cutting in; then decrease the level until the limiter operates only on loud peaks.

Limiters can be helpful for scenes in which sound levels change suddenly and for digital recordings where overmodulation is a particular problem. If limiters are relied upon too heavily (that is, if the recording level is set so high that the

limiter is constantly working), the sound loses much of its dynamic range and can seem flat and without texture. A *compressor/expander* (sometimes called a *compander*) like the dbx unit, compresses (reduces) the dynamic range of the sound during recording—to accommodate any loud volume peaks without overmodulating—and then expands the dynamic range again during playback. This method can be used to make high-quality recordings when the filmmaker is unable to make any level adjustments during the recording.

LOCATION SOUND

Ambient Sound

Ambient sounds are the background sounds that surround any recording space. They can come from birds, traffic, waves, refrigerators, fluorescent lights, stereos and the like. The best way to minimize their effect, when possible, is to eliminate them entirely. Don't shoot the birds, but do turn off refrigerators, air conditioners and close windows facing out to the street.[3] When possible, locations should be chosen with ambient noise in mind (see Sound Editing Technique, p. 454). Try not to set up shoots in an airport flight path or by a busy highway. Sometimes you can get permits to block off a street while you are shooting; otherwise, plan to shoot at a quiet time of day. Heavy *sound blankets* (furniture packing pads) can be used to dampen noisy windows or air vents. These can be clipped and hung on grip stands to make a quieter space near the actors or subject.

Audible background sounds should ideally remain consistent throughout a scene. Consistency is important for editing, since much condensing and rearranging of the movie's chronology are done at that time. An editor needs the freedom to juxtapose any two shots without worrying if the background tone will match. The audience will tune out the gentle ambience of an electric fan, but may notice if it pops in and out in every other shot. If you begin shooting a scene with the window closed, do not open it during the scene. In situations where you can't control some background sound (a neighbor's auto, for example), record some of the offending sound *alone* in case during editing you need to cover sections of the scene that lack it. In some cases, an inconsistency in the background sound will seem logical and doesn't need to be disguised.

Make every effort to turn off or lower any music that is audible at the filming location. Discontinuous music is a glaring sign that the chronology of shots has been changed. Recording music may also create copyright problems (see Chapter 18). If ambient music cannot be eliminated, or if it is part of the scene you are filming, plan your editing around it when you shoot.

You should always record about a minute of *room tone* at every location. Have everyone be quiet and stop moving while you record. Even if nothing in particular is audible at the location, every site has its distinct room tone, which is quite different from the sound of dead tape that has nothing recorded on it. Room tone—

[3]Many a crew has driven off from a location forgetting to turn the fridge back on. Frank Coakley suggests putting your car keys in it when you turn it off to remind you.

SOUND RECORDING TECHNIQUES 295

an expression that refers to outdoor sound as well—is used in editing to bridge gaps in the sound track, providing a consistent background.

Recording in Noisy Locations

If strong ambient sound is overpowering the sound you want to record, there are a number of solutions. First, try to get the microphone as close to the source as possible.

Lavalier mics are often useful for noisy settings. These are especially effective for a single subject or for situations where two persons are near each other. These mics can usually be concealed on the subject (see p. 267). They can also be hidden, for example, in a piece of furniture. Placing a lavalier in the center of a small table is sometimes the best way to mic unpredictable dinner table conversation. The mic should not be placed directly on the table surface where it will pick up the vibration of objects being put down onto the table. We have had success clipping mics on the handle of a coffee cup. The table's surface will help by reflecting sound into a mic if the mic is within a few inches of the surface.

When used with a wireless transmitter, lavaliers can provide good-quality sound in scenes with lots of subject movement and long shots where boom mics would be impractical.

Sometimes the best solution for unwanted noise is to use a directional mic. Always keep its pickup pattern in mind (see Fig. 9-12). Try not to let the subject come between the mic and a major noise source, like the street. Stand in the street to mic someone on the sidewalk; don't stand with your back to the buildings where you will pick up the sound of your subject and the street noise equally. With a super-cardioid microphone, if you can point the mic upward from below (or down from above), you can minimize street level background noise, including sound reflected off buildings.

With film cameras (and some video cameras), camera noise is a big problem. Avoid pointing the mic at the camera or its reflected sound (see Fig. 10-9). Put the camera in a barney (see Fig. 2-19) if possible.

Acoustics of the Recording Space

The size, shape and nature of any location affects the way sound travels through it. An empty room with hard, smooth walls is acoustically *live*, reflecting sound and causing some echoing. Bathrooms are usually acoustically live; sound may reverberate in them for a second or more before dying out. A room with carpets, furniture and irregular walls is acoustically *dead*; sound is absorbed or dispersed irregularly by the surfaces. Wide-open outdoor spaces are often extremely dead, because they lack surfaces to reflect the sound. Listening to the way a hand clap or whistle dies out is a good way to test the liveness of a recording space.

The acoustics of a location affect the clarity of the sound track and the loudness of camera noise. It's hard to hear clearly in an overly live room (a *boomy* location), since high frequencies are lost and rumbly low frequencies predominate. If you have tried to talk in a tunnel, you know what it does to the intelligibility of voices.

There are a number of ways to improve an overly reverberant location. You can use a directional mic and move closer to the sound source. A room can be deadened by closing curtains or by hanging sound blankets on stands and spreading

them on the floor. Avoid positioning a microphone near a smooth wall where it will pick up both direct and reflected sound; echo may be increased or sound waves may cancel each other, weakening the microphone's response. This may also occur when mics are mounted on a short table stand over a smooth, hard surface. Avoid placing the mic in a corner or equidistant from two or more walls where reflected sound may cancel or echo. Sometimes boominess can be reduced by filtering out low-frequency sounds below about 150 Hz (see Bass Filters, p. 299).

If a space is too live, even a quiet camera's noise will sound loud. When you point the mic away from the camera, you often are aiming at reflected sound bouncing off a wall. When this happens, deaden the space with blankets, move closer to the subject or use the pickup pattern of the mic to cancel out both direct and reflected camera noise.

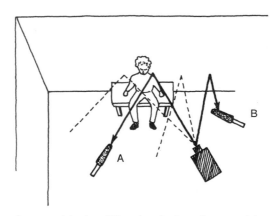

Fig. 10-9. Microphone positioning. Directional microphone positioned at (A) is pointed right at reflected noise from a film camera. Microphone positioned at (B) will reduce pickup of both direct and reflected camera noise. (For clarity in the illustration, the microphones are shown farther away from the subject than is optimal.) (Carol Keller)

MUSIC, NARRATION AND EFFECTS

Recording Music

Some suggestions for music recordings:

1. When you record an individual instrument, place the mic near the point where the sound is emanating (for example, the sound hole of a guitar or the bell of a saxophone).
2. When you record a number of instruments with one microphone, experiment with various mic placements to find the one that balances the instruments nicely. The mic should usually be somewhat above the level of the instruments, closer to the quiet ones than to the loud ones. One well-placed omnidirectional mic can often achieve good results. Sometimes a second

mic is added to capture a vocalist or soloist. When you use more than one mic, be careful to avoid phase cancellation. For stereo recording, see p. 301.

3. When recording amplified vocalists or instrumentalists, you generally want to mic the loudspeaker, not the person. When you record a person at a podium, you may get better sound by miking the person directly, but you must get the mic very close. Often with amplified speeches or music you can get a line feed directly from the public address system (or a band's mixing board) to your recorder. By doing this, you avoid having to place a microphone and you usually get good-quality sound (in the case of the band's mixer, you get premixed sound from multiple microphones).

4. Generally, you want to let the *musicians* control the volume. Avoid using automatic level control or making sudden manual adjustments to the recording level. Find the highest level that can accommodate loud passages in the music and then leave the level alone. If you're making a dub (copy) of an existing recording, you can find a good level before you make the dub. For live performances, professional recordists sometimes attend rehearsals, follow the musical score and make slight adjustments during rests or pauses between soft and loud passages. When recording music with an analog tape recorder, you generally want to use the fastest tape speed you can. With digital machines, use a high sampling rate and number of bits.

5. When making a dub from an existing tape, CD or other recording, don't use a microphone. Instead, connect the line output of the playback machine to the line input of your recorder.

6. When shooting a musical performance, plan to record fairly long takes. Unlike a lecture that can be cut into short segments and spliced together, musical performance sound must be relatively continuous. The camera should get a number of cutaways that can be used to bridge various sections or tie together takes from different performances. Shooting with more than one camera helps ensure that you will have sufficient coverage. For cutaways, get some neutral shots that don't show fingering or specific hand positions.

7. If you plan to use music in your movie, you should be familiar with music copyright laws (see Chapter 18).

Music Videos

Music videos present some challenges to the sound recordist. Generally, the band will have already recorded the new song for the video, and it will be made available to you on tape, CD or other format. During the shooting of the video, the band will lip-sync (sing) along with the song. The recordist is usually responsible for playing back the song. It's a good idea to record a scratch track on the set, which will help in syncing the footage to the song, and will capture any on-set banter or other sound that may be wanted by the director.

Shooting a music video with video cameras is fairly straightforward. As long as the playback is on a stable, speed-controlled format such as DAT or other time-coded media, sync should not be a problem. The singers' mouth movements captured on video should match up to the song in postproduction. Some video

cameras may drift slightly in speed. A timecode or sync generator may be used to keep the audio playback and the camera locked together. Even without it, if shots are kept relatively short, they probably won't reveal noticeable sync drift.

Shooting with a film camera for NTSC video release can be somewhat trickier. If the camera is run at the usual 24 fps, the picture will not hold sync with the song during editing. This is because the picture will be pulled down in speed by .1 percent during the film-to-video transfer (see Chapter 17). Compared to the master recording of the song, the singers on video will be moving their lips .1 percent too slow. One way to solve this is to run the camera at 23.976 fps or 29.97 fps. Shooting at 29.97 uses 25 percent more film.

Another solution is to shoot at standard 24 fps and *pull up* the music playback by .1 percent on the set. There are several digital and analog machines that can be set to play exactly .1 percent fast.[4] The lip-sync singing is then done to the speeded-up song, but when the footage is transferred to video, it will drop down to the speed of the original song. Always consult with the transfer house or other professionals before shooting.

Recording Narration

Narration (voice-over) should generally be recorded in a sound studio in a soundproof booth, since background sound in the narration can cause major problems. Any noise in the recording will be especially noticeable in the movie as the narration cuts in and out. For a low-budget production, or if you have to record on location, you can try building a tent with sound blankets and grip stands to try to isolate the narrator. Set the tent as far from windows and outside noise (like airplanes) as possible (basements sometimes work best).

Many people like the warm, full sound of a large-diaphragm studio mic like a Neumann U87 or U89. Use a good windscreen to avoid breath popping. For more on narration see p. 353.

Recording Sound Effects

Sound effects (*SFX*) are nonmusical, nonspeech sounds from the environment. The sounds of cars, planes, crowds and dripping water are all considered effects. Effects usually have to be recorded individually. Do not expect to get a good recording of effects during scenes that involve dialogue. An effect may be difficult to record well either because of practicalities (positioning yourself near a jet in flight, for example) or because it does not sound the way the audience has come to expect it (for example, your recording of a running brook may sound more like a running shower). It is often better to purchase prerecorded effects from a sound library or mix studio (see Chapter 15) or to try to simulate an effect (crinkling cellophane to produce "fire" sounds, for instance).

[4]An excellent resource on timecode and speed issues for music videos and many other situations is Wolf Seeburg's *Sync Sound with the New Media* (see Bibliography).

OTHER RECORDING ISSUES

Bass Filters

Many recorders and microphones are equipped with filters that reduce the level of low-frequency sounds. These filters are variously called *bass cut, bass roll-off, high pass* and *low-frequency attenuation (LFA)*. Some filters cut off bass fairly sharply at some frequency, say 100 Hz. Others roll off low frequencies more gradually, often diminishing them 12 dB per octave; thus the filter might reduce 150 Hz somewhat, 75 Hz quite a bit and 37 Hz almost entirely.

Filtering, also called *equalization*, is done to minimize the low-frequency rumble caused by such things as wind, traffic or machinery and microphone handling noise. The low-frequency component of these sounds is disturbing to the listener and can distort higher-frequency sounds. If low-frequency sounds are very loud, the recording level must be kept low to avoid overrecording, and this lowers the quality of the sounds that are more important (such as speech).

Microphones and recorders may have a two- or three-position bass roll-off switch. The first position (sometimes labeled "music" or "M") provides a relatively flat frequency response with no bass filtering. The next position ("voice" or "V") provides filtering below a certain frequency. If there is a third position, it rolls off bass starting at an even higher frequency (see Fig. 9-13). Do test recordings with the filter to judge its effect. On some mics, the "M" position is optimal for most recording, and the "V" position should be used only for excessive rumble or when the mic is very close to someone speaking. Sometimes the third position removes so much of the low end that recordings sound very thin and hollow.

There are two schools of thought on filtering bass: one is to filter liberally in the original recording, the other is to hold off as much as possible until postproduction. The first school argues that the low frequencies will be filtered out eventually, and a better recording can be made if this is done sooner rather than later. This must be weighed against the fact that frequencies rolled off in the original recording may not be replaceable later. The sound studio is a better environment in which to judge how much bass needs to be removed.

A prudent approach is to filter bass only when excessive rumble requires it or when trying to compensate for a microphone that is overly sensitive to low frequencies, to wind or to handling noise. Then filter only slightly—perhaps at the second position on a three-position roll-off switch. If filtering is done, keep it consistent in the scene.

Multiple Microphones

There are many situations in which you may want to use more than one microphone. Typical examples are when recording two people who are not near each other, recording a musical group or recording a panel discussion. Many recorders have provisions for two microphone inputs, and some machines can record from microphone and line inputs simultaneously (mics can usually be fed into the line input with the proper preamplifier or matching transformer on the cable.) A mic mixer allows several mics to be fed into the recorder. Try to get microphones that

are well matched in terms of tone quality. Sometimes a filter can be used on one mic to make it sound more like another.

When recording with multiple mics, be careful to avoid *phase cancellation*. This occurs when the peak of a sound wave reaches one mic slightly before or after it reaches another mic, diminishing the strength and quality of the sound signal. In phase cancellation, the diaphragm of one mic is pushed by the sound pressure while the other mic is being pulled and the two signals cancel each other out. The rule of thumb for avoiding this is that the microphones should be at least three times farther from each other than the distance from each mic to its sound source (see Fig. 10-10). Directional microphones that are angled away from each other can often be placed closer together.

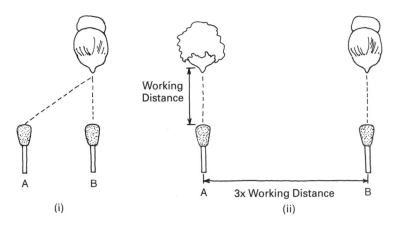

Fig. 10-10. Multiple microphones. (i) Distance from woman to microphone A is only slightly longer than distance to microphone B, leading to possible phase cancellation. (ii) Separation between microphones is three times the distance from each mic to its sound source. Now the distance between microphone A and the woman at right is sufficient to minimize the chance of phase cancellation. (Carol Keller)

Start with one mic and watch the level on a VU meter when you plug in the second mic—the strength of the sound signal should be increased, not decreased. Sometimes two microphones are wired differently, so that even if the mics are placed correctly, they cancel each other anyway. Also, when someone is *not* speaking, keep his mic level down to avoid unwanted noise; this is often difficult when recording unpredictable dialogue.

If the recorder has multiple tracks, this opens up various possibilities for multiple microphones. You can mix a boom mic with a lavalier (see p. 267). You can place two mics in different positions and choose whichever sounds best later. If different subjects have their own mics and recording channels, their lines of dialogue can be separated for editing and mixing purposes. Director Robert Altman developed a sixteen-track recording system fed by wireless microphones on individual actors, with each transmitter on a different frequency. With this system, the actors can freely improvise, and everyone's lines will be recorded well, something

that is almost impossible to do with only one mic. Phase cancellation can be avoided with multiple recording tracks, since the editor can choose the sound from one mic or another without trying to mix them together.

Stereo Recording

Most video and audio recorders have at least two tracks and are capable of recording in stereo. Some camcorders are equipped with dual built-in mics that give some stereo separation between the left and right sides.

Virtually every video and film format used for distribution has at least two channels for stereo sound; many have multiple surround channels as well (see The Mix, p. 467). However, it's important to make the distinction between *recording* on location in stereo and *releasing* the finished movie in stereo. For very many projects, dialogue scenes and the like are recorded in *mono*, even if those scenes will ultimately appear in a stereo sound track in the finished movie. A mono recording is made with one microphone (or more) on *one* audio track. It is very easy during postproduction to place a "mono" sound either on the left or right side to create a stereo effect if needed.

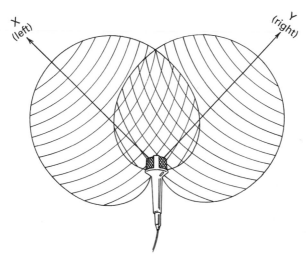

Fig. 10-11. Pickup pattern of a stereo mic in the X-Y configuration. Shown here, the two mic capsules are in one body. (Robert Brun)

Nevertheless, there are times when stereo recording is desired either for the entire production or for specific types of sound such as music, effects or wide shots (perhaps to capture the sound of a horse moving from one side of the screen to the other).

There are various techniques for recording stereo. Stereo mics built into camcorders usually employ the *X-Y* method (see Fig. 10-11). This uses two cardioid mics each pointed 45° to the side (the two mic capsules may be in the same housing). The X-Y method is straightforward and simple, though when the two mics

are separate—that is, not in the same case—mounting and controlling them must be done with care. It can sometimes be difficult to get the proper balance between the left and right side.

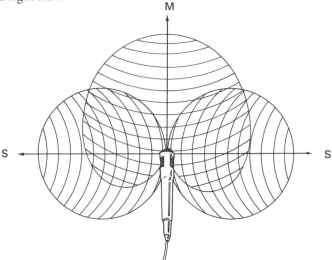

Fig. 10-12. Pickup pattern of a stereo mic in the M-S configuration. Shown here, the two mic capsules are in one body. (Robert Brun)

Fig. 10-13. Shure VP88 microphone. Versatile mic that can output a M-S signal or can be switched internally to provide a stereo (X-Y) output with a choice between low, medium or high stereo effect. Comes with a splitter cable for outputting the two channels. Use both output connectors for M-S or stereo output, or use just one in the M-S mode to record a mono signal from the cardioid capsule or the figure-eight capsule. (Shure Brothers, Inc.)

Some people prefer the *M-S* (*Mid-Side*) method. This also employs two mics: one with a cardioid pickup pattern and one with a figure-eight pattern (see Fig. 10-12). Mics like the Shure VP-88 have both mics built into a single housing. The cardioid mic picks up sound from the front and the figure-eight mic gets the left and right side image; each mic is sent to a separate track on the audio or video recorder. Later, the two tracks are "matrixed" through an M-S decoder to create the standard two-channel stereo effect.

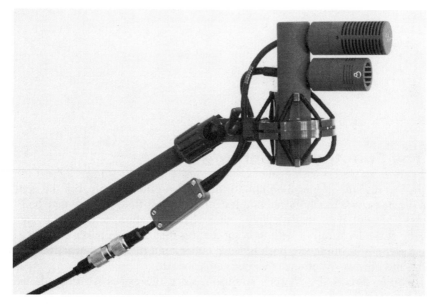

Fig. 10-14. Schoeps M-S setup showing separate cardioid and figure-eight mics that can be combined (matrixed) to create stereo. Shoeps makes very high quality professional mics. (Posthorn Recordings, NY)

If you keep the M and S tracks separate throughout the editing process, you will have a lot of flexibility in the mix, because you can then adjust the relative balance of the mid, left and right sound images, and you can easily isolate the mono signal from directly in front if needed. However, by doing so, you won't be able to hear the stereo effect until after you're done editing (unless you have an M-S decoder in the editing room). Some M-S mics (like the VP-88) allow you to output an X-Y (left-right) signal if you prefer; on some you can even choose how "wide" the stereo pattern is.

Lighting | CHAPTER 11

The Function of Lighting

Everything we do with cameras and lenses is about capturing light. Light is needed to register an image on film, or on a video camera's chip, but the lighting in a movie plays a much more complex role than just that. A scene may be lit by nature (the sun), with *available light* (using whatever natural or man-made light is already at the location) or with lighting fixtures that the filmmaker controls. The way a scene is lit influences both how we understand the scene—what we can see in it—and how we experience the scene emotionally.

Lighting directs the viewer's attention, since the eye is naturally drawn to bright areas of the frame. Lighting gives the audience cues about the time of day and season that a scene takes place. The angle from which light strikes an object or a face affects how we see shapes and textures. Side lighting casts shadows that emphasize depth, dimension and surface texture, while frontal lighting tends to flatten, compress and smooth over features.

Qualities of light have a powerful effect on the mood of a scene. Painters are often celebrated for the way they manipulate light and create particular moods. Andrew Wyeth, for example, evokes the gray, quiet feeling of the Maine landscape with extremely flat and even illumination. Rembrandt creates a much more dramatic effect by using a "chiaroscuro" style, in which pools of light and shadow are used to obscure as much as they reveal of a subject. Think of the qualities of light over the course of a day. A bright morning sun can feel cheery and safe, while a moonless night evokes mystery or tension.

On feature films, lighting is usually a top priority. The actors and sets must look their best and the mood of the scene must be right. Lights are positioned carefully, consuming much time and expense. The director of photography is usually responsible for the lighting design, which is as important as his or her mastery of cameras and lenses.

In documentary production, light is sometimes a low priority, thought of less for its mood than for its exposure value. In some cases there's just no time for care-

ful lighting. But sometimes good lighting takes no more time than bad. It may be as simple as using available light smartly.

In all productions, one of the key concerns is controlling contrast. Most natural and available light situations have a range of brightness that exceeds the film or video camera's ability to capture it. Often, lighting equipment is needed to make shadows less dark, or highlights less bright.

In the ongoing debate over which looks better, film or video, lighting often plays an important role. Because film is more expensive, people tend to do better lighting on film shoots. If the same care is used on video shoots, the difference between video and film is much less pronounced.

This chapter is written for film- and videomakers who may be working with a large crew or alone. For simplicity's sake, we'll refer to the person doing the lighting as the DP (director of photography).

LIGHT

Look at a painting, photograph or a scene in a movie that you think has interesting light. How is the painter or photographer achieving that effect? Start by identifying the light sources (you may not be able to see the source itself, just the light it produces). Examine each source for these factors that contribute to its effect in the scene:

1. What kind of shadow does it cast (crisp or diffuse)?
2. What angle is it coming from?
3. How bright is it (its intensity)?
4. How bright is it relative to other lights (the lighting contrast)?
5. What color is it?

When you're ready to shoot a scene, ask the same questions about the light sources. At times, you may specifically check, say, the angle or intensity of a given light. But at other times you will look at things more instinctively, evaluating the overall "feel" of the lighting but keeping these factors in the back of your mind.

Qualities of Light

The *hardness* of light is a way to describe the type of shadow it casts. *Hard light*, also called *specular light*, like direct sunlight on a clear day, is made up of parallel rays that produce clean, hard shadows that neatly outline the shapes of objects. Hard light is crisp and can sometimes feel harsh.

Soft, or *diffuse*, light is less directional. It is made up of rays going in many different directions and produces much softer, gentler shadows. The light on a hazy or overcast day is soft. It emanates from all parts of the sky at once. If it casts shadows at all, they are dull and indistinct.

Hard light can be produced artificially with *lensed* or focused lamps that emit a clearly directed beam. The spotlights used to single out a performer on stage are

extremely hard. The light from a car headlight is quite hard. Hard light can be created with a fairly compact lighting fixture.

Fig. 11-1. The relatively parallel rays of hard light cast a clear shadow (top). The scattered, more random rays of soft light cast a diffuse shadow (bottom). (Carol Keller)

Because hard light casts very distinct shadows, it is used to delineate shapes. It brings out surface textures and can cast dramatic, sculpted shadows. The classic Hollywood look of the 1940s is based on fairly hard sources. In a less flattering use of hard light, news photographers often use a simple, hard light that creates sharp shadows across the face.

Soft light sources produce a broad and even glow, not a beam of light. Soft sources are usually *indirect*; that is, the light from the bulb is first *bounced* off a white or silvery surface before striking the subject. In a classic umbrella light (see Fig. 11-11), the bulb shines into the umbrella, which reflects back a wide, diffuse pattern of light. To soften the light from any bulb, we need to spread the light out and disrupt the parallel rays. Another way to soften light is to put some type of translucent material between the source and the subject, which is not unlike what a typical cloth lampshade does on a household fixture.

Soft light is relatively gentle and tends to smooth out features and textures. Traditionally, female actors are lit with soft light to disguise any facial wrinkles or imperfections. A single soft light off to the side can provide delicate modeling of curved surfaces such as the face, because of the way it "wraps around" the curve with gradual shading (hard lights produce shadows that are more sharp-edged). Some people feel that soft lighting is more "natural." This is true in some situations; for example, window light is often fairly soft and may cast gentle, soft shadows. On the other hand, direct sunlight streaming through a window is usually quite hard and casts hard, crisp shadows.

(i) (ii)

(iii) (iv)

Fig. 11-2. Directionality of light. The woman is predominantly lit by one light. (i) Full frontal light. (ii) Three-quarter front light. (iii) Side light. (iv) Backlight or kicker. (Ted Spagna)

Directionality

As noted above, the direction or angle from which light strikes the subject influences how the subject appears on screen. Light coming from the general direction of the camera is called *front light*. *Front axial light* comes from very near the camera's lens; its shadows are mostly not visible from the camera position. Camera-mounted fixtures, such as those used for flash photography, provide front light, which illuminates all the visible surfaces of the subject. Full frontal lighting can be fairly harsh and usually uninteresting, since dimensionality and surface texture are minimized. However, the flattening effect may be desired. Fashion

models are often photographed with very frontal light, which makes their faces seem flawless and without dimension.

You can think of full frontal lighting as projecting from the number 6 on a clock face whose center is the subject. (Think of the camera as also positioned at the number 6.) *Offset* (the light at number 5 or 7) and *three quarter front light* (around 4:30 or 7:30) can be used for portraiture when more shadowing is desired.

Full side light (around 3 or 9) provides good modeling and indication of texture (since texture is revealed by the pattern of tiny individual shadows visible from the camera position). Side light can be quite dramatic. It produces shadows that fall clearly across the frame and distinctly reveal the depth of various objects in space.

Backlight originates from behind (and, in studio lighting, usually above) the subject. It tends to outline the subject's shape and to differentiate it from the background. Backlight can produce a bright edge or halo on a subject's hair and shoulders. When backlight predominates, called *contre-jour*, it can create a moody and romantic effect. If the background is bright and no light falls on the camera side of the subject, the subject will be in *silhouette*.

Fig. 11-3. The single candle produces fairly hard light (note the crisp shadows) and a very low-key lighting scheme with no fill illumination and deep shadows. (*The Penitent Magdalen* by Georges de La Tour, The Metropolitan Museum of Art, Gift of Mr. & Mrs. Charles Wrightsman, 1978)

We are also concerned with the *vertical* angle of light—that is, the height from which it strikes the subject. *Top light*, which shines down from directly above the subject, can make deep shadows in eye sockets. Gordon Willis used toplight in *The Godfather* to cast menacing shadows in Marlon Brando's eyes. Top light can also make landscapes seem more two-dimensional, since few shadows are visible (think of sunlight at noon on a bright day). Most film lighting is done with the key lights angled about 40° from the floor or slightly higher for the best modeling without casting excessive shadows. *Underlighting*, in which the light comes up from below the subject and casts shadows upward, occurs rarely in nature and is used in horror films to lend a ghoulish look to faces.

Lighting Contrast

Much of the mood or atmosphere of a lighting scheme is determined by the *lighting contrast*—that is, the relationship in light intensity between the brightly lit areas and the shadow areas. With great lighting contrast, there is a great difference in intensity between the bright areas and the deep shadows. With low lighting contrast (often achieved by using secondary lights to fill in the shadows), the lighting appears fairly flat and uniform throughout the frame. The degree of lighting contrast is often expressed numerically in terms of the *lighting contrast ratio* (see p. 337). Lighting contrast results from the relationship of the *key light* (which casts the primary shadows) and the *fill light* (which fills in the key's shadows). See below for more on these terms.

Fig. 11-4. Light from the large window is fairly soft (note gentle shadow angled downward from windowsill). The lighting scheme is relatively high-key, but would be more so if stronger fill light were added from the right side of the frame. (*Young Woman with a Water Jug* by Vermeer, The Metropolitan Museum of Art, Gift of Henry G. Marquand, 1889)

A *low-key* lighting design has high lighting contrast and a Rembrandt-like look, with dark shadow areas predominating over light areas. Low-key lighting is associated with night, emotion, tension, tragedy and mystery. Film-noir movies, as well as *Citizen Kane*, are lit in moody low-key lighting; the dramatic feel of the lighting is well suited to the black-and-white image. With *high-key lighting*, the lighting contrast is low and bright tones predominate, making everything appear bright and cheery. High-key lighting is used for daytime scenes, comedy and most studio television shows. In a high-key lighting scheme, the light is evenly distributed around the set, making it useful for situations in which several cameras are shooting simultaneously from different angles or when an actor must be able to move freely around the set without walking into deep shadows.

The terms *high key* and *low key* are sometimes confusing, since the key light is actually lower in intensity relative to the fill light in high-key lighting designs. One way to distinguish the terms is to remember that actors in comedies are usually high-key personality types.

LIGHTING EQUIPMENT

Lighting equipment may be owned by the filmmaker, production company or school, or it may be rented for individual shoots. Often the DP assembles a *lighting package* from a rental house according to the needs of each production or day's work.

Lighting Fixtures and Light Intensity

In the world of movie lighting, a lighting fixture may be called a *lighting unit*, *instrument*, *head* or *luminaire*. The bulb is referred to as a *lamp* or *globe;* changing a bulb is *relamping*. Lighting units are identified by type and power consumption. A 5K spot is a 5000-watt (5-kilowatt) spotlight. Lights are balanced for tungsten (3200°K) unless stated otherwise. Do not confuse degrees Kelvin with use of "K" that indicates wattage.

On the set you'll find many names used for various pieces of equipment; some are based on manufacturers' names, others are nicknames used in different parts of the country or in different countries.

The brightness of a light bulb is usually discussed in terms of wattage. *Wattage* is actually a measure of how much electric power is used (see Location Lighting, p. 343); some bulbs and fixtures put out more light than others for the same power consumption (that is, they are more efficient). In the case of two lights that employ the same type of bulb in the same fixture, a doubling of wattage implies a doubling of light output.

With the exception of certain focusing lighting fixtures, the intensity of illumination decreases the farther the subject is from a light. This is known as light *falloff.* The rule for typical open bulbs is that the falloff in intensity is inversely proportional to the *square* of the distance (see Fig. 11-5). Thus, moving an object *twice* as far from a lamp results in it being lit by *one quarter* the amount of light. Because of this, falloff is especially sharp when you are *near* the light source. Imagine

Fig. 11-5. The inverse square law. (1) Light falls off rapidly as you move away from the source: Moth B is twice as far from the candle as Moth A but receives one quarter the amount of light. Moth C is three times farther from the candle than moth A and receives one ninth the amount of light. (2) Light falloff is less severe when you are farther from the source: Moving from B to C is the same distance as moving from A to B, but the light falloff is much less (it falls off to about half the previous level instead of to one quarter). (Carol Keller)

a couch lit by a floor lamp at one end of the couch. A person sitting near the lamp could be lit four times as brightly as the person sitting next to him (an exposure difference of two stops). For even illumination, lights should be kept far away from the subjects so that slight changes in distance do not cause large changes in exposure. Soft light sources fall off more sharply than focused, hard light sources.

BULBS

Bulbs differ in the type and color of light they emit. If you're unfamiliar with color temperature and its use in film and video, see Chapter 5. Further discussion of white balance and video cameras is on p. 171.

Household Bulbs and Photo Bulbs

Common household incandescent bulbs can be used with video cameras as long as the camera can get a good white balance. They can also be used for black-and-white film shoots. Their color temperature, however, is about 2900°K, so the light they produce looks yellow-orange instead of white on tungsten-balanced color film. Sometimes professional 3200°K lighting units are used for the primary illumination for a film or video shoot, and household bulbs are used in a table lamp or other practical fixture (see Lighting Styles, p. 327). In this case, though the household bulb may look orange relative to the movie lights, it may seem natural in the scene.

Photo bulbs are available that use tungsten filaments similar to those in household bulbs, but the light emitted is designed to match tungsten-balanced film. Both 3200°K and 3400°K versions are available. A bluer, "daylight-balanced" version (rated at 4800°K) can also be purchased.

Photo bulbs may be either *photofloods* or *reflector floods*. Photofloods look just like household incandescent bulbs. Reflector floods are mushroom-shaped with

a built-in reflecting surface that projects a more directed beam of light (see Fig. 11-14). The R-40 is a commonly used reflector flood. Photo bulbs are the least expensive kind of artificial lighting for film, and they can be used with many home and amateur fixtures. They become very hot, however, and should only be used with fixtures that allow good upward ventilation. They are not very bright compared to other types of bulbs (about 1000 watts maximum) and their life span is short (often as little as 5 or 6 hours). After a few hours, photo bulbs darken from internal deposits, diminishing both the brightness and the color temperature, which may result in a reddish color cast.

Tungsten-Halogen Bulbs

Also called just *tungsten* or *quartz*, these bulbs employ a tungsten filament surrounded by halogen gas encased in a quartz glass bulb (see Fig. 11-9). Tungsten-halogen bulbs are the most commonly used bulbs for professional lighting instruments. The standard "tungsten" lighting unit is assumed to have a tungsten-halogen bulb rated at 3200°K. Tungsten bulbs are far smaller and more efficient than photo bulbs. The brightest ones are rated at about 20,000 watts. Unlike photo bulbs, they burn for hundreds of hours, do not diminish in brightness or color temperature over their life span and are more resistant to breakage during transport. Tungsten bulbs become very hot and are mostly used in heavy-duty fixtures for maximum safety and control. However, there are screw-in bulbs that can be fitted in well-ventilated household fixtures. Finger grease damages quartz glass, so use gloves or paper when handling the bulb. If the glass is touched, wipe it with alcohol. Carry a metal clamp for removing hot bulbs. Since quartz bulbs can explode, never turn one on when you or anyone else is directly in front of the fixture.

As noted above, tungsten bulbs are rated at 3200°K for use with tungsten-balanced film. These bulbs, and any other tungsten-balanced source, can be raised in

Fig. 11-6. Arri HMI lights with ballast units. HMIs are an efficient source of daylight balanced illumination. (Arriflex Corporation)

color temperature to better match daylight illumination with a blue *dichroic filter* or with blue gel material (see p. 325). This normally cuts the light's output by about half.

HMI Bulbs

Halogen-Metal-Iodide bulbs are an efficient lighting source that produces daylight-balanced illumination (5600°K or 6000°K). They put out three to four times as much light as tungsten-halogen bulbs for the same amount of electric power used. This improved efficiency means that bright lights can be run off a smaller power supply, possibly avoiding the need for special power lines or generators. Trying to match daylight with a tungsten source requires filters that cut out half the light; HMIs are far more efficient for daylight applications. HMIs also give off less heat than tungsten lights, which makes them more popular with actors and crews.

HMIs are generally operated using AC power (wall current) and require a heavy *ballast unit* to control the electricity going to the lamp. Most HMIs produce a pulsed light that seems continuous to the eye, but may result in flicker in the film or video image if used improperly.[1] To avoid flicker, the light pulses must be evenly distributed on each video or film frame. These are the guidelines:

1. Use a crystal-controlled camera. All video cameras and most sync-sound film cameras are crystal controlled.
2. Use a very stable power supply. In most technically advanced countries, the frequency of AC current is very stable. Care must be taken when using generators (use a crystal-controlled generator) or when shooting in the third world.
3. For film cameras, use a frame rate that is divisible into twice the AC frequency. Thus, in the United States and other countries where the AC power is at 60 Hz, a frame rate of 12, 15, 20, 24, 30, 40, or 60 can be used. At 24 fps, shutter angles from 60° to 200° will work fine, but a shutter angle of 144° allows for the *maximum variation* if camera or power is slightly off speed. In countries with 50 Hz power, you can film at 10, 12.5, 16.666, 20, 25, 33.3 or 50 fps without danger of flicker. In these countries, a camera run at 25 fps can use any shutter angle. A camera run at 24 fps can avoid flicker by using a 172.8° shutter.
4. For video cameras, when shooting in 60 Hz countries, a standard NTSC video camera at 30 fps can be used without flicker. In countries with 50 Hz power, PAL video cameras run at 25 fps should be flicker free.

These principles apply to all AC discharge lamps, including some fluorescent tubes (see below), HMI, CSI, sodium vapor and mercury vapor lamps (the latter two are often found in sports stadiums and parking lots; they may require special filtering for color balance).

If you need to shoot at other frame rates, there are *flicker-free ballasts* available that allow filming up to 10,000 fps. These may produce a high whistling sound in some settings.

Some HMIs can be powered by a battery. A 200-watt HMI puts out nearly as much light as a 1K tungsten unit.

[1] *Flicker* means that some frames are lit more brightly than others.

Fluorescent Bulbs

Fluorescent lighting falls into two categories: standard fluorescent fixtures typically found in office and institutional settings, and specially designed fluorescent lighting units for film and video work.

CONVENTIONAL FLUORESCENT LIGHTS. Standard fluorescent lighting fixtures are usually undesirable for film and video, but they may be unavoidable. The spectrum of light from standard fluorescent tubes is discontinuous and matches neither tungsten nor daylight illumination. There are several types of fluorescent tubes available (daylight, cool white, warm white) that vary in color. Daylight and cool white tubes may produce an unpleasant blue-green color cast. As long as all tubes in a scene are the same type fluorescent, most video cameras can achieve an acceptable white balance (you may want to experiment with the "daylight" position on the white balance control). Film cameras can be used with filters on the lights or the camera to improve color rendition, such as using an 85 filter or FLB for tungsten films or FLD for daylight-balanced films. With many color film stocks, acceptable color balance can be achieved in the lab even if *no* filters were used. It is better to get a good exposure with no filter than to be forced to underexpose with a filter.

Fluorescent lighting causes similar but less severe flicker problems than HMIs (see above). Standard film and video frame rates of 24, 25 and 30 fps are fine. (In the United States and other 60 Hz countries, the rule of thumb is simply not to use shutter speeds faster than ⅟₆₀ second; it is usually not necessary to have a crystal-controlled camera.)

Mixing fluorescents with other sources of light can cause problems (see Mixed Fluorescent Light, p. 342) Fluorescent fixtures at workplaces often shine straight down, resulting in overexposed hair and deep eye and nose shadows. Many DPs choose, whenever possible, to replace standard fluorescents with color-balanced tubes (see below) or to turn off the fluorescents altogether and relight with some other source. When shooting in supermarkets and other settings in which it is impractical to either turn off *or* replace existing tubes, a DP will sometimes use a professional fill light fixture that uses the *same* tubes, to at least maintain consistency.

FLUORESCENTS FOR FILM AND VIDEO. There are fluorescent lighting units available that overcome the problems mentioned above. A wide range of fixtures are made by Kino Flo using high-frequency ballasts that are flicker free and avoid the humming noise of standard ballasts. The KF55 tube is daylight-balanced at 5500°K and the KF32 is tungsten-balanced. Other manufacturers make fluorescent units as well. Banks of fluorescents can be used as key or fill lights. The light output is bright, soft and very even. Individual tubes—sometimes very small ones—can be used for out-of-the way spots or built into a set.

There are also fluorescent tubes available that can be used with conventional fixtures but produce a true color that reads correctly with either film or video. The Optima 32 bulb is tungsten-balanced and the Vita-lite and Chroma 50 tubes are daylight-balanced. When shooting in an office or other institutional setting, a movie crew will often replace the existing tubes with these bulbs.

Fig. 11-7. Kino Flo high-output, flicker-free fluorescent lights are available in true tungsten or daylight balance. (Kino Flo, Inc.)

TYPES OF LIGHTING INSTRUMENTS

Lensed Spotlights

The most controllable kind of lighting unit is a focusing spotlight. Some spots have a Fresnel lens (silent *s*, pronounced "freh-NEL") in front of the bulb (see Fig. 11-8). These lights emit focused, parallel rays of light that do not spread out much or diffuse over distance. Most spotlights are focusable, which means the bulb can be moved back and forth relative to the reflector or lens to produce either a hard, narrowly directed beam of light (*spot* position) or a wider, more diffuse, less intense beam (*flood* position). These, like most other movie lights, have a set of adjustable baffles called *barndoors*, which are used to block the beam from going where you don't want it.

Mole-Richardson makes a widely used line of studio equipment and you should learn Mole's names: a 5K lensed spotlight is a *senior*, while the 2K is a *junior* and the 1K is a *baby* spot. A *baby junior* is a 2K in a small housing. A *tweenie* has a 650-watt bulb and a *mini* or *tiny* is only 200 watts.

Focusing, lensed spotlights are versatile and very controllable and are used extensively on typical movie sets. They may also be used on location shoots, particularly when the production is supported by a truck and a larger crew. However, lensed units may be too heavy for a documentary being done with a small crew or

Fig. 11-8. LTM Pepper Fresnel. Compact, focusing lensed spotlight. Note Fresnel lens. (Fletcher Chicago/LTM)

involving a lot of travel. Some documentary DPs carry one or two lensed units and use mostly open-faced lights (see below).

Open-Faced Spotlights

Open-faced spotlights have no lens in front of the bulb. These are lighter and cheaper than Fresnel units and are often used on location and small-scale filming. While these nonlensed instruments can be focused by moving the bulb from spot to flood positions, they are less controllable or "cutable" than lensed units (because the beam is not as sharp-edged), and the quality of light is not as hard.

Open-faced lights have various names. Mole's 1K is a *mickey*, Ianero's is a *redhead*. A 2K may be a *mighty* or a *blonde*. Lowel's open-faced spots include the *omni-light* (maximum 500W) and the *DP light* (maximum 1K).

Nonfocusing Lights

There are a variety of lights that are not focusable. Some have lenses, some do not.

PAR lamps (for *Parabolic Aluminized Reflector*) are *sealed beam* lights that look like automobile headlights. PAR lights are available with different fixed lenses; some project a very narrow beam over great distances, others have a wider pattern. PARs may be used singly or in groups—typically, a grid of 2 × 3 or 3 × 3 lights on a frame (called *six lights* and *nine lights*, respectively). PARs put out a lot of light, and they can be used to simulate or augment sunlight, but they can be hard to control. *FAY* bulbs are PARs that incorporate a dichroic filter to produce daylight-balanced illumination. There are also HMIs in sealed-beam configuration.

Fig. 11-9. Colortran Mini Pro 650-watt (maximum) open spot with hand grip. The quartz bulb is clearly visible. (Colortran, Inc.)

Fig. 11-10. Broad. Bardwell & McAlister 1000-watt Mini-Mac with four-leaf barndoor. Note the tubular bulb. (Bardwell & McAlister, Inc.)

There are several types of nonfocusing, open-faced floodlights. *Scoops* are dish-shaped floodlights. *Broads* are rectangular and have a long tube-shaped bulb (see Fig. 11-10). Floodlights are sometimes used on the set as fill lights or to provide even illumination over a broad area. They are sometimes hard to work with because the light tends to "spill" where you don't want it.

Fig. 11-11. Soft lights. Lowel collapsible soft light (left). Umbrella reflectors (right). (Lowel Light Mfg., Inc.)

Soft Lights and Reflectors

The relatively hard light produced by a spot or a flood unit can be softened by placing some *diffusion* material in front of the unit. Diffusion spreads the light, disrupts the hard parallel rays and cuts down the light's intensity. One of the most common types of diffusion is light fiberglass matting called *tough spun* or *spun* (for spun glass), which will not burn under the high heat of movie lights. There are many other types of professional diffusion, including translucent plastic sheets like Lee 216 White Diffusion and the slightly milder Opal Tough Frost made by Rosco. Rosco's *Soft Frost* looks a bit like shower curtain material; because it is flexible, it won't rattle in the wind like some other diffusion material. Most types of diffusion are available in various grades including full, ½ (medium) and ¼ (light). If placed far enough from the heat of the fixture, any number of materials can be used for diffusion, including thin cloth, silk or rolls of tracing paper.

To obtain softer lighting, the light from the bulb can be bounced off a white or silvery surface; the larger the surface and the farther it is from the bulb, the softer the light. A *soft light* is a large, scoop-shaped fixture that blocks all direct light from the bulb so that *only* bounced light escapes. Studio soft lights are quite bulky, but there are collapsible models available that pack easily for travel. These include collapsible light boxes such as Lowel's RIFA light or a Chimera soft box.

Soft lighting can also be created with a spot- or floodlight by bouncing the light off walls, ceilings or reflecting cards. *Foamcore sheets* are lightweight, rigid and make a versatile bounce board that can be easily cut and taped to walls or mounted on stands. White cardboard *show cards* are cheaper but are sometimes not rigid enough. Using foamcore or cards for fill lighting can be a good way to fill shadows from lights without creating new ones (see Fig. 11-25).

Fig. 11-12. Collapsible soft boxes produce very soft, very even illumination and are convenient for travel. Lowel Rifa Lights shown here. (Lowel Light Mfg., Inc.)

An extremely lightweight *space blanket* or a foil sheet can be taped shiny-side-out to make an excellent reflecting surface on a dark or colored wall, and it will protect the wall from burning. Another way to create soft light is to use a photographer's umbrella, which is silver or white on the inside. The lighting unit is mounted on the stem and is directed toward the inside of the umbrella. Umbrella reflectors fold to a compact size for traveling.

Generally, the reflecting surface should not have a color cast. However, sometimes a colored surface is used deliberately to create an effect. A reflector with a gold surface may be used to provide a warm fill light. Space blankets usually have a blue side that can be used to approximate daylight when bouncing tungsten lighting units.

Reflectors of various kinds are also used outdoors to redirect sunlight. This is

Fig. 11-13. A light source can be softened by bouncing it and/or by projecting it through diffusion material. Note that the xenon light source produces a very circular, focused, narrow beam of light. Shown here with Xeno Mirror reflector. (Matthews Studio Equipment, Inc.)

commonly done to fill shadows on a sunny day. Usually you can get much more punch from a reflector than from a powered lighting instrument and it takes no electricity. Smooth, silvered reflectors provide relatively hard light, while textured silver or white surfaces are softer. Collapsible, cloth reflectors such as the Flexfill are popular for location shoots. They fold into a small disc for travel, and open to a larger circle with one side white and the other silver or gold. On windy days, all reflectors must be carefully steadied or the intensity of light on the subject will fluctuate.

Fixtures for Photofloods and Reflector Floods

Lowel makes a versatile set of fixtures that can be used with R-40 reflector floods, photofloods or even standard household bulbs. The *Lowel-light System* comes with a set of adjustable sockets that can be clipped, hung or taped on just about anything. Barndoors (for blocking off unwanted light) can be clipped onto reflector floods. The whole kit (without bulbs) packs into a small box.

When a typical household table lamp is used on a movie set, it is called a *practical*. Practicals are often part of the set design. They may also be present in documentary shoots. When a photoflood or screw-in halogen light is used in a practical, be sure the fixture is rated for the wattage of the bulb and that there is adequate upward ventilation to prevent burning or melting.

Fig. 11-14. Lowel-light fixture shown with R40 reflector flood and two-leaf barndoor. These fixtures can be used for a handy, inexpensive location kit. (Lowel Light Mfg., Inc.)

Camera Lights and Handheld Lights

Camera-mounted lights are commonly used for home movies (for which they are called *movie lights*), news gathering (where they are often called *sun guns*) and feature films (where they may be called *obie lights, eye lights* or *bash lights*). A camera-mounted light is useful when the camera is moving because the unit moves with the camera and provides shadowless light on the subject. This shadowless light can be a blessing if it is filling the shadows cast by other, stronger lights. However, if it is the only light on the subject, it can be a curse, since full frontal lighting tends to be flat and harsh.

Sun guns (actually a trade name that gained wide use) are often handheld and powered by battery. Even a standard tungsten spotlight can sometimes be fitted with a 30-volt bulb and powered with 30-volt battery pack or belt. Some packs run for less than 10 minutes. One belt may run about 50 minutes with a 150-watt bulb, or 20 minutes with a 250-watt bulb. Lights and power packs vary in capacity, and most require several hours to recharge (see Battery Power, p. 182). When the batteries run down, light intensity and color temperature drop. Battery-powered lights are useful for scenes in cars; some can be run off the car battery using an adaptor.

When a scene is lit with only one small light, it's not easy to make the lighting pleasant. With a handheld light, it's probably best to position the light a few feet to the side of the camera. The harsh shadows can be softened with diffusion on the light, although this sacrifices brightness. Some DPs bounce handheld lights off

the ceiling or a wall, producing a very diffuse light. To maintain constant illumination, hold the unit steady. It's often best to have an assistant hold the light.

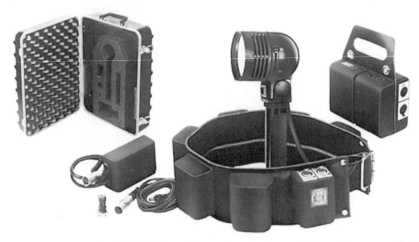

Fig. 11-15. Cine 60 handheld light with case, charger, battery belt and battery pack. This is a 100-watt, 12-volt system. (Cine 60)

Lighting Accessories

Spilled light, or just *spill*, is light usually from the edge of the beam that illuminates an area where you don't want it. Spill is primarily controlled with barndoors, which are adjustable flaps that mount on the front of the lighting instrument. Barndoors come in two- and four-leaf versions, the latter providing more control. They can be opened wide or closed down to produce a relatively narrow beam of light. An even narrower beam can be made with a *snoot*, which is a cylindrical baffle that fits over a spotlight.

Flags, which are also called *cutters* or *gobos*, are either rectangular metal cards, dark cloth on wire frames, or pieces of cardboard. They are often mounted on stands to cut off unwanted spill. The farther the flag is from the light, the sharper its shadow will be.

French flags are small cards on a flexible stem often mounted on the camera as an effective lens shade to block light spilling into the front of the lens (see Fig. 2-19). There is often a need to flag off a light *softly*, creating a gradual transition from light to dark rather than having a hard shadow line. This may be done with a *net*, which is a piece of very thin, dark netting often mounted on a three-sided frame. Nets come in single and double thicknesses and can be used in multiple layers for increased shadowing. Spill leaking from the back of a lighting unit can cause flare in the lens, or, if gels are being used, it can disrupt the lighting scheme with light of the wrong color. This spill can usually be blocked off with cards or flags. *Black wrap* is black aluminum foil that is very handy for controlling spill.

A *cucoloris* (usually called a *cookie* or *kook*) is a cutout piece of material placed in front of a light to cast a patterned shadow. Cookies are typically used to project the

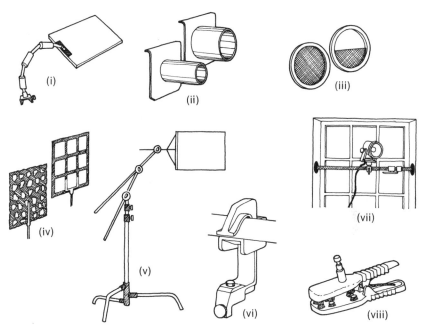

Fig. 11-16. Lighting accessories. (i) French flag. (ii) Snoots. (iii) Full scrim and half scrim. (iv) Cookies. (v) Century stand with three gobo heads and flag. (vi) Hanger for mounting on pipes or small beams. (vii) Polecat mounted in window well. (viii) Gator grip. (Representations are not drawn to same scale.) (Carol Keller)

shadow of a window frame or venetian blinds. By its color and angle, this simulation of window light can suggest a mood or indicate the time of day. Sometimes abstract, dappled patterns are used to break up uniform expanses of walls or floors or to create a transition zone between sunlit and shade areas. The shadow cast by any cookie or flag will be sharpest if it is placed closer to the subject than to the light and if the light source is hard.

There are many ways to reduce the intensity of a light. The simplest is perhaps just to move it farther from the subject. Nets can be used to shade or "feather" a light. *Silks* are white silk material mounted on frames like nets; they cut down the light while diffusing it somewhat (see Fig. 11-17).

Scrims are circular wire mesh screens that can be placed in front of a lighting unit, usually inside the barndoors, to reduce the intensity without changing the color temperature or the quality (hardness) of light. Inserting a scrim is the best way to reduce light intensity without changing anything else. A *single scrim* (usually indicated by a green frame) reduces the intensity about a half stop; a double scrim (red frame) cuts out a full stop. On a *half scrim*, half of the circle is left open. A half scrim can be used to solve the common problem that occurs when someone walks toward a light. Normally, as he approaches the light he will become brighter. To even out the illumination, raise the lighting unit fairly high above the subject and point it down at an angle. Use a half scrim to reduce the intensity of

the *bottom* of the light beam (which falls near the unit) without diminishing the *top* of the beam (which reaches into the distance). You could use a net or a silk to do the same thing (see Fig. 11-17). The word *scrim* also refers to a thin cloth used for diffusion.

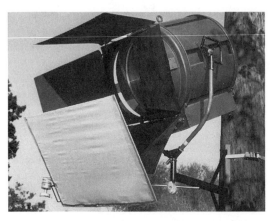

Fig. 11-17. A silk being used to cut the bottom half of the light beam; this evens out the illumination close to and far from the light. The light is attached to the telephone pole using a poultry bracket. (Matthews Studio Equipment, Inc.)

Studio lighting is sometimes dimmed with *shutters*, which act like venetian blinds. *Dimmers* are used in the home and in theatrical lighting to regulate light intensity. Dimmers lower the voltage going to the light, which not only makes the light dimmer, but usually results in the color temperature dropping as well (making tungsten lights more orange). There are some situations in which the lowered color temperature may seem natural (see Mixed Color Temperature Lighting, p. 341).

There are hundreds of devices for supporting lights and mounting them on various surfaces. Lights are usually supported by stands, which are collapsible for transport. *Century stands* (*C-stands*) have low-slung legs at different heights that allow several stands to be positioned close together. *Gobo heads* with multiple locking arms can be positioned in endless ways. An *alligator*, or *gator*, grip is a spring-loaded clip for attaching lights to doors, pipes and moldings. A *polecat* is like an expandable closet bar. A heavier-duty version is the *wall spreader*, which allows you to run a piece of lumber like a two-by-four between two walls. A polecat or a wall spreader can be used to hang lights near the ceiling without stands that might show in the scene. When shooting in offices or other rooms that have hung ceilings, a *scissors clip* allows you to mount lights right on the ceiling. A *wall plate* for mounting fixtures can be screwed or taped to vertical or horizontal surfaces.

Carrying several feet of opaque black fabric such as *duvetyn* ("doova-teen") can be very useful for creating limbo backgrounds, darkening a window or placing on a table for product shots.

Colored Filters and Gels

Dichroic filters, sometimes called *dikes*, are a special blue glass filter used to raise the color temperature of 3200°K tungsten sources to about 5500°K to match the color of daylight. These cut out about 50 percent of the light, reducing intensity by one stop. Dichroics are expensive, fragile, and must be fitted to a particular light.

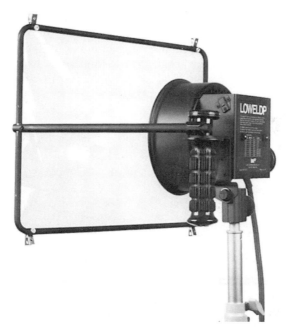

Fig. 11-18. Open spotlight with attached gel frame. (Lowel Light Mfg., Inc.)

A common way to change the color of light is to use *gels* (gelatine), which are made of flexible, transparent plastic that comes in small sheets and large rolls. Gels can be mounted on lights in *gel frames* or just attached to barndoors with clothespins.

CTO (*Color Temperature Orange*) gels are used to lower color temperature for converting daylight to tungsten-balanced light or otherwise warming a light source. *Sun 85* or ¾ CTO gels are roughly equivalent to an 85 camera filter (see Chapter 5) and are used to convert standard 5500°K daylight and HMI sources to tungsten. These filters cut out about ⅔ of a stop of light. Lee 204 and Rosco 3407 are full CTO gels which are slightly more orange and are used to convert skylight (6500°K) to tungsten.

CTB (*Color Temperature Blue*) gels are used to raise color temperature and make any source bluer. Some blue gels are referred to as *booster gels*, since they boost the color temperature. Rosco 3202 and Lee 201 are full CTB gels, used to bring a 3200°K tungsten source up to 5700°K daylight. These cut out about 1⅓ stops of light.

Gels can be purchased in full, ¾, ½, ¼ and ⅛ intensity versions, from deep color to pale, to make large or slight changes in color for precise matching of light sources. The deeper the color of the gel, the more it cuts down the light intensity.

Often the full CTB cuts out too much light, and a ¾ or ½ CTB is used instead, allowing a tungsten source to appear *slightly* yellow compared to daylight.

Gels are available in many other colors besides orange and blue. Sometimes the light from an HMI lamp seems *slightly* too blue; a ⅛ straw gel or a pale yellow may be used to "take the curse off" and warm the light a bit. There is a wide range of other colors for creating more theatrical effects.

Gels are also available in combination with neutral density (ND; see p. 160) or diffusion material. Blue Frost converts tungsten to daylight while adding diffusion—having both effects in one gel may prevent unneeded loss of light.

Gels should be replaced when heat from the lamp causes the center of the gel to become paler. Gels and the more rigid *acrylic filters* are often attached to windows to filter daylight (see Mixed Color Temperature Lighting, p. 341).

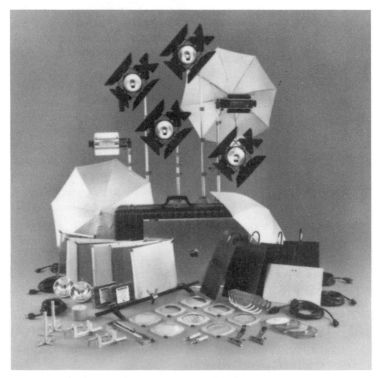

Fig. 11-19. Lowel Solo Kit. Location package includes two Omni-lights (650-watt maximum open-faced spots) and four Tota-lights (1000-watt maximum broads). Accessories include stands, flags with flexible stems, scrims, door/wall brackets, clamps, gel frames, reflector and umbrellas. Everything fits into the carrying case. (Lowel Light Mfg., Inc.)

Mounting Lights Safely

In close quarters a hot, falling light can do serious damage. Spread light-stand legs wide for maximum stability. Tape down light stands with *gaffer's tape* (a gray

fabric tape sold in equipment houses) or weigh them down with *sand* or *water bags*. Tape all power cables neatly to the floor or put mats over them in high traffic areas so no one will trip on them. Use plenty of good-quality gaffer's tape when you attach lights to a wall, and if you can, place lights where they will not strike anyone if they fall. Remember that tape loses its stickiness when hot. When possible, "safety" a hanging light by attaching a piece of *sash cord* or chain to a fixed point to catch the light if it drops off its mount. Gaffer's tape will often remove paint and wallpaper, so peel the tape back slowly as soon as possible after shooting to minimize damage.

LIGHTING TECHNIQUE

LIGHTING STYLES

Before beginning any movie that involves controlled lighting, decide on the lighting style you hope to achieve. The DP and director can look at movies, photographs and paintings for ideas.

Like everything else, lighting styles have evolved over the years. Black-and-white feature films of the 1930s and 1940s were usually lit in a highly stylized way. The goal was not "realistic" lighting, but something that would heighten the drama and the glamour. These films were shot on studio sets that often had no ceiling and only two or three walls. Lights mounted outside the set on overhead grids and elsewhere struck the actors from directions that would be impossible in a normal building interior.

In many feature films today, lighting is intended to be more "naturalistic"— that is, like the kind of light one would find in the real world. Many lights may be used, but the intent is to simulate the light that might normally occur in the filming space, whether it be from sunlight or man-made fixtures. One way to help give lighting a natural feel is to make sure that the chief light sources seem "motivated." Motivated lights are ones that seem to come from a logical source. For example, actual window light may be used for illumination, or lighting instruments may be set up near the windows to give the illusion that the light comes from the windows.

Often a few household fixtures are placed in a scene as practicals. These may actually light the subject or merely act as motivation for light from professional lighting instruments.

Even if the goal is naturalistic lighting, usually liberties can be taken to improve the lighting of faces or achieve particular effects. Of course, many movies do not seek realism at all, and lighting is used to create a dramatic, expressive ambience.

The sensitivity of film stocks and video cameras has improved, and it is increasingly possible to shoot indoors entirely with available light without introducing any special lighting equipment. This can be a real boon for documentaries (see below). For fiction films, ironically, it sometimes takes a lot of light to make a scene look really *unlit*, the way it does to the naked eye. For example, you may be able to shoot an interior scene with just window light, but this may result in the

windows being overexposed and the people appearing somewhat underexposed (see Fig. 4-23). To get a natural balance between the interior and exterior may require gels on the windows and/or a significant amount of light from inside (see Mixed Color Temperature Lighting, p. 341).

Documentary Lighting

Lighting a documentary can be tricky. You have to balance your desire for a certain style or look with the typical constraints of small crews, small lighting packages and short shooting schedules. Interviews can be lit fairly fast, but providing good lighting for an uncontrolled scene in which people move around a large space, either at work or at home, often takes more time and equipment. Sometimes large spaces are lit with a few lights bounced off the ceiling. This may give you enough light for exposure and is fairly even. However, this kind of light is flat and tends to be "toppy"—that is, coming from above and causing dark shadows in the eye sockets.

When shooting unscripted scenes of people living their lives, consider the effect the lights have on your subjects. If you are filming intimate scenes of family life and other potentially delicate moments, you want to do everything you can to minimize the disruption caused by the film crew. Bright lights can create an "on-the-set" feeling, and people under the lights may feel like they should "perform" when the lights go on. Also, since it's hard to light an entire house or location, the use of lights transforms some areas into filming spaces while others remain living space. All of this may disrupt the natural flow of life that you hope to capture. Sometimes you can mount a few lights on the wall or ceiling and basically leave them in place for the duration of a shoot, turning them on when needed. The less light you use, the more mobile and unobtrusive you can be. But this may come at some sacrifice to the image quality. For every scene, you must balance these concerns.

POSITIONING LIGHTS

A Basic Lighting Setup

A classic lighting technique is sometimes called *three-point lighting* because three basic lights are used to illuminate the subject: the key, fill and backlight. Each light has a particular function. Even if many lights are used to cover a large set, each light plays one of these three roles.

KEY LIGHT. The key is the brightest light and casts the primary shadows, giving a sense of directionality to the lighting. The key may be hard or soft; the harder the light, the bolder or harsher its shadows will be. The key's shadows must be watched carefully for the way they interact with the subject. The key light is usually placed somewhat off the camera-to-subject axis, high enough up so that the shadow of the subject's nose does not fall across the cheek but downward instead. This height helps ensure that body shadows will fall on the floor and not on nearby walls where they may be distracting.

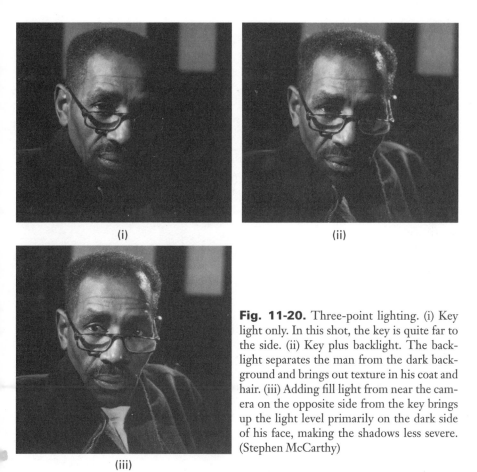

(i) (ii)

Fig. 11-20. Three-point lighting. (i) Key light only. In this shot, the key is quite far to the side. (ii) Key plus backlight. The backlight separates the man from the dark background and brings out texture in his coat and hair. (iii) Adding fill light from near the camera on the opposite side from the key brings up the light level primarily on the dark side of his face, making the shadows less severe. (Stephen McCarthy)

(iii)

FILL LIGHT. The main function of the fill light is to fill in the shadows produced by the key without casting distinct shadows of its own. Fill lighting is almost always softer than the key; it is usually created with a soft light fixture or a bounced spotlight. If the fill light emanates from a point close to the camera's lens and at the same level, its shadows will not be visible to the camera. The fill is generally placed on the opposite side of the camera from the key. Sometimes light is bounced off the wall or ceiling to provide flat, even fill over a broad area.

BACKLIGHT. Backlights (variants are called *hair*, *rim* or *edge* lights) are placed on the opposite side of the subject from the camera, high enough to be out of view. Backlight should generally be fairly hard, to produce highlights on the subject's hair. If a backlight is at about the same level as the subject and somewhat off to the side, it is called a *kicker*. Kickers illuminate the shoulders and the side of the face more than hair lights do. All backlights are used to give a bright outline to the subject, helping to separate the subject from the background and define shape.

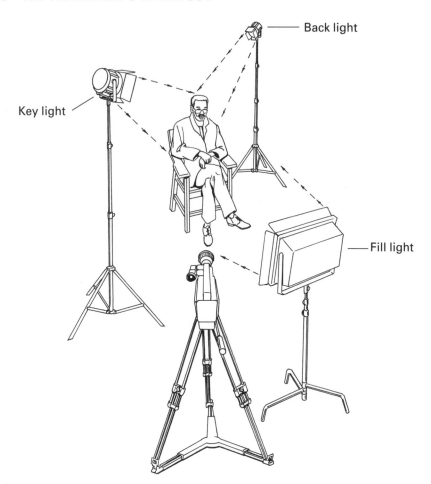

Back light

Key light

Fill light

Fig. 11-21. A three-point lighting setup, similar to the one used for Fig. 11-20. (Robert Brun)

SET LIGHT. In some situations, the key and fill lights adequately light the background. In others, a fourth basic type of light, the *set light*, is used to illuminate the background and selected objects. Sometimes parts of the set need to be given their own key, fill and/or backlights.

Lighting Faces

In medium and close shots that include people, the lighting on faces is extremely important. When lighting a set or location, if you know there will be significant close shots of people, the overall lighting should be designed to provide good facial lighting (even so, the lighting for wide shots will generally be tweaked or cheated somewhat when it comes time for close-ups). For the purposes of this discussion, let's assume you're lighting a single subject in a chair.

Fig. 11-22. Frontal facial lighting. Key is slightly offset to provide some modeling. Nose shadow falls near the "smile line" from the side of the nose to the corner of the mouth. Though the lighting is fairly flat, the background is dimly lit, and thus provides strong contrast with the foreground figure. (*Portrait of Jacques Louis Leblanc* by Ingres, The Metropolitan Museum of Art, Purchase, Wolfe Fund, 1918)

Start by positioning the key light alone, paying close attention to the shadows of the subject's nose and eye sockets. Every face is different; people with deep-set eyes and prominent noses will have more shadowing than those with flatter faces. The closer the key light is to the camera, the less shadowing there will be. Television news programs are often done with very frontal, flat lighting (see Fig. 11-2i). This is a functional lighting approach, and minimizes possibly objectionable shadows, but may be dull. If the key is brought around somewhat to the side (three quarter light), the face takes on more dimensionality (see Fig. 11-22). About 45° from the camera is considered fairly standard for the key position. In Fig. 11-20, the key is positioned quite far to the side (almost 90°) for a dramatic look. In this case, it is also fairly high to avoid reflections in the man's glasses.

Pay close attention to the way the eyes are lit. As the poet tells us, eyes are the windows to the soul. When you can't see the eyes, sometimes you feel like you can't see into the *person*. Generally, subjects face one side of the camera or the other. Often the lighting looks best if the subject is looking toward the light (thus,

Fig. 11-23. Far-side key. Key light positioned on far side of subject produces a rim of light on the nose and brings out skin texture. Virtually no fill light in scene creates a low-key dramatic look, which could be used for a nighttime scene. (*Portrait of Martin Baer* by Johan Hagemeyer, The Metropolitan Museum of Art. Gift of The Estate of Johan Hagemeyer, 1962)

if the subject is facing camera left, put the key light on the left side of the camera; see Fig. 11-24). This puts both eyes in the key light. If one eye is in shadow, the fill light can be used to bring up the illumination on that side (see below). Of course, you might choose to put one or both eyes in shadow to create a mysterious or spooky feel.

The key should generally be high enough so that the nose shadow falls down, not *across* the face (some DPs try to place the nose shadow on the "smile line," which extends from the nose to the corner of the mouth; see Fig. 11-22). The "standard" key is 45° above the subject.

More dramatic effects can be achieved by moving the key very far to the side. In Fig. 11-23, the subject looks off screen into a light that might be meant to suggest a distant window or lamp. Here, the key is actually coming from the far side of the subject. His nose is rim-lit with strong shadows falling across his face. This kind of look is well suited to a very low-key nighttime scene (see Special Lighting Effects, p. 342).

Fig. 11-24. Window-lit scene. Nearby window provides key light. Light reflected from the wall on the right provides fill on the dark side of the man's face. A splash of light on the back wall reinforces the sense of sunlight. (Stephen McCarthy)

Should the key light be hard or soft? It depends on how you want the audience to interpret the lighting. Direct sunlight is quite hard, indirect window light or the light of an overcast day is soft. You may like dramatic, crisp shadows or you may like a gentler look. Generally, *some* diffusion material (see Soft Lights and Reflectors, p. 318) should be used on the light to help make the key less harsh. Hard light will accentuate skin defects, makeup and lighting errors more than soft light. Soft light is more forgiving. One look that can be appealing is to use a quite soft key. The light will wrap around the face and you may need little or no fill light (see Fig. 11-24). Diffused lights do not "throw" as far as hard ones, so soft lighting units need to be placed closer to the subject. For soft light sources, as a general rule, the larger the surface of the light source and/or the closer it is to the subject, the softer the light will be.

After the key has been placed, some DPs "rough in" the fill light, others go next to the backlight. Backlight should be used when needed, but it can seem artificial or stagey if overused. Backlight can be very important to provide separation between the subject and the background (see Fig. 11-20). Some scenes just look *dull* without a little backlight to add luster to the hair and put some bright "kicks" in the scene. On the other hand, sometimes the subject and the background have adequate separation simply because one is significantly darker or lighter than the other, and you don't really need a backlight (see Fig. 11-22). Some scenes are meant to appear lit only by one source, and backlight might spoil the effect (see Fig. 11-24). However, sometimes if a backlight is subtle, it can add a little shine without calling too much attention to itself.

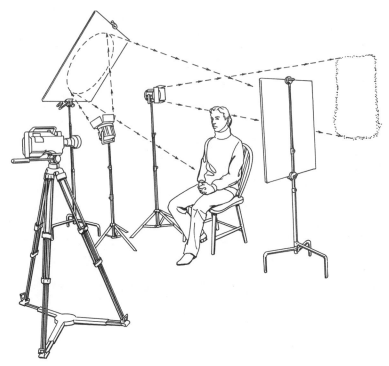

Fig. 11-25. "Window-lit" scene. A lighting setup that might be used to simulate the light in Fig. 11-24. Key light is bounced for a soft look. Fill lighting is provided by a white card just out of frame to the right. A set light provides the sun effect on the back wall. Flags and/or a cookie might be needed to create the desired effects on the walls. (Robert Brun)

Backlights should be placed high enough to avoid lens flare in the camera and angled down so that they don't strike the tip of the subject's nose. If a backlight causes flare or casts a noticeable shadow in front of subject, flag it off with the barndoors or a gobo. In Fig. 11-2iv, the backlight is positioned quite far to the side, functioning as a kicker to illuminate the side of the face and the shoulder.

The fill light is used to bring up the light level in the shadows cast by the key or the backlight. Put the fill light close enough to the camera so that it doesn't create a second set of shadows of its own. The difference in brightness between the shadows and the highlights is the lighting contrast. The contrast plays a big part both in how details will be reproduced in the film or video image and in the mood of the lighting. See Lighting Contrast, p. 309 for more.

Sometimes, fill lighting is provided not by a separate lighting unit, but by a reflecting surface. In Fig. 11-24, the wall on the right side of the room reflects back the sunlight, filling the shadows on the dark side of the man's face. In Fig. 11-25, a piece of white foamcore is used to simulate the same effect. A flexfill or other reflector (see Soft Lights and Reflectors, p. 318) may be used outdoors to do the same thing. Often, a white reflector needs to be quite close to the subject to provide significant fill.

There are various other techniques and tricks used to improve facial lighting. A low-powered eye light is sometimes used to add a little sparkle to the eyes, giving the subject an alert or alluring look. An eye light should not be so bright that it washes the face out with flat fill. Sometimes nets are used to delicately shade the top and bottom of the face, focusing attention on the eyes and mouth. A *clothes light* may be used to bring up the illumination on particularly dark or absorptive clothing.

As discussed in Chapter 8, facial shine can be very distracting and can be avoided with a basic application of powder (see p. 243).

Lighting Wide Shots

Wide shots or long shots that show a large part of a set or location can be harder to light than close-ups because of the greater area to be covered and the problem of hiding lights and light stands. Wide shots often involve people moving from one place to another, which adds the challenge of providing good light in several different parts of the set.

Generally, wide shots should be lit to establish mood and to cover the actors' blocking (movements). Proper facial lighting is a lower priority. Keep in mind that the eye is naturally drawn to light areas of the frame. Thus, the area in which the actors move is normally lit slightly brighter than the background or extreme foreground. Flags or nets can be used to diminish the light falling on unimportant areas such as broad expanses of wall. Much of the mood of the shot is established by the relation between the brighter action area and the darker background. Try to maintain this balance when you change camera position or lighting.

When you light any scene, it is usually more interesting to have pools of light and areas that are relatively dark than to have flat, even illumination throughout the frame. Pools of light also create a greater feeling of depth; a corridor, for example, seems longer if bright and dark areas alternate. Use fill light to provide illumination between the brighter areas.

When subjects move closer and farther from a light, the illumination falling on them can change significantly (see Lighting Fixtures and Light Intensity, p. 310). Sometimes a half scrim or other material can be used to even out the light (see Lighting Accessories, p. 322). In general, using a brighter, harder light from farther away will result in more even illumination than a softer unit closer to the subject. Sometimes a very bright light positioned *outside* a window or on the far side of the room is the best way to keep interior action evenly lit.

For a naturalistic look, every location needs to be examined for appropriate "motivating" sources for the lighting. Most daytime scenes include light coming through a window. Actual window light can often be used, but it must sometimes be simulated because it changes during the course of filming. If the window itself is not visible, you can position the light source wherever seems plausible. You can bounce light off a large white card for an overcast or "north light" look or use a large, focused spotlight or PAR light to simulate sunlight streaming in. When simulating sunlight, a warming gel (CTO; see Colored Filters and Gels, p. 325) is sometimes used over the light. If tungsten light is mixed with *actual* window light, some filtering must be done (see Mixed Color Temperature Lighting, p. 341).

If household fixtures are being used as practicals in a scene, sometimes they can provide significant illumination. You can replace the bulb with a photoflood or a screw-in halogen bulb. Or, you may be able to get away with using just a bright household tungsten bulb, but the color may read too red/yellow on film or video. Many practicals, however, can't handle this much heat or electricity, and often a bright bulb makes the practical look too bright on camera. The shade may overexpose, looking burned out. To look natural, the lampshade of the practical should read about two to three stops brighter than the faces of nearby actors. This varies, of course, with the type of shade and fixture.

Often, the opposite approach is taken with practicals. Instead of trying to light the subject with them, they are treated simply as set dressing. Sometimes a low-intensity bulb or a screw-in dimmer is used to keep the light subtle. Neutral density gels or diffusion material (see p. 318) can be hidden in the lampshade to dim down the shade or the spill coming out of the light. Then a professional lighting instrument is aimed in from off screen to simulate the light that would come from the practical. Be sure the instrument is flagged off so it does not shine *on* the practical and cast a shadow—a dead giveaway.

Frequently, one light can be used to accomplish several functions. If two people are talking across a table, a light can key one person while it backlights the other. This is called *cross lighting* (see Fig. 11-26). When an actor moves through his blocking, a given light may change from a key light to a backlight.

Cinematographer Nestor Alemandros (*Days of Heaven*) prided himself on being able to light a scene with as little as one or two lights. Many scenes require more lighting fixtures, but often, the fewer the sources, the cleaner the image looks. When there are many lights, you run the risk of many distracting shadows falling in different directions. To minimize this, keep actors away from walls, place them against dark rather than light walls, position furniture or props to break up the shadows and use diffusion to soften secondary lights. Moving a light closer to a person will diffuse the shadow he casts.

Bright, shiny surfaces in the frame attract the eye and are usually undesirable. Glints or kicks can be diminished by repositioning a shiny object or by applying washable dulling spray or even soap. Sometimes you can get rid of the reflection of a light in a surface by raising or lowering the camera a few inches or wedging a little tape behind a picture frame to angle it away from the camera. Reflections from smooth, nonmetal surfaces such as plastic, glass and water can be reduced by putting a polarizer filter on the camera. Avoid shooting glass or mirrors that will pick up the lights or the camera. If you have to film against white walls, take care not to overlight them. Usually, broad expanses of wall are broken up with pictures or furniture.

When a scene is to be filmed with both long shots and medium or close-up shots, it is typical to determine the blocking, set the lighting and shoot the long shots first. Then, as the camera is positioned closer to the subject, the lights can be cheated (moved) to maintain the general sense of the long shot while providing more desirable facial lighting. Close-ups are usually lit with slightly lower contrast lighting than long shots are so that facial detail will be clear. When the camera angle changes significantly, you can make many changes in the light without the audience noticing.

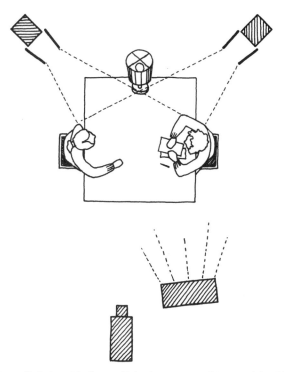

Fig. 11-26. Cross lighting. Each spotlight keys one subject and backlights the other. Lights are used in part to simulate practical illumination from the table lamp and are thus flagged off of it. Fill light is placed near the camera. (Carol Keller)

When shooting video, watching the image in a monitor can help you light, but beware of small and poor-quality monitors. On film shoots, often Polaroid pictures are taken to see how the light will look (although the motion picture film may respond differently) and to aid in relighting in case the scene needs to be reshot. (Polaroids are also very helpful for continuity purposes to record how props were arranged and how actors were dressed.)

Before you shoot, scrutinize the frame to make sure no light stands or cables are visible. Be sure no lights are producing flare in the lens (stand next to the camera and look at the front of the lens; if you see any light sources in the glass, try to flag them off). Rehearse the shot to check that movements of the crew and especially the microphone boom do not produce visible shadows.

Setting Lighting Contrast

As discussed in Chapters 4 and 7, both film and video systems have a limited ability to capture the range of brightness that the eye can see. When lighting a scene, you must pay close attention the *lighting contrast* (see Lighting Contrast, p. 309). To the eye, scenes always have less contrast than they do as rendered on film or video. Shadows that look natural to the eye may be rendered as black and

without detail. Bright highlights can easily overexpose and be rendered as areas of featureless white.

When shooting film, experienced DPs may judge the lighting contrast just by the way it looks or by measuring individual light sources with a light meter. When shooting video, it is possible to use a light meter, but often DPs on video shoots don't have one.[2] A good monitor can help you judge how the contrast looks on video, but a bad monitor may be worse than none at all. In general, video is less forgiving of high lighting contrast than film is.

If you have a light meter, measuring the *lighting contrast ratio* can help you determine the proper lighting contrast. This is the ratio of key plus fill lights to fill light alone (K + F : F). For a typical close-up, the lighting contrast is measured by reading the light on the bright side of the face (which comes from both the key and fill lights) and comparing it to the light in the facial shadows (which comes from the fill light alone). The measurements are most easily taken with an incident light meter, blocking or turning off the key light(s) to take the second reading. Some DPs prefer to use the incident meter's flat-disc diffuser when doing this to make it easier to isolate the light coming from individual sources.

If the bright side of the face is one stop lighter than the facial shadow, the ratio is 2:1. Two stops would be 4:1; three stops, 8:1. To the eye, 2:1 and 3:1 look quite flat, but this lighting contrast is considered "normal" by Kodak. This is a conservative standard. Kodak recommends that contrasts of 4:1 or higher be used for special lighting effects only, but it is common for filmmakers to work with these contrast levels. Low-key scenes, nighttime effects and many outdoor sunlit scenes are shot at ratios much higher than 4:1.

For either film or video, you should use lighting contrast to create the mood and look that you want. If you choose a high lighting contrast, bear in mind that you may lose detail in shadow or highlight areas. How much you lose depends on the film stock or video format, the exposure and how the project is handled during postproduction and distribution. As noted above, video cameras have a more limited exposure range than most film stocks (see p. 188), so lighting contrast must generally be kept lower for video than film shoots.

As a rule of thumb, a film or video image will generally *pick up* contrast through the various stages of processing the footage and copying it. So if you start with a somewhat lower contrast, you may find the image has gotten "snappier" without you doing anything. You can often *increase* the contrast later if you find the image too flat, but if it is originally shot with too much contrast, it may be difficult or impossible to recapture the lost detail.

[2] To use a meter with a video camera, you need to find the "exposure index" (EI) for the camera (as though it had an ASA/ISO number). Cinematographer Harry Mathias suggests this technique: using a waveform monitor and a standard chip chart, point the camera at the chart and open the iris until the brightest white chip (peak white) reads 100 IRE units on the waveform (the middle gray "crossover" chip should read about 55). Then hold the incident meter at the chart (pointed toward the camera) and fiddle with the meter's EI or ASA setting until the meter indicates the *f*-stop the lens is set at. You will need to recalibrate if you change lenses or the shutter or the gain setting.

If the contrast seems too high, the fill light can be moved closer to the subject or a brighter instrument can be used. Alternately, the key light could be dimmed with a scrim or moved back. Lighting contrast should be evaluated with respect to *all* parts of the frame, not just the light and shadow on faces. Walk around the set or location with an incident or reflected meter, or point a video camera at various parts of the set to get a sense of the range of exposure in the scene. If the background is in deep shadow, it may need additional light to keep the overall contrast down. Or, if a window is too bright it may need an ND gel to darken it up a bit. A bright wall can be made darker by flagging the light off it, or using a net to gradually shade the light (often you want keep the light on the actors and darken the upper part of the wall above them). Actors or subjects may be asked not to wear very bright or very dark clothing, high-contrast props can be replaced or set walls repainted in medium shades (see p. 243). In general, it is less disturbing if some areas of the frame are underexposed than if large or important areas are significantly overexposed.

LIGHTING CONTRAST IN DAYLIGHT. On a sunny day outside, the direct sunlight usually acts as the "key light;" skylight—and, to a lesser extent, reflections from buildings, objects and clothing—act as fill. On a bright day, the lighting contrast is often too great for film or video. If you expose properly for the bright areas, the shadows end up looking very deep and harsh. A classic problem is shooting people at midday under a bright sun; the eye shadows may make it almost impossible to see their eyes. That is why hazy or lightly overcast days, with their lower lighting contrast, are often ideal for shooting people outdoors.

There are a number of solutions to the problem of shooting in sun. For an interview or close shot, you can use a white card or a small reflector such as a flexfill to help fill the shadows. For a larger scene, a bigger reflector such as a *shiny board* with a silver or gold surface can also be used. Daylight-balanced lighting instruments can also be used, but it takes a lot of intensity to match the sun on a bright day.

Another approach is to try to diminish or soften the direct sunlight. An *overhead set* is a large frame that can be placed over the action to hold either a silk to diffuse the light, a net to cut down the light without diffusing it or a *solid* to block the light altogether. Overheads must be used carefully so that the shadow of the frame doesn't show in the shot, and neither does the brightly (and more harshly) lit background. The overhead must be held down securely when the wind blows. If sunlight is diffused in this way, it is easier to maintain consistency in the light over a day's shooting, since the material can be removed if a light cloud passes.

Whether or not you have reflectors or lights, try to use the angle of the sun to your advantage. When possible, put your subject in gentle shade near a building or by a tree. Don't shoot against a hot (bright) background like a bright sky or a white wall. Sometimes it's best to avoid shooting in the middle of the day when sun light is the harshest.

When shooting in direct sun, if the sun is not directly overhead, changing the position of the camera and/or the subject will have a big effect on the contrast. If the sun comes from behind the camera (front lighting), contrast will be fairly low,

but the subject may have to squint. Alternately, if the subject has her back to the sun, contrast will be fairly low on her face (all indirect light), but there may be a large contrast between her face and the background. If you now bring in a reflector from the camera-side of the subject, it will pick up the sun nicely and boost the illumination on her face.

When you shoot in cars or near windows, lighting contrast can be extremely high between the darker foreground interior and the brightly lit exterior (see Fig. 4-23). You might choose to add light to the interior or put neutral density gel on the windows. Without these steps, a compromise exposure is normally used.

CONTRAST VIEWING GLASSES. Some DPs set their lighting with the use of *contrast viewing glasses*, which are smoked glass monocles that cause the scene to appear to have higher contrast, more like the way it will appear on film or video. These glasses must be held to the eye only briefly, since the eye gradually adjusts, lowering the apparent contrast. It takes some experience to use these properly.

Color Contrast

Differences in color between two objects (their *color contrast*) help us to tell them apart and determine their position relative to each other. In black-and-white, however, a red bug and a green leaf may be indistinguishable because their tonal values are the same (they reflect the same amount of light). Thus, when shooting in black-and-white it is usually necessary to use slightly higher lighting contrast than you would in color and to make sure that there is adequate shading and/or backlighting to differentiate various objects from each other. It is also possible to use color contrast filters on the camera to separate tonally similar areas (see Chapter 5).

Color contrast is also important when shooting in color because the shades and intensities of colors play a large part in setting the mood of a scene. The color scheme in a movie can be controlled in wardrobe planning, set design and choice film stocks or the setup of a video camera. To make colors appear more pastel or desaturated, you can use camera filters such as a diffusion or low-contrast filter. Underexposure and overexposure also affect color saturation (see Chapter 4). During video postproduction (and/or film-to-video transfer) you can make many adjustments both to color saturation and the reproduction of individual tones (see Chapters 14 and 17).

Lighting and Exposure

When setting lights, the question arises: How brightly should a scene be lit? On a feature film, many DPs try to work at a given *f*-stop consistently throughout the movie, which helps them judge lighting setups by eye. Lens sharpness can be maximized by shooting at apertures two or three stops closed down from wide open (on an *f*/2 lens, shoot between approximately *f*/4 and *f*/5.6). Higher or lower *f*-stops may be used to increase or decrease depth of field. As a rule, the discomfort of both crew and actors, or documentary subjects, rises with the amount of light.

Mixed Color Temperature Lighting

Before reading this section, please see the discussion of color temperature and filters for film and video systems in Chapter 5.

A color video camera can render colors naturally in daylight or in tungsten light if it is properly white balanced (see p. 171). Similarly, with the proper filters, color film stocks can be used in either daylight or tungsten light and produce a pleasing color rendition (see p. 156). However, no video or film camera can shoot a scene that contains *both* daylight and tungsten light without rendering the former blue or the latter yellow/red relative to the other.

To take a typical example, you're trying to shoot an interior scene using window light, but there's not enough light for exposure, so you set up some tungsten movie lights to boost the light on your subject. If you balance the video camera for the tungsten light (or shoot tungsten film without a filter), the daylight from the windows will look very blue by comparison. If you balance the video camera for daylight (or use an 85 filter with tungsten film), the tungsten light will look much too warm (orange).

There are a few ways to deal with this problem. One is to make the tungsten light bluer, to better match daylight. This can be done with dichroic filters or full CTB (blue) gels on the lights (see Colored Filters and Gels, p. 325). However, this will reduce the lights' output by half or more. Also, when shooting tungsten-balanced film—and with some video cameras—an 85 camera filter is generally used for daylight, which cuts down the light intensity almost in half again.[3] This may not leave enough light to shoot.

In this situation, sometimes instead of using a full CTB gel on the lights, only a ¾ or ½ CTB is used. This lets more light through and results in the tungsten light appearing *slightly* yellow compared to the daylight. Also, if you're shooting film, you could use a daylight-balanced stock that requires no 85 filter.

Another approach is to balance the video camera for the tungsten light (or use no filter with tungsten-balanced film), and filter the *window* light with orange gel or acrylic sheets. Gel comes in large rolls and is easy to transport. Tape it carefully to the windows or it will show in shots that include the windows. Gels crease easily, will reflect the lights if mounted sloppily and are noisy in windy locations. Acrylic sheets, on the other hand, are inconvenient to carry, but they are good for mounting outside the window where they will not show. They are also optically sharper for shots that involve shooting *through* the window.

A sun 85 or ¾ CTO (orange) gel can be used to warm up 5500°K daylight to 3200°K tungsten balance. For dimming overly bright windows it can be very helpful to have some combination CTO/neutral-density gels (for example, 85 N6, which brings down the color temperature and cuts an additional two stops of light; see p. 160). While a ¾ CTO gel will make daylight match the color of tungsten, sometimes you want the window to look a little blue by comparison, to maintain some of the natural difference between the interior and exterior light. In this case, use a paler gel, such as a ½ or ¼ CTO, on the windows.

[3]With some color negative stocks you can get away with shooting in daylight without an 85 filter, and this is one instance where you may need to.

If a location has large windows and is illuminated primarily with daylight, or when you are shooting outside, often the best solution is to use an HMI (see HMI Bulbs, p. 313) or daylight-balanced FAY light (see Nonfocusing Lights, p. 316) which will give you plenty of light output and requires no filter to match daylight.

However, if window light is insignificant in a scene, it is often easiest to block the daylight out altogether (using curtains, sound blankets or show cards) and then light completely with tungsten.

MIXED FLUORESCENT LIGHT. See Fluorescents for Film and Video, p. 314 for discussion of fluorescent lighting. Ideally, anytime you are shooting with flourescent light, you should use Kino Flo or other true tungsten- or daylight-balanced tubes. However, if you are forced to shoot with conventional fluorescent tubes and plan to mix in daylight or tungsten sources, filtration is usually called for. Unfortunately, conventional fluorescents come in a variety of colors. Some fluorescents can be thought of as daylight with a green spectral element. Thus, window light can be filtered with Rosco's Windowgreen to match "cool white" or "daylight" fluorescents better; HMIs can be filtered with Tough Plusgreen and tungsten sources can be filtered with Tough Plusgreen 50.

Alternatively, the fluorescent tubes themselves can be filtered with Minusgreen to match daylight better or Fluorfilter to convert to 3200°K tungsten. The latter comes in sleeves that can be fitted over the fluorescent tubes, which reduce the green halo effect that sometimes occurs when fluorescent units are visible in a shot. If filtration is not possible, fluorescent lighting fixtures, such as the Molescent unit by Mole, can be brought in for additional light. Mixing conventional fluorescent light with other sources and mixing various types of fluorescent tubes can be very tricky. A three-color color temperature meter helps (see Fig. 5-5).

Special Lighting Effects

NIGHT-FOR-NIGHT. Sometimes you can shoot at night without supplementary lighting, particularly on city streets. However, often you need to augment whatever existing light there is. When using lights to simulate a nighttime effect (such as moonlight or streetlight), use hard lighting fixtures in an extremely high-contrast, low-key lighting scheme. Lights should be used to produce sharp highlights or rim lighting with very little fill. Shadows should be crisp and not diffused. Create pools of light—not flat, even illumination.

When the light level is low, the eye is less sensitive to color. If you go out on a moonlit night, the landscape seems desaturated and slightly bluish. Often, lighting fixtures on movies are gelled blue to simulate moonlight. A pale grayish-blue often looks more natural than an intense, saturated blue. Some DPs like to wet down streets and surfaces at night so that they reflect highlights.

Since night scenes can require many lights, especially for a wide shot, it is often better to shoot at the *magic hour* just before sunrise or just after sunset when there's enough light to get exposure on buildings and the landscape but it is sufficiently dark that car headlights and interior lights show up clearly. Although beau-

tiful, the magic hour is fleeting, often lasting only about 20 minutes, depending on the time of year and your location. Rehearse and be ready to go as soon as the light fades. It helps to have some supplementary light on hand for additional fill in the waning moments and for shooting close-ups when it gets darker. When you shoot magic hour scenes with tungsten-balanced color film, an 85 filter should not be used. In general, avoid shooting the sky during the magic hour because it will photograph too bright, or use a graduated filter (see Fig. 5-6).

DAY-FOR-NIGHT. Hollywood invented the technique of shooting night scenes during the day, using filters and underexposure to simulate a night effect (the French call this "American night"). Day-for-night often looks fake. It's easier in black-and-white where a red or yellow filter can be used to darken a blue sky (see Chapter 5). For color work, a graduated filter can be used. Ironically, day-for-night works best on bright, sunny days. Shoot early or late in the day when distinct sidelight or backlight casts long shadows that will seem like moonlight. Avoid shooting the sky and use intense lights in windows to make interior lights look bright relative to the exterior. Underexpose by two or three stops while shooting (after making the normal compensations for any filters). When shooting film, do not rely on trying to print down a normally exposed negative.

RAIN, SMOKE AND FIRE. In order to be visible on film or video, rain, smoke and fog should be lit from behind. Aim the lighting instruments as close to the camera as possible but flag them off so that no light shines directly in the lens and causes flare.

Sometimes firelight is simulated by placing an amber gel over the light and jiggling strips of paper or cloth suspended from a horizontal bar in front of the light. Even better, get a *flicker box*, which is an electronic device that allows you to dial up different rates of flicker. Sometimes DPs make fire effects (or simulate the light from a television) with very intense flickering and virtually no fill light, making the scene seesaw between very bright and very dark. In real life, that kind of flicker generally only happens if there's no other light in the room. For a typical fireplace or TV watching environment, usually people have a least *some* other light on, and the flicker on people's faces from a fire or TV is often fairly subtle. Sometimes, the most convincing effects are done with two or more lights that can be flickered alternately.

LOCATION LIGHTING

The Location

Whenever possible, scout locations prior to filming to assess lighting needs, the availability of electric power and to formulate a shooting plan (see p. 211). When scouting an interior location, bring a light meter and try to estimate the natural light at various times of day. Bring a camera or a director's finder to block out actors' movements and camera angles. Determine what lighting package you need. If any windows need to be gelled, will you need a ladder to reach them? A day at a

cramped location helps you appreciate why many movies are made in studios with high ceilings, overhead lighting grids, moveable walls and plenty of work space. Movie crews on location often break furniture and mar walls with lighting gear. You can save a lot of time by coming prepared with paint and repair supplies.

Electric Power

Lights for moviemaking consume a great deal of electric current. Before you shoot, try to determine if the location has enough power for your needs; otherwise, fuses or circuit breakers may blow, the production could be shut down or a fire could erupt.

To estimate your power needs, use the formula: volts × amps = watts. You want to find the number of amps your lights will use, since this is what overloads circuits and causes fuses or breakers to blow when too many lights are put on one circuit. Standard household current in the United States is delivered at about 110 volts, which can be rounded off here to 100. Every lamp is rated by the number of watts it consumes. In the home, a 75-watt bulb is typical, while, for filming, 1000 watts (1K) is more common. If you simply read the bulb's wattage and divide by 100, you get the number of amps the lamp requires (this formula includes a safety margin). A typical home circuit can handle 15 (or 20) amps, which is thus enough to run three (or four) 500-watt bulbs. Using any more lights will trip the circuit breaker or blow the fuse.

To determine how much power is available at the location, examine the circuit breakers or fuse box (often found in the basement). Count how many circuits there are and the maximum amperage of each one (amps are indicated with a number followed by "A"). Circuit breakers, which can be reset by flipping a switch when they are tripped, are found in most houses with newer wiring, but keep a few spare fuses in your lighting kit. Never replace a fuse with one of higher amperage, since the fuse is designed to blow before the wiring in the wall catches fire.

Often, circuits are labeled as to which rooms they are connected to. If not, plug lights into various wall outlets and turn the breakers off one at a time and see which lights go out. Extension cables can be run to distant outlets to distribute the load. Do not use thin, home extension cords, as they increase the load and may melt.

When too many lights or overly long cables are used, the voltage may drop (the equivalent to summertime brownouts), which lowers the color temperature of the lights. A 10-volt drop in supply lowers tungsten lights about 100°K. If there is no window light and all light sources are on the same supply, this color change is usually correctable.

To get around this and other typical problems of location power supplies, professionals usually *tie in* to the electric supply as it enters the house and use their own set of circuit breakers and electrical distribution cabling. This should only be done by a trained electrician; in some places, a permit must be obtained and the electrician must also be licensed.

In outdoor locations, a generator ("genny") or a set of car batteries can be used for power. Honda makes a portable, low-cost, fairly noisy generator that puts out 45 amps (5500 watts). There are also large truck-mounted generators that are much more powerful and quiet. Ten 12-volt car batteries ("wet-cells") wired in se-

ries can run regular tungsten lights at normal color temperature. As the batteries weaken, the color temperature and light output drop.

OUTSIDE THE UNITED STATES. Household power in the United States is supplied at 110 to 120 volts. It is alternating current (AC)—that is, it pulsates back and forth; it does so sixty times a second (60 Hz). In some countries, power is supplied at 220 to 240 volts at 60Hz. In most other parts of the world, the power is 220–240V, alternating at a frequency of 50 Hz.

Most AC equipment works equally well at frequencies of 50 or 60 Hz. However, clocks, some battery chargers and other equipment will not run properly if the frequency of the current is incorrect. Tungsten lights work fine with either system, but AC discharge lamps, including HMIs and fluorescents, may be incompatible with the camera speed or shutter (see HMI Bulbs, p. 313).

Virtually all equipment should only be used with the voltage it was designed for. Tungsten fixtures can be converted from one voltage to another simply by using a different set of bulbs. Some equipment may have a switch to select 110 or 220 volt use. Other equipment requires a voltage-changing device, of which there are two types. The *transformer* is relatively heavy for the amount of power (wattage) it can handle. It can be used with any equipment, but should not be overloaded. Transformers do not affect the frequency of the current. *Diode-type voltage changers* are extremely light (usually a few ounces) and, for their size, can handle much more power than transformers. They should only be used for lights. Since these work by converting AC current to DC, they should not be used with anything that is frequency dependent. Check with a technician on the requirements of your equipment.

While typical electric plugs in the United States use two flat blades and sometimes a round grounding pin, outlets found outside the United States have a different configuration. Other systems use plugs with two or three round pins or angled blades. Adaptors are available to convert from one type to the other or you can replace the plugs on your equipment if needed.

Picture and Dialogue Editing | CHAPTER 12

*My movie is first born in my head, dies on paper; is resuscitated by the liv-
ing persons and real objects I use, which are killed on film but, placed in
a certain order and projected on to a screen, come to life again like flowers
in water.*

— ROBERT BRESSON

This chapter is about the editing choices and styles used to shape a movie after
it has been shot. See Chapter 13 for discussion of film editing equipment (and
editing film on video). Chapter 14 is about working with video editing equipment.

Editing is the selection and arrangement of shots into sequences and the se-
quences into a movie. It is sometimes thought to be the most important element in
filmmaking. Many projects have been "saved" in the editing room.

The earliest filmmakers made films from one unedited camera take or shot. A
few years later, it became obvious that shots could be trimmed and placed one
after another, with the viewer accepting that the action occurs in the same setting.
The joining of two shots, with the abrupt ending of one shot and the immediate
beginning of the next, is called a *cut*. When editing film, the word *cut* applies not
only to the transition from one shot to another on screen, but also to the physical
cutting and joining (*splicing*) of the film (hence editing referred to as *cutting*). In
video, the term *edit point* is often used to indicate the point where a cut takes place.
When editing on a video system, the head (beginning) of a shot may be referred to
as the *In Point* and the tail (end) as the *Out Point*.

SOME FILM THEORY

Montage

Perhaps the most developed theory of film comes from the silent era and is
called Russian *montage theory*. The word *montage* comes from the French and
means to "put together" or "edit." The Soviet filmmakers claimed that the ability
to change images instantaneously was unique to film, and constituted its potential
as an art form. In editing, the image can shift from one person's point of view to
another's; it can change locales around the world; it can move through time. The

Soviets, for the most part, looked at the shots themselves as meaningless atoms or building blocks and claimed that meaning first emerges from the images through the juxtaposition of the shots.

In the early 1920s, Lev Kuleshov, a Soviet film teacher, created experiments to show how the meaning of a shot could be totally altered by its context. He took a series of shots of Mosjoukine, a famous contemporary actor, looking at something off screen with a neutral expression on his face. He then constructed a few different sequences. In one sequence, he cut from a medium shot of Mosjoukine to a close-up of a bowl of soup and then back to a close-up of Mosjoukine. In the next sequence, the middle shot, called an *insert shot*, was replaced with a shot of an injured girl. Kuleshov's students commented that the last shot in each of the sequences, called the *reaction shot*, showed the actor's great acting ability to convey subtly hunger in the first sequence and pity in the next.

In another of the Kuleshov experiments, a sequence was constructed as follows: an initial shot of Mosjoukine smiling, an insert shot of a gun and a reaction shot of

(i)

(ii)

Fig. 12-1. Three-shot sequence. (i) The meaning of the actor's expression depends on the insert shot. (ii) The meaning of the actor's expression depends on the ordering of the shots. (Carol Keller)

Mosjoukine frowning. Kuleshov then rearranged the order: first the frowning shot, then the gun and finally the smiling shot. In the first sequence, the actor's reaction seemed to be one of fear; in the second, one of bravery. The important point of these experiments is that the actor's expression is constant, but the viewer attributes changes in emotional states to him on the basis of the editing.

A girl looks off screen; there is a cut to a bomb blast and then a reaction shot of the girl. The audience assumes the girl is looking directly at the blast, even though the blast could have, in fact, occurred in another part of the world at another time. Sergei Eisenstein, the most renowned of the early Soviet filmmakers, claimed that *film space* was the constructed space of montage, not the space photographed in the shot. Film space was more than the simulation of real space; it could also be abstract. It is possible to cut from a shot of Kerensky, who was head of the Provisional Government and is a villain in Einstein's *October* (1927), to shots of a glass peacock to suggest that Kerensky suffers from the sin of pride. There is no suggestion, however, that the peacock and Kerensky share the same physical space. Two shots, edited together, produce a new meaning, and film space allows for these kinds of metaphorical relationships between images. In addition to narrative content and metaphor, shots can be held together by abstract elements like movement, tone, compositional weight and image size.

Similarly, Eisenstein saw film time not as the duration of real movement but as the time set up by the rhythms and juxtaposition of montage. An event may only take a split second in real time, but, as its importance may be great, its duration should be lengthened in film. In *Potemkin* (1925), Eisenstein extended time by showing a crying baby in a carriage teetering on the edge of a steep flight of stairs and then cutting to other shots before returning to the baby. Suspense is heightened by prolonging the event. Real time can also be condensed. Cutting from a horse race to a reaction shot of the crowd (a shot away from the main action is called a *cutaway*) and then back to the race allows a large portion of the race to be deleted. Similarly, a character's walk will seem continuous if you cut from him walking off screen to a point much further along in the action. Like film space, film time is also a construction created in editing.

Eisenstein also experimented with the montage of very short shots. In *Potemkin*, a sequence of brief shots of statues of lions in different positions cut quickly gives the illusion of their movement. A few frames of an attacking Cossack convey horror. There is no absolute rule for the minimum length of a shot; the minimum depends on the nature of the shot and the context. During World War II, it was found that plane spotters could recognize a female nude in one frame, but it took them much longer to recognize a Messerschmitt.

The directors in Hollywood never adopted the Soviet concept of montage in its broadest sense. In Hollywood, a "montage sequence" is a sequence of short shots that condenses a period of time. For example, the hero might be shown growing up through a sequence of five or six shots that show him at different ages. The aspect of montage that was accepted by Hollywood (indeed, the Soviets had discovered it in early American films) was the three-shot sequence—that is, actor looks off screen, cut to a shot from his point of view and then cut back to the reaction shot. Alfred Hitchcock constructed *Rear Window* (1954) almost entirely using this cutting technique.

Today montage theory underlies much advertising and some experimental films. The juxtaposition of women, happy teenagers and upbeat music with automobiles, soft drinks and other products is used to manipulate consumers. In experimental films, the tradition of montage seems to find new life. In Bruce Connor's *A Movie* (1958), *stock footage*—that is, footage purchased from a service (also called *library footage*)—from widely disparate sources, ranging from pornography to newsreels, is cut together to form a unified whole. Although the images come from different times and places, the viewer integrates them into a flow.

In Woody Allen's *What's Up Tiger Lily?* (1967), a Japanese action film is dubbed by Allen to change the story line completely. It is not that the original film has lost its meaning. The joke is the ease with which meanings are changed by editing, in this case, by altering the relationship of sound and image.

See Style and Structure, p. 222, for more on shooting and editing styles.

CUTTING STYLES

Invisible Cutting

In its simplest form, editing is a guide to focus audience attention. The editing style should have its reasons and every cut a motivation. *Invisible* or *match cutting* usually refers to the construction of sequences (or scenes) in which space and time appear to be continuous. Usually both fiction and documentary sequences are match cut to appear continuous. On a film set, however, shots are rarely done in the order that they will appear in the final movie. It is the role of the director to shoot scenes with adequate coverage so that the editor can construct continuous sequences. Every cut made in a documentary that was filmed with one camera, in fact, alters continuous time.

There are various ways to make action seem continuous. If the eye is distracted, a cut becomes less noticeable; therefore, editors "cut on the action" (a door slam, punch or coin flip) to hide a cut. The action draws the viewer's attention away from the cut and from any slight mismatch from one shot to the next. Overlaps of action (see Continuity, p. 218) allow the editor to cut just before or just after the action or on the action itself. Cuts tend to propel time forward and to pick up the pace. Sometimes the action looks too fast due to cutting, and the editor must include a few frames of action overlap between two shots.

Changing camera angle and focal length between consecutive shots disguises discontinuities and may make the cut "work"—that is, look as though it matches and is not jarring. Cutaways and reaction shots are tools that maintain continuity between shots that do not match. Cutting away from the main action to a reaction shot allows you to delete uninteresting dialogue or mistakes in the main action. Cutaways and reaction shots also allow the tempo of the film to be controlled through editing, which would be impossible with a continuous take.

The Jump Cut

The sequence of cuts that moves from long shot to medium shot to close-up is generally made up of match cuts. In other words, each of the cuts appears to occur

in the same space and time period. A disconcerting mismatch between shots is called a *jump cut*. To cut from a shot of a person sitting to a shot of the same person standing in the same spot creates a disconcerting jump in time. If the image size and angle don't change very much from one shot to the next (for example, two medium shots of the same person cut next to each other), the cut may appear to jump and feel unmotivated. A larger change in image size or angle could make the same cut in action seem natural.

The director Jean-Luc Godard, in the early 1960s, began to use the jump cut as a creative element in his filmmaking. He cut out what he felt were boring middle parts of shots or spliced together two close-ups of the same character with a definite jump in time. Not only did these jump cuts comment on the nature of film space, but they also created exciting rhythms that seemed to express the feeling of modern life.

The jump cut is also used for comic effect. In *A Hard Day's Night* (1964), director Richard Lester showed the Beatles cavorting about the landscape in a series of jump cuts. Today, jump cuts are used more widely in sequences where match cuts were traditionally used, and audiences have come to accept them as a routine part of the visual language of editing. However, keep in mind that jump cuts often do not work, and it makes sense to cover yourself with alternate shots, cutaways and the like, rather than be forced to resort to jump cuts to salvage a sequence. Sometimes a quick dissolve is used to cover what otherwise would be a jump cut.

Screen Direction

A basic rule of film editing is to try to preserve screen direction at cuts (see The 180° Rule, p. 216). Cutting from a shot of one person looking off screen to the right to a shot of another person also looking off screen to the right makes it appear that the two people are looking in the same direction rather than at one another. Much of the directional information in a chase sequence comes from screen direction.

When two shots violate the 180° rule and there is no shot available where the camera crosses the line, you should try to separate the shots with a neutral shot (for example, a shot taken *on* the line).

In editing, if a character walks off screen right, he should come in from screen left to appear that he is continuing on his walk. If he comes in screen right, he may seem to be returning to his previous spot.

Screen direction to the right is usually accepted by audiences as meaning travel from west to east; to the left is travel from east to west. A plane flying from New York to Paris that was shown on screen traveling right to left would be disorienting.

Joining Sequences

One traditional method of editing connects shots into a sequence with straight cuts and then brackets the sequences themselves with fades and dissolves. Fades work like theater curtains opening and closing on an act or like a sunset followed by a sunrise. Dissolves, on the other hand, suggest a closer connection between one sequence and the next. Like fades, dissolves convey the passage of time—sometimes short time gaps within a sequence and sometimes long periods, as when a close-up of a person dissolves into another close-up of the same person

shown at a much older age. When dissolves are used within sequences to signal short time gaps, their only function often seems to be to avoid jump cuts. Sequences can also be joined by many other visual effects, including wipes, digital video effects (see Chapter 14) or various film opticals (see Chapter 16).

Many filmmakers like to join two sequences together with a straight cut (that is, one follows directly from the other with no dissolve or other effects). This may create the problem of distinguishing cuts within sequences—those that signal no significant time change—from cuts between sequences where there is a significant change of location or time. Filmmakers like Luis Buñuel and Alain Resnais like to explore this ambiguity. On the other hand, even with straight cuts there are many cues to signal the audience that the sequence has changed including a change of sound level, lighting, color, dress, locale, image grain or contrast. Even dream and fantasy sequences may be introduced with a straight cut, unlike in the American films of the 1930s and 1940s in which they would be signaled by eerie music and a *ripple* or *oil dissolve*.

It is not unusual to see a contemporary movie with no effects other than a fade-in at the opening of the film and a fade-out at the end.

Another way to join two sequences is to *intercut* them (also called *parallel editing*). For example, the perils of the heroine may be intercut with the hero's race to arrive in time to save her. We cut back and forth to develop two threads of action simultaneously.

DIALOGUE EDITING

Dialogue and Scene Structure

In both fiction and documentary, dialogue editing is part of shaping the basic storyline. What gets said, and when, is a fundamental part of moving the story ahead. Careful editing of dialogue can have a big impact on individual sequences, even if the scene has been carefully scripted.

Unlike stage plays, which may include long speeches that work fine when delivered to a live audience, film dialogue often works best when it is quite simple and spare. Images, facial expressions and juxtapositions of editing should tell the story as much as dialogue when possible. Look closely at scenes in movies that you have found powerful; it's often surprising how little is actually *said*. Even expository documentary material often plays best when the dialogue is pared down to essentials.

When editing a scene, look for places where you can remove unnecessary dialogue. Sometimes you can begin the sequence after most of the setup has already taken place, doing away with unneeded exposition. Sometimes a pivotal line can be moved to the beginning of a sequence, allowing the rest to be made more succinct. Not every scene needs a beginning, a middle and an end. Real people often speak with false starts, digressions, repetition, long pauses or uninteresting detail, some of which can be removed to speed the pace of the scene. In a dramatic film, find places where a look from one character to another might replace dialogue. Let the *audience* fill in the details.

The use of simple cutaways is the most common method of condensing or rear-

ranging speech. A three-shot pattern is used. While one person is speaking, we cut to a person listening or to another relevant shot. During the cutaway, the speaker completes one thought and the sound cuts to another sentence (to the audience this sounds like the normal flow of speech). Before the picture cuts back to the speaker's face, pauses, words and whole sections of dialogue can be removed or added. The editor can construct any number of possible sentences from the collection of recorded words.

Sometimes cutaways are not needed to condense dialogue: a match cut or jump cut may work just as well.

Cutting away from sync-sound dialogue can be a useful tool for providing a sense of dynamic flow in a conversation. Say you cut from one person asking a question to a shot of someone else responding. If the picture cuts from the first person to the second before the question is finished, the editing may take on a more natural, less mechanical feeling (see Fig. 14-6). Showing the person being spoken to, and not just the person speaking, can give the audience insights into the characters as well as clues on how to interpret what is being said. Alfred Hitchcock insisted that what is said on the track should contrast with what is seen. Cutaways may be chosen to provide an interesting counterpoint to the spoken dialogue.

When the sound cuts before or after a picture cut (instead of in sync with it) this is called a sound overlap, split edit or L-cut (see Audio Edits, p. 409). Sound overlaps play a big part in creating the illusion of continuity across cuts (see Sound and Continuity, p. 455).

Replacing Dialogue

It is essential that the audience be able to understand spoken dialogue. Bad sound and unintelligible dialogue can quickly alienate viewers and make them stop paying attention to the movie. Listen critically to your dialogue tracks and avoid using takes that are hard to hear (for more on evaluating sound quality, see Evaluating the Sound Track, p. 455).

In fiction films, where the pacing of dialogue is often quite consistent from one take to the next, it is often possible to substitute the sound from one take with that of another (while keeping the picture from the original take). This can be used not only to improve sound quality, but to find better performances as well. Pauses between words usually need to be trimmed or expanded slightly to maintain sync.

When location audio on feature films is unacceptable, dialogue tracks may be replaced using ADR (Automatic Dialogue Replacement), also called *looping*. Actors are brought into a sound studio to redo their lines while watching repeating loops of picture. Traditionally, this process is slow and expensive. Often the timing is wrong or the voices sound "canned" and unnatural. Newer technology has made the process simpler: editing equipment can be easily programmed to play loops, and software such as SynchroArt's VocAlign can automatically adjust the timing of a redone take to match the pacing of the original take. The new takes must be equalized, and sound effects must be added to try to match the new tracks to the ones recorded on location.

Cutting Dialogue Tracks

When you are editing speech, it is often necessary to separate words that are spaced closely together on the track. This is a skill that improves with practice. Be attentive to breaths between words—avoid cutting in the middle of a breath. It's often better to leave the whole breath in place and plan to fade it down quickly in the mix (see Chapter 15).

Nonlinear editing systems make it easy to locate the beginnings and endings of words. You can display the sound's waveform and visually determine exactly where the word begins (see Fig. 14-25).

When editing 16mm or 35mm mag film, locating words can be trickier. You can run the sound slowly forward and back by hand (scrubbing). A useful aid is to put a piece of low-tack masking tape (sold in architectural supply stores) on the emulsion side of the track, beginning or ending on the frame you plan to cut. (The recorded track area on U.S. standard 16mm mag film is the top quarter of the film opposite the edge with sprocket holes.) This way you can try different versions of the cut without chopping the track to shreds. Be sure to remove any tape goo from the track or it will clog the heads.

Narration

Narration, or *voice-over*, is used in both documentary and fiction. It may be used to deliver information, provide the point of view of an unseen character, or allow an onscreen character to comment on the action.

Narration should be kept simple and clear—it shouldn't sound "written." When writing narration, practice speaking it aloud to be sure it sounds like natural speech. Avoid complex phrasing or vocabulary that will tax the audience's ability to understand.

Narration sometimes works best when woven in with sync sound from the scene. Look for places where you can float a line of narration, then bring up sync sound, then run another line of narration. This needs to be done carefully—if the narrator speaks over a close shot of someone else talking, it can sometimes be distracting.

Often, editors or directors record their own voices as a "scratch" narration during editing that will be replaced by the actual narrator after picture is locked. Some editing systems allow you to record directly into the system. Narration recording sessions should be logged to keep track of good and bad takes; often you want to combine parts of several takes. Narration should either be recorded with timecode or transferred to a timecoded format after recording to facilitate editing.[1]

Ideally, final narration should be recorded in a sound booth to get high-quality, clean sound with no background noise. Some narration sessions are done while watching the picture, but often this is not necessary. Instead, takes are timed with a stopwatch to make sure they are read at the right speed. See p. 298 for narration recording suggestions.

See Chapter 15 for editing music and other sound editing concerns.

[1]When editing in film, have the mag edge coded before you cut; see p. 380.

THE EDITING PROCESS

The editing process varies by type of production, type of editing equipment and individual editors' preferences. Feature films are usually edited by one or more editors and a staff of assistants. Independent filmmakers or corporate video-makers may work alone. The editing schedule and budget determine many of the procedures used in the editing room.

The Editing Room

Editing rooms have their own rites and rituals. Work space is usually cramped, and there is often material stored from other productions. Make certain all the material for your project is clearly labeled with the (working) title of the production, the name of the production company and the reel number. Store the camera original elsewhere (for example, at the laboratory vault or postproduction facility) until completion of editing. Make sure that camera original film footage or camera original master tapes are clearly labeled as such and that they are in a safe place!

The Editor and Assistant Editor

The editor, usually in consultation with the director or producer, decides how the film is to be cut. On traditional film projects (edited on film) sometimes the editor marks the shots to be cut and an assistant editor performs the physical act of cutting. The assistant also keeps the logbook, synchronizes rushes, reconstitutes outtakes and other tasks. In the past, this kind of relationship played an essential role in the training of new editors and provided useful feedback and aid to the chief editor. With the advent of video editing, the role of the assistant virtually disappeared on many mid- to low-budget television productions. Once the work-tapes were in hand and the editing room was set up, the editor could easily work alone. Nonlinear editing has revived the assistant's role somewhat. Assistants may be used to digitize footage, or to cut workprint on a feature, but often their work takes place at night or other times when the editor is not using the system. The diminished relationship between editor and assistant may lower postproduction costs, but it is also a loss to the editing process.

The Editing Log

Careful logging and recordkeeping during production can save a lot of time in the editing room. On a feature film, a script marked up by the script supervisor shows the editor which camera angles and takes were filmed for every part of the script (see Fig. 8-21). On a documentary, there may be a log of shots or topics discussed in an interview. Generally, the director will indicate the "circled takes" he or she considers good. On a film project, these may be the only takes that are printed or transferred to video. On a video project, logging during production can help you weed out unwanted footage that may not need to be dubbed. See below for more on this.

Production logs help you organize the editing room logbook. Before editing begins, a system should be in place that allows the editor to quickly locate every bit

of picture and sound. On a video project, there should be a list of all the camera original reels, with beginning and ending timecode and a listing of their contents. Once the material has been loaded into a nonlinear editing system, the system's bins and list management software can be used to organize, log and locate shots (see Organizing Clips, p. 428).

On a film project, there should be a camera original log that indicates the beginning and ending key numbers and the contents of every camera roll. Similarly, there should be a log of production audio with timecode numbers, if applicable. If the footage is transferred to video, a telecine log will usually be generated that correlates key numbers to video timecode numbers (see p. 521); this log should be checked for accuracy when loading material into a nonlinear editing system (see Error Checking, p. 396). If the project is being edited on film, the log should correlate camera roll numbers, key numbers and ink edge numbers (see p. 522).

Selecting Shots

As useful as they are for organizational purposes, production logs can sometimes get in the way of editing judgments. On the set, directors indicate the takes they like, often only having seen them once. Sometimes the director may be attached to a shot because it was hard to get. The editor, on the other hand, can bring to the project a fresh set of eyes, unbiased by what took place during production. Some editors prefer *not* to view dailies with directors so they can form their own opinions about what works and what doesn't. In this case, the editor may put together a first cut from the script and then discuss it with the director.

Similarly, though it saves money not to print or digitize takes considered "bad" on the shoot, these takes can be a gold mine to the editor who may be looking for something very specific to solve an editing problem. A take with a bad line reading may make a perfect cutaway. The dead air before a slate may supply just enough room tone to fill a hole (see p. 457). In his book *In the Blink of an Eye*, Walter Murch (who edited *Apocalypse Now*) talks about an unexpected drawback caused by the ability of nonlinear editing systems to instantly locate any shot from the log. In film and traditional videotape editing, you're forced to wait and watch while fast-forwarding or rewinding to find a shot. Nonlinear systems save this "wasted" time, but may deprive you of some serendipitous discoveries. Many times during rewinding you find shots you weren't looking for—shots that trigger new ideas for the cut.[2]

All of these are reasons to avoid too much "preselecting" of material prior to real editing.

That said, it must be pointed out that on many projects, the edit is created almost *entirely* by preselection. The director may take a screening cassette and create a *paper cut*—a list of the selected shots in their proper order, identified by timecode. Various logging programs are available that allow you to capture timecode and

[2]When working on nonlinear systems, some editors like to create a sequence of all the unedited takes together, forming a "virtual tape" of rushes that can be easily viewed from beginning to end.

still images of shots from a tape and shuffle them to the desired order on a personal computer (see Digitizing and Logging Clips, p. 426). Starting with the paper cut, the editor then assembles the shots, tunes the transitions and makes other adjustments. If your budget is limited, this technique may allow you to save time and money in the editing room.

When editing interviews, written transcripts make it much easier to see where things can be condensed or rearranged. On many documentaries it is standard practice to send out an audiocassette of interviews to a transcription service prior to editing.

PICTURE AND SOUND QUALITY. You must always try to translate what you see and hear on the editing system to what the audience will see and hear in the finished movie. Sometimes the editing system is not a reliable indicator of what the footage will look like.

For projects that originate on film and are edited on video, the telecine video transfer may not capture details in the highlights or shadows that may be visible later when film prints are made from the negative, or if a more careful video transfer is done. You may or may not be happy when you later see the hidden details. Be sure to check carefully for flash frames and nearby overexposed frames (see p. 373).

Any project edited on a nonlinear editing system may be digitized for editing at low resolution to save storage space. If you do so, bear in mind that during editing, landscapes and detailed shots may be hard to read. Walter Murch talks about the instinct to use a lot of close-ups because they are *easy to see* on the editing system. Wide vistas or even medium shots that may ultimately look great when the project is finished at high resolution can seem paltry during editing.

The need for good sound quality is noted above. Bear in mind that the small speakers and machine noise of most editing systems mask a lot of detail in the original audio recording. You may not be able to hear problems or even desirable-but-quiet sounds (see Chapter 15).

From Rough Cut to Picture Lock

To begin editing the movie, the unedited footage from the camera (*dailies* or *rushes*) is divided into shots you want to use (the *in-takes* or *ins*) and shots you put aside (the *outtakes* or *outs*).

An *assembly* (sometimes called a *string-out*) puts the shots in the order called for by the script. For unscripted material, an assembly may simply be all the sequences in chronological order. The *rough cut* is the first attempt at shaping the film. For scripted films, the assembly and first rough cut may be essentially the same thing. In a documentary, the rough cut may be made by shortening and reordering the sequences from the assembly.

The editor usually attempts to put together the rough cut fairly quickly, worrying not about the pace of scenes and getting everything to work well, but about establishing the overall direction of the work. It is generally easier to cut out footage than it is to add material. For this reason, most editors prefer to edit rough cuts on the long side. Rough cuts are often two or more times as long as the final film.

As the movie continues to be edited and refined, you may have several rough cuts. One of the nice features of a nonlinear editing system is that you can save different versions for comparison. When the basic scene order is in place and you start polishing individual sequences and transitions, this is called *fine cutting*. The rough cut becomes a *fine cut*. When you are done making changes to the picture, this is *picture lock* or *picture freeze*.

If you prefer, you can fine cut from the start of editing instead of making rough cuts. Even though this approach requires more time to complete the first cut, you may be better able to judge the editing. However, you may find it easier to fine cut and pace individual sequences *after* you've seen the overall direction of the movie as expressed in the rough cut.

Test Screenings and Feedback

Editing, whether done on a nonlinear system or a traditional film or video editing system, requires an intense, focused kind of thinking. You sit close to the screen and get deeply involved in large problems and tiny details. This is not a good environment to judge if the movie is really working. You need to step back occasionally and see it from a different perspective.

For projects that will ultimately be shown on a big screen—either in film or large-screen video projection—it's imperative that you view the movie on a big screen during the editing process. The transition from small screen to large can be startling. Sometimes the pace of the movie seems to speed up and sometimes to slow down. Wide shots that may seem boring on the small screen suddenly reveal fascinating detail. Close-ups may seem overpowering when ten feet tall. Cuts that draw the eye's attention from one side of the screen to the opposite side may seem a little jumpy on the small screen and very jarring on the big one. If you can't get access to a big screen, at least make a tape that you can take out of the editing room and view in a different setting.

Watching the movie with an audience is another important part of getting a fresh perspective. Even watching the movie with *one* person who is not part of the editing team will cause *you* to see it in a different way, with a different sense of the timing and content. Filmmakers vary on the value of test screenings with larger audiences. Some love to get feedback (or may be forced to get it by backers or studios). Some resent the idea of putting important, personal decisions to something that seems like a vote. Often, test audiences disagree with each other on which scenes should stay or be cut. One audience may laugh where another is silent. In the end, the filmmakers must make the editing decisions.

Another factor in test screenings is the problem of showing unfinished work. You can explain what a "rough mix" or "uncorrected picture" means all you want, but even experienced professionals may lack the ability to imagine what the movie will be like when finished.

Test screenings can be very valuable to determine if something in the movie is confusing, boring or really doesn't work. However, showing unfinished work can have drawbacks too. For more on showing unfinished work to backers or distributors, see Chapter 18.

Fig. 12-2. Palmer 16mm Interlock Projector for double system projection with picture and mag film on separate reels. (W. A. Palmer Films, Inc.)

Finding the Right Length

If your movie lucks out in the mix of writing, direction and editing, it could happen that the rough cut plays just fine at the length it was intended to. Congratulations, and enjoy the easy finishing process ahead.

For most projects, however, you have some tough decisions. The rough cut may be many hours long. Or the fine cut may seem too *short*. How do you find the right length for the project? Do you let the material dictate length, or do you try to cut it to a standard length?

Start by asking yourself what would make the best, tightest movie. If a movie is too long, audiences can turn on it, even if they liked it at first. Well-edited, taut movies keep audience energy high and allow the ideas and emotions in the film to emerge clearly. Be hard on yourself—don't hold on to a sequence just because you're in love with it; only keep it if it really works in the context of the whole film. Filmmakers sometimes talk about the process of paring down a rough cut as "killing your babies." If two sequences repeat the same idea or emotion, consider dropping one of them. If you can get away with starting a shot ten seconds later, trim off the head. Many filmmakers have had this experience: they finish a fine cut, declaring the movie finished and tight. Then, perhaps to fit a broadcast slot (see

below), they begrudgingly cut some time out. They comb the film for every slack or wasted moment. In the end, they like the shortened version better.

Be especially attentive to the first few minutes of the movie. Outside of a theater (where the audience is captive) some people will only choose to watch the movie if they're hooked in the first several scenes. On the other hand, if you start things out *too* quickly (in the first minute or so) you may lose people who haven't settled into their seats. If there are head titles (see below), consider developing the story visually under or between the titles—this keeps things moving even while people settle in.

LENGTH AND DISTRIBUTION OPPORTUNITIES. In determining length, you must also consider potential distribution. If you're making a feature film, typically these run about ninety minutes to two hours, give or take. If a film is only slightly over an hour, it may not be considered a "feature" for theatrical, festival or broadcast slots. If a feature runs substantially over two hours, exhibitors (theater owners) get nervous because it means they can have fewer shows per day and broadcasters may want to cut the film shorter to fit a two-hour (or even 90-minute) program slot.

Documentaries may be feature length, or they may be shorter. There are many more opportunities to show a one-hour documentary on cable or broadcast television than if the program is longer (even a series may sell to more markets if each show is an hour or a half hour).

For any broadcast slot, you need to deduct time for station IDs and advertising or promotions. A "one-hour" program may run 58 minutes or much less, depending on the broadcaster's needs.

When producing something for an educational market, keep in mind the typical length of a class in whatever age bracket you're targeting. Sometimes a one-hour film is cut down to 20 to 40 minutes for educational distribution. Movies for young children are often 10 minutes or less to accommodate short attention spans.

For corporate and industrial projects, about 10 to 15 minutes is sometimes the longest that busy executives or workers want to spend watching a movie. Short and punchy is better than too detailed and long.

Titles

Planning the titles and credits and placing them in the movie is part of the editing process (though the actual title design and production may be done after editing is finished). Titles and credits may be created by a professional designer at a title house or postproduction facility or you can work them out on your editing system or personal computer.

Some titles and credits appear as lettering over a plain background or other nonmoving graphic. Titles that appear over a moving film or video image are called *supers* (for superimposition, see Fig. 14-27).

When a name appears as static (nonmoving) lettering, this is considered a *title card*. If there are *head credits* at the beginning of the film, these are usually individual cards that fade in or cut in. Title cards may be supered or nonsupered, though some people use the term *title card* to mean a nonsupered title.

End or *tail credits* may be done as cards, but more often they are done as a *crawl*,

in which a long list of names moves up from the bottom of the screen. Vertically moving titles are also called *credit rolls* or *scrolls* (sometimes *crawl* is used to mean a line of horizontally moving type). The advantage of a credit roll is that the various credits can be given equal screen time (cards tend to favor the names at the top of the card) and the whole list can be read comfortably in less time. With cards, on the other hand, it may be easier to make changes or correct errors. Extensive head credits are common in Hollywood films (with the biggest star credits coming before the title), but lengthy head credits on student films can seem pretentious. There is a generally accepted order for various credits, which is often stipulated in contracts or union rules.

A rule of thumb is to keep titles on screen long enough to read them aloud twice. Experiment with pacing. Overly slow titles may slow down the film and bore the audience. Too quick titles may leave them frustrated.

When choosing a typeface for the lettering, avoid fonts that have very narrow lines or serifs (the angled lines that extend from and ornament some type styles). Usually, lettering should be no smaller than about ½5 of total image height (that is, no more than 25 lines on screen at once). Though feature films sometimes use titles that extend to the edges of the widescreen image, since most movies will at some point be shown on standard TV, it is safer to prepare titles that fit within the 4 × 3 rectangle (see Aspect Ratio, p. 37). Lettering for standard (non-widescreen) television should fit within the *TV safe title area*, which is smaller than the *TV safe action frame* marked in some camera viewfinders (see Fig 8-6). Film crawls often look best if centered on a central *gutter* with the job title extending to the left of the gutter and the name extending to the right. Look at movies for layout ideas.

Try to put superimposed titles over shots without excessive movement or complexity that might fight with the titles. Titles will make any camera jiggle especially noticeable. Supers can be made more readable by using *drop shadows*, which rim the letters with a dark edge to separate them from the background. Supers used in documentaries to identify film subjects are sometimes called *lower thirds*, since they fall in the lower third of the frame. Often, lower thirds are set against a dark rectangular *pad* to help separate them from the background. If lower thirds are anticipated, be sure to shoot your subjects with enough room at the bottom of the frame to accommodate titles.

If the project is distributed in foreign markets, you may be asked by broadcasters for a *textless version* of the movie so they can do foreign language titles. If you plan for this during post, you can create textless background elements on which titles can be added later.

In video, supered and nonsupered titles are both easy to do. In film, supered titles may cost more than nonsupered titles, depending on the printing method used. For more on generating video titles, see p. 443. If you are shooting titles on film, see p. 488.

Editing Film | CHAPTER 13

The first part of this chapter is about cutting film-originated projects the traditional way—using film editing equipment. The second part is about the special concerns when using nonlinear or videotape equipment to edit projects that were shot on film. See Chapter 1 for an overview of film editing, Chapter 12 for a discussion of editing styles and technique and Chapter 14 for more on video editing systems.

TRADITIONAL FILM EDITING

The world has moved toward using nonlinear video systems to edit film projects because of the power and flexibility these systems offer. Yet, as we discussed in Chapter 1, there are still reasons to edit films on *film*. Among them: (1) film editing equipment is now very cheap; (2) you can start a project on one film editing system and switch to another later with no problems other than having to bring your workprint to the next editing room; (3) the image you see in the workprint gives the best representation of what's in the original negative and can be viewed and projected to an audience with excellent color and clarity.

Film is the *original* nonlinear editing medium.

EDITING EQUIPMENT

The *editing bench* (see Fig. 1-12) is a table that may be equipped with the following.

Cores, Reels and Rewinds

In the editing room, film is usually stored on camera cores (see Fig. 2-17). Flatbed editing tables (see p. 366) can accommodate *core wound* (*tight wound*) film. Camera raw stock comes in 2" cores, but 3" cores are better for the editing room use, since they put less stress on long rolls of film. When the film needs to be put on a reel for projection or for work on an editing bench, it is mounted on a *split*

reel, which is made up of two halves that screw together. A *flange* is like half of a split reel and allows film to be wound on a core. Some flanges allow film to be wound around itself without a core. Short takes are often stored this way.

Fig. 13-1. Moviola rewind with long shaft, spacers, spring clamp and support. (J & R Film)

Handle core-wound film carefully, especially if it is not very tightly wound. Hold the film flat like a pie, with your palm underneath; otherwise, the center may fall out (*dishing*). If dishing should happen, find a splice, or make a cut, and separate the two halves. Place the half without the core on the plate of a flatbed editing table and tape the inside end of the film to a core put in the empty center. Run the machine so the plate spins, and hold the outer end of the film in place while the inner part of the load winds onto the core. After both halves are rewound, splice them back together.

Double-key reels have two square holes on each side for mounting the reel onto projectors or rewinds. *Single-key reels* have one square hole and one round hole. The round hole is "idiot proofing" to prevent the film from being loaded in a projector backward, making single-key reels good for release prints but troublesome in the editing room.

A pair of *rewinds* permit the film to be rewound or searched. Rewinds equipped with a friction or tension adjustment permit drag to be increased on the feed side to prevent film from *spilling* (unwinding without control) during rewinding. Drag can also be increased if rewinds develop the nasty habit of rotating by themselves.

Use the drag adjustment or your hand to put tension on the film as you rewind it. Leave no slack between reels, since the slack may suddenly be taken up and the film broken.

Rewinds may be fitted with long shafts to accommodate more than one reel (as when working with sound). Use an end support if more than four 16mm reels are

mounted on a shaft. Use reel spacers or camera cores between reels and use clamps to hold the whole assembly in place (see Fig. 13-1).

The Viewer (Action Editor)

Viewers (see Fig. 13-2) are helpful for cutting MOS (silent) sequences and for searching rolls for particular shots. The viewer image is generally not sharp enough to judge the quality of the focus on a shot. Use a projector to evaluate footage for focus and quality. Viewers equipped with a built-in sound head or used with a synchronizer (see below) can play sound and picture together.

Fig. 13-2. Hervic/Minette super 8 editor/viewer. (Hervic Corp.)

If you are editing original (not workprint), use a viewer with a simple film path to minimize the chance of scratching film. Never whip film through a viewer at rewind speeds. The better-quality viewers allow you to mark the frame on the viewer screen with a grease pencil. Avoid devices on viewers that mark the frame by notching or nicking the film.

The Splicer

In the editing room, virtually all picture editing is done with tape splicers that use clear *Mylar tape* to join pieces of film. Tape splices encourage experimentation, since pieces of film can be attached and separated easily. Placing many tape splices close together may make it difficult to judge a cut. During projection, tape splices may throw a couple of frames out of focus at the cut and, over time, the tape may discolor. Forewarn the lab if footage to be printed has tape splices, since ultrasonic cleaning may remove them (see Chapter 16).

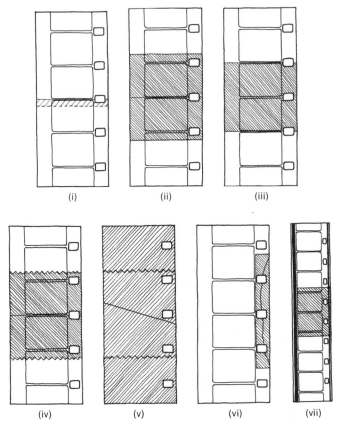

Fig. 13-3. Splices. (i) 16mm cement splice (shown here) extends into one frame. 35mm cement splice does not show up in the picture area. (ii) Tape splice that extends past the frame line. (iii) Tape splice that falls on the frame line. (iv) Tape splice on a Rivas splicer showing jagged edge. (v) Diagonal splice on magnetic sound film made with a Rivas splicer. (vi) Tape repair of torn perforations. (vii) Super 8 guillotine tape splice that does not cover the main magnetic sound stripe but does cover the balance stripe.

You should generally splice on the base side of film to avoid pulling off film emulsion. Splicing on only one side is faster in both making and removing the splice, but some projectors and editing machines will only take picture spliced on both sides (*double spliced*). Single-spliced picture may jam or jump in these machines. Double splices are stronger and do not stretch (telescope) like some single splices.

Tape is available in three basic forms: unperforated in rolls, perforated in rolls and precut perforated. The *guillotine splicer* (made by various manufacturers) is used with unperforated tape. The tape is stretched over the film and the splicer punches out the perforations. The tape lies across the frame line and is less visible on projection. Some models also have a diagonal cut for sound editing (see below).

Unperforated tape is the least expensive, costing about one fourth as much as perforated tape. The splicers themselves are fairly fragile and must be kept clean of glue and punched perforations. The tape is relatively thin, allowing it to pass through projectors well, but splices may telescope over time.

Perforated tape in roll form is used in 16mm and 35mm with the Rivas or Hollywood Film splicers. Some models cut the tape straight, along the frame line, making the physical cut less obvious than on those models that cut with a jagged edge that rests in the picture area. In either case, the tape is fairly thick and is noticeable upon projection. These splicers need less maintenance than guillotine splicers and do not leave little punched perforations to gum up the works.

Precut splices, the most expensive of the tape splices, are made primarily for the amateur market. They are very thin, easy to remove and make the best-quality splice for picture, but are relatively slow to apply and are not often used in the professional editing room. Kodak Presstapes show in the picture area but can be cut with scissors to make a splice that extends only to the frame line. They make the least noticeable splice of any and are sometimes used in emergency situations (as when original must be spliced without losing frames). Precut splices may be used with a Rivas splicer or an inexpensive *splicing block*, a grooved block with registration pins to hold the film and a slot to guide a single-edged razor blade for cutting.

Check each tape splice you make. Remove air bubbles by rubbing. Trim tape that overlaps the edge of the film (which happens with dirty guillotine splicers or poorly manufactured perforated tape) with a razor blade or sharp scissors; otherwise, the film may jam during editing or projection. See below for splicing mag sound.

CEMENT SPLICERS. Cement splicers are primarily used for splicing negative before printing and for fixing or joining reels of release prints. A cement splice is made by scraping the emulsion off one shot and then bonding the bases of the two shots together with fresh film cement for a strong union. One frame is lost where the emulsion is scraped at each cement splice.

Some older cement splicer models cut into frames on both sides of the splice, but the preferred newer models only cut into one of the frames. *Negative splices* are slightly narrower and cover less picture area than *positive splices*, but, when properly made, are as strong. In 35mm, the cement splice is outside the projected picture area, so the splice does not show on projection. In super 8 and 16mm, on the other hand, the splice does cut into the picture area and is visible on projection. A & B roll printing allows cement splices to be hidden in the smaller gauges (see Chapter 16). Consult Appendix H for techniques of cement splicing.

The Synchronizer

A *synchronizer* keeps film and sound track(s) locked together in the exact same relation to each other as you move from one part of the film to another. A synchronizer has one or more sprocketed wheels, called *gangs*, mounted on a revolving shaft. Sound and picture are usually mounted on separate gangs and are kept in sync frame-by-frame as the sprocket wheels engage the perforations of the picture and mag sound. You can mount a sound head on one or more of the gangs to reproduce

the sound through an amplifier and speaker (*squawk box*). If you also use a viewer, place it a standard number of frames from the sound reader and find a point where picture and sound are in sync. Place a point on the sound (like a slate or start mark) under the sound head, and place the corresponding point on picture in the viewer gate. The picture and sound will now be kept in sync by the synchronizer.

Fig. 13-4. Moviola four-gang synchronizer. The fourth gang is shown with a magnetic sound head attachment. The dial on the first gang is an adjustable frame counter. Most synchronizers also have a footage counter; this one has a time counter. (J & R Film)

To get decent sound reproduction, the film has to be cranked at around 24 fps. If the sound is low pitch, speed up the cranking; if high pitch, slow down. Sound through a squawk box is often barely intelligible. Nevertheless, almost all editing tasks can be done with the synchronizer equipped for sound reproduction. Additional gangs allow more sound tracks to be held in sync with the picture.

The synchronizer is also used to measure leader or film. Measure footage in feet and frames by setting the frame counter disc to 1 at the first frame, setting the footage counter to 0 and cranking the film through. Equal lengths of film can be measured by sandwiching the two strips together in one gang or placing them in different gangs. Most synchronizers read footage from left to right. Synchronizers are available with one to six gangs and may be ordered with gangs of different gauges—for example, one 16mm and one 35mm gang. This can be an excellent tool for calculating footages from one format to the other.

Flatbed and Upright Editing Machines

Flatbed editing machines (sometimes called *editing tables*) are generally preferred for editing 16mm and 35mm films. Popular flatbeds are made by Steenbeck, KEM and

Moviola. A *six-plate* editing table has three film transports and allows you to run one roll of picture along with two sound tracks (each transport uses one plate for the feed side and one for the take-up). An *eight plate* gives you the possibility of two picture and two sound reels (see Fig. 13-7). With an eight plate you can put the dailies on one pair of transports and the edited sequence on the other pair, making it very easy to search for shots and then splice them into the movie. You could also run one picture reel with three sound tracks. The transports can all be locked together in sync, or, by disengaging the clutch on any transport, you can run any combination or individual track separately.

Fig. 13-5. Moviola editor/viewer with three sound heads combines synchronizer, viewer and sound head—a less expensive alternative to a flatbed editing table. (J & R Film)

Some machines have a hollow, or *flickerless*, prism that cuts down on the image flicker present in the conventional prism. There is a story of an independent feature film edited on a flatbed that was never projected to check the footage. The flicker of the flatbed masked a flicker present on the film caused by camera malfunction. Only after the film was blown up to 35mm was it discovered that the image was unwatchable, and the film was never distributed.

Some flatbeds are modular (for example, the KEM Universal), allowing the machine to be expanded to various combinations of sound and picture heads. Modular machines may allow for a combination of super 8, 16mm or 35mm heads. Some editing tables have record heads for sound mixing. Many tables have a built-in *light box*, which is a lighted translucent surface that allows you to examine film frames with light from behind.

Starting in the 1920s, the standard machine used to edit films was the *upright*

Fig. 13-6. Moviola six-plate flatbed editing table. (J & R Film)

Fig. 13-7. Steenbeck eight-plate flatbed editing table. The model pictured is set up for editing 35mm picture with 16mm sound. (Steenbeck, Inc.)

Moviola. The upright Moviola is a motorized viewer with a sound reader that shows synchronized picture and mag sound film. It is used for marking shots and judging cuts, but the actual splicing is done on an editing bench. The image in the machine is small but sharp. Editing on an upright is usually intense and demands a great deal of energy. The machine is noisy and the editor is often standing, yet there are still some who prefer them.

Fig. 13-8. Moviola upright editing machine. (J & R Film)

Editing rooms, usually equipped with a six- or eight-plate flatbed editing machine, may be rented by the day, week, month or longer.

MATERIALS AND SUPPLIES

Leader and Fill

Blank film for threading and writing information on, called *leader*, should be attached to the beginning (the *head leader*) and the end (the *tail leader*) of every roll of dailies, camera original, magnetic film, assembly and outtakes. Use at least 5' to 6' of leader at the beginning and end of each roll and write on every leader the film title, name of production company and roll number, as well as "head" or "tail," depending on its position in the roll (see Fig. 13-12).

Lightstruck, a white or yellowish leader available from film manufacturers, is usually the least expensive. You can write on it with an indelible marking pen such

as a Sharpie. Lightstruck has a dull emulsion and a shiny base. The emulsion can be distinguished from the base in two ways. Hold the film obliquely to a light source to distinguish the dull from the shiny side, or place the leader or film between slightly moistened lips or fingers to see which side sticks, the sticky side being the emulsion.

Polyester leader (for example, Starex) is more expensive. It has no emulsion (both sides are shiny) and is available in a range of colors.

Slug, or *fill,* is unwanted film footage that is used to replace damaged or missing film in a cut and to prepare sound tracks for mixing (see Chapter 15). Discarded release prints may be available cheaply from the lab and used for slug. When this footage is used for picture slug, it is usually cut in upside down to distinguish it from the workprint. Some filmmakers find it distracting and use leader instead.

Leader and slug are available in 16mm, both single- and double-perforated. You can use double-perf leader as head or tail leader only if everything on the roll is double-perf. Otherwise, use single-perf so that the film will not be threaded incorrectly and rip the single-perf sections. 16mm magnetic film must have single-perf head and tail leaders since mag film is single-perf. Use single-perf slug in mag film rolls, because double-perf slug may cause head wear and unwanted noise. Single-perf leader enables you to distinguish easily when a roll is head or tails out. Because of the advantages of single-perf, some editing rooms only use single-perf leaders and fill.

When using magnetic film with leader or fill that has an emulsion side, make sure you splice the emulsion side of the leader to the *base* of magnetic film to avoid having the emulsion clog the sound heads. Avoid shrunken leader or film, since it may chatter and jam during projection.

Other Supplies

Mark your workprint with China marker (grease pencil), which rubs off easily. White and yellow are the easiest colors to see on picture. Do not use grease pencil on sound. Use editing gloves when you handle original or any footage that needs special care to prevent skin oils from getting on the film. Other supplies include splicing tape, fresh film cement, sharp scissors, single-edge razor blades, film cleaner and cleaning felt, masking tape, tape for marking cans, indelible marking pens and a hole punch.

FILM EDITING PROCEDURES

Handling Film Footage

Most films are edited with workprint, in which case the camera original should not be stored in the editing room (see p. 354). However, some super 8 and 16mm films shot on reversal stock are edited with the original. Original material is irreplaceable and needs special care. If you are in doubt about whether a piece of film is original or workprint, you can generally distinguish the workprint by looking at the key numbers (latent edge numbers). Original is almost invariably B-wind (see Fig. 4-11) and has key numbers that read through the base. Reversal workprint is A-wind, and its key numbers read through the emulsion. Intermediate materials (see Chapter 16) rarely have edge numbers.

When working with camera original, keep the editing room clean and dust free. But workprint, too, should be kept as clean as possible. At the end of each day's work, cover the tables and bins with plastic. Keep the floor, in particular, clean. Do not allow food and smoking in the editing room.

Hold film by the edges to avoid getting skin oils on the picture or sound oxide. Store rolls in cans or boxes (you can get special cardboard boxes that hold a roll of picture and sound).

Cinch marks are caused by pulling the end of a loosely wound roll to tighten it. Pushing down on the center of a tight-wound roll that has started to dish will also cause cinch marks. See p. 362 for instructions on fixing a dished reel.

A clean workprint allows you to judge the film better. It's likely that you'll show the film during the workprint stage to nonfilmmakers—investors, trial audiences or distributors—who may have little understanding or tolerance for scratched and dirty film. When cleaning a film for a screening, use any of several commercially available cleaners, such as Kodak Film Cleaner or Ecco 1500. When you clean magnetic film, be sure to use a cleaner that does not remove the oxide coating. Slightly moisten a lintless cleaning pad or felt with cleaner and sandwich the film in the folded pad as you slowly wind the film from one end to the other. Hold the pad near the feed reel and go slowly enough so that the cleaner will evaporate before the film is wound on the take-up reel; otherwise, there will be a mottle on the film, which can usually be removed by cleaning the film again. Reposition and clean the pad often to avoid the buildup of dirt that may scratch the film.

Assembling Sequences

Like all types of editing, film editing involves going through the rushes or dailies to select shots you want to use, then adding them to the edited sequence that you build up, shot by shot. Like digital nonlinear editing, film editing allows you to add or delete shots from the sequence at any point whenever you like. When removing a shot, you can cut it out and resplice the roll, shortening the sequence. Alternately, you might choose to remove a section of picture and replace it with leader or fill (called *slugging*) to maintain the previous length of the sequence and the sync relationship with the sound track.

When measuring a length of leader to replace a shot, there are several ways to ensure the two pieces of film are the same length. You can hold the two next to each other to mark the length or put them in a synchronizer. Many editing tables have a frame counter much like a yardstick, on which you can measure frames. You can also use a flatbed's film transports to measure out longer pieces. Put the leader in one of the sound transports, and mark the first frame of leader opposite the first frame of the shot you want to take out. Roll the film forward to the last frame and mark the leader accordingly. On some flatbeds you mark the frame that is centered in the picture head and the one directly on the sound head. On some machines, like many Steenbecks, you can get a more precise alignment by pulling the film down against the rollers on the side. Have someone show you the proper threading for this.

While editing sequences, individual shots can be hung on pins in a *trim bin* (*film bin*). Some editors put the shots in order in the bin before splicing them into

a sequence. As noted above, when working on an eight-plate flatbed, it's easy to take shots directly from the dailies to the rough cut without hanging them in bins first. Some people like to use two flatbeds—one to search footage and the other to run the edited cut.

Fig. 13-9. Trim bin. You can make your own bin by bolting a wooden rack to a garbage can lined with cloth or plastic. (J & R Film)

Trimming and Reconstituting

When you remove an entire shot or a section from the head or tail (a *trim*), hang it in a trim bin. Organize the pins in the bin by sequence or by edge code number so you can find footage when you want it. On feature films, many editors use *trim tabs* or *cinetabs*, which are small slips of cardboard hung in the bin to identify the shot on a given pin.

Footage not being used is considered outtakes or *outs*, but many shots will alternately be part of the ins and the outs as you experiment with the rough cut. One way to keep track of outs is to *reconstitute* them—that is, return them to their workprint rolls. Use ink edge code numbers or key numbers to determine their proper order. If the footage has sync sound, reconstitute in sync (see p. 375). It's helpful to have trims accessible in the bins, but the bins should be reconstituted

periodically when they get cluttered. Arrange shots on pins in order by edge number before putting them back into the outtake rolls. You will find that you can locate many shots that have mysteriously disappeared by looking at the bottom of the bin. When moving bins, tape the ends of the pins so shots don't fall off.

Successive fine cuts create their own outtakes. Incorporate these outtakes into the first outtake rolls; otherwise, if a trim roll is made for each version, it becomes difficult to find the extension of a particular shot, since it could be on any one of a number of rolls. It is easy to locate an extension if all the outtakes are reconstituted by edge number.

Things to Watch Out For

FLASH FRAMES. Check the beginning and end of each shot for *flash frames* (overexposed frames caused by the camera stopping with the shutter open or when the camera changes speed at the beginning or end of a take). Hold the end of the shot up to a white wall or a light box and look for variations in exposure. You must check carefully, since often a drastically overexposed frame is surrounded by several subtly overexposed ones. If you see a slight flashing at cuts when viewing the movie, this may mean you've left in some flash frames.

CUTTING FRAMES. When the negative is cut prior to printing, at least one *cutting frame* is needed at the head and tail of each shot to make the cement splice (see Chapter 16). If you are using two parts of the same take (a *split shot*), delete and put aside some frames of workprint between the two shots to allow for the cement splice. Some negative cutters lose only one frame, especially if they are warned that it is a split shot, but others, as a matter of course, leave a frame or more at each end of every shot pulled from the original. To be safe, you may want to leave three or more unused cutting frames between the shots. The number of unused cutting frames is sometimes called the *cut margin*.

FADES AND DISSOLVES. Unless blowups or other special printing is needed, films are generally printed on contact printers (see Chapter 16). Contact printers usually make fades and dissolves in lengths of 16, 24, 32, 48, 64 or 96 frames. Optical printers are not restricted in fade lengths. Check with your lab to see what is available.

A 48-frame fade or dissolve is fairly standard. The first and last quarters of these effects often show little noticeable change (that is, the first 12 frames of a 48-frame fade-in look dark, the last 12 have nearly full exposure), so they seem to go by quicker than the frame count would suggest.

If one shot is to dissolve into another, find the overlapping frames. For example, a 48-frame dissolve has a 48-frame overlap, 24 frames from each shot (see Fig. 13-10). Check the overlap to make sure there are no flash frames or unwanted movements. Store the workprint of the overlap frames in a special place so it can be checked at any time for sufficient length. Too often, the negative cutter comes across a marked dissolve on the workprint and cannot find the extension in the original.

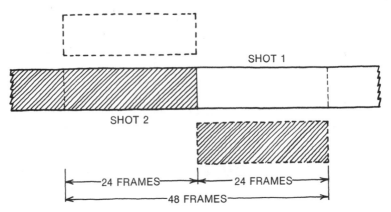

Fig. 13-10. Dissolve. Trim and put aside the workprint extensions of both shots to be used in a dissolve. A 48-frame dissolve needs a 24-frame overlap from *each* shot. (Carol Keller)

SHOTS WITHOUT KEY NUMBERS. Short shots (those fewer than 20 frames in 16mm) may not have a key number (see Fig. 4-12). Write the closest key number on the shot in grease pencil to aid the negative cutter when he or she is conforming (see Chapter 16). If for some reason an entire roll lacks key numbers, this may be a workprinting error (see p. 476) or because the original lacks key numbers. Consider having ink edge code (see p. 380) applied to the original and workprint before editing. Workprint without key numbers can be matched to the original by eye, but this is very difficult if the location of the shot on the roll of original is not known. Shots with a lot of camera or subject movement are the easiest to eyeball. Find frames with distinctive movement, line up the original and workprint in a synchronizer, and roll them in sync to find the head and tail of the shot.

FOOTAGE FROM DIFFERENT SOURCES. On some productions, stock footage (archival or library footage) is edited with workprint footage from camera original. Sometimes the stock footage is of the wrong wind and will either project flipped or will have to be spliced in base-to-emulsion and will be out of focus during projection. When you use stock footage, be sure the footage is available in a wind that will match the camera original (B-wind). Workprint is usually A-wind. Check the stock footage for wind and, if it is B-wind, send it to the lab to be workprinted or, if it is A-wind, to be duped to change winds. Check frame lines on stock footage to make sure they match the camera original (see p. 73). Sometimes optical printing must be done to correct significant differences. If stock footage has no key numbers, edge code it and its copy for negative matching. If you are only using some of the stock footage, it is sometimes less expensive to do clip-to-clip printing (see Chapter 16).

EDITING 16MM AND 35MM. There are certain important numbers to keep in mind when editing film, and the numbers vary from 16mm to 35mm. It can sometimes get confusing when moving back and forth between the formats (for exam-

ple when mixing a 16mm film on a 35mm system). Both formats run at 24 frames per second, but the 35mm frames are physically larger. Thus there are 40 frames per foot in 16mm and the film runs at 36 feet per minute; but there are only 16 frames per foot in 35mm and the film runs at 90 feet per minute (which is 2½ times faster). A 20-minute reel in 16mm is 720 feet; in 35mm it is 1800 feet. You can make the conversion in footage using a special editing calculator like a Reddy-Eddy, a 16/35 synchronizer (just dial the footage in one format and read the equivalent in the other) or by using any hand calculator.[1]

REEL LENGTH. Films are divided into manageable lengths for editing, mixing and printing called *reels*. A typical film will be made up of several reels. In 16mm, reels over 1000 to 1200 feet (27 to 33 minutes) are awkward to work with in the editing room. Though it is possible to print 16mm in longer lengths, some labs prefer that reels not exceed 1200' to minimize handling damage. The standard 35mm editing reel is about 10 minutes (1000') though 35mm films are generally printed and released on 2000' reels (22 minutes). Talk to the lab and mixing facility for their preferences. If you're cramped for space on the reel, remember that the head and tail of the reel is reserved for printing leaders; the movie itself can't be as long as the reel. When you're done editing, the reels need to be *balanced*, so each has approximately the same, full load. Be attentive to the scenes at which reel breaks take place, particularly the first scene on a new reel. Avoid having reel breaks where music is playing or before scenes with important information (in case the projectionist messes up the transition from one reel to the next). The heads and tails of reels tend to get a lot of wear and tear, so try to avoid very light scenes which show dirt more.

After a film is printed, the reels may be spliced together for projection or shown alternately on two projectors, using a changeover device. See 35mm Release Prints, p. 501, for inscribing changeover marks on the release prints. See Optical Tracks (Analog), p. 503, for special precautions in preparing sound tracks for multireel films.

MAGNETIC TRACKS AND SYNCING DAILIES

Sound Transfer

Sound is recorded during production with an audio recorder using ¼" tape, DAT or other formats. In traditional film editing, the audio is then *transferred* to sprocketed magnetic film (also called *mag stock* or *mag*) for editing with the picture. In 16mm, editing is usually done with *fullcoat*, which has sprocket holes like camera film but, like audiotape, is covered on one side with a brown or black oxide for recording the sound. In 35mm, editing is often done with *stripe*, which looks

[1]To convert a 16mm shot that is 10 feet, 3 frames long to 35mm footage, start by converting the shot length to frames. 10 feet × 40 frames/foot = 400 frames; now add the extra three frames to get a total of 403 frames. 35mm has 16 frames per foot. 400 frames ÷ 16 frames/foot = 25.18 feet or 25 feet, 3 frames.

Fig. 13-11. Amega 16mm magnetic film recorder/reproducer. Also known as a dubber. (Rangertone Research. Inc.)

like clear camera film but has a thin strip of oxide for the sound and a *balance stripe* on the other edge. When sound is transferred to mag you can edit it easily with the picture and the original recordings are safe from damage.

Fullcoat comes with either an acetate or a polyester base. Acetate base tends to shrink with age and low humidity, and it is more brittle than polyester, a condition that worsens as it ages. Polyester is less costly, more resilient, and less likely to tear. Polyester can, however, be tougher on equipment since it is so hard to break.

A roll of mag film may be slightly magnetized when you buy it. At some sound houses, it is standard procedure to demagnetize virgin mag film before it is used (see Erasure, p. 251). Filmmakers hoping to cut costs sometimes buy used mag film or discount brands. Avoid used stock that has many splices, scraped or worn emulsion, or has shrunk from age.

Sound transfers are typically done by sound houses that charge $60 or more per hour (it may take as long as two hours to transfer one hour of tape). It is often possible to get access to transferring equipment through schools or filmmakers you know, and doing your own transfers is not hard. Sound is usually transferred while the picture is being processed.

Wild (nonsynchronous) sound is transferred simply by playing the original tape and rerecording it on a magnetic film recorder, or *dubber*. (The word *dubbing* comes from "doubling"—that is, "to copy." *Dubber* is sometimes used to mean a machine that only plays back magnetic film.) Sync-sound tapes must be *resolved* to ensure proper speed during transfer. If you're doing your own transfers, be sure the system is set up to resolve sync tapes. For more on resolving, see Speed Control for Synchronous Recording, p. 254.

If a reference tone was recorded on the original tape, use it to set the recording level during transfer. The transfer level will normally be set so that the tone reads 0 dB on the transfer equipment's VU meters (this is true even if the reference tone was originally recorded at −8 dB on a Nagra modulometer; see Analog Recording Level, p. 288). But the reference tone is just a starting point; the level needs to be checked on the actual program material. If the transfers are being done by someone else, warn them of any unusually loud or quiet passages on the tape.

If the field recordings were made with timecode, you may want to use a transfer house that is equipped to print timecode on the mag film. However, some of these systems are not accurate enough to permit syncing up by number (see below).

Sometimes, a minimal amount of equalization is done during transfer; perhaps to roll off (reduce) low-frequency wind or rumble. See Chapter 15 for more on equalization.

Handling Magnetic Tracks

Some editors use a grease pencil to mark both workprint and mag film. However, if used on mag film, grease pencil can rub off from one layer on the roll to the next and eventually clog the playback head. A permanent felt-tipped marker such as a Sharpie will not clog the heads.

As noted above, when splicing leader into the sound track, be sure that if the leader has an emulsion, it is spliced so that the emulsion does not come in contact with the sound head. Always splice the emulsion side of the leader to the base side of the mag film. To prevent misthreading, use only single-perf leader for sound rolls, especially at the head and tail.

Tape splicers designed to cut picture usually work fine with mag film. White sound splicing tape may be used instead of clear tape, because it is easier to see on the mag film and it does not stretch as much, thereby avoiding sound dropouts. This is not always true with noperforated guillotine tape. While picture is sometimes double-spliced (that is, taped on both base and emulsion sides) for greater strength and rigidity, never splice the oxide on magnetic stock, or sound reproduction will be interrupted.

Many editors cut 16mm sound on the diagonal, using either a diagonal Rivas splicer or a guillotine splicer equipped with both straight and diagonal cutting blades (see Fig. 13-3). (Note: various makes of diagonal splicers cut at different angles; film cut with one often cannot be butted to film cut with another.) If a straight splice stretches or is badly made, when it passes over the playback head, there will be a brief moment when no mag film makes contact with the head. A diagonal splice, on the other hand, even if slightly stretched, ensures that *some* mag film will contact the head, thus minimizing dropout. A straight cut at the beginning

of a loud section of track can sometimes produce a popping or clicking sound; the same can happen if the mag film or splicer is magnetized. Diagonal cuts minimize these effects. The main drawback of diagonal splices is that if you are using the Rivas system, you will need to use two splicers.

If noisy splices indicate that your splicer is magnetized, demagnetize it immediately with a bulk eraser or a hand degausser. Make several test splices on blank mag film, and listen closely with the playback volume all the way up. This is best done on a dubber to avoid being misled by mechanical noises at the splice (which are heard on some flatbeds).

Syncing Up

When shooting with video camera, sound and picture are usually recorded together right on the videotape; they are already in sync and ready to be viewed or edited. When shooting film, picture and sound are recorded on different machines (double system), and the picture has to be put back together with the sound before true editing begins. This process is called *synchronizing the dailies, syncing the rushes* or, more commonly, just *syncing up* (pronounced "sinking"). When syncing is complete, every sync-sound shot on the picture is matched in frame-for-frame correspondence to the sound track; each roll of picture has a roll of mag film of equal length that can be played back with it.

In most sync filming, there is more audio recorded than picture. This is because the sound recorder is turned on before and off after the camera and because other wild sound (perhaps for sound effects) is recorded when the camera is not running. (Of course, there is also a certain amount of MOS—silent—picture.) Some editors remove all the wild sound during syncing and spool it up on separate rolls. Others leave most of it in place and splice the same length of leader or fill into the picture to keep it even with the sound roll. In general, *no footage should be removed from the picture roll* during syncing unless absolutely necessary: moving picture from one roll to another can result in confusion when searching for footage, and throwing picture away is often regretted later.

Syncing up requires an editing machine like a Steenbeck or Moviola, or an editing bench equipped with rewinds, a synchronizer, viewer, sound head and amplifier. There are many methods of syncing up; one is outlined in Appendix F.

In 16mm, two 400′ camera rolls are usually spliced together during syncing to form one roll for editing, which fits comfortably in a 1000′ capacity can. Longer rolls can be difficult to handle during editing, resulting in wasted time when searching for a particular shot. When the syncing is complete, each roll should have one set of start marks (see Fig. 13-12) at both the head and tail, along with proper labeling so that footage can be easily identified and put in sync when needed.

Many people find syncing up complicated at first and later wonder why it seemed so confusing. Entry-level jobs in film editing often require proficiency in syncing, so it is a skill worth mastering for the beginner who hopes to get employment as an editor.

Fig. 13-12. Properly marked head leaders for editing. The start marks are the X's that cover one frame only and are directly opposite each other on picture and sound. (Carol Keller)

Slates, Accuracy and Lip Syncing

Most double-system sync footage is filmed with the help of a *slate*, whether it be a clapper board, digital slate, slate light or a microphone tap (see Slating, p. 282). When syncing up a slated shot, be sure to line up the *first* point in the picture where the slate makes contact and the *first* point where it is audible in the sound. Sometimes the picture slate occurs *between* frames. Simply line up the exact point where you think the slate occurred in the picture with the first point where you can hear it on the sound track and then shift them slightly so that the two closest frames line up. Sound that is *slightly* late relative to the picture is often less objectionable than sound that is slightly early.

If audio has been recorded with a timecode-capable audio recorder and filming has been done with a timecode slate or in-camera timecode (see p. 283), then syncing can be done by matching the timecode in picture and sound. This is typically done when syncing double-system material for video editing. When editing on film, some labs can transfer mag film with timecode printed on it, but some of these systems do not produce frame-accurate sync. In this case, you would still have to sync up by other means and you would be burdened with numbers that are *slightly off*.

At some point you will undoubtedly have to sync up a shot that has not been slated. To do this, find a surrogate slate in the scene—the closing of a door or an object being placed on a table. Learn to sync up the movements of people's lips with their spoken words. Look for words that contain hard labial sounds like *b* and *p* for which the sound becomes audible *just* as the lips part. The *m* sound can be used, but it is not as precise.

After approximate sync has been determined, experiment by sliding the picture two frames ahead or two back to see if you can improve synchronization. Then try moving it one frame each way. A sync error of one or two frames is usually noticeable to attentive audiences. Syncing should be checked carefully (preferably by projecting dailies on a big screen) before edge coding (see below). Sync errors detected after coding are annoying, and after a print is made, very upsetting.

Syncing Nonsynchronous Footage

Footage that was shot with nonsynchronous equipment or with malfunctioning sync-sound equipment can still sometimes be put in sync. The trick is to run the

playback deck *slightly too slow* during the transfer to mag film; the transferred mag film will then be slightly longer than the accompanying picture. While you are syncing, if the footage begins to drift out of sync, you can cut out a few frames of sound, correcting the error. Playback decks with fine-tunable speed controls can be used to make the transfer. If large speed corrections are necessary, a digital pitch shifter can be used to restore the original pitch of the sound.

Edge Code (Ink Edge Numbers)

After footage has been synced up, an edge coding machine can be used to print identical ink numbers along the edge of the picture and sound rolls. By lining up the numbers, you can instantly ensure that the picture and sound for any shot are in sync. Also, the numbers allow you to quickly find any section of mag film, which is otherwise hard to do. These numbers are variously called *edge code, edge numbers, ink edge numbers, machine edge numbers, rubber numbers* or *Acmade numbers* (for one coding machine). They all mean the same thing. Don't confuse edge code with time-code or keycode (see Key Numbers and Edge Identification, p. 129).

Fig. 13-13. Edge code. After picture and sound rolls have been put in sync, ink edge code is printed identically along the edge of the workprint and the magnetic film.

In 16mm, edge code is printed every 16, 20 or 40 frames, depending on the setup of the coding machine. In 35mm, code is usually printed every foot (16 frames). There are different numbering systems; one system uses two letters followed by four digits (such as AA1234). Another format uses an eight-digit prefix, a four-digit footage count and a two-digit frame count (AB904434-1428 + 10). Whatever system being used, indicate a starting code for each roll when submitting the footage to the lab or coding facility. Every pair of sound and picture rolls will then have the same set of numbers printed on them.

When you get footage back from being coded, put the sound and picture in a synchronizer or editing machine and check that the numbers are in sync with your

start marks and that they run continuously without errors from the head of the roll to the tail.

On some machines, the ink can occasionally spread into the picture area. This is especially a problem in super 8. In general, ink numbering on the original should be avoided.

MARKING WORKPRINT AFTER PICTURE LOCK

When you're done editing (and the picture is locked or "frozen") the workprint is marked with grease pencil to indicate to the negative matcher how various splices are to be treated:

Indicates that shot 2 should begin black and FADE-IN to normal exposure. A 24-frame fade-in is indicated here.

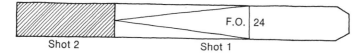

Indicates that shot 1 should begin with normal exposure and FADE-OUT to black. As marked, shot 2 would begin with normal exposure.

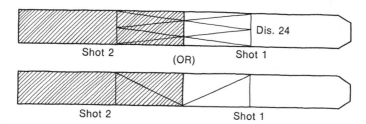

Indicates a DISSOLVE between shots 1 and 2. Note that this is simply a fade-out that overlaps a fade-in.

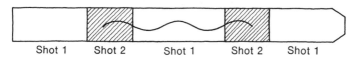

Indicates a DOUBLE EXPOSURE of shots 1 and 2 so that both will be visible simultaneously. This marking is also used for superimposed titles. The beginning and end of shot 2 are cut and spliced into their proper place, indicating the extent of the double exposure. Include enough frames so that there is a key number in each piece.

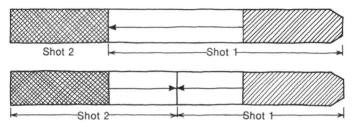

The EXTENDED SCENE marking is used when a piece of workprint has to be replaced with leader because of torn or damaged frames. The arrow indicates to which scene the frames of leader belong.

The UNINTENTIONAL SPLICE mark indicates that a shot has been cut in editing and then put back together, so no cut should be made in the original (normally, the negative matcher will plan to cut the original anywhere he finds a splice in the workprint). A careful matcher should check to make sure all splices are intentional regardless of the mark. You can make splices even clearer to him by putting vertical lines down the center of all *intentional* splices. It is a good idea to put vertical lines to mark the extent of fades and dissolves and to write their lengths in numbers on the workprint. Some negative matchers prefer the markings on the base, others on the emulsion. See Preparing the Original for Printing, p. 479, for more on this process.

EDITING FILM ON VIDEO

At one time, the process of getting a film project from the camera to the screen was fairly standardized. Budgets varied, techniques varied, but the general protocol of making a workprint, editing the workprint, conforming the negative and making prints was relatively predictable (see Film Editing, p. 13, for an overview). Today, fewer and fewer "film" projects are edited on film. Though nonlinear video editing has become the preferred method for many filmmakers, there is no one "standard" route through the process. Instead, there are many options and combinations of options. Choosing your route through the dizzying production and postproduction maze should be done in consultation with the lab or postproduction facility. At each juncture you must juggle questions of cost, time and control over the material. Before you even start shooting, talk to the lab, telecine house, editing facility, audio post facility and negative cutter. We cannot overstate the importance of discussing your plans and procedures with all concerned parties *before* you go to work.

In other parts of the book we address production techniques, film-to-video transfer, nonlinear editing and working with the film lab. In this section we will try to clarify some of the postproduction options by describing two possible scenar-

ios. These scenarios are not offered as recommendations, but merely as way to discuss your options. And there are plenty of other permutations. Later in the chapter we will discuss some of the particular issues of editing film-originated material on a nonlinear editing system.

Warning: the rest of this chapter may give you a headache or make you consider a different career altogether. Take two aspirin and remember that, though there are a hundred ways to get from the beginning of the process to the end, eventually you only have to pick *one*.

Scenario One: Shoot Film, Edit Nonlinear, Finish on Video

This scenario might be used for a project that is shot on film and destined primarily for video distribution or television broadcast. It is geared toward a relatively quick postproduction schedule. If film prints are needed, they are made by doing a video-to-film transfer from the final video master. Please see Fig. 13-14.

In this scenario, film may be shot in any format (35mm, 16mm or super 8) and production audio on location can be recorded in a variety of formats, including ¼″, DAT or others. In-camera timecode or timecode slates (see p. 283) during production will greatly facilitate syncing the audio, but timecode on the picture is not required. If audio has been recorded without timecode, it may be necessary to poststripe it with timecode or dub it over to a timecoded format to permit machine control of the sound during postproduction.

After shooting, the negative is processed (see Chapter 16) and prepared for the film-to-video transfer (the telecine session; see Chapter 17). When film dailies are made for feature films, it is common to separate the "circled" or selected takes (the "buys") for printing and weed out the other material (*B-negative*) prior to making the workprint. For video transfer, however, often the negative is left intact and everything is transferred (you can also fast-forward through undesired material during the telecine session.)

In this scenario, the film will only be transferred to video *once*, so a certain degree of care must be taken in color correction during the telecine session (more than for the "video dailies" in Scenario Two; see below). Even so, final color correction will be done later in the process.

In this scenario, the sound and picture are put in sync during the telecine session. The reason to sync up now is so that the master videotapes will have sound on them. This makes it easy to quickly create cassette copies to send to the director on location or to give to the production team for evaluation and logging. In Scenario Two, the sound is synced later, using the nonlinear editing system itself to do the work. Syncing on the nonlinear system may be the most economical route, especially if you own the editing system. It also may result in better sync. However, syncing on the editing system may delay getting the dailies out for viewing and may make it more cumbersome or sometimes even impossible to generate good-quality viewing cassettes.

Syncing in the telecine is very expensive. Particularly for a long-form movie, it can cost thousands to sync up in the telecine suite (although technology that speeds and automates the syncing process is improving rapidly). As a compromise

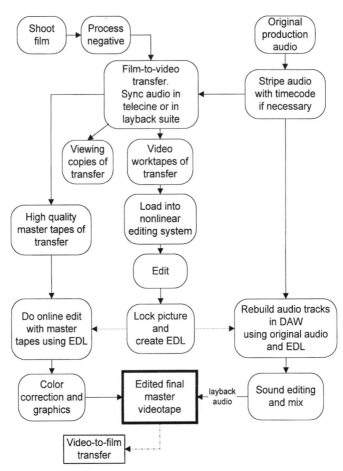

Fig. 13-14. Scenario One. A possible route for shooting film, editing on a nonlinear system and finishing in video. If needed, the edited video master is then transferred to film. On some productions, all the video and sound editing is done right on the nonlinear system without using any other equipment (see Fig. 14-11).

between syncing in the telecine and syncing on the editing system, some people transfer the picture without sound and immediately take the videotapes to a *layback suite*, which is an editing room specifically equipped to sync up sound to video (see Fig. 13-15). It bills at a lower rate per hour than the telecine. Not all facilities have a layback suite.

 In Scenario One, you leave the transfer facility with at least *two sets* of videotapes. One set is the high-quality master tapes, which will be put aside and used later to assemble the final master. These might be made on a digital format such as Digital Betacam. The second set are on a less expensive format and will be used as worktapes in the editing room to load the nonlinear editing system. Some transfers are done directly to computer drives or disks, bypassing videotape altogether.

Fig. 13-15. The layback suite is an editing room specifically set up for syncing audio sources to video. Less expensive than syncing sound in the telecine suite. (DuArt Film and Video).

After the footage has been loaded into the nonlinear editing system (digitized), the project is edited like any other video project (see Chapter 14). When you're done editing and the picture is considered "locked," an EDL can be generated of all the edit decisions (see p. 410).

At this point, some projects are finished right on the nonlinear editing system. This may involve redigitizing the material from the master videotapes at a higher resolution before outputting the finished product. This process is discussed in Chapter 14. See Fig. 14-11 for a possible route to finishing right on the nonlinear system.

Because some nonlinear editing systems aren't capable of working at very high resolution, and many systems are not equipped with high-quality video monitors, waveform monitors and other test equipment, projects that have sufficient time and budget may be taken to an online editing facility for finishing. Here, an online edit can be done using the master videotapes from the telecine and the EDL generated by the nonlinear editing system. This may be a traditional tape-to-tape online, or a high-end nonlinear system may be used. Final color correction is done as it would be for any video project, during the online or after using a video-to-video color corrector. Doing color correction on videotape works much better with digital than analog formats.

In this scenario, the audio you have been working with in the editing system is not of the highest quality (because it was digitized from relatively low quality worktapes). In order to get back to higher-quality sound, you could take the EDL from the nonlinear system and use it to rebuild the tracks on a digital audio

workstation (DAW). Essentially, this is like doing an online edit for audio only, using timecode to auto conform a high-quality version of the tracks you've already made. In Fig. 13-14, this is shown as being done from the original production audiotapes. You could use the master telecine videotapes if you preferred.

Alternately, to avoid having to rebuild the tracks, instead of using the lower-quality worktapes to initially load the sound into the nonlinear editing system, many people digitize the first time directly from the master telecine tapes (or the production audiotapes, as described in Scenario Two.) The audio is now captured into the editing system at a high-quality level and can be used for the final mix. This requires more storage space in the editing system's hard drives. The sound can still be exported to a DAW for further sound editing (see Scenario Two).

Regardless of which route you used for the audio, sound editing and sweetening now take place (see Chapter 15). Then a sound mix is done while watching the picture ("mix to pix"). Finally a *layback* is done to bring the mixed sound track back to the edited final master videotape.

At this point, the show is complete and can be duplicated as needed. If a film negative or prints are required for film distribution, a video-to-film transfer can be done from the video master. This must be done carefully, since the trek from film to video and back to film again can cause problems (see Chapter 17). It would be better to make film prints *directly* from the film negative instead of from video. However, doing the video-to-film transfer may be preferred to save money or time, perhaps because very few film prints are needed, or when the image manipulations done in the video environment would be prohibitively costly to replicate in film. A film sound track (usually an optical track; see Chapter 16) will be made at this time.

Scenario Two: Shoot Film, Edit Nonlinear, Finish on Film

This scenario might be used for a project that is shot on film and intended to have significant distribution with film prints, either for theatrical exhibition or film festivals. It is geared toward making optimal use of a nonlinear system for editing and then creating a film cut list for conforming the film negative. A high-quality video transfer is then done from the edited film, to be used for video and television distribution. See Figure 13-16.

Like Scenario One, this begins with film shot in any format and production audio that has been recorded in one of several possible formats. As noted above, it is a considerable advantage to record the sound with timecode and use timecode slates or in-camera timecode, but this isn't necessary. It would be possible to follow this scenario by poststriping the audio with timecode *after* shooting, but this can make syncing more difficult.

Unlike Scenario One, here the negative is transferred to video for offline editing purposes *only*. These are "video dailies" made as quickly as possible with minimal color correction (*one lite* transfer). To keep costs down in the transfer, no sound is transferred at this time. The telecine is equipped with a keycode reader and the computer compiles a database that correlates the film keycode numbers and the video timecode generated during the transfer (see Timecode in Postpro-

duction, p. 520). At the end of the telecine session you have a set of low-cost video worktapes for loading into the nonlinear editing system.

In this scenario, the production audio is transferred directly into the nonlinear editing system (see Some Sound Issues, p. 390). The sound and picture are then put in sync. Some nonlinear editing systems are able to automatically sync up footage using timecode.

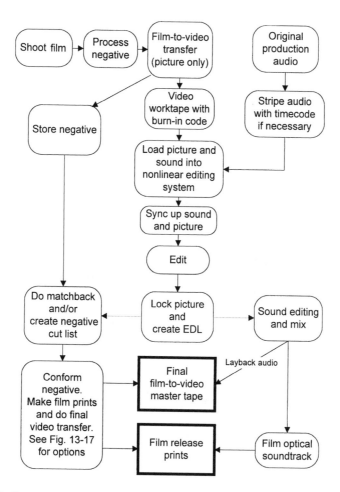

Fig. 13-16. Scenario Two. A possible route for shooting film, editing on a nonlinear system, then finishing on film. Final video transfer is done from the film negative or prints (see Fig. 13-17).

The movie is edited and then an EDL is generated of all the editing decisions. Some systems can generate a film cut list that tells the negative matcher exactly how to cut the negative (see Matchback and Film Cut Lists, p. 393). The negative

is then conformed and a final film-to-video transfer is done. See Working with Your Negative, below, for options on this.

In this scenario, audio was brought directly into the nonlinear system from the original audiotapes and the digitization was at a high quality level. This audio can be used for the finished sound track. You might be able to do all your sound work on the nonlinear system. However, many nonlinear systems lack sufficient audio capabilities. In Fig. 13-16, the audio is exported from the nonlinear system on computer drives using the OMF (or AAF) format (see Output, p. 420) and loaded

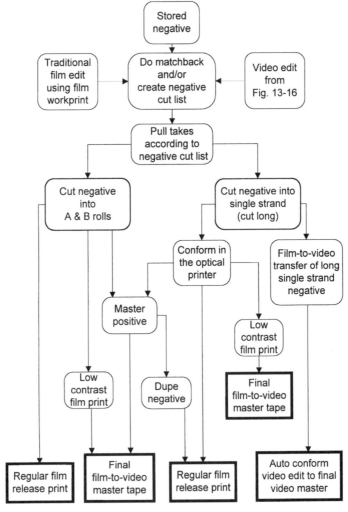

Fig. 13-17. Options for cutting film negative and creating film prints, intermediates and video transfers. The initial negative cut list may be produced from a video edit (see Fig. 13-16) or from a traditional edited film workprint.

directly into an audio workstation. Sound editing is done on the DAW and then the audio is mixed on the DAW or at a mix studio.

A layback is done to bring the mixed sound track to the final video master. The sound track for the film prints (an optical track; see Chapter 16) is made by the lab for printing on the release prints.

Working with Your Negative

In Scenario One, the film negative is used for the initial transfer of the rushes to video, and then never returned to again. One drawback to this is that when you're transferring *all* the rushes to video, you usually don't have time to do very careful color correction, and besides, you can't really judge color until the movie is edited. Doing tape-to-tape color correction after editing is of course possible, but your options are somewhat limited.[2]

Usually, a better transfer can be made *after* the film is edited, when you can see the shots in their proper order and really take the time to do careful color correction. If film prints are needed, as they are in Scenario Two, you will probably be going back to the negative anyway to conform it; see Conforming the Original (Negative Matching), p. 481. Another benefit to returning to the negative is that, if needed, it's easier to do several transfers in different aspect ratios or different international video standards (NTSC, PAL, etc.). See Chapter 17 for more on these topics.

If you decide to go this way, there are a few possible routes for making the film prints and the final video transfer (see Fig. 13-17). (If any of the following terms are unfamiliar, see Chapter 16.)

One route is based on the "traditional" way films are printed. It involves cutting 16mm film into A&B rolls (35mm can be done in a single strand). You can then make prints directly from the negative, or you can make a master positive and dupe negative and then strike prints from the dupe negative. The video transfer can then be done from a print or from the master positive (see below).

Another way to prepare the negative is sometimes called *auto conform* and involves stringing the shots in the movie together in one roll, but leaving individual camera shots "cut long" (often they are taken from flash frame to flash frame). By leaving the shots long, you have more flexibility to make alternate versions of the movie if needed. Using the EDL from the offline video edit, you can program an optical printer to "conform" the movie and generate a film print or a master positive. You could then use the print or master positive to do the final transfer to video.

Alternately, you can transfer the single strand of original negative *directly* to video, and use the EDL from the offline edit to auto-assemble the show in an online edit (the source timecode numbers need to be adjusted for the new source tape). If you don't need film prints, this may be the best option. See Conforming in Camera, p. 485, for more on this method.

[2]A technique developed by Encore Video in Los Angeles involves recording an "uncorrected" tape along with a color-corrected tape at the time of the initial telecine. This uncorrected "video interpositive" gives the colorist more flexibility later.

Which Source to Transfer From

As described above, you have several options in terms of what material is used for the final transfer to video. In some sense, your planning should work backward from the material you want to end up with. Here are some ways to think about it:

1. *Original negative.* Using the original negative for the transfer results in perhaps the sharpest, finest-grain picture, with the most flexibility for color correction. However, for transfers done *after* the movie is edited, going back to the original negative will entail doing an online edit of the show after it is transferred to video, which adds cost.

2. *Master positive.* For movies that have already been edited, a master positive makes an excellent source for the video transfer. A master positive (also called interpositive or IP) is a single-strand, low-contrast, positive copy of the original negative (see Intermediates, p. 497). It has tremendous latitude and will be already be color corrected before it gets to the telecine suite (although more correction will be necessary in the telecine). No online edit may be needed after transfer. The black-and-white version is called a *fine-grain master positive.*

3. *Print.* For reasons of cost, a master positive may not be feasible. Standard answer or release prints are often too contrasty for good transfers. A lo-con (low-contrast) print may be made for the transfer. Lo-con prints are grainier and more contrasty than negatives or master positives, and offer less flexibility for color correction. However, they do have the advantage of being already color corrected and edited. Since lo-con prints offer fewer options in transfer, the telecine session may go faster and save you money. Prints are generally complete with all titles and credits, which may or may not be an advantage depending on your needs (foreign broadcasters may want a "textless" version). Lo-con prints are too flat to be used later for regular theatrical projection. In black-and-white, instead of using special lo-con print stock, regular stock can be developed to lower contrast (gamma).

Some Sound Issues

AUDIO QUALITY AND CONTROL. Earlier in this chapter and elsewhere in the book we talk about the idea of exporting audio from the nonlinear system to a DAW for sound editing work and to a mix studio for mixing. For projects with sufficient budgets, there are real advantages to working on a dedicated audio workstation and, in particular, mixing in a optimal mix studio environment (see Chapter 15). Nevertheless, as nonlinear editing systems become more powerful, sophisticated audio editing capability may be part of the system or may be contained in separate software applications loaded on the same machine. Inevitably, more filmmakers will choose to do all their sound work right on the editing system.

Regardless of where the sound work is done, the project can benefit from working with high-quality audio right from the beginning—that is, capturing audio into the editing system at a quality level that is high enough that the audio can be used for the finished sound track. This might mean digitizing from the production audiotapes *directly* into the nonlinear system, using a sufficiently high sampling

rate (see Adjusting Video and Audio During Capture, p. 427) and then syncing on the editing system. Alternately, if audio is synced in the telecine or a layback suite, try to use a videotape format that has a high-quality audio track, such as Digital Betacam or S-VHS. If the videotape format does not have sufficiently high audio quality, sometimes a recording is made on DAT at the same time that the audio is synced in the telecine or layback suite. This is something referred to as a *simul-DAT*. This is a high-quality digital recording of the synced production audio with telecine timecode on it that can be used as your source tape for audio, either prior to picture editing, or during sound editing.

AUDIO SPEED CONTROL. In the United States and other countries where NTSC video is used, film shot at 24 fps will be slowed down by .1 percent when transferred to video. Sync sound recorded with the film must also be pulled down .1 percent either during the video transfer or when the audio is loaded into the nonlinear editing system (see Resolving Audio, p. 523). Some audio decks and editing systems have an audio pulldown setting to accomplish this. Sound tracks created or edited on a typical 30 fps nonlinear system must later be pulled up (speeded up) by the same amount after editing in order to create optical or mag tracks for film prints.

One exception to this is when working on the Avid Film Composer, which is a nonlinear editing system that runs at exactly 24 fps and permits you to bring audio recorded in sync with the film into or out of the system without changing the speed (see Resolving Audio with the Avid Film Composer, p. 524).

When working in a PAL or SECAM environment, film shot at 25 fps does not need any speed correction, and film shot at 24 fps may need to be resolved (see Film-to-Video Standards Conversion, p. 528).

Editing Video Assist Dailies

To save time and money, some filmmakers start editing videotapes recorded directly from the film camera's video assist (see p. 68). This allows editing to be done right on the set, giving instant feedback on the shooting and providing quick turnarounds for rush projects. It also allows you to preselect the negative that needs to be transferred to video later, which can save money in the telecine.

Though this technique is still developing, it is not as of now a replacement for editing negative that has been transferred in the usual way. As discussed in Chapter 2, the video assist image differs from the negative in two major ways. First, you get no reading of whether the exposure, processing or handling of the negative is okay (you must rely on the lab's negative report for this information). Second, the film camera's mirror shutter alternately sends light to the video assist *or* the film; the film and the video don't both record an image at the same moment. So if you edit the video assist tape, some of your edit points will be off slightly compared to where you might have cut if you were viewing a transfer from the negative.

As for sound, it is relatively easy to record audio on the video assist tapes by setting up a feed from the microphone mixer to the video assist VTR. But again, this is not the same as listening to the *actual* location audio tracks as recorded by the production audio recorder. Some filmmakers have used a high-quality VTR on

location to record both the video assist image *and* to function as a multitrack location audio recorder. To do this, they ran the film camera at 23.976 fps in order to facilitate audio postproduction with the 29.97 fps NTSC video/audio recorder. Consult with an expert before trying this at home.

Editing video assist dailies can be an effective tool for pre-editing material that will be edited in the usual way later. If used as the primary means of editing, for example on a very low-budget production, it can have serious drawbacks.

SPECIAL CONSIDERATIONS WHEN EDITING FILM ON VIDEO

For some projects, like the one described in Scenario One, film serves as the origination medium, but once the film footage has been initially transferred to video, the project is edited and completed just like any other video. For all intents and purposes, it becomes a video project, with the telecine master videotapes taking the place of camera original videotapes. If this is what you're doing, the rest of this chapter doesn't apply to you.

For projects like the one in Scenario Two, video is used as an editing tool with the goal of *returning to the film negative*. Everything done in the video realm is intended as a guide to the eventual cutting of the negative, and making film prints. Video and film are different animals, and some things you might do in a video edit do not easily translate back to film. When editing a project for *film finish*, there are a number of things you need to keep in mind.

Editing Reminders

When you're editing video you can repeat a shot as many times as you want. For example, you might want to use a certain establishing shot several times in your movie. In film, every shot is based on *one piece of negative*, which normally can only be put in one place in the movie. If you want to use the same shot twice, that footage will usually need to be *duped* (duplicated; see Chapter 16). Also, at the head and tail of every shot, the negative cutter needs at least a half frame to cement splice the negative (see Cutting Frames, p. 373). If you take a shot and cut it into two pieces, you need to leave at least one "cutting frame" unused between the pieces. Some nonlinear editing systems have a feature like Avid's "dupe detection" that warns you if you've reused any part of a shot or left insufficient cutting frames between shots.[3]

When making fades and dissolves, video editors can chose virtually any length effect. Film contact printing machines (see p. 481), on the other hand, offer a standard set of fade and dissolve lengths and you should try to use one of them. Check with your lab for available lengths. Standards usually include 16, 24, 32, 48, 64 or 96 frames, which (at 24 fps) is .67, 1, 1.33, 2, 2.67 or 4 seconds. If you are working on a nonlinear editing system running at 30 fps, the equivalent video effects are 20, 30, 40, 60, 80, and 120 frames (although some of these are not *exact* matches). Some nonlinear systems can print out an *optical list*, which will help you identify any nonstandard effects you may have used.

[3]When editing on a 30 fps nonlinear system, leave at least *two* video frames unused so you will be sure to have at least one film frame.

Bear in mind that fades and dissolves in film may look different than they do in video. In video, a shot being faded up from black or dissolved in over another shot will have a steady and gradual increase in exposure. In film, there is usually no visible change in the first quarter of the effect, a steeper "ramp" in the middle, then no change in the last quarter. Some nonlinear systems have a special fade to mimic the film look and the particular way light values mix in film as opposed to video.

As for more complex video effects, keep in mind that they will have to be re-created in film. Some nonlinear systems can generate detailed instructions for a film optical printer to help replicate a video effect. Some effects can be replicated on an optical printer, but may be expensive to do. However, many video effects have no simple equivalent in film. For a complex effect, it is often less expensive to do a high-resolution video-to-film transfer of that section. If there are many complex effects, it may be cheaper to transfer the whole movie from video to film and avoid going back to cut the original negative at all.

Matchback and Film Cut Lists

When you first transfer your film dailies to video, the telecine generates video timecode, which gets recorded on the telecine videotapes (see Video Timecode, p. 521). You can then edit the tapes on a nonlinear or traditional videotape editing system. When you're done editing, you make an EDL that lists all the editing decisions you made according the video timecode. Through the process of *matchback* (sometimes called *video matchback* or *film matchback*), a negative matcher can take that EDL and create a *film cut list*, which tells him how to cut the film negative to match your video edit. The matchback process converts a 30 fps video edit to a 24 fps negative cut list.

This is how matchback is done: Prior to the original telecine session, a punch mark is made on each roll of negative as a starting reference (see Video Dailies, p. 515). In the telecine session, the key number (see Film Keycode, p. 520) and the video timecode at that reference punch are logged. After editing, to find any point on the roll, we relate it back to the reference punch. As a much simplified example, let's say the reference punch is zero timecode (00:00:00) and the first shot we want, according to the EDL, starts at exactly one minute (01:00:00) and ends at 01:30:00. One minute in 16mm is 36 feet. We now go back to the roll of negative and, using the key numbers (or even a synchronizer), measure 36 feet from the punch mark to find the start of the shot. The end of the shot will be found exactly 18 feet later in the negative.

To help automate this process, the keycode system was devised. Using keycode, a nonlinear editing system can perform the matchback itself and generate a film cut list. Keycode is a machine-readable version of the key numbers that are exposed along the edge of the film negative (see p. 129). During the initial film-to-video transfer, the telecine machine reads the keycode and can burn the key numbers in on screen so a human can read them during editing (see Fig. 17-5). The telecine can also create a database or log that correlates the key numbers to the video timecode (see Telecine Logs, p. 523) which can be loaded into the nonlinear system. When you're done with your offline edit, the nonlinear editing system crunches these

numbers and generates a film cut list, which saves the negative matcher from having to create his own list.[4] Not all nonlinear systems can do matchback.

There are several types of film cut lists. A *pull list* tells the negative matcher which shots to take (pull) from each camera roll. A *scene pull list* indicates all shots taken in their entirety from flash frame to flash frame. An *assemble list* shows all the shots in the movie in their final order. A *dupe list* shows which material needs to be duplicated. A dupe list can be generated at any time during editing to check that no material has been unintentionally duplicated. A *change list* shows only the changes that have been made since an earlier version. This is helpful if a film workprint is being cut along with the edited video for test screenings (see p. 397).

When using a nonlinear editing system to do matchback, in order for the software to work properly, the system needs a reference point at the first frame of each clip. At this reference frame the machine needs to know the video timecode, the key number and the pulldown phase (A, B, C or D; see below for more on this). If you've entered the telecine log on disk directly into the nonlinear editing system, the system may have all the information it needs. If not, you may have to type the numbers for each clip manually into the bin list while reading them off the screen.[5] The pulldown phase for the first frame of a clip or for an In Point is sometimes called the *pullin*. See Pulldown Type, p. 514 for ways to determine the pulldown phase if it is not indicated on screen.

24/30 Translation

Please read Chapter 17 (particularly The Scanning Process and Pulldown Type starting on p. 512) to familiarize yourself with film-to-video transfer before reading this section.

In Europe and other parts of the world where the PAL and SECAM video standards are used, films shot for broadcast benefit from a simple relationship between the film frame rate and the video frame rate. These projects are often shot with a film camera running at 25 fps and are transferred to video that runs at exactly 25 fps. If, during video editing, a shot is edited to be 25 frames long, it will run exactly one second on screen and you can go back to the negative and find the original 25 frames of film from which that shot came. A one-to-one relationship between film and video. Very clean, very simple.

However, in the United States and other places where the NTSC video standard is used, when projects are edited using nonlinear or videotape systems working at 30 fps, you have to cope with a more complex translation from film to video and then back to film again. Film cameras are generally run at 24 fps and the film footage is transferred to video that runs at about 30 fps (actually 29.97 fps). One out of every two film frames is transferred to 1½ frames of video to stretch 24 fps to 30 fps. If you are editing a project, such as the one described in Scenario One

[4]Some negative matchers prefer to create the film cut lists *themselves* using their own software. All they want from you is a video timecode EDL along with a tape of the show with burn-in timecode on screen.

[5]If an entire camera roll is initially digitized in one clip, you may only need to enter this information once.

above, that will be finished in video *without going back to cut the film negative*, you generally don't need to be concerned with this. You simply edit the video in a way that looks good and basically forget about the fact that the images originated on film.

However, if you will eventually be cutting the negative, the translation between 24 fps and 30 fps will have an impact on your project, and on the way you set up the nonlinear editing system. As you can see in Fig. 17-3, for every four frames of film, two of the frames (A and C) are transferred to two fields of video, and two of the frames (B and D) are transferred to three fields. A, B, C and D all have different pulldown phases or types. When you make video edits, the total length of the shot and the pulldown type of the frames you've chosen may result in certain errors when you go back to cut the negative.

As an extreme example, imagine editing together in video a sequence of 30 very short shots that are each one frame long. This sequence will run for one second in video (30 video frames × $\frac{1}{30}$ second per frame = 1 second). Now imagine the negative matcher trying to reproduce this sequence by cutting the film. If she splices together 30 frames of film, the sequence on film will now run 1.25 seconds (30 film frames × $\frac{1}{24}$ second per frame = 1.25 seconds). To create a film sequence that runs one second, she would need to drop six frames, making the sequence 24 frames long, losing six of the images you selected.

A shot that runs five frames in video translates neatly and exactly back to four frames of film. The same is true of any multiple of five frames. Now imagine a three-frame shot in video (say, the first three frames in Fig. 17-3). The six fields that make up the three frames are A1/A2, B1/B2, B3/C1. This could be thought of as two and *a half* frames of film. If the negative matcher cuts the film sequence using the A and B film frames only, the film sequence will be slightly shorter than the video. If she makes the sequence with the A, B *and* C frames, the film sequence will be slightly longer than the video.

When you're editing your movie, you should go ahead and edit as you please, generally without worrying abut the 24/30 relationship. However, be aware that during the matchback process (whether calculated by the nonlinear editing system or later by a negative matcher), there will often be slight discrepancies between the video and the film. Most matchback programs are designed to drop or add a frame at the end of certain shots to keep the overall length and sync relationship between the film, video and audio within +/− 1 frame at all times. Usually, you won't notice the error; however this may produce slightly "soft" audio sync or create a situation, say, in which you originally cut one frame away from a flash frame in the picture, but the flash frame shows up after matchback. This is also the reason why you should leave *two* cutting frames in the video for the negative matcher so he'll be sure to have at least *one* in the film.

24 fps Nonlinear Editing Systems Versus 30 fps

To avoid the complications just discussed, films shot at 24 fps are often edited on nonlinear systems that run at 24 fps, using such systems as the Avid Film Composer. This way, there is a simple one-to-one relationship between the original film frames and the frames displayed on the nonlinear system. This means you

can edit at 24 fps and create frame-accurate film cut lists that correlate *exactly* to the original film negative, with none of the matchback discrepancies caused by converting from 30 fps back to 24 discussed above. These 24 fps systems are highly recommended for film projects in which the negative will be cut after the video edit.

Some of these systems work by undoing the 3/2 pulldown during digitizing, so they store on the hard drive a true 24 fps picture.[6] Other systems digitize a 30 fps video signal, but only *display* a 24 fps image that corresponds to the original film frames. The two types of systems should be equally accurate in terms of creating film cut lists, but the second method uses up more disk storage per second of material.

If you edit at 24 fps, you can still get a normal 30 fps video output if you need it, for example to make screening cassettes. There may also be times when you need a 30 fps EDL (perhaps for sound work or video rerecording). Keep in mind that slight rounding errors like the ones that occur when going from 30 fps to 24 (as described above) also occur when going from 24 fps to 30.

See Resolving Audio with the Avid Film Composer, p. 524, for more on working with this system.

Error Checking

As postproduction methods become more complex, it is increasingly easy for errors to be introduced into the various systems. If the film key numbers and video timecode are not correctly recorded in the telecine session and then correctly burned into the video or entered into the nonlinear system, then any cut lists or matchback generated by the editing system will have errors. These errors may cause the negative to be miscut. For this reason, some people distrust cut lists generated by nonlinear systems.

To prevent errors, it is very important to check the code numbers when you first receive your dailies from the telecine. While digitizing the material into the nonlinear system, make sure that the timecode and key numbers burned in on screen are consistent with the numbers on the editing system's timecode display and the telecine log. Verify that the pulldown phase is consistent with the burned-in pulldown field identifier (see Pulldown Type, p. 514, for guidelines on checking this). Talk to the transfer house immediately if you have any questions.

Michael Phillips suggests creating *confidence lists* to help verify that the numbers are correct. (These instructions are for Avid systems but a similar method can be done with other systems.) To do this, create columns in each bin with the following headings: START, CAMROLL, KN START, KN MARK-IN, CLIP NAME. Then load each clip in the source monitor and mark an In Point at the frame where the slate closes. This should bring up the key number for that frame in the KN Mark-in column. Do this for every clip and then print out the bin list on paper and send it to the negative cutter. The negative cutter can then check a few takes by running down to the slate and examining the actual key number on film. This way, he can verify that the key numbers entered into the system are correct.

[6]In Fig. 17-3, the system might capture only video fields A1, B1, C2 and D1.

SYNC ERRORS. When crossing between film and video systems, it sometimes happens that you lose track of a solid sync reference for the sound in the edited movie. For projects in which the film negative will be cut after video editing, it's a good idea to have the negative cut *prior* to sound editing as a safety precaution whenever possible. You then use a video transfer of the *finished* movie instead of a dub of the offline edit as the "bible"—the ultimate reference for sync. This could be a transfer from the negative, from an answer print or from a master positive (see Chapter 16). This way, any sync errors introduced during negative cutting can be compensated for during sound editing. If a film workprint was made during the picture editing stage (see below), the edited workprint can serve as the bible for both sound editing and negative cutting.

When You Have a Workprint

Feature filmmakers often make a film workprint of the negative even though editing will be done in video on a nonlinear system. This is because film workprint gives a much better indication of how the finished film will look, and may be preferable for test screenings. In this case, if desired, the workprint and sprocketed mag film may be put in sync the traditional way (using a film editing machine) prior to the transfer to video. The workprint and mag are edge coded (see p. 380) after they've been sunk up, and the edge code is recorded along with the timecode and keycode during the transfer (see Ink Edge Code, p. 522).

The edit is done in video on the nonlinear editing system. For the first test screening, the machine generates an assemble list with which you can conform the workprint to the video edit. You then do your test screening and go back to the nonlinear editor. After you make changes, the system generates a change list that highlights exactly where to change the workprint to match the new video version. Change lists are not practical when using a nonlinear system running at 30 fps.

If the workprint has been cut to match the video edit, it can be used to conform the negative in the traditional way (rather than by doing matchback), which some people still prefer as a way to minimize error.

SURVIVING THE STATE OF THE ART

New technologies—particularly, nonlinear editing—have transformed filmmaking. The new methods are great and wonderful and also confusing and intimidating. As a filmmaker, you may want to concentrate on making movies, but you find yourself dealing with things that seem more like rocket science. Given the many technical options and possibilities for things to go wrong, one thing is certain: you can only get through the gauntlet of production and postproduction by communicating early and often with the people with whom you'll be working. Talk to everyone in the production and postproduction chain. Don't be afraid to ask! And don't assume that because you once did something one way, the next person won't have a completely *different* way of working.

Editing Video | CHAPTER 14

This chapter is about working with video editing systems. We will first look at tape-based systems and then computer-based nonlinear editing systems. See Chapter 1 for an overview of video editing concepts, Chapter 12 for a discussion of editing choices and styles, Chapter 7 for more technical aspects of video recording, Chapter 17 for transferring film to video and Chapter 13 for specific issues of editing film-originated material on video.

The first videotape editing involved actually cutting and splicing pieces of 2″ videotape. Today, videotape editing is done by playing material from one tape and rerecording it on another. Digital nonlinear editing systems, which use computer drives instead of videotape to store material, are now preferred for most editing jobs, but tape editing continues to be used in some settings. Even if you plan to use a nonlinear system, it's still important to understand tape editing. In the digital era, many of the concepts and machines of videotape editing continue to be used.

VIDEOTAPE EDITING

Stages of Tape Editing
See Editing on Tape, p. 28, before reading this section.

These are the stages of "traditional" videotape editing, based on the idea of doing an offline edit with workdubs followed by an online edit using the camera original tapes:

1. *Make workdubs.* These are protection copies used so the camera original tapes are not damaged during editing.
2. *Log footage.* View the workdubs and make notes on the material (see The Editing Log, p. 354).
3. *Do offline edit.* During the offline, the workdubs are edited to determine the structure of the movie.
4. *Make EDL (edit decision list).* This is a list of every shot in the movie, speci-

fied by exact timecode address of the first and last frames of each shot used. Some systems can generate the EDL automatically; on lower-end equipment you must do it manually.

5. *Do online edit.* During the online, the final master tape is created by returning to the camera original tapes and editing them as determined by the EDL.

6. If complex sound editing is required, the audio is copied to a multitrack audiotape machine or to a digital audio workstation (DAW). This process is called *stripping* the audio or doing a *layover.* After adding to and mixing the sound track, a *layback* is done to copy it back to the master tape.

Offline and Online

The terms *offline* and *online* can mean different things depending on the context. The traditional tape offline edit implies using relatively inexpensive, lower-quality equipment so you can afford the time to shape and structure the movie. The end product of offline editing is not a finished, high-quality tape—in fact, offline cuts often have poor image quality and rough sound. The goal of offline editing is to produce an EDL. The EDL is made when you finish offline editing and the program is considered *locked.* When you go into the online session, the EDL allows you to make relatively quick and efficient use of the expensive online editing machines that edit your camera original tapes into a high-quality, finished master.

So, in one sense, "offline editing" means working on something that is not a finished product; the finished piece will be created *later* in the online stage. Offline and online are stages in the process.

But in another sense, the idea of offline editing equipment suggests something that works at a lower or "draft" quality and while online equipment is capable of "finished" or high quality; particularly in the digital era these distinctions can become blurred. You might be able to use the same equipment to turn out an offline or an online product. Or you might have an editing system that's not up to broadcast quality that would be considered offline equipment for a TV show but online equipment for a corporate video or a multimedia project.

When editing analog videotape, there is the inescapable fact that image quality deteriorates each time a tape is copied from one generation to the next. Since you usually don't want to risk editing with camera original tapes, the generally recommended practice is to do offline editing with workdubs followed by an online session. Even with digital formats (which can be copied without quality loss), there are benefits to following the offline/online protocol. In the following discussion, we will assume that both offline and online editing are planned, unless otherwise noted.

Tape Editing Systems

There are several different types of videotape editing systems, with different capabilities and uses. All are based on the idea of using two or more VTRs and a *controller* that operates them (see Fig. 14-1). The *source* or *playback* VTR plays the video footage while selected portions are rerecorded on the *record* or *edit* VTR. Usually there are two monitors to view the material: the *source monitor,* which shows what's playing on the source VTR, and the *record/edit monitor* (also called *program monitor*), which shows the edited program.

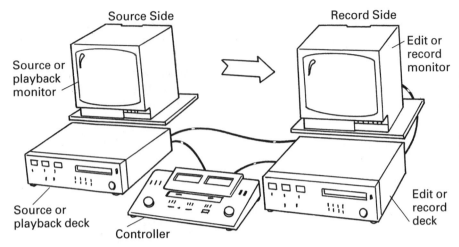

Fig. 14-1. Videotape editing. Material is played on the source deck and rerecorded on the edit deck. The controller operates both machines. Monitors allow you to view the source tapes as well as the edited sequence. (Robert Brun)

The source and record decks may be in a variety of tape formats. A typical small setup might use two S-VHS, ¾" or Betacam decks. Sometimes the source deck is a lower-cost unit without full recording capabilities. A large production facility might have an editing suite with a variety of VTRs in various formats that can be linked together as needed.

Systems with more than one source deck allow you to do dissolves and other effects (called *A-B roll* systems; setups that can't do dissolves are called *cuts only*). Some digital tape formats offer a "preread" feature that allows dissolves with only two decks (see Fades and Dissolves, p. 441).

The controller is the interface between you and the VTRs. Your ability to edit the movie the way you want very much depends on the power of the controller, particularly its ability to work with timecode (see p. 196). The simplest controllers, sometimes called *control track editors*, cannot read timecode.[1] Some VHS, ¾" or Hi8 editing system controllers do not use timecode. Without timecode, the accuracy and repeatability of editing decisions are seriously impaired; it is much harder to alter an editing decision or do an online edit. Many control track systems are not *frame accurate* (the actual cut may take place a few frames earlier or later than the point you selected). Lack of frame accuracy can be *extremely* frustrating when you're trying to do careful work.

Timecode editors use timecode recorded on the tapes to control the editing process. Timecode editors vary in their power. Most timecode systems are frame accurate, but some slip a bit when doing an edit. Some systems use timecode to

[1]Many control track editors use "pseudo timecode." This is a time display used for performing individual edits that is essentially just a running time counter that can be reset at any point. It looks like timecode on the display, but, unlike real timecode, it has no fixed reference to individual frames of video.

Fig. 14-2. Sony FXE-120 timecode edit controller offers A-B roll editing (controls up to three VTRs). Includes a video switcher/special effects generator as well as minimal audio mixing. Handles SMPTE and prosumer timecode formats. (Sony Electronics, Inc.)

Fig. 14-3. Panasonic AJ-LT75 Laptop Editor. Compact unit contains dual DVCPRO digital VTRs (also plays Mini-DV tapes). Timecode-capable, computer controller for cuts-only editing. (Panasonic Broadcast)

control individual cuts as you make them, but cannot "remember" the last edit when you move on to the next one. *Computer editors* keep a running list of every editing decision in the show and can automatically compile an EDL. Computer editors make it much easier to change edits and get ready for an online edit session. If your editing system does not create an EDL, you can edit with window

402 THE FILMMAKER'S HANDBOOK

dubs and compile the EDL manually (see EDLs and Control Track Editing Systems, p. 411). If the original footage was shot without timecode, you may be able to add it after shooting (see p. 198).

Some digital nonlinear editing systems have the ability to control videotape machines, allowing you to edit directly from tape sources (instead of the usual process of transferring the video to computer drives first; see Digital Nonlinear Editing, p. 415). This gives you increased flexibility, since you can put together a sequence, then use the nonlinear system's timeline to freely trim and rearrange the shots (see Fig. 14-18). However, to view any changes, you must wait while the system reassembles the sequence (you insert tapes in the source deck and the system records what's needed on the edit deck). This has advantages over conventional tape editing controllers, but is far less powerful than using a nonlinear system with hard drive storage.

Most videotape editing systems have a hand-operated control with one or two *jog/shuttle* knobs that allow you to move through the tapes forward or backward at various speeds.

RECORDING AND PLAYING TAPES

Assemble and Insert Recording

Most VTRs used for editing offer two modes of recording: *assemble* and *insert*. In *assemble* mode, everything on the tape beginning at the point where you start recording will be erased. The VTR replaces whatever was on the tape with a new video signal, new audio (if any), new control track (see p. 178) and new timecode. Assemble mode (sometimes called "crash record" or "hard record") is chiefly used when there is nothing already on a tape, or nothing you want to keep. If you want to copy (dub) one tape to another straight through without stopping, assemble mode works fine.

The problem with assemble mode comes when you record one shot, stop, then record a second shot. Every time you stop recording there is a break in the control track, which can make the picture roll or break up as the system adjusts to the new shot. On older or cheaper VTRs, the picture breaks up (you get a *glitch*) when you record the new shot on the end of the old shot. Newer VTRs can make that transition smoothly, but not if you record the new shot over *part* of the existing shot (you get a glitch where the new shot ends and the old one resumes). If you are recording timecode, the same limitations apply. Another problem is that from the point you start assemble recording the new shot, *all* the audio tracks from the old shot are replaced by audio from the new shot, which can be very limiting.

For these reasons, most editing is done using insert recording. In insert mode, you have a choice between recording video, any individual audio channel or a combination. Insert recording does not automatically erase anything on the tape—you get to choose what is replaced and what remains from any previous recording.

Insert mode avoids the picture breakup of assemble mode because it *does not replace* existing control track information. But this also means that there must be continuous control track on the tape before you can begin insert recording. Usually this is done by assemble recording a black, silent video signal on the full length of the tape before you begin work. This is called *blacking* a tape (see below).

Preparing the Edit Master

As noted above, most editing is done with insert recording, which requires that the tape you will be recording or editing *onto* (the edit master) be blacked before use. If your editing system reads timecode, the tape will need to be *coded* or *striped* with timecode as well.[2] Postproduction facilities and some nonlinear editing systems can generate a very stable, clean *blackburst* signal with timecode for blacking and striping tapes prior to an edit session. Online editing should only be done with a rock-solid signal on the tape. The choice between drop frame and nondrop timecode is discussed in Chapter 7.

For offline editing purposes only, if your equipment cannot generate black, you can sometimes use one blacked tape to black another. Have a postproduction house make you a good black tape. Then use assemble recording to black your edit master in one pass without stopping. This is not as good a signal as one coming directly from a black generator and, with analog tapes at least, should not be used to copy timecode (see below).

Here is a standard way to prepare an edit master tape:

1. Begin the tape at 00:58:00:00 timecode ("fifty-eight minutes") and then record 30 seconds of black *leader*.
2. Then come color bars and tone (see Bars and Tone, below) for one minute (from 00:58:30:00 to 00:59:30:00), followed by 10 seconds of black.
3. Then put in a 10 second video *slate* (using a character generator to create a title card that identifies the project name, production company, tape length, date, etc.)
4. At 00:59:50:00 record a *countdown*. The countdown displays numbers every second from 10 to 2, with a beep in the audio at each second so you know the picture and sound are in sync. (Since video and audio may get separated and remarried during postproduction, it's nice to have a visual check.) If you don't have a countdown, put black here. The program begins exactly at 01:00:00:00 ("one hour," also called "one hour, straight up").

If you are editing a project that will be finished on film, see Preparing and Delivering Tracks, p. 464 for guidelines on leaders.

Making Worktapes and Other Dubs

If time and/or money are very limited, you might risk editing with camera original tapes, but for most productions it is standard practice to make workdubs (also called *workprint* or *worktapes*) for editing. The workdubs should be made in whatever format your editing system uses. If you have the equipment, you can make your own workdubs. Many people buy lower-cost, used tape stock for making worktapes (see p. 180). To cut down time spent shuttling to locate shots, keep your worktapes fairly short (an hour or less) unless your system has a fast wind/rewind.

When making any kind of dub from one VTR to another, try to simplify the electronic path between the two decks. Avoid running the signal through extra

[2]On some formats, timecode is automatically added when the machine is put into record.

equipment like low-quality switchers, which might add noise. If you're working in a digital tape format, connect the two decks digital out to digital in (using "serial" mode or a FireWire connection), rather than going through the analog video connectors, whenever possible. For analog machines, if you're working in a component or color-under format (like Betacam, Hi-8, S-VHS or ¾″), try to avoid connecting the VTRs using the "Video Out" or "Line Out" jack on one deck and the "Video In" jack on the other. This will unnecessarily encode the video as a composite signal and then decode it. Instead, use component, S-video or "dub mode" connections. For more on connecting video systems, see Video Formats and Features, p. 194.

COPYING TAPES WITH TIMECODE. When analog tapes are copied, timecode tracks become degraded and indistinct. Use a *timecode generator* to read the code from the master and regenerate a fresh, clean signal whenever you make a dub. Timecode on digital tapes does not need to be regenerated; it can be copied directly from tape to tape.

When master tapes are recorded with timecode, the VTR or edit controller will display the timecode, but you can't see the numbers on the TV monitor. When doing offline editing, it's often helpful to make worktapes with *burn-in timecode* (see Fig. 1-18), which is visible over the picture (these tapes are called *window dubs*). If you are editing timecoded source tapes on an editing system that does not read timecode, you *must* have window dubs to be able to visually keep track of code. You can also burn in user bit information (see Timecode, p. 196).

HOW MANY GENERATIONS? In tape editing, you often need to make copies of copies, which results in lowered picture quality in analog tape formats. Generally, the better the original format, the more generations you can go down before the image is badly impaired. Component formats copy better than composite ones. There is no hard and fast rule about when analog copies becomes unacceptable. Rough estimates on maximum generations before significant impairment: 1″ tape, four to seven; ¾″, Hi8, S-VHS, two to three; regular VHS, one to two.

Digital tapes can be cloned through many generations without noticeable loss. Component digital formats like DV and D1 can be cloned almost indefinitely; composite digital formats like D2 may be limited to about 20. Digital clones (made digital out to digital in) are virtually perfect copies; if the signal is converted to analog and then back, there is some deterioration.

Bars and Tone

Color bars and an *audio reference tone* (*"bars and tone"*) are used as a way to standardize the playback of video and audio recordings. Color bars are a test pattern that displays the primary colors as well as white and black (see Fig. 14-4 and Appendix A). Professionals record bars in the camera at the head of every tape. When the camera tapes are brought back to the editing room, the bars are used to ensure that the playback decks reproduce the signal the way it was originally recorded. The white level (gain), black level, and color reproduction are set to standard levels. To make these adjustments properly you need a waveform monitor (see Fig. 7-2) and a vectorscope (see Fig. 5-3). For more, see Chapters 5 and 7.

Setting up tapes for playback is critical for online editing or for making tapes

Fig. 14-4. SMPTE color bars. See also Fig. A, Appendix A.

that contribute directly to the finished product. For offline editing, however, careful setup is not as important. Most offline systems lack a waveform monitor or vectorscope. However, the VTR may have a *video level meter* that can be used to get an approximate level setting.

Color bars are also used to make sure that each video *monitor* is correctly adjusted in terms of color and brightness (see Appendix A).

Once you have set up the playback to bars, you know the tape will look close to the way it looked when it was originally recorded. Even so, you may need to make further adjustments when you actually see the images. Even with bars on the tape, some shots may still be, for example, too "hot" (excessive video level) or too blue. Generally, you don't worry too much about color adjustments in an offline edit, but you do in an online.

Color bars are also recorded as a reference at the beginning of every editing master tape. If an online master has been carefully color balanced, the bars will help ensure that whoever dubs or plays back the tape later will set the color and brightness values the way you intended them to be.

The audio reference tone is similarly used to match the audio playback to the original recording. Professionals usually record tone along with the bars at the head of every camera tape. When using an analog camcorder or VTR, the tone is usually recorded at 0 VU on the camera's VU meter. With a digital camcorder, the tone is usually recorded at −20 or −18 on a digital recorder's peak reading meter.[3] When you play back the tape in the editing room, adjust the level so the tone reads 0 VU on an analog VTR's VU meter, or at −20 or −18 on a digital system with peak reading meters. Again, the level of the reference tone should be considered a starting point. You generally still need to boost or lower audio levels during the edit.

Along with the color bars, audio tone should be recorded at the beginning of every edit master tape, especially online tapes (see Recorded Information, p. 279).

Play and Record Settings

Both offline and online editing are based on playing source tapes on one machine and recording the edit master on an another. You want the video and audio

[3]See Setting the Recording Level, p. 288, if you are unfamiliar with these meter types.

to be properly recorded for each shot you select, so you need to check the whole chain from player to recorder. On some editing systems, this is done by playing a tape on the source VTR and pressing only "Record" (not "Record" *and* "Play" together) on the edit VTR. This should activate the meters on the record deck without putting the tape into motion.

Video levels should be checked by first setting up the system to color bars (see above). Also make sure the video monitors are correctly adjusted (see Appendix A). Then roll the source tape to the first shot you want. Check the video level and/or color. If the picture is unsteady, try adjusting the *tracking* (not all formats or machines have tracking control).

Audio levels can be set using a mixer and/or the audio level adjustment on the record VTR. If you're using a mixer, you want the mixer's meter to read at a normal level, neither too high nor too low, but the most important level meter to watch is the one on the record VTR. This is the only meter that tells you the *actual* level that will be recorded on the edit master tape (see p. 288 for suggestions on setting audio levels, and p. 452 for working with mixers).

Once you've set the recording level, adjust the speakers (the audio *monitor*) to a comfortable level. Try not to change the monitor volume during the edit session so you'll be able to judge levels by ear. The editing system should allow you to select whether you're monitoring the play deck or the record deck. You'll get the hang of switching back and forth while you edit.

OFFLINE EDITING

You've made your worktapes, prepared the edit master, set levels for proper playback and gotten a cup of coffee. You've looked through your logs (see Chapter 12) for your first shot, and rolled down to it on the source tape. You're ready to start editing.

Making an Edit

Linear videotape editing is a process of building up the movie (or a sequence in it) shot by shot. You start at the first shot and work forward. Go to the first frame you want to use. The edit controller will allow you to *mark* this frame; this is usually done by pushing a button while paused or rolling over the frame. This frame becomes the *In Point* (sometimes called *Mark In, Video In* or just *In*). You then go to the end of the shot and find the *Out Point* (*Mark Out*, etc.). Some edit points are easier to determine while running in slow motion, others are easier to judge running "at speed" (regular motion). We have just marked In and Out on the source side (Source In and Source Out).

Since you will be rerecording this shot onto the edit master tape, you need to tell the record deck *where* to record it. Normally you will be using insert edit mode (see p. 402). You now roll the record deck to the point where you want the shot to begin and mark this In Point. Note that you have now given the controller *three* points (Source In, Source Out and Record In). Normally, you would now select *preview*, and the controller will rehearse the edit for you, allowing you to see how it looks.

Most controllers will rewind the tapes between three and ten seconds from the

In Points before starting. This *preroll* is needed to get the machines up to speed before the edit occurs. If you don't have enough continuous control track or time-code ahead of your edit points for the preroll, the machine may not do the edit.

If you are happy with the preview, you then select *edit* and the controller will do the edit (sometimes called "performing" or "executing" the edit.) It's always a good idea to check or "review" an edit after you make it to ensure that everything worked both me-chanically and in terms of the picture or audio transition you were hoping for.

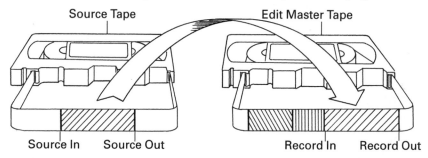

Fig 14-5. A basic video edit. When editing from the source tape to the edit master, each edit can be described by four points: Source In and Source Out specify which part of the source tape to use, and Record In and Record Out indicate where the shot is to be placed on the edit master. (Robert Brun)

Many an editor has gone through all these steps and found that the machine re-fuses to go into record mode. Check the *record inhibit* device on the edit master tape cassette. On some cassette formats this is a sliding red tab; on ¾" cassettes a red plastic button must be inserted in a hole. On VHS and conventional analog audiocassettes, a tab is removed on the back of the cassette to prevent rerecording the tape; put a piece of tape over the hole if you want to rerecord the cassette. After you've recorded your edit master, set the record inhibit so that no one will accidentally erase the tape.

Marking Edit Points

In the above example, we gave the controller three reference points to do the edit: Source In, Source Out and Record In. This is sometimes referred to as a *three-point edit*. Three points is all we need; in fact, most system will not *allow* you to mark the fourth point.

When a shot is very long, sometimes it's easier to just mark *two* points: Source In and Record In. You then begin this *open-ended edit*, pressing "Stop" after the ac-tion you want has finished. You can trim the end of the shot cleanly when you add the next shot.

When inserting a new shot into one that has already been recorded, often you want to specify Record In and Record Out. Say you had recorded a shot of a man lecturing, and you wanted to insert a cutaway of the crowd listening to him. Here, you might mark Record In and Record Out to indicate precisely which part of his speech to cut away from, and then mark Source In to indicate the start of the

crowd shot. In this case, we want to replace *only* the picture, while leaving the sound uncut. This is a "video only" insert. On many systems, this is done by deselecting all the audio channels on the insert edit controls.

Sometimes you are more concerned with where a shot *ends* than where it begins. Say your shot of the crowd has someone in the audience nodding off and you don't want to show it. You might mark Source Out just before the person dozes off. This is a *backtimed* edit (you are timing backward from an end point). Some controllers can then perform the edit using Record In, Record Out and Source Out. Other systems can't work backward and you need to give the controller the Source In point. You can find Source In by determining the time between Record In and Record Out (otherwise known as the *duration* of the edit) and then subtracting that from Source Out.

Making Changes

After previewing or making an edit, you may find you don't like the timing of the cut. If you want to adjust one of the edit points, you could mark a new In or Out. Alternately, you could use the *trim* control to adjust one of the existing edit points. *Trimming* in video means adding *or* subtracting frames from an edit point. It's important to remember that the "plus" and "minus" on a trim control refer to moving the edit point to an earlier or later timecode number. Timecode advances as you go forward in time. People get confused because they may think that trimming *plus* simply means "extend the shot" and trimming *minus* means "shorten the shot."

Say you have a shot of a man counting aloud from one to ten. You've tried putting a portion of it into the movie: the section where he says "four, five, six, seven." Now you decide to extend the tail (end) of the shot in order to include him saying "eight, nine." So you trim the Source Out to a *later* timecode number, which means pressing the *plus* button. (If you had wanted to make the end of the shot shorter, you could have pressed the *minus* button to move the Source Out point to an *earlier* timecode; now the entire shot would be him saying "four, five.")

Let's go back to the original shot and this time we'll trim the head (beginning) of the shot instead. To extend the head of the shot (to include him saying "two, three") you now press the *minus* button to move the Source In to an *earlier* timecode. If you had wanted to shorten the head of the shot (to start with him saying "six, seven") you would press *plus* to move the Source In to a *later* timecode.

Confused? Even experienced editors sometimes have to ponder this before pressing the trim button. To make matters worse, there are a few editing systems out there that do indeed use plus and minus keys simply to mean "extend the shot" and "shorten the shot."

Changes After an Edit Is Recorded

Say you just recorded two shots: a woman getting in her car, followed by a shot of her driving away. You now decide the action of getting in the car goes on too long. It's a simple matter to rerecord the second shot, and trim back the first one a bit while doing so. But what if you accidentally cut *too much* off the first shot (you lost three frames of the car door actually closing)? Many low-end edit controllers are not accurate enough to replace just the missing frames. You then have to go

back and *rerecord the whole shot* of her getting in the car and hope you don't accidentally cut into the shot before the end of *that* one. For this reason, it's often a good idea to leave shots slightly long in the early stages of videotape editing, trimming them tighter as you refine the cut.

AFTER MANY EDITS ARE RECORDED. After you have edited together a sequence (or several sequences), you almost always want to make changes: lengthen a shot here, lose a shot there or even drop a whole sequence. Rather than completely starting over, generally what's done during offline editing is to take the edit master tape from the record deck and put it in the source deck. You then create a new edit master. You can record new shots where needed, skip shots that are no longer needed and do a straight dub of sections where no changes are called for. With digital tape systems, this is relatively simple. With analog systems, you have to cope with the quality loss at each generation. One technique is to edit sections of the movie to different masters, so changes in one section won't affect another. Making changes to videotapes is a real pain. That's one reason why nonlinear editing systems are so popular.

Audio Edits

In the simplest cut from one shot to another, video and audio cut at the same time. First we see a shot of a man asking a question, then we cut to a shot of a woman answering him. This is a *straight cut*. Often, however, we want to *overlap* the sound. In this case we might begin the woman's answer over the end of the man's shot, letting the audio lead us into the cut (see Fig. 14-6). In video terminology, having the picture and sound cut at different points is called a *split edit*, *L-cut* or a *video-* or *audio-delay*.

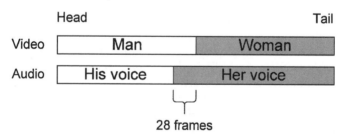

Fig. 14-6. Split edit. This illustrates a split edit or L-cut in which the woman's sound begins over the shot of the man. Her audio leads (precedes) the picture cut from the man to the woman by 28 frames.

When editing in insert edit mode, you can choose to record video, any audio track or any combination of video and audio tracks. To accomplish the overlap just described, first record the man's shot onto the master (both video and audio), leaving some extra room at the end after he asks his question. It's a good idea to let the tail of the shot run a bit longer than you think you'll need. That done, then go to the point on the master where you want to begin hearing the woman. Mark this as Record In, but on the insert edit selector, choose to record one audio channel and

not video. If you are using a computer controller, you can then roll forward to the point where you want the picture to cut to the woman, and mark this as the Video In point. With computer controllers, you can preset everything before doing the edit. With most control track editors the only way to select where the video cuts is by punching the video insert button during the actual edit. You will have to practice the edit a few times to get your timing right.

Split edits usually require a bit of juggling and/or backtiming using the counter to find the various audio and video edit points. Often there is a significant contrast in the quality or level of sound from the first shot to the second. If you have more than one audio track, you can smooth the transition by using one track to fade the sound from the first shot down while you bring in the sound of the second shot on the other track.

Be sure to keep track of hidden audio (see p. 412) while doing your offline edit.

THE EDL AND ONLINE EDITING

When you're finished with the offline edit (having done the rough cut, fine cut and then locked picture) you are ready to compile the edit decision list. The EDL is like a road map that will be used in the online to reconstruct everything you did in the offline. The EDL indicates the timecode addresses for the start and stop points of every bit of video and audio that came from the source tapes. It also shows exactly where each piece is to be recorded on the master tape. If the EDL is done properly, you can go into the online session with the source tapes and, by following your list of numbers, rebuild the edited movie from scratch. When the EDL is on computer disk, the online machines can often *auto-assemble* (also called *auto conform*) the show.

Keep in mind that an EDL only works with sources that have timecode. If there is *anything* in the movie that comes directly from a nontimecoded source (such as music from a CD or cassette, scratch narration, computer-generated graphics) you will have to re-edit these manually in the online session (very time-consuming). This is why it's smart to rerecord every element that lacks timecode onto a timecoded tape *before* you edit it into the offline tape.

It sometimes happens that a single source tape contains different shots that have the same timecode numbers (for example, when the timecode was unintentionally reset). If this happens, give each part of the tape a different reel number so you can find the shot you want in the online.

EDLs and Computer Editing Systems

If you've done your offline on a computer editing system, the system should be able to produce an EDL, which you can bring on disk to the online session. There are various standard EDL formats for different editing systems, including CMX, GVG, Sony and others. All EDLs include a basic set of data about each edit (see Fig. 14-7):

1. *Edit number.* Just a sequential number to help locate edits. Sometimes called *event number*.

2. **Source reel.** Tells you on which tape to find the source material. This is generally the camera tape number if the movie was shot in video. If shot on film, the source reel is the telecine transfer reel (which may have more than one film camera roll on it).

3. **Edit mode.** Indicates if the source for the edit is *Video*, *Audio* or *Both*. A1, A2, etc., indicates which audio channel to use.

4. **Edit type or transition.** May be a *Cut*, *Dissolve*, *Wipe* or *Key*.

5. **Duration.** The length of the transition, in frames. Cuts, being instantaneous, have no duration.

6. **Playback In** and **Out.** Also called *Source In* and *Out.* Tell you the beginning and end points of the source material to use.

7. **Record In** and **Out.** Give you the timecode address of where on the master tape to record the source material.

Edit number	Source reel	Edit mode	Edit type	Dura-tion	Playback in	Playback out	Record in	Record out
1	4	B	C		04:22:14:02	04:22:31:15	01:00:00:00	01:00:17:13
2	5	A1	C		05:06:30:11	05:06:31:09	01:00:16:11	01:00:17:13
3	5	B	C		05:06:31:09	05:06:42:02	01:00:17:13	01:00:28:06

Fig. 14-7. EDL (edit decision list). Information typically contained in a computerized EDL printout or display. The column headings and lines have been added here for clarity and are not part of a typical EDL. See text for explanation.

The events on the EDL may be listed in the order they appear in the program (A mode) or be grouped by source tape (B mode); see Online Editing, below, for more on these terms.

EDLs and Control Track Editing Systems

If you are working with an offline system that doesn't keep track of timecode or print out an EDL, you'll need to compile the EDL manually. With these systems, you are usually editing with window dubs that have burned-in timecode visible on screen. To make the EDL, you roll through the movie slowly, shot by shot, getting the precise timecode number at the beginning and end of each shot. The numbers can be entered into a program on a personal computer, or you can write them by hand on log sheets (see Fig. 14-8). There are many different log styles. Talk to the person who will be performing the online edit for his or her preferences.

EDLs for computer editing systems (see Fig. 14-7) have timecode columns for the source tape (Playback In and Out) and for the editing master tape (Record In and Out). When you use a control track editor for offline editing, *there is no timecode* recorded on the offline editing master tape. All we can list is the burn-in timecode for each shot in the show (Playback In and Out).

LOGGING AUDIO EDITS. With a timecode editor, indicating audio edits is fairly straightforward. For example, the EDL for the split edit shown in Fig. 14-6 would simply instruct the system to go to a certain timecode on the master and begin the

audio of the woman's voice. With a nontimecode system, there is no code on the master, so you have to indicate locations by referring to other edits. To indicate this audio edit you would in effect say, "Go to the end of the man's shot, back up 28 frames and start the woman's audio in that spot." In this case, the end of the man's shot functions as a *sync point*. The start of the woman's sound is then *offset* from the sync point by −28 frames.

Fig. 14-8. Offline EDL. With some offline editing systems, the EDL must be logged manually. The entries shown here indicate how the split edit in Fig. 14-6 might be logged (the numbers are typed here instead of handwritten for clarity). In the "record reference" section of edit #19 we see that the woman's shot is to begin 28 frames before the Record Out point of edit #18. The 28-frame "split edit delay" tells us that this begins as an audio-only edit, then switches to both video and audio after 28 frames. (Log form by Lance Wisniewski, layout by D. M. Schmitt)

Now, in this example, we've *told* you how much the offset is between the picture cut and the audio cut, but when you're editing, you have to figure it out for each split edit. You can use the frame counter on the controller to do it. To find the offset for this shot, zero the counter at the picture cut between the man and the woman, then roll back slowly until you hear the beginning of her sound. The counter will now indicate the offset.

To log this edit on the log sheet, you could indicate an *audio only* edit starting 28 frames before the end of the man's shot, with a 28-frame delay before switching to *both* video and audio (see Fig. 14-8).

HIDDEN AUDIO. Sometimes you make audio edits during the offline that you cannot log by watching the edit master tape. For example, you might have interviewed a baseball player, then cut together several lines of his dialogue to create

voice-over narration for a shot of a baseball game. The burn-in timecode on screen only pertains to the game shot. In this case, the various sound edits are *hidden audio*. Hidden audio can be a tremendous problem if you don't keep track of it while you're editing. If you wait until the offline is finished, you may not be able to reconstruct what you did.

One solution is to do the man's dialogue edits the first time on a *separate* worktape, where their timecode numbers will remain visible. You then dub the edited audio to the master tape (to put under the video of the ball game), returning to the earlier worktape when it comes time to log. Alternately, you could write down all the dialogue timecode numbers before covering the audio with picture. All audio should be timecoded! Whenever you go out to record wild sound (for voice-over, music or effects), record it with timecode or add timecode while dubbing it to videotape for editing.

List Cleaning

Even with computer editing systems that generate their own EDL, you may need to *clean* the list before the online. Say during the offline you had recorded a shot, then gone back and added five seconds to it. The system may list that as two separate edits. In the online, you'll want to record that shot in one continuous edit. After cleaning, the EDL will instruct the online decks to do just that. List management software may be part of the editing system or may be loaded on a personal computer. If you are compiling the EDL manually, list cleaning software can help locate errors as you log the list. Software can be particularly helpful if you decide at the last minute to add or delete a shot, which may cause all the shots that follow it to change Record In and Record Out timecode. (A change in the EDL that forces later edits to be adjusted is said to *ripple* the list.)

Online Editing

The online edit session is the time to rerecord the program at highest possible quality. Use the best equipment you can afford. Tapes should be set up and color balanced carefully (see Recording and Playing Tapes, p. 402). Tape-to-tape color correction is done during the online (or sometimes as a separate step later). Some systems allow you to store the color corrections for particular scenes, allowing you to quickly recall the corrections when you have other scenes that need the same correction.

Some editors like to start by recording the offline edit master directly on the online master as a check against errors (sometimes called *blueprinting*). As you do the online, you replace all the shots with newly recorded shots from the camera original tapes. This method adds time to the online, and ceases to be useful if you make changes during the online (which you often want to do when seeing all the shots and effects in place).

There are several ways to *execute* the EDL. You can start at the beginning of the list and work your way down. Sometimes called an *A mode assembly*, this allows you to check that everything is right as you progress. This is the best system if you did the offline with a nontimecode edit system, or if you want to make any changes during the edit. Doing a *B mode assembly* means recording all the shots from a given

source reel at a time, putting them where they belong on the master, leaving gaps where other shots will go. You then put up the next source reel and edit *that* one to the master. This saves time if there are a lot of source tapes, since switching and setting up tapes can be a hassle, but results in a mess if there are errors in the EDL. Some systems can work with more than one source deck at a time. *C mode* is a variant of B mode that records shots from individual source reels but takes them in ascending order on each source reel instead of the order they appear in the EDL.

Fig. 14-9. Online editing suite. In the traditional online suite, a trained editor/engineer controls a wide range of video and audio equipment. The client sits at the empty desk making phone calls. See also Fig. 1-24. (Mark Jacques/National Boston Video Center)

Make at least one *protection master* (*PM*) from the online edit master as insurance. With analog tapes, this is one generation down from the master; with digital tapes this is not an issue.

Online editing sessions can be very stressful (often a delightful mix of tension and boredom). If you're onlining at a postproduction facility, chances are you're spending more money than you'd like. If you're doing the online yourself, you have the pressure of getting everything right. Be as prepared as possible. If the EDL is on disk instead of handwritten, you'll save time in the online (also, you may be able to load it in and check it before the session begins). If the EDL is handwritten, be sure it's legible.

See p. 441 for video effects and titles used in online editing. See Chapter 7 for more on setting video levels and color. See Chapter 15 for sound editing issues. See Chapter 18 for the business aspects of booking an online edit session.

DIGITAL NONLINEAR EDITING

Before reading this section, see Video Editing, p. 28.

Nonlinear editing has transformed the making of films and videos. Most people who learned to edit using traditional film or videotape systems don't want to go back after they've tried nonlinear editing. If you know either film- or video-style editing, you'll quickly find familiar territory in the creative aspects of nonlinear editing, which combines the best of both. If you are not already computer literate, start by learning the basics of operating a computer. Some nonlinear systems use a Macintosh platform, others are PC (IBM) based.

When railroads replaced horse-drawn carriages, it changed not only how people got across the country, but how they *thought* about the country. Nonlinear editing systems (NLEs) are not merely a tool for cutting and rearranging the shots in a movie. Nonlinear systems often have capabilities to do sophisticated graphics, visual effects and sound editing, making them virtual "studios in a box." A filmmaker can do on his or her desktop what once required a suite filled with machines costing hundreds of thousands of dollars.

Fig. 14-10. Nonlinear editing system. In the FAST Video Machine system shown here, the computer is at left, the VTR is at right. (FAST Electronics US, Inc.)

With traditional film editing, the image is firmly rooted in the *material* of the film: the picture is captured on a negative; it is printed from the negative to another piece of film, and so on. With digital editing systems, the image is much

more fluid. Images for your movie may come from videotapes, be generated in the computer or be imported from another system miles away. Images and sounds can be transformed and processed in hundreds of ways. Once the movie has been edited, it may be rerecorded on videotape, or it can be sent as a computer file on disk or over the Internet. Thus, nonlinear systems are not simply *editing* machines, but have the potential to play a central role in a new kind of postproduction process.

What Does *Nonlinear* Really Mean?

While videotape editing is based on the idea of sequentially recording sections of tape (see Making an Edit, p. 406), nonlinear systems use a computer to organize and play pictures and sounds. In videotape editing, we select shots from one tape (the source tape) and rerecord them in sequence on another tape (the master tape). Say we record shots A, B and C in that order. If we later decide to lengthen shot B, and perhaps insert a new shot N after shot A, we basically have to start over from the beginning, recording a new master tape.

In nonlinear editing, the shots from the source tape are loaded into the computer. This process is called *digitizing* or *capturing*, and involves converting any nondigital video or audio material to digital form and then recording it on the computer's hard drives.[4] Hard drives give you instant, *random access* to any part of the footage (you don't have to "rewind" to get from the end of the footage to any other part—the drive head can move there in a tiny fraction of a second).

The idea of "editing" using a nonlinear system is really just building up a list of instructions telling the computer drives what to play next. In the example above, when we edit shots A, B and C together, we are simply telling the computer to find shot A, play it, instantly jump to shot B, play it, and so on. No material is rerecorded or moved on the drive.

If we now decide to lengthen shot B and insert shot N, all we do is alter the "playlist." Now the computer is told to play shot A, then jump to N, then jump to B, but this time play more of the shot than it did last time.

In nonlinear parlance, the individual sections of video or audio are called *clips*. By selecting the length of each clip and the order in which it is played relative to the other clips, we are "editing" the movie.

There *are* times when the computer may rerecord or create new material. Say instead of a hard cut you decide to dissolve between shots A and B. The computer will play the end of shot A and meld it with the first few frames of shot B. Some systems can do this on the fly (*real-time effects*), but others must first process or *render* this transition, storing the frames that contain the A/B overlap as a separate clip to be added to the playlist.

[4]The term *digitizing* implies converting analog material to digital form. If video or audio material was shot with a digital camera (say, a DV camcorder) it does not need to be digitized when loading it into the editing system. In this case, the term *capturing* can be used to mean loading already-digitized material.

GETTING WHAT YOU NEED FROM THE SYSTEM

Nonlinear editing systems vary in their capabilities. Some systems are capable of very high picture quality; others work at a lower quality. Some systems have lots of hard drive storage space; others are equipped with less storage. Some systems have the software and hardware to do complex sound editing; others have only basic sound capability.

Like many other aspects of filmmaking, in order to choose the nonlinear system for your project—or to know how to work with the system you have—you need to trace backward from the end product. What level of video quality do you need? If the movie is for TV broadcast, the standards for the video signal are much higher than if you're making a multimedia project for a Web site. On the other hand, you may care very little about the picture quality of the editing system if you're using it for "offline" work (see below) or editing a project that was shot on film and will be finished on film.

Other factors to consider include the amount of raw material. Do you have 50 hours of camera tapes for a long-form documentary, or only 30 minutes of animation you need to edit together? You'll need a lot less storage to handle the latter.

How complex are your sound needs? Do you need just one track of sync sound and a little narration, or will you be building a multilayered sound track with lots of effects and music? Do you hope to do all the sound work on the machine, or will you be using other sound editing systems (see Chapter 15)?

Sometimes when you're just starting a project you can't *say* exactly what you need yet, especially if you're new to the process. The question of what picture quality or resolution you need can be tricky. For an overview of what resolution means, and how it relates to picture quality through the entire production process, see Resolution, p. 33. By the time you're ready to edit, one of the biggest decisions in terms of resolution will have already been made: the capture (shooting) format for the movie has already been picked. Regardless of what camcorder format was used to shoot the movie—whether it be Hi8, DV, Digital Betacam or HDTV—the original tapes as they came out of the camera represent the highest resolution the video can have. Putting the video into a nonlinear system can only maintain or lower that resolution, it can't increase it. So one way to think about the postproduction process is to try to keep the quality and resolution as close to the original tapes as possible.

Following are some of the ways nonlinear editing systems can be used for different projects.

Nonlinear "Online"

Some systems are capable of working with a high-quality video signal. These may be able to work at full "broadcast quality" or, if you're not making shows for broadcast, quality sufficient for your needs.[5] If the machine has the graphics, effects and other capabilities that your project requires, you may be able to digitize

[5]See Broadcast Standards, p. 192, for more on broadcast requirements.

your tapes into the system, edit the movie and output a finished product. When used this way, the machine may be thought of as an "online" system (see Offline and Online, p. 399).

Nonlinear "Offline"

One problem with working with a high-quality, high-resolution video signal is that it requires a lot of storage space on the system's hard drives. Virtually all nonlinear systems use some form of *compression* to reduce the amount of data in the video, lowering the resolution and allowing you to store more minutes of material on the drives. Generally, the more you compress the video in the editing system, the lower the picture quality becomes. We will return to the idea of compression a few times in this chapter.

Depending on how a nonlinear system is configured, it may not have enough storage to allow you to digitize all your material at its highest quality. Or it may lack other features that you need to complete your movie. If so, the system can be used in an "offline" mode. In this case you would digitize your material at lower resolution, which reduces the picture quality, but allows you to edit more footage. The image doesn't look as pretty, but you still have all the benefits of nonlinear editing, and you can change and restructure the movie freely. When you're done editing, the system can produce an EDL of the show. You then have a few options:

1. You can take the EDL and do a traditional tape-to-tape online at a postproduction house (see Online Editing, p. 413). Most nonlinear systems can output an EDL in a standard format that can be entered directly (via disk or modem) into the post house's online system. Some nonlinear editing systems can control two or more VTRs so you could do a tape-to-tape assembly using your own system, perhaps with some additional rented decks.
2. If your system can accommodate it, you can redigitize at high resolution just the material used in the edited movie (the edited movie is generally much shorter than all the raw footage and thus may now fit on the drives. This usually requires timecode. Note that in the digital world, the same machine may be both an "offline" and an "online" system.
3. If you are editing material that originated on film and will be finished on film, the system can generate an EDL or film cut list to guide in cutting the film negative (see Chapter 13).

Input

As noted above, there are several ways to bring images and sound into the nonlinear editing system.

In most nonlinear systems, a videotape recorder (VTR) is used to bring raw video footage in. Preferably this VTR is a high-quality digital or analog machine that can be controlled by the editing system. If the nonlinear system has a VTR controller and a timecode reader, then you can automate some of the digitizing process (see batch digitizing and redigitizing, p. 425). For a low-cost setup you could use the camcorder itself as the input VTR. Particularly with some small-

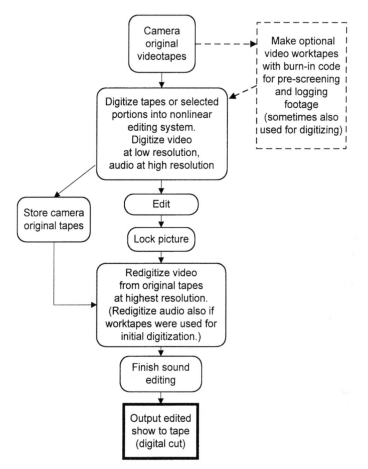

Fig. 14-11. A possible route for completing all video and audio editing using a nonlinear system. The video is first digitized at low resolution to minimize storage needs, then redigitized after the edit to maximize picture quality. On some productions, video worktapes are used to preselect material for digitizing and/or for doing the initial digitization. See Figs. 13-14 and 13-16 for options when working with film-originated material or for other audio and video editing options after picture lock.

format video systems, it may be necessary to *bump up* the camera tapes to a larger professional format before the footage can be digitized or online edited.

Many people digitize directly from the camera original tapes. However, editing may require going back to the tapes several times if you don't have enough storage to digitize everything in the first pass. Rather than subject originals to this kind of use (which can cause dropouts or other defects) on many projects, a dub or clone (see Making Worktapes and Other Dubs, p. 403) is made for use in the editing room, which also gives you an insurance copy in case something happens to the tape.

Audio can be digitized from tape, disc or other formats. Graphics can be im-

ported in a number of file formats (see Titles and Graphics, p. 443). If you use nontimecoded video, audio or graphics sources for your movie and plan to create an EDL to do an online edit later, see The EDL and Online Edit, p. 410.

Output

After the movie is edited, you have a number of options for getting the material *out* of the machine.

The movie can be transferred from the editing system directly to videotape (sometimes called *print to tape* or *digital cut*). Sometimes a high-quality VTR with multiple audio tracks is brought in just for this purpose. When possible, use a digital rather than analog tape format.

On a high-end system working at high resolution, the signal quality of a digital cut can be excellent. Nonlinear systems are now used to create programming directly for broadcast. However, on some systems, and/or at lower resolution, a digital cut may have a noticeably degraded picture compared to the camera original tapes. In a sense, a digital cut can be thought of as being two "generations" removed from the original. The video from the camera tapes is usually compressed when brought into the nonlinear system's hard drive and then decompressed when brought back out to the VTR. If the original is analog, it must be also converted to digital, and perhaps back. This may result in some loss of picture quality.[6] If your system is capable of higher resolution than the level you've been using to edit, you can maximize quality by redigitizing at high resolution and *then* printing to tape.

When time and budget permit, it is sometimes preferable to finish the project at a postproduction facility that has high-quality video monitors and test equipment that assist in doing good color correction and preparing the video to meet broadcast standards. In this case, you could use your nonlinear system to generate an EDL, then take the EDL and the original videotapes to the post facility to do the online edit either as a traditional tape-to-tape edit or using a high-end nonlinear system.

Increasingly, video and audio are kept in digital form and brought in or out of the editing system on removable computer disks or drives or sent via cable or network to or from other broadcast or postproduction equipment. Connecting the editing system to a network allows several people to work with the same footage. In a tight finishing schedule, this facilitates picture editing, sound editing, effects and graphics being done concurrently.

If you are making multimedia programs for CD-ROM or the Web, you may be creating QuickTime or other computer files that can be exported on disk or via modem.

Many nonlinear systems can create and read files in the *OMFI* (*Open Media Framework Interchange*) format, which is often referred to just as OMF. OMF provides a standardized way to exchange digital media between applications and across different platforms. OMF supports video, audio, graphics, animation and effects. It allows you to digitally transfer source elements, effects and detailed con-

[6]On the other hand, some systems are able to capture material with little or no compression. DV, for example, is very resistant to generational loss when brought in and out of the system on a FireWire (see The Capture Card, below).

trol information from one system to another. The newer *AAF* (*Advanced Authoring Format*) employs OMF to serve a similar function.

One important use of OMF is for sound editing. With OMF you can transfer multiple tracks of audio from one nonlinear system to another, or to an audio work-station (DAW). When using OMF you can transfer the sound itself and you can transfer a file that tells the other system how the sound is edited together into a se-quence, what level each section should be played at and so on. Avid describes this as transferring the "ingredients" (in this case, the sound) and the "recipe." In technical terms, the sound is in *media files* (see Digitizing and Logging Clips, p. 426) and the editing and control information is called the *composition* (and is sometimes referred to as *metadata*.) When transferring sound or picture using AAF/OMF you can choose to send either the media files, the composition or both (for more, see Preparing and Delivering Tracks, p. 464.)

Choosing a Nonlinear Editing System

There are numerous nonlinear editing systems on the market. Some manufac-turers use proprietary hardware and software and may sell fully assembled "turnkey" systems. It is also possible to put together lower-cost desktop systems by combining off-the-shelf computers, digitizing cards and editing software that may all be made by different companies.

Fig. 14-12. Editing screen from FAST Video Machine. (FAST Electronics US, Inc.)

Competition between manufacturers spurs constant improvements. As the market evolves, the best features developed by one company tend to be emulated by others. Still, there can be big differences between systems in terms of picture quality, ease of use, and cost.

To choose a system, talk with people who do the kind of work you do (or want

to do). Magazine reviews and Web sites are often the most current source of information. Since technology is changing fast, it's often a good idea to rent or lease unless you need the machine on a long-term basis. It's shocking how fast a "hot" machine can turn into a dinosaur. If you intend to buy, be sure to look into the cost and possibility of later upgrades. Good technical support from the manufacturer or dealer is essential whether you buy or rent.

Another consideration is the benefit of using the same system that others in your industry use. This makes it easier to find machines to work on, or, if you're a freelancer, to get work. If you're working alone, or on in-house projects, you have more freedom in choosing a system. If you need to interact with many production facilities and outside workers, then there is pressure to use a standard system. As of this writing, Avid plays a leading role in the mainstream film and television industries. Other systems include Media 100, Lightworks, Discreet Logic, Fast, Scitex and software applications like Adobe Premiere, Radius Edit DV and Ulead Media Studio. Many manufacturers make full-featured, top-of-the-line systems as well as lower-priced, more limited systems aimed at the corporate, multimedia and independent markets.

COMPONENTS OF A NONLINEAR EDITING SYSTEM

A nonlinear editing system is basically a computer with various devices attached or installed internally (see Fig. 14-13). The processing speed of the computer affects how quickly the system can create (render) video transitions and effects. Faster processors require less rendering time. The more effects you use, and the more often you work with a client watching over your shoulder, the more impact a fast processor will make on your work life. If you tend to work alone and/or with mostly straight cuts and dissolves, a less expensive system that takes longer to render may not limit you much.

The Capture Card

One of the most sensitive functions of the computer is *audio/video capture*. The capture system is responsible for digitizing and compressing the audio and video as you bring them into the system. The capture process is done by a combination of hardware (the *capture card*, sometimes called a *digitizing board*) and software. Compression is done to reduce the amount of space needed to store the digitized video or audio material. Capture systems vary widely in their methods and sophistication, which can have a big impact on picture quality. As of this writing, Media 100's Vincent card is considered one of the best on the market. See Digital Compression, p. 203, for more on these topics.

Some capture systems do little or no compression to the incoming video, which results in picture quality very close to the camera original tapes. Systems that can handle "uncompressed D1" for example, may be able to take the signal from a video deck of any format (except HDTV) without diminishing the resolution.[7] "Native

[7]Of course, an NTSC machine can't necessarily accept PAL format tapes, or vice versa. See Comparing Digital Video Formats, p. 206 for more on the use of uncompressed D1 or 601 video.

Fullscreen video monitor Bin monitor Edit monitor Speakers

VTR

Computer

3D effects

Hard drives

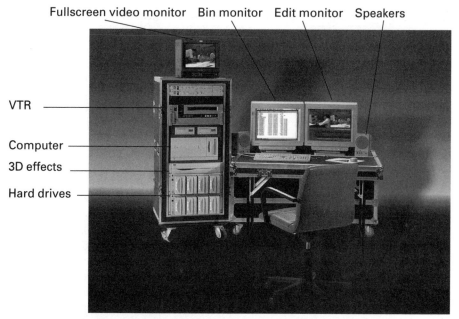

Fig. 14-13. High-end Avid "online" system. Shown here mounted in shipping cases for a portable editing studio. (Prime to Go)

Fig. 14-14. Capture card. DV Master with FireWire interface. (FAST Electronics US, Inc.)

digital" systems can accept video into the editing system without changing the original digital format—this provides an exact copy (clone) of the data from the camera tape to the computer with no additional compression. This may be done with a SDI (Serial Digital Interface) link or a FireWire connection (see p. 26).

For example, the DV signal is compressed in the camera when the tape is first recorded. Editing systems equipped to handle "native DV" can take the signal from a DV camera or deck using a FireWire connection. This is essentially a di-

rect transfer of the camera tape with no processing. This can be done with a relatively inexpensive transfer or capture card and allows you to bring material in and out of the editing system multiple times with no degradation. DV and some other digital formats allow data transfer at greater than real time rates. A system that transfers at 4X speed allows you to load an hour of material in 15 minutes.

Of course, if video is *not* compressed when it is brought into the system, you have to weigh the benefit of good picture quality against the drawback of relatively large storage needs. Uncompressed D1-level video requires about one gigabyte of hard drive storage for every minute of material. With native DV you can store only about 4½ minutes of material per gigabyte (see below).

Storage

Digitized video and audio clips are stored on computer disks. As of this writing, hard drives (magnetic disks) are generally used because they provide fast *access time* to quickly find material on the disk and they can move large amounts of data per second (high *data transfer rate* or *throughput*). Various kinds of *magneto-optical* discs are sometimes used, but they may not have sufficiently fast access time or high enough throughput if you are working at high picture resolutions (which require a lot of data). Sometimes drives are grouped together in sets to increase performance, such as a *RAID* (*Redundant Array of Inexpensive Disks*). In a RAID, multiple, *striped drives* allow the computer to take material alternately from two or more drives to speed up access time and throughput. With certain systems, striped drives are required for the system to achieve its highest resolution.

Storage capacity of computer drives is generally measured in megabytes (MB) or gigabytes (GB). One MB equals 1,000 kilobytes (kB); one GB equals 1000 MB. Sometimes people refer to systems in terms of how many "gigs" they have.

Having enough storage capacity makes all the difference in nonlinear editing. If you only have enough storage to work on a small portion of your footage at a time, you may find your creativity hampered. The cost of hard drives is dropping rapidly, and this may soon cease to be a limiting factor.

If you have filled the system's hard drives with material for your project, no other project can be edited on the system without overwriting your material. You will not lose your editing decisions (the sequence or EDL is easily stored on floppy disk) but you will have to redigitize any material that was lost. Similarly, if you choose to edit on another system you will usually need to redigitize your footage (see Chapter 7 for exceptions). Some systems are equipped with racks or docks to accept removable hard drives. Blocks of drives can be purchased or rented for the duration of a project, and stored or transported to another system or facility as needed. When switching between systems, be sure they both use compatible versions of the same software.

Monitors

The editing system's monitor allows you to view the picture and the graphical interface used to control the system. Get the biggest monitor you can—or better, use two monitors—to facilitate viewing all the displayed information. In addition to the computer monitors, it's also a good idea to have a TV monitor in the system. This is because the RGB computer monitor doesn't display the image the

way it will look after it has been converted back to a composite or component video signal (see p. 19). With an NTSC or PAL TV monitor you can check the image as it will eventually be seen; you can also view tapes directly from the VTR. Not all editing systems are equipped to output an encoded NTSC or PAL video signal. See Appendix A for setting up a monitor before working.

CAPTURING AND ORGANIZING CLIPS

Picture Quality and Storage Space

Before editing can begin, video and audio must be loaded into the system. Typically this is done by playing the source tape in the VTR and recording on the computer's drives. Most editing systems allow you to digitize video and audio material at various quality levels or "resolutions"—on some systems you must choose one resolution for the whole project, on others you can set resolution on a clip-by-clip basis. The higher the resolution, the better the picture looks, and the more space the material will occupy on the hard drives. If you have sufficient storage capacity on your drives, then digitize at the highest resolution and enjoy the crispest picture. Particularly for long-form movies, it is often the case that you have more footage than can be stored on disc at full resolution. You have several options:

1. You can digitize at a lower resolution (that is, use more compression to reduce the amount of data needed for each second of video, which will also reduce picture quality). Avid editing systems use a range of "AVR" numbers to indicate levels of picture quality. Some systems indicate picture quality according to the amount of data used to record the image, expressed in the number of kilobytes per frame (kB/frame). Other systems give you a choice of compression ratio; the higher the ratio, the lower the image quality (20:1 results in poorer quality than 5:1). Some systems give you other options for reducing the amount of data, including digitizing only one field per video frame, working at a lower frame rate or reducing the dimensions of the image. See Digital Compression. p. 204, for more on these topics.

2. You can digitize only enough material to work on a portion of the project at a time. For a drama, you could digitize selected takes only and use the VTR to search for alternative takes.

3. Since storage needs are most intensive when you begin editing and need to winnow down large amounts of raw footage, you could start by digitizing in low-quality "draft mode." As you work through the material, you can delete the outtakes (unused footage). When you're done with the rough cut, you then redigitize the edited movie at a higher resolution (this process is sometimes referred to as *resing up*). This is really only practical if the original tapes have timecode. If the nonlinear system can control the VTR, you may be able to do *batch redigitizing* in which selected clips are automatically replaced with a higher-quality digitization from tape. This process can include saving short extensions or *handles* at the beginning and end of each clip, giving you the flexibility to lengthen the clip later if you choose.

Digitizing and Logging Clips

When you digitize or capture a section of video or audio material into the editing system, it becomes a computer file (digital data) which is written (recorded) to the system's hard drives. This file is called a *media file* (or sometimes *source media file* or *source file*). Media files are often quite large. Say you digitized a shot of a boy jumping in a pool and then digitized a shot of him eating lunch. Each shot would become a separate media file (actually each shot may have one media file for the video portion and one for each audio channel). When you edit your movie, and decide to put the lunch shot before the pool shot, you are not moving the media files around. Instead, you move or arrange *clips;* each clip is a sort of "pointer" that tells the computer to go to a certain media file and play a portion of it (see What Does *Nonlinear* Really Mean?, p. 416). For any given media file you could have many different clips. For example, you could use a short clip of the boy jumping at the beginning of the movie, then use a longer clip showing him jumping and splashing in later on. Different clips can "reuse" the same source media data as often as needed (unless this is a project that was shot and will be finished on film; see p. 392).

Fig. 14-15. Digitizing controls and displays. Note waveform monitor and vectorscope at bottom.

Digitizing or capturing a continuous section of video onto the computer drives is often referred to as *digitizing a clip*. The captured material becomes a media file. The clip that points to *all* the video in that media file is the *master clip*. Any portions of the master clip used in the edited project may be called *subclips*. The same terminology can be used for audio clips.

Some people like to digitize large chunks of material into a single clip. How-

ever, when digitizing material with timecode, whenever there is a break in the timecode, you must start a new clip.[8]

Some people prefer to digitize individual shots or short sections as separate clips. This helps locate material later, and is more efficient if you only need a few shots from a long tape. Sometimes only "good" takes are digitized; this saves space, but can have some disadvantages (see Selecting Shots, p. 355). Cameras and editing machines equipped with Sony's ClipLink system allow the camera operator in the field to mark which clips to digitize.

The editing system should allow you to give each clip a name and type in comments or other information about the clip (see below). Clips may be digitized *on the fly*, which means that they are defined and labeled as they are loaded into the editing system. Some people prefer to preview the material before actually digitizing, when they can view the footage and log which clips they want and give them labels. This can be done using the editing system or, if the system is not available, using a VTR and a personal computer with a logging program, like MediaLog. With a cable between the VTR and computer, software like Imagine Products' The Executive Producer can automatically detect scene changes and record the timecode at the beginning and end of each shot. To log the footage, you go through the camera tapes, specifying by timecode address where clips are to start and stop, giving each clip a name and indicating which footage *not* to digitize. The log is entered into the editing system, which then proceeds to *batch digitize* or *batch capture*, automatically recording the selected footage onto the computer drives while labeling the clips.

Adjusting Video and Audio During Capture

When video and audio material is loaded into the editing system, various settings need to be adjusted or checked. First, just like in videotape editing, the playback source needs to be set up for proper color and audio reproduction. If the footage has been recorded with color bars and tone at the head of the source tape, use the editing system's waveform monitor and vectorscope to adjust video and color levels (see Bars and Tone, p. 404). If the system lacks these tools, set the levels by eye. Similarly, the audio level must be set so audio will be recorded at a proper level on the hard drives. Digital sources that are brought directly into the editing system in native digital form (for example via FireWire or SDI) allow no adjustment.

When digitizing, the editing system should allow you to choose which hard drive or *partition* (part of a drive) to record the material to. Sometimes editors digitize video to one partition or drive and send the audio to another. On some systems, this facilitates playback. Keeping video and audio separated may also help prepare for "resing up" later (see Picture Quality and Storage Space, p. 425) when you may want to delete *just* the media files for video, without losing your audio.

You will also have a choice of resolution. Video resolution choices are discussed

[8]Some prosumer cameras reset timecode to zero when the tape is removed. If you ever have a situation where two parts of the same tape have the same timecode, give them different reel numbers or you will have trouble finding the shot in an online.

on p. 425. Many editing systems give you a choice of sampling rate for digitizing audio: 44.1 kHz at 16 bits per sample is the equivalent of CD quality; 48 kHz is DAT quality, which is higher. If your audio is coming from a digital source, you may want to use the same sampling rate as the source to facilitate high-quality, direct digital-to-digital transfer of the audio.

The higher the sampling rate, the more disk storage is needed; however, compared to video, digitized audio requires a small fraction of the storage space. You can usually choose to digitize one or more audio tracks for each video clip; using multiple tracks may have more impact on your storage needs than using a high sample rate. See Digital Audio Recorders, p. 256 for more on the choice of sampling rate. See Sound Processing Devices, p. 449 for equalization when capturing audio. If you will be working with an audio postproduction facility for later sound editing or mixing, always consult with them *before* you digitize to find out their preferences.

If you are working on a project that was originally shot on film, audio material may need to be slowed down (pulled down) when digitized into the system (see p. 391). If the project was shot on film and will also be finished on film, you may need to identify the film pulldown phase of the first frame of each clip (see 24/30 Translation, p. 394).

Organizing Clips

As clips are captured into the editing system, they can be grouped together for convenience. Just as film editors use various bins to hang pieces of film or sound (see Fig. 13-9), nonlinear editing systems have *folders* or *bins* in which certain clips or edited sequences can be kept separately from the rest of the material. You may want to put all the clips pertaining to a certain group of scenes in one bin, keep edited sequences in another, and so on.

Keyframe	Name	Reel Name	In Time	Out Time	Tracks	Comments
Unavailable	*Title 1*	3	00:00:00:00	00:00:01:29	G	
	Backup	3	01:35:43:17	01:35:57:12	V A1 A2	
	Bus	3	01:35:51:05	01:35:53:05	V A1 A2	
	Sound FX		01:35:43:17	01:35:57:12	A5 A6	

Fig. 14-16. Bin. Media 100 bin display showing picture icon, clip name and other data about each clip in the bin, including the source video reel and timecode.

Most editing systems can display one or more frames from each clip as a still image. Sometimes called *poster frames*, *picons* (for picture-icon) or *thumbnails*, these can form a sort of storyboard to help you visualize how the clips can be edited together.

The clips can also be viewed in the form of a text list (see Fig. 14-16). The list will have several different *fields* of information about each clip, including the name of the clip, starting and ending timecode, and the tape reel from which the clip came. Many editing systems allow you to store several other fields of data for the clip. For example, you might want to list the shoot date or location or other items of interest (many systems support *user-editable fields*, so you can create your own categories). For a project that originated on film, you may need to keep track of keycode numbers, in-camera or audio timecode as well as camera roll, sound roll and telecine reel numbers (see Fig. 17-5). Though you may be able to enter this data by hand, there are various programs available that can automatically import this information into the clip list from logs generated at the shoot and/or, for a film-originated project, from the telecine session (see p. 521).

Many editing systems have sophisticated database management programs that allow you to quickly *sift* through the list of clips to find, say, all shots taken on a certain day or containing a certain character. Some systems can automatically locate all footage pertaining to a marked line in the script, including syncing up all footage shot at the same time by multiple cameras.

Logging and organization is important when using any film or video editing system (see Chapter 12). For nonlinear editing in particular, your ability to get the most out of the system depends on the clips being organized and identified in a logical and coherent way. Like any computer system, it's surprisingly easy to "lose" files if you're not careful.

CREATING AND EDITING SEQUENCES

The Editing Interface and Timeline

Like word processing software, nonlinear editing systems differ somewhat in their particulars, yet almost all have certain fundamental concepts in common. The *editing interface* is the method by which you control the system. Usually this is displayed on one or more computer screens divided into several areas or *windows* on the *desktop*. Usually there are two windows that display video (see Fig. 14-17). One of them is the equivalent of the *source monitor* in tape editing (see Fig. 14-1). Here you can view unedited clips and mark which portions you want to use. The second window is the *record* or *program monitor*. This displays the edited movie or sequence that you are creating. (Confusingly, the word *monitor* is used to refer to the computer screen as a whole and to individual windows on it.)

There may be other windows open on the desktop. Specialized *tool* windows display items such as titling or effects tools. The *bin monitor* displays the available clips in a bin (on high-end systems, the bin is displayed on a separate computer monitor from the other items).

Clips and sequences (edited groups of clips) can be played using keyboard commands or by touching onscreen buttons using the mouse. Some systems allow you to use a "manual user interface" which is a hand-operated jog/shuttle control, similar to a videotape recorder remote control (see Fig. 14-1). Some systems have a toggle interface similar to a flatbed film editing machine.

Source monitor Record monitor

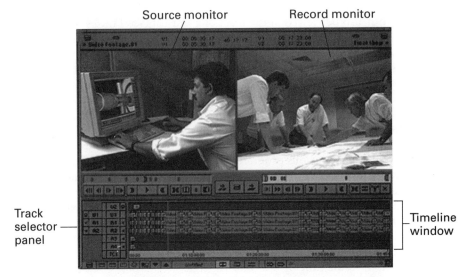

Track selector panel

Timeline window

Fig. 14-17. Editing interface from Avid Media Composer. (Prime to Go)

Fig. 14-18. Timeline. This Avid timeline shows one video track and two audio tracks in use. Frames from the video track are also being displayed at top. In the sequence shown here, the cut from the windmill to the cat is a split edit with the cat's sound leading the picture cut (compare with the split edit in Fig. 14-6).

Most systems employ a *timeline* that graphically shows how the clips are edited together (see Fig. 14-18). Most timelines use colored rectangles to represent video and audio clips. Timelines read from left to right, with markings showing time (timecode) advancing as you move to the right. Video clips are arranged on one or more "tracks" that the show clips you've chosen in order from beginning to end. The length of a clip on the timeline generally corresponds to the length of time the clip will play on screen. On some systems, the clips are arranged end to end, primarily on one video track. Other systems employ two tracks in a checkerboard fashion (see Fig. 14-19). The first shot in a sequence is on track A, the next on track B, the third on A and so on (this is not unlike A&B rolls in film printing; see

p. 482). An effects track between the two video tracks displays transitional effects, such as a dissolve, between clips on A and B.

Audio clips are represented in another set of tracks. These tracks can be edited independently of the picture, or the audio and video can be locked together to preserve sync relationships. People who have done film editing will find this "double-system" approach very familiar.

Most systems use a long vertical bar that crosses all the tracks and indicates the point at which the system is playing in play mode, or the point at which an edit will take place when you are in edit mode. This bar is variously referred to as the *cursor*, *play line*, *play bar* or *position indicator*. On most systems, the cursor moves across the timeline from left to right when you are playing a sequence; on others, the play line remains fixed on the screen and the timeline moves behind it.

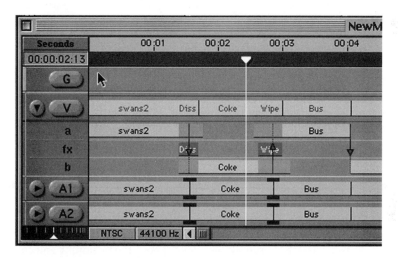

Fig. 14-19. Timeline. This Media 100 timeline displays alternating video clips on tracks "a" and "b" with transitional video effects between the clips on the "fx" track. The "V" track shows a composite of "a" and "b."

Generally you can view the timeline in a few different ways. You can *zoom in* to examine in detail how audio and video fit together at a particular cut or transition, or *zoom out* to see a sequence or the entire movie as a whole, to get a sense of the pacing and overall balance. Some systems can display still images (picons) from each clip as a kind of filmstrip, almost as if you were looking at a piece of edited film. There are several options for viewing audio clips on the timeline (see Basic Sound Editing, p. 438).

You Won't Hurt Anything

It's important to remember that clips arranged on the timeline are nothing more than pointers to the media files which are stored elsewhere on the hard drives (see Digitizing and Logging Clips, p. 426). You can delete, change, move or

copy clips without in any way affecting or damaging the original media that they point to. Nonlinear editing is thus completely "nondestructive." Once a clip is on the timeline, you can shorten or lengthen it at any time (assuming there is enough material in the original media; see Trimming Clips, p. 435). You can easily save multiple versions of an edited sequence and choose later which works best.

To further relax you about the editing process, keep in mind that most systems have *undo* commands, which allow you to easily correct editing mistakes. Some have many "levels" of undo, so you can go back several steps to fix something that went wrong.

However, as anyone who has used a computer knows, mysterious things occasionally happen to make you miserable. Files become corrupted or lost or the system refuses to respond. At the end of each day (or more often), make backups of your sequences and other files that you can (media files are usually not backed up because they're too big). Hopefully you'll be able to reconstruct anything you lose. The ultimate fallbacks are the original camera tapes. Unless, of course, it's three in the morning and the piece is due by eight. . . .

Marking and Assembling Clips

To begin editing the movie, start by identifying the clips you want to use. On most systems, you simply move the mouse to a clip in the bin and double click to play it in the source monitor. The entire, uncut clip is the master clip. If you want to use only a portion it, mark an In Point (start mark) and Out Point (end mark) in the source window. You have just *marked* the clip. It's ready to be put into the movie.

On some editing systems, you can place a clip on the timeline simply by dragging with the mouse from the source window to the timeline (*drag and drop*). Another way to bring a clip onto the timeline is by marking an In Point on the edited sequence and then giving a command to insert the new clip at that spot (see below). Just as in videotape editing, most edits can be defined with three points (see Marking Edit Points, p. 407). For example, we could specify the beginning and ending of a new clip (Source In and Source Out) and then specify where to place the clip in the edited sequence (Record In). Alternately, we might want to fill a specific gap in the edited sequence. In this case we could mark the beginning and end of the gap (Record In and Record Out) and then mark the beginning of the new source clip we're using to fill the gap (Source In). You don't have to find the fourth point that defines the edit (in this case Source Out); the computer will do it for you.

Just as in tape editing, there are times when you want to simply string shots together, without having to define the Out Points right away. Most nonlinear editing systems will allow you to do an *open-ended* or *two-point* edit. You simply mark the beginning of the clip and mark where to insert it in the sequence, and then trim the end of the clip later (see below). In fact, it is often good practice to start by building a sequence with clips that are a bit too long, since it is easier to judge where to cut after you have the basic sequence in place.

Backtimed edits (see Marking Edit Points, p. 407) are very easy with nonlinear systems. Say you need a clip to *end* at an important moment but the beginning is less critical. You can mark the Source Out, Record In and Record Out and let the system determine the Source In.

DIFFERENT WAYS OF WORKING. Most nonlinear systems allow you to do a given task several different ways, so you can find the style of working that suits you best. You can use the keyboard, mouse or a combination. Many pros find that they use the mouse very little.

On many systems, you can reshuffle clips on the timeline with the mouse, sometimes called *segment editing*. On some systems, you can move a clip anywhere on the timeline just by dragging it; on others, a clip will "snap" only to certain spots (like immediately touching another clip) to prevent you from, say, accidentally leaving an empty frame between clips.

You can also use the cursor or play line to define edits. Most editing systems include commands to bring a new clip onto the timeline starting or ending wherever the play line is located. You can also define edits using timecode numbers. Most systems have a timecode display running along the top or bottom of the timeline. You can generally click on a clip in one of the monitor windows and get a readout of the source and record timecode at the beginning and end of the clip (see The EDL and Online Editing, p. 410, if these terms are unfamiliar). Edits can then be performed numerically, by entering the timecode for In and Out Points.

Adding Clips to a Sequence

As you edit, you build up a sequence of shots. When you want to add a new clip to an existing sequence, you use one of the methods described above to indicate *where* on the timeline to insert the new shot. In nonlinear editing, you have two options about *how* the new clip will affect the clips that are already in the sequence. Say you have already built a three-shot sequence using clips A, B and C. Now you want to insert a new clip after clip A (see Fig. 14-20).

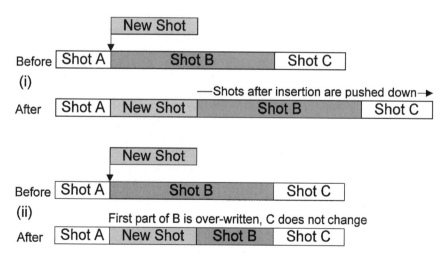

Fig. 14-20. Adding a shot. (i) With an insert or splice edit (film-style insert), the new shot causes existing shots after the insertion point to be pushed later in the sequence. (ii) With an overwrite edit (video-style insert), the new shot covers over existing material without changing the position of other shots.

In a *film-style insert*, you attach or *splice* the new clip onto the end of clip A. Clip B remains intact, but is pushed back (later in timecode). This is called *film style* because it's like the idea of cutting apart a roll of film, splicing in a new shot and then splicing the roll back together. Note that the roll of film gets longer by doing so. Similarly, the video sequence on the timeline gets longer when we splice in the new clip. If clip B began in the edited sequence at, say, one minute timecode prior to making the edit, it will begin at one minute plus the length of the new clip after we make the edit. Any clips following B will also be pushed back the same amount. In video terms, this edit has *rippled* all the clips after the edit; that is, it has changed the Record In and Out Points for every clip following the edit point.

Many people call this type of edit simply an *insert*. Other names include *splice* or *ripple edit*.

In a *video-style* edit, when we add the new clip, we *overwrite* (cover over) the existing sequence starting at the edit point and continuing until the end of the new clip. The new clip replaces the beginning of shot C. The end of shot C and the rest of the sequence is unaffected. Note that the total length of the sequence *does not change*. Like an insert edit on videotape, this edit in a sense "rerecords" the marked section of the sequence, replacing it with new material. Clips following the edit (later in the sequence) *do not ripple*; they remain in their original positions.

This type of edit is most often called an *overwrite or overlay*.

Insert edits are a very basic way of adding new material as you construct a sequence or build a string of sequences. Overwrite edits are useful for changing a sequence without changing its length or the sync relationship between picture and sound. Say you had edited a sequence of images cut to music, so that the pictures matched up to beats in the music and the overall sequence was exactly the length of the song. Using overwrite edits, you could add shots in the picture without disrupting the length of the sequence or the basic sync between picture and music.

Removing Clips from a Sequence

Say instead of adding a clip to the sequence A, B, C, we want to remove a shot. Again we have two options for doing so (see Fig. 14-21).

In a film-style edit, we delete clip B, and the end of clip A is "reattached" to the beginning of shot C. The total length of the edited sequence is reduced—it becomes shorter, in this case, by the length of shot B. Some people just call this *delete*; other names include *extract edit* or *ripple delete*. On many systems, when a clip is deleted, it is sent to the *clipboard* (a temporary storage area) and can be easily reinserted elsewhere in the sequence. Even without the clipboard, you can always go back to the original clip in the bin to reinsert the shot elsewhere.

In the video-style version, when we mark shot B for removal, the editing system replaces it with black "filler." The filler is really just a place-holder that keeps clips A and C in their original positions. This is equivalent to slugging a film workprint with leader or fill. The sequence maintains its original length, shot B is gone, and the space is easily filled with another shot later. Sync relationships and the total length of the sequence do not change.

This is called a *lift edit*.

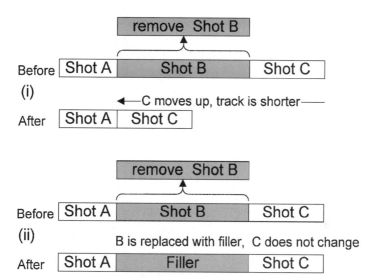

Fig. 14-21. Removing a shot. (i) With a delete or extract edit (film-style delete), removing a shot causes all the following shots to be pulled earlier in the sequence. (ii) With a lift edit (video-style delete), any material that is removed is replaced with filler. The rest of the sequence remains unchanged.

Many editing systems offer several other variations on the above-mentioned edits. However, you can perform most editing tasks with these four basic edits. To review: You can bring a clip to the timeline by splicing or by overwriting. You can remove a clip by extracting or by lifting.

Trimming Clips

After clips have been added to the timeline, you need to be able to adjust their length. This is a fundamental part of editing—fine-tuning transitions from one shot to another. Most nonlinear editing systems have a special *trim mode* that helps you to adjust the cut between two shots. Trim mode often has two windows: one displays the last frame of the outgoing shot, the other shows the first frame of the incoming shot (see Fig. 14-22). In video terms, "trimming" means to adjust an edit point, either to extend or shorten a shot. Once in trim mode, you can extend or shorten the tail (end) of the first shot, the head (beginning) of the second shot or both. On many systems, changing the length of a clip is as easy as clicking on the clip and dragging one way or the other with the mouse. The trim editor may allow you to preview the edit with a *looping* feature, which plays the transition repeatedly while you adjust it.

With most editing systems you have a choice: you can adjust trims by eye, you can click on a frame counter (that moves the edit point by a preset number of frames) or you can type in a new timecode number for the edit point. For more on trimming by frame count or timecode number, see Making Changes, p. 408.

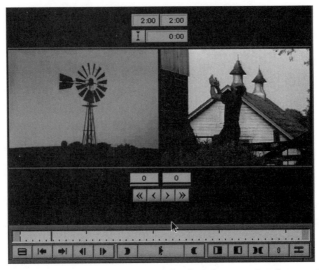

Fig. 14-22. Trim mode. This Avid trim tool displays the outgoing frames of one clip and the incoming frames of the next one. The buttons allow you to trim either or both clips.

Types of Trims

Like other types of edits, trims also come in film-style and video-style varieties (see Fig. 14-23).

Let's go back to our sequence of clips A, B and C. Say we apply a *film-style trim* to the tail of clip B. We can extend the shot (that is, move the tail of the clip to the right, which adds frames). This will push clip C further down, lengthening the overall sequence and rippling all the subsequent clips. Avid calls this a *single-roller* trim; Adobe calls it a *ripple edit*; Media 100 denotes this as *trim tail*.

If we wanted to shorten the tail of B, we could just as easily delete frames, moving the tail of clip B to the left. This will shorten the entire sequence and bring up all clips following the edit.

Starting again with the original A, B, C sequence, now let's apply a *video-style trim* to the transition between clips B and C. In this trim, we add frames to the tail of B and delete the same number of frames from the head of C. Clip B is extended and Clip C is shortened. Clip C now starts later, but since the clip has gotten shorter by the same amount, the clip does not move relative to the timeline. The tail of C remains in the same place and the overall sequence does not change length. The clips following the edit do not ripple. Avid calls this a *dual-roller trim*; Adobe calls it a *rolling edit*; on Media 100 this is *trim joint*.

As long as all the video and audio tracks are locked together, a single roller trim can be done without disrupting sync between picture and sound. A dual roller trim, on the other hand, can be done to an individual track without affecting the sync or length of any of the tracks.

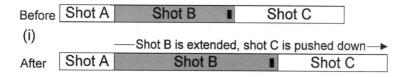

Before (i)

—Shot B is extended, shot C is pushed down—▶

After

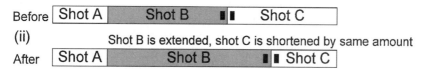

Before (ii)

Shot B is extended, shot C is shortened by same amount

After

Fig. 14-23. Types of trims. (i) With a single-roller trim (trim tail or film-style trim), the tail of shot B is extended, and shot C is pushed later in the sequence by the same amount. (ii) With a dual-roller trim (trim joint or video-style trim), the tail of shot B is extended and the head of C is overwritten by the same amount. Shot C becomes shorter, but its position in the sequence doesn't change.

OTHER TYPES OF TRIMS. Some nonlinear systems can perform other types of trims. A *slip trim* allows you to adjust a clip without changing its overall length or position relative to other clips. If you slip it to the right, you effectively trim back the head of the clip while extending the tail the same amount. This has the effect of allowing you to view a later portion of the shot without changing anything else.

A *slide trim* allows you to grab a fixed clip and slide it over adjoining clips. For example, in the A, B, C sequence, you could grab B and slide it to the right on the timeline. The system accomplishes this by extending the tail of A and trimming back the head of C. The net length of the sequence is unchanged.

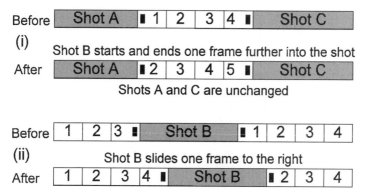

Before (i)

Shot B starts and ends one frame further into the shot

After

Shots A and C are unchanged

Before (ii)

Shot B slides one frame to the right

After

Fig. 14-24. Slip and slide trims. (i) After doing a slip trim, all shots remain unchanged in length and relative position, but we now view a different portion of shot B. (ii) With a slide trim, shot B is itself fixed, but its position in the sequence can be changed. As shown here, shot B is slid to the right, which causes the tail of A to be extended and the head of C to be overwritten.

Some systems are capable of a trim that combines aspects of both film- and video-style trims. Starting with the A, B, C sequence, we select the transition between B and C. We can shorten the tail of B by moving the transition to the left on the timeline, but instead of compensating (as you would in a video-style trim) by extending the head of C to the left by the same amount, we fill in the gap with black filler. This is essentially a single-roller trim that does *not* ripple the remaining clips.

When Trims Are Limited

Compared to film or videotape editing, trimming shots with a nonlinear system is a breeze. You just go to one end of the shot or the other and instruct the system to extend or shorten at that point. That's a lot easier than hunting down pieces of film from a bin, or rerecording videotape. But when trimming clips, it's important to remember the difference between a clip on the timeline and the media file it points to.

Say the original camera tape has a two-minute shot that gets digitized as a single clip by itself. During editing, you decide to put 30 seconds from the middle of the shot into your edited sequence. If you then decide to extend the head or tail, you can easily do so. Alternately, let's say you had put the *entire* two-minute clip into the sequence the first time. Now you try to extend the clip and the computer protests—the edit won't work. That's because there aren't enough frames in the media file to allow you to extend the head. You have "insufficient media" to do the edit.

You can avoid this situation by trimming back master clips by a few seconds at either end before bringing a shot into the edited sequence. This will also leave some frames available if you later decide to dissolve in or out of the shot.[9] For example, if you want a 30-frame dissolve at the start of a clip, you will typically need 15 spare frames at the head of the clip to use for the overlap with the previous clip.

On some systems, when you go into trim mode you see a display that indicates how far the media extends beyond the part of the clip you've selected. You can see right away if there's enough extra at the head or the tail to extend the shot. On systems that don't show "hidden" frames in the media, you can find them by using the *match frame* function. If you put the cursor on the first frame of a clip in the timeline and hit "Match Frame," the system will bring that frame up into the source monitor. You should then be able to see on the source window position bar how much longer the master clip is than the portion you're currently using in the edited sequence.

Basic Sound Editing

Nonlinear editing systems (and their cousins, the digital audio workstations or DAWs) have created a revolution in sound editing. By recording sound on computer hard drives, these machines allow you to freely cut, paste, copy and manipulate sounds. Because the system keeps track of timecode for every piece (clip) of sound, you can easily determine if the sound is in sync with the picture, you can quickly find material you're looking for, and you can precisely locate sounds in the original video- or audiotapes that were recorded in the field, if needed.

[9]Similarly, when redigitizing material (resing up), set the system to include sufficient handles (see above) at heads and tails of clips to permit trims and dissolves later.

As discussed above, audio tracks appear in the editing system's timeline in a way similar to video tracks. Many systems can accommodate a large number of audio tracks, which are usually *mixed down* to a smaller number (often one, two or four) before exporting the audio from the system onto videotape. When audio is exported on computer drives, the tracks may not need to be mixed down (see Chapter 15).

Most editing systems give you a choice of editing individual audio tracks independently or *locking* them to other video or audio tracks. When tracks are locked together, you can change them all simultaneously with a single edit. When sound and picture are brought into the editing system in sync, as they are when digitizing a typical camera tape, many systems can tell you whether the audio and video tracks *remain* in sync. If, during editing, you *slip* or move the audio relative to the video, a display will show you by how many frames the audio has been displaced. This can be tremendously helpful to guard against cutting errors, or to help you restore sync after making changes. Particularly on film projects, sound and picture may not be put in sync until *after* digitizing, using the nonlinear system to sync up. Some systems can also tell you if these tracks stay in sync.

One trick for keeping track of sync is like using a tail leader in film editing. Splice a short clip on the very end of all video and audio tracks. To check sync on the entire sequence, go to the tail and make sure all the tail clips are lined up.

Virtually all editing systems allow you to set the volume level of each clip individually, using a slider or other control. Some systems allow you to continuously alter levels throughout the clip. Sometimes called *rubberbanding*, this feature may appear as a line representing the volume level that runs along the length of the clip. You simply push the line up or down to change the level of any part of the clip. Fades and dissolves (*cross fades*) can be created as easily in audio as in video (see p. 441).

Audio clips may appear on the timeline as colored blocks. Many systems can also display *waveforms*, which show a tracing of the actual audio signal (see Fig. 14-25). Waveforms make it easier to determine exactly where words or other sounds begin and end. An audio *scrubbing* feature helps you find individual sounds by playing only short bursts of audio or by slowing down the apparent speed of the playback.

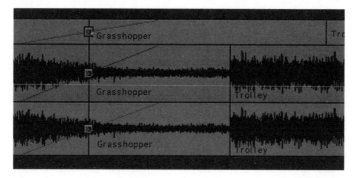

Fig. 14-25. Audio waveforms. On many editing systems, the timeline can display audio waveforms, which makes some editing tasks easier because you can see a visual representation of the sound.

L-CUTTING ON A NONLINEAR SYSTEM. There are many situations in editing in which you want the sound to change before or after the picture at a particular cut. For example, you may want to bring up the sound of someone talking before cutting to a shot of that person (see Fig. 14-6). Various terms for this effect include *L-cut*, *L-edit*, *split edit*, *overlap edit* or *sound overlap*. Creating an L-cut with a nonlinear system is very simple. Say you have two clips and you want to start the sound from the second clip over the end of the first (see Fig. 14-18). Make sure the audio tracks are not locked to the video (so they can be moved independently) and select them for editing. Simply do a video-style (dual roller) trim at the head of second clip's audio, moving the head of the clip to the left, into the tail of the first. Everything should remain in sync and no further adjustments are necessary. If there is more than one audio track, you *may* want to make the trim to only one. That way, sounds from the two clips can blend together; you may even want to do an audio dissolve.

For more on working with sound, see Chapter 15.

Transitions, Composites and Video Tracks

In nonlinear editing, dissolves between shots can be created, changed or removed with the click of the mouse. On some systems, transitional effects like dissolves can be made between clips on the same video track; on others, the effect goes between one track and another.

Having multiple video tracks opens up many possibilities. You can build shots with multiple layers of images superimposed together. This is called *compositing*. Some systems can play multiple composited images in real time, others must first render this effect, creating a single *stream* of video from the many sources before playing back.

Multiple video tracks can also facilitate editing when only one image is on screen at a time. Say you had a shot of a person speaking on one video track. You could put a cutaway of someone listening on another track. Instead of having to make an edit to insert the cutaway, as you would in film or videotape editing, you can simply slide the cutaway on its own track to any position that works.

Deleting Clips and Files from the Drives

There are various times when you want to remove material from the hard drives. You may have unneeded shots, in which case you may want to delete clips from the bins as well as the media files (both video and audio) that they are associated with (see, Digitizing and Logging Clips, p. 426). On some systems, you can delete the media files without deleting the clips, and then replace the media files with a higher resolution digitization from tape (resing up).

If you find your hard disks are getting full, you may want to get rid of the footage you're not using. If a master clip is very long (say you digitized an entire camera tape as one clip) and you only want to save a short subclip from it, it can sometimes be difficult to save just the part you want. Some systems will only allow you to delete entire master clips. Avid has a *consolidate* feature that allows you to mark and copy subclips to another part of the disk, then delete the master clip. However, if your disks are already jam packed, you may not have much room to

store the copies of the subclips. In general, if you digitized in relatively short clips the first time, you'll have more flexibility in managing your media storage.

When You're Done Editing

As discussed earlier, when you complete picture editing, you have several options in terms of finishing the project (see Getting What You Need from the System, p. 417). The manual or help files on your nonlinear system should have detailed instructions on how to perform various tasks. If you are making a digital cut (print to tape), see Recording and Playing Tapes, p. 402, for suggestions on preparing the master tape. If you are exporting an EDL to do an online edit, see The EDL and Online Editing, p. 410. If you are exporting your sound tracks for further sound work, see Chapter 15.

VIDEO EFFECTS FOR TAPE AND NONLINEAR SYSTEMS

The power to manipulate images is constantly growing. At one time, video effects were only done by editor-engineers in expensive postproduction facilities. While effects for some projects are still done this way, it is increasingly possible to do sophisticated image manipulations with low-cost video "mixers" or user-friendly software on a nonlinear editing system. Many nonlinear systems can be enhanced with *plug-ins* (added, standardized software), which open up even more possibilities.

If you're using a nonlinear system in an "offline" mode, and plan to do online video effects or film effects later, the system provides an invaluable chance to experiment. If you're using a nonlinear system to create effects for a project that will be finished on film, please see Chapter 13.

Nonlinear editing systems differ in their effects capabilities. High-end systems can do complex effects in real time. With lower-end systems, the machine may need to first render (create) the effect before you can watch it with the rest of the movie.

Basic Effects

In traditional video editing, simple effects are created with a *switcher*, which can merge the signals from several sources. In a typical online editing suite, the switcher has inputs for various tape decks, a copy stand camera, a character generator and various video signal generators. In many nonlinear systems, the capabilities of the switcher are built into the system. Basic video effects are sometimes called *switcher effects*; on a nonlinear system, they are found on the *effects palate*.

FADES AND DISSOLVES. Perhaps the simplest video effect is the *fade out* or *fade in*, in which the image dims to black, or emerges from black. In traditional tape editing, fades are created using a switcher to merge the video image with a black signal.

In a *dissolve*, the end of shot A fades out while the beginning of shot B fades in,

causing the images to melt together, softening the transition. Dissolves require that the two shots be overlapped (see Fig. 13-10). In tape editing, dissolves are created by feeding two source decks (one for shot A, one for shot B) into the switcher. The switcher merges the signals into one, which is then sent to the edit deck. If this is anticipated, be sure the two shots are not on the same tape (if so, dub one to a *B-reel* tape). Some digital tape formats can do dissolves with only two decks by "prereading" tape A, sending that signal to the switcher where it is merged with the image from tape B and recorded back on tape A.

Creating fades and dissolves on a nonlinear editing system is very simple. You can select the length of the dissolve and whether to *begin* the dissolve at the cut, *center it* on the cut or *end it* on the cut. Keep in mind that a bright shot will tend to overpower a dark shot, so a brighter shot will seem to dissolve in faster on a dark shot than vice versa.

Video fades and dissolves look different from the same film effects (see p. 374).

WIPES. In a wipe, image A replaces image B at a boundary edge moving across the frame. There are hundreds of wipe patterns. In some wipes, image A pushes image B off the screen vertically, horizontally or in a particular pattern (stars, cross, etc.). The edge of the wipe can be soft or hard or have a colored line.

KEYS. Keying is a way to superimpose two layers of video; one layer forms a sort of "keyhole" through which the other can be seen.

Fig. 14-26. Process shot. The airplane model is shot against a uniform colored background that will later be replaced by a filmed action background. (Kino Flo, Inc.)

In a *chroma key*, the keyhole is made up of every part of the image that is a certain color. A common example is a TV weather forecaster shown in front of a weather map. This is done by shooting the forecaster in front of a special blue-green background. The chroma key "keys out" everything of that particular blue-green and replaces it with the weather map. The blue color is a special hue not otherwise found in nature, so you don't accidentally key out, say, a blue tie. Chroma keys (or their film equivalent) are used for a wide range of special effects work where actors are superimposed on various moving backgrounds (say, near an explosion). The actor is filmed in front of a blue or green screen. The explosion footage is added later. These shots are sometimes called *blue screen* or *green screen* shots. The Ultimatte system is a popular chroma key device.

Another kind of key is the *luminance key* (*luma key*), which carves the keyhole based on brightness levels. Say you had a title card with white letters on a black background. You could key out the black background and replace it with a video image to create standard supered titles (see Fig. 14-27). Or you could key out the letters and replace *them* with another image, creating a video image in the shape of a word.

In film, the keyhole is made with black and white film "mattes" (see p. 492). In video, when matte or key data is included with the RGB color data in a graphic, it's called an *alpha channel*. A video layer can include a moving alpha channel, sometimes called a *traveling matte*. A traveling matte allows you to superimpose a moving foreground layer (whether it be an actor or a graphic) on a different background.

Titles and Graphics

There can be many uses for printed text and graphics in a movie. Some people refer to video devices that create text (or the text itself) as *chyron* (which is actually one company's text device) or *CG* (for Character Generator). Titles and graphics can be created on the nonlinear editing system or imported from other software applications. The use of such software as Adobe's AfterEffects and Photoshop have brought about a convergence of TV and computer graphics. Complex two- and three-dimensional animations as well as multilayered (composited) images can be created easily and merged with video. Many types of file formats can be used to import graphics into the nonlinear system, including QuickTime, JPEG, TIFF and BMP.

For suggestions on laying out titles and credits, see Titles, Chapter 12.

Digital Video Effects

Digital video effects (*DVE*) are effects in which the pixels in the image are moved or rearranged. Among the simpler effects are enlarging (zoom in or out) or repositioning images. *Flipping* an image means reversing it along a vertical axis (mirror image), which is useful when a shot has the wrong screen direction. Reversing an image top-to-bottom is sometimes called *flopping*.

One image can be peeled off another (sometimes called a *page peel* or *page turn*). More complex effects include wrapping the image around a shape, breaking it into bits and a mind-boggling array of two- and three-dimensional possibilities.

Many nonlinear editing systems can do complex DVE moves. The more "channels" of DVE a system has, the more simultaneous image moves can take

Fig. 14-27. Titling tool. Most nonlinear editing systems have a tool for generating titles. Note the frame lines for TV safe action and safe title areas. Compare with Fig. 8-6. (Bob Doyle)

place. Many effects are designed to change image size, position, rotation or transparency as the shot progresses. The DVE controller allows you to set *keyframes* for any of these parameters at different points in the shot, which form waypoints in the transition. For example, if you were moving a title across the screen from top left to bottom right, you might set a keyframe with the title at the top left, another in the middle and a third with it at bottom right. The DVE will then *interpolate* between the keyframes, filling in a smooth path from one to the other.

Motion Effects

Many video systems allow you to play video at various fractions or multiples of the original frame rate, creating fast or slow-motion effects, which you can then record on another tape or store on disk. To speed up action, the playback system drops frames. To speed up the footage by a factor of two (2X), the system plays every other frame, skipping the frame in between. To slow action, the system repeats frames. Video shot at 30 fps can be slowed somewhat and still produce a smooth effect, but film-originated material or PAL video shot at 24 or 25 fps starts to look blurred and discontinuous when slowed down too much. The best slow motion is produced by shooting at high frame rates (see Slow Motion, p. 51).

Some nonlinear systems have a "fit-to-fill" feature that allows you to decide how long you want a shot to last, and the system will calculate exactly what speed to play the shot (how many frames to drop or add) to fill that length. You could use this to adjust a shot so it will perfectly fit a gap in your edited sequence.

Changing the playback speed of audio will affect the pitch of the sound and may result in discontinuities in the sound. Some changes can be corrected using a digital pitch shifter (see Film-to-Video Standards Conversions, p. 528).

Some nonlinear editing programs, like Adobe Premiere, can create time-lapse sequences captured from normal footage played on a camera or tape deck. You can select how often to record single frames to make a stop-motion sequence. For more on time-lapse, see p. 53.

Other Effects and Controls

There are hundreds of *filter* effects, which process the texture or appearance of the image, such as adding blur or distorting colors. There is software that combines filter effects with motion effects to make video look more like 24 fps film. Cinelook software even allows you to emulate the look of individual film stocks.

There are numerous devices for processing video to improve or alter the signal. Sometimes the timing of the video signal deviates from a precisely clocked reference due to variations in the recording equipment or distortions in the tape. This can cause problems when preparing a tape for broadcast or when trying to synchronize material from different video or audio sources. A *time base corrector* (*TBC*) stabilizes the video signal and can bring a tape from a faulty camcorder or deck up to standards. TBCs may include *proc amp* controls for gain, pedestal and other settings (see Chapter 7).

Tape dropout is a momentary loss of recording that can result in a horizontal white or black line in video. A *dropout compensator* will fill that line with information taken from an adjacent line of video. *Enhancement* or *detailing* makes the image look crisper, but may destroy subtleties in the image structure. *Grain reducers* can minimize video noise, smoothing over the grainy look.

Sound Editing | CHAPTER 15

The Idea of Sound Editing

Sound editing refers to the process of refining, enhancing and balancing the sound for a movie. On a large production, sound editing is generally done by specialized sound editors who are not involved in the picture editing. A *sound designer* may be brought in to create unique textures or effects. On a small production, the same people may do both picture and sound editing, but the main sound work is done only after the picture is locked and the movie's structural decisions are all made.

Sound is often treated as an afterthought, something that has to be "tidied up" before a project can be finished. But sound is tremendously important to the experience of watching a movie. An image can be invested with a vastly different sense of mood, location and context, depending on the sound that accompanies it. Some of these impressions come from direct cues (the sound of birds, a nearby crowd, or a clock), while others work indirectly through the volume, rhythm and density of the sound track. The emotional content of a scene (and the emotions purportedly felt by characters on screen) are often conveyed as much or more by music as by any dialogue or picture. Even on a straightforward documentary or corporate video, the way the sound is handled in terms of minimizing noise and maximizing the intelligibility of voices plays a big part in the success of the project.

It is said that humans place priority on visual over aural information. Perhaps so, but it is often the case that film or video footage that is poorly shot but has a clear and easily understood sound track seems okay, while a movie with nicely lit, nicely framed images, but a muddy, harsh and hard-to-understand track seems objectionable and irritating.

The job of sound editing begins with the sound editor screening the movie with the director and the picture editor. If you're doing all these jobs yourself, then watch the movie with a pad of paper (try not to feel too lonely). Every scene should be examined for problems, where effects are needed, and where a certain feeling or quality of sound is desired. If music is to be used, the composer and/or music supervisor are brought in as well. Deciding where to place music and effects is called *spotting*.

Fig. 15-1. Mix studio. (Sync Sound, Inc.)

The sound editor then begins the process of sorting out the sound. The audio is divided into several different strands or *tracks*. One set of tracks is used for dialogue, another for effects, another for music and so on. Portioning out different types of sounds to separate tracks makes it easier to adjust and balance them. This process is called *splitting tracks*. Effects are obtained and other sounds are added, building up the layers of sound; this is sometimes called *sweetening*.

When all the tracks have been built, a *sound mix* is done to blend them all back together. The mix may be done in a studio by a professional *mixer*, or it may be performed by the filmmaker using an editing system or other equipment. A professional mix studio (also called a *dub stage* or *mix stage*) is designed with optimal acoustics for evaluating the audio as it will be heard by audiences. Though more costly, studio mixes are preferable to mixes done in the editing room or other multi-use space that may have machine noise, poor speakers or bad acoustics. For theatrical and broadcast projects, it is essential to mix in a good listening environment.

After the mix, the sound track is recombined with the picture for distribution. Often, different types of distribution require different types of mixes.

The Sound Editing Process

Like everything else in film and video, sound editing has been transformed by new technology. Nonlinear editing and the digital audio workstation (DAW) have changed not only how sound editing is done, but how we think about sound editing. Where there was once a standard path through the sound editing process, there are now many paths and types of equipment used.

How you do sound editing depends on how the project was shot and what equipment you have available. Here are some possibilities:

Fig. 15-2. Digital audio workstation (DAW). Pro Tools 24 system records, edits and mixes 24-bit audio. Shown with Mackie Human User Interface controller. (Digidesign, Inc.)

Projects Shot on Video

1. *Basic nonlinear edit.* Sound is digitized at high resolution (44.1 kHz sample rate or higher) when audio is brought into the editing system. Sound editing is done on the editing system. Audio is exported as a finished sound track, either with the video or separately (to be remarried to the picture after the online edit is done). This method is best for simple and/or low-budget projects. Some nonlinear systems have specialized audio-editing software loaded on the system. However, many nonlinear systems lack extensive audio editing power and the system may not be set up for serious mixing.

2. *Nonlinear edit; sweetening on DAW; mix in studio.* Picture editing and basic sound work are done on the nonlinear editing system. After picture is locked, audio tracks are exported to the DAW. There are different methods of getting the sound from the editing system to the DAW (see Preparing for the Mix, p. 461). Sound editing is done on a DAW, which gives maximal control over the process. Mixing is done in a mix studio, with good speakers and an optimal environment for judging the mix.

3. *Linear videotape edit.* Offline editing is done with worktapes, followed by online edit with original camera tapes. Simple sound mixing can be done during the online session. More complex audio sweetening is done by *stripping* the audio from the online edit master and *laying it over* to a DAW or multitrack tape format. Effects and music are added, then the mix is done. Audio *layback* is then done to remarry the sound to the picture on the master tape.

Projects Shot on Film

1. *Traditional film edit, film mix.* Production audio is transferred to 16mm or 35mm magnetic film for editing (see p. 376). Picture editing is done with one to three mag tracks. After picture lock, sound editing is done by splitting sound into several (or many) more mag tracks. Mag tracks are brought to the mix studio, where they are played on dubbers in sync with the picture while the sound is rerecorded on a *master dubber*, often in 35mm (see Fig. 15-9). Sound on the 35mm fullcoat master is then transferred to whatever formats are needed for distribution.
2. *Film-to-video transfer; edit nonlinear.* Film is transferred to video for editing. Production audio is transferred with it, or brought into editing system later. Please see Editing Film on Video, p. 382, for possible options.

Clearly, there are a lot of ways to get the job done (and there are more options and permutations than the ones listed here). The technology you use affects the particulars of how you work and in some cases how much control you have, but the fundamental principles of sound editing remain the same regardless of what equipment you use.

Sound Processing Devices

As discussed in Chapters 13 and 14, before any picture editing begins, the audio is transferred (rerecorded) from the original videotape or audio format used in the field to whatever format is being used for editing. For a typical video project, audio is recorded in the field on videotape in the camcorder and then transferred to, say, a nonlinear editing system. For a film project, the field audio might be recorded on DAT or ¼" tape, and then transferred to mag film or videotape or perhaps transferred directly into a nonlinear editing system.

Generally, the transfer should be fairly straightforward. You want to capture all the audio that's on the original recording without processing it (changing it) much.[1] Once the sound has been transferred, however, there are many ways to alter it to improve clarity or change the quality of the sound. Traditionally, most sound processing was done only in the mix, in the final stage of sound editing. However, most disk-based (nonlinear) editing systems allow you to process and change the sound "nondestructively," which means that you can experiment with various sound processing options during editing, and easily return to the un-processed version of the sound whenever needed.

Following are some common types of sound processors that may be part of an editing or mixing system.

EQUALIZERS. Equalizers allow you to selectively emphasize (*boost*) or deemphasize (*cut* or *roll off*) various frequencies throughout the audio spectrum. The simplest "equalizer" is the bass/treble control on a home stereo. *Graphic equalizers*

[1]You may want to roll off bass to reduce wind noise; see Equalizers, below.

have a separate slider or control for several different bands of frequencies across the range (see Fig. 15-3). *Parametric equalizers* allow you to select usually low-, mid- and high-frequency bands, and boost or cut them to varying degrees (see The Mixing Console, below). For more on frequency and equalization (EQ), see Sound, p. 245.

Equalizers have many uses. To increase the intelligibility of speech, you might boost midrange frequencies around 2 kHz (2000 Hz) to 4 kHz, and roll-off low frequencies below 100 Hz. Low-frequency roll-off is often used to minimize the rumble caused by wind and microphone noise (for more on bass roll-off, see Bass Filters, p. 299). Since wind rumble is *never* desirable, this is one type of EQ that should generally be done during the initial sound transfer.

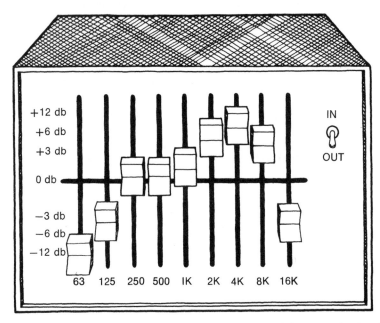

Fig. 15-3. Graphic equalizer. On the model illustrated, each slider controls a band of frequencies a half octave above and below the indicated frequency. When a slider is above the 0 dB line, the volume of sound in that frequency band is boosted; below the line, diminished. The equalization indicated here is a basic one for improving the clarity of many tracks (compare it with Fig. 9-13ii). Equalization should be done by ear and not by formula. (Carol Keller)

High-frequency noise (hiss) from tape or system noise can be reduced by rolling off frequencies starting above about 5 kHz or so. The sound of a voice on the telephone can be simulated by boosting frequencies between about 400 and 2000 Hz and rolling off all others. Good equalization is an art, and should always be done by ear, not by numbers.

NOTCH-PEAK FILTERS. Also called *dipping filters*, these filters are a bit like very precise equalizers. They allow you to pinpoint one or two frequency bands and *notch* (cut) them or *peak* (boost) them. Notch-peak filters are useful for isolating and removing specific noises, like the 60 Hz hum caused by fluorescent lights, with minimal disturbance to the rest of the track. Many kinds of interference are audible at both fundamental frequencies and harmonics; notching at two or three frequencies may be necessary for complete removal. To get rid of a noise, start by peaking it to make it as loud as possible. Once you've located it, then dip at the same frequency. It sometimes takes a long stretch of sound to find and isolate a noise. On a disk-based editing system, you could use a loop function to repeat the take.

COMPRESSORS. *Compressors* reduce the level of loud sections of the sound track. They can be set to act like limiters (see p. 293), cutting in sharply to protect against overmodulation, or they can be set to take effect at lower volume levels, cutting down the volume more gently. After the sound track passes through a compressor, it has a *compressed* dynamic range—that is, all sounds are closer to the same volume level. Compression is often used for material that is to be released on television (especially TV commercials). You may have noticed how commercials seem to blast out of your TV set compared to the regular program. With compression, formerly quiet sounds can be pushed up near the loud sounds so they won't be lost in the typical household noises of appliances, traffic and people talking around the TV set. After compression, the *average* sound level can be set much higher than before, hence the blasting commercials. Tracks that are excessively compressed have a flat and unnatural quality.

This type of audio compression is similar to knee compression used to extend the dynamic range of video cameras (see Fig. 7-1). However, this should not be confused with digital compression used to minimize digital storage needs (see Digital Compression, p. 204).

REVERB UNITS. The way sound waves reflect off the walls of an enclosed space gives your ear cues about how large the space is. This sound *reverberation*, which is similar to echo, gives a sense of "liveness" to sound (see Acoustics of the Recording Space, p. 295). A *reverb unit* can be used to add reverberation to sound after it has been recorded. With more reverb, sounds take longer to *decay*, making them seem like they were recorded in a larger or more reverberant space. Reverb units can make voices postdubbed in the studio seem more like they were recorded on location. Sound that lacks reverb is sometimes called "dry" or "tight."

NOISE GATES. Ambient noise is perhaps the biggest problem in location sound recording. Tape noise can be a big problem with analog recording. *Noise gates* minimize noise by acting like an automatic level control in reverse: whenever there is no clear sound signal (like speech) they *reduce* the recording level—because it is during the pauses that noise is the most conspicuous. Noise gates can make a noisy track clearer, but a heavily "gated" track will cause the background level to abruptly rise and fall, making it sound noticeably processed. Noise gates can also be used to make an overly reverberant track drier and to change the character of music.

Noise gates, compressors and other devices share certain types of adjustments. Take the example of using a noise gate to cut out refrigerator noise from a recording of a man talking in a kitchen. Start by imagining the gate as closed, allowing no noise or voice to get through. The *threshold control* determines how loud a sound must be to open the gate; the threshold might be set *just lower* than the man's voice. The *attack control* determines how fast the gate opens; generally you want a short attack time to open the gate quickly (a slow attack would make the voice fade in). The *hold control* determines how long the gate stays open; it should be long enough not to close during very short pauses. The *release control* determines how fast the gate closes; if this is too sudden, the gating will be obvious. Bringing the *gain control* up slightly allows a *little* refrigerator noise to leak into the silences, helping smooth over the effect.

DE-ESSERS. Compressors used to reduce the *sibilance*, or whistling, caused by S sounds in some people's speech are called *de-essers*. You can hear sibilance distortion sometimes by turning the volume very high on a radio with small speakers. Sibilance can be especially disturbing on a film's optical sound track (see Chapter 16); the de-esser compresses high frequencies (where sibilance distortion occurs) without affecting much else.

The Mixing Console

The *mixing console* (also called *recording console, mix board, mixer* and other names) is used to control and balance a number of sound sources and blend them into a combined sound track. The basic microphone mixer is discussed in Chapter 9 (see p. 271). Mix consoles used in postproduction range from simple, manually operated boards that may be part of an editing system to massive, computer-controlled boards used on a dub stage that can memorize and repeat the mixing cues for an entire program. Increasingly, mixing controls are incorporated into audio editing software. These "virtual consoles" are displayed on a computer screen (see Fig. 15-11). Some systems combine a computer screen display with physical sliders or buttons you can touch.

The full operation of a mixing console is beyond the scope of this book, but since many editing systems use a mixer to control various audio inputs, a short discussion may be helpful. The mix board accepts a number of *input channels*, or just *channels*. Each channel is controlled with its own *channel strip* on the surface of the board that has a *fader* or level control and other adjustments. You might use one channel to input a microphone, another to bring in sound from a VTR or audio deck. On each channel strip you can make individual adjustments to that source.

The channels can be assigned to various *buses*; a bus is a network for combining the output of two or more channels and sending it somewhere (just like a city bus takes people to work). The *mix bus* is the main output of the board, the *monitor bus* is the signal sent to the monitor speakers, and so on. You can send any channel you want to the *main mix*, where a *master fader* controls the level of all the channels together. You might choose to assign some channel strips to a *separate* output channel. This is sometimes done to create alternate versions of a mix, or when two people are using the board for different equipment at the same time.

Fig. 15-4. Mackie MS1402 mixer. Mackie makes a series of popular, versatile mixers. (Mackie Designs, Inc.)

In an editing setup, you will typically run a source VTR or audio deck into one channel of the mixer, make needed adjustments on the mixer, and then send the output of the main mix to your record audio/video machine (or send it into a non-linear system for digitizing).

Fig. 15-5 shows a channel strip from a Mackie 121-VLZ mix console. Starting at the top, you can see the jacks for a microphone input and a balanced or unbalanced line level input (see Audio Connections, p. 271). Below that is a switch for a low-cut filter which rolls off low frequencies below 75 Hz (often a good idea; see Bass Filters, p. 299). Below that is the *trim control*, which adjusts the level of the mic or line as it comes into the mixer (see below for setting this). Next are two *Aux* (*Auxiliary*) *pots* for sending the signal out for various uses. Then there are three EQ (equalization) controls, for high, mid and low frequencies. Turning each knob to the right boosts that frequency band, turning to the left cuts it. Some mix consoles have "fully parametric EQ," which allows you to fine-tune both the width of the band and where it is centered. Next down is the *pan pot*. If the mixer is putting out stereo (two channels), turning the pan control to the left sends the signal to the left channel, the other way sends it to the right. The *mute* button kills the sound from this channel (so you can hear the other channels without it) and the *prefader solo* allows you to hear *only* this channel, at its original level (before going to any fader). The *gain control* at the bottom controls the volume level for the channel. Twelve o'clock on the dial is marked *U* for *Unity Gain* (on some mixers this is marked 0 dB). Setting the level higher than U may degrade the signal.

To set up a channel on a mixer, plug the sound source (say, a VTR) into the channel input. Turn the trim control all the way down, and set the channel gain, the master fader and the EQ controls to U or 0 dB. Now play the VTR (with nothing

else playing) and adjust the trim control until the level looks good on the mixer's level meter (you will also need to adjust the level on the machine that's *recording* the sound). See Play and Record Settings, p. 405, for more on setting levels.

Now you can set the EQ where you like it, and use the channel strip and master fader to control the level as you choose. Generally, you want to avoid a situation where a channel's gain is set low and the master fader is set very high to compensate. If you're just using one channel, often it's a good idea to leave the channel's gain at U and use the master fader to ride the level.

Fig. 15-5. Channel strip from Mackie MS1202 mixer. See text. (Robert Brun)

SOUND EDITING TECHNIQUE

Editing dialogue and narration is discussed in Chapter 12. Basic sound editing methods are discussed in Chapter 14, for both videotape and nonlinear editing, as well as in Chapter 13, for projects edited on film.

Evaluating the Sound Track

All the audio in the movie should be evaluated carefully at the start of sound editing. Is the dialogue clear and easy to understand? Is there objectionable wind or other noise? Are there holes in the track where sounds or words have been cut out? If you have doubts about the quality of any section of audio, try equalizing or using other processing to improve it. Listen to the original video- or audiotape directly to see if it sounds any better. Consult a mixer or other professional for possible remedies. Be critical—if you think you're unhappy with some bad sound now, just wait till you see the movie with an audience.

For nondialogue scenes, the remedy may be to throw out the production sound and rebuild the audio with effects (see below). For dialogue scenes, you may need to use other takes, or consider automatic dialogue replacement (ADR; see p. 352).

Sound and Continuity

Sound plays an important role in establishing a sense of time or place. In both fiction and documentary, there are many times that shots that were filmed at different times must be cut together with the illusion that the shots actually occurred in continuous time. In one shot the waiter says, "Can I take your order?" in the next, the woman says, "I'll have the fish." These two shots may have been taken hours or even days apart, but they must maintain the illusion of being connected. The way the sound is handled can either make or break the illusion.

When you're editing, be attentive to changes in the quality, content and level of sound and use them to your advantage. If your goal is to blend a series of shots into a continuous flow, avoid making hard sound cuts that butt up two sections of audio that differ greatly in quality, especially if there is also a cut in the picture at

Fig. 15-6. Steenbeck 16mm six-plate flatbed editing table with two sound tracks and one picture head. Each track can be moved independently or in sync with the others. (Steenbeck, Inc.)

the same place. (Certain differences in quality and level can be smoothed over in a sound mix.)

Audiences will accept most changes in sound quality if they are gradual. If your editing equipment accommodates at least two tracks, you can make a long overlap where one track blends slowly into another. This *sound dissolve* (*cross fade*) can make changes in the sound much less abrupt.

The use of multiple tracks opens up numerous possibilities for reinforcing the illusion of continuous time. One technique is to add in a background track that remains constant and masks other discontinuities throughout the scene. Another is to insert sounds that distract the audience from jumps in the sound. For example, if you're cutting a scene in which there was audible music on location, there will be jumps in the music every time you make a cut in the audio track. If you add a short, sudden noise (like a cough or a car horn) you can often disguise the fact that phrases or sections of music have been removed. Anytime there is a sudden change in the background sound, try to position the cut from one piece of sound to the other *under* someone's word or other distracting sound.

Multiple tracks can be used to blend an isolated noisy shot containing, say, an airplane sound into other, quieter shots. In this case, airplane sound (which may be obtained from a sound effects library) is introduced before the shot, gradually faded in and gradually faded out after the shot. This progression gives the sense that the plane passed overhead during the three shots. As long as the sound as it is finally mixed doesn't cut in or out sharply, many discontinuities can be covered that way.

While gradual sound dissolves ease viewers from sequence to sequence, it is often desirable to have hard, clear changes in sound to produce a shock effect. Opening a scene with sound that is radically different from that of the previous sequence is a way to make a clean break, start a new chapter. When cutting from a loud scene to a quiet scene, it often works best to allow the loud sound to continue slightly beyond the picture cut, decaying (fading out) naturally. When a loud scene follows a quiet scene, a straight cut often works best.

When building tracks, don't forget about the power of *silence*. A sense of hush can help build tension. A moment of quiet after a loud or intense scene can have tremendous impact.

Sounds can be used as punctuation to control the phrasing of a scene. Often, the rhythm of sounds should be used to determine the timing of picture cuts in a sequence as much as any visual cues.

Sound Effects

For feature films and many other types of nondocumentary productions, it is common during shooting to record *only* the sound of the actors' voices, with the assumption that *all* other sounds (such as footsteps, rain, cars pulling up or pencils on paper) will be added later. Often, shooting takes place on an acoustically isolated soundstage; without added sound effects to bring a sense of realism, the footage would seem very flat. Documentaries often need effects as well, to augment or replace sounds recorded on location.

Sound effects (sometimes written *SFX*) are available from a number of sources. You can buy effects on discs and most mix facilities keep an effects library, which

can be dubbed over to tape or other format for your use. A good library has an astounding range of effects: you might find, for example, 50 different crowd sounds, from low murmurs to wild applause. Libraries such as Sound Ideas or the CBS Sound Effect Library offer effects for specific models of cars, species of birds, types of shoes, guns or screams.

At times, the most compelling effects may not be the obvious library choice. The flames in *Backdraft* were given a wide range of nonfire sounds to invest them with a sense of menace. For a feature film such as this, the sound designer will collect, sample and process sounds to create effects.

A *foley stage* is a special studio for creating effects while watching the picture. The floor may have different sections with gravel, wood or other surfaces to simulate different kinds of footfalls. A good foley artist can pour water, make drinking sounds and do other effects that work perfectly with picture.

Effects are sometimes used to create moods or impressionistic backgrounds that don't relate literally to anything in the image. Creative sound editing may involve burying abstract or unrelated sounds under the more obvious sounds created by people or objects on screen. Sometimes these effects are very subtle. A quiet, very low frequency sound may be barely audible but can create a subliminal sense of tension. As editor Victoria Garvin Davis points out, often the mark of a good effect is that you never even notice it.

Fig. 15-7. Foley room. The various floor surfaces are used to make different types of footsteps. Items in background are for generating other sound effects. (Sync Sound, Inc.)

Ambient Sound and Room Tone
The sound track should never be allowed to go *completely* dead. With the exception of an anechoic chamber, there is no place on earth that is totally silent. Every

space has a characteristic room tone (see p. 294). There are technical reasons as well as aesthetic ones why the track should always have *some* sound, even if very quiet. A background of tone or music is sometimes called a *bed*.

If the recordist has provided room tone at each location, you can lay it under the scene to fill small dropouts, larger holes or to provide a continuous background. If no room tone has been specifically recorded, you may be able to steal short sections from pauses on the set (like the time just before the director says "action") or long spaces between words. You may need to go back to the original field tapes to find all these moments.

Short lengths of tone can sometimes be looped to generate more tone. When editing mag film, this entails literally splicing the track into an endless loop and rerecording on another dubber. On nonlinear systems, this can often be done with a simple loop command. Listen closely to the loop to make sure there is nothing distinct that will be heard repeating.

If you can't get enough tone this way, you could try recording some, but many *atmospheres*, such as the sound of wind in the trees, are simpler to get from an effects library than to try to record. Another background is *walla*, which is a track of people speaking in which no words can be made out, which is very useful for scenes with groups or crowds.

Some sound editors like to put room tone even under music to provide a sense of "air" which is quite different from the pristine audio space of the music recording.

Music

Music may be *scored* (composed) specifically for a movie or pre-existing music may be licensed for use. An *underscore* (or just *score*) is music that audiences understand as being added by the filmmakers to augment a scene; *source music* seems to come from some source *in* a scene (for example, a car radio or a pianist next door). To preserve continuity, music is almost always added to a movie during editing and is rarely recorded simultaneously with the dialogue. (Of course, in a documentary, recording ambient music may at times be unavoidable.)

Fig. 15-8. Portion of a screen from Deck II, affordable audio mixing and editing software for desktop systems. (Macromedia, Inc.)

Music is a powerful tool for the filmmaker. Used right, it can enhance a scene tremendously. Most fiction films would be emotionally flat without music. But if the wrong music is used, or at the wrong time, it can ruin a scene. Though there are many movies with catchy themes, or where well-known songs are used to great effect, it's interesting how many movie scores are actually quite subtle and nondescript. Listen to the score for a movie you've liked. Often, the most powerful scenes are supported by very atmospheric music that doesn't in itself make a big statement.

A case can also be made for times when music should be avoided. In some documentaries and in some moments in dramas, music can have a kind of manipulative effect that may be inappropriate. No matter what music you choose, it unavoidably makes a kind of editorial comment on the action. Sometimes audiences should be allowed to form their own reactions, without help from the filmmaker (or composer).

Typically, during the rough-cut stage, movies are edited with no music or with *temp (temporary) music*. The editor and/or director go out and find music they like and "throw it in" to the movie during editing just to try it out. This can be a great way to experiment, and find what styles work with the picture. The problem is that after weeks or months watching the movie with the temp music, filmmakers often fall in love with it, and find it very disturbing to take it out. There are many reasons why the temp music *must* come out, ranging from it having been used in another movie, to the likelihood that you can't afford it, to the fact that you've hired a composer to write a score. Often, composers have ideas that are very different from the temp music you've picked, and they may not be able or willing to write something like the temp track if you ask them to.

Every composer has his or her own method of working, and the filmmaker and composer must feel their way along in finding the right music for the show. A *timing sheet* should be prepared, showing every needed *music cue* and its length. The director should discuss with the composer what each scene is about, and what aspects of the scene the music should reinforce. Even if you know musical terminology, describing music with words can be tremendously difficult. Often, the conversation turns to far-flung metaphors about colors, emotions, weather, whatever is useful to describe the effect the music should have on the listener. What makes great composers great is their ability to understand the ideas and emotions in a scene and express that in music. Scoring is often left until the very last moment in postproduction, but there is a lot to be gained by starting the process as early as possible.

If you can't afford or don't want an original score, you can license existing music. Popular songs by well-known musical groups are often very expensive. Music libraries sell prerecorded music that can used for a reasonable fee with minimal hassle. See Chapter 18 for discussion of copyright, licensing and the business aspects of using music.

EDITING MUSIC. When music is scored for a movie, the composer will generally design each passage to fit perfectly with the picture. If the music has the same timecode as the picture, it's very easy to place it properly in the show, during sound editing or in the mix. Nevertheless, there are times when music needs to be cut or repositioned to work with the edited scenes.

Cutting music is easier if you are familiar with the mechanics of music. Some

picture cuts are best made on the up beat, others on the down beat. Locating musical beats on a nonlinear system may be easier if you view the audio waveform (see Fig. 14-25), which allows you to *see* some musical phrases.[2] Often, fading in or out is the best way to shorten a section of music. With care, you can usually remove notes, phrases or verses from musical passages if needed. A musical note or another sound (like some sirens) that holds and then decays slowly can sometimes be shortened by removing frames from the *middle* of the sound rather than from the beginning or end.

Source music that is meant to appear to be coming from, say, a car radio is usually equalized to match the source. In this case, you might roll off both high and low frequencies to simulate a tinny, "lo-fi" speaker.

Some Sound Editing Issues

FRAME ACCURACY. When editing picture, we are accustomed to thinking in terms of cutting on *frames*. A cut or edit point must take place on, say, this frame or the next. Sound editing often requires more precision than that: a sound might need to be trimmed exactly *halfway* between two frames to be cleanly cut off. Some editing systems do not allow you to cut in less than one-frame increments; these include 16mm mag film,[3] videotape and some nonlinear video editing systems. More precision can be had with 35mm mag film (which has 4 perfs per frame) or a DAW (some DAWs allow you to cut at the sample level, less than 1/1000th of a frame).

POPS AND CLICKS. Sometimes on nonlinear systems, you get a pop or click where two sound clips meet on the same track. To avoid this, you may have to put the clips on separate tracks (see below) and do a short dissolve.

When editing mag film, clicks at splices may mean the splicer is magnetized. Diagonal splices are generally better than straight cuts for minimizing problems at cuts. See Chapter 13 for working with mag film.

AUDIO SCRUBBING. Many sound edits can only be made by listening to the track slowly. The term *audio scrubbing* comes from the use of reel-to-reel tape recorders, where you can manually pull the sound back and forth across the playback head in a scrubbing motion to find individual sounds. This can be also be done with mag film. Scrubbing on any analog system means that the sound will be much lower in pitch. Some digital systems offer you the choice of analog-style scrub (slow and low) and a digital version that plays a small number of frames at full speed. See which works best for you.

CODING NEW MATERIAL. Sound editing generally involves bringing new audio material (such as music, effects, narration) into the editing room that did not

[2]If you're editing mag film, beats can be hard to find, especially at slow speeds. Some editors jab at the mag film with a felt-tipped marker as every beat passes the playback head at normal speed and then cut the track accordingly.

[3]To work around this problem, you can sometimes stick a tiny piece of tape on the oxide side of the mag film to briefly lift the track off the playback head.

originate with the original production sound. This material should be timecoded or, for a traditional film edit, edge coded before cutting it in to your sound. Lack of code can cause problems later. Take the example of grabbing a sound effect or music from a disc and recording it on your editing system. The piece you recorded is fine, but if you later need to go back to the original source to rerecord or extend it, or to do an online edit, without code it can be difficult to determine which part you used. If you lay it off to a timecoded tape (or have the mag film edge coded) first, you'll have more control later.

TRIMS AND OUTTAKES. Whoever is doing the sound editing will want access to *all* the audio material recorded for the movie. This includes trims, alternate takes, wild sound. Crucial pieces of room tone or replacement dialogue may be hiding in unexpected places in the tracks. Plan to deliver to the sound editor all the material used for editing, the logs, as well as the original production audio- or videotapes if needed.

PREPARING FOR THE MIX

Everything done in sound editing is geared toward the mix. The better your preparation, the better the movie will sound and the faster the mix will go. Regardless of whether the mix will be done by a professional mixer or by you, go through the entire sound track and be sure you've provided all the sounds needed. During the mix, changes or new effects may be called for, but try to anticipate as much as you can.

Mixes are done with different types of equipment, but all mixes share the same fundamental principles. One machine (or group of machines) *plays back all your audio tracks* in sync with each other and in sync with the picture. Another (or the same) machine *plays the picture* (either from digitized video, videotape or film) in sync with the audio tracks. Another (or sometimes the same) machine *records the mixed sound*, generally on more than one track. The record machine, audio playback and picture playback all maintain frame-accurate sync relative to each other.

The sound mixer, sometimes called the *rerecording mixer*, presides at the console. Like an orchestra conductor, he or she determines how the various tracks will blend into the whole. Some mixes require two or three mixers operating the console(s).

Splitting Tracks

As discussed at the beginning of this chapter, prior to the mix, the sound is split into different tracks to help the mixer control the different types of sound. During picture editing, the sound may be on one or two tracks (as is typical with traditional film and videotape editing equipment) or more (which is possible with most nonlinear editing systems). After the picture has been locked, and it's time to prepare for the mix, the tracks should be split in a very specific way to facilitate the mix.

Sounds are segregated onto different tracks according to the type of sound; for example, dialogue, music, narration and effects are usually all put on separate tracks. Actually, each type of sound is often spread on a *group* of tracks (you may need several tracks to accommodate, say, all your effects). This layout is used partly so the mixer knows what to expect from various tracks, but also so that he can minimize the

Fig. 15-9. Mix studio dubbers. Six playback transports are at left, one master record transport is at right. All can be run in interlock. (Rangertone Research)

number of adjustments made during the mix. Say you have narration in your movie. If all the narration is on one track, and there is *nothing else* on that track, then the mixer can fine-tune the level and EQ for the narrator's voice and then quite possibly *never touch that channel again* during the mix. If, on the other hand, the narrator's voice keeps turning up on different tracks, or there are other sounds sharing his track, the mixer will constantly have to make adjustments to compensate.

A simple documentary might be mixed with four tracks: two for sync sound, one for narration and one for miscellaneous effects (background tone and the like). A complex feature film with a lot of effects might need well over a hundred tracks. When there are many tracks, often a *premix* is done to consolidate, say, many effects tracks into a few that can be more easily balanced with the dialogue and music.

Talk to your mixer for his or her preferences before splitting tracks. Many mixers prefer tracks to be laid out according to the following scheme: the first tracks contain dialogue, the next narration, then music, and finally effects. If there is no narration or music, the effects tracks would follow immediately after the dialogue. If your movie has very little of one type of sound (say, only a couple of bits of music), you can usually let it share another track (in this case you might put music on the effects track).

Obviously, if you have three effects all playing at once, they all need separate tracks. But even if one piece of dialogue follows another with no overlap, the two are generally split onto separate tracks if they vary in level or sound quality. This makes it easier for the mixer to set the level or EQ for each piece separately. Actually, the guidelines for this depend somewhat on the technology being used and the way you want to work. In a traditional film mix using mag film played on dubbers (see Fig. 15-9), if one piece of sound immediately follows another on the same track, it is difficult or impossible for the mixer to make separate adjustments to the level of each sound and have the level change take place *exactly* at the cut. Instead, by putting the two pieces on separate tracks, the level and EQ for each can be set on *separate* channels beforehand. Then, during recording, as the cut flies by, the sound cleanly switches from one preset track to the other.

At the other end of the technology spectrum, there are the nonlinear editing systems and DAWs. With these systems, you *can* go through the show clip-by-clip, making individual adjustments to different sounds that immediately follow each other on the same track. Sounds do not necessarily have to be split onto separate tracks to adjust them separately. You can even make dissolves between two sounds on the same track.

Fig. 15-10. AudioVision digital audio workstation. This high-end system combines full-screen picture display with audio editing and mixing capabilities. (Digidesign, Inc.)

464 THE FILMMAKER'S HANDBOOK

As of this writing, many mixers who use digital technology and automated consoles may still want you to split two pieces of sound if their EQ or level needs to be set differently. The reason is that the mixer (and you) want the mix to go as fast as possible. When sounds are on different tracks, it is easier to adjust the EQ for the clips separately, without having to make as many changes. Also, even with a computer-controlled board that can memorize the mixer's moves and allow him to fix things later, on the first pass he may be trying to mix manually—the old-fashioned way—and splitting tracks makes his job easier.

In general, if one clip or piece of sound follows another on the same track and you can play them both without changing the EQ, hearing a click or making a large level change, then *leave* them on the same track. Tracks should be split when two sections of sound are different from each other in level or quality and you want them to be similar or if they are similar and you want them to be different. Thus, if two parts of a sequence are miked very differently and need to be evened out, put them on separate tracks. If the difference is due to a change of background tone, it often helps to overlap the head and tail extensions of the shots to ease the transition by doing a sound dissolve. The more overlap you provide the mixer, the more flexibility he will have in controlling the dissolve.

How many tracks do you need for each type of sound? Say you're splitting your dialogue. You put the first piece on one track, then put the next on the second track. If the next split comes in less than eight to ten seconds, you should put that piece on a *third* track rather than going back to the first. The goal is to give the mixer enough time to react (consult your mixer on his preferences). Work through the movie shot-by-shot to determine how many tracks you need. Sometimes you have a situation where, say, you need only two effects tracks for one scene and two for the next, but since they butt up or overlap each other, you have to run *four* effects tracks for the show. Sometimes you'll need an extra track for optional effects or alternate dialogue takes to give the mixer more options. You don't want to use more tracks than are necessary; on the other hand, having more tracks can often *save* you money in the mix.

Preparing and Delivering Tracks

As outlined above (see The Sound Editing Process, p. 447), there are many types of equipment used to do sound editing. Before splitting your tracks, ask the mixer or sound studio how they like the tracks prepared.

If you're preparing tracks for a mix using a nonlinear editing system, and plan to bring your tracks to another facility or system to actually perform the mix, there are different ways to get the sound from one system to the other. As discussed in Chapter 14, audio and video material in a nonlinear system are stored as media files on the system's hard drives. The file that contains the editing and control information for the audio clips you've used in the show is stored separately (this is called the composition). It is possible to export either the audio media files, the composition, or both using OMF or similar formats (see Output, p. 420). The transfer is usually done on computer drives or discs. You should set the system to add handles or extensions on each clip, which remain "invisible" unless needed



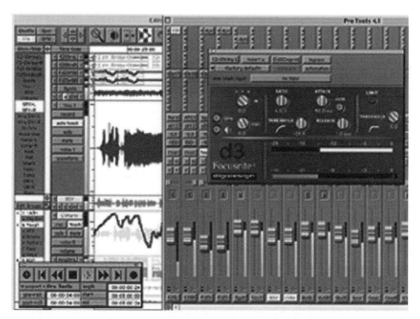

Fig. 15-11. Pro Tools audio editing and mixing software. Widely used professional system. (Digidesign, Inc.)

later to perform dissolves between clips.[4] The system usually gives you an option to keep any level or EQ adjustments you've already made; often you *don't* want to keep them so the mixer can make his own.

The other way to export sound from the nonlinear system is to lay it off to tape (print to tape). Here you are simply rerecording each track on a videotape. Depending on the tape format, you can only do two to four tracks at a time (you may have to use several tapes to get all your tracks over). This method is more cumbersome and makes it harder to manipulate the sound later.

Either of these methods should only be used if the audio was digitized at high resolution from a good source. If the sample rate is too low, or if an analog original has been copied on a poor format or through several generations, the audio may not be high enough quality for the mix. If this is the case, and the original audio was recorded on a timecoded format, a DAW can reconstruct a high-quality "online" of just the audio using the original field tapes and the EDL or an OMF file.

If you are editing film the traditional way, you can build your tracks with strands of mag film. When you're done sound editing, many mix facilities will then transfer your mag film tracks to another format for mixing. See Appendix G for a method of preparing tracks on mag film.

A common method of labeling tracks uses letters for each track in a group: thus you might have *Dia. A, Dia. B, Dia. C* and *SFX A, SFX B*, etc. If the movie is divided

[4]If possible, about 300 frame handles (ten seconds) gives the mixer a lot of flexibility.

into reels (see below), each reel is given a number; so a given track might be labeled, say, *Reel 3, Mus. A.* Ask the mixer for track labeling preferences.

REEL BREAKS AND LEADERS. Both film and video projects may need to be broken into shorter lengths (*reels*) for completion if the entire movie can't be edited, mixed or finished in one chunk.

For projects that will be finished in video, you may need to divide the show into sections to accommodate tape lengths or for mixing.

For projects that will be finished and printed on film, see Reel Length, p. 375, for guidelines on dividing up reels. When preparing film projects, each reel should begin with a standard *SMPTE leader* (sometimes referred to as an *Academy leader*). This has the familiar eight-second countdown. You can get SMPTE leader from the lab; you can also get a video transfer of it for use with nonlinear editing systems. The leader counts down from "eight" to "two" with two seconds of black following. The frame *exactly* at two should have a *sync pop* or *beep* edited into all sound tracks (see Fig. 16-7). On a nonlinear system, the beeps can be made by editing in a single frame of reference tone. The sync pops aid in keeping the tracks in sync during the mix and are essential for putting the film optical track in sync with the picture; see Optical Tracks (Analog), p. 503. A tail leader with a beep is also recommended.

When editing on a nonlinear system, decide where the reel breaks should occur, then separate each reel into its own sequence beginning with a different hour timecode. Thus, reel one might begin at 01:00:00:00, with reel two starting at 02:00:00:00 and so on. For projects that will be finished on film, some people put the SMPTE leader *before* the hour mark, so that the beep at two takes place—for the first reel—at 00:59:58:00 and the first frame of the movie appears at the hour straight up (01:00:00:00). (This is the typical way video projects are handled; see Preparing the Edit Master, p. 403). However, some mixers and negative cutters prefer that the SMPTE leader *begin* at the hour mark, so the beep at two would appear at 01:00:06:00 and the first frame of picture starts at 01:00:08:00.[5] Talk to the mix facility, lab and/or post house for the way they want the reels broken down.

Cue Sheets

In a traditional mix, *mix cue sheets* (also known as *log sheets*) are drawn up, which act like a road map to show the mixer where sounds are located on each of the tracks (see Fig. 15-12). Since the filmmaker or editor is usually present to make aesthetic judgments, the cue sheets need only provide basic information. The mixer wants to know *where* each track begins, *how* it should start (cut in, quick fade or slow fade), *what* the sound is, *where* it should cut or fade out and *how far* the track actually extends beyond this point (if at all).

The location of sounds is indicated by timecode or, for some film projects, by footage count (see Appendix G). Noting picture and dialogue cues helps as well, especially the last line of dialogue on outgoing tracks. Make notes about any special treatment of the track relative to other tracks (such as "keep low").

[5]In 16mm, with the "Picture Start" frame of the SMPTE leader used as zero (01:00:00:00 in video) the first frame of picture occurs at exactly 4 feet, 32 frames.

With many DAWs, cue sheets are unnecessary, since the mixer has a graphical display showing where sounds are. Individual clips can be given labels right on the screen.

THE MIX

Arranging for the Mix

Professional sound mixes are expensive (from about $150 to $350 per hour or more); some studios offer discounts to students and for special projects. Try to get references from other filmmakers before picking a mixer. Mixers and filmmakers sometimes have conflicts. Mixers tell tales of antsy filmmakers who haven't slept in days giving them badly prepared tracks and expecting miracles. Filmmakers tell of surly mixers who blame them for audio problems and refuse to take suggestions on how things should be mixed. If you can combine a well-prepared sound editor with a mixer who has good ears, quick reflexes and a pleasant personality, you've hit pay dirt.

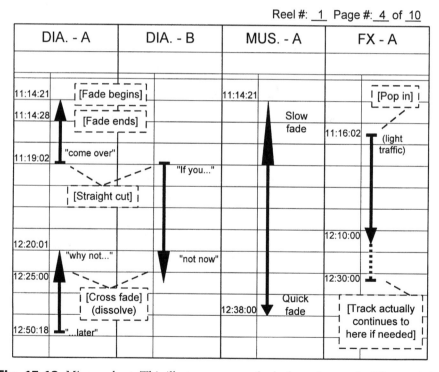

Fig. 15-12. Mix cue sheet. This illustrates one method of notating tracks. The words in quotations are dialogue cues. Bracketed comments are for readers of this book and would not appear on a typical cue sheet. Film mixes may be done with footage count rather than timecode.

Depending on the complexity of the tracks and the mixer's facility, a mix can take two to ten times the length of the movie or more. Some feature films are mixed for weeks, with significant re-editing done during the process. For a documentary or simple drama without a lot of problems, a half hour of material a day is fairly typical if the work is being done carefully. Some studios allow you to book a few hours of "bump" time in case your mix goes over schedule; you pay for this time only if you use it. The more time you spend talking, or reviewing sections that have already been mixed, the more it will cost. Newer, random-access *digital dubbers* that play the sound from computer drives or magneto optical discs do away with the time wasted winding and rewinding.

Mix Choices
The sound mix is a constant series of (often unspoken) questions. Is the dialogue clear? Is this actor's voice too loud compared to the others? Is the music too "thin"? Have we lost that rain effect under the sound of the car? Do we need a different explosion? Left alone, a good mixer can make basic decisions about the relative volume of sounds, equalization and the pacing of fades and dissolves. Nevertheless, there are many questions for which there is no "correct" answer. The mixer, director and sound editor must work together to realize the director's goals for the movie.

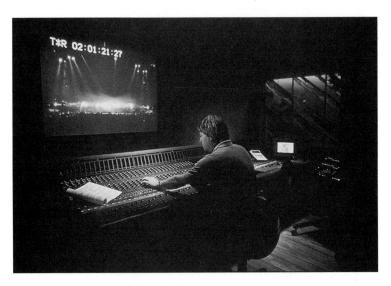

Fig. 15-13. Mixer at work. (Sync Sound, Inc)

See Sound Processing Devices, p. 449, for some of the systems used to adjust or improve sound quality during the mix.

Today, most movies are shown through more than one form of distribution. A movie may be shown in theaters, on television, through home video and possibly

in several different languages. Distribution technologies include videotape, disc (DVD, laser or CD), television (broadcast, cable or satellite) or film prints. The various routes may call for different adjustments during the mix, or for different mixes altogether.

Number of Channels

Different distribution methods offer various possibilities in terms of how many channels of sound are reproduced. The complexity of the mix depends on how many channels you need.

THE FORMATS. 16mm film prints with optical sound tracks (see Chapter 16) reproduce mono (one-channel) sound. The film may be shown on a projector with a single speaker built in (bad idea) or it may be shown in a theater that has many speakers. Regardless, there is only *one* channel of sound. Many student films are recorded, edited and mixed in mono. It is also possible to make 35mm film prints with mono sound and some independent films are shown this way.

Virtually every *other* means of showing a movie today has the possibility of at least two channels of sound and some have six or more.

In typical home music or TV sound, "stereo" means two channels (left and right). Stereo adds presence to music and allows you to place sounds on one side or the other, giving a sense of dimensionality. A movie can be released in stereo, *even if all the production sound was recorded in mono.* In fact, this is often the case. The sound recorded in the field may be taken with a single mono microphone and recorded on one track in the camcorder or audio recorder. During editing, additional tracks are introduced, such as music and effects. Finally, in the mix, the mixer portions the sounds out to either or both of the two stereo channels. Music tracks may have true stereo separation while dialogue is often positioned identically on the left and right, making it essentially "two-channel mono." Many television programs, corporate videos and other movies are done this way.

In the film industry, "stereo" is understood to include a *surround channel*. In a movie theater, surround speakers are placed along the sides and rear of the theater. Sounds that are assigned to the surround channel include ambience (atmospheres) and some special effects which surround the audience, adding a sense of realism. Proper theater stereo also has a *center channel* so that the sound of actors speaking on screen will appear natural, coming directly from the screen instead of seeming off balance for people who are not sitting in the middle of the theater.

Films mixed for *Dolby Stereo* thus have at least *four* channels, with left, center and right speakers hidden behind the screen, and surround speakers at the rear and sides of the auditorium. Many film prints are made with Dolby Stereo optical tracks (see p. 503). The four channels are specially encoded so they can be recorded on just two channels, so a "stereo" (two-channel) film print can carry all the information for the four playback streams. When a film is to be mixed in Dolby Stereo, arrangements must be made to license the use of the format.[6]

[6]See Sound for Film Prints, p. 503, for other theatrical formats.

Movies not intended for theatrical exhibition may still make use of similar technology for TV broadcast or distribution on formats such as VHS tape or CD. *The Dolby Surround Pro Logic* format extends the same idea as Dolby Stereo for reproduction in the home. Again, four channels of sound are recorded on just two channels of the tape or disc.

Dolby Surround Pro Logic provides great versatility for a wide range of playback equipment. If the format is used for a TV broadcast or home video release, people who only have one speaker (say, in an older TV set) receive a mono signal with all the sound. People who have two speakers (in a typical "stereo" TV) will receive a two-channel signal. And people who have a "home theater" setup with left, right, center and surround speakers and a Pro Logic Decoder in their system can "unfold" the matrix into the four channels for the full effect.

In case that's not enough for you, a newer format has been introduced: *Dolby Digital (AC-3)*. This is found on DVDs and is used by some digital broadcasters. This format also includes left, center and right channels across the front of the room and adds separate left surround and right surround channels. There is a sixth channel for subwoofer (low bass) sound. Since this last channel is limited bandwidth, the format is sometimes referred to as having "5.1 channels." Since it is a digital format, Dolby Digital sound can be copied and transmitted without quality loss. It is also digitally compressed, and can pack all six channels into less space than a single channel on a compact disc requires.

There are other multichannel formats, including *DTS*.

CHOOSING A FORMAT. As a producer, you must decide how you want to take advantage of these formats. In some cases broadcasters or others may require programming in a certain format, in other cases it may be optional. Mixing for many channels adds time and complexity to the mix. Some movies are greatly enhanced by multichannel reproduction; on others it may add very little. A television show, corporate video or multimedia project might be mixed in basic stereo (just two channels) on the assumption that most viewers will *not* have a home theater setup and will hear the sound through relatively small speakers on a TV, VCR or computer. Some independent films are released for theatrical exhibition in basic stereo or even, gasp, mono. Particularly for a nonaction, non-special-effects movie (and in the type of theaters where many independent films are shown), many audiences never notice the difference.

Level and Equalization

How or where a movie is shown affects not only how many channels you use, but the basic approach to sound balancing. In a theater, the space itself is quiet and the speakers are big and loud enough so that quiet sounds and deep bass come across clearly. In a typical home TV environment, on the other hand, the set may have a very small speaker, and the room may have plenty of competing sounds from people talking, the street, appliances, whatever. Sound that is mixed too quietly will be lost, as will deep bass (low-frequency) sounds. The use of compression can help save some of the quiet sounds (see Compressors, p. 451).

If you mix for a theater environment (whether for film or video projection) you

usually have a lot of dynamic range to play with (see p. 246). You can make sounds very quiet or very loud. Music can be, at times, very subtle and still be audible. For typical TV mixes, dynamic range is more limited and you generally have to make the music much louder relative to other sounds in order for it to punch through. This volume level may be overpowering in a theater setting.

If you're only doing one mix, compromises are called for. Most mixers can play your sound through either large or small speakers so you can estimate what the mix will sound like in different environments.

You need to keep in mind not only the screening environment, but the delivery format. Digital video formats like DV or DVD or digital film print formats (see p. 506) have low noise and excellent frequency response (see p. 247). Even analog video formats like VHS can have high-quality hi-fi sound (if recorded using the hi-fi tracks and played on a hi-fi deck).

Traditional analog optical tracks for film prints are more limited. 35mm optical sound with noise reduction (see p. 503) can be quite good, but 16mm optical sound is at the bottom of the heap in terms of sound quality. When mixing for 16mm film print release, quiet sounds should be raised to a medium level to avoid losing them in the noise, and mid to high frequencies should be boosted to offset the optical track's deficient high-frequency response. Subtleties in the sound will be lost. Maximizing the intelligibility of voices is a top priority when mixing for 16mm. Further degradation comes from the bad adjustment and small speakers of many projectors, which cut off both high and low frequencies, and the fact that films are often shown with the projector in the same room as the audience, which masks quiet sounds.

See Chapter 16 for more on sound for film prints, projectors and the screening environment.

Foreign Release

For foreign distribution when translation to another language is called for, you will generally need to supply an M&E (*music and effects*) *track*. An M&E is used for dubbing the movie in another language. The M&E mix contains all the non-dialogue sound that will be used as a bed for the foreign language voices. On a documentary, the M&E may just be a mix without narration, since the "dialogue" is often inextricable from the "effects" (they're all recorded together on location).

Sometimes dialogue for a drama or documentary is subtitled instead of dubbed. If there is narration, sometimes that is dubbed even if the dialogue is subtitled. Broadcasters may ask for an "undipped" version of the track with no narration. *Undipped* means a track that has *not* be lowered or *ducked* as it normally would be whenever the narrator speaks. You can prepare for this by first mixing the entire film with undipped music and sync sound, then returning to the beginning and making a dipped a version with narration exclusively for domestic use.

See Chapter 18 for more on preparing a movie for foreign release.

The Film Laboratory | CHAPTER 16

This chapter is about the various stages of processing and printing film, including developing the original, making workprint, conforming the original (negative matching), film printing and film projection. Film-to-video transfer (for video editing or distribution of projects shot on film) is discussed in Chapter 17, and film editing is discussed in Chapter 13.

Dealing with the laboratory is, at times, the most difficult and frustrating technical aspect of filmmaking. To avoid the usual lab problems, know what instructions the lab needs, what can be reasonably expected of the lab and how to evaluate their work. Although laboratories sometimes do careless work and make errors, their number of errors seldom equals that made by filmmakers. Filmmakers tend to blame all technical faults on the laboratory, and it is a rare lab that will admit that *it* has made an error.

To choose a lab, talk to filmmakers in your area. In some cities, the nearby labs are fine, but sometimes you are better off working with a lab in another city. You may find a single lab that can do everything you need. However, on some productions, one lab is used for processing the negative, a video transfer facility does transfers, an optical house does the titles and another lab makes the final prints. See Chapter 18 for business arrangements when dealing with labs.

THE FILM LAB DURING PRODUCTION

Shooting Tests

After a lab has been selected, tests are sometimes made of camera, sets, actors (screen tests), costumes and makeup. But what is of greatest concern here are tests of film stock and processing. For testing, use lighting and locations similar to that used in the final production. Print the tests in the same way you will make the release prints (see below). Reviewing tests that have only been workprinted can sometimes be misleading, especially in 16mm.

Processing the Original

Deliver the film to the lab as soon as possible after it is exposed. Pack core-wound film in its black bag and tape down the end so the film does not unravel in transit. Prominently mark EXPOSED on the can, so no one mistakes it for unexposed stock. See Camera Film Capacity, p. 62, for unloading magazines and preparing cans for the lab. See Handling Film Stock, p. 130, for general considerations in handling unprocessed film.

Each film shipment to the lab should include the following information (labs will often supply a form for these items or use a camera report). The first ten items should be marked on each can of unprocessed camera original.[1] Normally, a letter or purchase order accompanies the shipment. Many of the items below are discussed later in this chapter.

1. The production company name.
2. The working title of the production. Don't change the title in midproduction or the lab may lose your materials.
3. Both the common name of the film stock (for example, Vision 500T) and the emulsion number (such as 7279). See Fig. 4-10.
4. The amount of footage and the gauge. Mark if super 16.
5. Special processing instructions, including force developing, for example, PUSH ONE, PUSH TWO or instructions for flashing. It is a good idea to discuss any special processing with the lab before ordering the work.
6. The camera roll number. Never repeat a camera roll number.
7. The date.
8. The approximate footage where any camera jams or torn perfs occurred. The lab will do a hand inspection to see that no problems will occur in the processing machines that will ruin your footage and possibly footage from another production.
9. Any tests, for example, 15-FOOT TAIL EXPOSURE TEST.
10. For a daylight spool on which you wish to save a run-out shot or a darkroom (core) load, mark OPEN ONLY IN DARK. If the core has popped out, mark NO CORE or AIR WIND.
11. What should the lab do with processed original? HOLD ORIGINAL means it should be stored in the lab's vault.
12. Do you want a workprint? If so, do you want:
 a. Color or black-and-white? Any special stock?
 b. Single- or double-perforated? Request print-through key numbers.
 c. One-light print? Best light? Standard light? Timed and color corrected?
 d. For returning workprint: Pickup? Shipped? Insurance?
 f. Request the timing sheet.
 g. Special instructions, for example, day-for-night scenes or unusual color balance.

[1]As discussed on p. 66, some of this information will normally be written on a piece of tape or a label when the camera magazine is loaded, and the label can be moved to the can when the magazine is unloaded.

h. In 35mm, make sure the camera report details which takes are to be printed.
13. The name, address, telephone number of person to contact in case of questions (or the name of director and cinematographer, if applicable).

If editing is to be done on a nonlinear system or another video system, you will need to have a video transfer done from the negative or from a film workprint. See Editing Film on Video, p. 382, for an overview of this process and Preparing for the Transfer, p. 515 for ordering instructions for the transfer.

SPECIAL PROCESSING INSTRUCTIONS. In tricky lighting situations, you can make a test to determine if any compensation is needed in processing, for example by pushing (forced development) or flashing (see Chapter 4 for discussion of these terms). Sometimes, for convenience, the exposure test footage is included on the same roll as other footage. The test can be at the beginning of a roll (*head test*) or at the end (*end test* or *tail test*). Tail tests are preferable and most common, since they avoid the need to rewind the film and are easier to find. Clearly identify the test footage on the can (for example, END TEST 15′). Lab personnel will process the test according to your directions; then they'll view it and/or show it to you. After consultation, the whole roll is processed according to the results of the test. Not all labs do postflashing.

STORING THE NEGATIVE. If you don't have a cool, safe place with low humidity to store the original, have the lab store it until it is conformed. Find out if the lab charges for this service, and get a tour of the lab's vaults—a romantic name for what may be a chaotic, dusty back room. There are also warehouses that specialize in film storage where film can be kept in temperature- and humidity-controlled spaces for an added charge.

THE WORKPRINT

Workprint is a protection copy of the camera original used for editing. Though one can edit films shot with reversal stocks using the original, generally this is considered too risky except on very low budget productions. Negative stocks need to be printed just to be viewable. The edited workprint is then used to conform the camera original (see p. 481).

The workprinted camera rolls are called *rushes*, or *dailies*, because the lab turns them out quickly. The lab processes the dailies overnight and the filmmakers view them the following day or evening (small labs may not deliver this fast). When a lab delivers the rushes the *same day* they receive the unprocessed negative, this is sometimes called *daylighting*. The workprint is nearly always an A-wind contact print (see Fig. 16-1).

Timing the Workprint

Workprint is usually made on a contact printer that can make exposure and/or color corrections for each shot (labs usually refer to shots as "scenes"). There are

two basic types of workprint that can be ordered—*timed* and *untimed*. An untimed print, also called a *one-lite* print, is made with the same printing light for the entire camera roll; no compensations are made for exposure or color differences from one shot to the next. A one-lite print is sometimes made with a *standard light*, which is around the middle of the printer's scale. For example, a Bell & Howell Model C printer has a range of lights from 1 to 50 points, the lab's standard light being around 25. Cinematographers working in controlled environments, such as the film studio, often request the standard light print, which makes any errors in exposure or color balance immediately apparent.

Sometimes the one-light print is made for *best lite*. The lab technician, called the *timer* or *grader*, looks over the whole roll and decides if, on the whole, exposures need compensation. A compromise is made, and a light is selected that will give a good overall result. If there are gross differences from shot to shot, the lab will sometimes make a few corrections even on a one-lite print.

For a *timed workprint*, the lab makes scene-to-scene corrections, choosing the best light for each take, but there may be a surcharge of 30 percent or more for this service. This is also called a *graded* or *color-balanced workprint*. You should not expect these corrections to be as accurate as those on an answer print (see p. 500).

Some labs, as a matter of course, include the *timing sheet* (also called the *exposure report*) with your workprint. The timing sheet is a record of the printer lights used when making the workprint. If a best-lite or timed print is ordered, it is important to get a timing sheet and interpret it. Timing corrections can cover mistakes that you need to know about for future shoots. If you know the lab's standard light, it is easy to see which exposure or color balance errors are being compensated for. For example, with negative, if the lab is using more light than standard, then the negative is too dense, that is, overexposed. With reversal, more light than standard means that the reversal was underexposed. If your results are consistently overexposed or underexposed, check your equipment.

Often, the filmmaker working within a tight budget cannot afford a timed print. If sections of a one-lite workprint are badly timed, it may be worthwhile to have them reprinted, since the workprint is often viewed by many people.

Sometimes you need to give the lab special instructions for workprinting. The timer may attempt to bring intentionally underexposed scenes (for example, day-for-night shots) or scenes with colored gels (say, at a nightclub) back to normal unless he is given special instructions, preferably in writing. If you shoot a gray card at the head of each scene this can help the timer color balance a normal shot (see Standardizing Color Reproduction, p. 153).

In feature film production, send the lab a *camera report* or *camera sheets*, which, among other things, lists all the takes by footage number and circles those takes to be printed (see Fig. 8-20). To save money, you may print only those camera takes the director feels are usable. Many labs will only do this for 35mm and will not selectively workprint 16mm film. The camera report should also include timing information, for example, exterior ("Ext") or interior ("Int"); "Day" or "Night"; special instructions ("print slightly red") or special effects ("day-for-night").

Other Workprint Options

In 16mm, workprint may be ordered on double- or single-perforated stock. Double-perf stock is often easier to run through synchronizers and other equipment. Single-perf allows the editor to quickly determine which end is heads and which is tails, and is less likely to splice a short shot in upside down. The choice is not critical, but it is better not to mix single- and double-perf on the same production.

Some labs routinely print workprint on spliced stock, which means that occasionally there may be a cement splice, which is not too serious, but sometimes there is a color shift or slight fogging of a few frames at the splice. Printing on unspliced stock can be done for a surcharge.

Printing color rushes on black-and-white print stock sometimes saves a few cents per foot but may prove dangerous because some types of color fogging don't show up in black-and-white. Furthermore, editing choices that depend on color are hard to make.

The lab can attach a SMPTE focus leader at the head of your dailies to assist in checking that projectors and editing systems are properly set up and are not cutting off too much or the wrong part of the image.

Edge Numbers on Workprint

Most camera stocks, other than those in super 8, have key numbers (latent edge numbers) photographed on the edge of the film (see p. 129). *Always* instruct the lab, in writing, to print these numbers on the workprint, which should be done at no extra cost. When the workprint is returned, make sure the print-through key numbers are legible. They are essential for conforming camera original and workprint. If the lab forgets to print them, they should make another workprint at no extra charge. They may offer to print matching ink edge code (see p. 380) on original and workprint, but this is not a good practice.

THE LAB REPORT

Many laboratories supply a *lab report* with the rushes. The lab report lists gross camera errors and damage to the film (for example, significant exposure errors, scratches and edge fog). When you are filming on location, someone at the lab can read the report to you over the phone.

When you choose your lab, find out which errors the lab will check for in its report. If you cannot view the rushes on a daily basis, try to get the lab to include information about bad focus, improper collimation on a zoom lens, dirt in the gate, flicker, breathing, poor image registration, dirt (or "sparkle"), cinching or static marks. Certainly any processing errors should be noted. Make sure the lab sends you the workprint timing sheet.

The lab report is *especially important* when no film workprint is made and the movie is being edited on video, which may mask some errors.

SCREENING THE RUSHES

The cinematographer and director should look at the rushes as soon as possible, preferably the day after shooting. View the workprint on a projector, since editing machines may hide errors such as image flicker, slight softness of focus and bad registration. Sometimes the cinematographer screens rushes without sound to concentrate on camera problems. Evaluate whether scenes need to be reshot and what remedial action can be taken to remedy errors.

One of key problems with editing films on video is that the cinematographer may be denied the opportunity to view the image on a big screen, directly from a film print. The video dailies may not reveal problems that will later be evident when film prints are made or the final video transfer is done. Also, the video may not reveal subtleties that the cinematographer needs to see to evaluate lighting and shooting choices.

Troubleshooting Errors

SCRATCHES OR CINCH MARKS. If you see a scratch during the screening, check *immediately* for its source. The lab report may note whether the scratch is on the emulsion or base (*cell* scratch). If there is no notation on the lab report, stop the projector and hold the scratched film at an angle to a light source so that you can see the reflection of the light on the film. Twist the film in relation to the reflection to see if the scratch is actually on the film. If it is not on the workprint, the scratch is on the original. If it is on the print, check whether it is also on the projector feed reel. If it is, the scratch was made before projection. If not, the projector is making the scratches. Clean the projector (see p. 508) and check for emulsion buildups or tight rollers before continuing the screening.

Most scratches on original come from the camera, although some come from laboratory or manufacturer errors. A scratch test (see p. 73) prior to filming will usually show a manufacturer error or a camera scratch. If a scratch is precise with no wobble or if it has a slight fuzziness on the edge of the scratch (a sign of a pre-processing scratch), it is probably a camera scratch. Emulsion scratches are usually camera scratches, since most lab rollers touch only the base side. Further questions to help detect the origin of scratches are: Does the camera scratch now? Do only those rolls shot in a particular mag show the scratch? Did an inexperienced person load the camera? If you're unsure, discuss the matter with the lab and ask (though do not necessarily trust) their opinion.

Base scratches can generally be removed by buffing. Liquid-gate printing (see below) often hides base scratches and some light emulsion scratches. You can ask the lab to check whether a scratch is on the emulsion or on the base. A base scratch defracts light (that is, it does not let light pass), so it will appear black on reversal and white (and uncolored) on a positive print from negative. Emulsion scratches let light through; they appear white or colored on reversal and black or colored on a positive print from a negative.

Cinch marks appear as discontinuous oblique scratches usually caused by handling film poorly, such as pulling unraveled film tight or squeezing dished, core-

wound film back into place. Liquid-gate printing or buffing may remove cinch marks on the base. Thin camera original (underexposed negative or overexposed reversal) will print with more noticeable scratches and cinch marks.

WORKPRINT CHATTER. Old shrunken film or recently processed unlubricated film (*green film*) often chatters during projection. If the workprint makes noise and is unsteady, it may only need lubrication. In any case, the problem generally stops after projecting the film a few times. Check whether the lab forgot to lubricate the film. If you want to do this yourself, use film cleaner with lubricant.

DIRT ON THE FILM. Dust or dirt that shows black on the screen is less noticeable than when it is white. Dirt on reversal films shows up as black, while dirt on the processed negative original will appear white when printed (called *sparkle*). If the *print itself* is dirty, the dirt shows up black. If you see dirt on a projected print, clean the print by running it through a felt moistened with film cleaner (see p. 371). A noticeable amount of dirt on the felt (assuming this is the first projection) warrants a complaint to the lab. If the dirt is on the original, it may be due to lab handling, dirty changing bags, mags or cameras. The lab's ability to handle film cleanly, especially in the more critical negative-positive process, is a key consideration in lab selection.

EDGE FOG. Edge fog is caused by a light leak that fogs the film before processing. Edge fog lowers contrast, often unevenly, and changes as the camera moves in relation to the light source. The effect is similar to lens flare, but, unlike lens flare, edge fog appears on camera original *outside* the image area. On color film, it often has a strong color cast.

Light leaks can be caused by a loose magazine lid, a loose camera door, a bad magazine-to-camera fitting, a hole in the changing bag, not packing core-wound film in the black bag or inadvertently opening a can of unprocessed film. Edge fog at the head or tail of spool-wound film is to be expected. See Light Leak Test, p. 74.

STATIC MARKS. Static marks appear as lightning bolts or branches of light (see p. 132).

PROCESSING ERRORS. *Reticulation* is the breaking up of the image into cell-like patterns caused by a sudden change in the temperature of processing solutions. Chemical staining appears as blotches, sometimes colored. *Blue comets* are blue streaks that occur on some color stocks when metal reacts with the film in the developer. The metal may come from the camera magazine and may not be the lab's fault. Uneven development shows up as waviness in the tonalities and sometimes as an overall mottled appearance. Exhausted developer may show up on print as uneven development or, sometimes, as low contrast. Spotting, mottling and streaking can be caused by improper drying. Consult the lab immediately to find out if a processing error is on the original. In the event of their error, most labs will only replace stock and refund the cost of processing.

RAW STOCK DEFECTS. Defects in the raw stock are often difficult to distinguish from processing errors. Mottling may come from defects or processing errors. The manufacturer will usually accept responsibility for replacement of defective stock and sometimes processing costs. Out-of-date or improperly stored stock will show increased fog and graininess and decreased contrast and film speed (see Chapter 4).

DIRTY GATE. Dirt and hairs may be in the camera gate or the projector gate, extending out into the image, often from the top or bottom edge. Change the frame line adjustment in the projector. If the dirt moves with the frame line, it means the dirt was in the camera aperture.

CAMERA DEFECTS. For bad registration and breathing in the gate, see Chapter 2. Flicker in the image may be a camera motor defect or a problem with lighting, particularly HMIs or other pulsed lights (see Chapter 11). A partial vertical ghostlike blurring may mean the camera shutter has a timing error. If vertical blurring covers the entire image, most likely the pressure plate was not holding the film in place (lost loop) and the claw never engaged the film (see Chapter 3 for lens problems).

OTHER WORKPRINT ERRORS. Workprint usually projects properly when it is wound base out. If you find that the print must be loaded emulsion out in order to project properly, it may be because the lab has printed the original flipped. An optical print (see below) may be printed in camera original position (which does project emulsion out), but this is extremely rare for workprint. If the film seems flipped and the camera original was reversal, *be careful:* you may be projecting the original. Sometimes if the overall look or contrast of the print is different from other workprint, the lab may have used a different print stock.

PREPARING THE ORIGINAL
FOR PRINTING

This section is about the steps that take place after the film has been edited in preparation for printing and/or video transfer. Let's briefly review the first part of the film editing process. When you buy raw stock to shoot your movie, it already has key numbers (see p. 129) photographically exposed on it by the manufacturer. You then go out and shoot with this stock and give it to the lab for processing. This film, which went through the camera, is called the *camera original* or just *original*. Though some people shoot reversal original, negative stocks are more common.

If you plan to edit the movie using film editing equipment, you generally have a film workprint made from the original, as discussed above. On the workprint, the key numbers from the original are visible alongside the picture. You edit the workprint, and when you're done, you mark it to indicate where you want fades or dissolves (see p. 381). You then give the workprint to a negative cutter (also called

a negative matcher or conformer), who measures every shot you selected, and, using the key numbers, finds every corresponding piece of the original. He *matches* the original to the workprint, re-creating your edit using the pristine original.

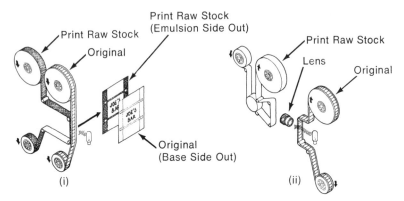

Fig. 16-1. Contact and optical printing. (i) A contact printer: the original is printed in emulsion-to-emulsion contact with the print stock. The inset shows how this changes the wind. Usually the original reads through the base (B-wind), and the contact print reads through the emulsion (A-wind). (ii) The optical printer: a lens is used between the original and print stock. The wind can be preserved or changed on an optical printer. (Carol Keller)

Fig. 16-2. Simple optical printer. The camera is at left, the projector at right. The control box advances the camera and projector in sync or independently. The lens is mounted on a bellows to allow you to change the magnification or reposition the image. (J-K Camera Engineering)

Alternately, if you plan to edit the movie using video equipment (either a non-linear or videotape system), a different procedure is followed. The camera original is transferred to video, at which time a log is made that correlates the key numbers on the film to the timecode numbers of the video transfer (see Chapter 17). You then edit your movie. When you're done editing, a list is compiled of all the shots in the edited movie according to timecode (the EDL). Then *video matchback* is done to match the timecode of each shot in the video back to the key numbers on the original film (see Chapter 13).

Regardless of whether you edited on film or video, the negative cutter will take all the rolls of camera original and select or "pull" all the shots you used in the edited movie. He will then splice these shots together in one or more rolls in preparation for making film prints or perhaps for doing a transfer to video. There are several ways the shots can be spliced together ("conformed"), depending on what type of film was used, what type of printer will be used and how the film will be printed or transferred.

Types of Printers

A *printer* is essentially a machine that duplicates one piece of film onto another. The camera original and the unexposed printing stock move past an aperture where the intensity and the color of light exposing the stock can be controlled. Prints can be made either by putting the original in contact with the print stock on a *contact printer* or by projecting the original onto the print stock through a lens on an *optical printer* (see Figs. 16-1 and 16-2). *Continuous printers* move the original and printing stock at a uniform speed, while *step printers* move the two strips past the aperture one frame at a time, holding the strips stationary during exposure. Contact prints are almost always made on a continuous printer, and optical effects on a step printer.

In general, using a contact printer is less expensive than printing optically. Dailies are made on a continuous contact printer—the least expensive printing method. Before the negative is conformed, a decision is made about what type of printer will be used to make the prints or intermediates. For example, a standard 16mm release print may be made on a contact printer, but if a blowup to 35mm is anticipated, an optical printer will be needed at some point. The original is conformed appropriately for the printer that has been chosen.

CONFORMING THE ORIGINAL (NEGATIVE MATCHING)

Conforming the original must be done with utmost care and precision. The work should be done in a dust-free space, with editing gloves to protect the original from finger smudges. Dirt and scratches must be avoided. Negative stocks are especially vulnerable: dirt on negative prints white, which is more noticeable than reversal dirt, which prints black; negative emulsions are softer than those of reversal and more easily scratched. Cutting errors made during conforming can be disastrous, and badly made splices can cause serious problems if they jump or come apart during printing. Although some filmmakers choose to do this precise, tedious and time-consuming task themselves, others gladly pay professionals to do it

for them. *Negative cutters* (also called *conformers* or *negative matchers*) may charge a few hundred dollars for a 400' reel of 16mm film. Some charge per cut instead of per foot, which may be cheaper or more costly, depending on how the film is edited. If you have a negative matcher do your conforming, you won't need to involve yourself much in the process, but be sure to ask how he or she wants things prepared.

Some filmmakers cut and arrange the original but let the lab do the final splicing. The filmmaker normally puts scribe marks (see Appendix I) at the frames to be spliced. Ask the lab how they want the footage prepared. For further information on conforming your own original, see Appendix I.

There are four principle ways of laying out the original for printing (and sometimes video transfer). Each has its advantages:

Single Strand

Splicing the conformed original into a single strand (also called *A rolling*) is simple and straightforward. Labs charge less to make prints from a single strand, but there can be real disadvantages in this method. First, depending on the printing machine used, the lab may not be able to make the complete color and exposure corrections for each shot that it could if the film were on more than one strand. Second, when using a contact printer, fades on negative stocks and double exposures, superimposed titles or dissolves on either negative or reversal stocks are normally not possible, since these effects require the overlapping of two shots. These effects may be done from a single strand if all or part of the film is optically printed.

Perhaps the greatest drawback to printing from a single strand in 16mm and super 8 is that splices, whether made with cement or tape, will show on the screen. Virtually all professionally made films are printed using a more expensive technique that makes cement splices invisible. If you must print a 16mm or super 8 film with tape splices, be sure the splices are tight and unstretched. Redo any bad ones. Double-splice the film with guillotine tape or Kodak Presstapes that have been cut on the frame line (see Fig. 13-3). Always inform the lab if a film has tape splices.

It is far more common to print from a single strand in 35mm than 16mm, since the frame line is wide enough to make cement splices that do not show on screen and the image does not deteriorate as noticeably when it is duplicated; thus fades and dissolves can be made in an optical printer on a second-generation piece of film, which is then spliced into the single strand original. In 16mm, the two generations would compare badly when spliced together.

A&B Rolls

Splices can be made invisible by printing from multiple strands of original. *A&B rolling* (also called *checkerboard printing*) is the most common way of printing 16mm films. This involves dividing the shots from the original onto two rolls and spacing them with black leader. Thus, the first shot of the movie is on the A-roll, with black leader opposite it on the B-roll. The second shot is spliced onto the B-roll, and leader of the same length fills the space on the A-roll.

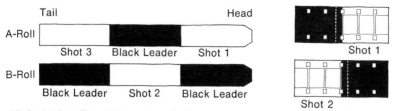

Fig. 16-3. A&B rolling. Three shots laid out on A&B rolls with black leader as spacing (left). The overlap for the 16mm cement splice occurs over the black leader, not over the picture (right). (Carol Keller)

To print the A&B rolls, first the A-roll is run through the printing machine with the print raw stock. The actual shots on the roll are exposed onto the print stock, but wherever there is black leader nothing happens. Then the B-roll is threaded up with the print stock. The shots on this roll occur only where black leader was on the A-roll. They are exposed onto the print stock and the black leader on the B-roll now protects the shots that were already printed from the A-roll. By using completely opaque black leader, you can be sure that although the print stock must be run twice—once for the A-roll and once for the B-roll—each shot in the film will be printed onto unexposed sections of the print stock.

This technique leads to invisible splices simply because the overlap needed to make the cement splice occurs *over black leader*, through which no light reaches the print stock. The last frame of shot 1 is clean, and the quarter-frame overlap for the splice occurs on the next frame of black leader. Similarly, the first frame of shot 2 is clean, its overlap being on the preceding frame of leader. For this method to work, the emulsion must be scraped off the original film and never from the black leader; otherwise, light could penetrate the splice.

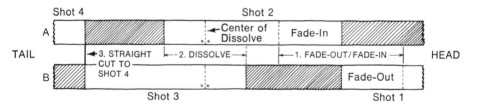

Fig. 16-4. The A&B roll layout for: (1) Fade-out on the B-roll followed by fade-in on the A-roll; (2) Dissolve from A-roll to B-roll; (3) Straight cut from B-roll back to A-roll. The fades indicated in 1 are for reversal film only. (Carol Keller)

One major advantage of A&B rolling is that two or more images can be exposed on the same section of print stock simply by putting the images opposite each other on the A&B rolls. Double exposures, dissolves and superimposed titles can all be accomplished in this way. Sometimes a third roll, or C-roll, is used for triple exposures, for dissolving from one superimposed title to another, for a supered title

placed over a picture dissolve or for beginning a second picture dissolve before the first is completed. Each additional printing roll increases the cost of the print.

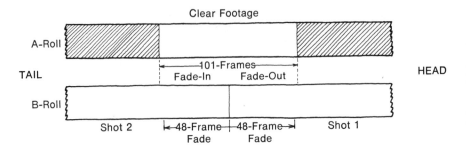

Fig. 16-5. The A&B roll layout for a fade-out at the end of shot 1 followed by a fade-in on shot 2 on negative stocks only. Some labs request that the clear footage be somewhat longer than the fades it is covering. (Carol Keller)

Fade-outs (and fade-ins) with negative stocks are done by splicing a section of clear leader opposite the picture on another roll. Where the picture is supposed to become darker, the light through the clear footage is *increased*. For color negative films, clear camera original is used instead of clear leader because it contains orange *masking* necessary for proper color reproduction. Some labs request that the section of clear film be somewhat longer than the fade it is covering.

The other benefit of using A&B rolling is that most labs are equipped to make full color and exposure corrections for each shot. If the length of black leader between two shots on a roll is not sufficient for the printer to readjust for the second shot, additional (C or D) printing rolls may be used. Consult with the lab about minimum spacing of shots and effects.

Zero Cutting

Another technique for making invisible splices is *zero cutting*. In zero cutting, the shots are laid out similarly to those in A&B rolling, but with at least a four-frame overlap at each splice (usually the overlap is much greater). When the printer reaches the end of a shot in one roll, its shutter closes very rapidly. When the printer reaches the same frame on the next roll, the shutter opens. If this is done with a continuous printer, the result is a dissolve of one-frame duration, which may be noticeable on some cuts. On a step printer there should be a normal straight cut. Not all labs can do zero cutting; if they can, there is usually an additional charge per cut.

The main advantage of zero cutting is that shots need not be trimmed to conform to the edited version of the film. Instead, shots can be included in their entirety—the way they came out of the camera—with the printer programmed to print only certain sections. This means several different edited versions can be made of one film. Films that are zero cut in this way often require four or five printing rolls to accommodate all the excess footage. Unlike A&B rolling, opaque black leader need not be used to space the shots on the rolls.

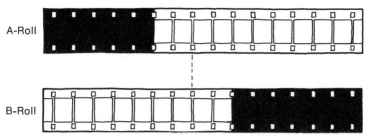

Fig. 16-6. Layout for zero cutting from A-roll to B-roll. The overlap may be far greater than the four frames pictured here. (Carol Keller)

Conforming in Camera

Another method that, like zero cutting, allows for invisible splices and the possibility of making multiple versions of the film involves using an optical printer. The original is spliced into a single strand. Shots may be taken in their entirety (from flash frame to flash frame) or they may be trimmed to nearly their finished (edited) length. The original is loaded in the projector of the printer, and the print raw stock is put in the printer's camera. The printer is programmed by footage count to print only the desired frames. When the chosen end point of a shot is reached, the print stock is held in place while the original is advanced to the beginning of the next shot. Because the original and the print stock can be moved independently of each other, dissolves, double exposures and superimposed titles can all be done with this single-strand technique. This method, sometimes called *in-camera conform*, *conforming in camera* or *auto conform*, requires the use of an optical printer, which is expensive, but it saves the cost and trouble of conforming the original in the traditional way. Often, optical printing is needed for other reasons anyway (to produce high-quality superimposed titles or when making a blowup), in which case conforming in camera may be the most economical route.

For an in-camera conform to be successful, your negative cutter should be experienced with the particular lab that is completing the work. Not all negative matchers and labs can perform this service.

CONFORMING FOR VIDEO TRANSFER. A version of auto conform is sometimes used when negative is to be transferred to video after a movie has been edited. This might be done if the movie was edited on film (and thus the negative had never before been transferred to video) or if the movie was edited on video, but the initial video transfer was a one-lite video daily (see Chapter 17) that lacked sufficient color correction.

The process begins just like any other method of conforming. You deliver the edited movie to the negative matcher either as a cut workprint or as a video. He then creates a single strand of negative, as described above (see Conforming in Camera.) The negative is then transferred to video with careful color correction.[2]

[2]If you are unfamiliar with the terms and concepts of video transfer or video editing, see Chapters 13, 14 and 17.

After the transfer, an EDL is created so the new video material can be taken to an online edit suite and automatically conformed to the edited movie (in other words, the system will re-create a finished version of the edit that you delivered to the negative matcher). If you originally edited on film, this EDL is made by taking the negative matcher's list of key numbers for every piece of film and calculating the equivalent timecode in the video transfer. If you edited on video, you already have an EDL, but the original source timecode numbers from the offline edit need to be replaced with timecode from the new video transfer.

Auto conform requires an online edit to reassemble the movie. If film prints are needed, it may be less expensive to do your video transfer from a film intermediate or print and *not* use the auto conform process for the video transfer (transferring from a print or intermediate may not require any further editing, saving time and money).

For auto conform to work, good coordination is essential between the negative matcher and the video transfer and editing facility. See Chapter 13 for more on using an auto conform as part of the video transfer process.

See Fig. 13-17 for an overview of conforming, printing and video transfer options.

Printing Leaders

All film original submitted to the lab for printing should have standardized head and tail leaders attached (see Fig. 16-7). A negative cutter will normally prepare leaders; you only need to be concerned with them if you are doing the conforming yourself. Information should be written on the leaders in India ink, never grease pencil. The leaders should be spliced emulsion-to-emulsion and base-to-base with the original. The black leader preceding the first image on the film should be replaced with SMPTE head leader, which contains the familiar 8-second countdown (in the case of A&B rolls, the leader is put only on the B-roll). *SMPTE*, or *Society*, *leader* (see Appendix G) should be fresh and of the same wind as the original (normally B-wind). This leader is available at all labs. Sound films should have a beep tone applied to the sound track opposite the number 2 (see Appendix G).

It is simplest to submit sound tracks with the film in *editorial* or *dead sync*. This means that if the sound track and the picture are loaded in a synchronizer with the start marks on their leaders in sync, then the first frames of sound and picture will be in sync as well (as the magnetic track is pictured in Figure 16-7). If a film is submitted along with its optical sound master, it may be lined up in *projection sync* (also called *printer sync*). Projection sync takes into account the fact that the optical sound reader on a 16mm movie projector is located 26 frames (20 frames in 35mm) ahead of the aperture where the picture is projected (see Figure 16-9). If the projection sync mark on the optical sound track is in line with the start mark on the picture, the first frame of sound in 16mm will come 26 frames ahead of the picture (as the optical track is pictured in Figure 16-7).

All picture leaders should contain only one printer start mark. Start marks on sound tracks should be clearly labeled for either edit or projection sync. If you submit all materials in edit sync, the lab will put the track into projection sync for you.

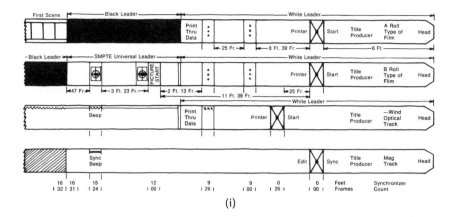

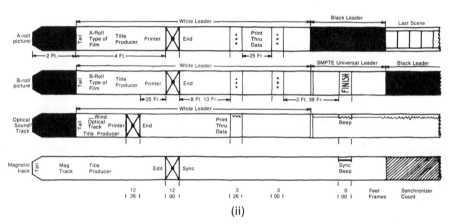

Fig. 16-7. Head (i) and tail (ii) printing leaders for 16mm A- and B-picture rolls, optical sound track and corresponding magnetic track. When the optical track is in edit sync, the three *x*'s on the track line up with the three dots on the picture rolls. When it is shifted into projection sync, the *x*'s line up with the three *x*'s on each picture roll. On the magnetic tracks used for mixing *only*, a punched start mark is usually made on the frame opposite Picture Start on the SMPTE leader (with no other start mark). Note the sync beep or pop on the sound tracks opposite the "2" on the SMPTE head leader and the "finish" frame on the tail leader. (Carol Keller)

PICTURE CUE SHEETS. When the original is submitted to the lab for printing, a cue sheet, which indicates the location and length of each effect, should accompany it. The footage counter is normally zeroed at the printer start mark (although some people zero at the "Picture Start" mark on the SMPTE leader in case the lab changes the head leader to suit their own system). Dissolves are indicated as a fade-in on, say, the A-roll and a fade-out on the B-roll beginning at the same frame. Ask the lab how they want cue sheets prepared.

PREPARING FILM TITLES

The use of titles and credits in movies is discussed on p. 359. Today, many film-makers use video-generated titles for film projects (see p. 443). A computer-ized video titling system makes it easy to lay out and adjust the lettering or other graphic elements. The video titles can be edited directly into the video version of the movie, or transferred to film to be cut in with the film original. Video-gener-ated titles transferred to film vary in quality. High-end systems are routinely used for big-budget feature films. Low-cost systems, on the other hand, may result in titles that look unsharp on a big film screen or produce motion artifacts that make moving titles like crawls seem unsmooth. If you're considering video-generated titles, be sure to look at tests or samples from the machine.

The traditional way to create titles for films is, unsurprisingly, to shoot them *directly* on film. While professionals generally have a title or optical house do their titles, student and independent filmmakers can often get good results with static (nonmoving) titles by making and shooting their own (crawls and other moves are hard to do yourself). Alternately, you can do the design work and have a profes-sional shoot the titles with an animation camera setup.

The simplest way to make titles is to shoot lettering on paper or cardboard. Titles can be created on a computer and printed with a high-quality laser printer. If you don't have a good printer, you can bring the titles on disk to a copy or print-ing shop that can print them for you. Of course, you may prefer to do the titles by hand. See p. 359 for guidelines on laying out titles.

If titles are to be superimposed over other film footage (see Fig. 14-27), it is es-sential that they have high contrast. Light lettering should be placed against a very dark, uniform background. In the supered title, you want the background on the card to *completely* disappear. Even for nonsupered titles, the background should generally be uniform and fairly dark to as to not draw the eye's attention or show dirt and scratches too much.

Put the titles on a vertical surface and shoot with a tripod-mounted camera (or use a copy-stand arrangement on a horizontal surface). Place lights on both sides of the title at a 45° angle from the surface to minimize reflected glare in the direc-tion of the camera. Use a good lens shade and flag the lights off the camera to avoid flare. The title should be illuminated evenly; hold your finger perpendicular to it in the center and in the corners to check that both lights cast equally dark shadows.

Steadiness is critical, so use a good camera. An incident light meter is best suited for checking the exposure for most front-lit titles (use the flat disc diffuser, if possi-ble). If you have enough stock, bracket your exposures (shoot not only at the expo-sure you think is correct, but a half stop or so above and below it as well). After processing and workprinting, always project the titles on a big screen before cutting them into the original to ensure that they are straight, steady and well exposed.

Many camera film stocks don't have sufficient contrast or sharpness to make high-quality titles. To obtain good contrast, you can use a fine-grained, high-contrast stock like Plus-X. Even better is Kodak's High Contrast Positive 7362

(called Hi Con). Hi Con is designed to produce deep blacks and bright whites, with few of the tonalities in between (see Fig. 4-4). Before you shoot Hi Con, check with the lab to see at what ASA they rate it. Bracket exposures in one third or one fourth stop increments and, ideally, run an exposure test at the lab on the same day you plan to process the footage. Hi Con can be developed either as reversal or negative; clear lettering on an opaque background can thus be produced either by shooting black letters on a white field or white letters on a black field. There are disadvantages to processing Hi Con titles as negative if the rest of the film is reversal. The frame line on the titles will be white, and if it does not perfectly match the frame line in the rest of the film, the mismatch will be bothersome.

To get really good contrast, titles should be lit from behind. A printing house will set titles on Kodalith or other high-contrast sheet film in order to produce clear lettering on a perfectly opaque background. Opaquing ink is often used to block pinhole imperfections, and an X-Acto knife is used to scrape any density out of the letters. When a Kodalith is illuminated from behind (usually done on an animation camera setup), maximum contrast between lettering and background is achieved. This technique is especially recommended when you are preparing superimposed titles.

PRINTING SUPERIMPOSED TITLES. How superimposed titles (or *supers*) are printed is a subject that confuses many people. Supers appear on screen as lettering over a filmed scene (the "action"). For maximum legibility, the lettering is usually white, or a light color. The simplest supers are those that are *burned in*. Titles are shot with Hi Con stock and developed to appear as clear lettering over an opaque background; they are then spliced into a separate roll to be printed with the rest of the movie.[3] In printing, first the action that appears under the titles is exposed onto the print stock. Then the roll containing the titles is double exposed onto the same section of print stock. The clear letters burn through to produce white titles on reversal prints or black titles on negative-positive prints (remember, a negative turns dark in areas that receive light).

To produce white supers on a negative-positive print, or black supers on a reversal print, you must withhold *all the light* in the area of the lettering. This may be done by exposing the scene and the titles *simultaneously* on the print stock (not one after the other as described above). Use titles that have opaque lettering on a clear background to mask any light from reaching the print stock where the lettering is. One way to visualize this is to imagine the letters casting a shadow on the print stock. This is often done with an optical printer that has a separate head to hold the titles between the projector (which holds the filmed scene) and the camera (which holds the print stock). Sometimes *bi-packed* titles are made with the titles in the projector and the filmed scene and the print stock sandwiched (bi-packed) in the camera. Using an optical printer is more expensive than contact printing.

Instead of making prints directly from a camera original, often intermediates are made as protection copies from which to strike prints (see Intermediates, p. 497).

[3] In 16mm, the titles are sometimes spliced into either the A- or B-roll for A&B roll printing (see p. 482) or they may be part of a separate C-roll.

If the movie was shot with negative stock, this usually means making a master positive and dupe negative; for films shot on reversal stock, an internegative may be made. In either case, white supered titles can be inexpensively burned into a dupe negative or internegative using a contact printer. Titles are prepared so that they appear as clear lettering on an opaque background. The titles are then contact printed with the dupe negative. Where the lettering burns into the scene, the image turns black after development. When the dupe negative is then contact printed onto the release print, these black letters will hold back the light, producing white supers.

Professionals often have titles shot on 35mm stock (even for 16mm films) to get the cleanest, sharpest lettering. Often, an optical house (see below) is used to design and film the titles. For supered titles, you supply them with the negative for the action over which the titles appear and they return to you a second-generation copy of the negative (see Intermediates, p. 497) that contains the action and the supers. They also give you a workprint for editing. The new negative can now be spliced in with the rest of your camera original during conforming (see p. 481). Then the movie as a whole can be contact printed, which is simple and economical.

OPTICAL EFFECTS

The term *optical effects* (or just *opticals*) refers to a wide range of image manipulations that are traditionally done using an optical printer (see Types of Printers, p. 481). Increasingly, these effects are being done digitally, in a video or computer environment, and then transferred to film when needed. Video effects are discussed in Chapter 14.

Companies that specialize in optical effects are called *optical houses*. Some labs have an optical department as part of the lab. Experimental filmmakers often do optical effects themselves, using a camera/projector arrangement (see Fig. 16-2). If you are doing a straightforward film in 16mm, you may never even deal with optical effects.

Optical work is expensive and time-consuming and often has to be redone to get it right; get an estimate from the optical house before you begin. The optical house should not charge you for its own mistakes; however, if you change your mind about an effect, you will of course have to pay extra. Fill out a specification sheet (usually supplied by the optical house). Also, mark the effects you want on your workprint or on leader. The lab should return your original film, a workprint of the effects and the effects themselves in the desired emulsion position (usually they will be negatives, supplied in same wind as your original).

Optical effects that are printed separately from the rest of the film will be at least one generation removed from other scenes in the film (see Print Generations, p. 495). In 16mm, the loss in quality is less noticeable if an entire sequence (as opposed to one shot or a part of a shot) goes through the same number of generations. In 35mm, however, fades and dissolves are often made optically, spliced in midshot, and the change in generations passes unnoticed by the general audience (but if you watch closely, you can often see a change of color or exposure just

before and after a dissolve). Sometimes 16mm optical work is blown up to 35mm and then reduced back to 16mm for superior results, especially when working with supered titles (see above).

If you need to print a section of the original and don't want to cut the roll, you can do *section printing* (also called *clip-to-clip printing*) using either an optical or contact printer. For a surcharge, the lab prints only the sections you indicate in the original.

Optical Effects Between Sequences

FADES AND DISSOLVES. In 16mm, fades and dissolves are usually printed directly from the camera original A&B rolls. This is done with an inexpensive contact printer and keeps the number of generations down. However, fades that are very long (say, over 128 frames), very short or very close to one another may have to be done on an optical printer. Optically made fades and dissolves are more precise than those done on a contact printer from A&B rolls. As noted above, 35mm fades and dissolves are often done with an optical printer.

WIPES. In a *wipe*, one scene replaces another at a boundary edge moving across the frame. The variety of wipes is endless; some optical houses offer over a hundred varieties. In some wipes one image pushes another off the screen either vertically, horizontally or diagonally. *Flip-over* or *page peel* wipes turn one image over like a book page to reveal another image.

Changing Apparent Camera Speed

FREEZE FRAMING (STOP FRAMING OR STOP ACTION). The *freeze frame* is one of the most common optical effects. A single frame is repeated, which makes the action appear to have stopped or frozen. The effect can be used at the beginning, middle or end of a shot. The dynamic grain pattern of the original is also frozen, so the grain is static and more apparent, giving the image the appearance of a still photograph with visible grain. If there is no movement in the frame, a sequence of a few frames may be alternated back and forth so the grain will change and appear more natural. Sometimes the head or tail of a shot is frozen—not for the effect, but to increase the length of a shot. Freezes are sometimes used to end films, since they suggest ambiguity or holding a moment in time.

FAST MOTION. The apparent speed of the original action can be increased by *skip printing*. Here, every other frame is printed to double the speed or every third frame is printed to triple the speed.

SLOW MOTION. The speed of the original action can be slowed down by *stretch printing*. By printing every frame twice, the speed will be cut in half. Print every frame three times to slow motion by a factor of three. Stretch printing, unlike skip printing, results in a jerkiness in the action. The image seems to alternate between freezing and moving. The effect is very different from slow motion achieved by running the camera at a higher frame rate (see Slow Motion, p. 51).

Films shot at 16 fps (the old 16mm silent speed standard) that are to be run at 24 fps (usually to add sound) are stretch printed. To do this, the lab prints every odd frame twice. But, here too, the action is liable to be jerky. Another, more complicated method helps to smooth out the action: odd frames are repeated, but a double exposure is made of the repeat frame with the adjacent even frame. A series of frames 1, 2, 3, 4 . . . would be printed 1, 1 + 2, 2, 3, 3 + 4, 4 . . .

REVERSE ACTION. A scene may be printed with the last frame of the original placed first in the print, showing the movements in the shot in reverse (that is, run backward).

Other Image Manipulations

CHANGES IN IMAGE SIZE. The image can be enlarged to change composition, to crop unwanted elements from the picture (for example, a mike boom or dirty aperture) or to enlarge some element. The image can be repositioned to adjust an off-angle horizon line. Sometimes shaky camera movements can be steadied by optically reprinting the scene. Of course, changing image size increases grain and lowers sharpness.

In an *optical zoom*, an area of the frame can be progressively enlarged in successive frames to approximate the effect of a zoom. This will progressively enlarge grain size and decrease sharpness. Optically zooming into a freeze frame exaggerates the effect since the grain pattern of the freeze frame is constant.

If the film will be transferred to video, image repositioning or enlargement can more easily be done during the transfer.

MATTES. *Mattes* are strips of film with opaque areas that block light from selected portions of the frame. The matte may have a shape like a keyhole or television screen and be fixed, or it may move to follow some action (*traveling matte*). The edges of the matte can be hard or, as in a matte-simulating binoculars, soft. Use mattes for split-screen shots that show two or more scenes simultaneously. If you hide the boundary, a shot can be created where the same actor plays two roles. Traveling mattes can be used to insert filmed backgrounds, usually exteriors, for studio shots that are set up in front of special blue backdrops. Mattes and keys, which are related, are usually easier to do in a video environment (see Keys, p. 442.)

SUPERIMPOSITIONS. An image can be optically superimposed on one or more images. Superimposition may also be made from A&B rolls or during principal photography. Multiple exposure yields the sum of the exposures. For example, a dark tone exposed on a light tone results in a lighter tone. A bright beach scene exposed with a night scene will wash out almost all the dark tones. In general, multiple exposures work better with darker scenes than with lighter scenes.

Whereas in typical multiple exposure the images are consecutively exposed on the print stock, in *bi-pack exposure*—a kind of superimposition made on an optical printer—light passes through two strips of film *simultaneously* to expose the print. Here a light tone superimposed on a dark tone yields a dark tone. You can ap-

proximate the results of bi-packing, but not multiple exposure, by sandwiching two pieces of film and viewing them on a light box or viewer. Bi-packing film is more expensive than using multiple exposures, but usually works better for lighter scenes.

CHANGE OF EMULSION POSITION. As discussed in Chapter 4, contact printing a B-wind original results in an A-wind copy. With optical printing, the change in emulsion position is optional. Optical printing could be used to make a copy that preserves the emulsion position of the original; thus the original and copy could be spliced together without one appearing out of focus relative to the other, as may otherwise happen.[4]

Labs sometimes use the expression *camera original position* instead of B-wind. If optical effects will be cut in with camera original, request that the effects be printed in camera original position. Footage from different sources may not match emulsion positions. One solution is to optically reprint all the shots that read through the emulsion so that they read through the base (B-wind); then all the shots can be printed together.

BLOWUPS AND REDUCTION PRINTING

Films can be changed from one gauge to another using an optical printer. Enlarging from a smaller gauge to a larger (for example, from 16mm to 35mm) is called a *blowup*. Going from a larger gauge to a smaller is called *reduction printing* or, sometimes, *blowdown*. Blowups must be done very carefully, since all defects are enlarged with the image. Reduction printing is somewhat less critical, though may require image repositioning when going from a widescreen to a non-widescreen aspect ratio (see Fig. 1-30).

Blowups and reduction printing are expensive. If a number of prints are needed, the most economical route is to do the blowup or reduction printing to an intermediate (see Intermediates, p. 497) and then use *that* to make relatively inexpensive contact release prints. However, sometimes a filmmaker is strapped for cash or needs just *one* print, say, for a festival screening. Then you might make a *blowup print*—directly from the small-gauge original to the larger-gauge release print. This saves money in the short run, but means starting over from scratch if additional prints are needed.

If the shooting ratio is low, it is sometimes less expensive to shoot the movie in the larger gauge to begin with, rather than pay for a blowup later. And the quality will be far superior.

Super 8 Blowups

Today, distribution of super 8 films has virtually disappeared. In the United States, most people shoot super 8 as an origination format for video transfer or for blowup to 16mm or 35mm.

Although there are relatively inexpensive methods of blowing up super 8 to

[4]An A-wind copy could also be "flipped" and spliced base-to-base with the B-wind original, which preserves focus but results in a reversed image (mirror image).

16mm with a continuous optical printer, custom work demanding scene-to-scene corrections or invisible splicing must be done on the more expensive step printer. Ask the lab how to prepare super 8 for blowup and invisible splices.

To minimize grain, use fine-grain (often relatively slow-speed) stocks when shooting super 8 for blowup. Of course, some people shoot super 8 precisely because they *like* the grain.

16mm and Super 16 Blowups

Blowups from 16mm and super 16 (see p. 9) are generally done for low-budget feature films that receive theatrical distribution. The super 16 format, having a larger frame and wider-screen aspect ratio, was basically designed for blowup. If you know at the start of the project that you will need a blowup, shoot super 16 if possible. On the other hand, many films shot in regular 16mm have been successfully blown up later when 35mm theatrical or festival distribution became a possibility.

A film originally shot in 35mm will generally have much finer grain than a movie blown up to 35mm from a smaller format. Therefore, when shooting 16mm or super 16, do everything you can to minimize grain. Use fine-grained film stocks and avoid underexposure of color negative. Slightly overexposing color stock up to one stop produces the finest-grain blowup (for more on grain and exposure, see Chapter 4). Avoid very high or very low lighting contrast (see Chapter 11). Avoid flashing and force processing (pushing). Don't do optical effects that add generations to the 16mm original.

REGULAR 16MM. When composing images during the shoot, keep in mind the aspect ratio you intend to distribute the film in. In the United States, most theaters show films at 1.85:1, though some can accommodate 1.66:1, which is the standard used in most European theaters. When shooting regular 16mm, be aware that the top and bottom of the frame will be cropped. Some viewfinders are marked for 1.85 aspect ratio (see Fig. 2-10). 1.66 cutoff is very close to the top and bottom of the TV safe action area. Even if the film was not shot with blowup in mind, if the framing is not too tight you will probably be fine.

When the blowup is made, it is often recommended that a 1.66 or 1.85 hard matte be used, essentially creating a black border at the top and bottom of the image. This way, if a critical part of the image is being cut off, you can reposition the image up or down by scanning (see Fig. 1-30ii). You can decide on a scene-by-scene basis whether to crop from the top, the bottom or both. This allows some flexibility in what is essentially a reframing of the original shot.

SUPER 16. Super 16 provides about 40 percent more picture area than regular 16mm, resulting in increased sharpness and less grain in the blowup. Super 16 is not itself a release format. It extends the 16mm picture area into the area normally occupied by the sound track or by the extra set of perforations on double-perf film. You must therefore use single-perforated film, and the laboratory must be equipped to handle the format. Clearly identify super 16 film so that it receives proper handling.

The super 16 image has an aspect ratio of about 1.69:1. If the framing at top or

bottom has not been very tight, theatrical projection can be done at 1.85 without serious cropping. Projection at 1.66 results in minor cropping from the left and right (see Fig. 1-30i). For traditional TV and video at 1.33, the sides will be cropped more. Unless a pan and scan will be done (see Aspect Ratio, p. 37), avoid putting important details at the sides of the frame.

For 16mm release, a 16mm reduction print can be made from the 35mm blowup or a 16mm optical print can be made from the super 16mm original by re-centering and cropping the sides of the image. For more on framing and aspect ratio, see p. 220.

PREPARING AND PRINTING THE NEGATIVE. During editing, keep in mind that 35mm is printed in 2000' reels, so keep your 16mm printer rolls under 800'. If the movie has *already* been edited and had the negative conformed, some labs can re-balance the reels for 800' lengths without difficulty. You may still need to recon-figure the sound track to 20-minute sections for preparing the optical track (see Optical Tracks (Analog), p. 503).

After editing, the negative must be carefully prepared for printing. Any badly made splices in A&B rolls (see A&B Rolls, p. 482) will tend to jump in an optical printer because the sprocket teeth that hold the film stationary are separated from the printer gate by a few frames (in contact printers the sprocket teeth hold the negative and the print *right* at the area of exposure). Be sure the splicer is properly adjusted. Zero cutting (see Zero Cutting, p. 484) can eliminate jumping at splices, but may produce a slight dissolve at cuts. It's a good idea to splice together a test reel of outtakes to see if the splicer and optical printer are working properly.

The conventional procedure is to blow up from the 16mm or super 16mm negative to a 35mm master positive and then contact print the master positive to a 35mm dupe negative. This has the advantage of less generational loss (since the master and dupe are both 35mm), which helps minimize grain. Also, if additional dupes are needed, they can be easily contact printed from the master positive. However, an alternate approach is to make a *contact 16mm* master positive from the 16mm original, and *then* blow up the 16mm master positive to a 35mm dupe negative. This avoids jumping at splices (since the spliced original is run though a contact printer) and is thousands of dollars cheaper for a typical feature. The re-sults can look excellent.

PRINTING THE FILM

Print Generations

After the film is edited, the conformed original is printed, which is done either di-rectly onto release print stock or onto intermediate materials from which the release prints will be made. Sharpness is lost and grain increased every time a duplicate is made. A print made directly from the camera original is referred to as a *first-generation print*. Copying adds a generation. Thus a print made from a copy of the camera original would be a second-generation print, and so on. Optical effects and stock footage are virtually always at least one generation removed from other scenes

in the film. The trained eye can usually distinguish scenes in a film of different generations. The filmmaker has to decide how many generations are acceptable, and then take into account that more generations may be added later by duplicating; for example, a subtitled print is often an additional generation away from the original. There is a point in the duplication process where contrast increases to an unacceptable level and the graininess and fuzziness of the image increase so much that the image appears to fall apart. The difference is greater in smaller gauges—for example, a 16mm print loses more relative to the original than a 35mm print.

Special effects often require many layers of images, which is why digital technology has revolutionized the field. Once in the "digital domain," images can be built and copied through many generations with no quality loss. After the effects are created, they can be transferred back to film (see Chapter 17).

Liquid (Wet) Gate Printing

Optical printing tends to emphasize dirt, scratches and cinch marks on the camera original. If the original is immersed in or coated with a liquid of the same refractive index as the film when it passes the printer's aperture, base scratches usually will not show, surface emulsion scratches may be minimized and graininess is sometimes lessened. This process—*liquid gate*, or *wet gate*, *printing*—is particularly useful for making optical effects and printing negative original. The improvement of the print can be dramatic. Some telecines are equipped with liquid gates for video transfers. Some labs use wet gate printing as a matter of course for contact and optical prints, some charge extra and others don't do it at all.

Printing Exposure and Color Balance

The amount of exposure for each scene, as well as the color balance of color film, must be controlled to correct exposure errors in the original, and to provide creative control for the filmmaker. The old printer scale divided the increments of exposure into 21 steps or *light points*. Each point represents an equal increment in print density. Newer machines generally have a scale of 0–44 or 0–50 points.

Color balance is controlled either by inserting colored filters in the path of the printing light (*subtractive printing*) or by dividing the light into three separate filtered sources (red, green and blue), which are modulated by light gates and recombined at the printer aperture (*additive printing*)—see Chapter 5. Additive printing is far superior.

When printing, changes in the printer light must be made precisely at the beginning of each shot. Most modern printing machines are computer-controlled and make programmed timing adjustments by footage count without any physical alteration of the original (older machines required tabs or notches on the film to cue the machine).

Many labs do not update their film printing machines nearly as often as other image processing equipment. Some machines can only make timing changes *between* shots, as opposed to within a shot. However, other printing machines can change lights virtually instantaneously and may be able to improve a scene, say, that pans from bright sun to heavy shade, by making a timing change midscene rather than by using a compromise light.

Today, most labs use a video color analyzer such as a Hazeltine unit to time the negative. The timer or grader sees the image projected on a video screen and can set the exposure and color balance, much as a colorist corrects the image during a video transfer (see Chapter 17). The settings are stored and repeated by the printing machine when the print is made.

The Dry Lab

Dry labs have no processing equipment, only printing equipment. These labs send the exposed printing stock to another lab for processing. They are sometimes able to turn out release prints in volume at lower prices than conventional labs, and some dry labs will allow you access to a video analyzer for timing. If your film needs this kind of attention (for example, because it has nonstandard color that continually changes), you may want to consider the use of a dry lab. There are disadvantages to their use, however. When a conventional lab does both timing and processing and then makes a processing error, they will redo the work at no extra charge. With a dry lab, you have to work out the various eventualities item by item. Conventional labs make daily test strips to calibrate the analyzer and processing. Inquire at both the dry lab and at the lab that does the processing to see if this is done.

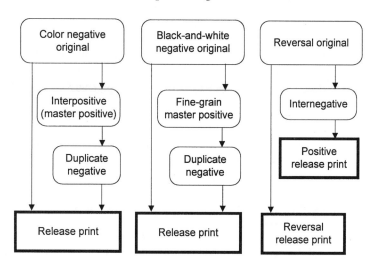

Fig. 16-8. Film printing options. See Fig. 13-17 for negative cutting and video transfer options.

FINAL PRINTING

Intermediates

You've edited your movie. The negative has been conformed, titles and opticals have been cut in and printing leaders have been prepared. The film is sent to the lab for final printing. The rolls of spliced original represent the total effort put into the

film at this point; therefore, make it a point to minimize handling. Printing from spliced materials has its dangers; splices can pull apart after repeated cleanings and trips through the printer. Even if handled carefully, the original will start to show wear after several prints. Negative is more vulnerable to damage than reversal. Some labs do not like to pull (make) more than a few prints from color negative original.

If a large number of prints are to be made, standard practice is to duplicate the original onto an *intermediate* to be used for making release prints (that is, the prints for distribution). Intermediates serve several purposes: they protect the original from handling; they serve as an insurance copy; they allow quantity printing at a lower price; they allow some effects to be added more efficiently; and duplicates are available for subtitling in different languages. However, if you are only making a few release prints, printing directly from the original avoids the cost of making an intermediate and achieves the highest quality. Intermediates are sometimes referred to as *preprint elements*.

COLOR NEGATIVE ORIGINAL. Intermediates for color negative original are usually made in a two-step process. The original negative is printed to an *interpositive (IP)*, also called a *master positive*. (IP is the generally preferred term for color intermediates, but since "master positive" can be used for both color and black-and-white, we will use it mostly in the discussion below.)

After the master positive is made, it is printed to a *dupe* (duplicate) *negative*. Release prints are then made from the dupe negative. This not only protects the original negative, but the master positive makes an excellent source for the video transfer (see p. 389). The master/dupe process allows white supered titles without adding generations to the effects (see p. 489), and several dupes can be made without handling the original. Printing from the single strand dupe neg is cheaper than printing from A&B rolls.

There are other forms of intermediates for color negative originals. *Color separation negatives* are three separate records of the color original made on panchromatic black-and-white film through red, green and blue filters, respectively. Each strip contains the color information of *one* of the three color emulsion layers of the original. Although very expensive, they use no color dyes and creates a permanent, nonfading record of the colors.

At one time, a reversal film stock (*color reversal intermediate* or *CRI*) was commonly used to make a one-step duplicate of color negative original. CRIs are rarely used today.

REVERSAL ORIGINAL. For films shot with reversal original, an *internegative* can be made from the original. The internegative now serves the same function as a dupe negative. This allows release prints to be made in the standard negative/positive process instead of trying to strike reversal prints from reversal original, which sometimes results in lower-quality optical sound tracks (see p. 503).

BLACK-AND-WHITE NEGATIVE. To control contrast, black-and-white negatives are duplicated by a two-step process. First, the negative is printed onto a *fine-grain master positive*, and then the master positive is printed onto a *duplicate negative*. Ide-

ally, the dupe negative has the same tonal characteristics as the original. As black-and-white processing has become less common, this has become one of the weakest links in the creation of release prints with proper contrast.

OPTICAL VERSUS CONTACT PRINTING INTERMEDIATES. Intermediates are sometimes optically printed. Optical printing may achieve sharper results than contact printing, and some effects (like freeze framing, supered titles and repositioning the image) can be made while duplicating. With the master/dupe process, generally only the master is printed optically. Sometimes optical printing increases contrast and apparent graininess as unwanted side effects. Wet gate printing, as discussed above, can help a great deal.

Particularly for 16mm films, optical printing sometimes results in slight jumping at splices due to the way the film moves through the printer gate. Sometimes a contact intermediate is steadier, particularly for a blowup (see Preparing and Printing the Negative, p. 495).

Print Options

PRINT COLOR BALANCE. When making a print, you must instruct the lab whether to balance it for tungsten or xenon projection. Most professional projectors used in theaters and larger institutional screening rooms employ a *xenon* lamp or other light source with a color temperature of about 5400°K. Most amateur projectors or small projectors used in classroom settings have a *tungsten* bulb of about 3200°K. Tungsten-balanced prints look slightly blue on a xenon projector, and xenon prints look slightly too warm, or red, on a tungsten projector. For more on projection, see The Projector, p. 507.

PRINT STOCKS. Camera stocks are matched to companion print stocks to produce an image of proper gamma (see Chapter 4). The gamma is usually higher than you might expect to compensate for the loss of contrast due to stray light in screening rooms and poor-quality projection systems. Companion stocks are manufactured with the assumption that the scenes on the original have average contrast. If your overall imagery is flatter than normal, consider a print stock with higher gamma or process the stock to a higher gamma.

If you are making a print intended for transfer to video, you can order a *low-contrast* (lo-con) unspliced print that is optimized for telecine transfer (see p. 390).

Cleaning the Negative

Use extreme care when handling the negative to avoid dirt, scratches and cinch marks. The laboratory should clean the negative before making prints. Dust on the film may become embedded in the emulsion and be nearly impossible to remove. The safest cleaning method is *ultrasonic cleaning*. As the film passes through a solvent bath, high-frequency vibrations remove all but the most firmly embedded dust particles. Both ultrasonic cleaning and wet gate printing may destroy tape splices and gradually weaken cement splices. Notify the lab if the printing rolls have any tape

splices. Buffing or wet gate printing will often remove base scratches and cinch marks. For badly embedded pieces of dirt, hand cleaning or *spotting* may be needed.

The Answer Print

The first print from the conformed original is the *answer print*. It is a timed, color-corrected, trial print (see Timing the Workprint, p. 474, if you are unfamiliar with the idea of print timing). Answer prints are made before any intermediates or release prints. All the effects made directly from the original or from opticals (including fades, dissolves and superimpositions) are on the print except those that may be made on an intermediate. Answer prints may have an optical sound track (see p. 503) and, if the image is acceptable, may become usable prints. Sometimes a *silent* answer print is made without a sound track if the sound hasn't been mixed yet or for various other reasons.

Generally you should let the timer do the color corrections for the first print on his own. Then screen and/or discuss it with him to make any changes for the next print. Nevertheless, tell the timer in advance of any special timing instructions, such as night scenes or scenes that should have an unusual color cast. Often filmmakers get very accustomed to the timing of the workprint and are shocked by the new timings in the answer print. The lab may take several days to produce the first answer print.

In 16mm, you generally pay for the first answer print at one price, and "additional corrected prints" are made at a lower price. It may take a few answer prints to get everything right. Unless the lab makes gross errors, you pay for each additional print; but generally these prints are usable even if not perfect. In 35mm, some labs will make a certain number of answer prints for a high flat fee until you accept a print, at which time the earlier prints are destroyed. There are methods, mostly used only in 35mm, that allow for corrections to be tested and made without printing the whole film. One method entails printing a few frames from each scene, and another uses trims from each.

EVALUATING THE PRINT. View the answer print (or any other print being evaluated) on a projector you know or under standard conditions. The lab will often have a projection room that meets industry standards for image brightness and color temperature. If the print is balanced for tungsten projection (see above), view the print on a tungsten projector; if balanced for xenon, be sure the projector is xenon. Otherwise you will not be able to evaluate the print's overall color rendering.

Carefully check for conforming errors, invisibility of splices, smooth cuts without image jumping, quality and suitability of effects (at this point it is easy to change the length of a fade). Not only should scenes have the desired color balance and density, they should also match within sequences. If the print shows dirt from the original, have the printing rolls cleaned before striking the next print. If there are scratches or cinch marks, you may want to do a test to see if wet gate printing will help. Check the workprint to see if dirt or scratches resulted from the initial processing. If there is a sound track, listen carefully for good sound reproduction without distortion or excess noise.

Once you have viewed the film on a projector, you may want to put it on an editing table so you can stop and make notes of needed changes. Some labs have editing machines with either tungsten or "xenon" filtered light sources. Write down a list of shots that need correction. It is best to screen the print with the timer at this point. Otherwise, note errors by footage count from the "Picture Start" mark on the head leader or put masking tape on the problem scenes, so that the timer knows where to correct the next print.

Check Prints

At least one answer print is made before making any intermediates such as a master positive/dupe negative. After an intermediate or blowup is made, a *check print* is struck to verify that all went well. It may be on the check print that you can see for the first time some supered titles or other printer-made effects. The check print costs less than an answer print but more than a release print.

The Release Print

A *release print* is a print intended for distribution—finished and ready to be shown. Minor timing errors on a check print or an answer print can usually be corrected when the release print is made. If the errors are serious, the intermediate materials may have to be redone. If the check print is acceptable, then one-lite release prints can be made. Labs generally don't charge for timing corrections when they make release prints. However, if you have an intermediate that can be printed with one printer light, you can more easily change labs. Sometimes labs specializing in release prints offer a better price. However, the best-quality release prints are generally obtained by staying with the original lab.

There are price breaks for release prints ordered in quantity. At some labs all the prints have to be ordered at once, while at others the price breaks come as you cumulatively reach certain amounts. The rate-card price is usually negotiable when making several prints.

35MM RELEASE PRINTS. 35mm prints are usually mounted on plastic or metal reels and shipped in heavy-duty ICC or other metal or plastic cases. The reels of film should be taped or otherwise secured to prevent unspooling in shipment.

35mm prints are usually about 20 minutes long. Some theaters will splice all the reels into a single platter for projection. The sound should be prepared with pullups in anticipation of the reels being spliced together (see Optical Tracks (Analog), below).

Some theaters will keep the reels separate and use two matched projectors. They *change over* from one projector to the other at the end of each reel to avoid an interruption for reloading. *Changeover marks* are small circles inscribed in the upper right-hand corner of a few frames at the end of each reel to cue the projectionist when to start the next projector. The lab can put marks on the print, or on a dupe negative so they appear on all prints. Counting backward from the last frame on a reel, the marks appear on frames 25 to 28 and 196 to 199. Most labs or projection facilities have a mechanical scriber that makes a neat changeover mark.

16MM RELEASE PRINTS. You can ask the lab to mount release prints on *single-keyed reels*, which have the key-shaped center hole on only one side. This is intended as idiot-proofing to ensure that the film is mounted correctly on the projector. Single-keyed reels are inconvenient in the editing room.

You should splice at least 6' of single-perforated leader at both the head and the tail of the film. Some people put green leader at the head, red at the tail. Use only single-perf leader to help distinguish the head from the tail and to ensure proper threading. Mark the leader with HEAD or TAIL, the name of the film and your name or company name. Most films are printed with SMPTE head leader immediately before the picture. If you splice on SMPTE leader, make sure the leader is of the same wind as the film (B-wind for camera original, A-wind for most prints). SMPTE leader can help the projectionist to focus the projector before the film begins. Unfortunately, many projectionists don't bother to focus until much later.

Films in 16mm that are longer than a half hour (1200') are usually printed in at least two sections, and, if the sections are to be spliced together for projection, the sound should be prepared with pullups (see Optical Tracks (Analog), below). Films in distribution are usually mounted on reels of 1600' or less. A 2400' reel can accommodate a 66-minute film but may be dangerous due to the strain it places on the film in projection. Projection facilities equipped to handle big reels can show a program of a few hours' length in one piece. In this case, the projectionist will splice the reels together. You may want to put changeover marks (see above) on the print for theaters that use two projectors.

All prints get scratched, but 16mm prints are particularly vulnerable. Always clean the projector gate before use (see Adjusting and Operating the Projector, p. 508). Protective coatings to guard the print against scratches are available. One of the best coatings, *3M Photogard*, must be done at 3M's plant. However, prints with Photogard are difficult to splice with tape, making them unpopular with some projectionists.

PRINT CARE AND HANDLING. When labeling print containers for shipment, be sure to put your return address *inside* the case, since many shippers will cover over exterior labels. Indicate if a case or reel is part of a set (for example, "Reel 2 of 3").

Prints should be kept clean and free from damage. Broken perforations may be repaired with splicing tape. Preperforated tape can be applied to just the edge of the film without obscuring the picture. Trim it precisely with sharp scissors or a razor blade. A perforation repair device like the Perf-fix or Cine-Bug systems can restore perfs to a film that lacks an entire edge. Usually the head and tail of a print get the most abuse because of handling and dirt. Ample head leader is thus very important. Filmmakers engaged in quantity distribution often have the lab prepare replacement sections of the first 100' of a film.

For distribution, you may want to use a film shipping house (see Chapter 18) that can inspect and repair prints whenever they come back from being shown.

For more on film prints and projection, see below.

SOUND FOR FILM PRINTS

As discussed in Chapters 9 and 15, sound for movies is recorded, edited and mixed using a variety of technologies. Whatever method is used to create the sound track, it is eventually combined with the picture in a *composite* or *married* print.

The traditional and still most common type of composite print employs an *optical sound track*, which uses a photographic process to record and play the sound. Some film formats use magnetic stripes along the edge of the film for sound. These include sound-striped super 8 film used by consumers (see Fig. 1-4) and six-track 70mm prints for big theater projection. The use of magnetic tracks on film prints has become limited in recent years.

Newer technologies used for 35mm and larger formats make use of a digital optical sound track, as well as methods of syncing the film projector to audio playback from a compact disc or other format.

Optical Tracks (Analog)

Optical sound tracks are a worldwide standard in 16mm and 35mm. They are exposed on the film print photographically. They look like wavy lines along the edge of the film (see Fig. 16-10). In the projector, an *exciter lamp* shines a narrow beam of light through the sound track. As the area (thickness) of the track varies, so does the amount of light that can pass through it. A *photocell* on the opposite side of the film converts the changes in light into a changing electrical signal, which is reproduced as sound. Today, optical tracks use this *variable area* system (an earlier system used variations in track density to modulate the light beam).

In 35mm, optical sound may be mono or stereo. With *Dolby Stereo* encoding, the stereo track can accommodate four channels of sound (for more on the use of multichannel sound, see The Mix, p. 466). Dolby Stereo prints also employ *Dolby SR (Spectral Recording)* noise reduction to minimize the noise that is inherent in optical sound tracks. 35mm optical sound can be very high quality.

On the other hand, 16mm optical sound is far inferior. The frequency response of 16mm optical sound only runs up to 5500–7000 Hz. The optical sound track itself is capable of greater range, but few projectors are adjusted to make use of it. Because of their high noise levels, 16mm optical tracks also have limited dynamic range (often less than 40 dB). When the film print gets dirty, the noise, which sounds like a gentle boiling or crackling, increases. Though stereo 16mm optical tracks exist, most projectors only work in mono. See Chapter 15 for more on mixing for 16mm optical tracks.

MAKING OPTICAL TRACKS. To make an optical track, you supply the lab or sound facility with the movie's sound on DAT, mag film or other format. They will play it while recording with an *optical recorder* that exposes the track photographically on a piece of film called an *optical sound master*. After development, the optical sound master is then contact printed with each release print. At each step in the process, the density of the optical track must be carefully controlled. It is often an advantage to have the optical master prepared by the lab that prints the film. If you have a sound house do it instead, it is imperative that you choose one that has a close

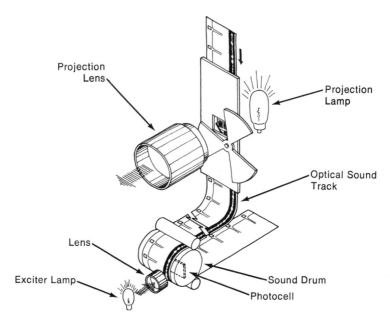

Fig. 16-9. Film projector and optical sound. Light from the exciter lamp shines through the optical sound track. The resulting variations in the light are registered by the photocell (shown in cutaway). In 16mm, the optical sound reader is separated from the film gate, where the image is projected by 26 frames. (Carol Keller)

Fig. 16-10. Dolby Stereo film prints employ a two-channel optical sound track with four channels of audio encoded on it. They employ Dolby SR noise reduction. (Dolby Laboratories)

working relationship with the lab and has calibrated their equipment in concert with the lab.[5]

Some optical masters are A-wind, others B-wind. An optical master prepared for prints made directly from the original negative should work with prints made from a dupe negative. However, for films shot in reversal, a master made for prints struck from the reversal original normally won't work with prints struck from an internegative. Talk to the lab if you plan to make intermediates.

KEEPING OPTICAL TRACKS IN SYNC. When you submit a sound track to the lab to make an optical sound master, it should be prepared according to the standard SMPTE leader format with an audible beep at the "2" (see Reel Breaks and Leaders, p. 465). On the master, the beep will appear as a frame of squiggly lines in an area where the track is otherwise quiet and smooth. The lab will position this frame several frames ahead of the 2 when it makes the release print (see Fig. 16-7). The separation is 26 frames in 16mm and 20 frames in 35mm; this corresponds to the distance between the sound reader and the picture gate on the projector (see Fig. 16-9). Without the beep, the lab has no accurate way to put the track in sync with the picture. Be sure to tell the lab if the track was transferred from video or a nonlinear system so they can check that the proper speed adjustments have been made.

WHEN REELS ARE SPLICED TOGETHER. If optical sound masters or prints with optical tracks need to be spliced together, the splice line should be covered in the track area with a diamond-shaped "bloop" mark that avoids a loud click at the splice. Blooping ink or precut blooping tape can be obtained at the lab.

As discussed earlier, for projection it is common to splice together the various reels that make up a movie and show it in one continuous strand. An interesting thing happens if you splice together two reels of a release print and then run them through a projector. Say you have a 16mm print and you splice the first frame of reel two to the last frame of reel one. When the splice runs through the projector, the picture will cut from one reel to the next, but the sound won't change until about a second later. Actually, you get 26 frames of silence after the cut, at which point the sound from reel two starts with the first 26 frames cut off. Not good.

Why does this happen? Look at Fig. 16-9. The film is moving from top to bottom, so as the cut moves through the projector it first passes the film gate but doesn't reach the sound reader until about a second later. The optical sound for any frame of picture is actually located on the print 26 frames ahead of the picture (20 frames in 35mm).

To create a smooth, natural cut in which the sound and picture change in sync, we must add 26 frames of sound *from the head of reel two to the tail of reel one*. This can be done before, during or after the mix. It simply means duplicating this short

[5]They must periodically run a *cross-modulation test*, or *cross-mod*. When you get a low-quality optical track, you can request such a test. The test can be done at the head or tail of your track. It is an exposure and printing check that involves a middle-frequency tone and a low-frequency tone. If the track is properly exposed, the lower frequency should be maximally canceled out.

section of sound and splicing it onto the tail of reel one's track. Mixers do it as a matter of course at the mix. This is sometimes called a *pullup* (but should not be confused with the use of "pull up" to mean speed up). A pullup should be done to the tail of every reel in the film except the last one. This is *only* needed for film prints and does not apply to editing together reels of video.

Other Sound Systems

There are several types of sound systems used for showing theatrical films in properly equipped theaters. *Dolby Stereo Digital* prints incorporate both the analog Dolby Stereo optical track described above and a digital optical sound track positioned between the sprocket holes (these are referred to as *Dolby SR-D prints*). Dolby Digital makes use of six channels of digital sound. Dolby SR-D prints can be used with the many older projectors equipped for Dolby Stereo as well as newer, digital sound systems.

Fig. 16-11. Dolby Digital prints employ a matrix of dots between the sprocket holes for the 5.1 channel digital sound track. An analog Dolby Stereo optical track is printed as well for use when necessary. (Dolby Laboratories)

DTS (*Digital Theater Systems*) sound uses a CD to play six channels of digital sound along with the film print. *Sony Dynamic Digital Sound* (*SDDS*) is an eight-channel digital optical system that uses a matrix of digital dots on the film, similar in appearance to the ones in Fig. 16-11.

Lucasfilm Ltd.'s THX system involves standards for the playback environment, regardless of the film format. THX-licensed home theater systems are based on Dolby Pro Logic Surround decoding (for more on these formats, see The Mix, p. 466).

FILM PROJECTORS AND THE SCREENING ENVIRONMENT

Once a satisfactory release print is in hand, you may imagine that you've survived all possible technical surprises in the production process. Don't forget to take into account the variables introduced by screening facilities, projectionists and audiences, which all greatly affect the way the film comes across on screen.

When films are distributed theatrically, the filmmaker often has little or no control over the projection process. Unfortunately, even in first-run movie houses, the projectors may be badly maintained or adjusted. When films are shown nontheatrically, you may have more ability to influence or control the projection. (Of course, today many nontheatrical screenings are done in video, not in film. See Appendix A for adjusting video monitors for screenings.)

The Projector

Projectors are usually the weak link in the chain of equipment that transfers the image from the world to the screen. Filmmakers frequently spend thousands of dollars for cameras with steady movement and sharp lenses and then show their films on jittery projectors with cheap, dirty, low-contrast lenses. In fact, poor projection plays a major part in lowering the resolution of the film system when taken as a whole.

In 35mm, the theater will have a set of lenses for projecting different types of prints (flat, anamorphic) on the screen. For nontheatrical screenings in 16mm, you may be dealing with an ancient, portable projector wheeled in for the screening. In 16mm, the standard projector lens is about 50mm (2"). Automatic threading on 16mm projectors often does not work very well. With some automatic projectors it can be difficult or impossible to unthread the projector if the film jams.

When choosing a projector, look for one that projects a bright, steady image and reproduces sound clearly. Playing a film with a slow music track is often a good test of the projector's reproduction quality. Make sure the projector allows easy access to the film gate for cleaning. The optical sound reader on a 16mm projector needs to be adjusted precisely; this should be checked occasionally by a technician with a test film. Some optical sound readers are set to optimize either A-wind or B-wind release prints, or they may be adjusted in a compromise position. If some films sound better than others on your machine, this may be the reason.

Most small projectors used in homes, schools and institutions use tungsten bulbs, and some release prints are color balanced for tungsten projection (see Print Color Balance, p. 499). Larger screening facilities usually have projectors with xenon arc lamps or other arc sources. Xenon lamps are brighter and bluer in color than tungsten bulbs of comparable wattage. Release prints made for xenon projection will look slightly too red when shown on a tungsten projector. Tungsten-balanced prints will look too blue or "cold" on a xenon projector. You could try to warm up the image with an 85 filter (which would bring the 5400°K color temperature of the arc closer to the 3200°K of tungsten projectors), but this results in a significant loss of brightness.

Typical projectors employ a two- or three-bladed shutter (instead of the half-moon-shaped shutter used in cameras) to reduce the sensation of flicker. This means each frame is flashed on the screen two or three times, with an instant of darkness between each flash. The more rapid the flashes, the more constant the projector's light seems. Some projectors have five-bladed shutters, which help reduce flicker at slower speeds but cut down on the projector's brightness.

Projectors in 16mm and 35mm run at 24 fps. Many super 8 projectors run at

24 fps or 18 fps (the latter may be indicated as *silent* speed). Many projectors will run at slow-motion speeds, but this should only be done if the metal screen *heat shield*, which falls between the lamp and the film, is working properly. *Analysis projectors* allow projection at very slow speeds and advancing the film in one-frame increments for examining footage closely.

Double-system projectors can play the picture and a separate roll of magnetic film sound track in interlock (See Fig. 12-2). These machines are mostly used to screen the workprint with its sound track before a composite print is made. Double-system projection can also be done in a mix studio or preview theater.

Adjusting and Operating the Projector

Keep the film path of the projector clean, especially the area of the film gate behind the lens. This is *especially important* in 16mm and super 8. Dirt and emulsion dust regularly accumulate in the gate and can easily scratch the film. Use a cotton swab with alcohol or acetone to clean both sides of the pressure plate and the rim of the aperture. Acetone is a powerful cleaner and should never be used on plastic or the cemented metal of sound heads. Clean the gate before every film screening. Clean the projector's lens as you would a camera lens (see p. 110) and if there's a projection room window between the projector and the screen, use some Windex or other household glass cleaner to clean it. Hairs that lodge in the gate during a screening can often be blown out with a can of compressed air while the film runs.

If you're running the screening, try to focus the picture and adjust the sound *before* the audience arrives. Focusing can be done with the naked eye, with binoculars, or with an assistant at the screen if the throw is great. If you focus the projector on the *grain* and not the image itself, you will be sure to maximize sharpness even if the scene itself was filmed out of focus. As the projector warms up, the focus will drift slightly and will need readjusting.

Most projection systems have a tone quality adjustment (bass/treble). Optical sound tracks often sound best with this adjustment set a bit toward the treble. Adjust the level and the tone with someone standing in the middle of the room who can signal when the sound seems clear but not overly scratchy. Amplifiers and speakers on portable projectors are of notoriously low quality. Many projectors have a line output jack, which allows you to run the sound through an amplifier and better speakers for improved sound reproduction.

The Screening Environment

Films should be shown in rooms that are as dark as possible. Exit lights should be positioned or flagged so that their light does not fall *on* the screen. Stray light on the screen has the same effect as flashing the film stock before processing: the black tones look lighter and the overall contrast is reduced. Theater walls should be a dark color to prevent light from reflecting back onto the screen.

The size of the projected image is determined by the focal length of the projector's lens and the distance from the projector to the screen (the *throw*). For any given projector, the larger the image is projected, the dimmer, shakier and less sharp the image will look. However, a large image—if suitably bright, steady and sharp—will have more impact on the audience than a small one. The big screen is

largely responsible for the greater power that movies have compared to television. It is sometimes recommended that audience seating extend back no further than six times the width of the screen. The image usually looks sharpest if it is surrounded by a black border; dark curtains are often used to frame the picture.

Screens are available in several types, with various surfaces. *Matte screens* are made of white cloth or painted wood. A wall can be used for screening if it is painted with a bright, flat white paint. Matte screens usually give the best color reproduction, and they can be viewed from a sharp angle (for example, from the outermost seats in the front rows.)

Lenticular screens are made of a ribbed fabric that acts like a lens, focusing the reflected light back toward the center of the audience. As a result, the image is brighter than that of a matte screen for viewers sitting near the line from projector to screen and dimmer for those sitting at the sides of the seating area. Some lenticular screens use an aluminum paint surface and may be four times as bright as a matte screen; they can be used in rooms that are not completely dark.

Beaded screens have tiny glass beads embedded in the surface. They are very bright and very directional; only a narrow viewing area down the center of the room shows an acceptable image. With these screens, the room must be completely dark. The reflected image is extremely luminous (the whites are very bright and even the dark areas reflect light), but the image may be somewhat less sharp than that produced on a matte surface.

Whenever possible, the noise of the projector should be dampened or isolated from the audience. Avoid projectors with built-in speakers. In properly equipped theaters, a projection booth with a double glass window isolates the machinery from the audience. For informal setups, the projector can sometimes be placed in another room (projecting through an open door) or in an open closet to block its noise. Some people build a ventilated housing for the projector, with a window in front and an access door on the side.

Detachable speakers should be separated from the projector and placed near the screen, which gets them closer to the audience and reinforces the sense that the sound is being produced by the action on the screen. In regular movie theaters, speakers are placed *behind* the screen where they project through thousands of perforations in the screen's surface.

"Live" or reverberant rooms may make the sound track echo and seem boomy and unclear. Curtains, furniture, sound-absorbent tiles and the audience itself all help reduce reverberation.

Film–Video Transfers | CHAPTER 17

This chapter is about converting film footage to video, and converting video to film. We will also discuss issues of shooting video and computer monitors with either film or video cameras. See Editing Film on Video, p. 382, for strategies on preparing film for transfer to video.

FILM-TO-VIDEO TRANSFER

In contemporary filmmaking, virtually every film gets transferred to video, if not for editing then certainly for broadcast or video distribution. When transfers are done for editing purposes, they may be done as *video dailies*. Here the goal is to do a quick pass with minimal color correction. After the film is edited, a second transfer can be done with careful tuning of the image. On some projects, the film is transferred only once. In Chapter 13 we discussed strategies of how to plan the video transfer in the context of editing and finishing the film. This section is about the actual process of doing the transfer. For some filmmakers, video transfer plays an integral part in their creative control of the image. For others, their involvement in the transfer is limited to sending the footage to the transfer house and receiving the videotape when it's done.

The Telecine
The *telecine* is a device for converting film to video. It has a transport to move the film footage across a scanner that reads each frame and converts it to a video signal. Broadcast-quality telecines are very sophisticated. Many can handle a variety of film formats (35mm, 16mm, super 16, super 8). The telecine's precision film transport can accommodate either positive or negative film at several different speeds with no danger of scratching. One of the most widely used telecines is the Cintel (formerly Rank Cintel) *flying spot scanner*. Flying spot systems use a CRT to project a beam of light on the film as it passes the scanner (see Chapter 6). *CCD scanners* use digital CCD technology to read the film. Popular CCD machines are

made by Philips and by Bosch. Both flying spot and CCD systems produce excellent results.

Fig. 17-1. Telecine. Cintel Ursa Gold flying spot scanner. (Cintel, Inc.)

In addition to true telecines, there are other devices that can be used to do film-to-video conversions. The *film chain* is made up of a film projector that projects the image directly into a video camera. To avoid flicker with an NTSC video transfer, the projector must have a five-bladed shutter (this is also needed if you want to videotape a scene in a movie theater without the movie image flickering unnaturally). Film chain transfers are less expansive than true telecines and they provide much less control over the film movement and image. The film chain projector mechanism is not gentle enough to allow transferring negative. Another device looks like a flatbed editing machine (or may be attached to one) and is particularly useful for low-cost transfers of synced workprint for video dailies (see Fig. 17-2).

At the other end of the spectrum, there is a new breed of very high resolution film scanners used to create high-definition images on video or stored as computer data files. These may be used for HDTV transfers or when computer special effects are to be done (see High-Resolution Film Scanners, p. 526).

In general usage, the word *telecine* is often used to mean *any* film-to-tape conversion.

Fig. 17-2. Steenbeck transfer system allows you to do a basic, low-cost video transfer from film workprint using a flatbed editing table. The transfers can be used for video editing or screening cassettes. Note video camera at left. (Steenbeck, Inc.)

The Telecine Suite

The telecine works in concert with several other pieces of equipment in the telecine room or suite. The *color corrector* is a computer-controlled system that allows the telecine operator or *colorist* to program color and other image settings. Some widely used color correctors are made by Amigo, da vinci, Dubner, Pogle and Sunburst. The suite will usually have a variety of audio input devices, including a dubber to play mag film as well as audiotape decks including ¼" and DAT machines for playback of *production sound* (sound recorded during shooting). For film and audio recorded with timecode, some telecines can automatically sync the sound and picture. A typical telecine suite will allow you to record video on a variety of tape formats. Some are equipped with hard-disk video recorders. A film cleaning machine may be nearby.

The Scanning Process

In Europe and countries where PAL or SECAM video is standard, transferring from film to video is fairly straightforward. Film footage for television is often shot at 25 frames per second and the video runs at 25 fps. Thus each frame of film is transferred to one frame of video in a simple one-to-one (1:1) relationship.[1]

In North America and other places where NTSC video is standard, things get a little more complicated. Standard film speed is 24 fps. NTSC video runs faster, at about 30 fps. If we simply transfer each frame of film to one frame of video, when

[1]For PAL/SECAM transfers from 24 fps film see International Standards Conversion, p. 527

we later play back the video, the action will run too fast. Something that took a minute on film will last only about 48 seconds on video. Motion will look speeded up and the sound track will quickly go out of sync. We need a way to stretch out the film as it goes to video.

To keep the footage at the correct speed, some frames of film are transferred to more than one frame of video. A standard sequence called *3/2* ("three two") *pull-down* or *2/3 pulldown* distributes every group of four film frames to five frames of video (see Fig. 17-3). This creates six additional frames every second, bringing us from 24 fps to 30. The term *pulldown* in this sense refers to the idea of the inter-mittent film shutter mechanism that pulls down a frame of film, holds it for a cer-tain amount of time, then pulls down the next frame (see Fig. 1-2).

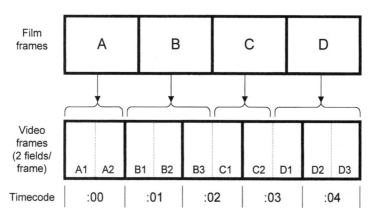

Fig. 17-3. 3/2 pulldown. Four frames of film running at 24 fps are transferred to exactly five frames of video running at 30 fps (actually, both film and video are running .1 percent slower). In the "A frame transfer" pictured here, the A film frame is the first in the sequence and the video frame to which it is transferred has a timecode ending in :00. Other transfer sequences are also possible. See text.

NOT SO FAST. There is one important wrinkle to the description above. As we discussed in Chapter 7, though NTSC video is often referred to as a 30 fps system, it actually runs at 29.97 fps, which is .1 percent slower. Especially when working with film and video technologies together, it is important to think of NTSC as a 29.97 fps system, *not* 30.

We saw above that by using 3/2 pulldown, we could make a tidy relationship between 24 fps film and 30 fps video. However, since the video is in fact run-ning .1 percent slower, at 29.97 fps, we must also slow down the film in the telecine by .1 percent, to 23.976 fps. Your eye cannot detect this slowdown, but it means that real time is disrupted. If you film a clock on the wall at 24 fps, then do a standard transfer to video at 23.976 fps, the clock will seem to run .1 percent slow. The chief importance of this is that if you record sync sound while filming, *you must also slow the sound* by .1 percent during the transfer to keep it in sync with the picture (see Resolving Audio, p. 523).

Confusingly, the term *pulldown* is also used to refer to this slowing down of picture or sound, as in, "Don't forget to pull down the sound .1 percent in transfer." Similarly, speeding up may be referred to as *pulling up*, as in, "Will this DAT machine pull up from 29.97 to 30?"[2]

Pulldown Type

As you can see from Fig 17-3, when transferring 24 fps film to 30 fps video, some film frames are transferred to one frame of video (two fields) and some are transferred to 1½ frames of video (three fields). The relationship between a video frame and the film frame from which it originated is given names such as *pulldown phase*, *3/2 pulldown type*, *pulldown field identifier* and others. Pulldown phase is generally of *no concern* to you if you plan to edit and finish the project in video. However, if you plan to edit on video and then go back to *cut the negative* so you can make film prints or additional film-to-video transfers, then you need to be aware of the concept.

For every group of four film frames, each frame in the sequence has a slightly different reproduction in video. The four film frames are given the letters A, B, C and D (see Fig. 17-3).

1. Frame A is transferred to both fields that make up video frame 1. (Two fields total—A1, A2—no timecode change between the fields.)
2. Frame B is transferred to both fields of video frame 2, and to the first field of video frame 3. (Three fields total—B1, B2, B3—timecode change between fields 2 and 3.)
3. Frame C is transferred to the second field of video frame 3 and the first field of video frame 4. (Two fields total—C1, C2—timecode change between the fields.)
4. Frame D is transferred to the second field of video frame 4 and both fields of video frame 5. (Three fields total—D1, D2, D3—timecode change between fields 1 and 2.)

In one common way of transferring film, the A film frame is transferred to video frames whose timecode numbers end in :00, :05 and multiples of 5 frames after that.[3] Thus the A frame falls on timecode 01:00:00:00, 01:00:00:05 and so on. This is sometimes called an *A frame transfer*. It makes life a bit simpler since it's easy to remember where the A frames occur. This may be called "2/3 pulldown" because the first film frame in the sequence gets two video fields, the next gets three, the next two and so on.

Another method starts with the B frame. This would technically be "3/2 pulldown," because the first film frame gets three video fields. It *makes no difference to the picture* (the video image) which method you use, but it does affect some bookkeeping chores. There are other possible sequences as well. Many people use the term *3/2 pulldown* to mean *any* of these methods.

The pulldown sequence can be one of the more confusing concepts in film-

[2]And the term *pullup* has other meanings as well! See When Reels Are Spliced Together, p. 505

[3]Assuming you have nondrop timecode with no breaks.

making. You generally only need to think about it when using nonlinear or video-tape editing systems to generate film cut lists or sometimes EDLs (see Chapter 13). The good news is that many telecine machines record on every field of video a pulldown identifier that tells you whether this field is A1, A2, B1, B2, B3, etc. The pulldown identifier may be burned into the picture along with the timecode so it is readable on screen (see Fig. 17-5).

If the pulldown type is not indicated, you can figure it out for any frame by slowly rolling through the videotape. For example, if two fields are identical and there is no timecode change between them, you're looking at an A frame (note that the A frame is special in having this simple one-to-one relationship between film and video frames). If three fields are identical but there is a timecode change between the first and second field, you're looking at a D frame. This method will not work on some nonlinear editing systems that digitize only a single field for every frame of video.

In general, nondrop timecode makes it easier to manage bookkeeping. Mixing drop frame and nondrop in the same project can cause problems during matchback (see Chapter 13).

PREPARING FOR THE TRANSFER

The following are some considerations in planning, ordering and doing a film-to-tape transfer. As noted above, transfers can be loosely thought of in two categories: (1) *video dailies*, which are done for editing purposes, often with the intent of going back to the film negative after editing to make film prints or do additional transfers; (2) *final transfers*, which are done for edited films. The distinctions between the categories can get blurred since on some projects the film is only transferred once, so the dailies also function as final transfers; on other projects, the final transfer may require additional video editing to complete the show. Nevertheless, the two types of transfers generally call for different approaches.

See Editing Film on Video, p. 382, for discussion of options in planning the transfer and the choice of what form of the film to use. Consult with the transfer facility for their preference. Particularly for video dailies, it is *essential* that you talk with the negative cutter *before* making any arrangements for the transfer to find out the cutter's needs and working procedures.

Video Dailies

For video dailies, the negative cutter or lab must prepare footage for the transfer and may need to check it after. Whoever is doing the transfer must be instructed how you want things done. The following items should be specified and/or discussed when you place your order:

1. *Punch head of each camera roll or flat.* A punch mark is made in the negative to serve as a reference point where the film key number and video timecode can be logged (this is needed for the matchback process, see Matchback and Film Cut Lists, p. 393). This is *only* needed for projects that will be finished on film (cutting the negative) or retransferred after video

editing. Many people like to have a punch made at the head of each camera roll or wherever there is a break in key numbers (that is, wherever two pieces of film are spliced together). Some negative cutters only want a punch at the head of each *film flat* (also called *lab roll* or *lab reel*) which may be made up of a few camera rolls spliced together. Some people like to have the punch made at a film frame whose key number ends in 00. This is not necessary, but may help you track down errors if they occur.

2. *Timecode.* Many people request an A frame transfer (see above), which should result in the frame punched at the head of each roll or flat being an A frame. For editing purposes, nondrop timecode (ND) is generally best. You generally want to request that the material be transferred with continuous timecode.

3. *Letterboxing.* For widescreen film projects, you often want to have the material transferred in letterbox format (see Aspect Ratio, p. 37) so the entire frame can be viewed. However, for movies that will be finished on conventional (non-widescreen) video, you may want to have the image enlarged and cropped to fill the frame.

4. *Burn-in numbers.* For a project that will be finished on film, you will want to have various numbers visible on screen, including video timecode, key numbers, pulldown identifier and production timecode (if applicable, see p. 520). Specify where you want these placed—for example, in the black borders of a letterboxed image (this allows the numbers to be masked out later if you prefer not to see them on screening cassettes). For non-widescreen movies, you generally want the numbers placed outside the safe action area (see Fig. 8-6). If the project will be finished on video and no further transfer is planned, request a transfer with no burned-in numbers; you can make dubs with burn-in timecode later if needed.

5. *Audio syncing.* Do you want audio synced in the telecine session or will you do it later (see Editing Film on Video, p. 382, and below)?

6. *Videotape format.* You should have a choice of what type of VTR is used to record the transfer (see below).

7. *Color correction.* Do you want the colorist to adjust the image for each scene or just once for the entire roll (which is less expensive). See below for more.

8. *Telecine log.* Do you want a log file of the transfer, including key numbers and timecode, delivered to you on floppy disk (see Telecine Logs, p. 523)?

9. *Shipping and storage.* Do you want the negative returned to you or stored by the lab or transfer facility? What type of shipping do you want for the videotape and/or negative?

For video dailies, you have a choice of transferring *all* the footage so you have easy access to it in the editing room, or you could transfer only "circled takes" that were indicated in the camera report or log as being good. If sound is being synced during the transfer, then transferring only selected takes can save some money. If sound is to be synced *after* the telecine, stopping and starting to skip bad takes is sometimes more time-consuming than transferring them. Also, if you find later

that you want to use the untransferred takes, you may wish you'd transferred them in the first place.

Generally, video dailies are made directly from the camera original negative. Color correction may be minimal (one-lite transfer) or may be done more carefully if no further transfer is planned. Whenever negative is used for any process, handling should be kept to a minimum. Any unnecessary shuttling in the telecine should also be avoided. The negative should be ultrasonically cleaned just prior to transfer.

On some feature films, a film workprint is made to allow for test screenings and because the workprint gives a better indication of what's in the negative than a video transfer does. In this case, the workprint may be transferred to video for editing, instead of doing the transfer from the negative. Transfer costs can be minimized by syncing the workprint with the mag film prior to transfer and cutting out unneeded material.

When *any* dailies are done, whether on film or video, the footage needs to be evaluated carefully for camera, stock or shooting problems. See Screening the Rushes, p. 477, for some of the typical problems.

The Video Recording Format

Most transfer facilities offer a variety of video recorder formats to choose from. For final transfers, a high-quality component digital format such as Digital Betacam, DCT or D1 should be used if you can afford it. Composite digital formats such as D2 or D3 do not provide quite as good a signal.

For video dailies on projects that will be finished on film or when another transfer is planned after editing, you might use a low-cost format that's compatible with your editing system. If audio will be synced in the telecine or in a layback suite (see Editing Film on Video, p. 382) consider transferring to a format that has high-quality audio capabilities, such as digital Betacam or S-VHS so that the audio brought into the nonlinear system can be used for the finished sound track. If audio will be synced on the nonlinear system, it can be captured *directly* from the production audiotapes into the system, so the audio capabilities of the videotape format are not as critical.

If the film will only be transferred once, you generally don't want to risk playing the video "camera original" tapes other than for the final online, so workdubs are often made for editing.

Many telecines can do field-accurate edits on the videotape, allowing you to join reels together or insert retransfers of individual shots without rerecording the whole tape. When projects are to be edited in video, some telecines are equipped to record directly to computer hard drives, without going to videotape first. This can speed up the process of getting the film footage ready to edit.

Keep in mind that you may need to make several master transfers to different aspect ratios, different edits (full length and TV cutdown) or different video standards (NTSC, PAL; see p. 527).

Booking a Transfer

Film-to-tape transfers are generally billed on an hourly or per-project basis. Transfer time will be longer than the running time of the material; how much longer

depends on the material, what's being done to it and how carefully it's done. Talk to the transfer facility for estimates. As a ballpark, video dailies without scene-to-scene color correction (*one lite*) may take 1½ to 2 times the running time of the footage; dailies with sound and color correction may take 3 times the running time; careful color correction of a finished film may take 15 to 20 times. Footage with many short shots may take more time to transfer than material with long takes.

Understanding how film translates to video is an art, and a good colorist will contribute enormously to the way your film looks. Ask for recommendations to find a good colorist. In a *supervised transfer* you get to be present. In an *unsupervised transfer*, which usually costs less, you let the colorist work alone. Be sure to let the colorist know in advance of any special looks you're going for. Some transfer facilities will charge you per foot instead of per hour for unsupervised work.

IMAGE CONTROLS IN THE TELECINE

There are many ways to control or manipulate the way the picture looks in the telecine session.

Color Correction

The colorist must adjust the image to meet certain technical requirements (see Broadcast Standards, p. 192), but many of the adjustments are made on the basis of what looks good, and what works within the context of the film's story line. Keep in mind that the image you see on the high-end monitor in the dark telecine room is sharper and has richer blacks than what viewers will see on their badly adjusted TVs in brightly lit living rooms.

Telecine image controls include *lift* (black level), *gain* (white level) and *gamma* (contrast); see Chapter 7 for more on these terms. There are also controls for the hue and saturation of the primary colors (see Chapter 5). For video dailies, filming a gray card at every scene on location can help expedite rough color balancing (see Standardizing Color Reproduction, p. 153). Many telecines have a secondary color corrector that allows you to change specific colors without affecting other colors. You could use this, for example, to warm up skin tones without affecting the overall balance of the scene. Or you could redecorate a set by changing the wall color without affecting the furniture. Once you have color corrected a scene, the computer can recall the settings if you encounter another shot from the same location. Many systems have a *frame store* that allows you to grab a frame from one scene and compare it with another. Most systems allow you to program a change in exposure or color *during* a shot (called a *dynamic*).

CONTRAST IN THE TELECINE. The range of brightness in the film negative is often greater than the video image can reproduce. If you make the video image dark enough to read detail in the bright areas of the film, the shadows may be rendered without detail (crushing the blacks). Or you could choose to bring the overall brightness up to see detail in the shadows, at the risk of overexposing the bright areas. The negative may have detail at both ends of the range, you just can't necessarily reproduce it in video.

Generally, it's an advantage to use the negative or a master for the telecine transfer. This gives the colorist the most flexibility to go for detail in the highlights or the shadows, depending on your needs. If you use a print instead, there is not as much detail to be had in the extremes. Sometimes this has benefits. Often you want shadows to go *really* dark, either to set a mood or because there's something in the shadows you never intended to be seen. Sometimes when working directly from the negative it can be hard to get the shadows to go completely black. When transferring from a print this is usually not a problem.

STORING AND REPEATING CORRECTIONS. Modern telecines can automatically detect cuts in the picture, and allow you to store an EDL of the color corrections for an entire film on computer disk. You can then go back and adjust shots if needed. Bear in mind that the color settings on some telecines drift somewhat from day to day or over longer periods of time. To avoid problems, some colorists prefer to color correct and transfer one reel at a time; that is, color correct the reel, clean the negative, lay it off to tape (record it) without stopping, then move on to the next reel. If multiple versions of a transfer are needed (perhaps at different aspect ratios) it may be safest to transfer all versions of each reel before moving on to the next reel.

Other Telecine Image Controls

Beyond simply reproducing what is on the film, telecines can provide tremendous creative control over the image.

Shots can be moved horizontally (X axis), vertically (Y axis) or re-sized (Z axis). This allows you to *pan-and-scan* a widescreen image for conversion to a narrower aspect ratio, which is typical when feature films are scanned for traditional TV (see Aspect Ratio, p. 37). You might want to enlarge the image, to remove unwanted objects near the edge of the frame, or to zoom in on something important. Many telecines can squeeze or unsqueeze an anamorphic image. Varying the horizontal magnification is sometimes used to creatively distort images.

Telecines offer a variety of frame rates for speeding up or slowing down motion or creating freeze frames. Off speeds can be used for effects on individual shots, or entire films can be *time compressed* or *expanded* to fit a certain broadcast length. Speeding up a feature film 3 percent can shave 3½ minutes off the running time without making any cuts. Some movies actually play *better* if sped up a little for the small screen. With any speed changes, you need to watch carefully for motion artifacts like strobing that may be introduced, especially in scenes with fast subject or camera movement. Speed changes will affect the pitch of the sound (see p. 523).

Film may have a certain amount of *weave* or unsteadiness in the telecine gate, causing the entire image to float slightly. This may go undetected in a straight transfer, but be painfully apparent if nonmoving video titles or effects are later superimposed on the image (titles that are already on the film are not a problem). Some telecines use pin registration (see Fig. 2-3) or electronic systems to increase steadiness.

Other image processing features include *enhancers* that increase the apparent resolution of the image by making details stand out more. Enhancement should be used sparingly because it also increases visible noise and grain. Many systems

are equipped with *grain reducers*, which can help soften the appearance of film grain. Some telecines are equipped with *wet gates*, like those used in film printing machines, which can help minimize dirt and scratches (see Chapter 16).

TIMECODE AND AUDIO IN THE TELECINE

Timecode in Postproduction

The use of timecode adds an enormous amount of control to the postproduction process. By recording timecode on picture and sound, we can locate and coordinate footage throughout the post process, and many laborious tasks can be automated. Older or lower-end equipment may not be able to work with all the possible types of code. Following are some of the coding systems that may be used on a film project edited on video.

FILM KEYCODE. The film manufacturer exposes key numbers along the edge of the film that can be read after the film is processed (see p. 129). Key numbers identify every frame of the original negative and are essential for cutting it after editing (although some projects are finished on video and never return to cut the negative). Keycode is a bar code version of the key numbers that can be read by machines. Many telecines have keycode readers, allowing them to track the negative as it goes through the machine. Key numbers run in an unbroken sequence from the beginning of each camera roll to the end.

Fig. 17-4. AatonCode reader. Mounted on the telecine, the reader head scans the in-camera timecode exposed along the edge of the film (see Fig. 2-20). A similar head on the telecine reads keycode. (AbelCine Tech)

IN-CAMERA TIMECODE (ALSO CALLED FILM TIMECODE). Some film cameras have the ability to expose timecode along the edge of the film near the keycode (see Fig. 2-20). In-camera timecode is often set to record the time of day at the moment each frame of film is exposed. For sync sound shooting, the audio recorder in the field also records time-of-day (TOD) code.

During the film-to-video transfer, a special reader in the telecine can read the in-camera timecode. The Aaton Keylink system can provide automatic syncing by matching up the in-camera code with the audio timecode (some number crunching is required to reconcile what may be different frame rates). Auto syncing can also be done in some nonlinear editing systems. In-camera timecode will usually have breaks in it every time the camera stops.

Cameras without in-camera timecode capability can be used with timecode slates (see Fig. 10-4). By filming the slate, we can see the timecode at that instant just by looking at the image on screen. The same timecode is recorded in the sound.

AUDIO TIMECODE. Some ¼″, DAT and other audio recorders are equipped to record timecode (see Chapter 9). As just noted, when the film camera records the same timecode as the audio recorder we can easily sync the sound and picture. Audio timecode will usually have breaks in it whenever the audio recorder paused in the field, though it is possible to record audio with continuous timecode.

Even if an audiotape was recorded without timecode, code may need to be added to it for the machines to control the tape during the telecine session or later. Having timecode on the audio provides a handy way to locate and identify portions of the sound recording, regardless of whether timecode slates or in-camera timecode were used.

VIDEO TIMECODE (ALSO CALLED TELECINE TIMECODE). The film and audio timecode just discussed can be referred to as *production timecode* since this code is recorded in the field during the production of the movie. When the processed film is transferred in the telecine suite, the telecine generates basic *video timecode* that is recorded on each reel of video. Sometimes referred to as *telecine timecode*, this is standard video timecode, no different from the timecode you would use for any video recording. It allows each video reel of the transfer to have its own unique, ascending timecode that runs continuously from the beginning of the reel to the end (note that each video reel may contain more than one film camera roll).

For standard NTSC transfers, this will typically be standard SMPTE 30-frame timecode.[4] This is the timecode that will be used as the primary timecode for editing on a nonlinear or videotape system. When needed, you can work back from the video timecode to determine the key numbers for any shot (which is typically done when conforming the negative for projects that will be finished in film, see Matchback and Film Cut Lists, p. 393).

[4]Note that even if you plan to edit on a nonlinear editing system that works at 24 fps (for projects that will be finished on film), the initial film-to-video transfer is usually done with standard 30 fps video with normal timecode. When you later digitize the material into the editing system at 24 fps, the system will reconstruct 24-frame code (see 24 fps Nonlinear Editing Systems Versus 30 fps, p 395). PAL transfers will normally be 25-frame EBU code.

INK EDGE CODE. On feature films for which a film workprint has been made, ink edge code numbers are printed on the workprint and mag sound after they have been put in sync (see p. 380). Some video editing systems keep track of these numbers (sometimes called "Acmade numbers") to facilitate cutting the workprint (see p. 397).

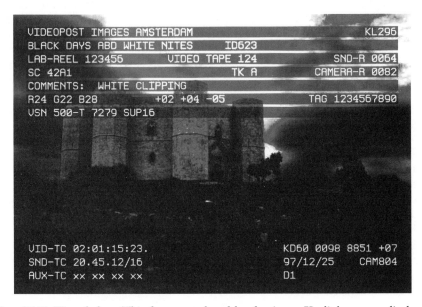

Fig. 17-5. Virtual slate. This frame, produced by the Aaton Keylink system, displays a wide range of data pertaining to the film transfer. (AbelCineTech)

LAB-REEL = the lab reel or film flat number; each flat may contain more than one camera roll.

VIDEO TAPE 124 = the reel number of the videotape recorded in the telecine.

SND-R = sound roll number.

R29 G24 B22 = automated color readings based on Greyfinder gray card measurement (see Fig. 5-4).

+02 +04 −05 = additional color correction done by colorist for this scene.

TAG 1234 . . . = arbitrary number used to identify this scene.

VSN 500-T . . . = raw stock description embedded in the keycode.

SUP16 = film gauge.

VID-TC = video timecode generated by the telecine and recorded on video tape.

KD60 0098 . . . = film key number (read from the keycode on the film).

SND-TC = if in-camera timecode or a timecode slate was used in shooting, that timecode appears here. The number should match the timecode recorded on the field audiotapes. This code can be sent from the telecine to the audio playback machine so the audio can chase the picture for automatic syncing of sound and picture.

CAM804 = each camera has its own number; useful for multicamera work.

AUX-TC = edge code from the mag film follower (dubber). This applies only when transferring synced film workprint with mag track that has ink edge code.

D1 = pulldown field identifier.

TELECINE LOGS. Without doubt, all these codes create an enormous amount of information to deal with. It can be kind of overwhelming. You may ask, "Who needs to know these numbers?" Well, if you're planning to edit on a nonlinear system and then return to the film negative to make film prints or do additional video transfers, then you will probably want the video timecode, key numbers, pulldown identifier and production timecode (if any) entered into the nonlinear system (see Matchback and Film Cut Lists, p. 393). Depending on how the matchback is done, you may not need all this information for the video edit. If there is no production timecode and you plan to transfer the negative only once, edit on video and never return to the negative, you may not want anything more than the basic video timecode recorded on the master videotapes (usually inserted into the VITC, see Timecode, p. 196).

To simplify and automate the process of getting the various codes entered into the nonlinear editing system, a *telecine log* can be generated in the telecine session that correlates the code numbers for each shot that is transferred. There are several logging systems, including Keylink by Aaton, KeyLog by Evertz, FLEx by Time Logic and OSC/R by Adelaide Film Works. These programs create a log file which is a database of the different code numbers that pertain to each shot and may also include pulldown type, scene and take numbers, camera roll, sound roll and telecine reel numbers. The log file can be stored on disk and entered into many nonlinear systems so you never have to write the numbers manually. The data can also be displayed on screen (see Fig 17-5). Some of the most popular log file types include ATN (Aaton), FLEx (Time Logic) and FTL (Evertz). When you hear someone request a "FLEx file" they are talking about a telecine log file. Particularly for projects that will be finished on film, the numbers from the log file should be checked carefully after loading the material into the editing system (see p. 396).

The future of postproduction lies in computer software that ties together *all* the data collected about sound and image. Some systems can bring forward script notes made on the set as well as color balance information from the telecine.

Audio Sources in the Telecine

When transferring edited, finished films to video, we generally need to transfer the finished, mixed sound track as well. For films that have not yet been edited, we may want to transfer the production sound and sync it to the picture either during the telecine session or after.

Telecine suites are usually equipped with a number of audio playback devices. There is generally a dubber to play sprocketed mag film (see Fig. 15-9). At one time, this was the standard way that mixed sound tracks were brought into the telecine. Today, sound for movies may also be recorded on ¼" tape, DAT, videocassettes, computer drives or other formats.

Resolving Audio

Before sound can be transferred to video, it must be made to run at the proper speed for the video. Adjusting the speed of an audio source during playback is called *resolving*. See The Scanning Process, p. 512, before reading this section.

In countries where the PAL or SECAM video is standard, resolving can be very

easy: when film is shot at 25 fps and transferred to video at 25 fps, it keeps real time. Sound recorded on DAT or other digital formats can be played back normally and will run at the proper speed to sync to the video. Timecode-capable audio recorders can be set to 25-frame timecode, and the code will match the picture. Sound recorded on a Nagra ¼" recorder will generally have a 50 Hz pilot tone and will playback at the right speed with a 50 Hz reference signal from the telecine (see p. 254).

In North America and other places where NTSC video is used, you have to compensate for the fact that film shot at 24 fps will be slowed down ("pulled down") by .1 percent when transferred to video. You must pull down the sound by the same amount. Tapes made on a Nagra will generally be recorded with a 60 Hz pilot tone. If we give the Nagra a playback reference of 59.94 Hz (.1 percent slower than 60 Hz), it will keep sync with the picture. Similarly, the dubber in the telecine suite can be set to run .1 percent slow to ensure that mag film matches the picture. When sound is recorded with a DAT or other digital recorder, sometimes the digital sound can be slowed down by .1 percent and sometimes it must be converted to analog form first before being resolved to the proper speed.

When sound is recorded with a timecode-capable recorder, the goal is to make the frame rate of the video match the speed of the audio *after the audio has been slowed down*. Most timecode-capable audio recorders have the ability to record a *special* audio timecode whose time base is a true 30 fps, *not* 29.97. If you record audio at 30 fps with 30 fps nondrop timecode, and then pull it down .1 percent in the transfer, the code will now have a frame rate of 29.97, which matches the video perfectly (see Setting Timecode in Camera and Recorder, p. 285).

There are certain speeds at which a film camera can be run that *do not* require any pulldown in the audio. Some film cameras can be operated at 29.97 or 23.976 fps, speeds which are sometimes used for filming TV monitors (see p. 531). Since these speeds can run on the telecine without being slowed down, real time is maintained, so the audio should not be pulled down.

RESOLVING AUDIO WITH THE AVID FILM COMPOSER. The process just described of slowing down the sound by .1 percent applies to situations when audio is being synced to standard NTSC video, whether it be in the telecine session, in a layback suite or when production audio is being captured directly from the field audiotapes into a typical nonlinear editing system running NTSC video at 29.97 fps. The key thing to remember is that film that was shot at 24 fps actually runs through the telecine at 23.976 fps, so the audio needs to be slowed down by the same .1 percent.

The Avid Film Composer is a nonlinear editing system capable of running at *precisely* 24 fps for editing film-originated projects that will be finished on film (see 24 fps Nonlinear Editing Systems Versus 30 fps, p. 395). The Film Composer takes video that was transferred in the usual way, undoes the 3/2 pulldown and restores the footage to true 24 fps (not 23.976). There is no .1 percent slowdown. The rules for resolving audio are slightly different with the Film Composer, and some people find them confusing.

If you want to sync up on the Film Composer by bringing production audio

directly into the system—e.g., from a DAT or a Nagra tape recorded in the field—bear in mind that the Film Composer is running the picture at exactly 24 fps. Thus a self-resolving Nagra or DAT machine can transfer audio directly into the system (this allows direct digital AES/EBU transfers from a consumer DAT machine). The Film Composer's speed is controlled by the *Video Slave Driver (VSD)* which can be set to 1.00 audio pulldown. This is real-time recording, just like traditional mag film transfers.

However, if you are bringing in material from a *video*tape or other source that is referenced to a video signal, you must slow the Film Composer down by .1 percent to match its speed. In this case you would set the VSD to .99 pulldown during digitizing. This applies, for example, if audio has been synced in the telecine or layback suite and is therefore already in sync on the telecine videotapes. Later, during playback the Film Composer will bring the speed up by .1 percent so the picture plays at 24 fps and the sound is in sync. Another example might be bringing in SimulDAT audiotapes recorded during a telecine session (see Some Sound Issues, p. 390). The SimulDAT audio is in sync with the film that was running in the telecine at 23.976 fps. It could be brought into the Film Composer using an analog connection with the VSD set to .99, or, if the DAT playback machine can be set to play .1 percent faster, the audio can be brought in digitally via AES/EBU.

Michael Phillips, developer of the Film Composer, suggests this rule of thumb to remember the settings: Whole numbers go with whole numbers and fractions go with fractions. Thus, when digitizing from a Nagra using a 60 Hz pilot or anything that is in sync with 24 fps film, use the 1.00 setting; when digitizing from a video source at 29.97 fps, or anything that is in sync with film running at 23.976 fps, use the .99 setting.

The VSD can also be used to control playback of the Film Composer. You can output audio at 23.976 fps for transfer to video, at exactly 24 fps for making film sound tracks or at 29.97 fps for special purposes.

With PAL projects, the VSD is always set to 1.00 for digitizing.

Syncing Audio

Once the sound is running at the right speed, we need to line it up with the picture.

For finished films, the mixed sound track may have timecode that matches the picture, making alignment simple. Mixed tracks with or without timecode often have a *sync pop* exactly two seconds before the beginning of the program, which can be lined up to the on-screen countdown leader at the head of the tape (see Reel Breaks and Leaders, p. 465).

To sync the production sound for video dailies, we must realign the sound and picture every time the camera stops (for the basics of syncing rushes, see p. 378). How this is done depends on what kind of slates and sound recording were done in the field. Syncing may be done in the telecine suite, in a layback suite or on the editing system (see Editing Film on Video, p. 382).

1. *Manual slates, no timecode.* If filming was done with a camera and recorder that are not timecode-capable, then syncing must be done the old-fashioned

way. The visible clap stick or other slate is located in the picture, and the sound of the slate is located in the audio, and the two are lined up (see Slates, Accuracy and Lip Syncing, p. 379, for syncing material with or without slates). Some telecines or editing systems may require timecode on the audio in order to control the playback. If so, the production audio can be poststriped with code, or dubbed over to another format with timecode.

2. *Timecode slates.* If filming was done with a timecode-capable audio recorder and a timecode slate (see Fig. 10-4), then locating sync is much simplified. The telecine is stopped on the frame where the slate was "clapped." The timecode number on the slate is entered into the computer. The audio playback will then *chase* to that timecode, putting sound and picture in sync. Some systems need a few frames or seconds of unbroken audio timecode to come up to speed. This is why five to seven seconds of *preroll* are often recorded in the field prior to the slate (some systems do not require preroll). When syncing is done on a nonlinear editing system, a similar procedure is followed, though no preroll may be necessary. Timecode slates may be easier to read in the telecine where the image can be zoomed in than on a low-resolution editing system.

3. *In-camera timecode.* If filming was done with a timecode-capable camera (which records timecode on the edge of the film; see Fig. 2-20) and a timecode-capable audio recorder, then syncing can be totally automated. Properly equipped telecines can read the timecode on the film and on the audio and match them up. Newer systems being developed are intended to allow the telecine to do a continuous run through a reel, syncing up on the fly without stopping (though it may be necessary to stop between some shots to allow the audio playback to keep up). Some nonlinear editing systems can also automatically sync material that has identical timecode in picture and sound.

HIGH-RESOLUTION FILM SCANNERS

There is a newer generation of film transfer machines capable of very high resolution. These are sometimes called *digital film scanners* or *film data scanners*. The Philips Spirit Datacine and Cintel's Klone and C-Reality are high-resolution scanners. Some of these machines can do standard-definition telecine transfers, high-definition (HDTV) video transfers and transfers directly to computer file formats that are not "video" in the usual sense but can be used with computer workstations for special effects and other work. Some transfers can be done at real time, but high-resolution scanning may be slower.

For data file creation, to capture the full definition of a 35mm film frame, a "4K" resolution may be used for big-screen feature film effects work. For 16mm and less critical 35mm applications, 2K may be used.

One intriguing possibility for the filmmaker is to make a high-resolution data file, with each frame of film transferred to one frame of data—a one-to-one relationship with no interlace, pulldown or other messiness. From that data "master" you can generate *any* needed type of video, including HDTV, NTSC, PAL at 24,

25, or 29.97 fps in whatever aspect ratio you want. And you could also do high-quality transfers back to film (see below).

Fig. 17-6. Cintel Klone high-resolution scanner. (Cintel, Inc.)

INTERNATIONAL STANDARDS CONVERSION

When a movie is to be distributed internationally for broadcast or home video, it must be made available in multiple television standards. In terms of television markets, NTSC and PAL are the most widely used; SECAM is used in fewer areas (see Composite Systems, p. 195). HDTV and other digital and/or widescreen formats add to the list of versions a producer may need to create for domestic and worldwide distribution.

Film-to-Video Standards Conversions

If the movie has been finished in film, it can be transferred directly from film to the proper video standard in the telecine. This generally produces the best results, but may be expensive. Transferring film shot at 24 fps to NTSC video is described earlier (see The Scanning Process, p. 512). Transferring film shot at 24 fps to the 25 fps PAL or SECAM standards may be done in two different ways. One method is to speed the film up to 25 fps in the telecine, which allows a simple 1:1 transfer from each film frame to each video frame. The movie now plays 4.1 percent faster, so a 60-minute program will run 57:36. The audio needs to be played 4.1 percent faster to maintain sync. Speeding up the audio will increase its pitch, making voices and music sound higher. A digital pitch shifter, such as a Lexicon unit, or a digital audio workstation can be used to bring the pitch back down 4.1 percent. Listen carefully to determine if the sound track can handle this processing. Dialogue may sound okay, but sustained musical notes or other continuous sounds may have hiccups or discontinuities.

Another method of transferring film shot at 24 fps to PAL or SECAM involves a pulldown similar to the 3/2 pulldown described above (see p. 512). In this case, to increase the frame rate from 24 to 25, only two additional fields of video need to be created every second. One advantage of this method is that the movie after transfer should have the same running time as the original film (instead of being 4.1 percent faster).

It is becoming increasingly popular to transfer movies shot at 24 fps directly to a 625/50 component standard (see Component Systems, p. 195), which can be released directly in PAL or SECAM and converted to a 525/60 NTSC format using a video-to-video device (see below). The quality of the 525/60 version is said to rival transfers made directly from film to NTSC. See High-Resolution Film Scanners, above, for a similar process.

Video-to-Video Standards Conversions

Digital technology has radically improved the quality of video-to-video standards conversions, making it possible to directly convert, say, a PAL tape to NTSC or vice versa. Nevertheless, it's important to watch the program closely for objectionable motion artifacts, such as strobing during camera or subject movement.

For reasons of cost or convenience, movies that originated on film that have already been transferred to video may be converted from one video format to another, rather than returning to the film to do a second film-to-video transfer in a foreign standard. As we saw above, when 24 fps film is transferred to NTSC video, 12 extra fields are created every second, to make 60 fields total. When the NTSC video is converted to PAL, these 60 fields have to be reduced to 50 (2 fields times 25 fps). This can result in "smearing," which lowers resolution and causes motion artifacts. If the standards conversion is poor, some broadcasters may ask to be supplied with a film print to do a film-to-video transfer themselves.

Newer, digital video-to-video standards converters produce better results. Among them is the DEFT (Digital Electronic Film Transfer) system and the TK-32, which take the NTSC video and undo the 3/2 pulldown, re-creating the original 24 fps film frame rate with no added fields. These frames are then transferred to PAL in a

simple 1:1 relationship. This results in a much cleaner conversion. There may still be some motion artifacts, especially if the source tape has been video edited after the original film transfer. Video-generated titles that move (like crawls; see p. 359) show a certain amount of jitter. This process also speeds up the movie by 4.1 percent (see above for time and sound issues related to the speedup). DEFT transfers are done in the United States at DuArt in New York and Encore Video in Los Angeles.

VIDEO-TO-FILM TRANSFERS

Video-to-film transfers are used to make film negatives or prints from video material. As of this writing, video-to-film conversions are primarily used by two distinct markets. At the high end are big-budget feature filmmakers that use computer workstations to create special effects and then need to make film negatives of this material to cut in with the rest of the movie, which was shot on film. Often these effects begin as filmed scenes, are scanned using high-resolution film scanners (see High-Resolution Film Scanners, p. 526), enhanced with effects in the computer and then output onto film again. On a high-budget film it is sometimes more costly to build sets or backgrounds or wait for the right weather than to shoot with the intention of scanning the film, fixing the scene on a workstation and then transferring back to film.

The lower-end transfer market is people making independent or television movies who cannot afford to shoot film (or choose to originate in video for other reasons) but need to make film prints to show in festivals or for theatrical release. Sometimes projects that originate in film are edited in video and transferred directly back to film (without returning to the negative) to save time or cost.

This is an interesting time for video-to-film transfer. On one hand, new technologies are developing, quality is improving, and demand for these transfers is increasing as growing numbers of moviemakers choose to originate or edit projects in video. On the other hand, video projection is improving rapidly and will at some point make it unnecessary to put images on celluloid in order to view them in a theater. With current technology, a trained eye can usually tell the difference between film prints made only from film elements, and video-to-film transfers (especially with lower-cost methods). Filmmaker and writer David Leitner (who supplied much of the information for this section) points out that video and film have inherently different characteristics and it may not be productive to expect video transferred to film to mimic the look of film-originated material.

Video-to-Film Systems

There are several different systems for converting video to film, which range widely in complexity and cost. At the highest level currently are *film recorders*. These systems use either a cathode ray tube (such as the Solitaire by Management Graphics) or a laser (such as the Lux by Digital Cinema Systems) to record very high resolution images onto 35mm film. Film recorders are very slow, taking several seconds per frame (not frames per second!) and costing several dollars per frame, putting them out of reach of all but high-budget film projects.

The *electron beam recorder (EBR)* uses an electron beam to transfer to three successive film frames the red, green and blue information from each video frame. The three film frames are then optically printed with colored filters to create a normal film negative. EBRs are expensive but create excellent results. For years, perhaps the best-known EBR tape-to-film transfers were done at Image Transform, now called Four Media Company (4MC) in Los Angeles. The Sony Pictures High Definition Center (SPHDC) uses EBRs with high-definition video technology. Standard-definition videotapes are upconverted to HDTV and put through a line doubler to increase resolution. Sony has facilities in Hollywood, London and Tokyo. EBR transfers cost from a few hundred dollars to several hundred dollars a minute.

The original video-to-film conversion method is the *kinescope* (see The Video Recorder, p. 18). This system uses a high-quality color monitor with a special film camera running at 23.976 fps (for NTSC) with a 144° shutter (see below) to create a flicker-free film image from the video. A *kinescope* (or *kine;* rhymes with "skinny") is the most economical transfer method and produces quite good results. (As of this writing, DuArt in New York can make a 90-minute 16mm negative and print with sound for less than $7,000 and Film Craft in Detroit, which uses a slightly different technology, charges less than $9,000 for a sound print.)

Most systems cannot transfer to both 16mm and 35mm; you may need to do a blowup or reduction to get the final film format you want. The choice between 16mm and 35mm should be made on the basis of budget and distribution plans (see Chapter 1).

Preparing for and Evaluating the Transfer

Before choosing a transfer facility, talk to filmmakers you know and ask to see samples of the facility's work. Once you choose a facility, work closely with them to prepare your video prior to transfer. David Leitner strongly urges that filmmakers do short tests of their footage before investing in the full transfer. Many problems are not evident on small video monitors that will become glaringly obvious on a big-screen projection. Transfer technology has improved a great deal, and some transfers will make video scan lines (the raster) invisible. Other systems completely mask scan lines in some scenes and only partially in others. Look for other image defects such as interlace artifacts (in which straight diagonal lines look like stair steps) and color fringing.

In preparing the video, you may need to edit the show to create reel breaks in the proper places (see Reel Length, p. 375). Do color correction on the video *before* the transfer and be aware that detail may be lost in shadow and highlight areas on some systems. Video titles may look soft (unsharp) after transfer to film, and moving titles (crawls) may cause problems. Traditional (4:3) aspect ratio video images may need to be repositioned for widescreen transfers (see Aspect Ratio, p. 37).

If you're considering a video-to-film transfer, shoot your movie with a component (not composite) digital video format and use the highest-resolution, best-quality camera you can (consider the quality of both the format and the particular camera, CCD and lens). PAL and SECAM cameras, being inherently higher resolution than NTSC and closer to the film's 24 fps frame rate, can produce excellent

results. In Europe, PAL transfers are done in Zurich at Swiss Effects and in London at Colour Film Service.

When material has been shot on film, transferred to video and then transferred back to film, you can get strange artifacts. When possible, use a high-end transfer system that deconstructs any 3/2 pulldown and restores the original 24 fps image before printing on film.

SHOOTING VIDEO MONITORS

There are many instances when it is necessary to shoot video or computer monitors with either film or video cameras during the production of a movie. This may include scenes in which a character is watching TV or shots of a computer monitor to illustrate something on the screen. Shooting a video monitor full screen with a typical film camera results in lower resolution than doing a true kinescope or other tape-to-film transfer.

Sometimes shooting monitors is very straightforward. For example, shooting an NTSC video monitor with an NTSC video camera requires no special adjustments. However, whenever the frame rate or scanning rate of the monitor does not match the frame rate or shutter speed of the camera, the screen image will seem to flicker. A horizontal *shutter bar* or *hum bar* will appear in the image when the camera exposure is slightly longer or shorter than the time it takes the monitor to *refresh* (complete the raster pattern). The hum bar may appear darker or lighter than the rest of the picture. Some monitors look worse than others. In some situations you may feel that the flicker is acceptable, but in others it can be very distracting or make the monitor look like it is old or badly out of adjustment. There are various ways to solve this problem, depending on your equipment and your needs.

SHOOTING MONITORS WITH FILM CAMERAS. When Hollywood features include scenes in which a TV is visible, they often use special 24 fps video playback decks with 24 fps monitors so they can run the film camera at 24 fps and get a flicker-free image on the TV monitor. Similarly, filmmakers working in PAL countries can shoot a 25 fps PAL video monitor with a standard film camera running at 25 fps and get a clean image on the monitor.

Most other combinations require a precise speed control (either from built-in camera settings or an external unit like a precision speed control; see Fig. 2-9). For some work you may also need a variable shutter. For example, you can film an NTSC video monitor (which runs standard 29.97 fps video) using a film camera running at 29.97 fps with a standard 180° shutter. The speed control should have a *phase shift* adjustment. If you see a hum bar on the video screen when looking through the camera's viewfinder, push the "Phase" button until the bar is no longer visible (you can also try turning the camera on and off). Note that filming at 29.97 fps and then projecting the film at 24 fps will result in slowed motion and the sound going out of sync (though you will not have this problem if you're planning *only* to transfer the film to video, which you can do at 29.97 fps). Be sure to

consult with the transfer house in advance about proper speed or timecode settings for the sound recorder to maintain audio sync.

You can maintain sync when shooting NTSC monitors by running the camera at 23.976 fps with the shutter set to 144°. Some newer cameras are manufactured with this as a shutter option. Typical 16mm camera viewfinders will be misleading about hum bar, since they often have a 180° mirror even though the shutter is set to 144°. The eyepiece should show two thin darkened bands. Push the "Phase" button until the top edge of one darkened band is just off the screen (the other will now appear directly in the middle of alternate frames). Slight overexposure will help to burn out the line so it won't be too noticeable. Motion shot at 23.976 will appear normal when projected at 24 fps and the footage can be transferred to video at real time. Again, consult the transfer house on audio.

Computer monitors are particularly tricky because they may run at various refresh rates. You can experiment with the precision speed control. With no film in the camera, dial the speed control until the hum bar becomes stationary, then, when filming, use the phase control to make sure it's off the screen. Cinematography Electronics also makes a Film/Video Synchronizing Control that attaches to a monitor and drives the camera and sound recorder at the right speed. You could also use a scan converter (see below) to output a standard NTSC or PAL video signal from the computer.

When filming video or computer monitors, use a reflected, not incident, light meter. The color temperature of many monitors is close to daylight (6500°K). Use

Fig. 17-7. Film/video synchronizing control automatically synchronizes a film camera to another source signal such as a computer, video monitor, projector or another camera. (Cinematography Electronics)

a color temperature meter to check or use an 85 filter for tungsten film if you have enough exposure. Some monitors offer a choice of color temperatures. You may need a fairly fast film to get enough exposure. Use a long lens from a good distance away so the monitor image will appear flat and rectangular.

SHOOTING MONITORS WITH VIDEO CAMERAS. Shooting monitors with modern video cameras is greatly simplified because many cameras are equipped with variable electronic shutters. Some cameras have specific features to match the shutter speed of the camera to the scanning frequency of the monitor. Sony's system is called "Clear Scan." One Sony digital Betacam offers a range from 30.4 to 7000 Hz in over 500 steps or increments. Changing the shutter speed of a video camera affects the exposure time, but the basic frame rate (29.97 fps in NTSC) is not affected (see The Shutter, p. 185).

When shooting any monitor, be sure to white balance the camera on the monitor and set exposure carefully.

If your camera cannot accommodate the scan rate of the monitor you want to shoot, or if you want a direct feed from your computer to your VTR, you can get a *scan converter*, such as the Scan Do by Communications Specialties, which accepts most forms of computer video and will output a standard component or composite NTSC or PAL signal.

Fig. 17-8. Scan converter. Scan Do Pro converts high-resolution computer video into NTSC or PAL video in composite, S-video and RGB formats. (Communications Specialties)

Producing and Distributing the Movie | CHAPTER 18

This chapter is about the business and legal aspects of getting a movie made and then getting it shown when it's done. The scope of this book allows for only a general discussion of these topics, to help you frame the questions you need get answers for. A general proviso for everything that follows: Nothing here should be taken as legal advice or as a replacement for consulting an experienced attorney, accountant or other professional. Also, because laws and customs vary from country to country, bear in mind that practices may vary outside the United States. For those who cannot afford traditional legal services, many states have groups such as Volunteer Lawyers for the Arts that can assist you.

BUDGETS AND BUSINESS ARRANGEMENTS

Budgets

The *budget* is an accounting of what every aspect of the movie costs. Prior to production, the *estimated budget* plays a key role in getting the project financed and under way. Not only is the bottom line important, but the way the budget is drawn up has an impact too. For professionals, the details of the budget make it clear to funders exactly where the money is going to be spent. For novices, a well-drawn budget helps reassure funders that you understand the production process. That said, when preparing a budget for fund-raising purposes, a certain amount of summarizing is called for. An investor or granting agency may be interested in the line item for equipment, but may *not* want to know which camera accessories you're planning to rent. For feature films, some production managers and others specialize in reading scripts and drawing up budget estimates based on the use of locations, size of cast, special effects and the like. Preparing and managing the budget is generally one of the producer's key jobs.

During production, the budget is used to track expenses to ensure that the

movie remains within the estimate (or, as often happens, to painfully detail how much *over budget* things have gone.)

On a Hollywood feature, the costs of stars, script, salaries and overhead may be the bulk of the budget; film and processing may be less than 10 percent of the total cost. For a student project, on the other hand, if friends donate time and the school has equipment, the cost of film or tape may represent virtually 100 percent of the cash needed to make a movie. When calculating your film/tape costs, work backward from the estimated length of the finished movie, multiplied by the expected shooting ratio (see p. 229). Sometimes a shoestring fiction film can be cheaper than an unscripted documentary because the action is predictable, entailing a lower shooting ratio.

There are many ways to organize a budget. Different types of productions (features, documentaries, corporate projects, multimedia) call for different budget formats. There are several computer software packages (such as Movie Magic Budgeting) that help you lay out a budget and track expenditures. You can make your own using any spreadsheet program. Michael Weise's *Film and Video Budgets* has many sample formats (see Bibliography). Professionals may be reluctant to share complete budgets with you, but may give you the layout they use without the actual numbers filled in.

One type of budget divides expenses into *above-the-line* and *below-the-line* costs. Above-the-line costs are the producer's, director's and key actors' salaries and those costs incurred before production even begins, like the story rights and/or script (the *property*). Below-the-line costs include all equipment, materials and other salaries involved in production. *Negative costs* of a film are all items prior to the marketing and distribution costs. *Distribution costs* include making release prints or dubs, advertising and promotion, and running the distribution office.

It often helps to divide the budget chronologically, separating the costs of *preproduction* (research, casting, scouting, planning), *production* (film or tape costs, equipment rental, travel and food for the crew) and *postproduction* (editing and the various *finishing costs:* music, mixing, online costs or negative matching, titles and prints or dubs).

Many projects begin with only enough cash to shoot, hoping to raise completion money later. You will sometimes hear the expression "in the can" used to refer to the cost of production (as in, "We got it in the can for $10,000!"). This figure does not include marketing and distribution costs, and often doesn't include finishing costs like music rights, mixing, etc.

Materials, equipment and labor are sometimes donated to a production (or provided at discount), especially for small or nonprofit projects. It's important to include these *in-kind* contributions on the budget but indicate that they are not normal cash items. Investors or funding agencies will want to see a budget that includes both types of support, since they are interested in the full value of the production.

Near the bottom of many budgets is an item for *contingency*, which is usually 5 to 15 percent of the entire budget. This figure is intended to cover the unexpected: equipment breakdown and delay, reshooting or unplanned shooting costs

(insurance may cover some of these items). Since movies are often budgeted months or years before they are finished, the contingency allotment may also compensate for script or production changes and inflation; some people figure inflation into each budget line item instead.

In addition to the *direct costs* of getting the movie made, in some budgets the production company adds a fee for *overhead* and, for commercial projects, *profit*. Overhead includes the costs of running your business independently of the project, such as renting your office space, business insurance and the like.[1] Profit is money over and above any actual expenses. Some producers list overhead/profit as a percentage of the total budget; sometimes this is listed as a "production fee." Sometimes profit, overhead and/or contingency charges are buried in the budget by marking up all the *other* line items. For a commercial project, for example, the production company will often mark up outside labor and materials costs as part of their fee for doing business.

Overhead and profit figures vary widely by the type of project, the total budget and what the market will bear; talk to producers you know for suggestions. In some cases, such as corporate or sponsored projects, a fee of 15 to 35 percent (or much more) above the direct costs of making the movie is not uncommon. On the other hand, for nonprofit, grant-funded projects, indirect costs are often not even reimbursable.

Budget Line Items

Following are some expenses to consider when doing a budget. Not all items apply to all types of productions. Some of the headings are for the purposes of this book and would not be used in a typical budget.

PREPRODUCTION	PERSONNEL AND TALENT
Research Script writing Location scouting Budget preparation Casting Hiring crew Setting up office, etc.	Producer Director Assistant director Production manager Script supervisor Lead actors Extras Narrator

[1]General overhead should not be confused with direct, project-related administrative costs, which could include accounting and legal costs, production insurance, facility rentals or in-house salaries. These direct expenses of the project are usually specific line items in the budget.

PRODUCTION PERSONNEL	PRODUCTION EXPENSES
Camera, assistants	Camera package
Sound, boom	Sound package
Gaffer	Lighting package
Grips	Grip package
Makeup/hair	Supplies and expendables
Set designer, construction	Props and sets
Art director/stylist, costumer	Studio rental
Production assistants	Film and/or tape (audio and video)
Still photographer	

TRAVEL AND LOCATION	ADMINISTRATION
Airfares	Office rental and expenses
Excess baggage	Telephone and photocopy
Vehicles, mileage, parking, tolls	Shipping and postage
Lodging	Insurance (production,
Location fees	negative/tape, E&O)
Crew per diem and/or meals	Repairs
	Legal and accounting
	Contingency

POSTPRODUCTION	
Editor	*Video Post*
Editing room, supplies	Burn-in workdubs and/or
Editing system and	screening cassettes
peripherals/accessories	Online edit, extra machines
Titles and graphics	Audio layover and layback
Music rights and recording	Tape masters and dubs
Narration recording	
Transcripts	*Film Post*
Stock footage or stills	Film processing
Motion control shoot of stills	Video transfer and stock
Sound editor, equipment	Audio syncing
Mix-to-pix, recording stock	and/or:
	Workprint
	Sound transfer, mag stock
	Edge code

FILM FINISH	DISTRIBUTION
Titles and opticals	Film prints and/or video dubs
Negative matching	Screening cassettes
Fades and dissolves	Telephone, postage, shipping
Optical sound track	Poster, press kits, stills, flyers,
Answer print	ad slicks, postcards, study guide
Master positive/dupe negative	Advertising and promotion
Check print	Press screenings, publicist
Release prints, reels and cases	Mailing lists
Video transfer	Festival fees, travel

Hiring Crew and Actors

To make a movie, you generally have to get people to work with you, either for money or sometimes not. A well-planned, well-run production creates a good working environment that can lead to you getting (a) good footage; (b) a good reputation; (c) a good chance of working with people you like in the future. Craft unions were organized in the film industry as a way to standardize what personnel are to be paid and to limit what they can be asked to do. Productions range from highly organized (unionized) feature or television movies, to smaller, nonunion film or video projects, to student or independent projects in which no one is being paid. Regardless of the type of production, crews work best when they feel they are being treated fairly and the producer is looking out for their needs.

Start by making a workable plan for how large a crew you need (see Chapter 8). Talk to experienced filmmakers for advice. Even on small productions in which everyone is wearing two or three hats, think through who will perform various tasks. Novice producers often neglect tasks (forgetting, say, that props can't get to the set by themselves) or ask too much of the crew (perhaps by failing to schedule enough setup time when the company moves to a new location). To avoid a crisis, discuss with the crew in advance what they will be asked to do, and what they need to do it.

Union and other professional personnel usually have a set *day rate* that they charge; they may have different rates depending on the type of production. Outside of union productions (where strict rules guide payment schedules), it's important to be clear about what the day rate entails: some people consider a day eight hours, others ten. After the "day" is over, the overtime period begins. Overtime may be at "time and a half" (1½ the hourly rate) for a certain amount of time, then may escalate to double time or more. Sometimes producers ask for a *flat rate*, which is a fixed day rate with no additional pay for overtime.

Producers who are strapped for cash may try to get the crew to work for less money. *Deferred salaries* are paid after the film is finished and begins to generate income; many consider this a euphemism for free labor. Another bargaining technique is to offer lower salaries in exchange for *points*—a percentage of the film's eventual income. The problem with this is that "income" may be defined as what

is left over after many expenses have been deducted (see Distribution, p. 556). Often, personnel will work for less if they feel they are getting a career opportunity: for example, a camera assistant getting a first break to work as director of photography.

When hiring crew or asking someone to work for free, be up-front and realistic about the schedule. Don't ask someone to work for a flat day rate and neglect to mention that you have 18 hours of material to cover. Be explicit about how overtime will be treated. Draw up a *deal memo* to lay out responsibilities and compensation (union members sign a standard deal form).

Union rules are very specific about meals and breaks, but even on nonunion shoots remember that a crew that's overworked and underfed will not perform well. Keep snacks or coffee close at hand.

Actors are often referred to as the "talent" in the United States. Some actors are unionized, some are not. Professional movie and TV actors in the United States generally belong to the Screen Actors Guild (SAG) and/or the American Federation of Television & Radio Artists (AFTRA). The union stipulates a minimum pay rate (*scale*) for different types of productions (depending on budget level and type of distribution) and the prominence of the role (more for lead actors with speaking lines, less for silent extras). Many actors charge more than scale but may lower their rates if they like a project. Contact the union or a casting agent to discuss the many regulations associated with using union talent.

To simplify accounting, many productions hire an outside *paymaster*, which is a service that handles all the paperwork and certifies that proper union payments are made. A paymaster may be necessary when union talent is hired by a production company that is not a union *signatory* (does not have a contract with the union).

Renting Versus Buying Equipment

The advantages of owning a camera or other equipment include certain tax benefits, familiarity with the idiosyncrasies of a particular piece of equipment and the avoidance of rental problems, such as unavailability of equipment, defective equipment, out-of-town rental hassles and costly short-term insurance policies.

Renting, however, avoids the problems of yearly overhaul and maintenance, interest payments and yearly insurance premiums. Also, you can choose the most appropriate equipment for a particular shooting situation and not be limited by what you may or may not own.

Filmmakers can often raise the money to buy equipment when they have been hired to shoot a movie over an extended period of time. They can buy the gear and then rent it to the production on which they are working, charging rental house rates. Two or three months of use can pay for half the initial cost of a piece of equipment.

If you plan to rent, research the rates at a number of rental houses. It is often cheaper to rent from a big company even if it is farther away and transportation costs are added; some houses charge no rental while the equipment is in transit. Longer-term rentals are discounted. Typically, the weekly rate is 4 times the daily rate; the monthly rate may be 12 times the daily rate. Some houses allow you to

pick up the equipment Thursday afternoon and return it Monday morning for one day's rental charge.

Business Arrangements

In the making of a movie, there are many times when you may need to obtain services, equipment or materials from organizations like equipment rental houses, studios, labs, postproduction facilities and mix houses, as well as from independent contractors like animators or graphic artists. Each type of business has a different set of assumptions about the way things are done, yet there are certain ground rules that seem to apply when working with different types of suppliers.

To identify suppliers you want to work with, get recommendations from people who have done projects similar to yours. Watch the end credits of movies and read the trade press for ideas. When talking to a supplier, don't be afraid to ask for references of projects they've worked on. If you're lucky enough to find a supplier you like where you live, you can avoid the hassles and risks of shipping and travel and you have the advantage of face-to-face contact, which often makes things go more smoothly. Nevertheless, many filmmakers work with labs and other suppliers in another city. In the United States, the best-known facilities are generally in Los Angeles or New York. Overnight shipping, E-mail and faxes help shorten the distance between you and the supplier.

To deal effectively with a postproduction house, lab or other organization, find out whom to contact if problems arise. Sometimes a salesperson will be assigned to your account. With some facilities, it's better to deal with a manager or technical personnel. Some labs have *expeditors* to personally oversee your production and help usher material through the various departments that may be involved in processing your order. At very large labs, there may be expeditors who are independent contractors who can be hired for about a 10 to 15 percent surcharge on the lab bill.

To minimize the chance of problems, lay out as clearly as you can *in advance* what you need done, and when you need the work performed. Give warnings of impending deadlines and try to get a clear commitment up front that the supplier can do the job. If problems do arise, stay cool and try to work through it with the supplier. There are plenty of producers with quick tempers who think that fury and threats are a good way to "get results." If this is your reputation, suppliers may choose not to work with you. Don't be bashful if a supplier has screwed up your order, but maintaining a sense of respect for all involved will usually increase your chances of getting what you want.

Many companies have a *rate card* of standard prices charged for goods and services. You can often get a discount, sometimes sizable, from the rate card prices if the supplier likes the project, if you're a student or if they need the work. At some facilities, virtually *no one* pays rate card rates. Don't be afraid to negotiate. The worst that can happen is they will refuse to budge on price. You can sometimes get lower rates from a facility by agreeing to work at off hours (like late night) or with junior, less experienced personnel. Sometimes you can get goods and services donated (see Contributions, p. 546).

For jobs that are charged on an hourly basis, be clear about when "the clock is

running" and when it's not. For example, in some situations, short breaks and lunch are off the clock; in others, it is assumed to be part of a day's work. Some facilities bill for machine setup time, others start charging only when you actually start work. If a machine goes down or there is a problem caused by the facility, most places will deduct this time from your bill.

Sometimes a supplier will give you a *flat bid* for an entire job instead of charging you piecemeal for individual items or on an hourly basis. This may be a big cost savings. Flat bids can be problematic, however, if the scope of the job changes as you go along. You might ask for a bid based on, say, three eight-hour days of work. But when the work stretches into long overtime on each of those days, the supplier may want to change the price. Or the work may be done in the time allotted, just not the way you like it. You have less power to ask for changes when the supplier knows that you're not paying for them. Sometimes suppliers agree to very low bids and later regret them. The work suffers. You may be better off paying a bit more and keeping everyone happy.

Often, one has a choice between contracting with several different suppliers to do different portions of a project. You may get a better deal on one part from Company A and on another part from Company B. These savings have to be weighed against the loss of accountability. If the same company does your titles and online edit, then you won't have to pay for time wasted in the online trying to fix problems with the titles. If two different companies do the work, the title people may fix the problem, but you probably won't get reimbursed for the extra online costs.

CREDIT. Having credit with a supplier simplifies delivery and payments for goods and services. Since filmmakers are notorious for being bad credit risks, you may encounter problems unless you're part of a company with a good credit history or until you establish a clean track record with the supplier. Usually the credit terms are *net* (the full amount) within 30 days. Suppliers will, at times, defer payment until a movie is completed and may waive an interest charge on unpaid balances.

If you cannot obtain credit, you must pay COD or in advance. Advance payment avoids the inconvenience of getting personal checks cashed and may expedite the return of materials. If you do not have credit and must pay for the work before you see it, you lose an important negotiating position should you feel the lab or facility has made an error and the work should be redone. An outstanding balance increases your leverage in negotiations.

Insurance

There are many types of insurance available for film and video production. *Negative/tape insurance* covers damage to the negative or original videotapes from fire, theft or loss in transit. *Faulty camera, stock and processing insurance* covers loss or damage to film due to defects. These coverages normally do not include "human" errors, like setting the exposure incorrectly. *Camera and equipment insurance* covers loss or damage; often only the cash value of the equipment at the time it is lost is recoverable. *Extra expense coverage* provides reimbursement for delays in shooting

due to damaged or late equipment, sets and the like. *General liability* covers bodily injury and suits arising from accidents on the set. *Errors and omissions insurance* is discussed below. The premiums for these policies are usually determined as some percentage of the film's budget, with specified minimums.

FUND-RAISING

Many nonfilmmakers fantasize that the filmmaker's life is one of endless creativity, with days filled with one artistic experience after another. There may be a few filmmakers who live like that, but for most, moviemaking involves seemingly short periods of real creative work and seemingly endless amounts of *business.* And when it comes to business, the biggest item is often *finding money for the next project.* Unless you're wealthy, if you want to initiate your own projects you'll need to raise money. "Independent filmmaking" is usually defined as working outside a studio or other large organization that bankrolls and controls your work. But even if you're on salary with a large corporation, you may still need to convince others to fund your project. Raising money can be one of the most arduous and painful parts of making a movie.

How you go about raising money depends on the type of project. A feature film may begin with just an idea (a "concept") or perhaps a *spec script* (speculative—written before a deal is in place). A documentary might begin with an idea, a written proposal or perhaps some preliminary footage. Generally, the more you can set in place before going to a funder, the better your project will look. This is especially important if you don't have an established track record. Thus, you may have an easier time getting a drama funded if a well-known actor agrees to play the lead. Sometimes an endorsement from well-known people helps. On some projects, the producer signs up a group of "advisers" or "consultants" to lend credibility to the proposed project.

Funders—whether they be film studios, broadcasters or foundations—love nothing more than sure bets. They want to minimize their risk by putting money into projects that seem likely to offer a return on their investment (in the case of a foundation, return may be measured not in dollars, but in visibility or community outreach). This is why money tends to go to established producers or to fund projects that resemble previously successful projects (hence the production of Hit Film, the sequel). If you are new to the business, or trying to *do* something new, you will have an uphill battle. In this case, you may find that funders will only support you after the project is fairly far along or has received other backing ("first money" is always the riskiest). You may have to do a lot of legwork without being paid. This could include writing or commissioning a script yourself, or doing substantial research. Sometimes *seed* or *development money* can be obtained to develop the proposal or script, begin serious fund-raising or do other preproduction work. Be aware that receiving development money can sometimes require you to give up some or all ownership or control of the project.

If it's feasible to shoot selected scenes of a drama or documentary, you can often improve your chances by preparing a short *trailer* (coming-attractions promo) or sample reel. Some people put together short excerpts with narration, to describe

the project and pique interest (for a drama, sometimes a slick theatrical trailer is made to give investors a sense of how the film might be marketed). Another approach is simply to edit together a few selected scenes, which may better indicate the movie's style and the director's ability.

Though *you* may have a clear idea of what the project will look like and how great it will be, funders can be stunningly unimaginative when it comes to sharing that vision. Examples are legion of successful movies that collected a thick pile of rejection letters along the rocky road to completion. Often, the same funding sources have to be approached more than once before they say yes. But before you approach *any* potential funder or investor, think hard about whether the project is really ready. Surely there are movies that have been bankrolled by distributors on the basis of an unpolished rough cut; but there are probably far more examples of projects that were shown before they were presentable, and ended up turning off the very people the filmmakers hoped to entice. In a crowded marketplace, you may only have *one* shot at many potential funders.

Commercial Funding

Feature films intended for theatrical release are usually financed by studios, film distributors, investor groups or others who invest in exchange for a share of the film's future earnings. Investor funding is a complex topic; laws governing film investment vary from state to state. If you plan to solicit investors for your project, first consult an attorney familiar both with film investment and tax law. You will need a prospectus that details fund-raising plans, production costs, likely income when the project is done and the plan for returning the backers' money. If only a few backers are needed, perhaps the simplest arrangement is to form a *limited partnership (LP)* or the related *limited liability corporation (LLC)*, in which the investors supply capital and the filmmaker may retain control and responsibility for the project.

Many fiction films and documentaries, especially those by filmmakers with established reputations, are funded wholly or in part by the entities that will distribute the finished product—this may include film distribution companies, broadcast or cable TV organizations, or publishers (for a multimedia project, for example). *Bankable* projects, like the sequel to a successful film, can be presold to distributors to raise production money. Often distribution rights are divided so that one distributor buys domestic distribution rights and another buys foreign markets. Often, independent producers are unable to sell a film prior to production, but may be able to raise completion money after the project is under way if it looks promising.

Television networks or stations may be persuaded by a proposal or script to fund all or part of a project, or they may hedge until the movie is done. Selling a movie prior to production is considered a *presale;* when it's bought after it's done or nearly done, this is considered an *acquisition*. Ironically, television executives generally offer much more money for a movie that has not yet begun—and is therefore a greater risk—than for one that is finished. This may reflect their desire to control and get credit for the project. Completed movies, especially ones without a strong reputation, often face a buyer's market. Single shows are often hard to

fit into a broadcast schedule and they are much harder to promote than a series. Unless your movie fits into the format of a pre-existing series, sometimes it's easier to raise a lot of money for a limited series than it is to raise relatively little money for a single show.

While funding for a movie is being arranged, temporary cash shortages can often be covered by loans from banks and other sources of credit. Many filmmakers get credit from labs and equipment houses to defer these costs. Credit cards have been used to raise cash quickly for starting or finishing a production. The advantage of a credit card is you don't have to convince anyone to give you the money; the disadvantage is the high interest rate you'll pay if you carry the debt for more than a month.

Getting Grants

The funding sources discussed above are generally only available to projects that are likely to earn a profit or find a sizable audience on television or through other distribution channels. Many documentary, experimental, educational and short fiction movies never make a profit (or, in some cases, even recoup their costs); some of them are made with a relatively small, non-mass-market audience in mind. These projects must usually be subsidized by government or private donations. In many countries, there are government-run or private agencies at the national, state/provincial or local level that give grants for production or distribution.

Some grants are given to filmmakers on the basis of their previous work and are not intended to support any particular project. Others are given for specific projects, and the filmmaker's past work is used to determine if he or she is capable of completing the task. Producers with no track record are always at a disadvantage. If you have no relevant prior work to show, consider teaming up with someone more experienced.

Outright or *direct grants* are cash funds for the project. Sometimes grantors require you to "cost-share" by funding part of the budget with your own or others' cash or with in-kind donations of services, materials or facilities (see below). *Matching grants* are given with the stipulation that some money be raised first from *third-party* (outside) sources. A 50 percent match means that the granting agency will give you a dollar for every two dollars you raise from someone else. Often, just the fact that the granting agency has endorsed the project by giving you a grant helps you leverage money from other sources.

For most grants, there is a sizable delay between the time you submit your application and when grant funds are released. Six months or even a year is not uncommon. Plan ahead. As one producer said, "It was three years between the time I conceived of the film and when I was fully funded. By then, I wasn't really interested in shooting it."

Before submitting an application to a granting organization, do your homework and find out what kinds of projects have been funded in the past and what criteria they used to select grantees. If you can, talk to or meet with the agency's staff, both to learn about the organization and so that they know you and your project before the review panel meets. Although the staff usually does not pass judgment on proposals (generally outside reviewers do), they can help in various ways.

When writing a grant proposal, keep in mind that it will be read by panelists who are sifting through many applications; they'll need to understand what you want to do as quickly as possible. Simple, direct and clear prose is important. Most applications require you to summarize your proposal in a paragraph or two (and/or a line or two); be sure to formulate a clear and succinct idea of your project and its goals. Your proposal should be tailored to the guidelines of the agency and the project should be represented in a way that is consistent with their interests.

The budget is a very important part of a grant proposal (see Budgets, p. 534). Read the application carefully to see how the granting agency wants it done.

As mentioned above, granting agencies like to see their money put to good use. Many moviemakers take the attitude that their responsibility ends with making the movie (which is no small thing, since many media grant projects are never completed). However, with many grants you can increase your chances of getting funded if you demonstrate a serious commitment to showing the movie when it's done. The more specific you are (and the more interest in the project you can demonstrate from broadcasters or potential users), the better your project looks.

You are often asked to submit a sample movie when applying for grants. A tight, well-made ten-minute piece is usually better than a long, slowly developing feature. In fact, many panels won't watch more than ten minutes anyway. Find out the viewing procedures and cue up a tape to the best scenes if necessary. You can "set up" the clip with a short, written description.

There are many sources of information on available grants. Search the Internet, or go to your local library for books on granting organizations. The Foundation Center has a network of libraries and clearinghouses that list granting agencies and keep a tally of projects funded in the past. State arts councils often have similar lists. See the Bibliography for suggestions of books, periodicals and Web sites.

When searching for a grant, don't just look at the obvious choices for media-related funding. Sometimes you can get money from sources that don't specialize in media, but who have an interest in topics addressed by your project. There are many private foundations or corporate-giving programs that have a particular focus or local interest. A drug company might give a grant for a medical-related project. A bank might give money for a locally produced project as part of their community support. These funders are often looking to maximize the impact of their investment and the amount of publicity they'll get. Be resourceful and prepare yourself for lots of rejection: given the choice between funding a needed machine at the local hospital and supporting a film or video project, you can guess what many companies will do.

NONPROFIT STATUS. Some grants are only available to nonprofit organizations or indirectly to filmmakers working under the aegis of one. Nonprofit groups in the United States are sometimes referred to by their tax code status $501(C)3$. Nonprofit status doesn't prevent a funded movie from turning a profit. However, the filmmaker must often establish that the primary goal of the project is social, educational or artistic—not just profit.

As mentioned above, commercial filmmakers often create for-profit corpora-

tions solely to produce one movie; this may be for tax or liability reasons. Nonprofit corporations are more difficult to set up. It is usually simpler to affiliate yourself with an existing nonprofit group, which can function as your "conduit" or *fiscal agent* through which to apply for funding. Many organizations will perform this service: film foundations, universities, church groups. Typically, the supporting group will take 5 to 15 percent of the funds raised as a fee, but this is sometimes waived. Often you can apply for state funds in a state where you don't live, as long as you work with a fiscal agent in that state. Try to find a nonprofit group whose goals or mission are related to the project you're proposing.

One advantage of certain types of nonprofit status is that individuals or corporations that support the project may be able to deduct their contribution from their taxes. This factor can be a powerful incentive for wealthy contributors.

Contributions

Resourceful filmmakers (and also desperate filmmakers) are always on the lookout for ways to get goods and/or services donated to a project. Food, air travel, props and labor may be offered by persons or companies in exchange for a tax deduction, a credit in the film or the chance to see a film in production. A company may support a local film to be a good neighbor or, for a larger project, for the advertising. An airline may offer free tickets to a project if a shot of one of their planes is included in the film. (Airlines may supply free stock footage of planes in flight, saving you the cost of getting it from a stock footage library.) For a high-visibility feature film, companies will actually pay the producers to include their products in scenes. (There are *product placement* specialists whose job it is to create such tie-ins. Product placement deals are not allowed for projects made initially for TV broadcast.)

Interns will work on productions for experience or sometimes for college credit. Such production assistance can be valuable to both parties but there are also risks for both: unscrupulous producers often ask too much of unpaid assistants; and, on the other side, free labor often proves the dictum that you get what you pay for.

By putting a notice in the newspaper, you can sometimes get extras to act in crowd scenes for free. It's a good idea to offer them something in exchange for their presence (for example, food and/or entertainment).

Corporate and Sponsored Projects

Many filmmakers earn substantial income (or work full-time) making movies paid for by various corporations. These projects range from in-house training films, to promotional or marketing pieces, to projects about various topics that the company funds as part of its image building. Often, producers will be asked to submit competitive bids to get the job. Be careful of bidding too high *or* too low—a lowball bid may send the message that you're not very good. Producing a project for a corporate bureaucracy can be fraught with the too-many-cooks problem. Be sure to identify who you are reporting to (and who you *actually* need to satisfy, which may be an entirely different person or group). Try to structure the deal with payments at clearly defined intervals (completion of script, completion of shoot-

ing, etc.). It's a good idea to have formal sign-offs at each stage, to certify that the client finds the work satisfactory; you never want to find out after it's too late that they didn't like a choice you made several steps earlier.

LEGAL AND COPYRIGHT ISSUES

Movies, books, musical compositions and other creative works are *copyrighted* so that no one may legally duplicate or use material from the work without permission. When you make a movie, you are granted a copyright to protect your work. If you want to use other people's copyrighted material in your movie (for example, a song or a film clip), you need to obtain permission (a *clearance*). Clearing copyrighted material usually involves getting a signed permission or *license*, and paying a fee.

There are other types of signed permissions or *releases* used to establish that you have the right to use someone's appearance or performance, to shoot at a given location or to tell someone's life story.

Getting required permissions can be a lengthy and expensive process. The permissions themselves may be high-priced, and there may be legal fees and administrative costs in tracking down the rights holders and negotiating a license or other deal. Hollywood studios are often extremely careful to clear all needed rights, and even some that may *not* be needed. Why? They have lawyers on staff and they're looking for maximum protection. If people know you have a lot of money, they may sue you even if they don't have a legitimate claim. Just defending a suit can cost thousands of dollars even if you win.

At the other end of the scale, student and independent moviemakers sometimes don't get the permissions they need, hoping that the chance of litigation is low.

While the need for some permissions is clear-cut, other types of clearances fall into a gray area: even lawyers may disagree about whether they're needed or from whom the permission should be sought. For example, under the *fair use laws*, you may be able to use some copyrighted material without permission (see p. 553). You can't always be sure when fair use covers you. Sometimes lawyers can only offer their opinion. The producer must ultimately make the judgment and take the responsibility.

To compound the problem, while claiming ignorance of copyright or privacy law is no defense for wrongdoing, if you ask for permission for something and are turned down by the rights holder—and then go ahead and use the material anyway—you are in worse legal shape than if you had never asked in the first place. Never ask for permission unless you know you need it.

It's unlikely that anyone will come after you if you put a copyrighted song into a video that you only show privately to friends in your living room. However, as soon as a movie is shown or distributed publicly, especially for a fee, you become vulnerable to a lawsuit if you've used copyrighted material, someone's appearance or a protected life story without permission. If you lose, you'll pay damages and may also be required to re-edit or stop showing your movie. Distributors, TV broadcasters and some film festivals may not accept a movie if the required clearances have not

been obtained. But even prior to distribution, you will probably need to deal with E&O insurers (see below), who will want to see your permissions.

The greater exposure your project gets, and the more money it generates (or the more money *you* have), the greater the chance someone will take legal action, justifiably or not. To protect yourself, consult an entertainment or copyright attorney *before* finishing your movie. For an excellent review of these issues, see Michael Donaldson's *Clearance and Copyright* (in Bibliography).

PROTECTING YOUR WORK

Copyright and Other Protections

When you copyright a movie, the copyright coverage includes dialogue, sound track, music and photography (film/video footage). Neither the title of a movie nor the ideas or concepts contained in it are protected.[2] The broad ideas for plots and settings cannot be owned, but verbatim excerpts of dialogue can be.

Copyright law has evolved in recent years, and some people are familiar with older, now obsolete statutes. According to worldwide copyright agreements, copyright applies to a script or movie as soon as you commit it to paper, videotape or film. This is automatic and immediate and does not require a formal notice or copyright registration with the government (though there are good reasons to register; see below). Sometimes a script is registered prior to casting when the project is in preproduction. Generally, the movie as a whole is registered when it is done.

Another form of protection for scripts and written treatments prior to the making of the movie is to register them with the Writers Guild of America (WGA) script registration service. For a fee, the WGA keeps a copy of your script on file for a period of years. If another project comes out that you feel has plagiarized yours, the registered script can help establish that your material predated theirs. Be sure that the WGA registration is noted on the cover of your script when you give it to people to read.

When trying to get a project started you are often in a catch-22 situation: if you don't tell anyone about the project, you can't generate interest in it; if you do tell, you're vulnerable to people stealing your ideas. When pitching a feature film idea, your ideas are protected somewhat if you are represented by an established talent agency that can help track whom you told your ideas to in case someone later uses them. Even without an agent, you can back up your claims to having pitched ideas for any project by keeping written records of all your conversations and writing follow-up letters after meetings and calls to establish a "paper trail." Whether it will be worth pursuing a lawsuit if you've been wronged is a whole other question.

Registering Your Copyright

As noted above, your work is copyrighted as soon as it exists in tangible form; however, you gain increased protection by registering the copyright. Two steps

[2] While titles can't be copyrighted, they can be restricted on other grounds. A *title search* is done to establish that the title you choose is available for your use.

should be taken as part of the copyright process. First, include a copyright notice in the movie's credits. This is usually something like "Copyright © 1999, [*copyright owner's name*]. All rights reserved." You can also add "[*Your country*] is the first country of publication for purposes of the Berne Convention."[3]

In the United States, to register a copyright contact the Register of Copyrights, Library of Congress, Washington, D.C. 20559. You will fill out an application, pay a small fee and submit a copy of the movie and a written description of it for archiving. You are asked to submit the "best edition" of the work; for a film project, this would normally be a film print, but you may be able to submit a videotape, which will cost you less. Generally, it's a good idea to register the copyright as soon as you finish the movie. For maximum protection, the registration should take place within three months of the date of "publication," which is defined as the first time the film is offered for distribution to the general public, whether by sale, rental or loan. Merely showing the film without offering it for distribution is not considered publication. Showing your film to a distributor is not considered publication. But making copies and offering it to the public is. Your copyright extends only to the aspects of your movie that are original to your production; material in the movie licensed from other copyright holders remains part of *their* copyright.

Errors and Omissions Insurance

Errors and Omissions Insurance (E&O) is a policy that protects producers, distributors and broadcasters from any suits arising from libel, slander, invasion of privacy and copyright infringement claims. It covers legal fees and settlements with a specified maximum per claim as well as a maximum for all claims together. Producers of big-budget feature films may get E&O policies before shooting begins or prior to the film's release. Independents often don't think of E&O at all, especially if there's nothing in the movie that is particularly provocative or risky from a libel or copyright standpoint. However, bear in mind that many distributors and broadcasters will require you to have E&O coverage, and the price of your policy will be partly determined by how carefully you have covered all your legal bases (that is, made sure you have the permissions and clearances you need). Your lawyer can help you through the process and may be asked to sign off that all due procedures were followed. The underwriter of the policy will decide if anything seems risky. Most policies are for three years, figuring that if you haven't been sued by then, you're not going to be. Some policies charge additional fees for every different means of distribution (e.g., festival and/or theatrical, broadcast, home video); try to find one that covers all in one blanket policy.

[3]Sometimes the year is indicated with roman numerals, which makes the date harder to read. Is it possible this convention arose as a way to keep future audiences from knowing how old a movie is?

RELEASES FOR REAL PEOPLE, PLACES AND THINGS

Talent/Appearance Releases

People appearing in movies customarily sign a release in which they give permission for the filmmaker to use and publicly exhibit their picture, sound and/or likeness. There are many versions of a release form (see below) that the actor or film subject signs.

APPEARANCE RELEASE

Person Appearing: _____

Title of Film: _____ (the "Film")

Production Date: _____

Production Location: _____

I authorize _____ (the "Producer"), the Producer's agents, successors, assigns, and designees to record my name, likeness, image, voice, sound effects, interview and performance on film, tape, or otherwise (the "Recording"), edit such Recording as the Producer may desire, and incorporate such Recording into the Film and all related materials, including but not limited to literary, promotion and advertising materials. It is understood and agreed that the Producer shall retain final editorial, artistic and technical control of the Film and the Film content. The Producer may use and authorize others to use the Film, any portions thereof, and the Recording in all markets, manner and media, whether now known or hereafter developed, throughout the universe in perpetuity. The Producer and/or the Producer's successors and assigns, shall own all rights, title and interest, including the copyright, in and to the Film, including the Recording and related materials, to be used and disposed of, without limitation, as the Producer shall determine.

Signature: _____

Address: _____

Date: _____

Social Security #: _____

Put your name or the production company's name as "Producer." For a dramatic, corporate or other project in which the producer hires or arranges for all persons appearing in the movie, the release may be part of an actor's contract. In this case, the release usually starts "For consideration received . . ." If the release is

not part of a contract, it is a simple matter to have people sign a release when they go on camera.

For some documentaries, it is standard practice to have all subjects sign a release. Usually it's a good idea to get the signing out of the way *before* shooting. In some documentary situations, however, it's awkward or impossible to get signed releases from everyone. Though a detailed, signed release is preferred by lawyers, it is also possible to use a shorter, less intimidating version, or even to record a verbal "release" on videotape, audiotape or sync-sound film. Explain to the subjects what your movie is about, how you hope to distribute it (that it may be shown on TV, theaters, home video and other means) and that you're asking for their unrestricted permission to use their appearance. In a group setting, you can explain the project to the group and ask anyone who doesn't consent to let you know or perhaps leave. For concert or crowd situations, sometimes the filmmaker distributes written notices or has an announcement read aloud that states, in effect, that a person's presence constitutes consent to being filmed.

There are certain circumstances in which no releases are needed. If you are filming the public goings-on at a newsworthy event, for example, you have the same right as news photographers to shoot without permission (not, however, for product endorsement; see below). If you secretly shoot someone's intimate sidewalk conversation, however, you may go beyond the limit of the public's right to know.

E&O underwriters and broadcasters want you to get releases, but experts are divided on the actual value of releases for documentaries. If a subject can establish that he has been defamed by your presentation of him, a signed release may not stand in his way of suing successfully.[4] In a privacy infringement case, on the other hand, the mere presence of a camera crew may be sufficient grounds to establish that the subject was aware that what he said or did would be made public. Court precedents in both libel and privacy law are complex and ever-shifting; when in doubt, it's simplest to ask permission before filming or at least to ask those with objections to leave the area.

For all types of productions, you can't use footage of a person commercially to advertise a product or company (or the movie itself) if you haven't got a release and if the release doesn't specifically grant that permission. The release above includes advertising, but some people prefer the legal language that the person appearing waives *right of publicity*. Some actors will not agree to this clause without additional payment. Many of the rules governing other types of releases and licenses have special provisions when the footage will be used for promotion or advertising.

People, Places and Things

Whenever a real person, location or trademarked/copyrighted item is shown or referred to in a movie, there is a chance that someone may object. On feature films, a *script clearance report* is done by combing the script for references to proper names, addresses, business names, radio stations, etc., and checking to see if these

[4]Some releases contain language in which the subject releases the producer from any claims arising from invasion of privacy, defamation, false light and all other rights.

correspond to actual people and places (for example, if there's a character with the same name as a person who actually lives in the city where the script is set). There are research services that can prepare a report for you or you can do it yourself with a phone book, a map and other sources. Avoid using names of living persons, actual phone numbers or auto license plates in the area where the story is set. Be particularly careful with negative references: if the criminals in your movie run the Acme Corporation in Chicago, and there happens to be an Acme in Chicago, the owners may take action against you. It's safer to make up your own names (and avoid last names whenever possible). Private people may give you a written release allowing you to refer to them, but you do not automatically have that right.[5]

You should have a *location release* signed by the owner of any location where you shoot, specifying his agreement that you shoot there and that the location appear in the film. This is particularly important if this is a recognizable business with signs or other visible trademarks. You may be required to replace or not show the signs. When shooting on public streets, parks and other facilities, you generally need city permits as well as an insurance bond (not to mention a police detail to supervise).

Nevertheless, as attorney Michael Donaldson points out, you have a right to make a realistic film, and including product names or trademarks in a scene may be fair game. Generally, *incidental* depiction or reference to a trademarked product is okay, as long as the reference isn't derogátory. But if the item is particularly *featured* either by the way it is filmed or commented on, you should get a written release to do so. As noted above, sometimes manufacturers will *pay* you to include references to their goods.

In documentaries, common practice is somewhat different than what is described above. Many times location releases are not obtained, trademarked objects appear regularly, and people often refer to or comment on other real people. Whenever the movie makes a negative comment that disparages someone, you should be particularly careful. Either make it clear that this is being offered as *opinion* and not fact, or, if it is being presented as fact, try to have at least two independent sources to confirm that it is really true.

USING COPYRIGHTED MATERIAL

Many movies use material previously created by someone else, including stories, music and film clips. These almost always need to be cleared for use. For example, if you want to write a script based on a short story, you need to *option* the story from the rights holder (usually the author, who can be found through the publisher). The option gives you the right to develop the script for a period of time. Usually an *option-purchase agreement* is done, which provides for a comparatively lower fee for the option with a specified higher price paid if the movie actually gets made.

There are a few exceptions when you don't need to obtain clearance to use existing work. One example is work that is in the *public domain*. The most common

[5]"Public" (famous) persons have more limited rights of privacy. Deceased persons have no right of privacy. Their estate *does* retain the right of publicity, to control any advertising related to the deceased. The estate may also control use of film clips showing the deceased.

type of public domain material is work that was never copyrighted (like traditional folk songs) or work for which the copyright has lapsed. Works created in the United States more than 75 years ago are likely to be in the public domain. But mere age or traditional history are not proof of public domain status; renditions or arrangements of the work may have newer, applicable copyrights. A *copyright report* can be obtained from a law firm or done at the Library of Congress to determine public domain status.

Another way that copyrighted material may be used without permission is through the *fair use* provisions of copyright law. Fair use is a murky territory, and many people make a lot of assumptions based on a little knowledge. The idea of fair use is to permit (normally short) excerpts of material for the purposes of scholarship, news reporting and such. The guidelines are somewhat vague. To determine if an excerpt qualifies as fair use, the law considers whether the purpose is "of a commercial nature or is for non-profit educational purposes;" the nature of the copyrighted work; how much of the copyrighted work is excerpted; and the impact of the excerpt on the potential value and market for the copyrighted work.

Never assume that an excerpt you want to use is covered by fair use unless an experienced attorney confirms it.

Clearing Music

Many filmmakers have had the following experience. They know a song that would be *perfect* for their movie. They scurry around, trying to figure out how to get permission to use it. Weeks or months later, they get a response back from the holders of the copyrights. They discover that the song is not available, or, if it is, the fee just happens to be many thousands of dollars more than they have in the budget. Welcome to the world of music licensing.

Clearing music (and movie clips; see below) is one of the thorniest jobs a producer can do. It often requires extensive research, long delays and complex negotiations. If you ever have the experience of trying to clear many songs for a movie, you'll probably never want to do it again. Many filmmakers prefer to hire music clearing services who can shortcut the process with their network of contacts.

If you want to use a pre-existing recording, you'll need to obtain permission to use the musical *composition*, as well as permission to use the particular *recording* of it. Often a publishing company controls rights to the composition and a record company controls the recording itself. Sometimes producers can't afford the recording if it's by, say, a famous rock star. They may license the rights to the composition and get someone else to perform the song.

To secure rights to a composition, start by contacting the publishing company. The Harry Fox Agency (offices in New York and Los Angeles) represents thousands of publishing companies. If they don't handle the composition you want, contact one of the *performing rights societies:* ASCAP (American Society of Composers Authors and Publishers), BMI (Broadcast Music, Inc.) or SESAC (Society of European Stage Authors)—all have offices in New York (ASCAP and BMI are also in Los Angeles). Usually the sleeve for a recording indicates which society the publisher belongs to. The rights society can tell you how to contact the publisher.

To include a musical composition in your movie, you need *synchronization* or *sync*

rights—so named because the music is synchronized to the picture. To perform the music in public, you need *public performance rights*. In the United States, public performance rights for theatrical films are generally included in the deal you make for sync rights; you don't have to pay for them separately. For movies that are broadcast on television, the broadcaster usually obtains the public performance rights. If you want to put out a sound track album from the movie on CD, tape or other format, you will also need *mechanical rights*. If you plan to make significant changes to a song (say, to alter the lyrics) you may need to negotiate *adaptation rights*. Some composers or publishers will not allow you to make such changes.

If you want to use a pre-existing *recording* of the song, contact the owner of the recording—usually the record company (look on the sleeve of a CD for the address). You will need a *master use license* to use the actual recording (performance) in your movie. You should also ask the record company if any *reuse fees* are due the performers on the record. At one time, you would have also needed to arrange to get a copy of the master tape in order to have a high-quality audio dub. Today, you can get the audio recording itself from a consumer CD or other digital format.

So, for the classic situation of trying to clear a recording by an artist you like, you will be requesting (1) a sync license with public performance rights from the publisher and (2) a master use license from the record company. Both of them will ask you to submit a written request that details the nature of your movie, how you plan to distribute it and the way the music will be used. You'll pay more if the song is used under the movie's titles or otherwise featured; you often pay less if it will only be background music in a scene.

How the movie will be distributed (by which *media*), where it will be shown (in which *territories*) and for how long (for what *term*) also affect the price of the license fee. Big-budget feature films generally clear music rights for *all media* (theatrical, broadcast and free cable TV, pay cable TV, home video and formats not yet invented) in *all territories* (domestic and foreign) *in perpetuity* (forever). This "buyout" of all rights is by far the most desirable in terms of simplifying business arrangements; however, you may not be able to afford it. Getting just the rights you need is usually cheaper. For example, students often make a deal to acquire just *film festival rights*. Or you might get *nontheatrical rights;* or theatrical rights to art houses but not first-run movie theaters (see Distribution, below, for more on these terms). Some rights holders will only offer a limited (say, five-year) term. In some license agreements, the term for home video is "in perpetuity," but additional payment must be made per video unit sold. The rights holder will usually have a standard contract for you to sign.

Keep in mind that acquiring rights is a *negotiation*. The rights holder will name a price that may take your breath away; then it's up to you to come back with a lower price. Sometimes they'll consider it, sometimes not. If you're poor and struggling and working on a worthy project, they may make a special exception. If you're too poor (or not part of a reputable organization), sometimes they won't even *talk* to you—it's just not worth their time. If you're negotiating with several rights holders and can find one who offers a lower price, sometimes you can get the others to agree to a lower price too. Often this is done on a *favored nations* basis, which means that for the deal to go through, no one is favored, *all* parties

must agree to the same price. One advantage of using a music clearing service is that they know whom to negotiate with and the standard rates being paid for licenses. You may or may not be able to bargain for a better deal on your own.

Some public broadcasting entities, such as PBS, have blanket agreements and compulsory licenses that may allow you to use music without clearing it with rights holders. This only applies to the television broadcast. You may still need other rights if the movie is shown elsewhere.

Even if the licensing process goes well, it can take months. If a song is integral to the movie (say, if a character sings it), be sure to start as early in preproduction as you can. After the movie is done, you must prepare a *music cue sheet*, which details which compositions you used, the performing rights society and how the music appears in the movie. This is essential for all parties to collect proper royalties.

LIBRARY MUSIC. To avoid all the rights issues mentioned above, you can use prerecorded music from a *production music library*. There are many library collections available. This music is packaged specifically for reuse. You pay an affordable fee usually for each *needle-drop* (a continuous section of a recording used once). The necessary rights come with the fee.

ORIGINAL SCORES. Having an original score written for a movie also avoids most of the headaches mentioned above. When producers have an original score composed, often the producer will own the rights to the music, in which case the music is considered a *work made for hire*. Sometimes the composer will lower his or her fee in exchange for retaining the music rights, in which case the producer must have a license to use the music. If the movie is shown widely on television, or in non-U.S. theaters, there can be sizable royalties paid to the holder of the rights.

Clearing Movie Clips

If you want to use a scene from an existing movie in your film (whether it be a full-screen excerpt or something visible on a TV in one of your scenes), you usually need to get written permission. Clearing clips is much like clearing music, and just as fun. Start by identifying who owns the copyright to the movie you want to use. Sometimes this is the production company, sometimes it is the distributor or television network. Particularly for older films, the film may have been bought and sold several times since it was made. Some companies have a clip licensing department and actively seek deals with licensees like you. Others are extremely protective of their film library, throw up every possible barrier, and may simply refuse you.

As discussed above, you may need to negotiate the fee for the clip. Unfortunately, even after you license the right to use a clip, you may still have to get permission to use various elements *in* the clip. For example, if there is music in the clip, you generally need to obtain separate licenses for it. The musical composition (even if it is just underscore) may be owned by the studio or by the composer; you need to obtain a sync license (see above), usually for a separate fee. Similarly, the right to use the music recording itself (the master use license) may come with the clip, but sometimes you must license *that* separately. Some people choose to license the clip without any music and compose their own if necessary.

If there are actors in the clip, SAG and AFTRA (actors' unions; see p. 539) have regulations governing the "reuse" of actors' performances in union productions. Recognizable actors may need to give consent and be paid; stars may waive their fee. The SAG contract governing films made before 1960 is different, and may allow you to use some clips for certain uses without paying actors or getting permissions if you *billboard* the clip by putting the name of the film on screen or having it said verbally each time a clip is shown. You can avoid billboarding by clearing and paying the talent. Contact a SAG office for details.

The WGA (Writers Guild of America) and DGA (Directors Guild of America) also have regulations governing the reuse of material.

STOCK FOOTAGE LIBRARIES. There are many *stock footage libraries* or *archives* that supply footage to producers specifically for reuse (see Bibliography). These services may specialize in particular types of material, such as sports, historical, nature or news. Usually the fee is determined by the length of the clip and how you plan to distribute your movie (like music rights, you can license rights to many media or only a few). Generally, you pay a small fee to get a selection of possible clips; after you edit your show, you pay a higher rate based on the exact number of seconds you use.

Keep in mind that while the library supplies the clip, you may still need to *separately* clear what's *in* the clip, including music, actors, news anchors and such (see above). Sometimes libraries supply pirated footage for which even the clip *itself* is not cleared and you may risk a lawsuit if you use it without the owner's permission.

DISTRIBUTION

Distribution refers to the process of getting a movie shown to audiences. There are many different ways to bring movies to potential viewers, including theatrical exhibition, TV broadcast, home videos and multimedia. Some movies make use of several distribution channels, some only a few. We will first outline various distribution possibilities, then discuss the process of launching a movie into the marketplace. For a good overview of distributing independent film and video, see Morrie Warshowski's *The Next Step* (in Bibliography).

Theatrical Distribution
Theatrical distribution means showing movies the old-fashioned way: in commercial theaters to paying audiences. Hollywood and independent feature films generally seek theatrical distribution as the first outlet for the movie. Theatrical distribution can be tremendously risky. The costs of advertising, promotion, making prints and running the distribution campaign are high; the chance of making a profit is relatively low. When a studio releases a slate of several films in a year, usually most of them lose money. The one or two "blockbusters" that make huge profits are counted on to carry the other movies. However, a theatrical run plays an important part in raising public awareness about a movie and garnering reviews. A splashy theatrical release will boost the price of the movie when it is later sold to TV or home video. So a money-losing theatrical experience may still be a good investment in the long run.

If you are an independent producer, you have two major hurdles to jump. The first is getting a *distributor*, the second is getting the movie into theaters. Some people choose to *self-distribute*—that is, take on the distributor's duties themselves. Unfortunately, many independently produced feature films never get distributed at all.

What does a theatrical distributor do? Typically, a distributor will *acquire* a movie when it's done or nearly so (sometimes distributors develop projects from script stage or earlier). Often, independent movies are picked up for distribution when they're shown at film festivals. If several distributors are vying for a movie, or if strong profits are anticipated, they will offer a sizable *advance* for the film. This is an advance on royalties—whatever the producer is paid as an advance will be deducted from his share later. For many low-profile films, the advance is small, or even zero. Even if the advance to the producer is low, the distributor should commit to spending a reasonable amount on *P&A* (*prints and advertising*)—the basic marketing costs for the picture.

The distributor then puts together a marketing campaign for the movie. This includes having a poster or *one-sheet* created and designing newspaper *ad slicks*. Typically, a *trailer* (coming attractions reel) is made to be sent to theaters in advance of the movie's opening. TV ads and other promotions may be worked up.

The distributor then goes about trying to *book* the movie into various theaters. The theater owners are the *exhibitors*. Exhibitors often need to be convinced to take a particular independent film. Theaters range from large *first-run chains*, which generally only show mainstream Hollywood product, to smaller *independent theaters* and *art houses*, which may also show a variety of other movies, including smaller, older or foreign films. Independent theaters are currently as endangered as small family farms. Theater chains are often programmed from a central office; independent cinemas may hire *a booker* who selects the movies for several theaters.

Novice producers are often shocked by how much of the income generated by their movie does *not* go to them (more experienced producers aren't shocked, just depressed). The total amount of money paid by audiences buying tickets is the *box office gross*. The exhibitor then takes his share and what's left over goes to the distributor (*total film rental*). There are different types of exhibitor/distributor deals. The common *90/10 deal* gives all the box to the exhibitor until his basic expense (the *house nut*) is paid off; after that, the distributor gets 90 percent and the exhibitor gets 10 percent. In another arrangement, the exhibitor pays the distributor an agreed-on minimum (*floor*) dollar amount, or flat percentage of the box office.

As a ballpark figure for all films, distributors get about half the box office gross. Distributors of independent films may average around 35 to 45 percent of the gross. When you hear that a certain film grossed, say, ten million dollars and cost five million, that movie probably has not broken even when distribution costs are figured in.

But wait—when do you, the producer, get paid? The exhibitor pays the distributor a film rental and then the distributor deducts *his* fee, often around 25 percent. Then all the distribution costs, including advertising, the costs of film prints, and other promotion is deducted. *Finally*, the producer gets what's left over (if anything); this is the *producer's net*. Ouch. A film can gross thousands or even millions of dollars with hardly anything coming back to the producer. This is why it's

so important to get the largest advance up front that you can, and not rely on getting your money from the "back end," which may be nonexistent.

WHICH DISTRIBUTOR, IF ANY. If you're lucky enough to have interest from more than one distributor, you may have a hard choice to make. The advantage of large distributors is that they may pay good advances and can afford substantial P&A budgets. One disadvantage is that if your movie is not immediately doing well at the box office, they may drop your film and go on to the next one. A distributor with a smaller slate of films will usually have less money, but may work longer at trying to keep your film afloat (by trying it in different markets or playing in small venues).

Sometimes filmmakers get no good offers and choose to handle distribution themselves. No one will give your film more TLC than you, but be prepared to put in many months of full-time work. There are several ways you'll be at a disadvantage compared to regular distributors. They know the good theaters in each city and who books them; you will have to figure it out. Distributors can command the best play dates and can sometimes keep a film in a theater even if it's not doing well. Some exhibitors are notorious for not paying up. A distributor can get payment by threatening to pull his next film, which is leverage *you* don't have.

Nevertheless, self-distribution may be the best or only way to get your movie shown. You'll have far more say over how the movie is promoted and you'll get to keep more of the profits. A film shipping house, such as Transit Media (Hohokus, New Jersey 07423), can simplify your work by storing, shipping and inspecting the film prints. You might also consider a *service deal* with a booker or small distributor to handle the booking arrangements for a fee.

One approach sometimes used by both self-distributors and regular distributors is called *four-walling*. Here a theater is "rented" from the exhibitor for a flat fee. Since the exhibitor has no risk, he may take more of a chance on a small film. The distributor then gets to keep the entire box (less the rental fee).

Television

In terms of sheer audience size, no means of distribution even comes close to TV. Even an unpopular, low-rated TV program can garner millions of viewers. Many filmmakers complain, justifiably, that the type of programming found on television is often conservative and fairly uniform but compared with theatrical distribution, TV is a remarkably democratic medium. TV viewers will tune in to many types of programs, including public affairs, documentaries, nature and even dramas that they wouldn't go see in a theater. Cable and satellite broadcasting have widely increased the selection of programming, but ratings and advertising still drive the industry. For viewers to be aware of a program, money must be spent on marketing. In a kind of vicious circle, marketing dollars tend to go only to shows that are expected to draw lots of viewers.

The majority of television programming is either produced by television entities or commissioned by them. If you work for a network or for a regular supplier of programming, then you're aware of the intricacies of getting a new show on the air. If you're an independent producer hoping to sell your movie to television, there are a number of ways to approach it. Start by identifying existing series that

might make a good fit with your movie (whether you have actually produced it yet or not). Some series, particularly on public television, actively solicit proposals and works-in-progress from independents. As noted above, single programs can be awkward to distribute and market on TV—you're almost always better off being part of a series.

Consider working with a television *sales agent*. Sales agents know who the key decision makers are and how much has been paid in the past for shows like yours. Sales agents can be indispensable for foreign television markets, since they generally attend the international TV markets (see below) and have contacts in countries where it would be nearly impossible for you to make inroads.

In the United States, public television (PBS) is one of the chief outlets for independently produced programs. You can work with individual PBS stations as "presenting stations" to the network, or you can go directly to the PBS national headquarters in Washington. Some PBS programming is broadcast on most of the stations around the country on the same date ("hard feed"). Some shows are distributed to stations on an individual basis: each chooses when or if to broadcast the show ("soft feed"). The latter makes promotion much more difficult. APS (American Program Service) programming is soft fed, and may offer more opportunities than national series for independently produced shows. Often the broadcasters and/or the producer have to go out and find *underwriters*, usually corporations, to sponsor the production, acquisition or promotion of a show. Ironically, producers bringing finished films to PBS sometimes find themselves essentially having to raise the money to get the show on the air.

Nontheatrical Distribution

There are many types of nontheatrical distribution, including *educational* (schools and universities), *institutional* (such as libraries and community groups) and *corporate*. This is sometimes referred to as *A/V* (*audiovisual*) distribution.

Many movies and multimedia projects are made expressly for nontheatrical markets. These include educational pieces designed as curriculum aids, training programs, how-to's and the like. Nontheatrical distribution is also a significant aftermarket for movies that have already appeared in theaters or on television. At one time, nontheatrical distribution was done with film prints that sold for many hundreds of dollars; now virtually all movies are distributed on video for substantially lower prices.

Like theatrical distribution, you may choose to work with a distributor or you may self-distribute. Nontheatrical distribution is a specialized business, and some companies do this exclusively. Some theatrical distributors have a nontheatrical division; others contract with a subdistributor to handle this market.

Most nontheatrical distributors have a catalogue of the video and multimedia product that they handle. Distributors have mailing lists of people who have rented or bought similar movies in the past, and they may have a sales force familiar with key personnel in school systems, libraries and corporations. For some distributors, however, mailing out the catalogue once a year is the extent of their marketing effort. Whereas theatrical distributors generally deduct marketing expenses from the producer's share of the income, many nontheatrical distributors

do not deduct expenses. Instead, they pay the producer a flat percentage or royalty for each video sale or rental. The producer might get about 10 to 30 percent of the gross, depending on the deal.

The chief reasons to self-distribute are the potential to make (or keep) more money and the opportunity to do individualized marketing for your movie. Self-distributors generally print up a flyer or brochure and may do a mass mailing to likely buyers, using computerized mailing lists. There are lists available for almost every category of buyer or field of study. For example, you can get a list of all public libraries across the country or teachers in women's studies programs. Your flyer should list awards, reviews and endorsements by people in the field you are targeting. The response rate to a mailing is often only a few percent, but this may be enough to generate a profit.

You should also have a poster made that can be distributed for individual screenings. Many nontheatrical movies are accompanied by study guides or training materials.

To self-distribute in the nontheatrical market, plan to invest several thousand dollars. It can be a full-time job, especially in the first few months of the movie's release. The campaign requires an initial outlay for videos, publicity, business forms, shipping and costs such as festival entrance fees. There is the continuing overhead for telephone and promotional mailings. Those self-distributors who have turned a profit have done so by streamlining the mechanical aspects of scheduling, shipping and billing. Many distributors and self-distributors work with a *fulfillment house* (like Transit Media, see above) that takes the orders, ships the videos and does the billing for a fee. Often, the fulfillment house will have a toll-free phone number to service phone orders.

Certain costs, like advertising, do not increase much for two films instead of one, so it can be cheaper to work with someone who is distributing a similar film. Distribution cooperatives, like New Day Films, help keep costs down by pooling resources.

Home Video and Retail Marketing

Home video distribution refers to selling videos either directly to consumers, to wholesale and retail sales outlets or to video stores that rent videos to consumers. Some movies are made specifically for this market, but when others go "direct-to-video" this is the black sign that they failed to find theatrical or other distribution. The home video market exploded in the 1980s with the proliferation of VCRs. As the twenty-first century develops, satellite and cable "video-on-demand" technologies will likely shrink the traditional home video market. Similarly, the 1990s brought an explosion of multimedia programs distributed on CD-ROMs; increasingly the World Wide Web may be used to deliver these programs electronically with no physical disc changing hands.

Videos are often released into the home video market in two stages. First they're sold for a relatively higher price (often $40 to $150) to video stores, who rent them to customers. This is the *rental price*. After a period of several months, the price is then dropped to a lower level so consumers will purchase videos directly to keep at home (the *sell-through price*). In recent years, there has been

tremendous downward pressure on prices, since Hollywood studios have dumped product on the market for $20 or less. Now consumers are reluctant to spend more than that to buy a video. Keep in mind that if a retail outlet or a fulfillment house sells a video or multimedia title to consumers for $20, the distributor will generally receive about $10 or less. You need to sell a lot of units to make money in this market.

Other Distribution Issues

FOREIGN DISTRIBUTION. Foreign markets can be very lucrative in both theatrical and TV distribution. Starting when you first plan, cast or shoot your movie, try to make it interesting and accessible to a foreign audience. To prepare the movie for foreign distribution, there are several things you need to do. The sound must be mixed to allow for translation in other languages (see The Mix, p. 466). You often need a textless ("generic") version of the movie without any titles (see Titles, p. 359). You will also need a transcript (*continuity*) of the finished program, preferably with timecode references to facilitate translation. You will need video masters in different formats (NTSC, PAL and sometimes SECAM; see Chapters 7 and 17).

MULTIPLE RIGHTS AND REVENUES. Many movies have the potential to make money in several different markets. How the rights to these markets are handled can make a big difference to your bank account.

When selling a movie to a broadcaster, try to hold on to as many rights as you can. If someone commissions you to do a project, and pays the whole bill, she may want all rights to foreign, home video and any subsidiary markets, but you may be able to share in a portion of these markets. If production funds come from several different entities, you're in a better position to retain these rights, which can be very valuable.

If you sell a movie to TV and hope to pursue theatrical distribution, try to get the broadcaster to agree to a theatrical "window" prior to the air date (see below for more on this). On the other hand, if you've already sold to TV before you approach a theatrical distributor, he may be much less interested in your project. Normally, the distributor will want to share in the proceeds from a TV sale; this is one of his main hedges against losing money on the theatrical run. Expenses are usually *cross-collateralized*, which means that any new income, say, from a TV sale, goes first to paying off other accumulated debt before anything is paid to the producer.

LENGTH. The length of a movie can have a big impact on its distribution opportunities. For more, see p. 358.

LAUNCHING A MOVIE

When a Hollywood studio releases a new movie, there is a well-oiled machine ready to distribute and promote it. The studio has access to an established network of contacts for theatrical, television and home video distribution. The studio often has an in-house marketing department experienced in creating advertising cam-

paigns and working with the press. For independent producers, on the other hand, releasing a movie can be a bewildering experience of trying to get attention for it and ultimately find a home with distributors, broadcasters, theaters or other outlets.

Different movies have different goals or needs when it comes to distribution. If you've just finished an independent feature, you might be looking for a distributor, press coverage, a theatrical opening and then aftermarkets of television and home video. But many movies are not intended for theatrical distribution (or just don't get the chance). If you've made a movie intended for TV, you might be looking for a broadcaster (or several in different countries). If your movie has already been bought (or was commissioned) by a TV network, you may only be looking for ways to maximize your press coverage and viewership for the broadcast.

If your movie has the potential to be shown through a variety of distribution channels, it's important to plan the release carefully. When a movie is released to the right markets in the right order and at the right time, exposure and potential profits can be maximized. We will outline the release of a hypothetical feature film in order to highlight some of the distribution options.

Often the first step for an independent movie is film festivals and markets (see below). These are used to raise industry awareness about the movie and get some press (but not *too* much; see below). Distributors attend the major festivals and markets looking for new movies to acquire.

After you sign on with a distributor (or decide to self-distribute), the first commercial release is theatrical distribution. Hollywood films are often released in many cities simultaneously (*wide release*) in order to maximize the effect of advertising and press coverage in national media. Smaller films are often given a "limited release" (also called *platforming*) by playing in a few cities and then spreading out if things go well. Many exhibitors will want to see how a film performs elsewhere before booking the movie themselves. Opening in major cities like New York and Los Angeles can be very expensive (advertising costs are astronomical) and very important (everyone's watching the box office).

The marketplace is crowded with movies and other entertainment options and you don't want your film to get lost. Often, independent films are programmed to open in quiet periods, far from the major summer and winter holiday releases from the big studios. Sometimes small films are *counterprogrammed* by deliberately offering them as an alternative to holiday studio fare. The timing of your release should be planned around getting the most press coverage and attention possible. Theaters generally open movies on Thursday night or Friday. Get as many people as you can to go that *first weekend*, because by Monday morning the theater decides whether to pull your film or, if you're lucky, hold it over.

The next step is home video or perhaps educational video. If a movie has a potential to be used by schools and institutions, it can be released to the nontheatrical market at a much higher price than video stores and consumers will pay for home video. After several months, you then move on to the home video release, first at a rental price and, after that, at sell-through (see above). Some movies are never released on home video. On the other hand, some movies go *directly* to home video after a theatrical run to capitalize on any existing public awareness.

Then there is the television release. Some movies are bought or commissioned

by free (traditional broadcast) networks, others by pay or premium services (cable or satellite). Some movies play on one and then the other. Some TV executives will commission a film and actively encourage a theatrical run prior to the air date (as a way to boost attention and prestige). Others see this as *undermining* their press coverage or prestige and insist on the movie premiering on television. There have been a few notable examples of movies that had a limited TV release on a pay service and then went on to a successful theatrical run, but usually a TV airing means the end of theatrical opportunities. Choosing a good air date (relative to holidays, elections, major sporting events, ratings "sweeps weeks" and such) is very important.

The reason to do home video *prior* to TV is the assumption that people are less likely to *pay* to watch a movie if they can see it for free on TV. On the other hand, for movies that don't get released theatrically, a TV broadcast can help land a home video deal. Some broadcast programs have a *tag* at the end of the show telling viewers how they can buy videos, which can be a good marketing device.

Festivals and Markets

Perhaps the best way to get attention for a new movie is to enter it in a film festival. The top festivals worldwide include Berlin, Cannes, New York, Sundance and Toronto. A large group of distributors, agents and international press attends these festivals, and a successful screening can be a huge boost to a movie. Generating "buzz" can help in many ways. For films that don't have obviously bankable elements like big stars or hot stories, distributors may be influenced as much by *other* people's reactions as by their own. (There's a joke about the studio executive who went to see a movie alone. Afterward, a friend asked him what he thought. He said, "I don't know, I saw it by myself.")

The best festivals are very competitive and often require premieres. (If the film has been shown elsewhere in the same country or sometimes the same continent, you may be disqualified.) You can easily lose the opportunity to play at "smaller" festival while waiting for a bigger one to decide. There are hundreds of festivals around the world, which can provide a fabulous opportunity for you to travel and see your movie with different audiences. Many festivals specialize in particular topics (nature, gay and lesbian, educational, etc.) and festivals often provide a forum for the most interesting discussions about your movie and others.

At one time, there was a clear delineation between *film* festivals and *video/TV* festivals. This distinction is becoming increasingly blurred as projects that originate in either medium can be transferred to the other for festival screenings (see Chapter 17), and many festivals now have both types of projection equipment. Nevertheless, distinctions remain between festivals geared more toward theatrical films and those that accept more television-oriented or nontheatrical fare.

A good source of information about festivals and markets is *The Independent*, published by the Association of Independent Film and Videomakers (see Bibliography).

MARKETS. A film or TV market can be thought of as a festival for industry people where the focus is not on watching and enjoying movies but on selling and buying them. Some film festivals, such as Berlin, have a market associated with

them. One of the chief markets for American independents is the Independent Feature Film Market (IFFM), sponsored by the Independent Feature Project in New York every September. Some markets, such as MIP in France and NATPE in the United States, are primarily for buying and selling television programming.

Though markets don't necessarily accept *any* movie, they are far less selective than festivals. The filmmaker pays a fee, has one or two screenings, and has the opportunity to invite distributors, broadcasters and festival programmers to see the finished movie, a work-in-progress or sometimes to discuss a script or proposal.

Sometimes filmmakers have a *producer's rep* or a TV sales agent to represent the movie and negotiate deals at either festivals or markets. The rep or agent generally has contacts among the potential buyers. Agents and reps have no problem pushing and touting a movie, whereas the people who actually *made* the movie often do. Nevertheless, unless you have a very marketable movie or an established reputation, you may have trouble getting a producer's rep. You may do better to look for offers on your own and use an agent or a lawyer to help negotiate when you actually get a deal.

Anyone who has been to a market knows what a demoralizing experience it can be. The doors to the screening room swing back and forth like an Old West saloon as buyers rush to catch ten minutes of one movie and five of another. A few movies get sold with great fanfare while the other filmmakers are left glumly wondering why they've gotten no offers.

It's very important to remember at both festivals and markets that most movies and careers advance much more slowly than the fantasy of being "discovered" and instantly catapulted to the top. Often, a market or festival will lay the groundwork for a deal, but it may take several months to materialize. Sometimes one festival gets you noticed, but it isn't until the next one that someone comes forward with an offer. The brutal fact is that many films *never* get distributed or even invited to festivals, and you may have to start over again from scratch or consider another career path. Don't be hard on yourself if things don't work out the way you dreamed.

When you go to a market or festival, put your best foot forward by designing an appealing poster and handouts or other materials that pique people's interest. Do your homework and try to determine which distributors or buyers are most appropriate for your project (often you can get the catalogue of buyers in advance of a market, or use the previous year's guide). Find a way to invite the buyers or make them aware of your movie. But treat them with respect. There are stories of aggressive filmmakers who stop at nothing until some executive watches their movie. But this kind of harassment is why many weary buyers and programmers, who see hundreds of movies a year, will do *anything* to avoid having to actually talk to filmmakers. Trust the fact that if your movie is good, people will talk about it, and things will start to happen.

Publicity

Notwithstanding the above, there's nothing wrong with trying to increase the chance that people will know and talk about your movie. It's called *publicity*, and today virtually no theatrical film, TV program or nontheatrical video can be successfully released without it. If you're rich or backed by a large corporation, you can afford to take out ads to increase awareness of your movie. But publicity, in the

form of feature pieces, interviews and reviews, is a lot cheaper and often more ef-fective. There are many types of media available to get the word out, including newspapers, magazines, radio, TV and the Internet. For some movies, the goal is to interest the general public. For some projects, such as a corporate or educa-tional video, your publicity may be targeted at a specific market or industry group.

If you can afford it, hire a *publicist*, whose job it is to bring your project to the at-tention of papers, magazines and broadcast entities that might cover your movie. A professional publicist will have a list of editors, writers and producers to contact. Sometimes publicists are hired for a festival debut, to increase awareness and facilitate getting a distributor. But be careful about overexposing a movie prior to its actual release in theaters or on television. For example, if a newspaper reviews a movie for a festival, it may decide not to run that review again when the movie is released. For general circulation (as opposed to industry-only) media, insist on short "capsule" reviews at festivals, so the full review can be held off till later.

Put together a *press kit*. This should include a synopsis, list of awards, credits and short biographies of the key participants.[6] Some people put several publicity photos in each press kit; others save money by supplying photos only when requested.

The need for good still photos cannot be overemphasized. You should have pictures of the actors in role or, for a documentary, the movie's subjects. Often, frame en-largements made from the movie itself are not high enough quality[7]; have both color shots (generally slides or "chromes") and black-and-white stills taken on the set or during production. Get some shots of the filmmakers as well. Having good still images can mean the difference between a paper running your pictures or not. Offer a few to choose from, since competing media may not want to run the same image. Having compelling images is also essential for the poster and ad campaign.

On many movies, an *electronic press kit (EPK)* is done with video footage show-ing the moviemakers on the set. You will need to supply TV stations with a video reel of clips from the movie for reviewers' use. Be sure to make many copies of the movie (*screening cassettes* or *screeners*) to give to writers and critics. When possible, hold press screenings or invite reviewers to public screenings so they can see the movie with an audience. Some critics prefer to watch videos by themselves.

To improve the chance of a feature piece being done about your movie, empha-size the "hooks" or angles that make your movie special, timely or relevant. Did you lure a famous actor out of retirement? Is your movie about World War II being broadcast on the anniversary of D-Day? Did the film make use of local tal-ent? Is there an incredible story about how the movie got made?

Keep in mind that substantial lead time may be needed between when a feature piece is done and the date it actually appears in print or on the air. Contact editors far in advance. If you're going to be in a city, perhaps for a festival, you can some-times do print or radio interviews and have them "banked" until the movie is actu-ally released.

[6]Reviews may be included as well, but generally not for press kits going to other critics.

[7]Improved digital video formats may change this. For movies shot on film, 16mm frame enlargements are often too grainy; 35mm is much better.

APPENDIX A
ADJUSTING A VIDEO MONITOR

We all watch TV and use computers without much thought about how the screens are adjusted for brightness and color. When making movies, proper adjustment of monitors is critical for evaluating and controlling the image. Adjusting a monitor during playback only affects the way you *see* the picture, it *won't change the actual recording in any way*. However, the adjustment of a monitor, especially monitors used while shooting, affects your ability to make other adjustments that do change the recording.

Start by adjusting the viewing environment. Ideally, monitors should be viewed in a dimly lit room (but not completely dark). Avoid lamps or other light sources that fall directly on the screen. For production work, a hood or shade can be fitted over the monitor when outdoors.

Many TV sets have automatic or "smart" settings for color and brightness; turn these off if you can.

Whenever possible, video monitors should be set up (adjusted) using video that contains SMPTE color bars (see Bars and Tone, p. 404). Setting up without bars is much less accurate and takes longer. Many cameras have color bar generators. When setting up a monitor in an editing or screening environment, use a video source that has standard bars recorded on it (see below).

Some professional monitors allow you to switch to a *blue only* setting, which makes adjustments much simpler. If your monitor lacks such a switch, you can use a blue gel camera filter to approximate the same effect.

Two of the main controls on the monitor are *brightness* (which may be indicated by an icon of the sun) and *contrast* (also called *picture*, and may have an icon of a half moon). Ironically, when you change the "brightness" control your eye perceives this largely as a change in contrast.

Color monitors also have adjustments for *color* (also called *chroma*, *chroma gain*, *saturation*) and *hue* (also called *tint* or *chroma phase*).

An excellent resource for setting up monitors is Joe Kane's *A Video Standard*, which is available on DVD and other formats and includes test patterns, instructions and a blue filter for setting up video and multichannel audio playback.

Set the Black Level
The control labeled "Brightness" on many monitors actually controls the *black level*, which is the value of the darkest black parts of the image. This is a kind of baseline or "ground zero" for video levels.

Start by turning the contrast and color controls down. Then turn the bright-

ness all the way down. Raise the brightness until the black areas in the image just start to turn gray, then lower it slightly. When setting up to SMPTE bars, the lower right corner of the bars has what's called a *PLUGE* pattern consisting of three stripes: one is at black level, one is slightly "blacker than black," one is slightly lighter than black (see Fig. A). Lower the brightness until the two darker stripes merge together, raise it again until you can see three stripes, then decrease it until the darker stripes just merge again.

Fig. A. SMPTE color bars (see also Fig. 14-4).

When brightness is set too low, you lose detail in the blacks (crushed blacks). When brightness is set too high, the blacks look muddy or gray. Some TV sets will not hold a good black when the overall picture is extremely bright or dark.

Set the Peak White Level

The "Contrast" or "Picture" control adjusts the level of the bright whites and midtones. It sets the distance or separation between the black level and the brightest whites. Bring the contrast up until the brightest areas of the picture are comfortably bright, but don't set it so high that the bright areas seem to *bloom* (get fuzzy and larger in size) or other geometrical distortions occur. When setting up to bars, turn the contrast up only until the white bar doesn't get any brighter. Often, setting the contrast will change your black level, so you may have to go back and forth between the contrast and brightness settings a few times.

Set the Color

Be sure any "automatic tint" controls are off and stay off. Color and hue should be set together. They will affect each other, so you may have to do each more than once.

Fig. B. When adjusting color (chroma) on a monitor that displays blue only, these two bars and the patches under them should have the same intensity.

Set up to SMPTE split color bars whenever possible. If your monitor can be switched to display blue only or if you have a blue filter, adjust the color until the outermost bars of the pattern and the small rectangles just below them are matched in intensity (see Fig. B). Adjust the hue until the inner two bars match the rectangles below them (see Fig. C). If you have full-field bars instead of SMPTE split bars, use each adjustment to match the intensity between the two bars in each pair.

Fig. C. When adjusting hue (tint) on a monitor that displays blue only, these two bars and the patches under them should have the same intensity.

If you don't have a way to display blue only, look especially at the yellow and magenta bars (second and fifth from the left). There is only one hue setting in which both will be right. The yellow should be pure, without any hint of green or orange. The magenta bar shouldn't be red or purple. Color level should be rich but not oversaturated.

Getting accurate color without bars is very difficult, since there is no way to know what colors should look like. The best you can do is to go for the most pleasing skin tones. Make the hue and saturation (color intensity) of the skin as natural as possible. Some monitors have a detent or click at the middle position on the setting. Consider this a starting point.

Sharpness

Some monitors have a *sharpness* control (also called *aperture* or *detail*) that adds a light line around the edges of things in the scene. In actuality, this *reduces* fine detail, even though shapes look bolder. Turn this all the way down, then raise it until you *just* reach the point where added lines appear. Get used to watching pictures without added "sharpness."

One exception is that some camcorders have a detail adjustment that can help

you focus while shooting. The picture doesn't look "natural," but you can clearly see what's in and out of focus.

Termination

Some monitors have multiple connectors so you can input and output the signal. These can be used to send the signal into the monitor and then out again to connect to another piece of equipment (the signal is then "looped through" or "bridged"). This way, you can connect several monitors together on one line (such as a waveform, vectorscope and several video monitors).

The last monitor on the chain (or the only monitor if there's only one) needs to be "terminated." Some monitors have a switch labeled "75 Ohm Terminator" or just "75 Ω." Switch to the 75 Ω position to terminate. You can also get a 75 Ω terminator plug to attach to one of the monitor jacks. Don't use *both* a plug and the switch.

APPENDIX B
DEPTH OF FIELD TABLES

See Depth of Field, p. 86, and Depth of Field Charts, p. 92, before using these tables.

This appendix contains two tables. The first is in feet and inches, the second is in the metric system.

To use these tables: (1) Find the lens aperture you are using (expressed as a T-stop) in the Lens Aperture column at upper left. Read across that row to the right until you locate the lens focal length at which you are shooting. This is the column in which the depth of field is indicated. (2) Find the point at which the lens is focused in the Point of Focus column on the left side of the chart. Read across that row to the right until you come to the column you located in (1). These figures indicate the near and far limits of the depth of field as measured from the focal plane. For example (using the Ft. & In. table), at T8, a 100mm fixed focal length lens focused at 10 feet provides a depth of field from 9-0 to 11-4 (that is, 9 feet to 11 feet 4 inches).

This method is used for a $\frac{1}{500}''$ circle of confusion. For $\frac{1}{1000}''$ inch circle of confusion read depth of field two columns to the right. For $\frac{1}{2000}''$, read four columns to the right.

Traditionally, $\frac{1}{500}''$ circle of confusion was used for 35mm filming, and $\frac{1}{1000}''$ was used for 16mm. Video cameras with a $\frac{2}{3}''$ CCD are fairly close to the 16mm image and $\frac{1}{1000}''$ should be usable.

With newer, sharper lenses and film stocks, sometimes a smaller circle of confusion is used. David Samuelson suggests that $\frac{1}{1000}''$ or $\frac{1}{1400}''$ should be suitable for most modern lenses and stocks without any diffusion. Sometimes $\frac{1}{2000}''$ is used for 16mm. Generally, the larger the image will be magnified, the less leeway you have and the smaller the circle of confusion should be. Since 16mm must be magnified more than 35mm to fill the same size screen, a smaller circle of confusion is generally used for 16mm than 35mm.

Depth of field is a geometrical calculation, and the f-stop, a geometrical measurement, should be used for depth of field estimations. These charts were calculated with f-stops but are expressed in terms of T-stops, allowing $\frac{1}{3}$ stop for the difference. For most lenses, using the T-stop with these charts will be fairly accurate. If your lens is not marked in T-stops, using the f-stop will give a slightly stingy figure for depth of field.

Depth of field is not an absolute, and these charts only provide an approximation. Rely more on eye focus than charts, especially for very long focal length lenses or regular lenses at close focusing distances and wide aperture.

Depth of Field Tables: Feet and Inches
Nearest and Furthest Point of Acceptable Focus

Lens Aperture (T-stop) — Lens Focal Lengths in Relation to Lens Aperture (mm)

For ⅟₅₀₀ in. circle of confusion use tables as printed.
For ⅟₁₀₀₀ in. circle of confusion transpose focal lengths two columns to right.

T-stop											
T2				21	25	30	35	42	50	60	70
2.8			21	25	30	35	42	50	60	70	84
4		21	25	30	35	42	50	60	70	84	100
5.6	21	25	30	35	42	50	60	70	84	100	120
8	25	30	35	42	50	60	70	84	100	120	140
11	30	35	42	50	60	70	84	100	120	140	170
16	35	42	50	60	70	84	100	120	140	170	200
22	42	50	60	70	84	100	120	140	170	200	240

Point of Focus Measured from Focal Plane (Feet) — Fixed Focal Length Lenses and Most 16mm Type Zoom Lenses

Point of Focus	N/F											
3-0	Near	1-11½	2-2½	2-4¾	2-6½	2-8	2-9	2-9¾	2-10½	2-11	2-11¼	2-11½
	Far	6-7¼	4-8¼	3-11¾	3-7¾	3-5½	3-3½	3-2½	3-1¾	3-1¼	3-0¼	3-0½
3-6	N	2-2½	2-5¼	2-8¼	2-10¾	3-0½	3-2	3-3	3-3¾	3-4½	3-5	3-5¼
	F	9-3¼	6-0¾	5-0¾	4-5¼	4-1¾	3-11	3-9½	3-8½	3-7½	3-7	3-6¾
4-0	N	2-4	2-8½	2-11¾	3-2¾	3-4¾	3-6¾	3-8	3-9¼	3-10	3-10¾	3-11
	F	15-5	7-9¾	6-2½	5-3½	4-10½	4-6¾	4-4¾	4-3¼	4-2¼	4-1¼	4-1
4-6	N	2-6	2-11¼	3-2¼	3-6½	3-9	3-11¼	4-1	4-2½	4-3½	4-4½	4-4¾
	F	25-2	10-1	7-6¼	6-2¾	5-7¾	5-2¾	5-0	4-10	4-8¾	4-7¾	4-7¼
5-0	N	2-7½	3-1½	3-5¾	3-10	4-1	4-4	4-6	4-7¾	4-8¾	4-10	4-10½
	F	75-0	13-1	9-1	7-3	6-5½	5-11¾	5-7½	5-5¼	5-3½	5-2¼	5-1½
6-0	N	2-10½	3-5¾	3-11	4-4½	4-8¾	5-0½	5-3½	5-5¾	5-7½	5-9	5-9¾
	F	Inf	23-10	13-2	9-7¼	8-3	7-5	6-11½	6-7½	6-5¼	6-3½	6-2½
8-0	N	3-3	4-0½	4-8	5-4	5-10½	6-4½	6-9¼	7-1	7-4	7-6½	7-8
	F	Inf	Inf	30-2	16-2	12-8	10-9	9-10	9-2¼	8-9	8-6¼	8-4½
10-0	N	3-6¼	4-5¾	5-3	6-1¾	6-10¼	7-6¾	8-1½	8-7¼	9-0	9-3½	9-5¾
	F	Inf	Inf	Inf	27-6	18-7	14-9	13-0	11-11	11-4	10-10	10-7
15-0	N	3-11¾	5-3	6-4	7-8½	8-10¼	10-1	11-1½	12-0	12-11	13-5	13-10
	F	Inf	Inf	Inf	Inf	50-0	29-6	23-1	19-11	18-2	17-0	16-5
25-0	N	4-5	6-0¾	7-7	9-7¾	11-7	13-9	15-9	17-9	19-3	20-10	21-11
	F	Inf	Inf	Inf	Inf	Inf	Inf	61-0	42-7	36-9	31-4	29-3
50-0	N	4-10	6-10	8-11	11-11	15-0	19-0	23-0	27-4	32-0	35-7	38-9
	F	Inf	Inf	Inf	Inf	Inf	Inf	Inf	Inf	200-0	100-0	70-0
Inf	N	5-4	7-11	10-9	15-7	21-3	30-3	42-3	60-3	80-0	120-0	170-0

35mm Type Zoom Lenses

Point of Focus	N/F											
5-0	N	3-2	3-7	3-10	4-1½	4-3¾	4-6	4-7½	4-8¾	4-9½	4-10¼	4-10¾
	F	19-9	9-9	7-8	6-6¼	6-0¼	5-7¾	5-5½	5-5¾	5-2¾	5-1¾	5-1¼
6-0	N	3-6	4-0	4-4	4-9	5-0	5-3	5-5¼	5-7	5-8¼	5-9½	5-10
	F	177-0	16-2	10-11	8-7	7-8	7-0½	6-8¾	6-5¾	6-4	6-2¾	6-2
8-0	N	3-11	4-7	5-2	5-9	6-2	6-8	7-0	7-3	7-5¼	7-7¼	7-8½
	F	Inf	94-0	23-0	14-1	11-8	10-2	9-10	8-11½	8-8	8-5½	8-4
10-0	N	4-3	5-1	5-9	6-7	7-3	7-11	8-4	8-10	9-1¼	9-4½	9-6¼
	F	Inf	Inf	70-0	23-1	16-11	13-10	12-7	11-8	11-1	10-9	10-6
15-0	N	4-9	5-11	6-11	8-3	9-4	10-7	11-5	12-4	13-0	13-6	13-11
	F	Inf	Inf	Inf	154-0	43-3	26-11	22-2	19-4	17-10	16-10	16-4
20-0	N	5-1	6-5	7-8	9-5	10-11	12-8	14-0	15-5	16-5	17-5	18-0
	F	Inf	Inf	Inf	Inf	195-0	51-0	35-11	28-10	25-8	23-6	22-6
50-0	N	5-8	7-7	9-7	12-6	15-8	19-10	23-6	28-3	31-2	36-0	38-10
	F	Inf	Inf	Inf	Inf	Inf	Inf	Inf	260-0	120-0	82-6	70-3
Inf	N	6-2	8-8	11-5	16-4	22-0	31-9	43-0	61-7	85-6	125-0	170-0

Depth of Field Tables: Metric
Nearest and Furthest Point of Acceptable Focus

Lens Aperture (T-stop) — Lens Focal Lengths in Relation to Lens Aperture (mm)

For 0.05mm circle of confusion use tables as printed.
For 0.025mm circle of confusion transpose focal lengths two columns to right.

(T-stop)											
T2			21	25	30	35	42	50	60	70	
2.8		21	25	30	35	42	50	60	70	84	
4	21	25	30	35	42	50	60	70	84	100	
5.6	21	25	30	35	42	50	60	70	84	100	120
8	25	30	35	42	50	60	70	84	100	120	140
11	30	35	42	50	60	70	84	100	120	140	170
16	35	42	50	60	70	84	100	120	140	170	200
22	42	50	60	70	84	100	120	140	170	200	241

Point of Focus Measured from Focal Plane (Meters)
Fixed Focal Length Lenses and Most 16mm Type Zoom Lenses

Meters	N/F											
1-0	Near	0-6	0-72	0-78	0-84	0-88	0-91	0-93	0-95	0-96	0-97	0-98
	Far	2-5	1-65	1-40	1-25	1-17	1-11	1-08	1-05	1-04	1-03	1-02
1-2	N	0-72	0-82	0-89	0-97	1-02	1-07	1-10	1-13	1-15	1-17	1-18
	F	4-41	2-30	1-84	1-58	1-45	1-37	1-31	1-28	1-26	1-24	1-23
1-3	N	0-75	0-86	0-95	1-03	1-09	1-15	1-19	1-22	1-25	1-26	1-27
	F	5-37	2-72	2-1	1-76	1-61	1-5	1-44	1-39	1-36	1-34	1-33
1-5	N	0-82	0-94	1-05	1-15	1-23	1-3	1-35	1-39	1-42	1-44	1-46
	F	18-7	3-82	2-69	2-16	1-93	1-78	1-69	1-63	1-59	1-56	1-54
1-7	N	0-87	1-02	1-14	1-27	1-36	1-45	1-51	1-56	1-59	1-63	1-65
	F	Inf	5-54	3-43	2-60	2-27	2-07	1-95	1-86	1-83	1-77	1-75
2-0	N	0-94	1-11	1-26	1-42	1-54	1-66	1-74	1-81	1-86	1-91	1-93
	F	Inf	11-2	4-98	3-4	2-86	2-53	2-35	2-23	2-15	2-10	2-07
2-5	N	1-03	1-25	1-44	1-66	1-82	1-98	2-11	2-21	2-29	2-35	2-39
	F	Inf	Inf	10-2	5-20	4-02	3-40	3-08	2-88	2-75	2-67	2-62
3-0	N	1-07	1-36	1-59	1-86	2-07	2-28	2-44	2-59	2-71	2-79	2-85
	F	Inf	Inf	33-4	8-03	5-51	4-41	3-89	3-57	3-37	3-25	3-17
5-0	N	1-24	1-65	2-0	2-45	2-84	3-26	3-62	3-94	4-22	4-43	4-58
	F	Inf	Inf	Inf	Inf	21-6	10-8	8-12	6-85	6-15	5-75	5-51
8-0	N	1-36	1-87	2-35	3-0	3-6	4-3	4-95	5-59	6-15	6-61	6-95
	F	Inf	Inf	Inf	Inf	Inf	60-0	21-0	14-1	11-5	10-1	9-42
17-0	N	1-147	2-1	2-71	3-62	4-54	5-73	6-95	8-28	9-56	10-7	11-7
	F	Inf	Inf	Inf	Inf	Inf	Inf	Inf	82-0	35-1	25-0	21-0
Inf	N	1-62	2-42	3-29	4-74	6-48	9-22	12-9	18-4	26-0	37-1	52-0

35mm Type Zoom Lenses

Meters	N/F											
1-5	N	0-97	1-08	1-16	1-24	1-3	1-35	1-39	1-42	1-44	1-46	1-47
	F	5-55	2-86	2-27	1-95	1-8	1-69	1-63	1-59	1-56	1-54	1-53
1-7	N	1-03	1-16	1-26	1-36	1-44	1-51	1-55	1-6	1-62	1-64	1-66
	F	13-0	3-94	2-86	2-35	2-11	1-96	1-88	1-82	1-79	1-76	1-74
2-0	N	1-1	1-27	1-39	1-53	1-63	1-73	1-79	1-85	1-89	1-92	1-94
	F	Inf	6-87	4-05	3-04	2-64	2-4	2-27	2-18	2-13	2-09	2-06
3-0	N	1-28	1-53	1-74	1-98	2-18	2-38	2-52	2-64	2-73	2-81	2-86
	F	Inf	Inf	18-9	6-97	5-03	4-12	3-75	3-48	3-33	3-22	3-16
5-0	N	1-47	1-84	2-18	2-61	2-99	3-41	3-72	4-03	4-26	4-46	4-59
	F	Inf	Inf	Inf	Inf	18-3	9-79	7-78	6-64	6-07	5-69	5-49
10-0	N	1-66	2-17	2-68	3-4	4-14	5-05	5-79	6-64	7-32	7-99	8-44
	F	Inf	Inf	Inf	Inf	Inf	Inf	40-4	20-8	15-9	13-4	12-29
20-0	N	1-77	2-38	3-03	4-02	5-12	6-64	8-03	9-8	11-4	13-2	14-51
	F	Inf	Inf	Inf	Inf	Inf	Inf	Inf	Inf	85-2	41-64	32-33
Inf	N	1-89	2-63	3-49	4-99	6-7	9-69	13-1	18-8	26-0	38-0	52-0

APPENDIX C
HYPERFOCAL DISTANCE TABLE

If the lens is focused at the hyperfocal distance, everything from half that distance to infinity should be in acceptably good focus. See Chapter 3 for limitations on the use of hyperfocal distance and depth of field tables.

To use this table: (1) Find the lens aperture you are using (expressed as an ƒ-stop) in the column at left. Read across that row to the right until you locate the lens focal length at which you are filming. This is the column in which the hyperfocal distance is indicated. (2) Find the circle of confusion you are using on the lower left side of the chart. Read across that row to the right until you come to the column you located in (1). This is the hyperfocal distance for the focal length/ aperture combination you are using.

A circle of confusion of 1/1000″ (0.001) is often used for 16mm work (see Appendix B).

Lens Focal Lengths (mm)

f-stop																	
1						9	11	12.5	15	17.5	21	25	30	35	42		
1.4					9	11	12.5	15	17.5	21	25	30	35	42	50		
2				9	11	12.5	15	17.5	21	25	30	35	42	50	60		
2.8			9	11	12.5	15	17.5	21	25	30	35	42	50	60	70		
4		9	11	12.5	15	17.5	21	25	30	35	42	50	60	70	84		
5.6	9	11	12.5	15	17.5	21	25	30	35	42	50	60	70	84	100		
8	11	12.5	15	17.5	21	25	30	35	42	50	60	70	84	100	120		
11	12.5	15	17.5	21	25	30	35	42	50	60	70	84	100	120	140		
16	15	17.5	21	25	30	35	42	50	60	70	84	100	120	140	170		
22	17.5	21	25	30	35	42	50	60	70	84	100	120	140	170	200		

Circles of Confusion

Hyperfocal Distances

0.001in	2ft 6½in	3ft 7in	5ft 3in	7ft 3in	10ft 6in	14ft 9in	20ft 6in	29ft 6in	41ft	59ft	82ft	118ft	164ft	236ft
0.002in	1ft 3in	1ft 9½in	2ft 7in	3ft 7½in	5ft 3in	7ft 4in	10ft 6in	14ft 9in	20ft 6in	29ft 6in	41ft	59ft	82ft	118ft
0.025mm	0.8m	1.1m	1.6m	2.2m	3.2m	4.5m	6.3m	9m	12.5m	18m	25m	36m	50m	72m
0.05mm	0.4m	0.56m	0.8m	1.1m	1.6m	2.2m	3.2m	4.5m	6.3m	9m	12.5m	18m	25m	36m

APPENDIX D
LENS ANGLE/FOCAL LENGTH TABLES

This chart shows the correlation of focal length and lens angle for different formats. The two video columns on the right refer to ½″ and ⅔″ CCD imagers. In larger professional video cameras, ⅔″ CCDs are often used. Some consumer video cameras have CCDs as small as ¼″. It is the *width* of the image being registered on film or on a video CCD that determines the relationship between focal length and horizontal lens angle.

Start by finding the format you are using in the column headings at top. The lens angle or focal length will be found lower down in the same column. To find a horizontal lens angle, find the focal length you are using in the upper left part of the table and read across until you find the column for your format. To find a focal length for a given lens angle, find the lens angle in the lower left part of the table and read across until you find the proper column.

To calculate the vertical lens angle, divide the horizontal lens angle by the first part of the aspect ratio.

You can also use these charts to compare focal lengths between different formats. For example, say you wanted to find what focal length lens you would need to use with a video camera that has a ½″ CCD to match the image produced by a 16mm camera with a 25mm lens. Using the top chart, we see that a 25mm lens in 16mm produces a lens angle of 22°. Using the bottom chart, we see that a 22° lens angle calls for a focal length between 14 and 18mm on the ½″ video camera.

This chart is reprinted by kind permission of David Samuelson and Focal Press from his *Hands-On Manual for Cinematographers* (see Bibliography), which has many useful charts and calculations for image making.

Lens Angle/Focal Length

	Regular 16	Super 16	Acadmy 35mm	Full Frame	Ana-morphic	Vista-Vision	65mm	½″ Video	⅔″ Video

Format

Image Width (Projector aperture)

	Regular 16	Super 16	Acadmy 35mm	Full Frame	Ana-morphic	Vista-Vision	65mm	½″ Video	⅔″ Video
Inches	0.378	0.463	0.825	0.945	0.838	1.418	1.913	.252	.346
mm	9.6	11.76	20.96	24.0	21.29	36.01	48.59	6.4	8.8

Aspect Ratio

	1.33:1	1.66:1	1.37:1	1.33:1	2.35:1	1.5:1	2.2:1	1.33:1	1.33:1

Lens Focal Length (mm) — Horizontal Lens Angle (°)

Lens Focal Length (mm)									
400	1.4	1.7	3	3.4	6.1	5.2	7	.9	1.2
250	2.2	2.7	4.8	5.5	9.8	8.2	11	1.5	2
200	2.7	3.4	6	6.9	12	10	14	1.8	2.5
150	3.7	4.5	8	9.1	16	14	18	2.4	3.3
135	4.1	5	8.9	10.2	18	15	20	2.7	3.7
100	5.5	6.7	12	14	24	20	27	3.6	5.0
85	6.5	7.9	14	16	29	24	32	4.3	5.9
75	7.3	9	16	18	32	27	36	4.9	6.7
50	11	13	24	27	48	40	52	7.3	10
40	14	17	29	33	60	48	63	9.1	13
35	16	19	33	38	68	54	70	10	14
30	18	22	39	44	78	62	78	12	17
27	20	25	42	48	86	67	84	14	19
25	22	26	45	51	92	72	88	15	20
20	27	33	55	62	112	84	101	18	25
17	32	38	63	70	128	93	110	21	29
14.5	37	44	72	79	145	102	118	25	34
10	51	61	93	100	187	122	135	35	47

Lens Angle (°) — Lens Focal Length (mm)

Lens Angle (°)									
1	550	674	1201	1375	2440	2063	2784	367	504
1.5	367	449	801	917	1626	1375	1856	244	336
2	275	337	600	687	1220	1032	1392	183	252
3	183	225	400	458	813	688	928	122	168
4	137	168	300	344	610	516	696	92	126
5	110	135	240	275	488	412	556	73	101
7	78	96	171	196	348	294	397	52	72
10	55	67	120	137	243	206	278	37	50
15	36	45	80	91	162	137	185	24	33
20	27	33	59	68	121	102	138	18	25
25	22	27	47	54	96	81	110	14	20
30	18	22	39	45	79	67	91	12	16
40	13	16	29	33	58	49	67	9	12
50	10	13	22	26	46	39	52	7	9
60	8	10	18	21	37	31	42	6	8
80	6	7	12	14	25	21	29	4	5
100	4	5	9	10	18	15	20	3	4

APPENDIX E

A COMPARISON OF RUNNING TIMES AND FORMATS OF 8MM, SUPER 8, 16MM AND 35MM MOTION PICTURE FILMS

Running Times and Film Lengths for Common Projection Speeds

Film Format	8mm (80 Frames per Foot)				Super 8 (72 Frames per Foot)				16mm (40 Frames per Foot)				35mm (16 Frames per Foot)	
Projection Speed in Frames per Second	18		24		18		24		18		24		24	
Running Time and Film Length	Feet	Frames	Feet	Frames	Feet	Frames	Feet	Frames	Feet	Frames	Feet	Frames	Feet	Frames
Seconds 1	0	18	0	24	0	18	0	24	0	18	0	24	1	8
2	0	36	0	48	0	36	0	48	0	36	1	8	3	0
3	0	54	0	72	0	54	1	0	1	14	1	32	4	8
4	0	72	1	16	1	0	1	24	1	32	2	16	6	0
5	1	10	1	40	1	18	1	48	2	10	3	0	7	8
6	1	28	1	64	1	36	2	0	2	28	3	24	9	0
7	1	46	2	8	1	54	2	24	3	6	4	8	10	8
8	1	64	2	32	2	0	2	48	3	24	4	32	12	0
9	2	2	2	56	2	18	3	0	4	2	5	16	13	8
10	2	20	3	0	2	36	3	24	4	20	6	0	15	0
20	4	40	6	0	5	0	6	48	9	0	12	0	30	0
30	6	60	9	0	7	36	10	0	13	20	18	0	45	0
40	9	0	12	0	10	0	13	24	18	0	24	0	60	0
50	11	20	15	0	12	36	16	48	22	20	30	0	75	0
Minutes 1	13	40	18	0	15	0	20	0	27	0	36	0	90	0
2	27	0	36	0	30	0	40	0	54	0	72	0	180	0
3	40	40	54	0	45	0	60	0	81	0	108	0	270	0
4	54	0	72	0	60	0	80	0	108	0	144	0	360	0
5	67	40	90	0	75	0	100	0	135	0	180	0	450	0
6	81	0	108	0	90	0	120	0	162	0	216	0	540	0
7	94	40	126	0	105	0	140	0	189	0	252	0	630	0
8	108	0	144	0	120	0	160	0	216	0	288	0	720	0
9	121	40	162	0	135	0	180	0	243	0	324	0	810	0
10	135	0	180	0	150	0	200	0	270	0	360	0	900	0

Typical Running Times of Films

Film Format	8mm				Super 8				16mm				35mm	
Projection Speed in Frames per Second	18		24		18		24		18		24		24	
Inches per Second	2.7		3.6		3.0		4.0		5.4		7.2		18.0	
Film Length and Screen Time	Min	Sec	Min	Sec	Min	Sec	Min	Sec	Min	Sec	Min	Sec	Min	Sec
Feet 50	3	42	2	47	3	20	2	30	1	51	1	23	0	33
100	7	24	5	33	6	40	5	0	3	42	2	47	1	7
150	11	7	8	20	10	0	7	30	5	33	4	10	1	40
200	14	49	11	7	13	20	10	0	7	24	5	33	2	13
220	—	—	—	—	14	40	11	0	—	—	—	—	—	—
300	22	13	16	40	20	0	15	0	11	7	8	20	3	20
400	29	38	22	13	26	40	20	0	14	49	11	7	4	27
500	37	2	27	47	33	20	25	0	18	31	13	53	5	33
600	44	27	33	20	40	0	30	0	22	13	16	40	6	40
700	51	51	38	53	46	40	35	0	25	56	19	27	7	47
800	59	16	44	27	53	20	40	0	29	38	22	13	8	53
900	66	40	50	0	60	0	45	0	33	20	25	0	10	0
1000	74	4	55	33	66	40	50	0	37	2	27	47	11	7
1100	81	29	61	7	73	20	55	0	40	44	30	33	12	13
1200	88	53	66	40	80	0	60	0	44	27	33	20	13	20
1600	—	—	—	—	106	40	80	0	59	16	44	27	—	—

Number of Frames Separation Between Sound and Picture

	8mm	Super 8	16mm	35mm
Magnetic Track	56	18	28	28
Optical Track	—	22	26	20

Figures in the table are for reel-to-reel projection in which the sound precedes the picture.

The speed of 25 frames per second is used for 16mm TV films, and increasingly for other 16mm sound films, in 50 Hz countries.

Reprinted by permission of Eastman Kodak.

APPENDIX F
A TECHNIQUE FOR SYNCHRONIZING
THE RUSHES

1. Load the workprint and the mag film in the synchronizer or editing machine. They are usually loaded on the left so that the forward direction is from left to right. For this discussion, we will assume the material is set up in this way.
2. Use the slate or other point of reference as a guide for putting the sound and picture for the first shot in sync with each other (see Slates, Accuracy and Lip Syncing, p. 379). This requires shifting the position of the rolls with respect to each other.
3. Once the first shot is in sync, move the workprint and the mag film backward (to the left) to the head (beginning) of the picture roll. On the right-hand side of the machine cut off any excess laboratory leader on the picture (although if it contains the lab order number for the roll, you may want to leave some of it) and trim the sound roll at the same spot. Splice on about 6' of plain, single-perforated leader on both rolls. Anytime you splice leader or fill onto the sound, make sure it is positioned with the base toward the sound head.

 Continue moving backward onto the leader about a foot or so, and mark a start or head sync mark with a Sharpie at the same frame on both rolls (see Fig. 13-12). At the head of the leaders write your name, the name of the film, the camera roll number and either HEAD PIX or HEAD TRACK on the picture and sound, respectively.
4. Move the picture and sound forward to the end of the first shot. The end can usually be located by the flash frames—overexposed frames that occur when the camera stops between shots. Mark both sound and picture with the number 1 at the same frame.
5. Go forward and sync up the second shot. You will again need to shift the sound and picture relative to each other to accomplish this.
6. After the second shot is in sync, roll the sound and picture backward together to the number 1 you just marked on the picture. Mark a second 1 on the sound at the same frame. Search through the sound roll by hand to find the first 1 you marked on it.
7a. You will usually find the first 1 toward the head of the roll (to the right), which occurs whenever there is more sound than picture (normally the recorder runs longer than the camera). Move both rolls slightly to the

right, and cut the sound from the left-hand edge of one of the frames marked 1 to the left-hand edge of the other (for consistency's sake, always cut on the left-hand edge of a marked frame). Splice the sound roll back together, and hang the wild sound you have just removed on a bin or spool it up on a separate roll.

7b. If you find the original 1 toward the tail (end) of the roll (to the left), this indicates that there is not enough sound to cover the picture (perhaps because the audio recorder started late on the second shot). Cut a piece of leader that is the same length as the distance from the left-hand edge of one 1 to the left-hand edge of the other. Often you can use the editing machine or synchronizer to measure the leader quickly. Splice the leader at the appropriate frame marked 1; this will depend on whether the first or the second shot has insufficient sound. When you have finished, both the first and second shots should be in sync; realign them if necessary.

8. Now go forward to the end of the second shot, and mark it with a 2 on the same frame of both sound and picture.

9. Return to step 5; this time you will be syncing up the third shot, and so on.

10. At the tail of the picture roll, cut the sound at the same spot and splice tail leaders on both rolls, marked as before but with tail sync marks and TAIL PIX and TAIL TRACK written on the leaders.

This method is fast and leaves a string of wild sound of which each piece is marked according to the shot from which it was removed, which helps in identifying it later. If you prefer to leave any wild sound in the sync rolls, you can do so simply by splicing the same length of leader into the picture at the corresponding spot.

APPENDIX G
SPLITTING 16MM AND 35MM MAG
TRACKS PRIOR TO THE MIX

This section is about splitting magnetic film tracks during sound editing in preparation for the sound mix. See Chapter 15 for guidelines on how and why to split tracks. See Chapter 13 for handling mag film tracks. This discussion is strictly about the physical chores involved in dividing up the mag tracks.

Split mag tracks are a little like A&B rolls for printing picture (see Fig. 16-3); on each roll, sections of mag film alternate with sections of nonmagnetic leader that act as spacers. Clean, unshrunken slug or fill, spliced with the mag film emulsion-to-base, is usually used for this purpose.

Before setting up to split tracks, you should have already gone through the film and marked the splices where tracks are to be split (see p. 461 for more on this). Tracks can be split on a flatbed editing machine, but it is far easier to use an editing bench with a synchronizer and rewinds. Put the edited sound track rolls on the left. Also put on the left as many rolls of leader as you will ultimately have tracks. This is limited by the number of gangs on your synchronizer; the rolls may have to be done in two or more groups. It is crucial to load up the picture also so you can check for cutting errors.

Put all the rolls in sync on the synchronizer. At the head of each roll, splice about 15' of single-perf white leader that is properly labeled with production company name, film title, "head" and the track letter (some people identify tracks by number, not letter).

Only on the picture roll, splice a Society of Motion Picture and Television Engineers (SMPTE) head leader between the first frame of picture and the white leader. SMPTE or Society leader (sometimes called Academy leader, which is actually a different system) contains the familiar countdown from 8 to 2, followed by a short section of black leader (see Fig. 16-7). If you can't get SMPTE leader from the lab, you can fake it by marking the proper frames on your own leader. The frame at 8 is marked "Picture Start"; this is a good point at which to synchronize all the rolls. Use a hole punch (available at stationery stores) to punch the same frame on each of the sound rolls. On the 144th frame after the picture start (that is, 3', 24 frames in 16mm, 9' in 35mm) is the 2 frame. This frame should be spliced out on the sound rolls only and replaced with a frame that has a distinctive tone (about 1000 Hz is standard) or, more simply, left in with a stick-on *sync beep* (also called a *sync pop*) applied to the track area. In the United States, the track is

located in the top quarter of the oxide on the side that has no sprocket holes. The European standard has the track in the center of the mag film.

When the film is projected, all the tracks should beep when the number 2 appears on screen, which tells the mixer that all the tracks are in sync, and, if he listens to them individually, that all the tracks are audible. The sync beep is also necessary for lining up the optical track in printing (see Optical Tracks (Analog), p. 503). The first frame of the movie appears on the 192nd frame after the "picture start" frame (4', 32 frames in 16mm, 12' in 35mm).

Mix dubbers run at high tension. Rivas splicers, which use preperforated tape, make stronger splices than guillotines and should be used for the final splicing if possible.

For mixing and printing, films are broken down into segments of convenient length called reels. See Reel Length, p. 375, for more on reel breaks.

If the film will be printed in more than one reel, you may want to prepare 26-frame pullups (for 16mm) while splitting tracks, or you may wait until the mix (see When Reels Are Spliced Together, p. 505.)

At the end of the film, splice on an SMPTE tail leader and put beeps at the tail sync mark on all the sound tracks to be able to check that all the rolls remained in sync throughout the mix. Add about 15' or 20' of white leader after the beeps, which is needed so that the dubbers can be run past the end of the film and then back, and properly label the tail leaders.

Preparing the Picture

Prior to the mix, the workprint should be double spliced and run through a synchronizer or projector to check the splices; with guillotine splicers, the sprocket holes are often incompletely punched out. Many filmmakers make a slop print (a workprint of the workprint) to have a splice-free copy for the mix, since every minute of delay in the mix is very costly. Making a slop print also allows the negative cutter to conform the original to the workprint before the mix is complete.

When doing a cue sheet, indicate the location of sounds by footage count. The footage counter should be zeroed at the "Picture Start" frame on the SMPTE leader. You can usually round off the foot/frame measurement to the nearest quarter foot (for example, in 16mm, 10', 22 frames is about 10.5'). Some mixers will want the footage indicated in 35mm feet (see p. 375 for conversion from 16mm to 35mm footage counts).

APPENDIX H
CEMENT SPLICING

The types of cement splicers are varied, ranging from large foot-operated models to small portable units. Splicers used for acetate-base films use cement to fuse together the overlapping ends of two pieces of film. (For polyester-base films, large, expensive splicers fuse the pieces of film together, generally without the aid of film cement.) Follow the instructions for the particular type of splicer you have and get someone to show you how it works. Before you attempt to splice important material, practice with scrap film until you are proficient. While practicing, test your splices by yanking on them. The film should snap before a well-made splice comes apart. Twisting will make most splices come apart, but will give you a way to compare the comparative strength of test splices.

Hot splicers have a heating element to speed the drying of the film cement, and are faster to use. Since the heating element takes a fair amount of time to warm up, hot splicers are often left plugged in during the whole working day (or, in busy editing rooms, they may never be turned off). However, some editors feel splices made with the heating element on do not last as long. These editors often use hot splicers because of the quality of their construction but use them with the heating element turned off.

The film cement contains a solvent that dissolves film base, and, when dry, will weld together two properly prepared pieces of film. It is important to use a high-quality *fresh* cement. When exposed to air, this solvent evaporates, and the film cement becomes gummy and will no longer make a good splice. To keep the cement fresh: keep a small working supply of cement in a small well-capped glass bottle, and discard the contents every couple of hours. Store the bulk supply (which generally need be no more than a pint bottle) separately.

Keep the splicer clean of emulsion, properly adjusted and the scraper sharp. Acetone will dissolve both emulsion and film cement. You can use it to clean both the splicer and the small bottle that holds the film cement.

To splice: Place the film in the splicer, emulsion side up. Use the scraper to remove *completely* the emulsion and binder from the section of film to be overlapped (see Figs. A and B). Make sure the scraped area is clean and dry before applying the film cement. On some splicers you must moisten the emulsion with water or saliva before scraping, and on others you can dry-scrape. You must also remove magnetic striping (if any) in the area to be spliced, either by scraping or by dissolving it with film cement and wiping it away. When scraping emulsion you must be careful not to scrape too deep and gouge the exposed base (see Fig. E).

Any wax or dirt on the base of the overlapping piece of film (that is, the film to be spliced to the area where the emulsion has been scraped) may interfere with a good weld. To remove any foreign material, wipe with an alcohol-moistened cloth or apply a small amount of film cement and immediately wipe it off with a soft cloth. Some editors also lightly scrape the base on the overlapping piece of film. Again, be careful not to scrape too deeply.

Apply the cement to the area where the emulsion has been scraped in a thin, even layer. *Immediately* press the base of the overlapping section onto the scraped, cement-coated area. Open the splicer, and wipe off any excess cement. Rub the splice firmly with a soft cloth to give added assurance of a good splice. Check that the splice is transparent; hazy areas or bubbles are signs of a poor splice.

A properly made splice can be removed from the splicer after ten to thirty seconds (depending on the type of film cement). A hot splicer cuts the time down to five to ten seconds. Though the film can be projected immediately, the splice cures and becomes stronger over time (two or more hours).

Causes of poor splices include: emulsion or binder not completely removed; excessive scraping weakening the base, causing the film to break; too great a delay in joining the sections of film after applying cement; too much cement, making a messy splice and also possibly causing the film to buckle in the projector gate; too little cement, making the weld too weak; wax or oil not removed from the base of the overlapping film; old or unsuitable film cement.

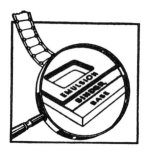

Fig. A. If a small section of motion picture film were to be magnified to a great size, we would see that the film is made up of more than one layer. In the above illustration the thickness of the various layers is exaggerated.

Fig. B. It is impossible to cement the base side of one piece of film to the emulsion of another. The emulsion and binder must first be completely removed so that the two film base surfaces can come in direct contact with each other.

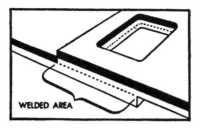

Fig. C. A good motion picture film splice is actually a weld. When a perfect splice is made, one side of the film base is dissolved into the base of the other film. With most splicing apparatus this requires from 10 to 20 seconds.

Fig. D. If any emulsion or binder remains on the base in the area where the splice is to be made, a good weld will not result and the splice may not hold.

Fig. E. Scratching or gouging the prepared film base near the emulsion edge should be avoided. Such scratches (A) weaken the weld and may cause the film to break at this point. Fine abrasive scratches are not serious.

APPENDIX I
CONFORMING FILM ORIGINAL

See Chapters 13 and 16 before reading this section. When you have finished cutting workprint, it should be marked in preparation for cutting the original (see p. 381). The following discussion assumes that the film is loaded on the editing bench on the left side so that forward movement is from left to right.

The work space should be clean and dust-free. Handle the original only with white editing gloves, which are available at most labs. The cement splicer should be properly aligned and used only with *fresh* cement (see Appendix H for more on cement splicing). Never mark the original with a grease pencil; only use India ink or scribe marks (see below). Any black leader used should be fresh and *completely opaque*. The cans in which the original is stored should be marked with the key numbers (latent edge number) so that any shot can be located by number. It is extremely helpful to have two pairs of rewinds. One pair can be used for searching for shots, while the other is used for splicing and, with the aid of a synchronizer, for matching workprint with the original.

Some conformers (also called negative cutters) work by first logging the edge numbers of each shot in the workprint and then culling *all* the shots from a given roll of original at one time. This cuts down on the handling of the original, since each roll does not need to be rewound every time a shot is taken from it. The shots are then put aside (see below) and assembled in proper order when all the shots have been cut. Other conformers work by culling each shot from the original in the order it appears in the workprint. This involves more handling of the original rolls but may reduce confusion. Most conformers find it simpler to first cut all the shots out of the original and then cement splice them rather than trying to do both tasks at the same time.

Place the edited workprint in the front gang of the synchronizer and wind down to the first shot you want to conform until you find the first key number. Lock the shot in place by turning down the lever on the front of the synchronizer. Locate the corresponding shot in the original by its key number and place it in the second gang of the synchronizer in precise frame-to-frame alignment with the workprint.

Unlock the synchronizer and run the two pieces of film back to the head of the shot in the workprint. Mark the frame where the original is to be spliced with *scribe marks*—two small scratches made *outside the picture area* on either side of the sprocket hole where the splice is to be made. Roll both pieces of film to the right slightly until the scribe marks are to the right of the synchronizer. Cut the original with scissors at least a half frame beyond the frame you just marked (which is to the right on most editing setups). This half frame is needed to make the cement

splice. Some people routinely leave a frame and a half extra, which is fine as long as the frames aren't needed for another shot.

Now wind down the workprint and original to the tail of the first workprint shot and scribe the original at the last sprocket hole of the shot. Roll the footage slightly to the left of the synchronizer and again cut the original a half frame longer than the workprint shot.

Some conformers wind up each shot separately (either on a core or around itself) and wrap the last few winds in a piece of paper that identifies the shot by its key number. Sometimes white leader is attached with a very small piece of tape to the head and tail of each shot to protect it. The other widely practiced technique is to tape the shots in a continuous strand on a reel. This is only feasible if the shots have been culled in the order they appear on the workprint. Some people feel this is a poor practice, since tape can damage the original and the gum may be hard to remove. Only low-tack masking tape should be used on the original.

When cutting any shots to be used in a dissolve (which is only possible with A&B rolls unless you plan to use an optical printer), do not forget to cut at the *end* of the dissolve mark on the workprint; that is, the shot should be cut one-half the length of the dissolve longer than where the splice occurs in the workprint (the splice is at the center of the dissolve). On the original, sometimes a small *x* is marked on either side of the sprocket hole at the center of the dissolve (see Fig. 16-4). This should be done outside the picture area on both the A- and the B-rolls, as this helps in aligning the rolls later.

When you are preparing A&B rolls, it is advisable to have a synchronizer with at least three gangs. Begin by preparing the printing leaders as described in Chapter 16 (see Fig. 16-7). Line up the printer start marks in the synchronizer. The SMPTE leader is usually spliced on the head of the B-roll immediately following the white printing leader. Black leader is spliced opposite it on the A-roll and trimmed to the same length (run both strands in the synchronizer to measure where to cut). The first shot of the cut original film is then placed on the A-roll, with black leader spliced on the B-roll opposite it, and so on.

Remember that fades are laid out differently for reversal films than they are for negative films, while dissolves are laid out the same for each (see Chapter 16).

It is imperative that the emulsion of the black leader never be scraped during splicing, as this will defeat the purpose of checkerboard printing—invisible splices. Only scrape the original film on the overlap you left when trimming each shot. The workprint should be run in the third gang of the synchronizer so you can constantly check that you've correctly positioned shots and effects on the A&B rolls. After the rolls are spliced, they should once again be checked against the workprint for cutting errors.

Don't forget to do a cue sheet to instruct the lab concerning fades and dissolves (see p. 487).

See *Cinematography* by Kris Malkiewicz (in Bibliography) for a more detailed description, with illustrations of how to conform original.

BIBLIOGRAPHY

General

Filmmaker. Monthly magazine primarily addressing the concerns of independent feature filmmakers.

The Independent. Monthly magazine published by the Association for Independent Video and Film (304 Hudson St., New York, NY 10013). Contains news and features on all facets of independent production.

Millerson, Gerald. *Television Production.* Boston: Focal Press, 1990. Comprehensive guide to television production techniques. Particularly useful for studio and multicamera productions.

Ohanian, Thomas A., and Phillips, Michael E. *Digital Filmmaking.* Boston: Focal Press, 1996. The use of digital technology in preproduction, production and postproduction. Interviews with industry professionals combined with technical expositions on video and film systems. The authors are developers of the Avid Film Composer and Media Composer and there is much here on nonlinear technology.

Videomaker's Handbook: A Comprehensive Guide to Making Video. Boston: Focal Press, 1996. Assorted articles from *Videomaker* magazine on various aspects of video production. Written for the amateur or others working primarily with consumer or prosumer equipment.

Wilson, Anton. *Cinema Workshop.* Los Angeles: American Cinematographer, 1983. Technical articles on batteries, cameras, sound and light.

Production and Business Aspects

Academy of Motion Picture Arts and Sciences. *Academy Players Directory* (8949 Wilshire Blvd., Beverley Hills, CA 90211). Photographs of actors with agent listings. Regularly updated.

Association of Motion Picture and Television Producers. *Guide to Location Information* (8480 Beverly Blvd., Los Angeles, CA 90048). Regularly updated.

Directors Guild of America. *Directors Guild of America Directory* (7950 West Sunset Blvd., Los Angeles, CA 90056). Lists members of the Directors Guild. Regularly updated.

Donaldson, Michael, C. *Clearance & Copyright.* Beverly Hills: Silman-James Press, 1996. As the cover says: everything the independent filmmaker needs to know. Excellent resource, particularly for feature films.

Goodell, Gregory. *Independent Feature Film Production.* New York: St Martin's Press, 1998. Manual on independent feature film production. Good on unions, casting agencies, budgeting and distribution.

The Hollywood Production Manual (1322 North Cole Ave., Hollywood, CA 90028). Contains guild and union rules and rates. Lists production facilities in the Los Angeles area.

Honthaner, Eve Light. *The Complete Film Production Handbook*. Boston: Focal Press, 1997. Comprehensive guide to production management, including setting up a production office, hiring talent and crews, dealing with unions and releases. Includes specific forms needed for all the business aspects of shooting a feature or TV show.

Motion Picture, TV and Theatre Directory (Motion Picture Enterprises, Tarrytown, NY 10591). Useful lists by category of suppliers of production and postproduction services and equipment. Contains listings of such items as negative matchers, labs and stock footage libraries. Published semiannually.

Russo, John. *Making Movies: The Inside Guide to Independent Movie Production*. New York: Dell, 1989. Various aspects of making a low-budget feature, with "tips and tales" from various filmmakers.

Wiese, Michael. *Film and Video Budgets*. Los Angeles: Michael Wiese Film Productions in conjunction with Focal Press, 1990. Many sample budget forms with detailed explanations of line items.

Writers Guild, *Writers Guild Directory* (8955 Beverly Blvd., Los Angeles, CA 90048). Lists members of the Writers Guild and their agents. Regularly updated.

Film Camera and Lenses

American Cinematographer (P.O. Box 2230, Hollywood, CA 90028). A monthly magazine devoted to camera and lighting techniques. Although it has a strong bias toward large crew production, there are numerous articles on low-budget film and video.

Carlson, Verne, and Carlson, Sylvia. *Professional Cameraman's Handbook*. Boston: Focal Press, 1994. Outlines standard industry practice for the camera crew and describes in detail all the professional 16mm and 35mm cameras.

Hart, Douglas C. *The Camera Assistant: A Complete Professional Handbook*. Boston: Focal Press, 1997. Thorough guide to professional camera equipment and the duties of a camera assistant. A must for people seeking crew work as an assistant.

Malkiewicz, Kris I. *Cinematography*. New York: Van Nostrand Reinhold Co., 1973. Covers most technical aspects of motion picture production. Well-written and well-illustrated. Includes an excellent section on cutting your own negative.

Ray, Sidney F., ed. *Photographic Lenses and Optics*. Boston: Focal Press, 1994.

Ryan, Rod., ed. *American Cinematographer Manual*. Hollywood: American Society of Cinematographers Press, 1993. Camera threading diagrams, 35mm formats and many useful charts. A standard manual for professional cinematographers.

Samuelson, David W. *Hands-on Manual for Cinematographers*. Boston: Focal Press, 1994. Excellent resource for camera threading, lenses, special effects and other aspects. Many useful charts and formulas for optical and film calculations.

Samuelson, David W. *Motion Picture Camera and Lighting Equipment: Choice and Technique*. Boston: Focal Press, 1987. Gives brief descriptions of many camera and lighting techniques, accompanied by clear drawings.

Samuelson, David W. *Motion Picture Camera Techniques*. Boston: Focal Press, 1984. Many techniques and hints while "on the set."

Video Cameras and Other Video Equipment

Beacham, Frank. *American Cinematographer Video Manual*. Hollywood: American Society of Cinematographers Press, 1994. A professional cameraperson's guide to video systems.

Mathias, Harry, and Peterson, Richard. *Electronic Cinematography: Achieving Photographic Control over the Video Image.* Belmont, CA: Wadsworth Publishing Co., 1985. For the cameraperson who wants to understand how a video camera achieves different looks. Technical.

NewMedia. Monthly magazine for multimedia and digital video production. San Mateo, CA.

Poynton, Charles. *A Technical Introduction to Digital Video.* New York: John Wiley and Sons, 1996. For technical people who need to design, build and program—hardware and software—systems that include video.

Videography. Monthly magazine on professional video production, technology and applications.

Ward, Peter. *Basic Betacam Camerawork.* Oxford: Focal Press, 1994. Detailed rundown of Betacam operation and camcorder use in general.

Lighting

Box, Harry C. *Set Lighting Technician's Handbook.* Boston: Focal Press, 1997. Thorough guide to professional lighting gear and techniques. A must for someone seeking employment as gaffer or a lighting assistant.

Malkiewicz, Kris. *Film Lighting.* New York: Prentice Hall Press, 1986. Examines lighting technique through direct instruction and interviews with cinematographers. A good resource for people with basic knowledge looking to improve their technique.

Millerson, Gerald. *Technique of Lighting for Television and Film.* Boston: Focal Press, 1991. Thorough grounding in lighting theory. Less useful for practical setups.

Sound

Forlenza, Jeff, and Stone, Terri, eds. *Sound for Picture: An Inside Look at Audio Production for Film and Television.* Emeryville, CA: MixBooks, 1993. Accessible articles about and interviews with professional recordists and sound editors on how they work.

Huber, David Miles, and Runstein, Robert. *Modern Recording Techniques.* Indianapolis: Sams, Howard W. & Co., 1995. Thorough. Specializes in concerns of studio music recording.

Lyver, Des. *Basics of Video Sound.* Boston: Focal Press, 1995. Accessible guide to microphone and recording techniques for video.

Nisbet, Alec. *The Use of Microphones.* Boston: Focal Press, 1989.

Rona, Jeffrey. *Sychronization from Reel to Reel.* Milwaukee: Hal Leonard Corp., 1990. Accessible yet technical resource on timecode and other recording issues, particularly for the musician working with MIDI and film/video equipment.

Seeberg, Wolf. *Sync Sound for the New Media.* Los Angeles: Wolf Seeberg Video, 1996. Written for the professional recordist. A wonderfully detailed guide to recording sound with different types of timecode, digital audio recorders and when doing music videos or shooting monitors. Available from Wolf Seeberg in L.A. at 310-822-4973.

Film, Exposure and Laboratory

Association of Cinema and Video Laboratories. *Handbook: Recommended Procedures for Motion Picture and Video Laboratory Services.* Bethesda: The ACVL (P.O. Box 34932), 1982. Leader preparation and lab services.

Dunn, Jack F., and Wakefield, George L. *Exposure Manual,* 3rd ed. Hertfordshire, England: H. P. Books, 1981. A thorough discussion of characteristic curves, exposure and exposure problems.

Eastman Kodak Company. *The Book of Film Care.* Rochester, NY: Eastman Kodak Co.,

1992. Covers storage preservation, maintenance, rejuvenation and projection of movie film.

Eastman Kodak Company. *Eastman Professional Motion Picture Films.* Rochester, NY: Eastman Kodak Co., 1992. Technical description of Eastman Kodak professional films and explanations of film data sheets, exposure and lab processes.

Eastman Kodak Company. *Student Filmmaker's Handbook.* Rochester, NY: Eastman Kodak Co., 1996. Guide to film stock and exposure issues.

Fuji Photo Film Co. *Fuji Film Photo Handbook: Photographic Properties of Fuji Motion Picture Films.* New York: Fuji Photo Film.

Happe, L. Bernard. *Your Film & The Lab,* 2nd ed. Boston: Focal Press, 1983. A clear, well-illustrated manual on lab technology and preparing material for lab work.

Hirschfeld, Gerald. *Image Control: Motion Picture and Video Camera Filters and Lab Techniques.* Boston: Focal Press, 1993. Thoroughly illustrated manual showing the effects of different filters, exposures and processing on the image. Written by an experienced cinematographer.

Kallenberger, Richard, and Cvjetnicanin, George. *Film into Video: A Guide to Merging the Technologies.* Boston: Focal Press, 1994. Everything you ever wanted to know about telecines. Very readable but mostly written for colorists-in-training.

Editing

Brown, Steven E. *Videotape Editing: A Postproduction Primer.* Boston: Focal Press, 1993. Technical guide, particularly useful for those interested in working as an online tape editor.

Cohen, Steven J., ACE, and Pappas, Basil. *Avid Media Composer Techniques and Tips.* Available via E-mail at Basil90069@aol.com. Shortcuts and suggestions written by pros for working editors.

Hollyn, Norman. *The Film Editing Room Handbook.* New York: Lone Eagle Publishing, 1998. A guide to the skills needed to be a professional assistant editor. Useful for those seeking employment.

Murch, Walter. *In the Blink of an Eye.* Beverly Hills: Silman-James Press, 1995. Insightful views on editing, from the editor of *Apocalypse Now* and *The Unbearable Lightness of Being.*

Ohanian, Thomas. *Digital Nonlinear Editing.* Boston: Focal Press, 1993. Very technical exposition on the engineering underlying the development of nonlinear editing systems.

Oldham, Gabriella. *First Cut: Conversations With Film Editors.* Los Angeles: University of California Press, 1995.

Reisz, Karel, and Miller, Gavin. *The Technique of Film Editing.* Boston: Focal Press, 1995. A classic text, though a bit pedestrian.

Rubin, Michael. *Nonlinear: A Guide to Digital Film and Video Editing.* Gainesville: Triad Publishing Co., 1995. An excellent overview of how nonlinear editing systems work. Particularly useful for the film editor making the transition to nonlinear.

Distribution

Bowser, Kathryn. *AIVF Guide to International Film and Video Festivals.* New York: The Foundation for Independent Video and Film, 1996. Listing of festivals worldwide. See also the AIVF Web site, below.

Bowser, Kathryn. *AIVF Guide to Film and Video Distributors.* New York: The Foundation for

Independent Video and Film, 1990. Listing of primarily nontheatrical distributors. See also the AIVF Web site, below.

Franco, Debra. *Alternative Visions: Distributing Independent Media in a Home Video World.* Los Angeles: The American Film Institute Press, 1990. Examination of nontheatrical and home video distribution.

Pierson, John. *Spike, Mike, Slackers and Dykes: A Guided Tour Across a Decade of American Independent Cinema.* New York: Hyperion, 1995. Witty and packed with information about producing and releasing independent features.

Warshawski, Morrie, ed. *The Next Step: Distributing Independent Films and Videos.* New York: Foundation for Independent Video and Film, 1995. Well-informed articles on many aspects of distribution. A valuable introduction to the field.

WEB SITES

General

American Film Institute — afionline.org
Wide-ranging resource with links to many sites.

Association for Independent Film and Video Makers — www.aivf.org
Useful resource for independent producers.

eXposure — www.exposure.co.uk
Resource for beginning filmmakers.

Film Maker — www.FilmMaker.com
How to's and links to many sites.

Filmunderground — www.filmunderground.com
Informal advice and resources.

Independent Feature Project — www.ifp.org
Organization for filmmakers, festival programmers and distributors. Hosts annual Independent Feature Film Market in New York.

The Mining Company — http://filmmaking.miningco.com/
Numerous links and resources on many film/video topics.

Industry News and Magazines

Filmmaker Magazine — www.filmmag.com
Articles from the magazine and resource listings.

IndieWIRE — www.indiewire.com
News on independent filmmakers, festivals and releases.

National Alliance for Media Arts and Culture — www.namac.org
Online support for independent media artists.

NewMedia Magazine — www.newmedia.com
Latest digital video and multimedia software, equipment and techniques.

Employment

Crew Net Freelancer's Directory — www.crew-net.com
Film and Television Careers — http://filmtvcareers.com
Interviews and advice.

Mandy's Film and TV Directory www.mandy.com
 Database of film and television producers, technicians and facilities around the world.
 Includes help-wanted listings.
Showbiz Jobsite www.flash.net/~msellars/elguapo.htm
 Includes help-wanted listings.

Film Databases
Internet Movie Database www.imdb.com
 Comprehensive listing of films and credits.
Film Finder www.filmfinder.com
 Database of reviews and recommendations.
Sundance Database www.sundance.org/search.html
 Every film shown at the Sundance Film Festival since 1985.

Other
Global Film and Media Access www.global-film.com
 Database of professionals and companies, with free listings and production forms.
International Entertainment, Multimedia and Intellectual Property Law and Business Network
 www.medialawyer.com
 Legal resource, with information on entertainment, multimedia and property law, and
 with links to other legal and business sites.

Manufacturers and Products
AbelCineTech http://www.abelcine.com
 Aaton film cameras. Rentals, sales, service.
Avid Technology www.avid.com
 Nonlinear editing systems and other digital products.
Coffey Sound http://206.214.38.87/index.html
 Professional audio products and links to other audio sites.
Eastman Kodak http://www.kodak.com/go/motion
 Professional motion picture films, and articles on their use.
Fletcher Chicago www.fletch.com
 Wide range of video and audio equipment, sales and rentals.
Fuji http://www.fujifilm.co.jp
 Professional motion picture films.
Sony Professional Products http://bpgprod.sel.sony.com
 Video and audio equipment.

INDEX

italicized page numbers indicate figures

double-system projectors, *358*, 508
dovetail finders, 62
Dreyer, Carl, 237
drop frame (DF) timecode, 197
dropout compensators, 445
dropouts, 180, 252
drop shadows, 360
dry labs, 497
DTS (Digital Theater Systems) sound, 506
dubbers, *376*, 377, *462*, 463
duplicate negatives, 498–99
dust on the lens, 110
Dutch angle shots, 219, *220*
duvetyn fabric, 324
DV (digital video) equipment, 25–26, *26*, 423
DVD (digital video disc), 28, 34–35
dye couplers, 116
dynamic contrast circuits, 191
dynamic microphones, 249, 262
dynamic range, 246

ear prompters, 243
EBU timecode, 197, 285
edge code, 129–30, *129, 130*, 522
 film editing and, 380–81, *380*
 on workprint, 476
edge fog, 478
edge numbers, *see* edge code
Edison, Thomas, 222
editing, 2, 346
 cutting styles, 349–51
 dialogue editing, 351–53
 editing process, 354–60
 montage theory, 225–26, 346–49
 see also digital nonlinear editing; editing
 film on video; film editing; sound
 editing; videotape editing
editing film on video, 382–83
 error checking, 396–97
 fades and dissolves, 392–93
 matchback and film cut lists, 393–94
 material used for final transfer to video, 390
 shoot film, edit nonlinear, finish on film,
 386–89, *387*, 392
 shoot film, edit nonlinear, finish on
 video, 383–86, *384*, 389, 392
 sound issues, 390–91
 24/30 translation, 394–96
 video assist dailies, 391–92
 working with the negative, *388*, 389
 workprints, 397
editing interfaces, 429–30, *430*
editing logs, 354–55
editorial sync, 486

editors, 354
EDLs (edit decision lists), 30, 398–99,
 410–14, *411, 412*, 418, 420, 486
educational distribution, 2, 359, 559
8mm film, 5, *5*, 6, 579–81
8mm video camcorders, *24*
8mm videotape, 24
eight-plate editing tables, 367, *368*
Eisenstein, Sergei, 348
electret condenser microphones, 262
electricians, 209
electron beam recorders (EBRs), 530
electronic image stabilization (EIS), 240
electronic press kits (EPKs), 565
emulsion, 111
emulsion position, change of, 493
enhancement, 445, 519
equalization, 253, 299, 450, 453
equalizers, 247, 449–50, *450*, 453
erect image finders, 62
errors and omissions insurance (E&O), 549
establishing shots, 214
exhibitors, 557
expeditors, 540
exposure
 backlight and, 144, *145*
 controlling exposure, 147, 150, 174–75
 "correct" exposure, 132–33
 film speed and, 51, 54
 incident light and, 133–35, *134*
 lighting technique and, 340
 over- and underexposure, 149–50
 printing and, 496
 raw stock and, 148–50
 reflected light and, *134*, 135–36
 shutter speed and, 48
 special exposure conditions, 146–47
 video camera settings, 173–75, 188–91, *189*
 see also light meters
exposure index (EI), 117
exposure range and error, 148–49
exposure reports, 475
extension bellows or tubes, 100
extract edit, 434
extra expense insurance, 541–42
extreme close-up shots, 214, *215*
extreme wide angle lenses, 81, *96*
eyepieces, 61–62

facial lighting, 330–35, *331, 332, 333, 334*
fades, *see* dissolves and fades
fair use laws, 547, 553
fast lenses, 99
fast motion, 53–54, 444, 491

microphones (*cont'd*)
 sound quality, 265–66
 stereo recording, 301–3, *301, 302, 303*
 windscreens for, 266–67, *266*
 wireless (radio) microphones, *260,*
 269–70, *269, 270*
middle gray, 135
mired values, 164
mirror shutters, 59–60, *59*
mise-en-scène, 225, 226
mix cue sheets, 466–67, *467*
mixers, 467, *468*
mixes, 447
 arranging for the mix, 467–68
 for foreign release, 471
 level and equalization, 470–71
 mix choices, 468–69
 number of channels, 469–70
 preparing for the mix, 461–67
mixing consoles, *270,* 271, 452–54, *453, 454*
mix studio dubbers, *462,* 463
mix studios, 447, *447*
modulation transfer function (MTF), 122,
 122
modulometers, 290, *290*
monitors, *16,* 17
 adjustment of, 171, 567–70
 composition in, 220–22
 for digital nonlinear editing, 424–25
 shooting, 49, 531–33
 TV sets, comparison with, 170*n*
 video camera viewfinders, 170–71, *170*
 widescreen, *36,* 38
montage theory, 225–26, 346–49
MOS cameras, 56–57
MOS shots, 227
motion control film and video setups, 54
Motion-JPEG compression, 205
motors for film cameras, 56–57
Movie, A, 349
movie clips, copyright regarding, 555–56
moving camera shots, 215
moving-coil microphones, 249, 262
moving image, 3, *4*
MPEG compression, 205–6
M-S method of stereo recording, *302,* 303, *303*
multimedia projects, 2
multiple rights and revenues, 561
Murch, Walter, 355, 356
music, 458–59
 editing, 459–60
 copyright issues, 553–55
 original scores, 555
 recording techniques, 294, 296–98

music cue sheets, 555
music videos, 227, 297–98

Nanook of the North, 5
narration, 298, 353
narrative styles and shooting, 225–29
naturalistic lighting, 335–37
natural perspective, 81
negative cleaning, 499–500
negative costs, 535
negative film, 7, 112–13, *112,* 124–25, 133
negative matching, 481–87, 591–92
negative/tape insurance, 541
neopilot tone, 254
neutral density (ND) filters, 160–61
Newton's rings, 167
nickel-cadmium (NiCad) batteries, 182, 183,
 184–85
nickel-metal-hydride (NiMH) batteries,
 182, 184
night-for-night, 342–43
night scenes, 146
nitrate film, 5
NLEs, *see* digital nonlinear editing
noise floor, 246
noise gates, 451–52
noise reduction units, 256, 503
nonfocusing lights, 316, 318
nonlinear editing, *see* digital nonlinear editing
nonprofit status, 545–46
nontheatrical distribution, 559–60
nontheatrical rights, 554
notch-peak filters, 451
NTSC standard, 18, 50, 195–96, 197
 transfer concerns, 512–13, 527–29,
 530–31
Nyquist, Henry, 200

October, 348
offline editing, 29–30, 399, 406–10, *407*
ohms, 271
Olympiad, 51
OMF media format, 420–21
omnidirectional microphones, *261,* 262,
 262, 264
1A filters, 160
100 percent picture white, 190
180° rule, 216–18, *217,* 350
online editing, *29,* 30, 399, 410–14, *414*
open-ended edits, 407
open-faced spotlights, 316, *317*
optical effects, 15, 490–91
 between sequences, 491
 blowups and reduction printing, 493–95

takes, 214
talent/appearance releases, 550–51
tally lights, 179
tape focus, 90
tape saturation, 288
telecines, 510–11, *511*
 see also film-to-video transfers
telephoto lenses, 81, 99–100
teleprompters, 243, *244*
television distribution, 2, 359, 558–59
test screenings, 357
textless versions, 360
T-grain technology, 123
theatrical distribution, 2, 556–58
35mm cameras, 11, *11*, *62*, *63*
35mm film, 5, *5*, 6, 7, 11, 32–33, 35, 42
 comparison of running times and
 formats, 579–81
35mm release prints, 501
three-point edits, 407
three-point lighting, 328–30, *329*, *330*
three-shot sequence, *347*, 348, 352
threshold of hearing, 246
throw, 508
thumbnails, 428
THX sound system, 506
tilt-focus lenses, *102*
tilts, 229, 233
timbre, 247
time base correctors (TBCs), 445
timecode, 22, *22*, 169, 196
 copying tapes with, 404
 in film-to-video transfers, 520–23
 in-camera (film) timecode, 70, *71*, 284,
 521
 recordkeeping during shooting, 241
 sample rate and, 286
 sound recording and, 283–86, 521
 videotape editing with, 410–13
 video timecode, 196–99
timecode editors, 400–401, *401*
timecode generators, 285, *286*, 404
timecode readers, *520*, 521
timecode slates, 283–84, *284*, 286, 521
time-lapse, 53–54, 445
timelines, 430–31, *430*, *431*
time-of-day (TOD) timecode, 198, 521
timing sheets, 475
titles, 359–60, 443, *444*, 488–90
title searches, 548*n*
TK-32 transfer system, 528–29
tone quality, 247
top light, 309
tough spun, 318

T power, 273
tracking, 99, 233
track shots, 234
trailers, 542–43, 557
Train Coming into a Station, 222
transfer tape, 167
transformers, 345
trim bins, 371–72, *372*
trimming, 372–73, 408, 435–38, *436*, *437*
tripods, 229–31, *230*, *231*, *232*, 233–34
truck shots, 234
T-stop, 85, 139
tungsten-balanced film, 126, 156–57
tungsten-halogen bulbs, 312–13, *317*
tungsten projection, 499, 507
TV cutoff, 220–21
TV lines per picture height, 193
TV safe action area, *58*, 59, 221, *221*
24/30 translation, 394–96
two shots, 214, *215*

ultra-contrast filters, 164
ultrasonic cleaning, 499
U-matic videotape, 24, 35
undercranking, 53
underlighting, 309
underwriters, 559
union labor, 538–39
unit production managers, 209–10
upright editing machines, 367, 369, *369*
user bits (U-bits), 198
UV filters, 160

variable bit rate compression, 206
variable shutters, 48–49, *49*
variable-speed motors, 56–57
vari-burst filters, 164
vectorscopes, 153, *154*, 404, *426*
vertical blanking, 193
vertical interval timecode (VITC), 197
Vertigo, 98
Vertov, Dziga, 237
VHS (video home system) videotape, 23, 35, 36
video assist dailies, 391–92
video assists, 68–69, *69*
video camcorders, 18, *20*, *40*, 168–69, *169*
 operation of, 178–82
 sound recording with, 21–22, 259–61
 see also video cameras; videotape recorders
video cameras, 16–17, *16*
 advanced features, 185–87
 cleaning heads, 180
 collimation, 109
 color video cameras, 18